"Our grandchildren, not u

Peter I, fron ... had with A.D. Menshikov
while building the Petropavlosk Fortress ...

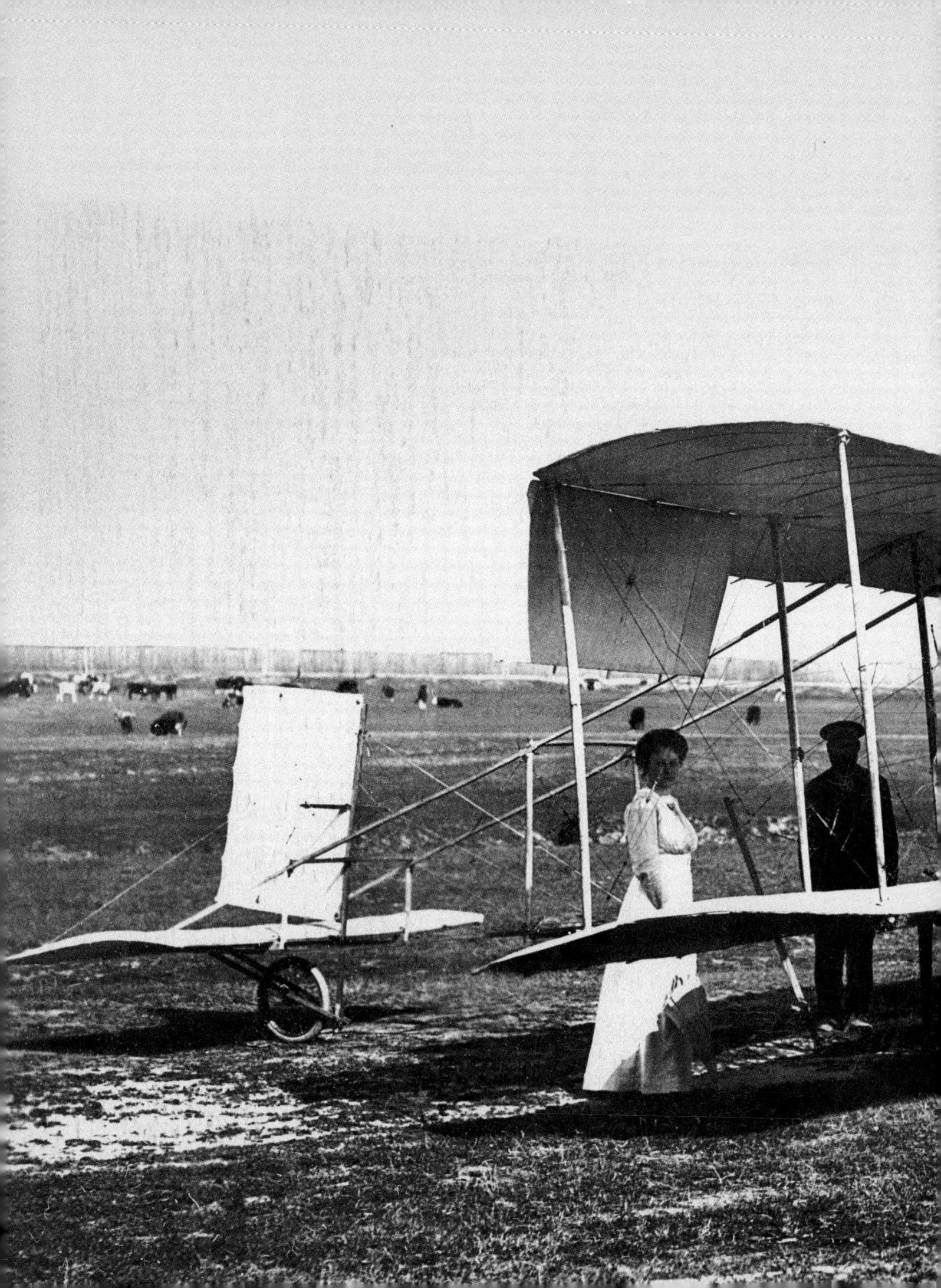

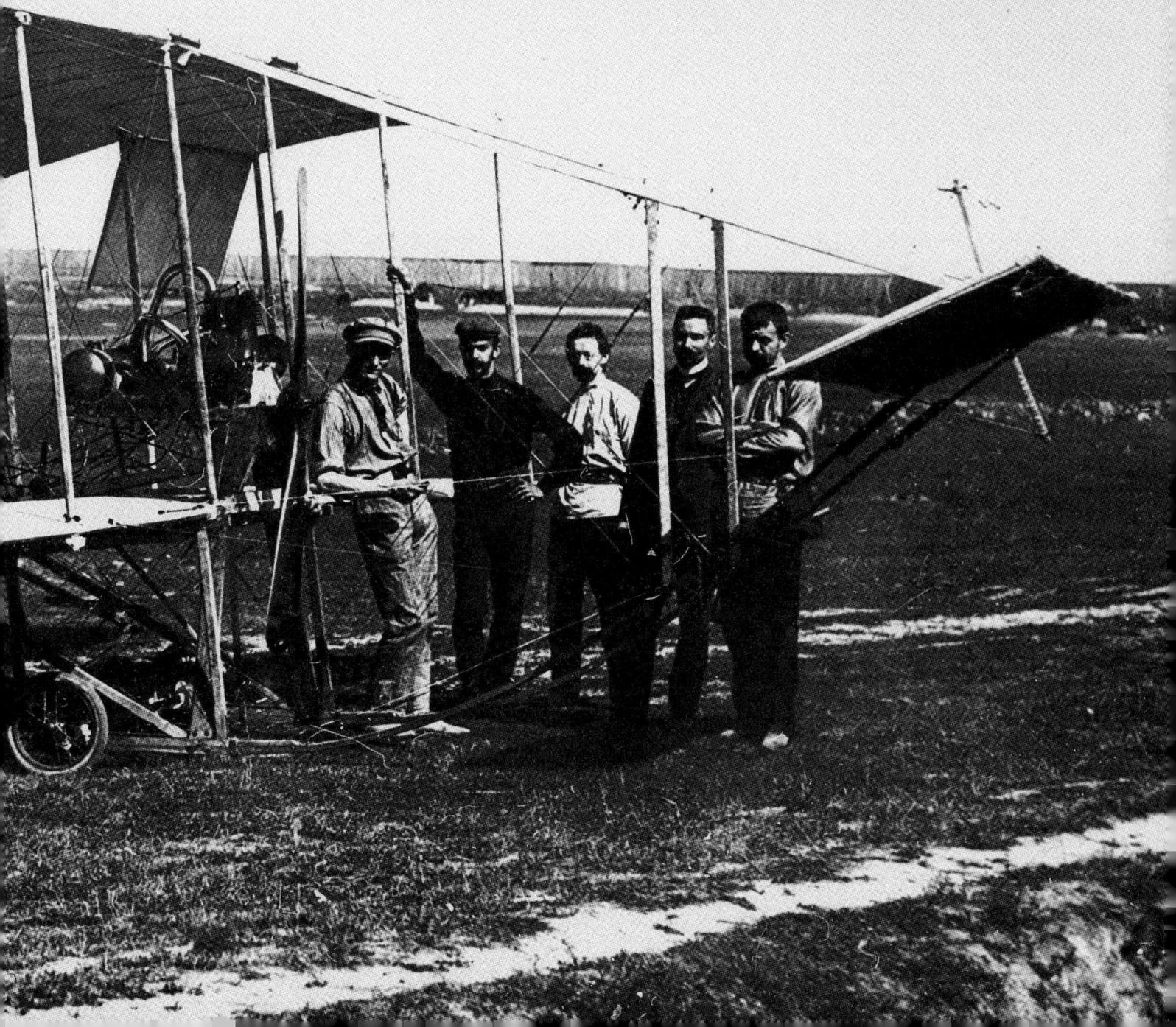

1. The first Russian-built airplane, designed by a graduate of the St. Petersburg Institute of Railway Engineers and a professor at the Kiev Polytechnical Institute Prince A.C. Kudashev (second from the right in the photo) after the first flight. 1910.

Gennady Petrov

IMPERIAL RUSSIAN AIR FORCE

In Photographs at the Beginning
of the Twentieth Century

LIKI ROSSII
ST. PETERSBURG

IMAGES DE RUSSIE
LA BERLIÈRE

UNIFORM PRESS LTD.
LONDON

2013

Petrov, G.F. The Russian Imperial Air Force: In Photographs at the Beginning of the Twentieth Century: Album. - St. Petersburg, Liki Rossii - 264 pgs.

Author-Compiler: *G.F. Petrov*

Head of the Editing-Publishing Group: *E.P. Shelaeva*
Editors: *D.B. Mitiurin, N.I. Deryabina*
Academic Consultants: *V.Y. Krestiyaninov, I.B. Shelaev*
Layout: *N.S. Bandurina*
Desktop Publishing: *N.V. Makarova*
Proofreader: *G.S. Yakusheva*
Preparer of Photographs for Print: *N.S. Bandurina, N.V. Makarova*
Preparer of Indices: *O.R. Mitiurina*
Printed and bound in India by Imprint Digital Limited

This book is dedicated to the pioneers of Russian aviation and aeronautics at the end of the 19th century until 1917.

G.F. Petrov's collection of photo-documents contained here has been a basis for many historical studies, which, however, were never published in an independent edition. Additionally, the photographs from the Central State Archives of Cinematic and Photographic Documents of St. Petersburg and the National Library of Russia were used.

The reader will encounter many rare photographs in this book, which document the first Russian flights in hot-air balloons and airplanes, Russian aviation festivals, the activities of Russian airplane-building factories, the creation of Russian naval aviation, the Russian Air Force's participation in World War I, as well as combat activity of that unique Squadron of "Iliya Muromets" Airships, which was the prototype for future strategic aviation. 409 photographs in all went into this album.

ISBN 978-5-87417-436-1 (Liki Rossii)
ISBN 978-2-36880-003-4 (Images de Russie)
ISBN 978-1-90650-940-8 (Uniform Press)

UNIFORM
PRESS

An imprint of Unicorn Press Ltd www.unicornpress.org

Table of Contents

From the Author

The history of world aviation is considered to have started in 1903, when the American plane designers, brothers Orville and Wilbur Wright, rose in the air in their flying machine.

But when did Russian aviation start? With the creation of the Imperial Pan-Russian Aeroclub (in 1908)? With the first, albeit unofficial flight of a Russian citizen, or the appearance of the first qualified Russian aviator (both having taken place in 1909)? With the first flight in a domestically built plane or the country's first aviation festival (in 1910)?

Every one of these dates has its own «pluses» and one large «minus» - it turns out that the hundred-year jubilee of domestic aviation slipped past modern Russians practically unheeded. How could it hardly stir up any kind of emotions, and only slightly recall those feelings that gripped our ancestors at the beginning of the twentieth century, when the entire country «rooted» for aviation, and the public idols - those dashing pilots - competed against each other to see who could go higher, farther, faster?

In our country today planes are built as usual, aviation festivals take place, aviators continue to use their bravery to delight crowds, though it's true they aren't breaking records as much as making emergency landings.

This is not a very optimistic state of affairs, and the author did not set out to change that, but simply remember... remember that large and important layer of our past, which was buried underneath the relics of the collapsed empire; remember the people, who created a foundation, which survived even under that wreckage, and made a basis for the creation of Soviet aviation, leading straight to modern Russian aviation.

Over the course of many years the author gathered the most varied historical materials on the Russian Air Force, paying particular attention to photographs as sources more demonstrably and impartially factual than any memory of an event.

The author was not dissuaded by the fact that relatively few good illustrated publications dedicated to pre-revolutionary domestic aviation have come out in Russia, especially since wonderful illustrated books are periodically published in the West, detailing the first steps in aviation in France, Great Britain, Germany, the United States, and Italy.

Hopefully, this album of more than 400 photographs portraying the history of Russian aviation at the beginning of the twentieth century will be met with interest by the reading public, and it will be the first in a series dedicated to the equally bright historical events of the Soviet era.

I would like to sincerely thank all who supported this album and helped in its publication, providing both knowledge and photographs: M.A. Maslov, B. I. Stepanov, D.A. Sobolev, D.B. Mitiurin, G.V. Galli, V.V. Petrov, A.A. Demin, V.V. Korol, A.B. Soloviev, D. Griniuk, K.F. Geust (Finland), and N. Eastway (England). Besides photographs from my own personal collection, photo-material in the book also comes from the St. Petersburg State Archive of Film and Photo Documentation, the Photo-archive of the Central Naval Museum, the House of Aviation of M.V. Frunz photo-archive (Moscow), and also from a series of private collections.

The First Attempts at "Flight" in Russia

In Russian folklore there are more than a few legends and stories, wherein the heroes have the ability to fly or use special gadgets for this purpose - either a «flying carpet» or «flying ship». According to legends, strange flying devices («flying horses») were even used during the siege of Tsargrad led by Prince Oleg of Novgorod in 907.

We have also heard of the rare Russian trailblazers, who tried to rise into the heavens. For example, in chronicles written during the reign of Ivan the Terrible (1547-1584) appears the «peasant Nikitka, a slave of the boyar son Lupatov, who flew with homemade wooden wings in the Alexander Settlement, for which he was executed by the Tsar.»

In the middle of the 18th century Mikhail Vasilievich Lomonosov tried to build models of flying machines while he experimented with aerial phenomena. The scientist knew and described the characteristics of hot air rising, and on February 4, 1754, at a conference of the Academy of Sciences he made a presentation about the special «aerodynamic machine» he created that could rise into the atmosphere: a self-registering wind gauge and aerial thermometer. In fact, Lomonosov was on the way to making a small sized helicopter, but he couldn't reach the desired results.

In the last quarter of the 18th century Russia began to receive news more from France about successful flights made in devices lighter than air, especially in aerostats. The Russian consul in France Prince I.S. Baryatinskyi told Catherine II in 1783 about experiments by the brothers Joseph-Michel and Jacques-Etienne Montgolfier and J.Charles. On November 24 of that year, an attempt was made in Russia at flight: in St. Petersburg in the square near the Hermitage a small balloon filled with gas was released into the air. On March 19, 1783, a pilot-less hot-air balloon was also released in Moscow. However, these experiments didn't make the empress enthusiastic for flight, and under the pretext of an excessive fire risk she banned hot-air balloons in 1784 from March 1 to December 1 (nobody wanted to fly in the winter).

In 1786, the French aeronaut Francois Blanchard proposed to make demonstration flights in Russia, but he was refused.

The first flight in Russia in a hot-air balloon took place during the reign of Alexander I. French ballooner Andre Jacques Garnerin invited him on a flight, and on June 20, 1803 in St. Petersburg, the Tsar rose into the air with his wife to a height of 2000 meters in the presence of the royal family and a large confluence of the public. After that followed other flights both in St. Petersburg and Moscow. On July 18 in St. Petersburg the general of the infantry, S.L. Lvov, flew with Garnerin, becoming the first Russian to fly in a hot-air balloon. From the parade grounds of the Cadet Corpus the balloon successfully reached Krasnoe Selo at a height of around 3000 meters. It was obvious that the general participated in

this risky experiment in order to assess the possibilities of using flying machines in military affairs for Alexander I and army command.

The possibilities of flight naturally came to the attention of scientists. In Summer 1804, the St. Petersburg Academy of Sciences organized the first Russian scientific flight in an aerostat, implemented by academician Y.D. Zakharov and Flemish physicist and ballooner E.Z. Robertson.

From then on, the «Moscow Offices» repeatedly reported about domestic enthusiasts' flights in hot-air balloons. Also in 1804, journalists wrote about the first female Russian, Alexandra Turchaninova, making a half-hour flight from Moscow to Tsaritsyn together with Eliza Garnerin. In 1805 at the Neskuchny Gardens the army doctor at the Lefortovskyi Hospital Ivan Kaminskyi flew in a balloon of his own design. In 1828, it was noted that Ilyinskaya - a brave woman and an «uneducated member of the petty bourgeois», - flew in an aerostat of her own design.

In 1869, the first Russian agency for military aeronautics was created under the Main Engineering Department (MED) of the War Ministry - the Commission for Consideration of Questions for Applying Aeronautics for Military Purposes, headed by the hero of the Sevastopol Defensive Engineer-General E. I. Totleben.

The first specialized journal for aeronauts - the «Aeronaut» - also stoked interest in the problem of mastering airspace. It was published from 1880-1883 by the initiative of the military engineer Colonel P. A. Klinder. In one of the first issues appeared a discussion of a project by designer O. S. Kostovich (1851-1916). The project's name used a foreign word - «Aeroscaphe», - meaning «flying ship», as well as the name «Russia». Kostanovich oversaw the construction of the device in 1881 and suggested adding onto it a motor that he designed, though for various reasons he wasn't able to finish the project.

In December 1884 the «Commission for the Application of Aeronautics, Carrier Pigeons, and Watchtowers for Military Purposes» was created, the secretary-recorder keeper of which was Colonel A. M. Kovanko. Already after two months in February 1885 from the conclusion of this Commission the Aeronautical Command was formed, renamed in 1887 to the Training Cadre Air Park. It was situated south of Volkov Village near St. Petersburg (now the area of the Volkov Orthodox Cemetery). A. M. Kovanko gave 33 years of his life to this labor of love. Under his leadership the Training Air Park was recognized as the scientific-technical center of aeronautics in Russia and a real forge of cadres.

Demonstration and test flights undertook the task of popularizing aeronautics in various Russian cities. The first free flight of military aeronautics in Russian history (under the direction of Lieutenant A. M. Kovanko and Second Lieutenant A. A. Trofimov with French ballooner G. Rudolfi) took place on October 6, 1885. Having risen to a height of 2250 meters and staying in the air around five hours, the aeronauts successfully landed in the surroundings of Novgorod.

On August 7, 1887 in Klin, Dmitry Ivanovich Mendeleev rose into the air in a hot-air balloon, and his support meant a lot for the development of aeronautics. He manned the balloon Russian during a total solar eclipse for three hours and 36 minutes. Flying 120 km D. I. Mendeleev made observations of the sun (by rising above a cloud) and landed not far from the city Kalyazina.

The names of such talented enthusiasts of this new undertaking forever remained in the history of Russian aeronauts: M. A. Ruikachev, N. E. Zhukovskyi, S. A. Chapluigin, S. K. Dzhevetskyi, V. D. Spitsin, A. F. Mozhaiskyi, and K. E. Tsiolkovskyi.

In May 1890, after approval of the Provisions about Aeronautical Part and Founding of the Training Aeronautical Park, a new era started in mastering airspace in Russia - a school appeared for preparing military cadres for aeronautics.

At the beginning of the twentieth century the military began to be more interested in flights managed aerostats - dirigibles, as well as those heavier air flying devices the airplanes.

It is agreed that the history of airplanes in Russia start in the 1880s with A. F. Mozhaiskyi's flying device with full-size steam propulsion. Tests of the device took place in June 1883 near Dudergof Station not far from Krasnoe Selo. The question of whether it actually flew remains unanswered. Nevertheless, it is obvious that this event was a great historical milestone, as Mozhaiskyi managed to predict many design solutions, which today are considered classic.

At around the same time in the 1880s, numerous studies began to take shape in the area of aerodynamics. Thanks to N. E. Zhurkovskyi the world's first specialized institute of aerodynamics was founded in 1904 in Russia.

The real impulse of aviation and construction of planes in different countries was made by the success of the Americans, the brothers Wilbur and Orville Wright, who carried out the first manned horizontal flight on their plane the Flier-1. The Russian government, however, did not immediately appreciate the possibilities of this invention, focusing instead on creating aerostats. This period was characterized in Russia by more organized actions and demonstration flights of visiting aviators.

In January 1908, the Imperial Pan-Russian Aeroclub (IPAC) was established in St. Petersburg, which had already been founded in

Odessa. The first point in the charter concerned the promotion of aeronautics in Russia in all its forms and in different applications, predominatly scientific-technical, in the military, and in sport. An aviation school was also organized at the Aeroclub, and the plane Farman was purchased. At the same time, club members V. A. Lebedev and A. E. Paevskyi were sent to France for training.

However, they were not the first Russians to fly in planes, but two officers - N. I. Uteshev and S. A. Nemchenko - detached to France in connection with construction of a new aerostat. In December 1908, both flew over Paris as passengers with the Wilbur Wright.

The first subjects of the Russian Empire to fly by themselves in a plane was, probably, the member of the Odessa Aeroclub A. A. van der Skruf. On July 20, 1909, he managed to fly about 300 meters in the plane Brazen acquired by the Aeroclub from France. However, when he tried to repeat his achievement before a special commission, his plane broke apart during takeoff.

The first Russian pilot to receive a diploma (as well as eighth in the world) was Count Charles (Karl Karlovich) Lambert, a Russian descendent of French knights and royal musketeers. The Official Pilots License, No. 8, was given to Count Lambert by the French Aeroclub on October 7 (20 by the Julian calendar) 1909.

In 1909, M. N. Efimov was sent to Europe to master aviation knowledge at the expense of Odessa banker Ksidias. Efimov became the second certified Russian pilot, receiving a «breve» (pilot 's diploma) on February 15, 1910. At the French Aeroclub, No. 31. After returning home, Efimov made a flight under direction from the Odessa Aeroclub on March 7, 1910, and on the next day he repeated it for everyone in Odessa.

The third certified Russian pilot was the Moscow native Nicholai Evgrafovich Popov, who received a «breve» from the French Aeroclub, No. 50. The third and fourth places on the list of Russian pioneer aviators were taken by the above-mentioned V. A. Lebedev and A. E. Paevskyi from the St. Petersburg IPA (becoming the first Russian flight instructors upon their return). Another Odessan stands out from that list, the former racing cyclist S. I. Utochkin, who was actively flying in Spring 1910, but did not receive his certification from the Imperial Pan-Russian Aeroclub until January 1911.

1910 was an important year for Russian aviation. On March 6, the decision was made about creating an air force fleet. The realization of this, as it was described founding document, followed these points:

a) «training officers of the army and navy, and, if resources allow, other personnel to fly in heavy air devices;

b) the creation of a fleet of planes with a full supply of equipment, fully capable of using them, according to the rules of the army and naval ministries and aviation squadrons.»

At the end of March, after military aviator Lieutenant S. F. Dorozhinskyi, certain officers were sent to France for training as motorist-mechanics: Captains L. M. Matsievich, S. A. Uliyanin, M. M. Zelenskyi; Staff Captain B. V. Matuievich-Matsievich, Lieutenant G. V. Piotrovskyi, Lieutenant M. S. Komarov and a few non-commissioned officers. All told, in the prewar years about 250 people were sent abroad for training and internships.

In Russia pilot training took place at a few institutions: the Officers Aeronautical School, founded in Gatchin in 1910; the Sevastopol School (founded in 1910 as well); the Aeroclub Schools in St. Petersburg, Moscow, Kiev, Odessa, Tiflis; and the theoretical aviation courses at the St. Petersburg Polytechnical Institute and Moscow Higher Technical Institute. Naval pilots trained in St. Petersburg, at the School of Naval Aviation, in Baku and Sevastopol, as well as at the Krasnoe Selo School of Higher Piloting and Air Battles. In all there were 17 training institutions at the time in Russia for flying cadres.

Also in 1910, 11 flying devices were ordered in France. The idea for aviation exhibitions came from there as well. In September 1909, in the halls of the Elysee Palace in Paris was the first international aviation exhibition to commemorate Louis Blerio's flight over the English Channel in a plane of his own design. The latest developments in aeronautics and aviation were displayed at the exhibition: air-balloons, manned aerostats (dirigibles), planes (completed models and those in development), and various motors. Subsequently in 1910 from April 25 - May 2 in St. Petersburg was held the First International Aviation Week - a large aviation festival, demonstrating the possibilities of aviators and planes. Similar events continuously took place in various cities across the Russian Empire until World War I.

In 1910 the first Russian plane designers also appeared: A. S. Kudashev, I. I. Sikorskyo, and Y. M. Gakkel. The first company for building series of planes for aviation schools and aeroclubs was the «First Russian Association of Aeronautics», created in 1909 (after 1910 it had the same name as a mechanical factory). There updated planes of the Farman IV type were prepared and renamed Russia-A; on the basis of this widely-known plane L. Blerio developed the plane Russia-B.

Grand Duke Alexander Mikhailovich stood at the head of military aviation, paying a lot of attention to and worked for the development of airmanship. According to him, as he was quoted in 1913 in one of the issues of the journal «The Air Force - the Strength of Russia», Russia at that moment occupied the second place in the world, after France, for developing an air force.

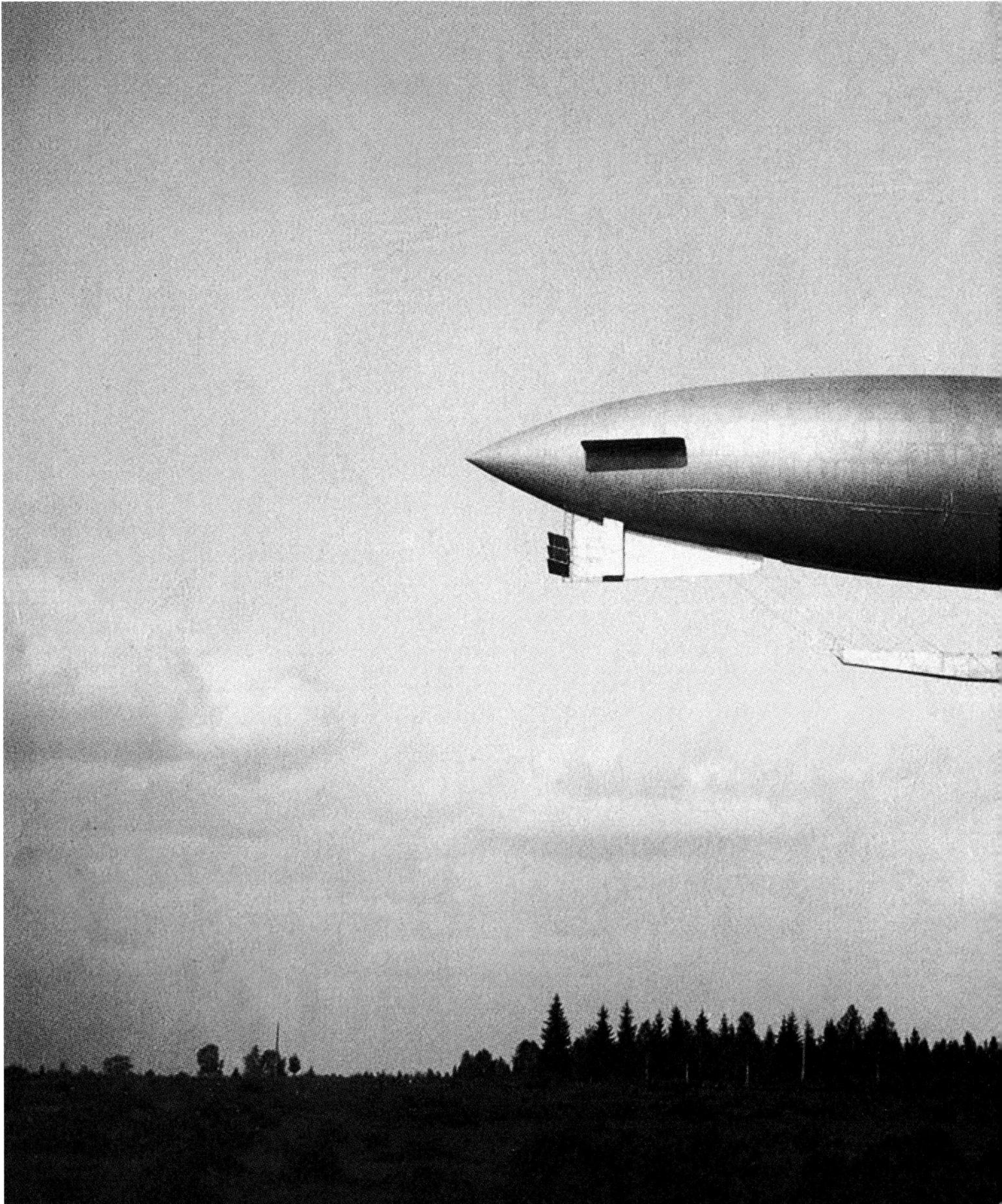

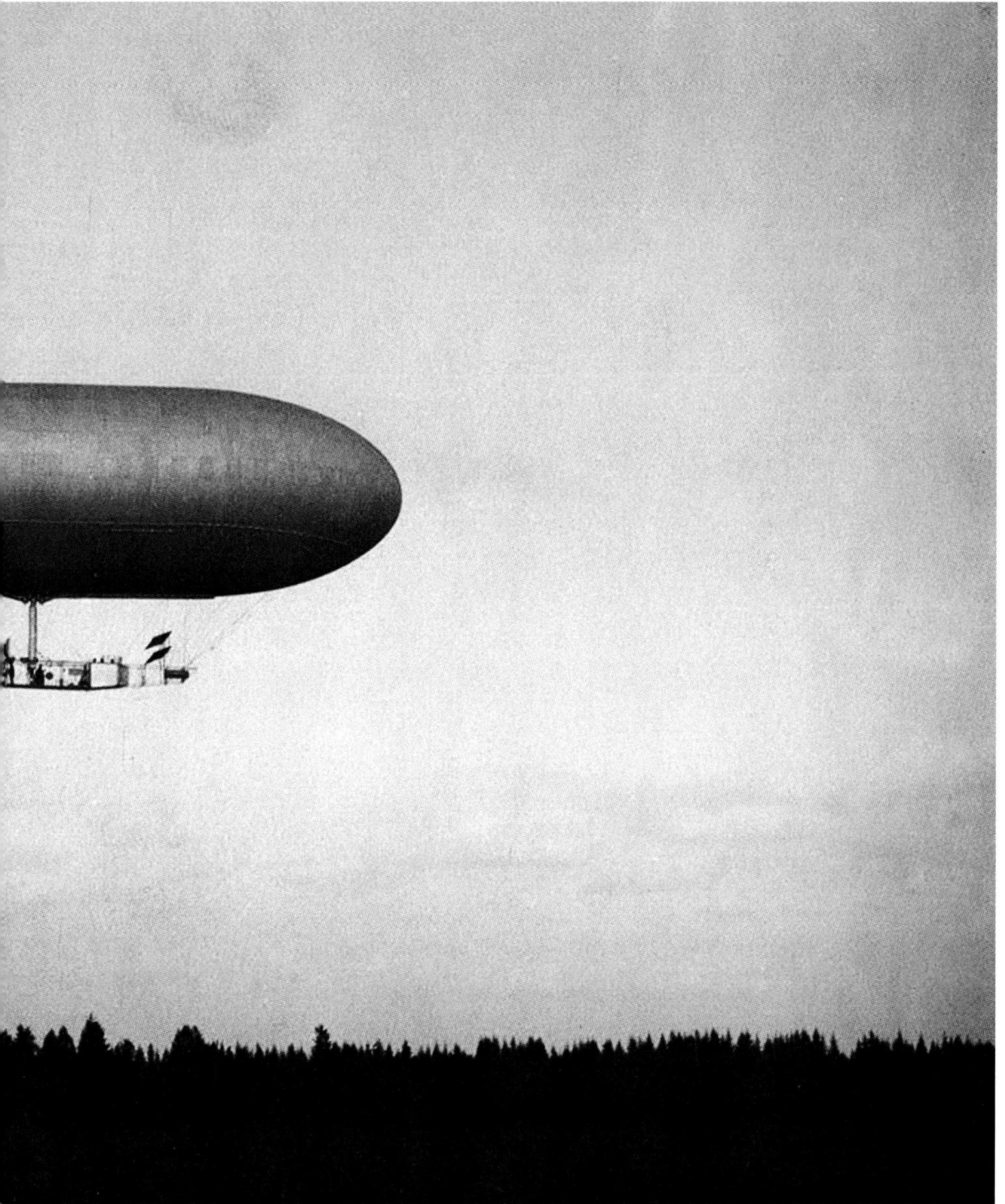

2. The dirigible Yastreb (Hawk), built in 1910, with a crew of four men at a height of 180 meters.
August 12, 1912.

The Academic Aeronautical Park, officially an institution on July 14, 1890, became an experimental center of aeronautics for the army and navy. According to regulations, 6 officers and 88 enlisted men served at the Park during peace time, while during war, 14 officers and 216 enlisted men served there. A detachment of military airship pilots went through in-depth examinations during the Narvsko-Krasnoselsky Maneuvers at the capital garrison, which took place in August 1890.

Two balloon aircraft played a part: the Strepet, with a capacity of 640 cu./m, and the Kolibri (Hummingbird), with a capacity of 188 cu./m. They were used in different weather conditions, both tethered and in free flight to observe the actions of the "enemy" soldiers.

The detachment of military balloonists again took part in a few military maneuvers, including at Krasnoye Selo and near Kiev. During the Kiev Maneuvers, even Adjutant General M.I. Dragomirov, who commanded the soldiers of the district, ascended in a balloon.

It was soon recognized that this new kind of technology should be used for military goals. The first photos from the air, taken by A.M. Kovanko, marked the start of developing a national aerial survey. At about that time, military doctors also began to study the effects of flight on the human organism, carrying out tests at various heights and in various climactic conditions.

In 1896, the Russian National Manufacturing and Artistic Exhibition in Nizhny Novgorod showcased the recent achievements in the area of aeronautics. Examples of instruments, various mechanisms, cloth for covers, as well as airship models were placed in a special pavilion at the Academic Aeronautical Park. A small air-balloon with a capacity of 640 cu/m. was also displayed, and interested parties had the chance to take flights in it.

In Kiev in 1898, demonstration ascensions in balloon aircraft with meteorological instruments were carried out during the Tenth Conference of Russian Doctors and Naturalists. The Academic Aeronautical Park did interesting experiments in the 1890s to search for and locate sunken ships. Thus, a hot air balloon ascended over the Baltic Sea, equipped with a winch from the old convoy Samyed, to find the coastal defense battleship Rusalka (Mermaid). Although the Rusalka was not found, the experiment showed the advantages of using balloon aircraft, particularly in locating nautical mines placed at certain depths.

Before long, the navy began to use balloon airships with military ships, and interesting experiments were carried out in the Black Sea Fleet. At the same time, aeronautical departments were being organized at fortresses: at Ossovets in 1892, at Novogeorgievsk and Ivangorod in 1893, at Warsaw in 1897, and at Brest-Litovsk in 1902. Field aeronautical squadrons were also created, which participated in flights during military maneuvers.

In 1900, the Academic Aeronautical Park participated in an international exhibition in Paris, where it received positive ratings, and its director, Alexander Mikhailovich Kovanko, was given a high award with the words: "For the combination of design and use, which has been yielded to aeronautical science." The award can be considered an appraisal of all Russian aeronautic enthusiasts' achievements in the 19th century.

In terms of combat, the Russians first used aeronautical devices during the war with Japan, which started on February 9, 1904, with the attack of the Japanese fleet on the Russian Pacific Ocean Squadron in Port Arthur. After a week, Colonel A.M. Kovanko was given orders from command to form a separate alliance of military airship pilots, known as the Siberian Aeronautical Company.

5 officers, 193 enlisted men, and 4 aerostats from the Siberian eronautical Company were sent to the Far East. Captain K.M. Boreskov, the son of Lieutenant General M.M. Boreskov (who initiated the use of electricity in the military), was appointed as captain. The alliance arrived in the Chinese city of Liaoyang, and already on July 10, 1904 they began work with the Tenth Army Corps. The commander of the Corps himself, Lieutenant General K.K. Sluchevsky, ascended in the aerostat as an observer (the aerostat was piloted by the commander of the Company Captain K.M. Boreskov).

An aeronautical park was also formed in Vladivostok in 1905, commanded by Captain-Engineer F.A. Postnikov. The fortress there had an aeronautical company of 9 aerostats and 9 kite aerostats. This unit was created very quickly because the Japanese had placed mines in April 1904 at the access point of a Russian naval military base. The balloon aircraft could lead a search for the mines, thanks to their high vantage point.

The aircraft pilots' effective flights attracted the attention of Calvary General A.V. Kaulbars, commander of the Second Manchurian Army, who visited the Company and became acquainted with the pilots' technology. As a result, Kaulbars became an active supporter of military aeronautics and did a lot for its development. During World

War I, he lead balloonists and aviators on the Northwest Front.

The military experience of K.M. Boreskov's detachment in the Far East, and in St. Petersburg at the Aeronautical Park, allowed for the development of equipment, such as new gas-promoting instruments. This technology was demonstrated for Emperor Nicholas II in June 1904, as he appraised the experience and mastery of the aeronauts. On July 26, 1904, by High Decree number 396, the first Eastern Siberian Aeronautical Detachment was created, which included two companies commanded by A.M. Kovanko. The battalion was formed in Warsaw, and the aeronauts went to the Far East at the end of August. They arrived in the Chinese city Harbin on October 5th, and later went to Mukden.

15 officers were awarded with St. George Crosses for providing reconnaissance information about the Japanese position from air balloons, while A.M. Kovanko received an honorary gold sword with the inscription "For bravery" and the rank Major General. When they returned to St. Petersburg, the aeronauts continued research at the Academic Aeronautical Park under the supervision of A.M. Kovanko, developing new direction-controlled aerostats.

Designers famous for making balloon airships devised projects for controlled aerostats at the end of the 1880s. They were O.S. Kostovich, M. Malyikhin, K.A. Tsiolkovsky, and K.Y. Danilevsky. Although only at the beginning of the twentieth century, when powerful motors appeared, was it possible to bring the Russian designers' new ideas into reality.

In 1887, K.A. Tsiolkovsky presented the idea of an all-metal frameless dirigible, with changes to flight and capacity, using pre-heated gas. O.S. Kostovich had suggested this very interesting project earlier: a controlled, large-capacity aerostat, capable of carrying 200 kg of cargo and up to 10 crew members. This model, which began to be built in 1889, couldn't be finished because of financial troubles - many projects were so bold, that Russian bureaucrats could not believe them to be possible. Mendeleyev designed a high-altitude aerostat with a hermetically sealed cabin that can be thought of as the first model of a stratostat. In 1900, K.Y. Danilevsky received a patent for the design of the flying device Mikst (Mix). He wanted to combine in one design the possibilities of both an aerostat and airplane.

One of the future organizers of Russian military aviation, Sergei Alexeivich Ulyanin, made a kite aerostat, a construction of 7-10 kites, which could rise to a height of 200 m with four observers and a

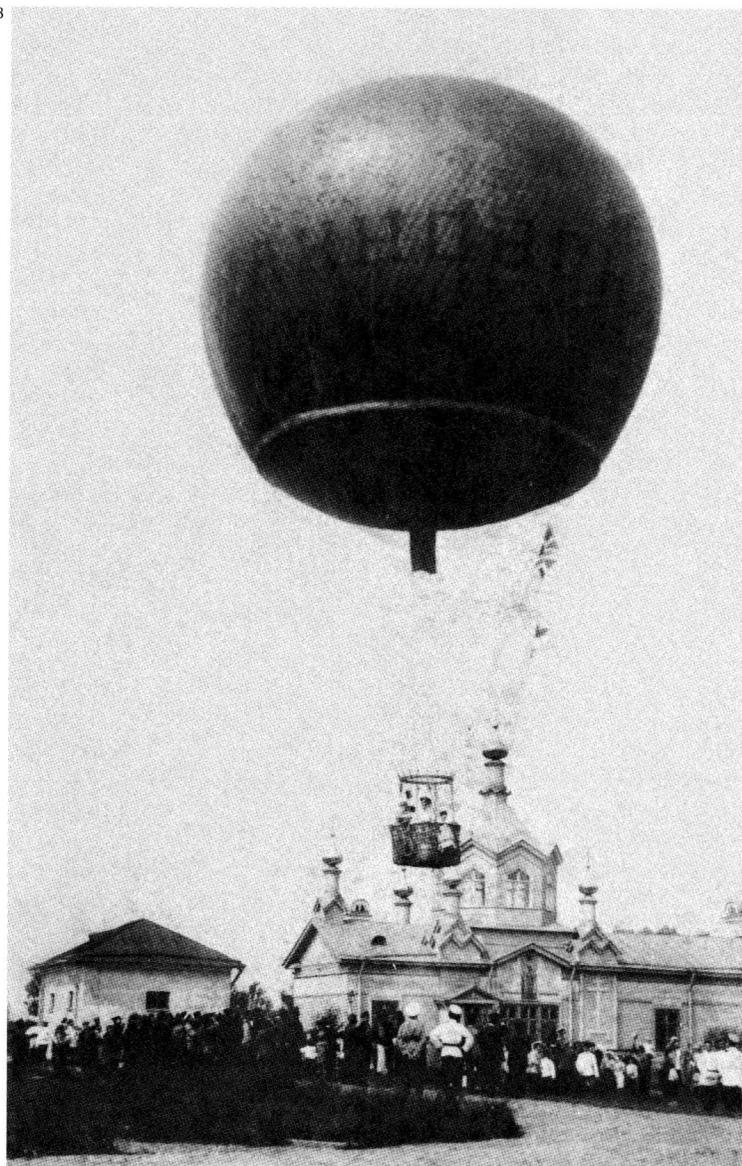

3. One of the attractions at the Nizhniy Novgorod Fair: the chance for people to fly in a hot-air balloon. *General Vannovsky* from the Treugolnik Works.
1896

signal and scientific instruments. Moreover, it included articulated wings, which automatically deployed in weak winds. V.V. Kuznetsov was also enamored with kites and created a box design useful for meteorological studies.

Work on manned aerostats began to intensify in 1906, as the Russo-Japanese war had shown that the possibilities of tied air-balloons were so limited.

At the time, there were three types of manned aerostats (rigid, in the style of the Zeppelin; semi-rigid, as in the style of the Swan, and soft, like the Percival), which were already being used in a number of European countries for military maneuvers.

The flight of the first dirigible built in Russia (a project of Air Force Staff Captain A.I. Shabskyi) was executed on August 28, 1908, at the Volkov Field. The domestic dirigible was called Training, as it was very useful in the teaching of future Air Force pilots. With an 8 horsepower car motor, it could pick up a speed of up to 30 km and rise to a height of more than 500 meters.

The next dirigible, Merlin, built in 1908-1910 at the Izhorskyi Works by V.F. Naydenov, became a real source of pride for Russian designers. It had a capacity of 5750 cu./m, and had two motors of 50 horsepower each. The dirigible made its first flight on July 30, 1910, under the supervision of Captain S.A. Nemchenko, with a crew that included Colonel N.I. Uteshev, Lieutenant Kanischev, Captain K.A. Antonov, and two senior mechanics - Gogolinskyi and Naumov. After the tests, the Merlin was given to the 9th Airship Squadron in Riga, becoming the first domestic dirigible put into service in the Russian army.

Since there weren't specialized production units in Russia for building airships, orders for them were given to factories: Dukes, Izhorskyi, Russo-Baltic and others. These plants manufactured mechanisms and instruments, while covers were made in St. Petersburg at the Treugolnik Works.

Military balloonists mastered the aerostats for the army during maneuvers. In 1910, the War Ministry formed the 21st Airship Squadron with tethered aerostats. An airship training park was transformed into the Officers Airship School, in which up to thirty officers (non-permanent personnel) were taught everyday.

At the same time, the Main Engineer Administration worked to acquire up to ten manned aerostats. Two dirigibles were built abroad - the Swan and Golden Eagle, on which in 1910 trained 5 aircraft commanders, 6 generals, two mechanics, and 4 motor mechanics. The Swan flew over St. Petersburg more than once in the Summer of 1910, bringing attention to the new possibilities and developments in aeronautics. Soon the dirigibles Dove, Hawk, Falcon, Albatross, Kestrel, and Mix were built. In the middle of 1911, about 10 army dirigibles were being used in the field.

Before World War I, the military command decided to build two large capacity dirigibles (of 20,000 cu./m and even 30,000 cu./m). They started to build them at the Izhorskyi Works, but the dirigible Air Cruiser, with a capacity of 32,000 cubic meters, could not be finished. However, the second, which received the name Giant (with a capacity of 20,000 cu./m), could be built, and soon started to be flown in tests. It was indeed an air giant of impressive size, but at one of its flights in the Winter of 1915 it suffered a catastrophe, after which it was not repaired. Aeronautics, as separate military technology, more and more began to yield its place to new types of heavier flying machines - airplanes.

In Spring 1914, the visiting French military delegation to the Officers Aeronautical School highly rated the achievements of Russian aeronautics. At the beginning of World War I in Russia, there were 15 dirigibles in the army, starting with a capacity of 3,000 cu./m to up to 10,000 cu./m. Squadrons using directions from aerostats positioned themselves in Lutsk, Berdichev, Bialystok, Lida, Salizi and other cities near the Front. In order to service the military dirigibles, hangers were brought to Berdichev, Salizi, Brest-Litovs, Kovno, Grodno and Bialystok.

The dirigibles were advantageous, in that they had a large radius of action and large carrying capacity. The Condor and Golden Eagle were added to the Second Airship Squadron at the Brest-Litovsk fortress, and the Condor, fitted with a radiotelegraph station, presented a serious danger for the enemy. As such, the Germans would try to destroy the airships, but the dirigible Aster successfully bombed a German position. The dirigible Albatross was also actively used in the naval theater.

During World War I, the number of airship squadrons of the Russian army grew from 14 to 87, showing how useful they were to the military.

On December 7, 1916, by order of the Commander-in-Chief, the position Staff Officer for Aeronautics of the Field General Inspector of the Air Force was created. That date, by order of the Air Force chief of staff on August 2, 2000, was declared the Day of the Creation of the Air Force in modern Russia.

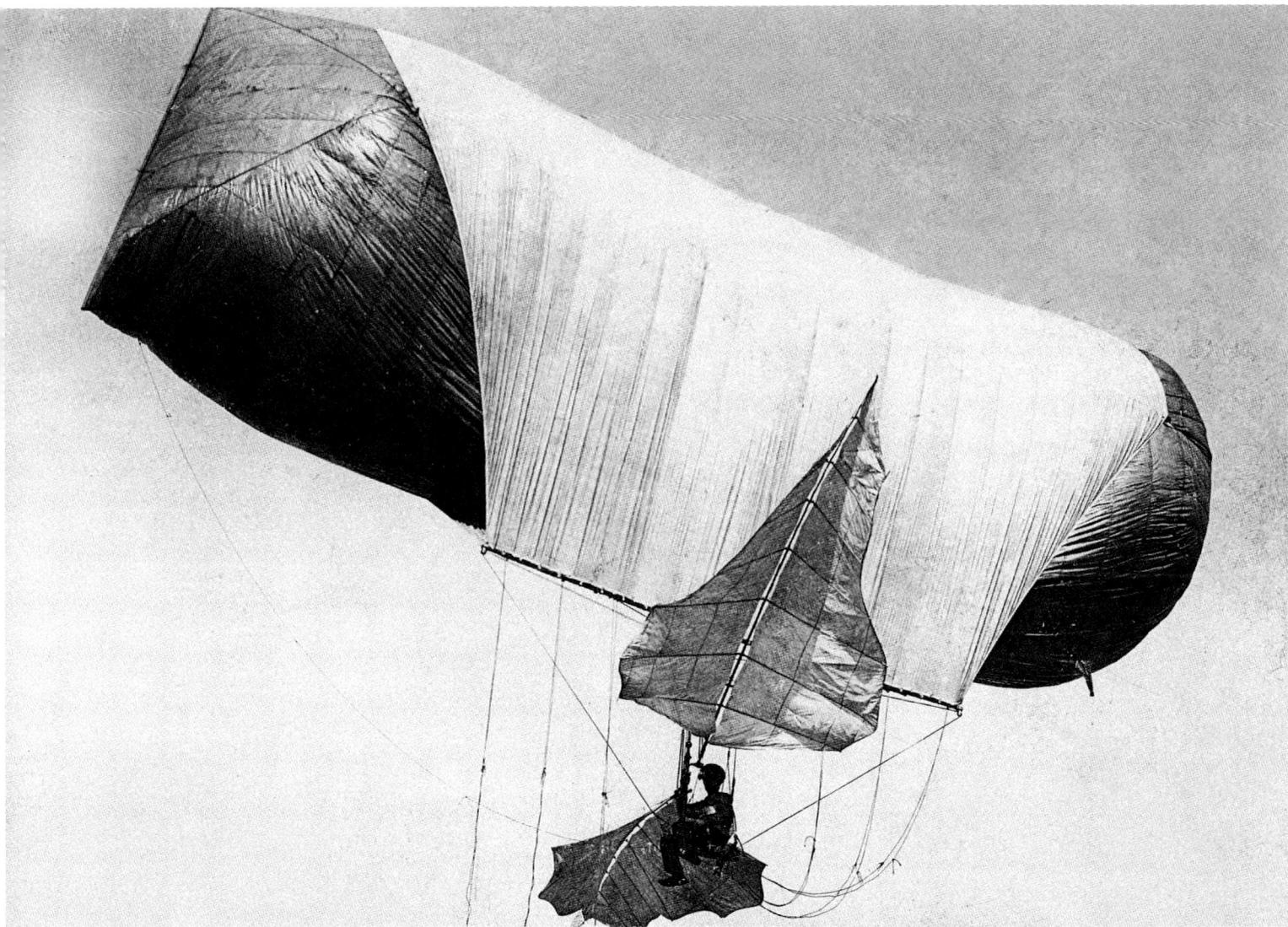

4. In the air in an aerostat like the Mikst (Mix), flown by the famous Doctor of Medical Science K.Y. Danilevsky from Kharkov, Ukraine.

1907

A pilot flew an aerostat with the help of wing-oars. The flight distance depended on the stamina of the ballooner.

Later in 1911, B.V. Golybyov and D.S. Sukharzhevsky built a small dirigible with the name Mikst.

5. View of Vasiliyevsky Island from a height of 800 meters.

Photo by A.M. Kovanko.
St. Petersburg. 1896

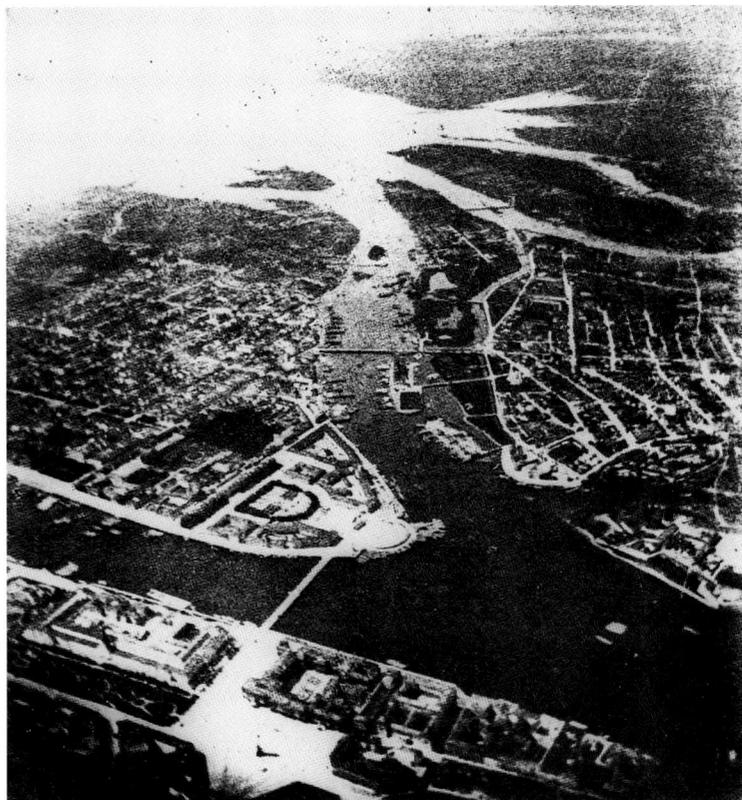

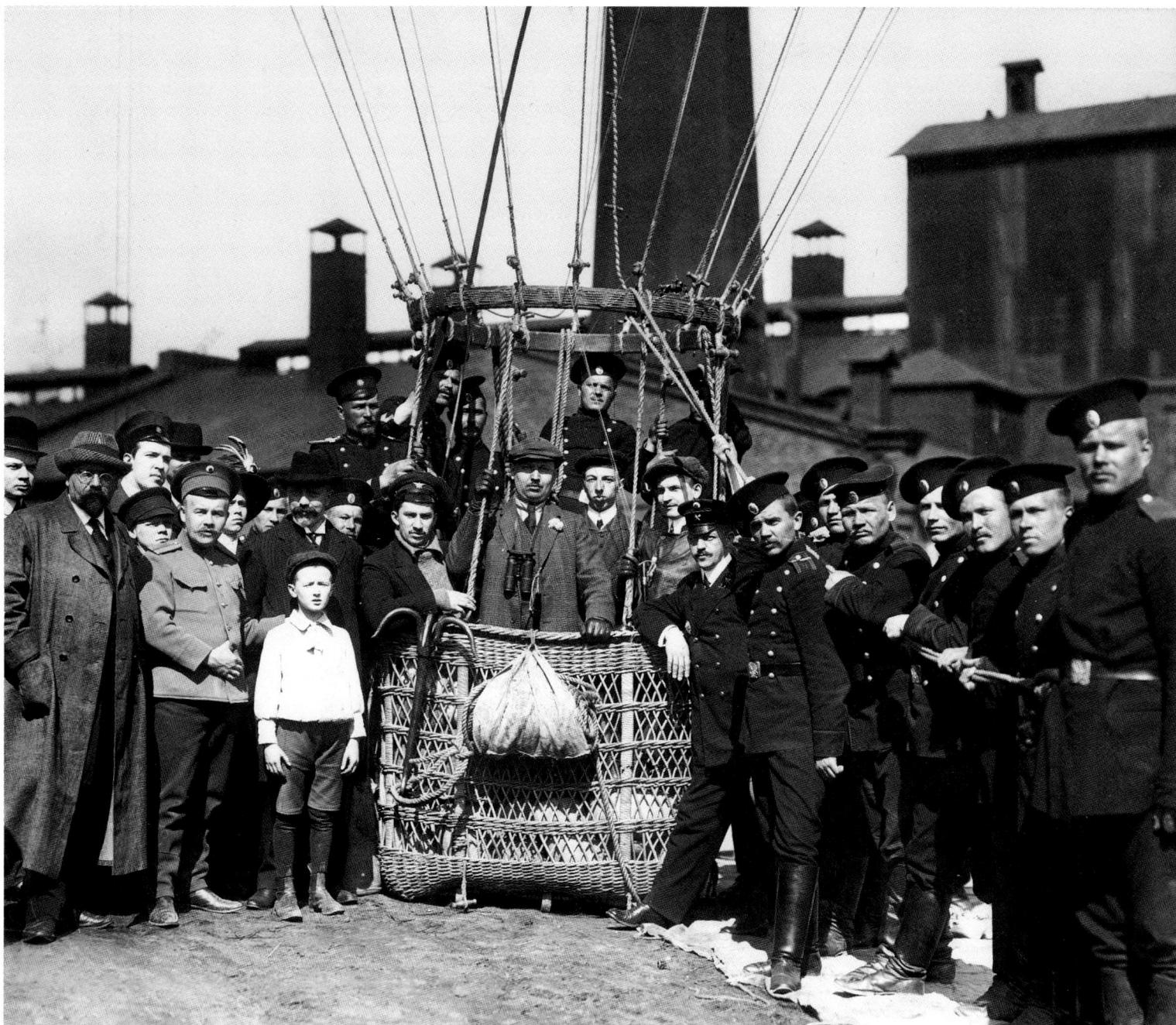

6. A group of ballooners in front of a hot air balloon preparing for lift off during the Pan-Russian Festival of Aeronautics. In the center is A.N. Sredinsky, with designer and inventor V.V. Kuznetzov on the left of him.
1910

7. Participants at the Ballooners Conference at the lift off of the balloon *General Vannovsky.*
St. Petersburg. 1904

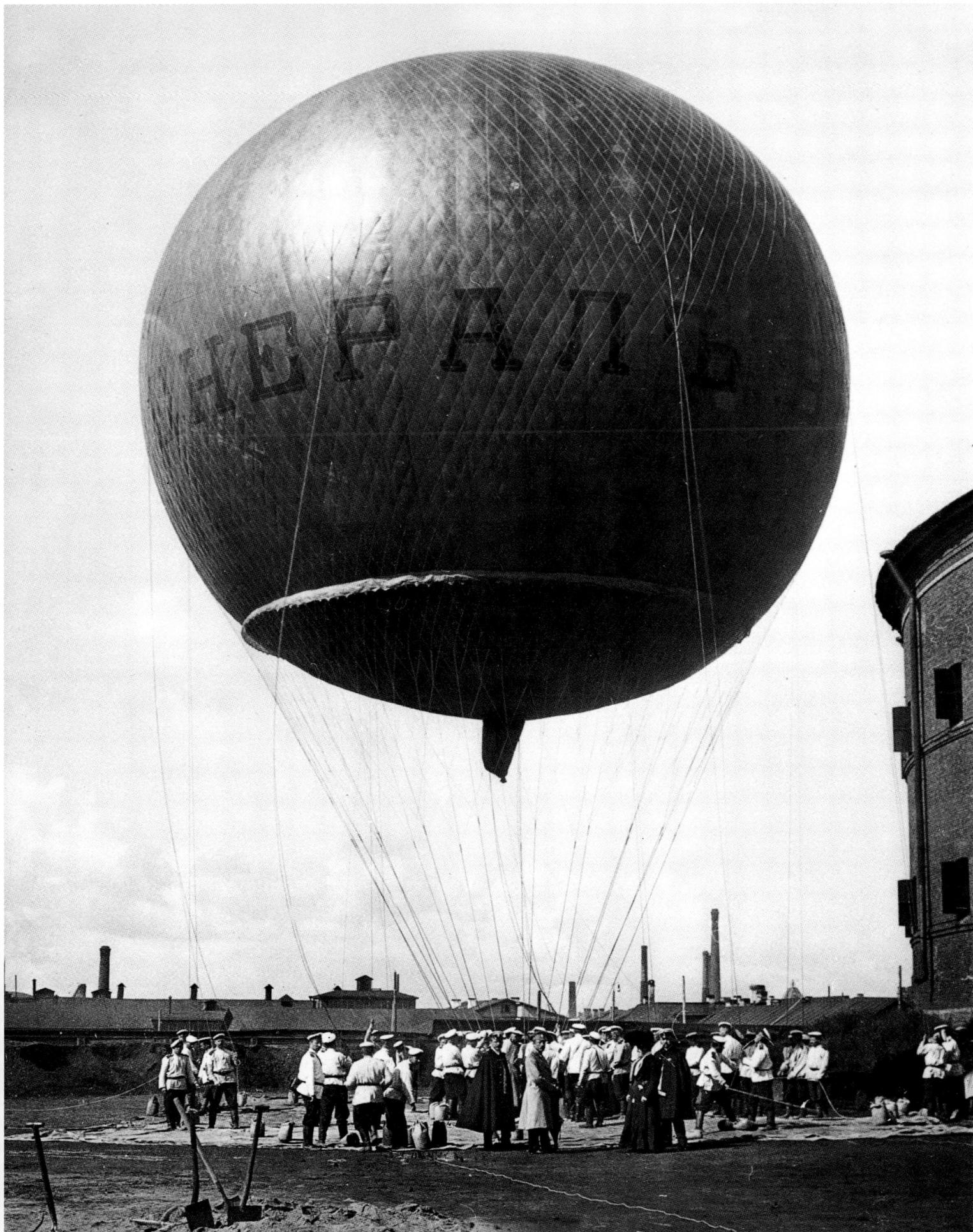

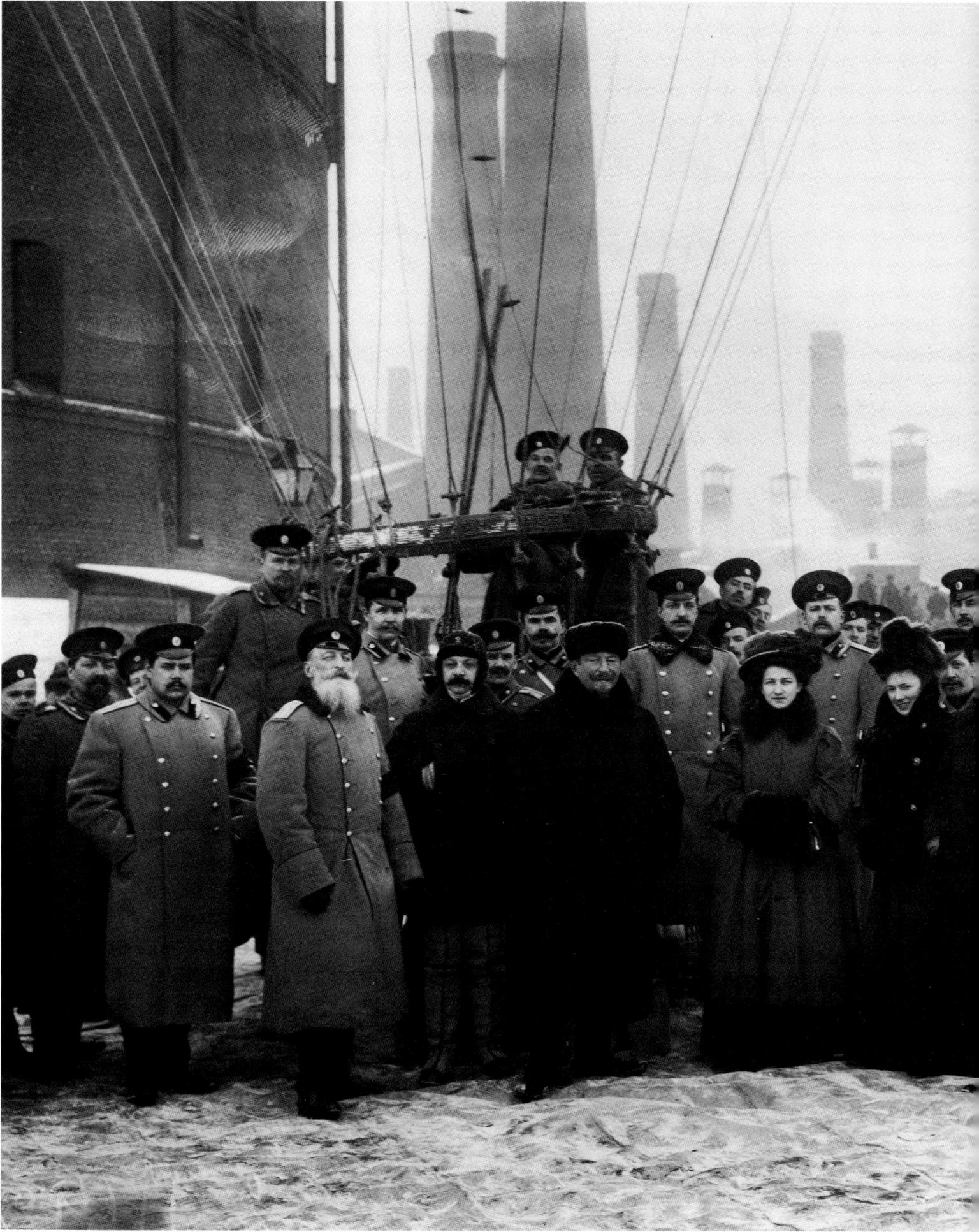

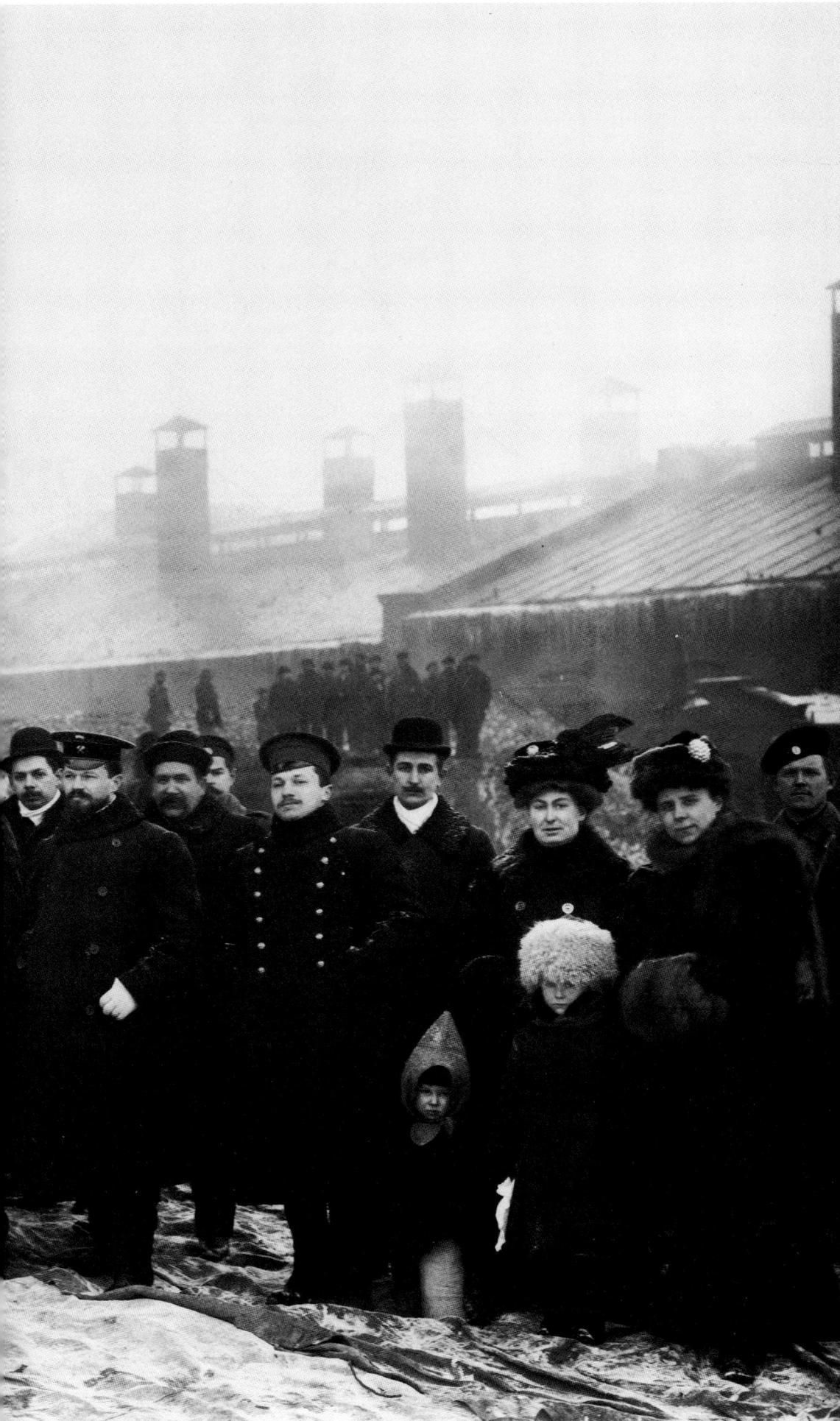

8. Members of the Imperial Pan-Russian Aeroclub in front of the basket of a balloon. In the front, second from the left (with the white beard) is A.M. Kovanko, fourth from the left is the chairman of the club Count I.V. Stenbok-Fermor, fourth from the left (in the bowler) is V.A. Lebedev.
1911

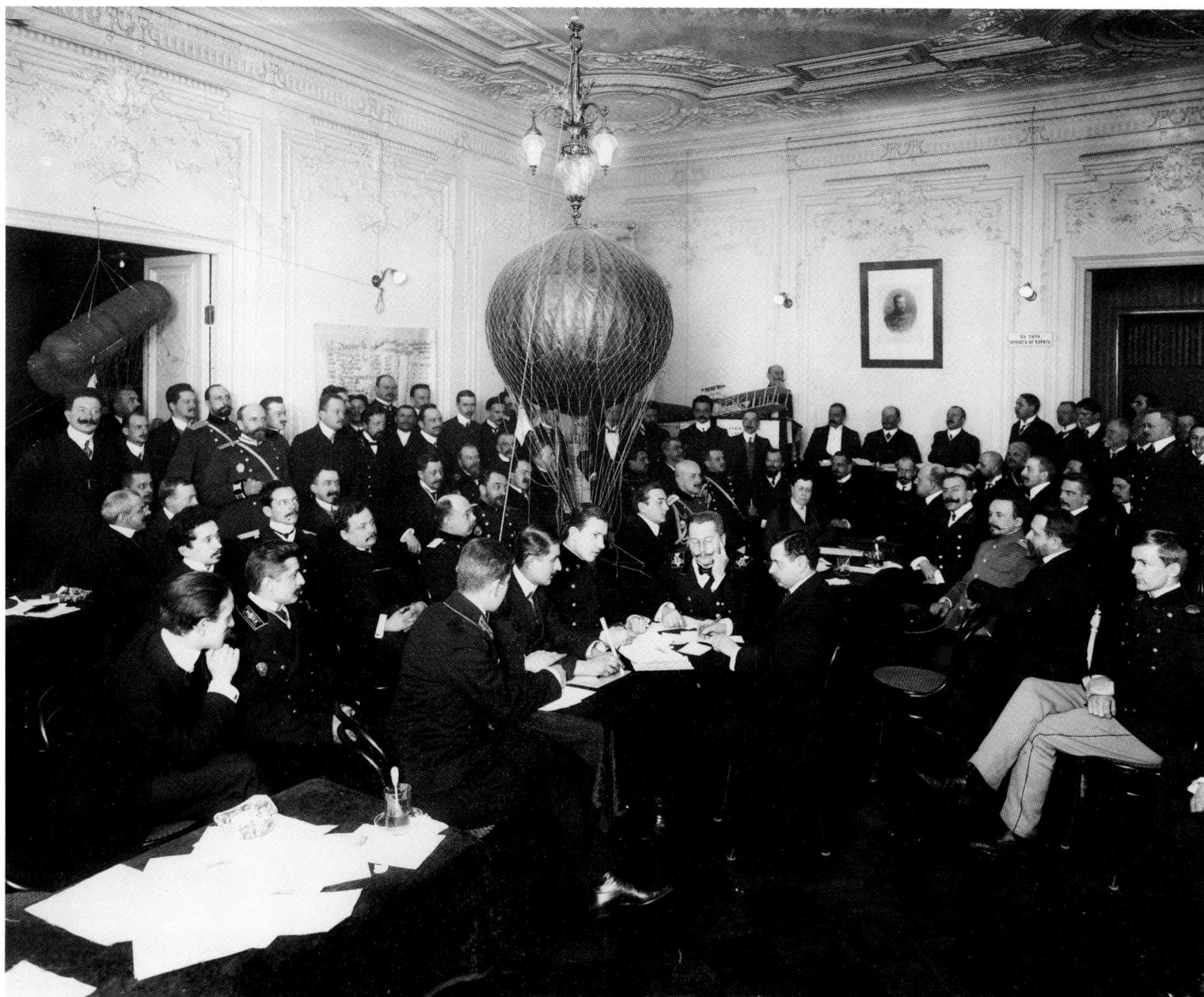

**9. Evening at the premises of the
Imperial Pan-Russian Aeroclub,
at a meeting of the International
Committee of Aeronautics.**

St. Petersburg. 1911

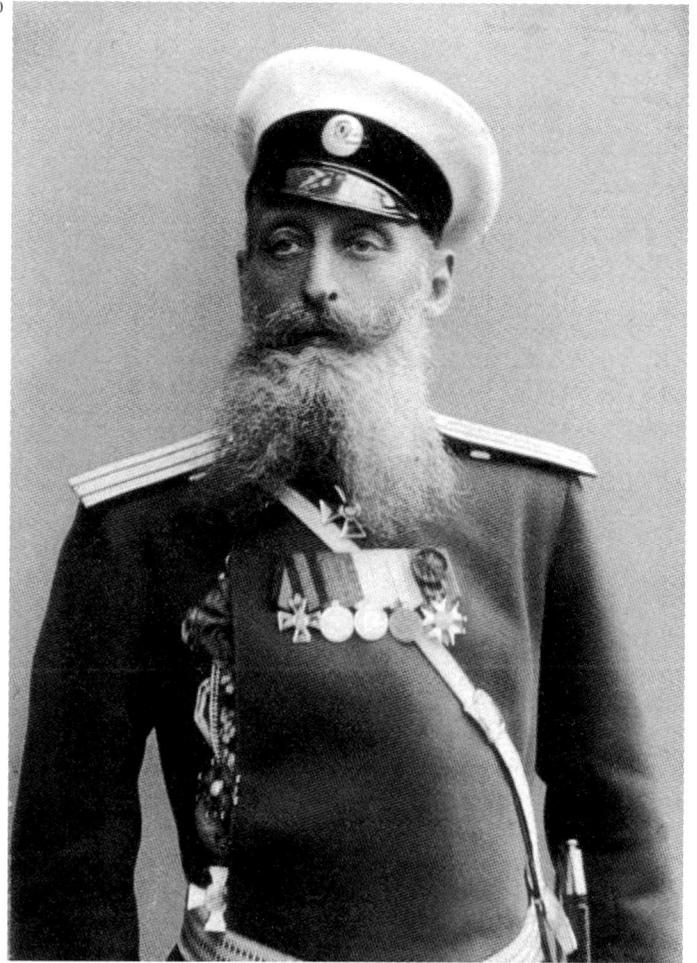

10. Head of the Academic
Aeronautic Park Colonel
A.M. Kovanko.
1900

11. View from the basket of an air
balloon of the Volkovo Field and
the Officer Aeronautics School.
1916

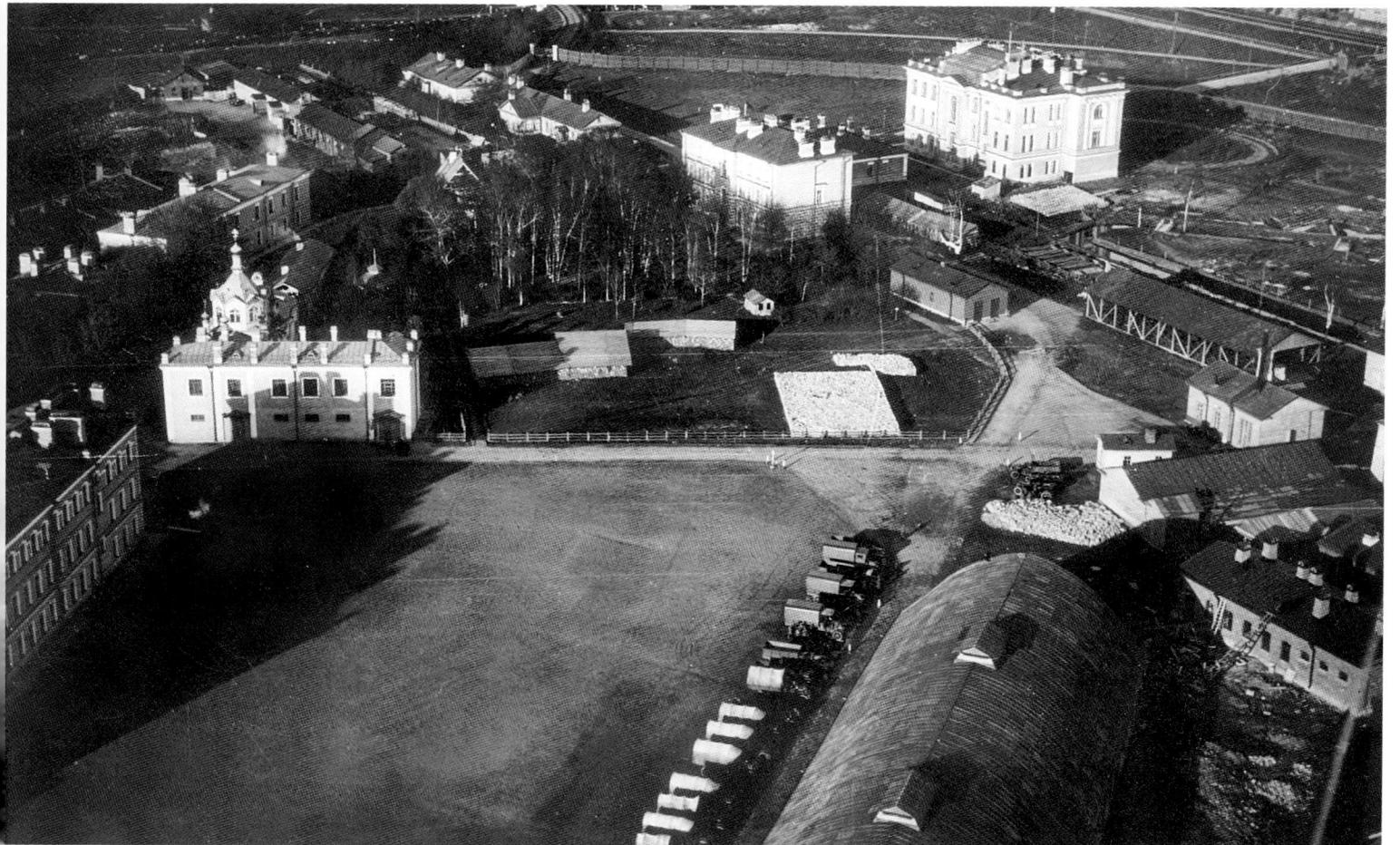

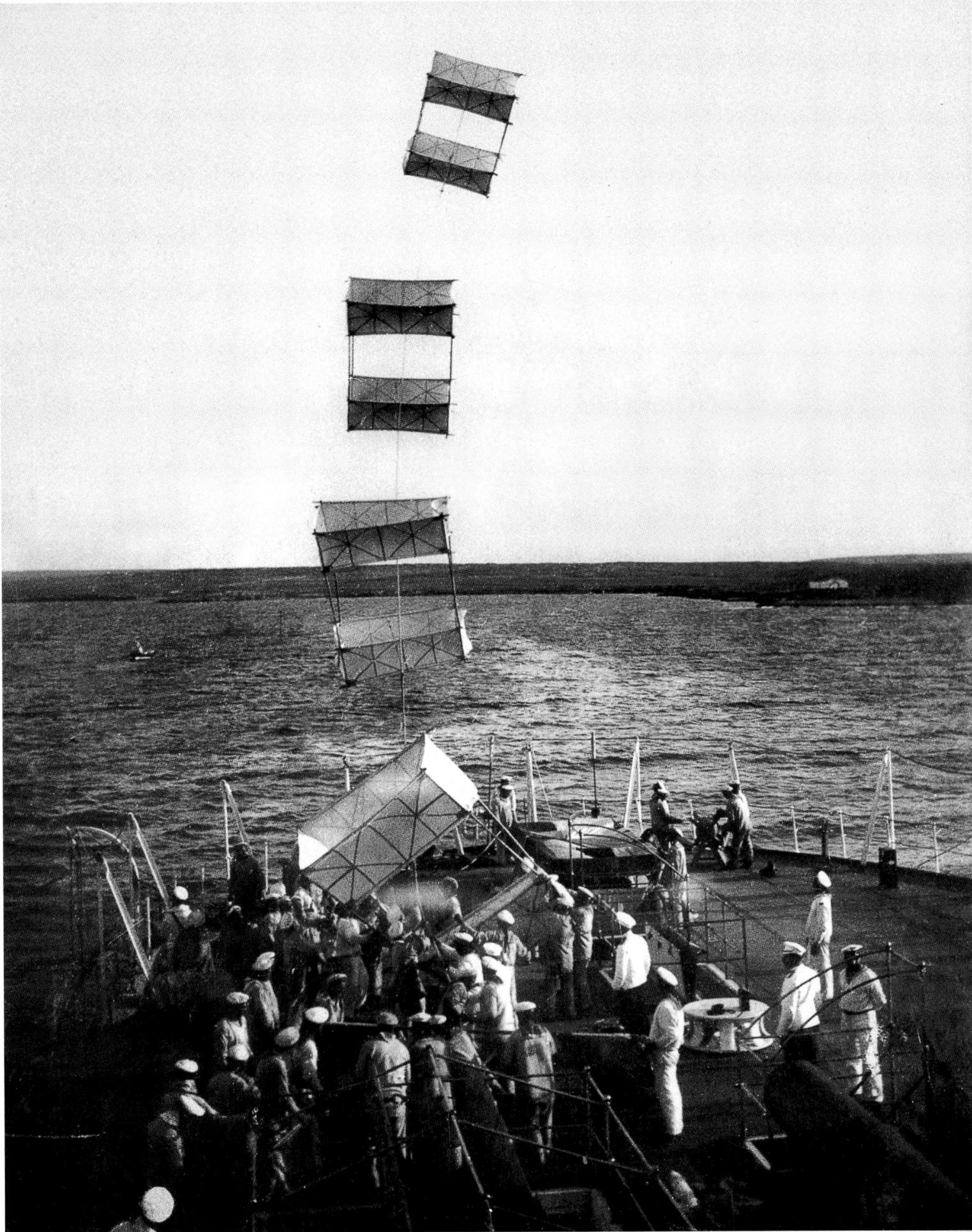

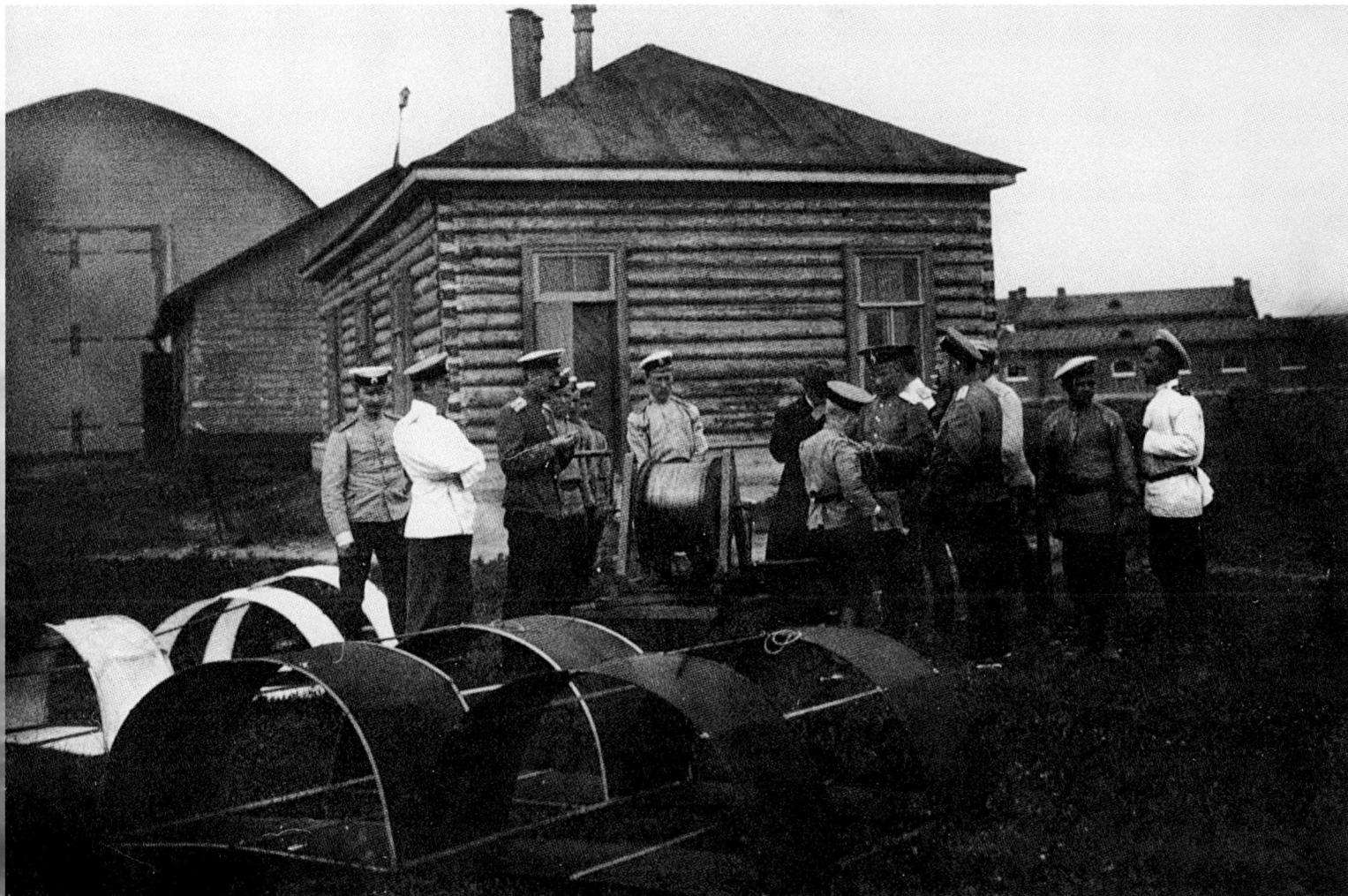

12. Lift off of the kite aerostat from the deck of a battleship.

Baltic Fleet. 1901 — 1902

13. At the Academic Aeronautic Park. Among the instructors is designer V.V. Kusnetzov.

St. Petersburg. 1901 — 1904

14

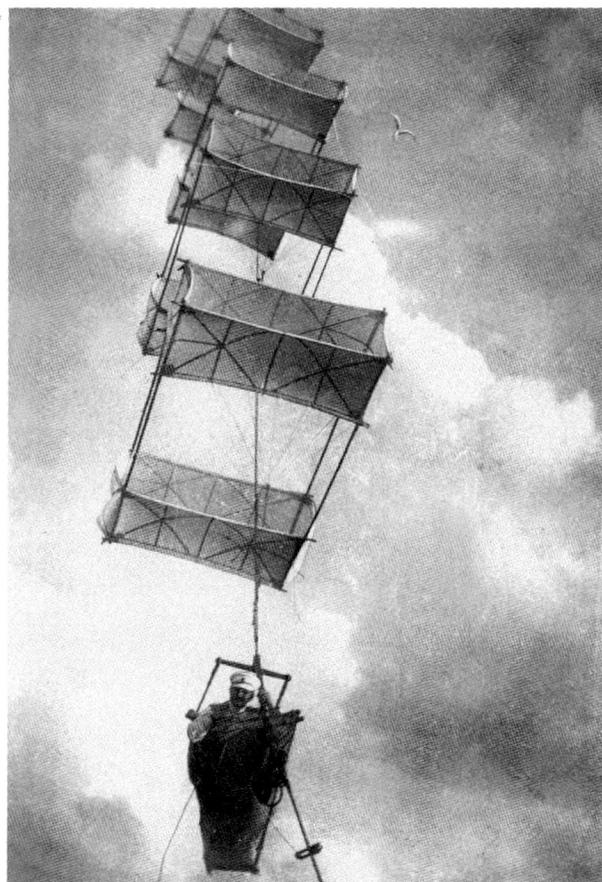

14. An observer (a "Zmeenavt"), flying a kite aerostat, lifts off in a basket.

Baltic Fleet. 1901 — 1902

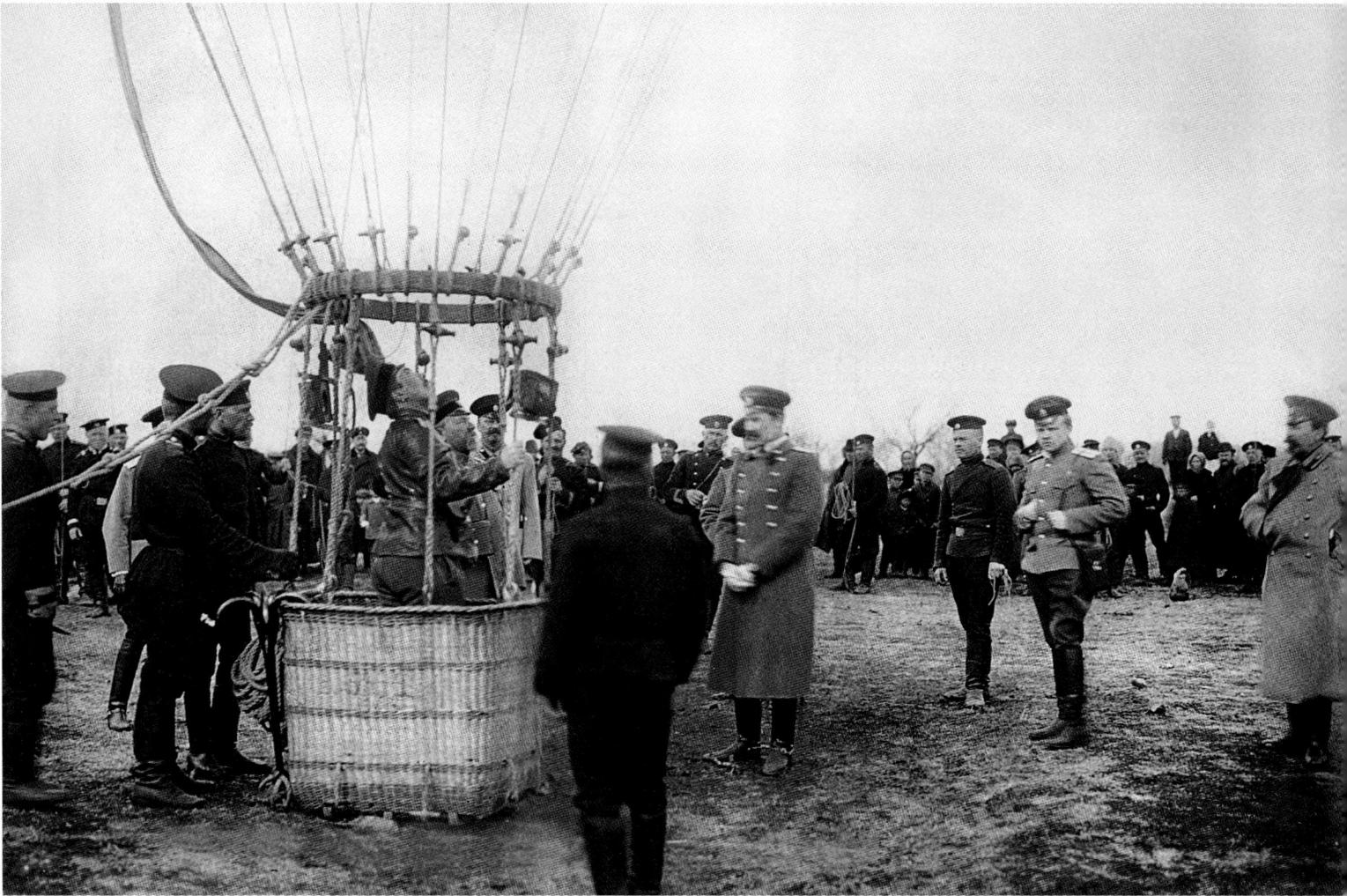

15. Preparations for the flight of a military observer on a tethered aerostat during maneuvers of the St. Petersburg military garrison.
1903–1905

16. Participation of the two tethered aerostats *St. Petersburg* in military maneuvers at the Kursky Garrison.
1902

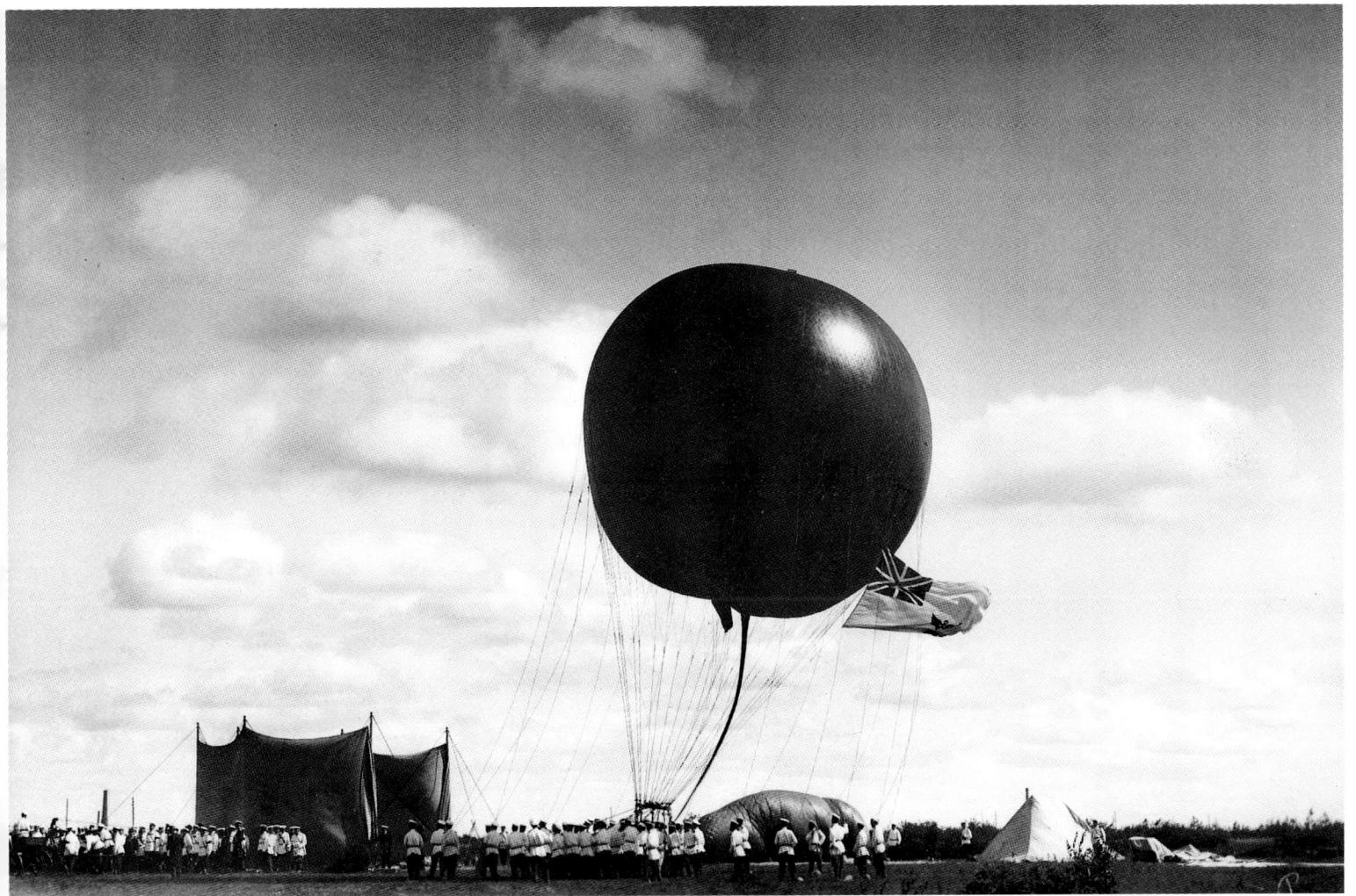

17. An air balloon on maneuvers at the St. Petersburg defense command before a demonstration for Nicholas II. 1900

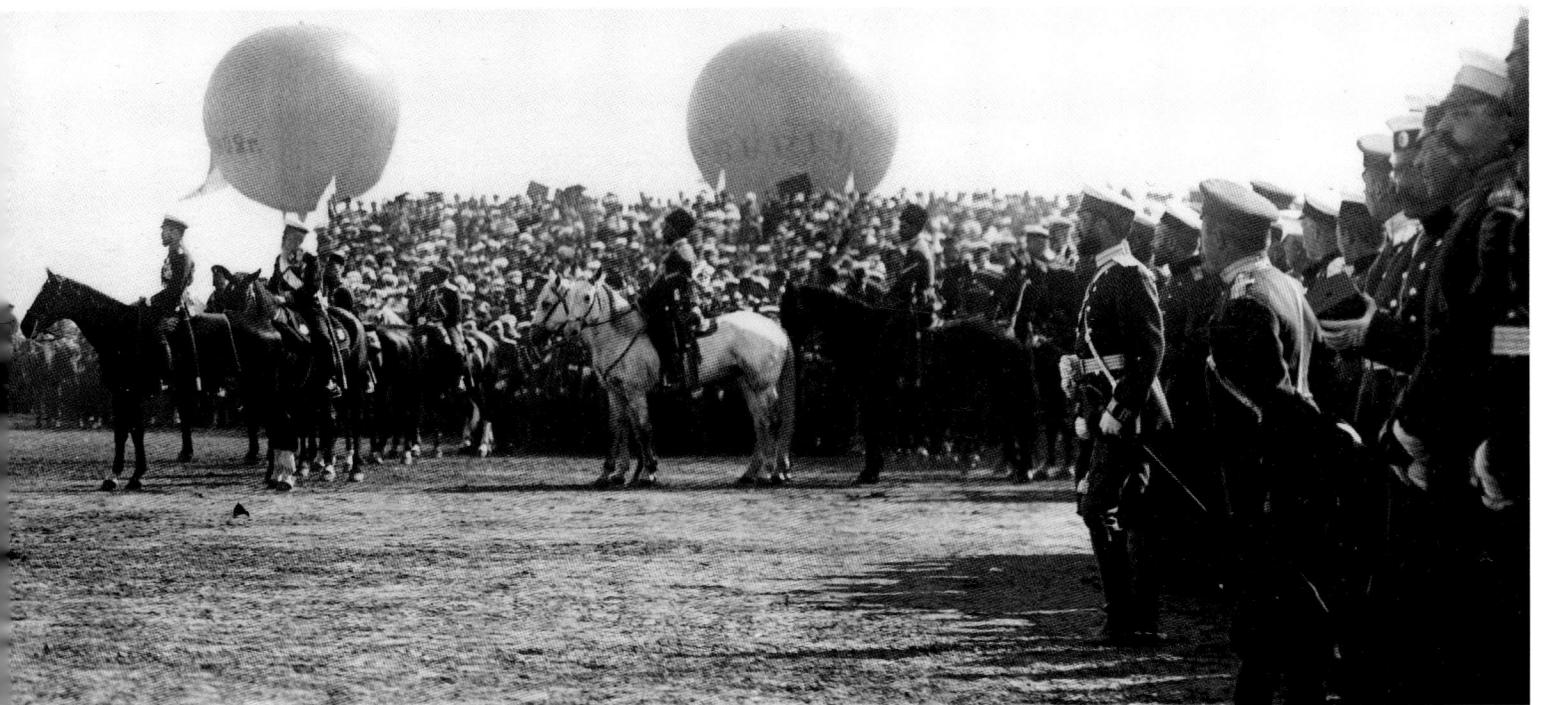

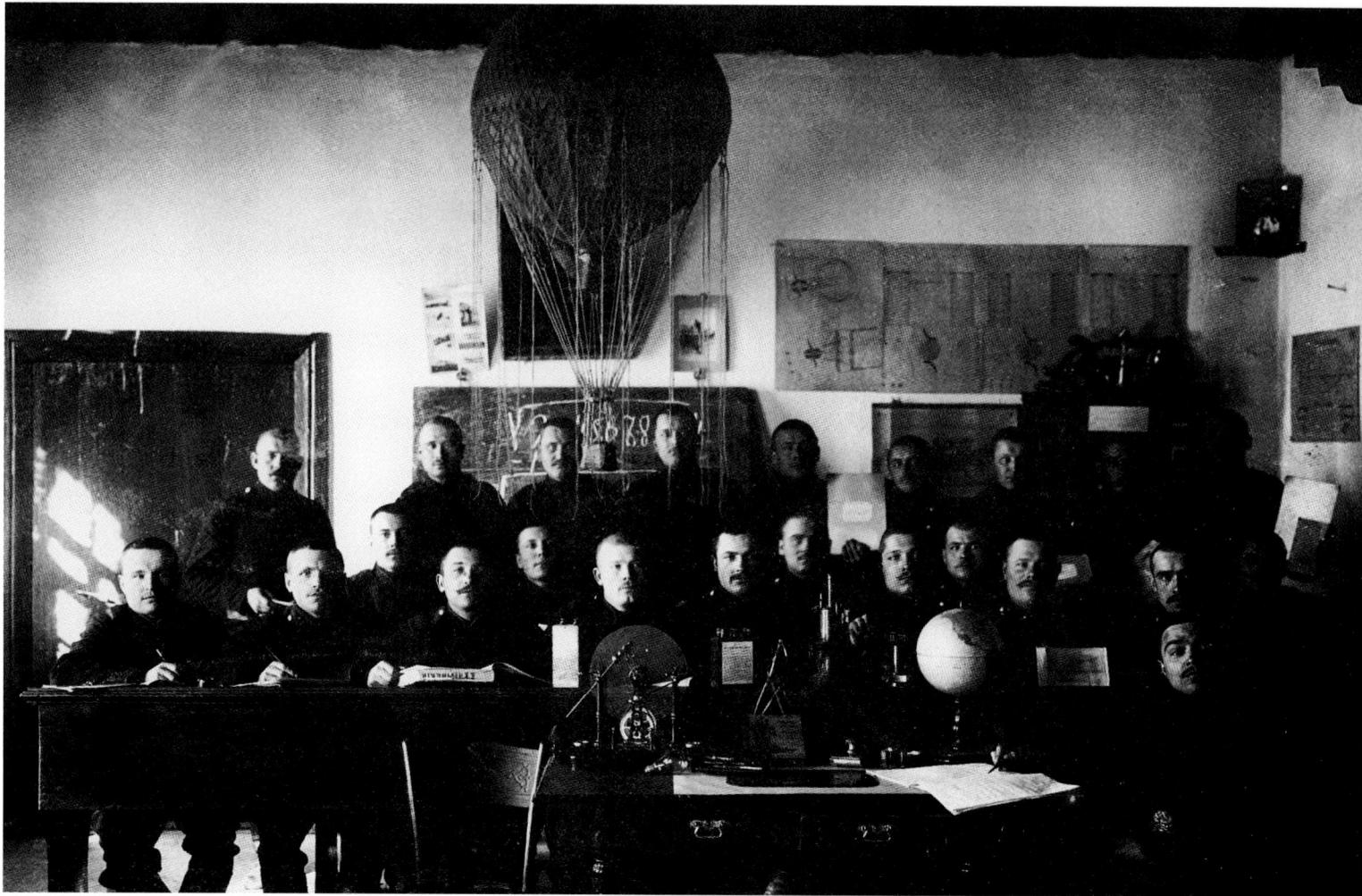

18. Students of a theoretical course of study for technical aeronautics at the Academic Aeronautical Park.

St. Petersburg. 1906 — 1908

19. Aerostat on a free flight over the field of the Academic Aeronautical Park.

St. Petersburg. 1906 — 1908

20. On the grounds of the Aeronautical Park is a hanger with an aerostat.

St. Petersburg. 1908 — 1910

21. Lift off of an observer in a kite aerostat like the Percival, towed by a steamship with a barge on the outlet to the Gulf of Finland.

St. Petersburg. 1910.

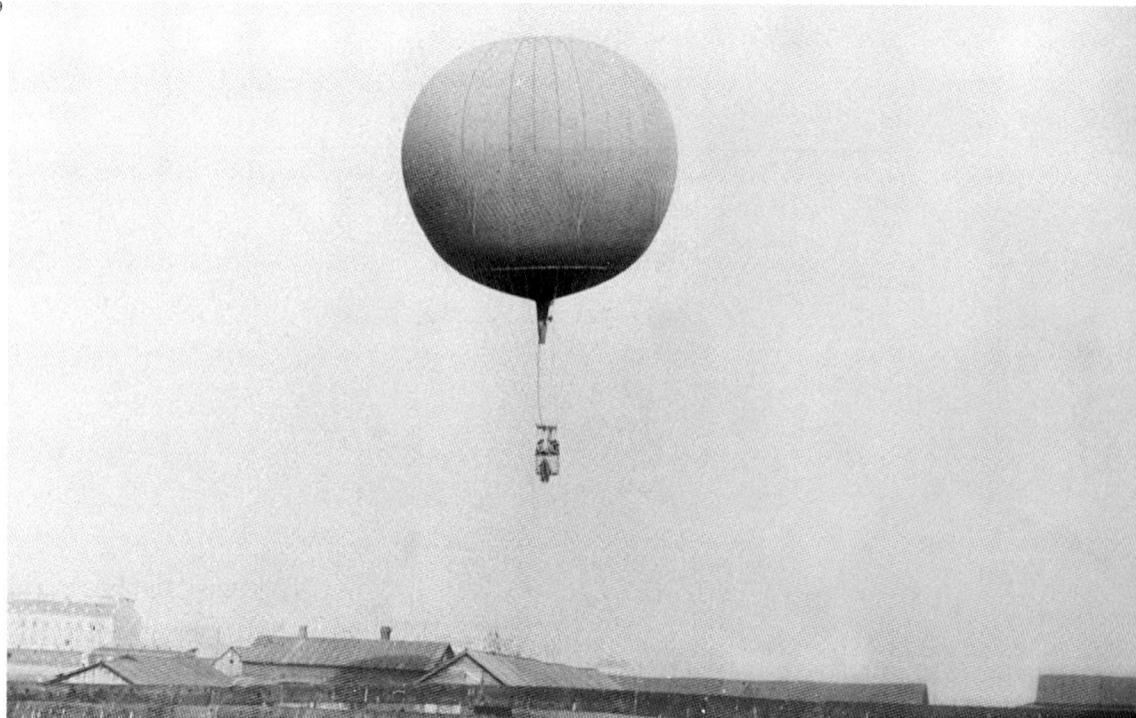

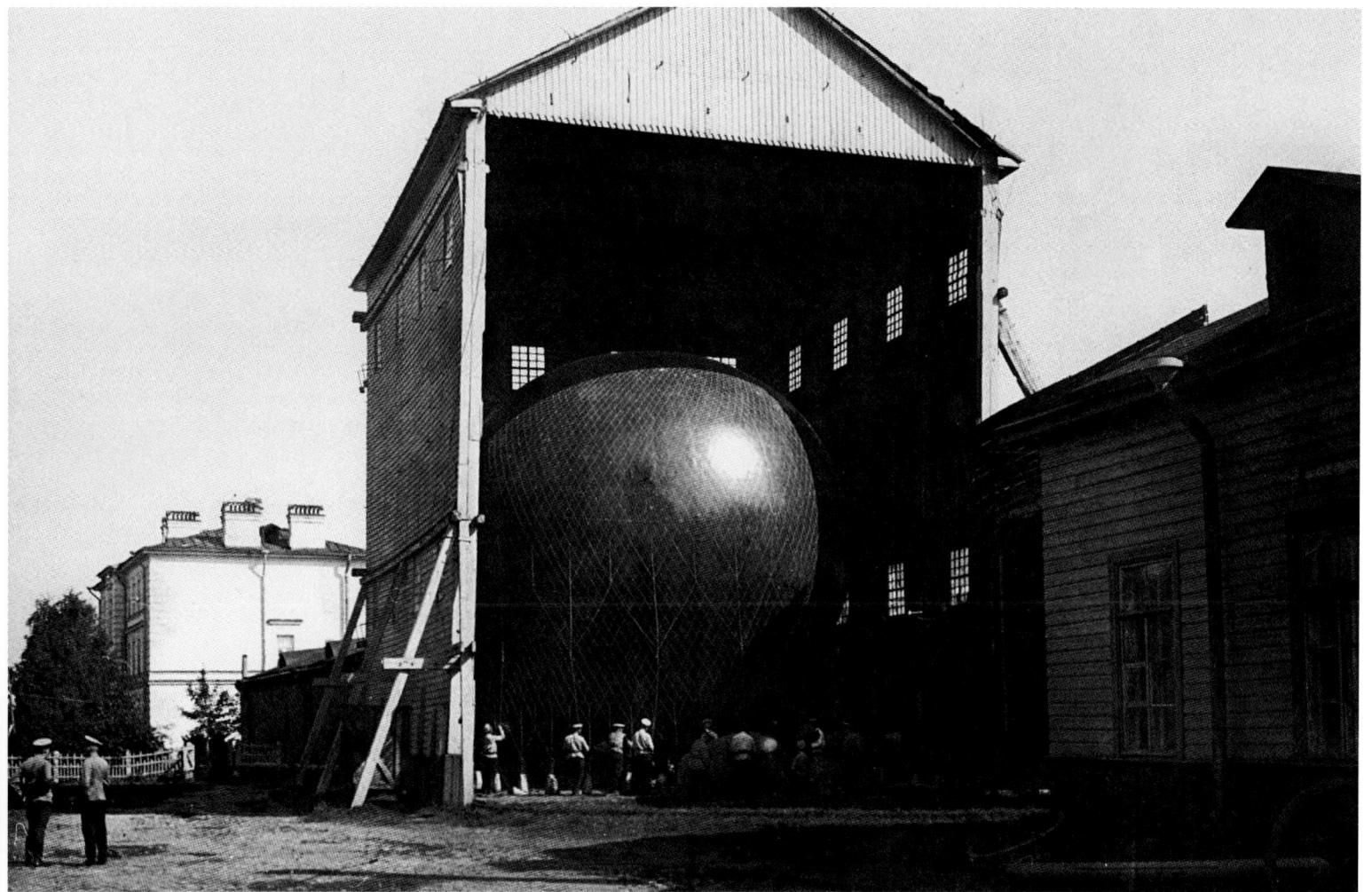

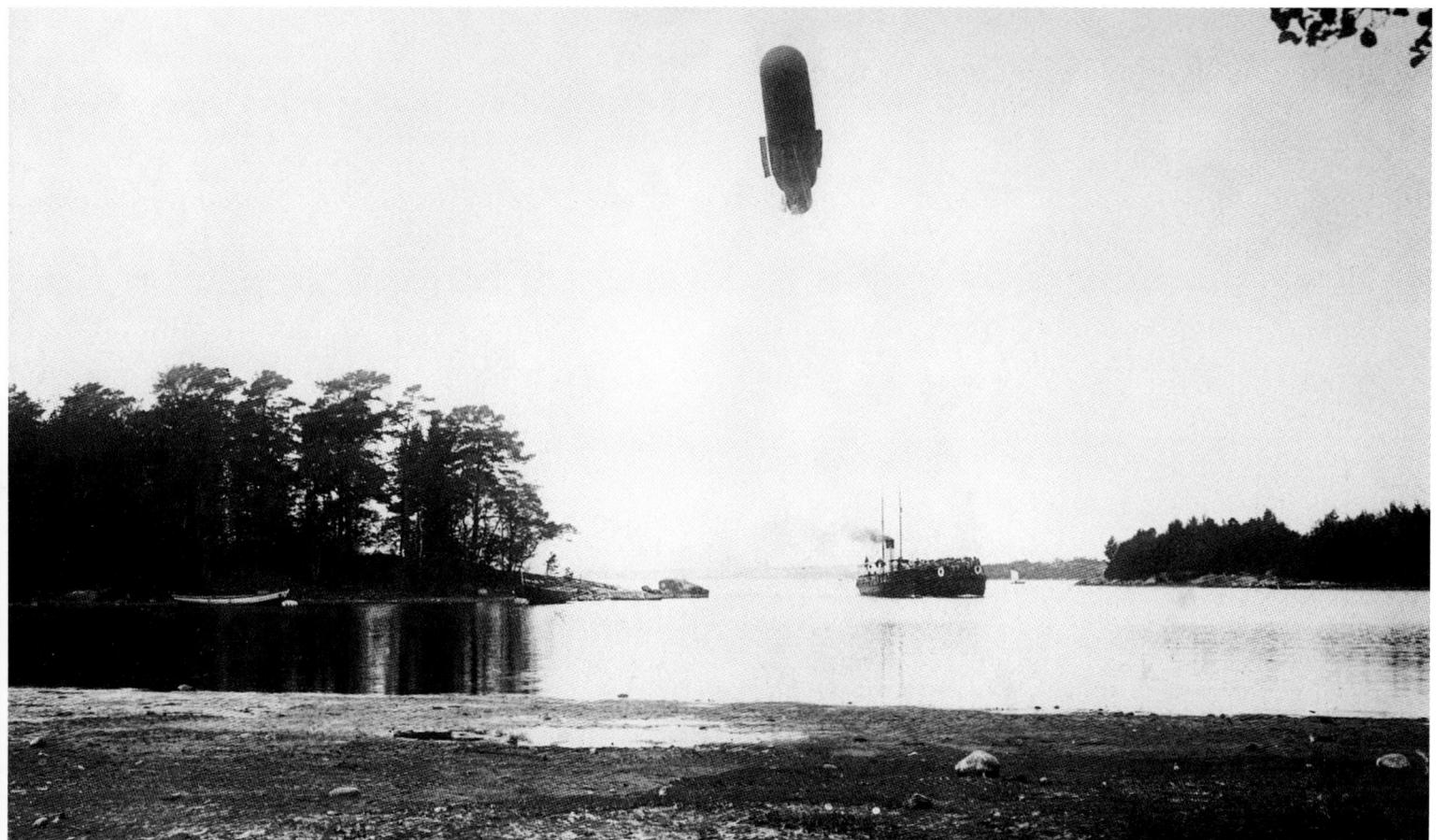

Balloon Aircraft and Dirigibles

22. View from an air balloon from a height of 600 meters over the Sevastopol harbor.
1901

23. Lift off of the air balloon *Kobchik (Red-footed Falcon)* under the command of M.N. Bolshev from the base of the Maritime Aeronautical Park of the Black Sea Fleet (based in the Kamyshovo harbor).
1902

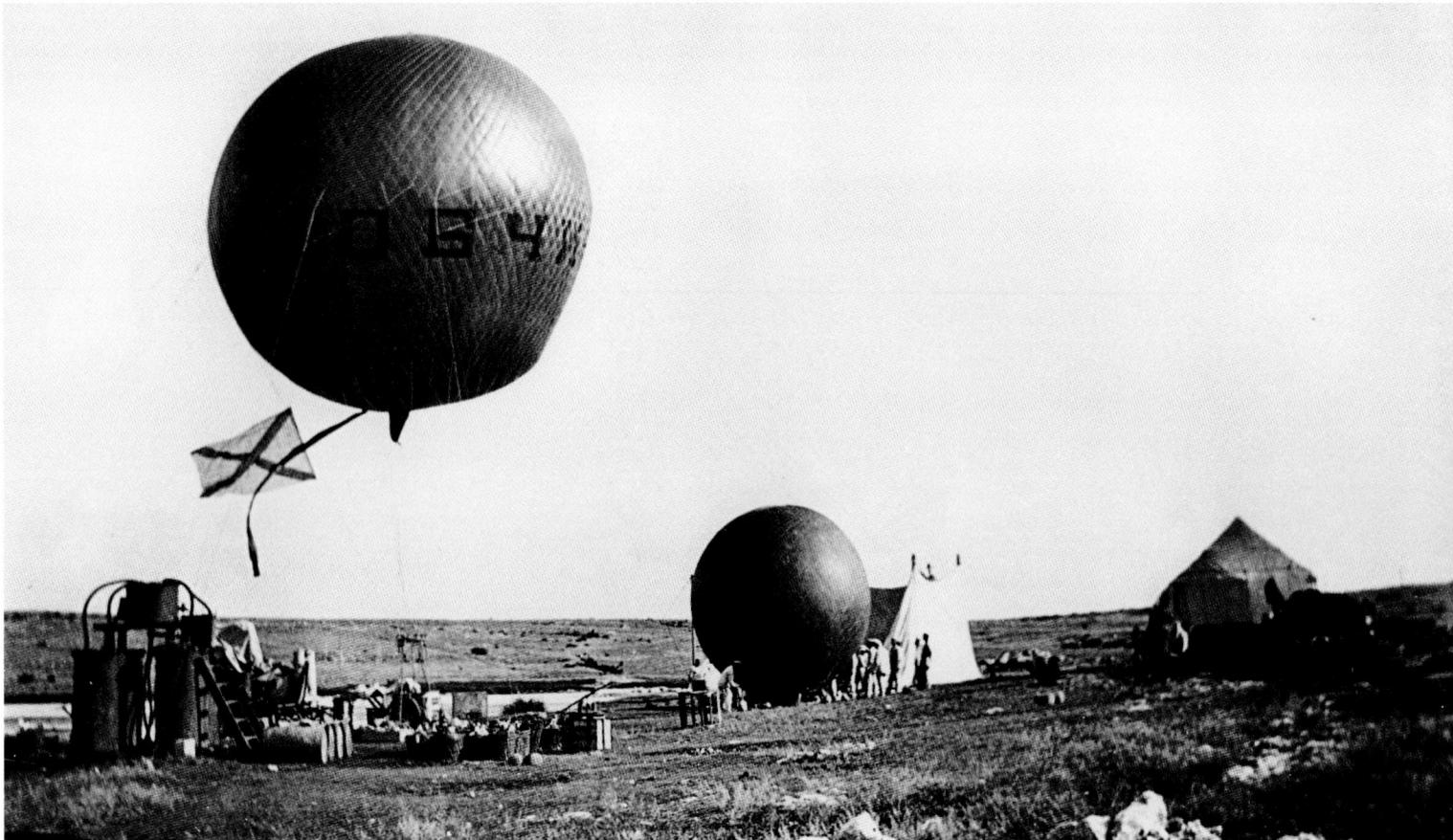

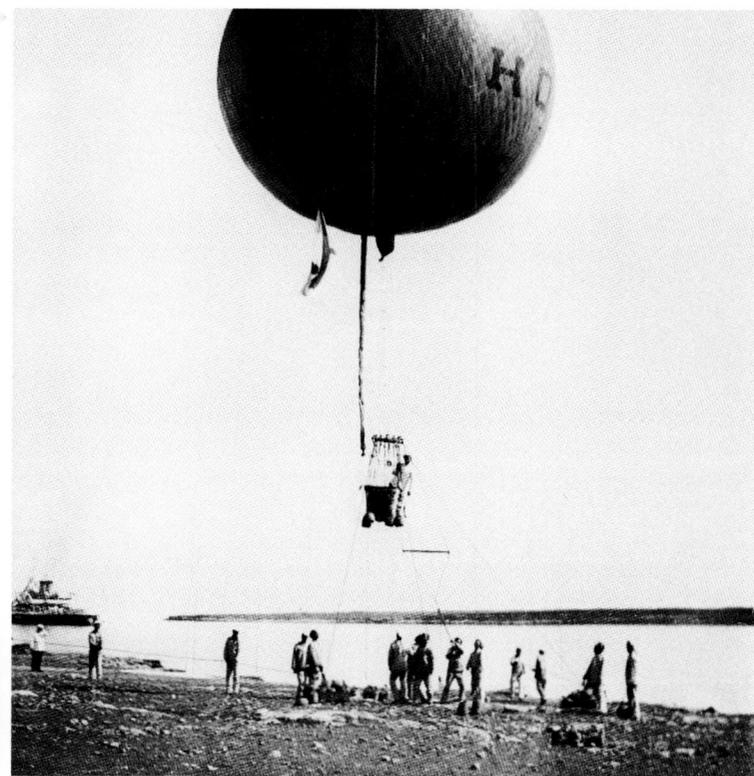

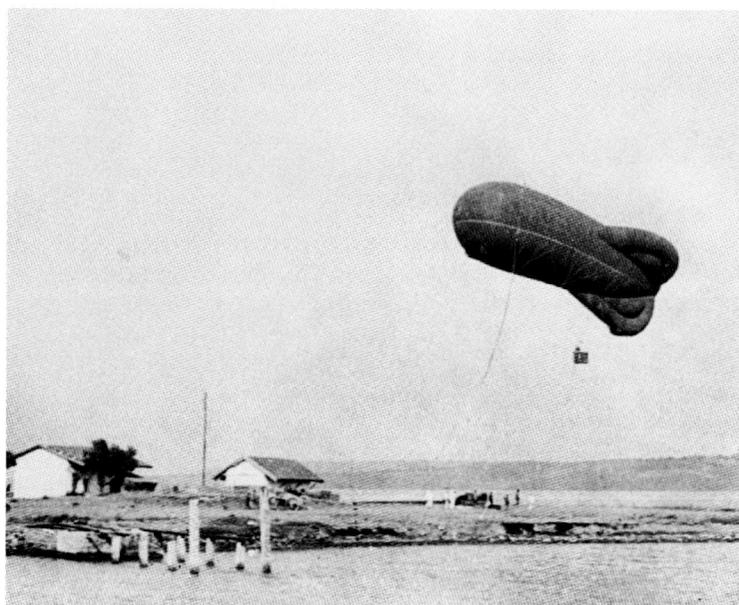

24. The observation balloon *Kobchik* **with an observer during preparations for departure to sea on the gunnery battleship** *Chesma*.
Black Sea Fleet. 1902

25. The tethered aerostat modeled after the *Kako* **with an observational basket.**
Black Sea Fleet. 1916

26. View of the battleship *Prince Potemkin-Tavrichesky* **from an air balloon, which lifted off from the battleship** *Sinop*, **designed by M.N. Bolshev to adjust artillery fire.**
Sevastopol. Maneuvers of the Black Sea Fleet. 1904

27. The battleship *Chesma* **with an observational balloon on the Sevastopol Road returning from gun practice.**
1902

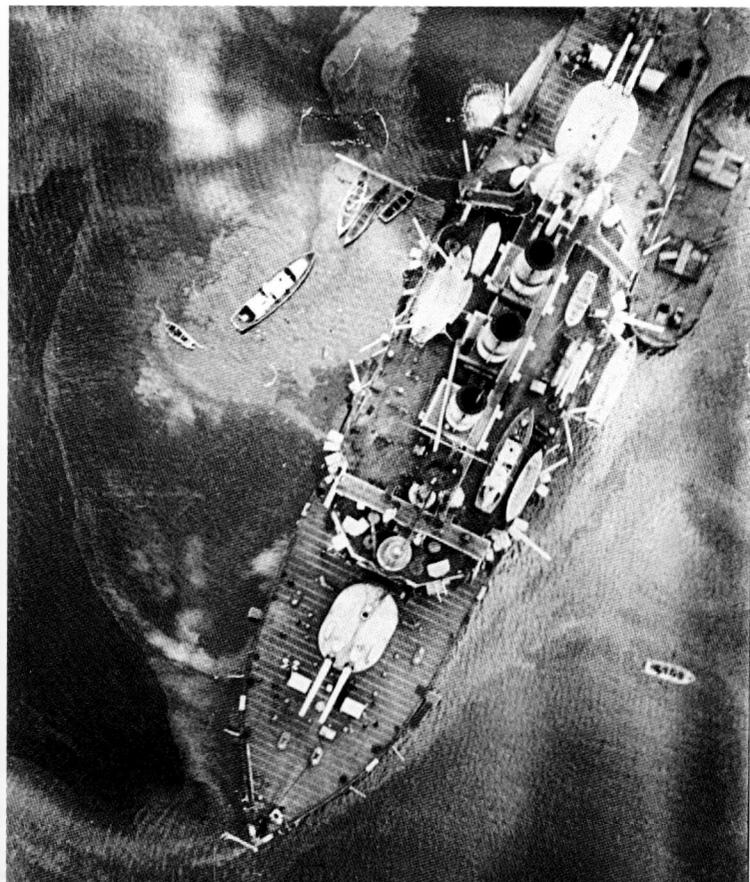

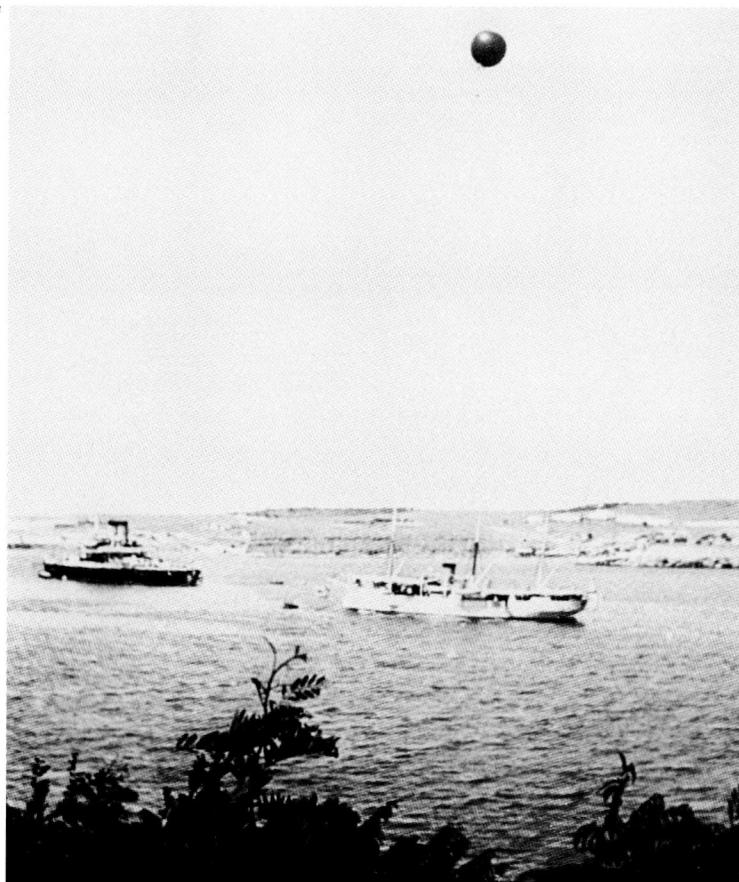

Balloon Aircraft and Dirigibles

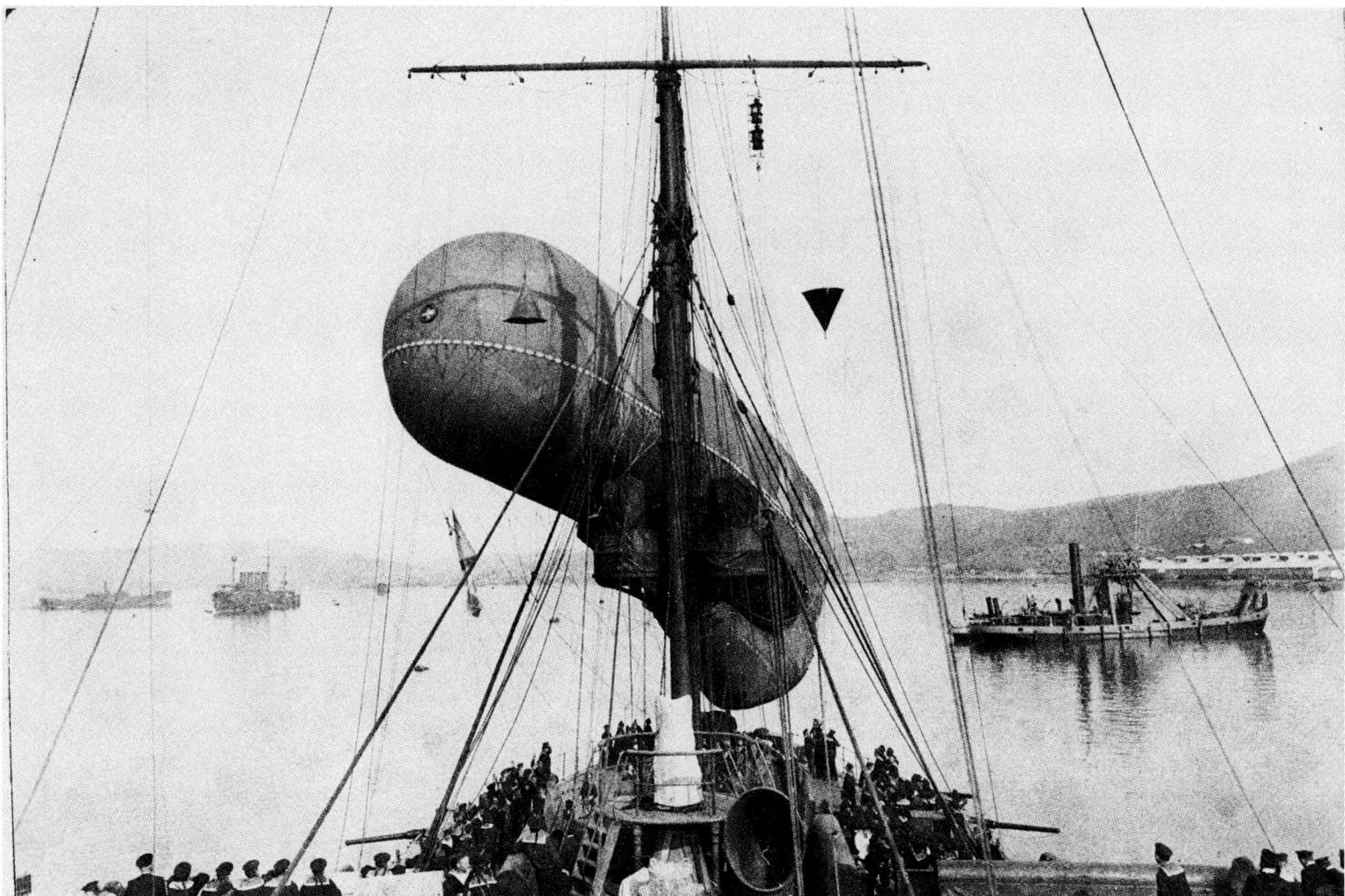

28. Lift off of a kite aerostat on the cruiser *Russia* before departing for a campaign to Tsugaru Strait.
Vladivostok. June 10-12, 1905

29. The air balloon *Yactreb (Hawk)*, under the direction of N.A. Gudim, over Vladivostok.
1904 — 1905

30. The cruiser *Russia* with an aerostat on campaign.
Far East. 1905

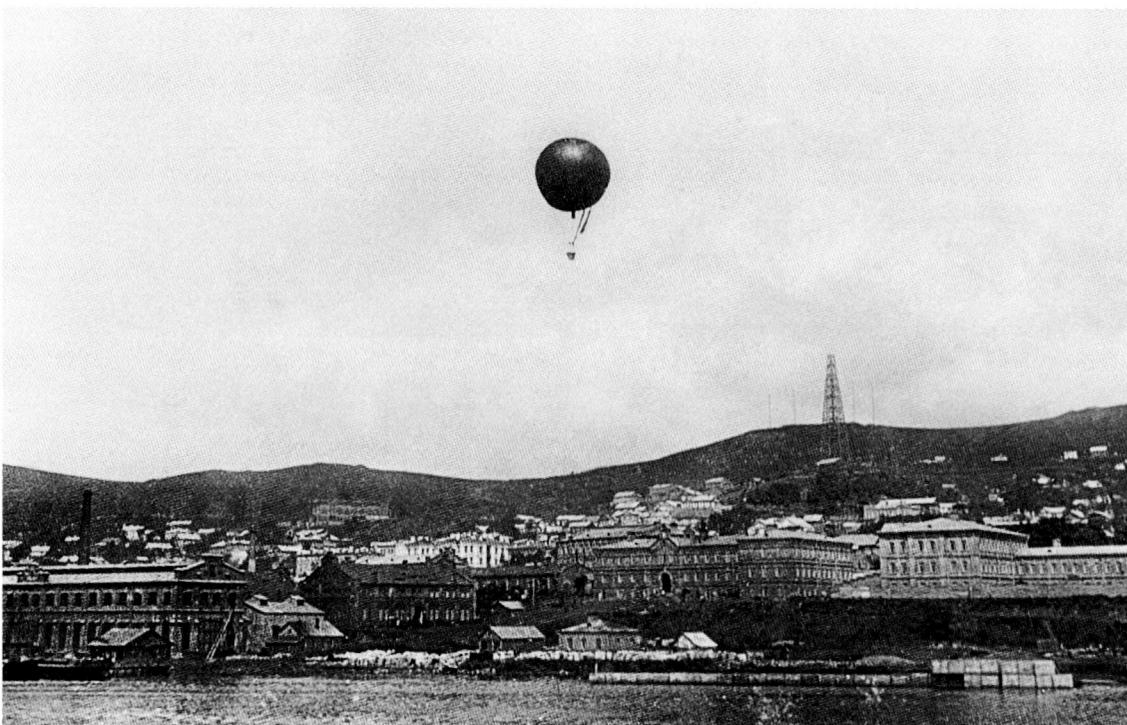

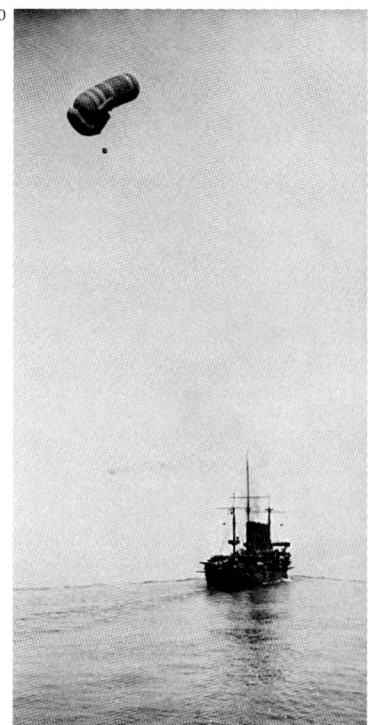

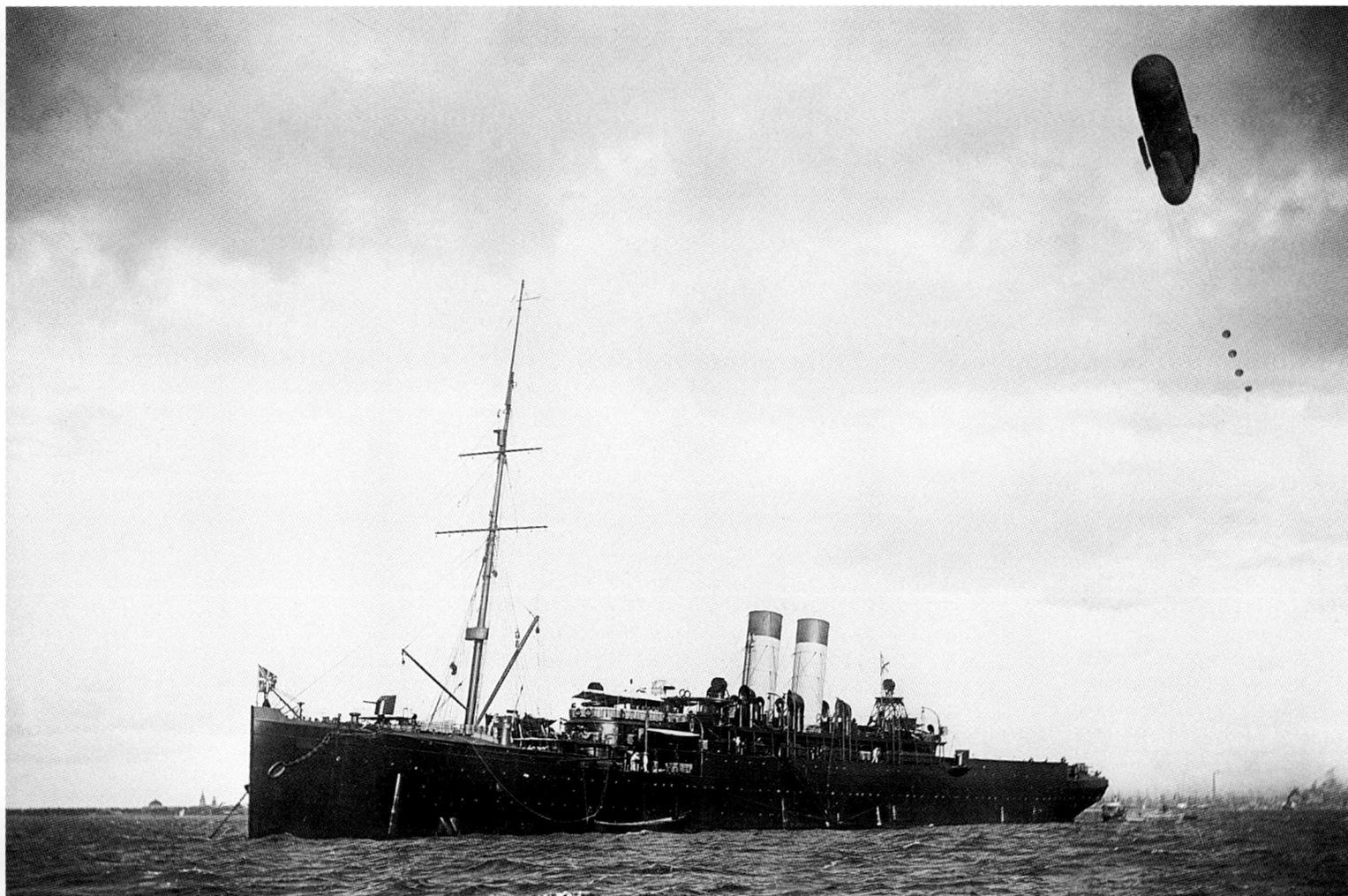

31. The second-class aeronautical cruiser *Rus* with an aerostat on the Big Kronstadt Road.
1905

During the Russo-Japanese War, retired Lieutenant Captain Count S.A. Stroganov introduced an initiative to build a special reconnaissance ship equipped with aeronautical weapons. The idea was put into action, and the steamer Lahn, acquired from the steamship company North German Lloyd, was outfitted. On October 24, 1904, the ship left Bremerhaven, and on November 1 was officially given to the Naval Department when it arrived in Libau. On the same day, Nicholas II named the ship Rus and added it to the list of second class cruisers (of the 13th Fleet Crew). In Summer 1905, tests with tethered aerostats took place on the ship in Kronstadt. From May 17 until September 1, 1905, 258 tethered aerostats made take-offs from the ship (186 with observers and 72 without).

32. View of Vladivostok from the basket of an aerostat.
1905

32

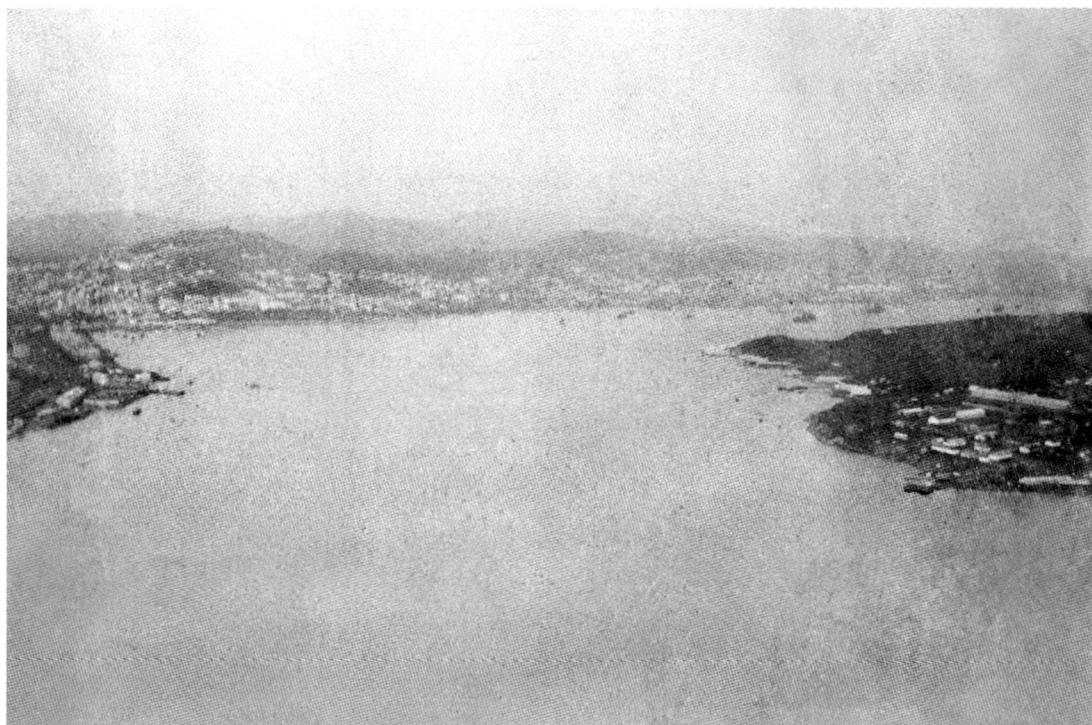

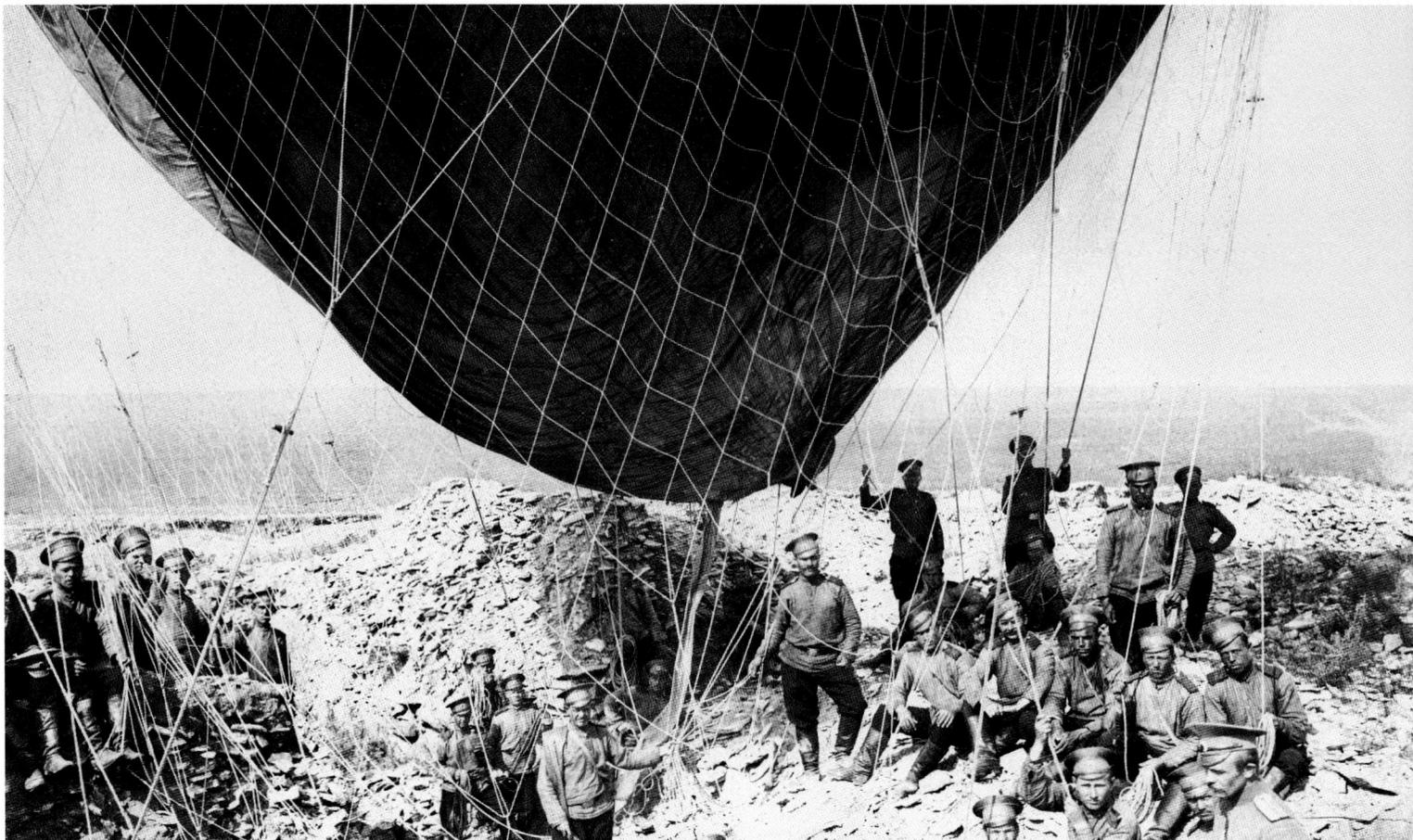

33. Soldiers and officers of the 4th Siberian Aeronautical Company with an aerostat.

1906 — 1908

34. Air gas bags, from which aerostats were filled with gas before take-off.

4th Siberian Aeronautical Company 1907

35. An officer and enlisted contingent of the aeronautical detachment during field training.

Irkutsk District. 1907 — 1908

34

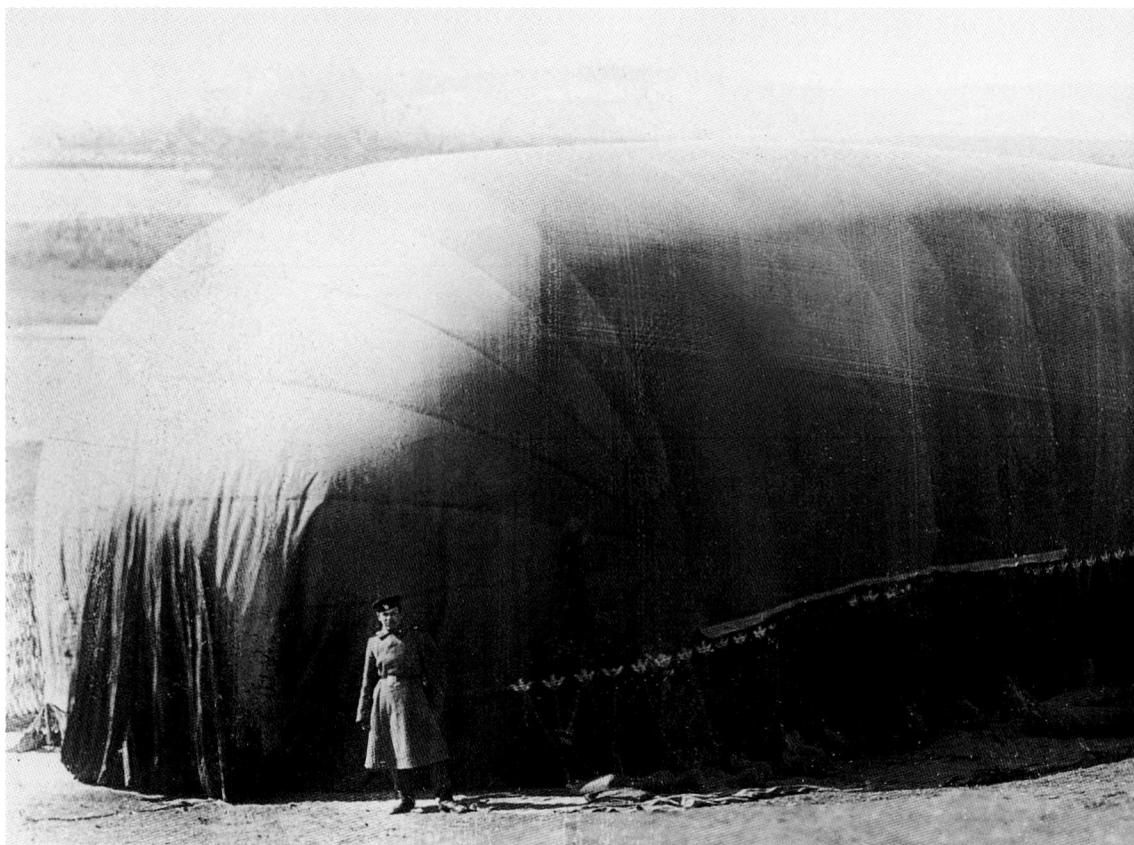

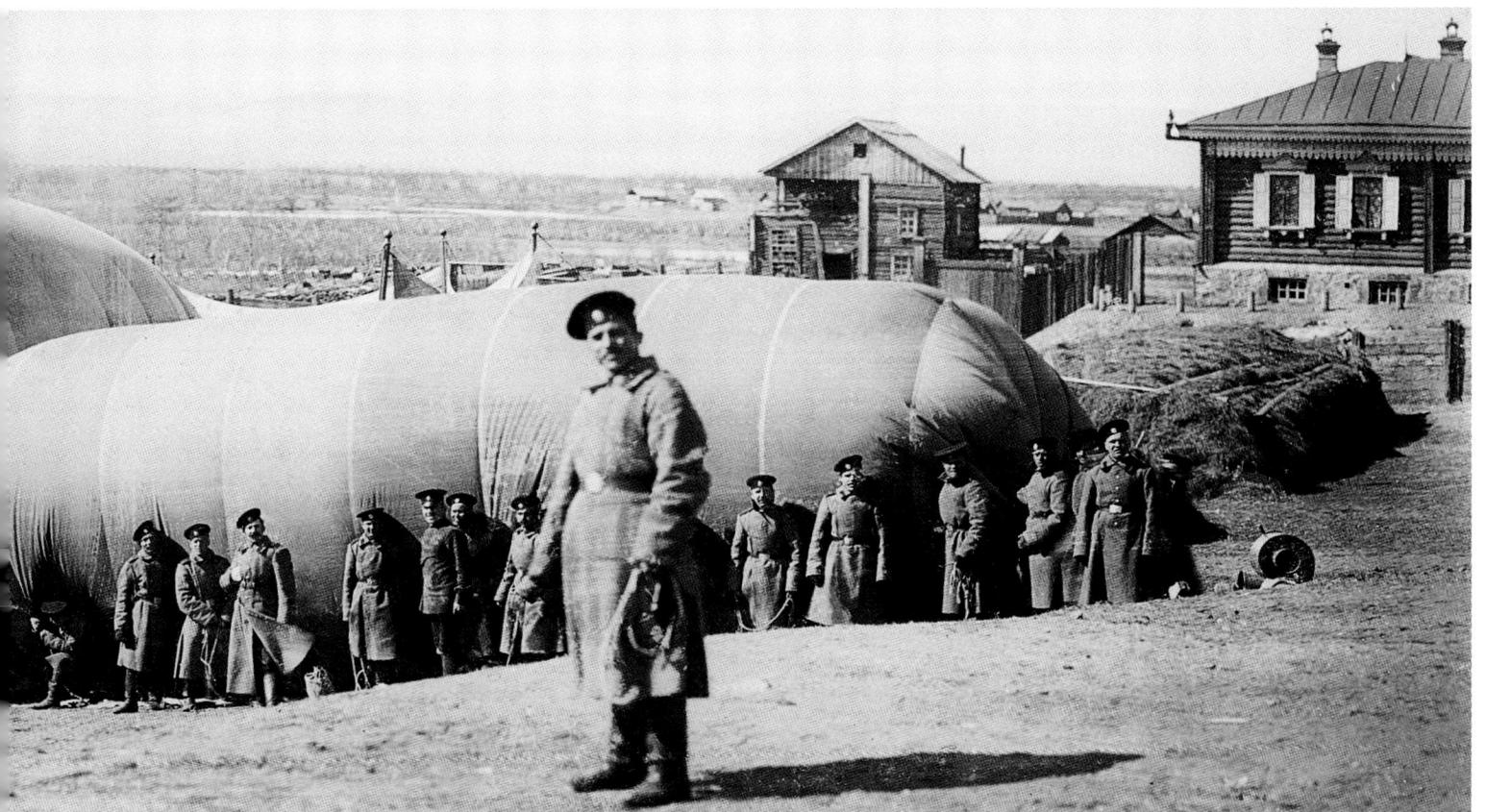

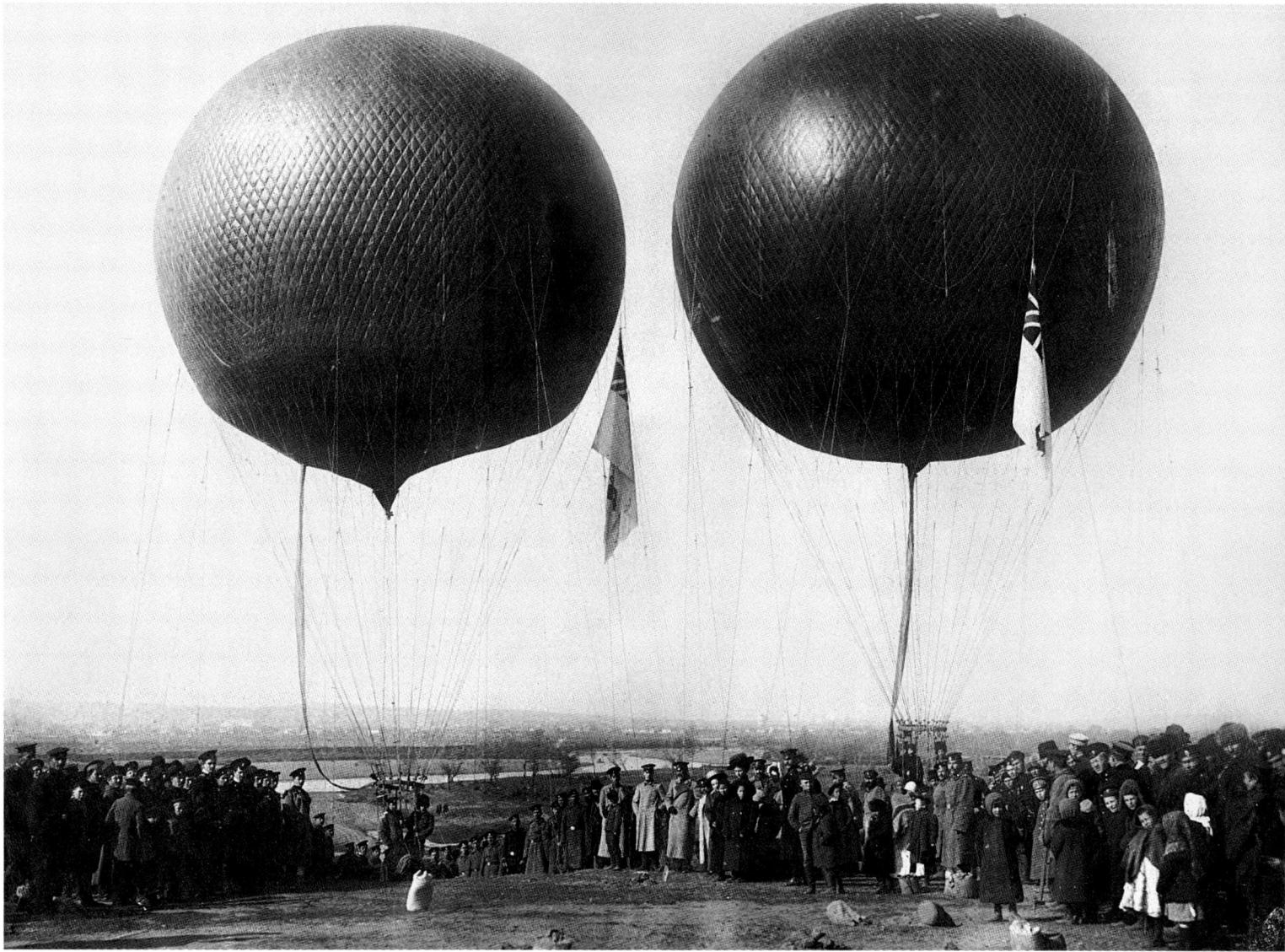

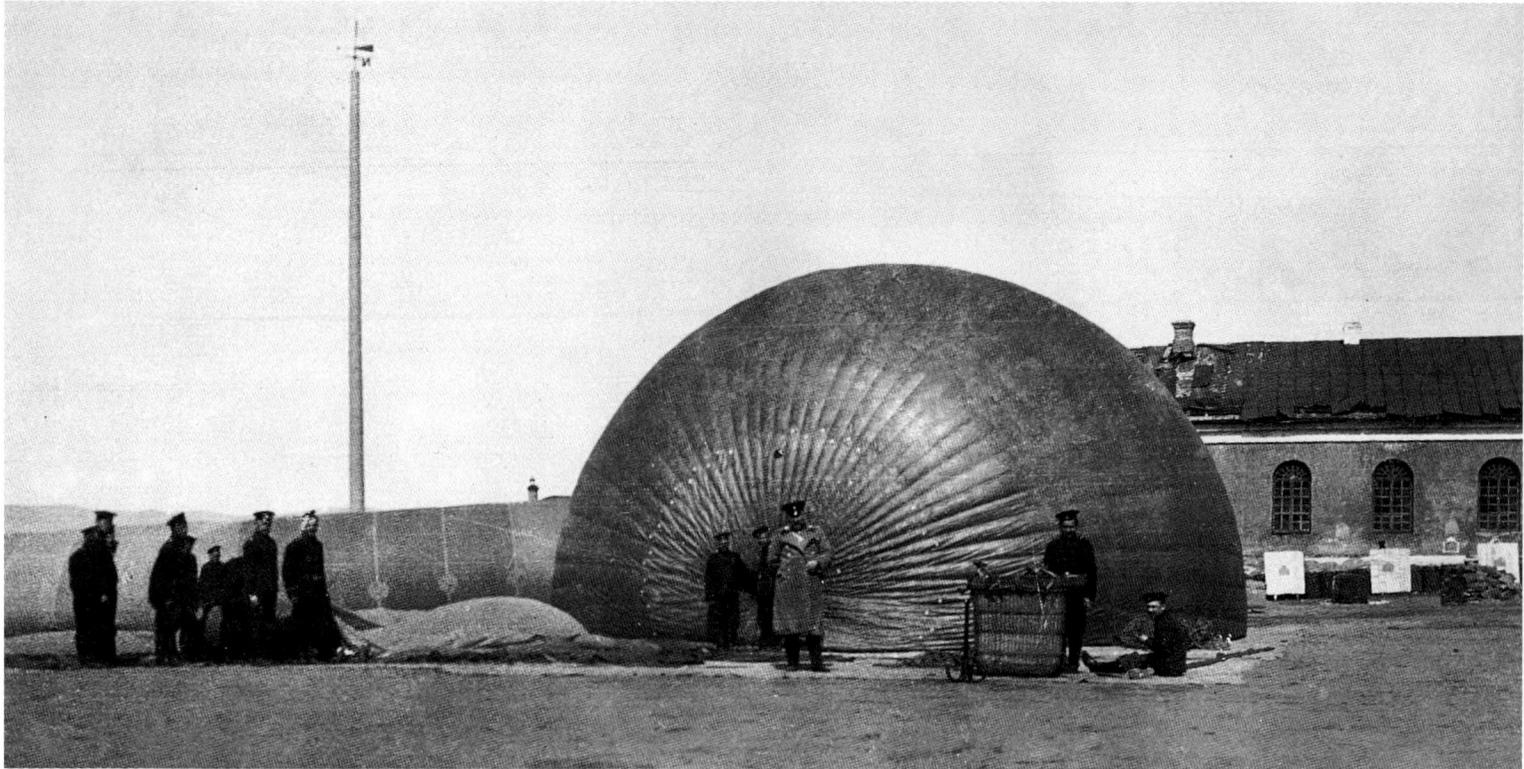

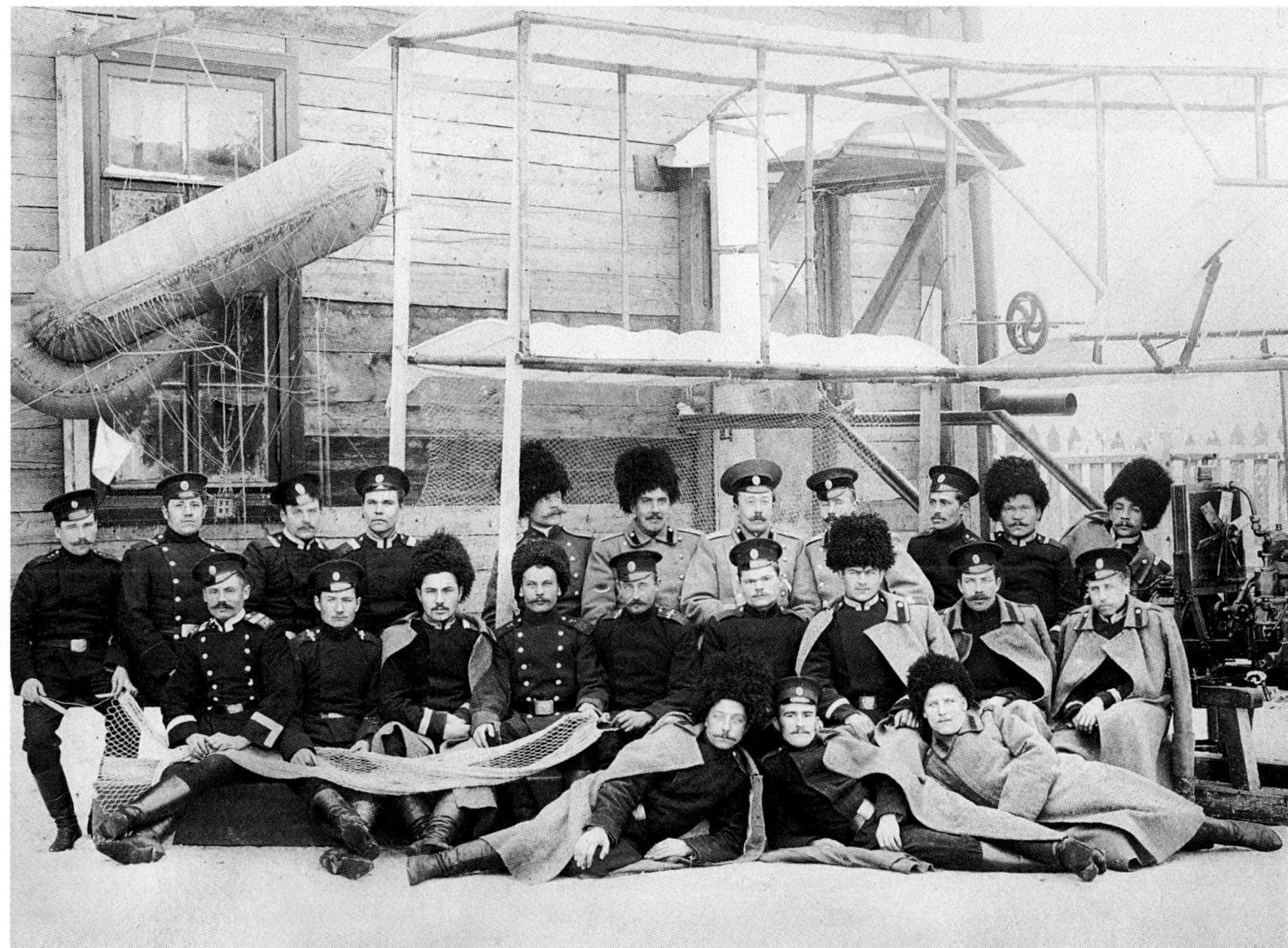

36. Tethered aerostats of the aeronautical contingent on war maneuvers.
Siberian Precinct, Irkutsk District. 1907 — 1910

37. Siberian Aeronautical Company. While filling a tethered aerostat with gas.
Chita District. 1907 — 1910

38. Detachment of the Siberian Aeronautical Company with educational texts and models.
Chita District. 1906 — 1908

39. View from an air balloon of an outdoor aeronautical company.
Chita. 1907 — 1910

39

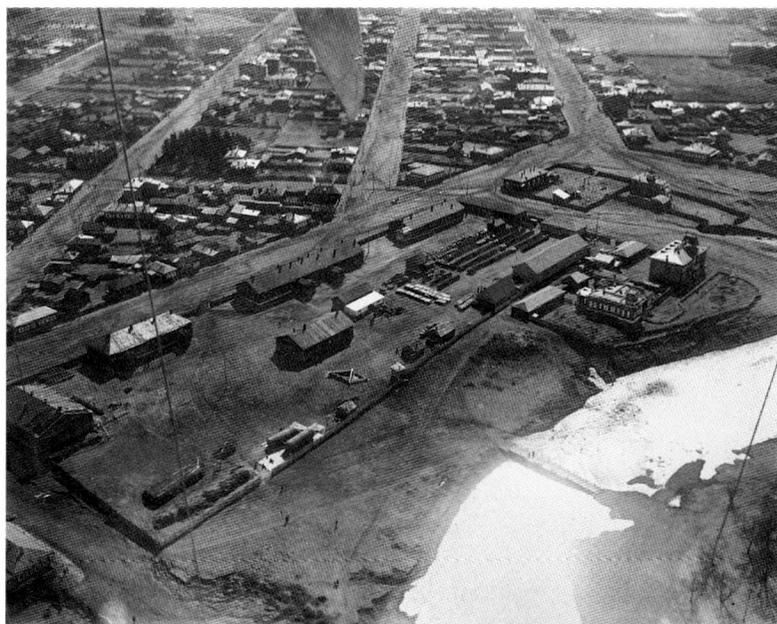

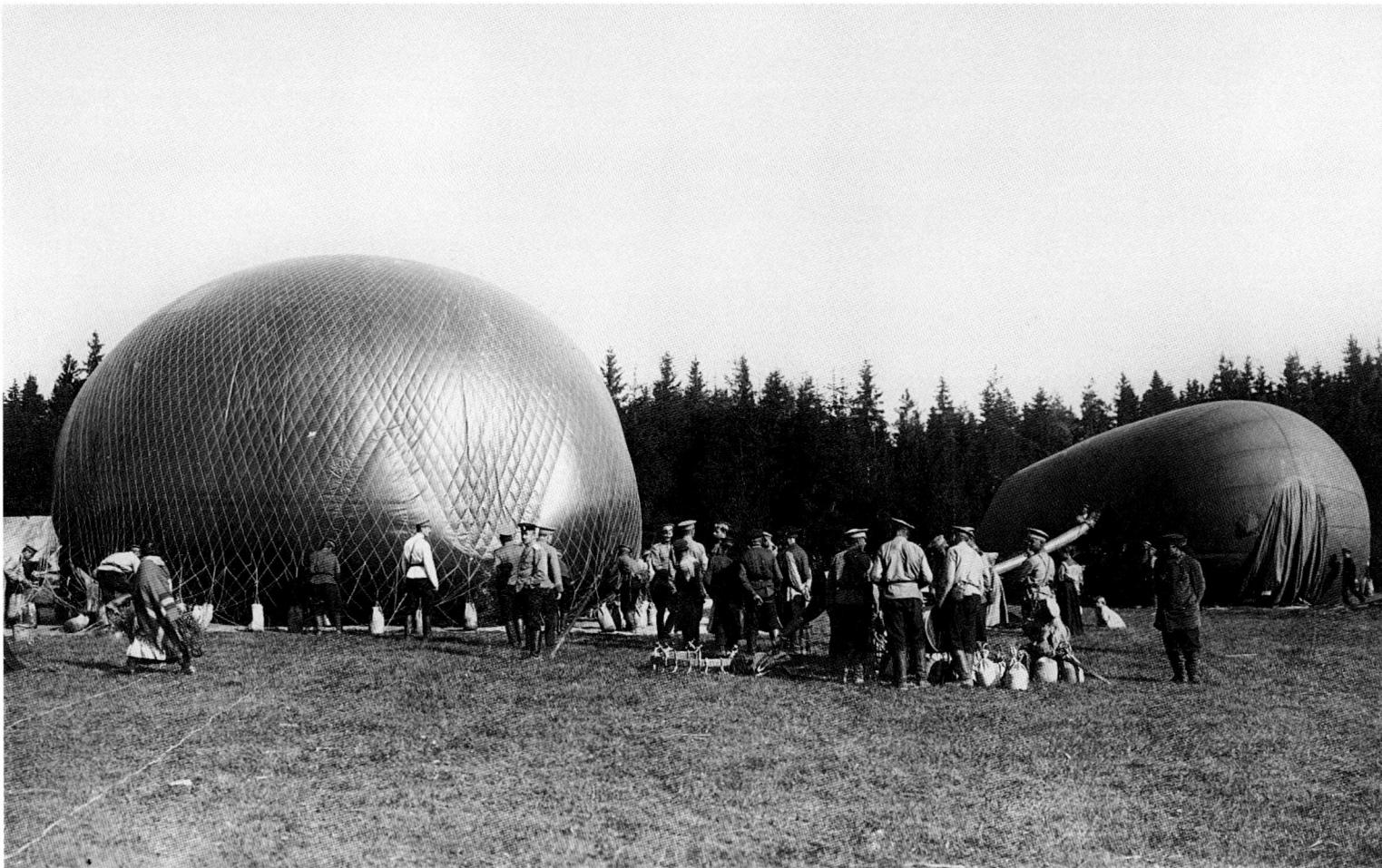

40. Preparation of aerostats for demonstration flights before the arrival of Nicholas II.
A student company of the Officers Aeronautical School.
Krasnoye Selo District. 1905 – 1906

41. Unsuccessful landing of the aerostat *Chaika (Seagull)* **in the valley of the river Lefu. In the basket is Alexander Kovanko (A.M. Kovanko's son) and N.A. Gudim.**
1904 – 1905

42. Air balloon with the flag of the aeronautical troops during field training in Krasnoye Selo.
Summer 1907

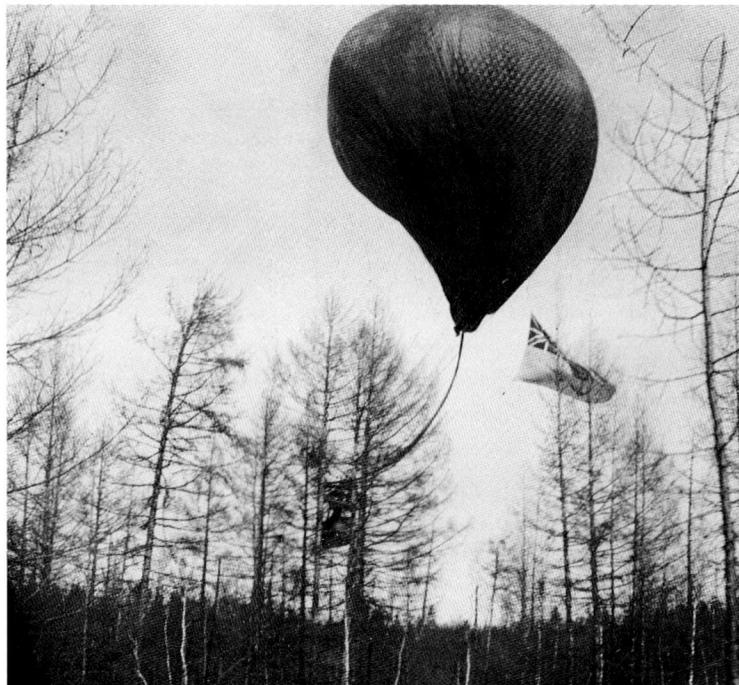

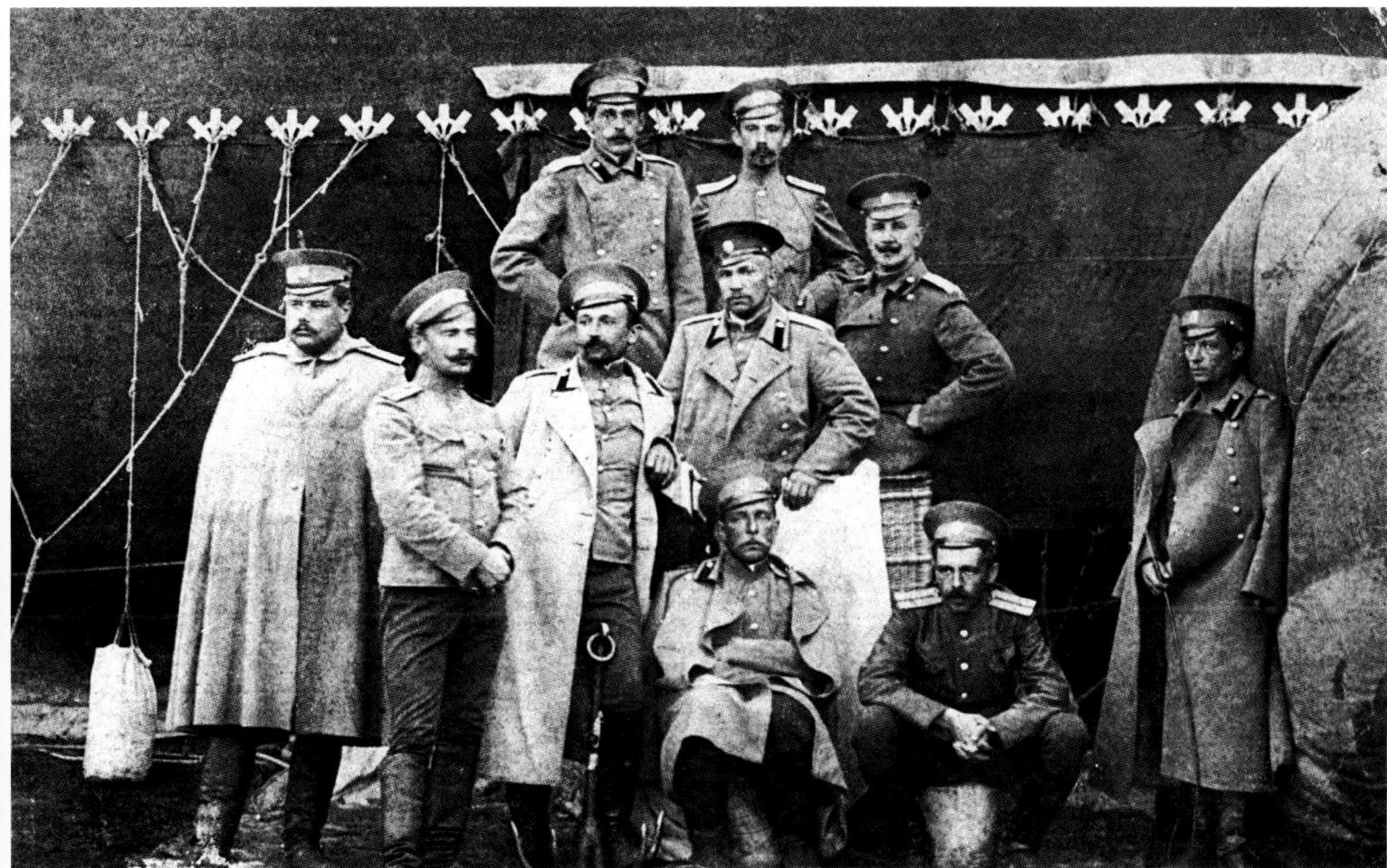

43. Balloonist-aeronauts of the Officers' Aeronautical School. In the middle row (standing), fourth from the left is pilot N.N. Danilevsky.
St. Petersburg. Fall 1910
Ballast weights can clearly be seen in the picture, which fastened to the cover of the balloon with special cartridges.

44. Aeronaut and constructor N.N. Danilevsky (second from the right in the white overcoat) converses with French engineer A.E. Garut, the inventor of the motorized winding machine, made for air balloon take-offs.
St. Petersburg. 1907 — 1908

44

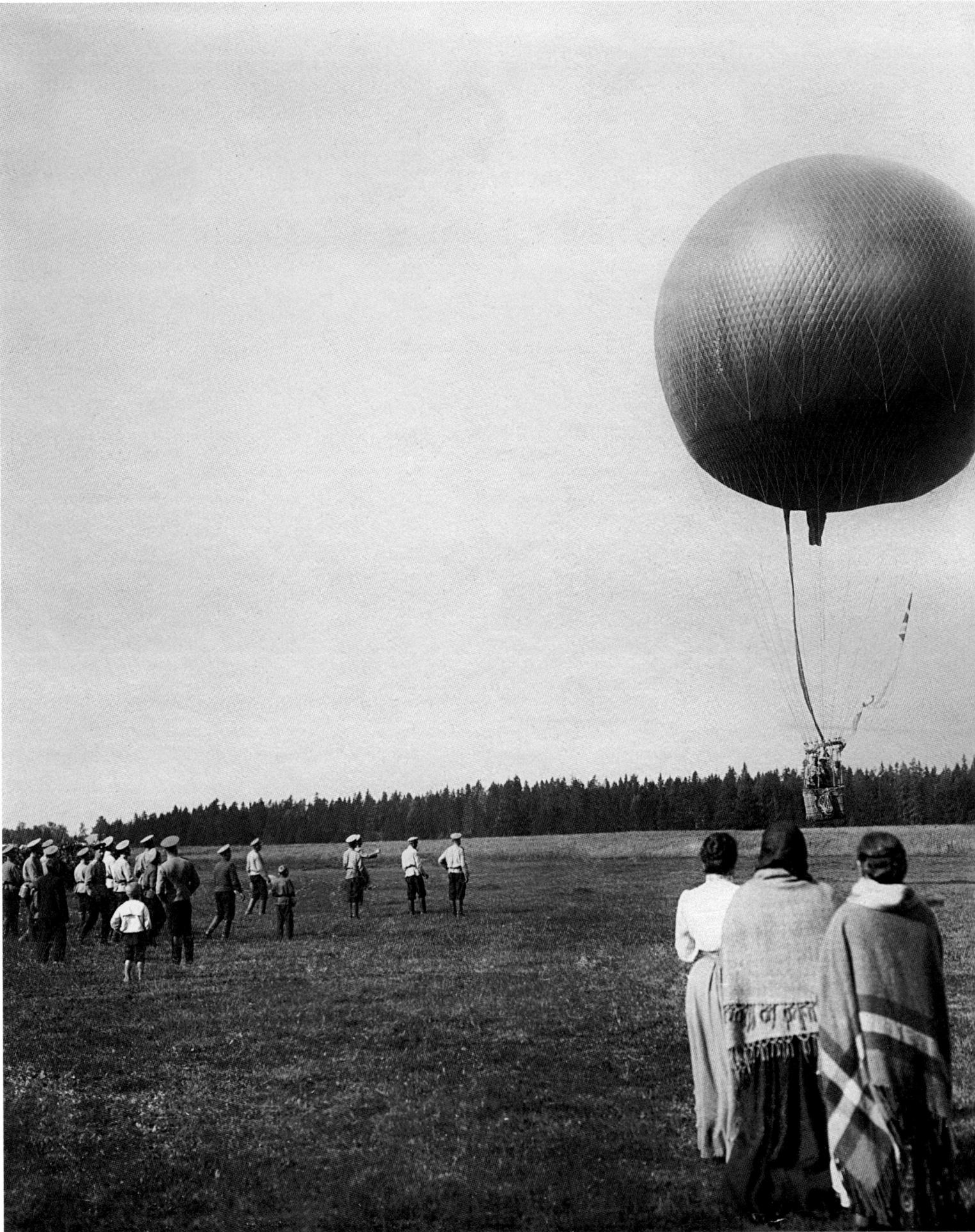

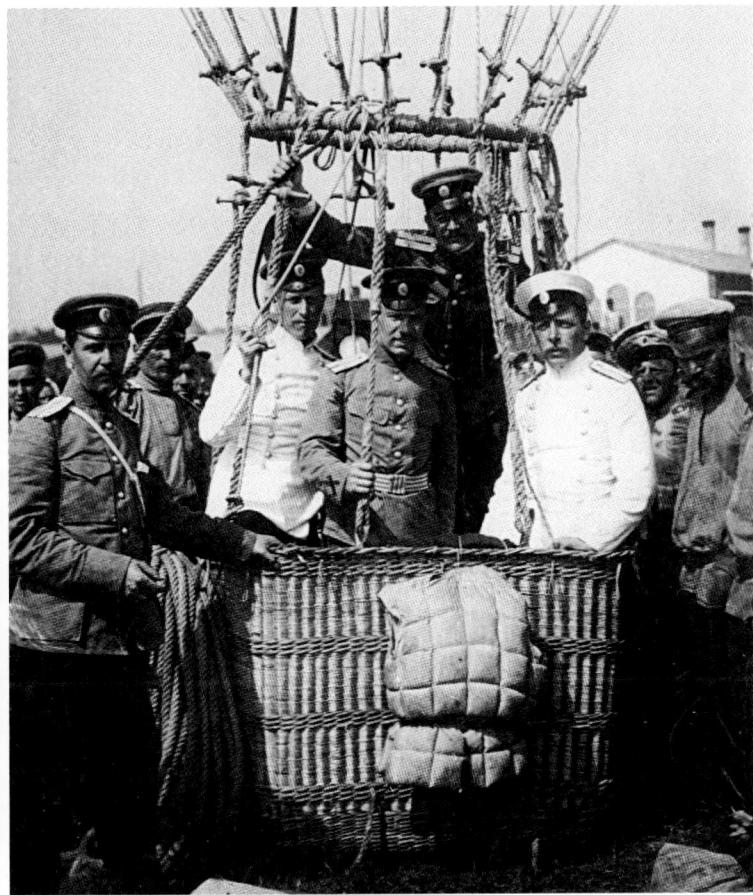

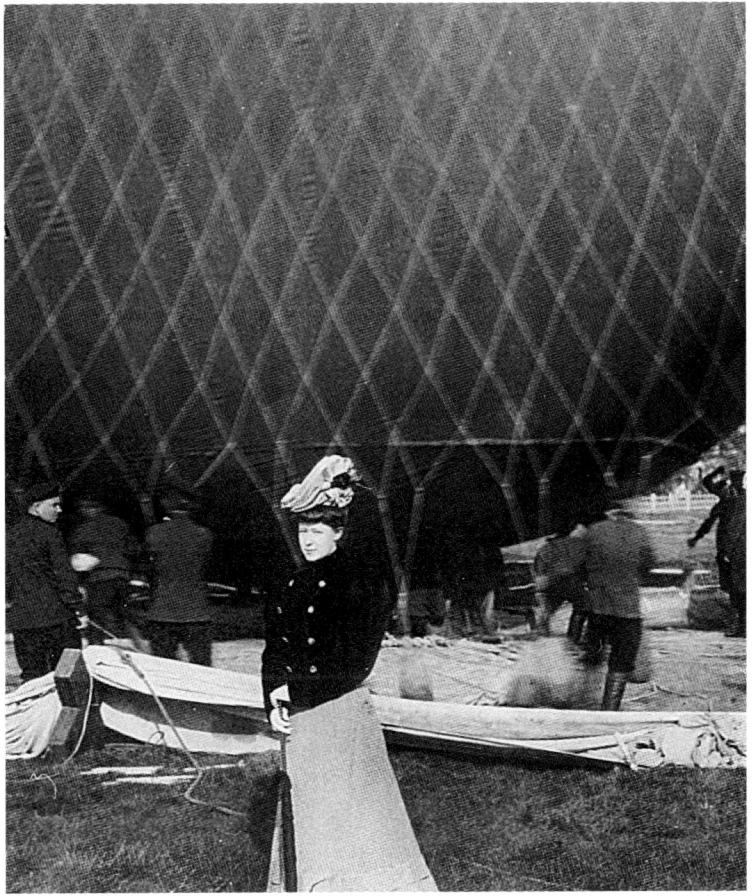

45. Observers and attendant personnel of the Aeronautical Park on the field during a take-off of an air balloon.

St. Petersburg. 1910 — 1911

46. Aeronaut and constructor N.N. Danilevsky in the basket of a tethered aerostat (in the center) with military observers and students of the Officers Aeronautical School.

St. Petersburg. 1908 — 1910

47. N.N. Danilevsky's wife on the field during her husband's flight.

1908 — 1912

48. In the foreground is an instrument for receiving hydrogen in field conditions with N.N. Danilevsky.

St. Petersburg. 1907 — 1908

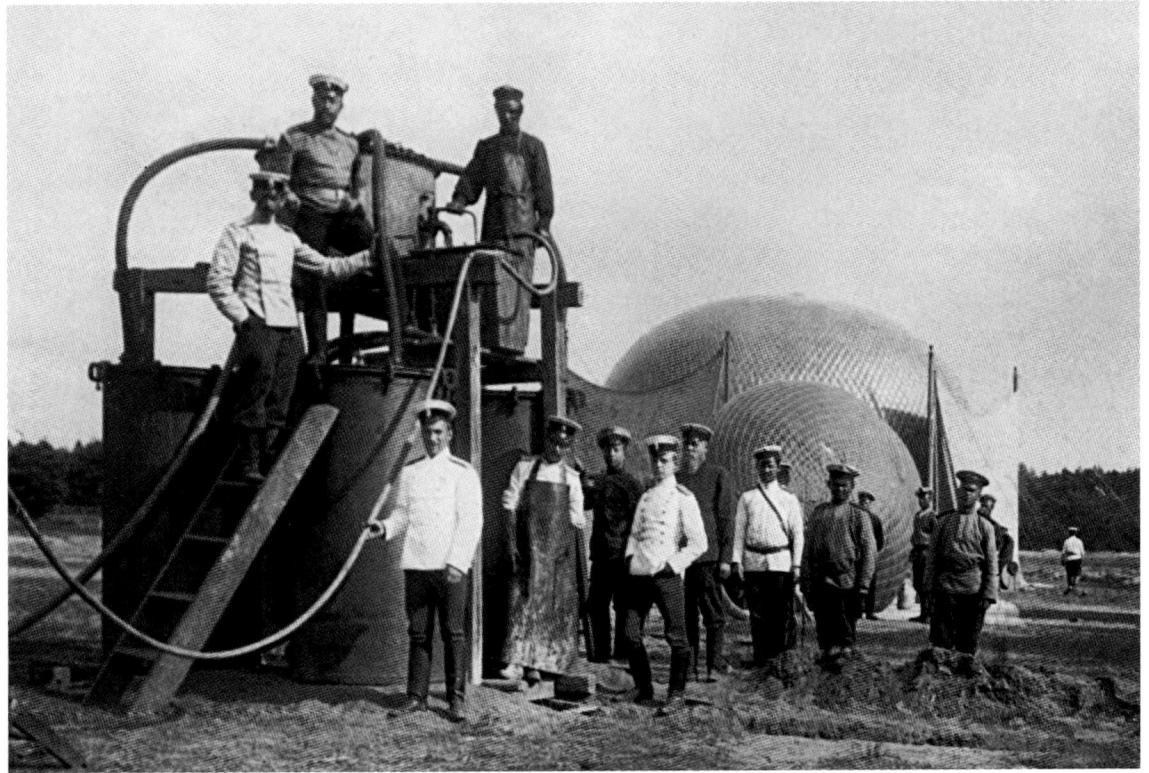

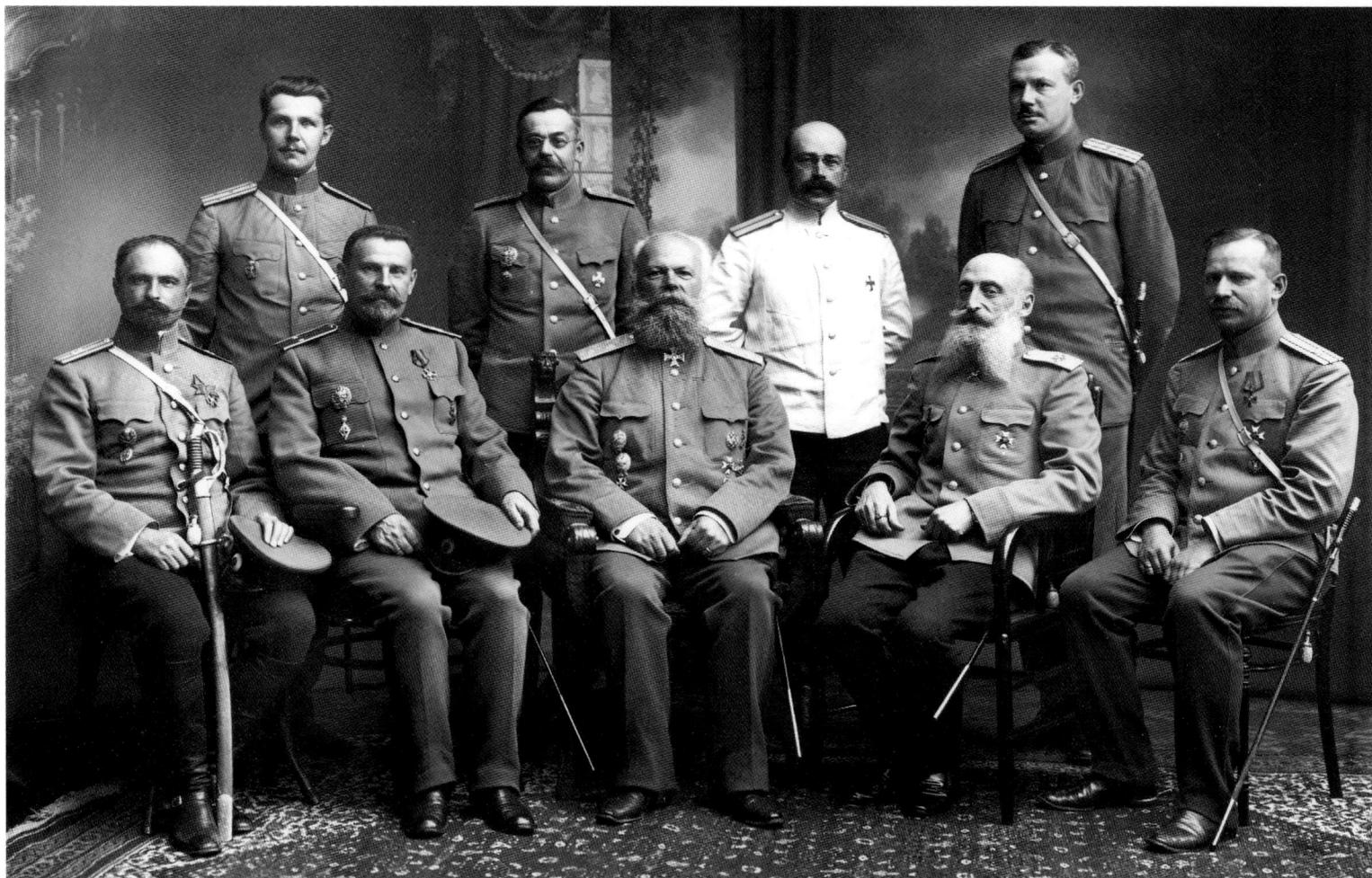

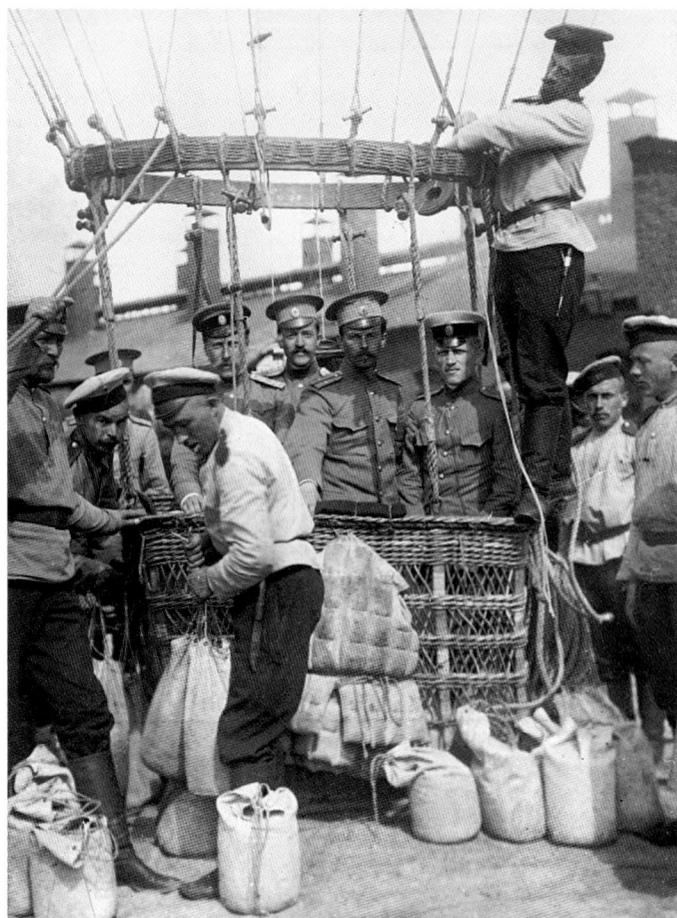

49. Aeronautical Park. A group of older aviation officers. (Sitting left to right: Lieutenant-Colonel V.M. Novitsky, General Lieutenant N.V. Alexandrov, General Lieutenant N.A. Kirpichev, General Major A.M. Kovanko, Lieutenant-Colonel N.I. Uteshev; standing second from left is S.A. Nemchenko).
1910

50, 51. Preparing trainee pilots on tethered aerostats with two and four local baskets at the Officers Aeronautical School.
St. Petersburg. 1910

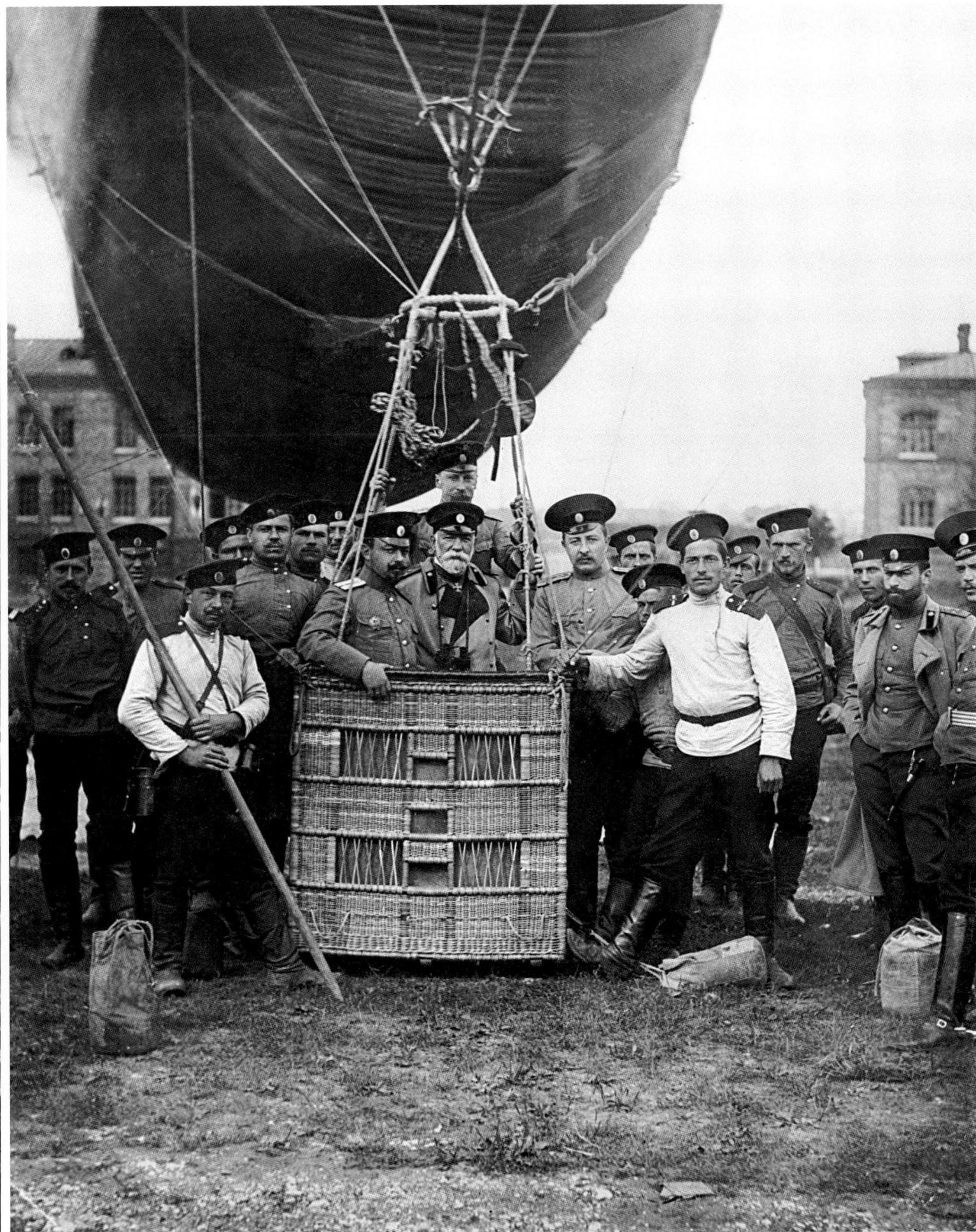

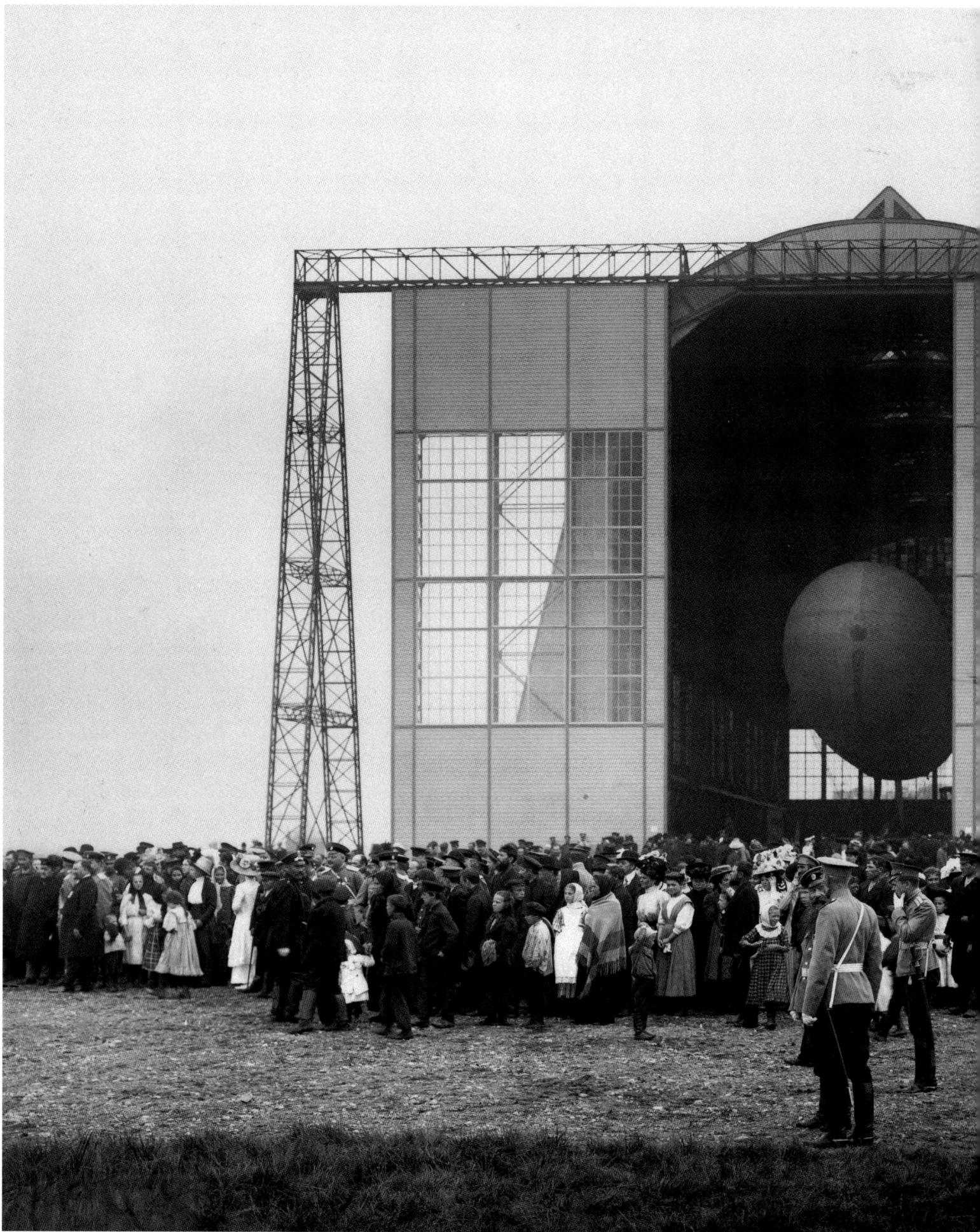

Russian Imperial Air Force

52. Ceremonial opening of the special hanger for dirigibles on the Volkov Field at the Officers Aeronautical School.
1909
In the hanger is the first dirigible of the Training *series.*

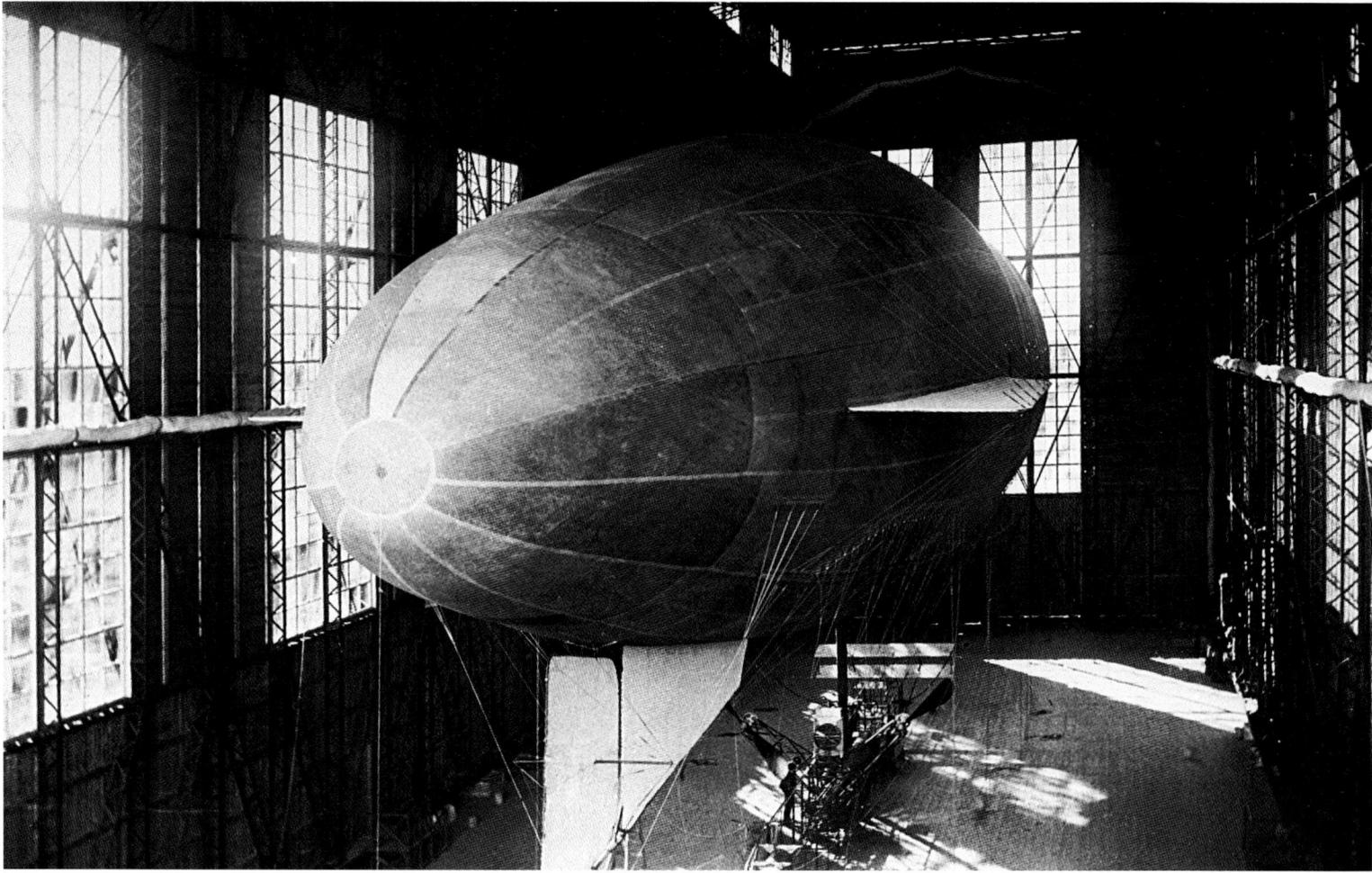

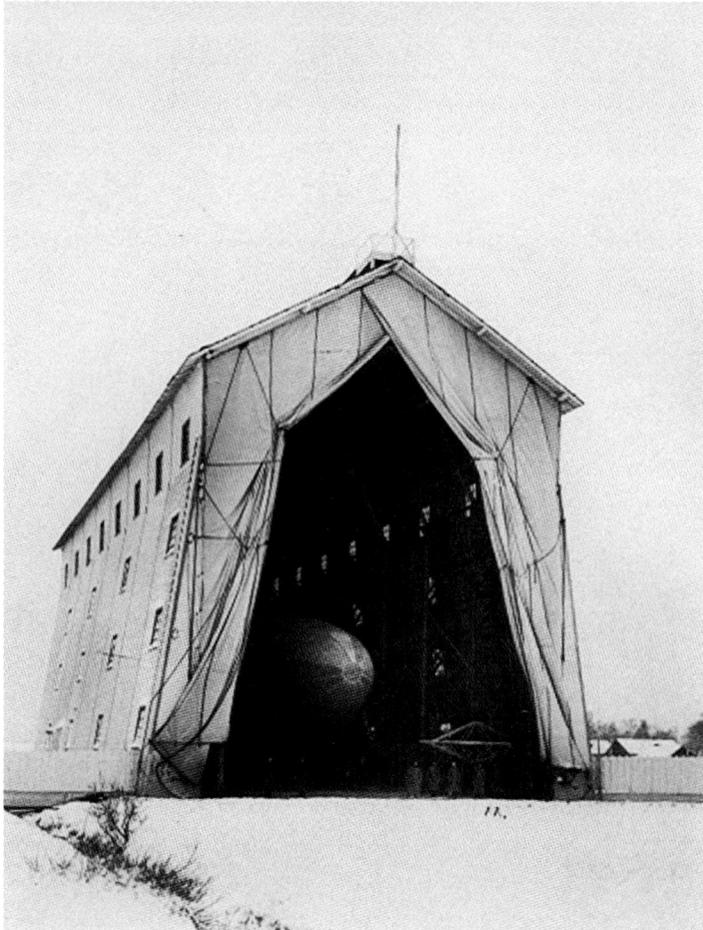

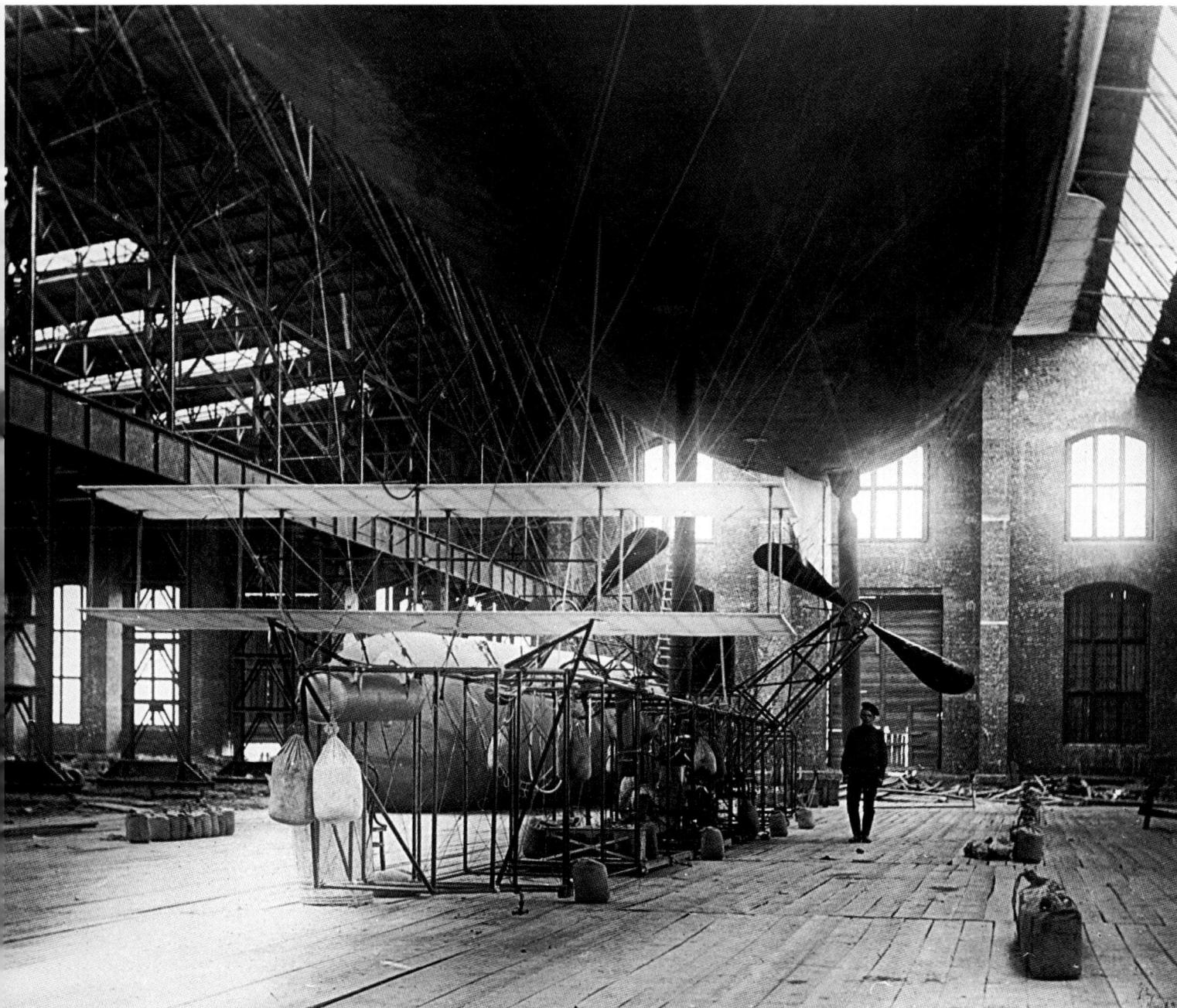

53. A small dirigible of the *Golub (Dove)* **type.**

Izhorsky Works (city Kolpino). Summer1910

In Fall 1910, the Golub *(technical characteristics: capacity 2275 cu./m, Kerting engine of 75 liters per second) received a prize for arrival at the First Aviation Week at the Kolomyazhsky Raceway.*

54. A collapsible portable hanger for small dirigibles.

1910 — 1915

55. Frame of a cabin with motor on the dirigible *Yastreb (Hawk)* **during installation in a stationary hanger.**

St. Petersburg. 1910

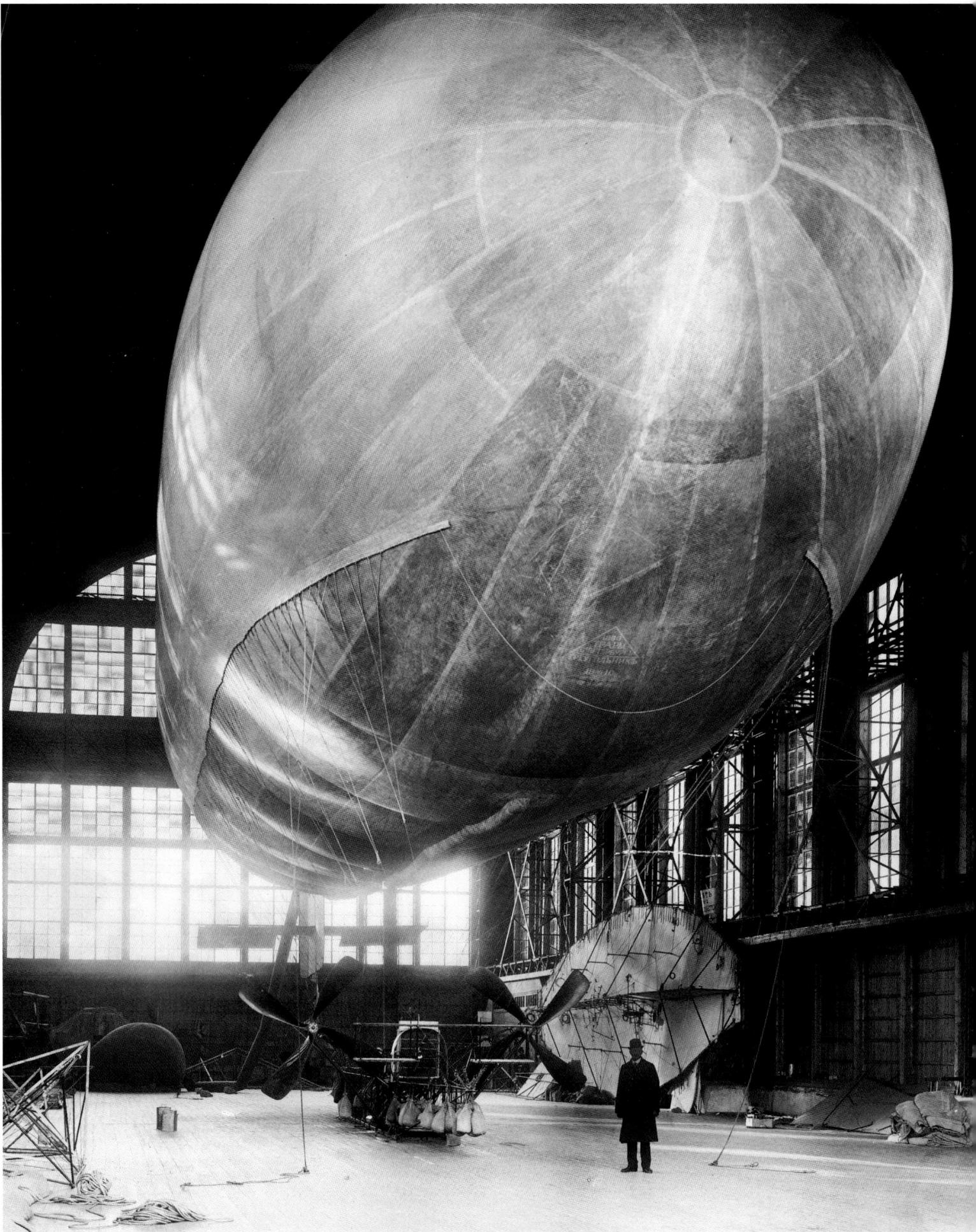

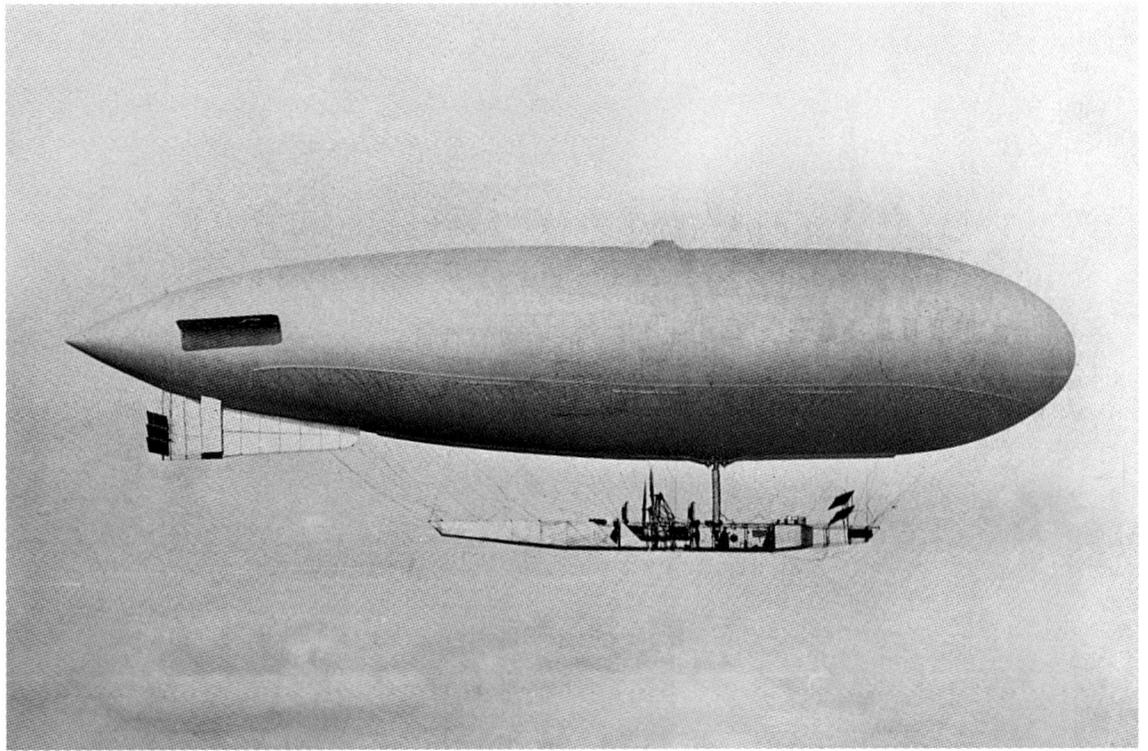

56. The dirigible *Yastreb (Hawk)* **in a hanger.**
St. Petersburg. 1910s
At the start of World War I the Yastreb *was part of the Twelfth Aeronautical Company*

57. The dirigible *Yastreb* **in flight.**
St. Petersburg. 1911—1912
Built in Moscow by the factory Dukes (designer — A.I. Shabsky).

58. Approach of the dirigible *Lebed (Swan)* **to a hanger on a base for Russian dirigibles in the village Salizi (today it's the township Kotelnikovo near Gatchina).**
1910

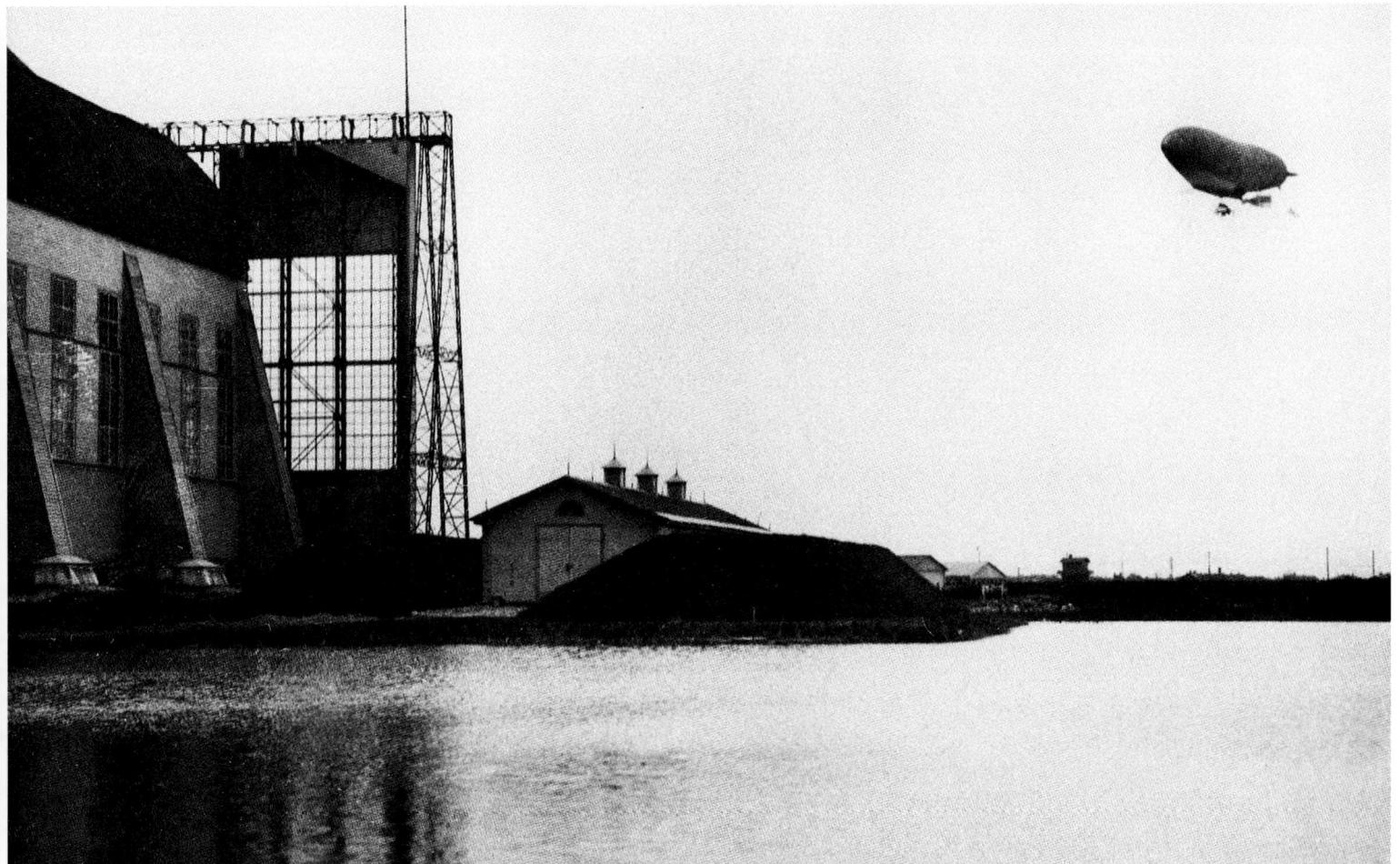

Balloon Aircraft and Dirigibles

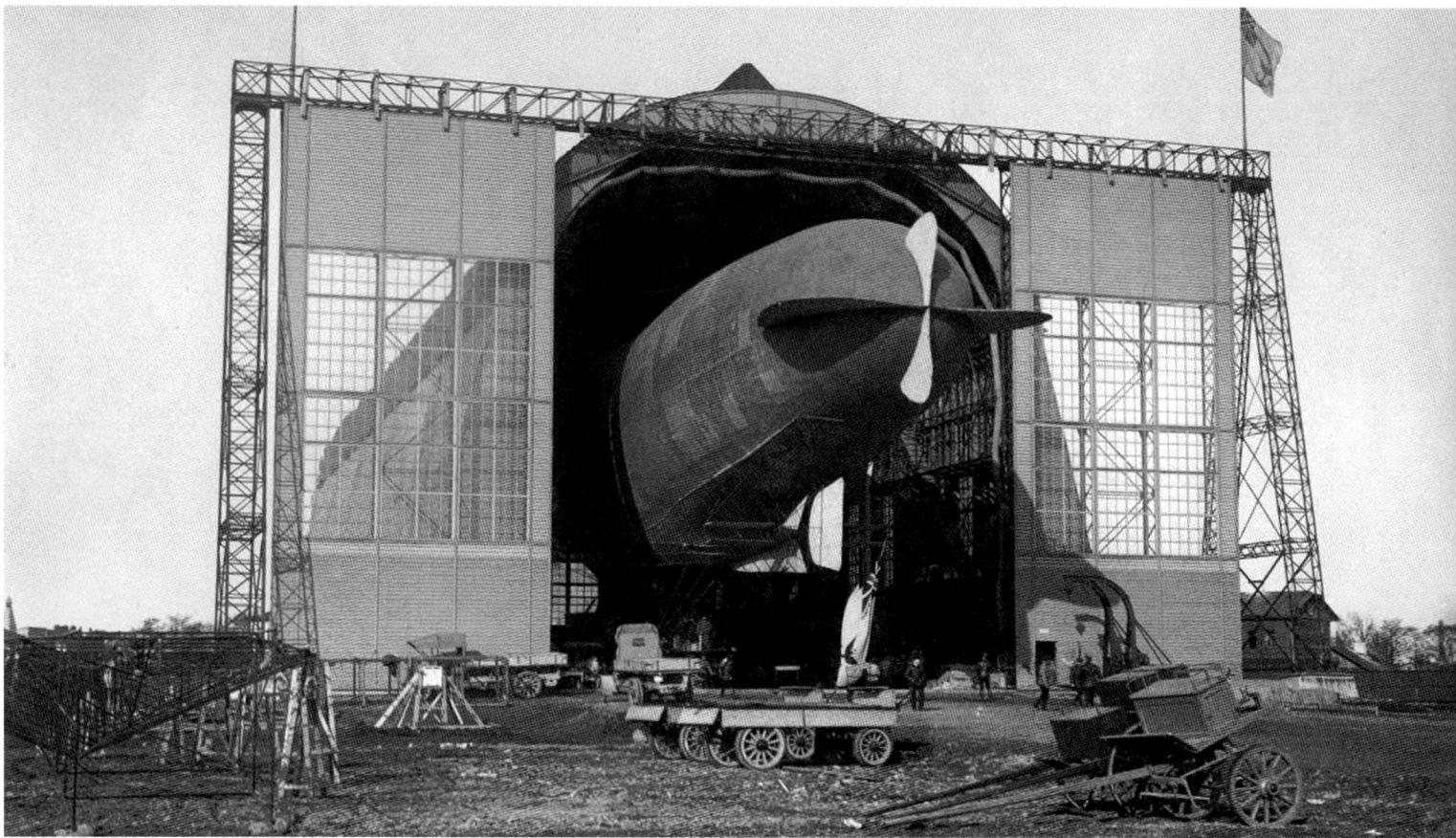

59. Withdrawal of the dirigible *Lebed (Swan)* **from its hanger.**

Village Salizi. 1910

The Lebed *was the first dirigible ordered abroad by the War Ministry. Capacity: 4500 cu./m, speed: 36 km/hr.*

60. The dirigible *Lebed* **over the Kolomyazhsky raceway.**

St. Petersburg. 1912 — 1913

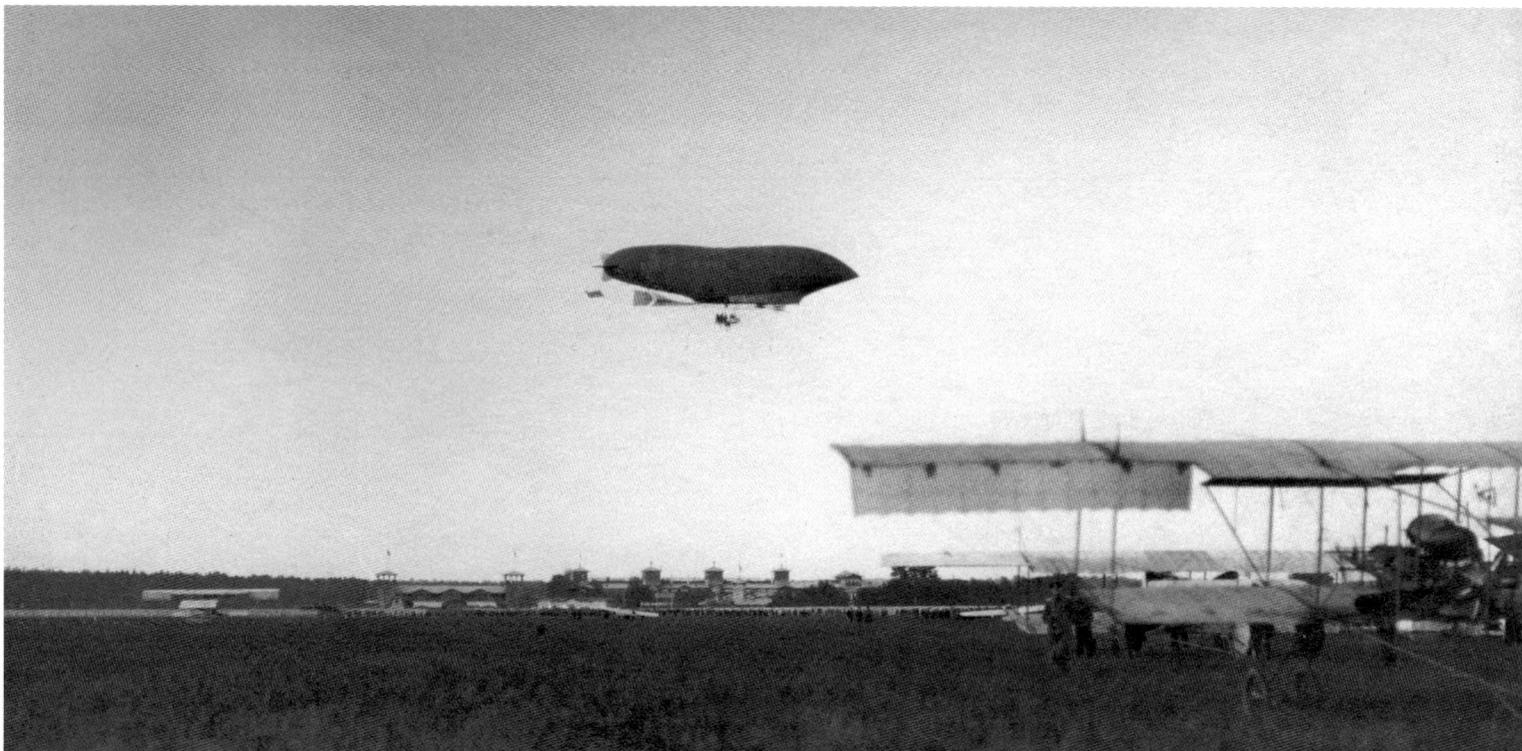

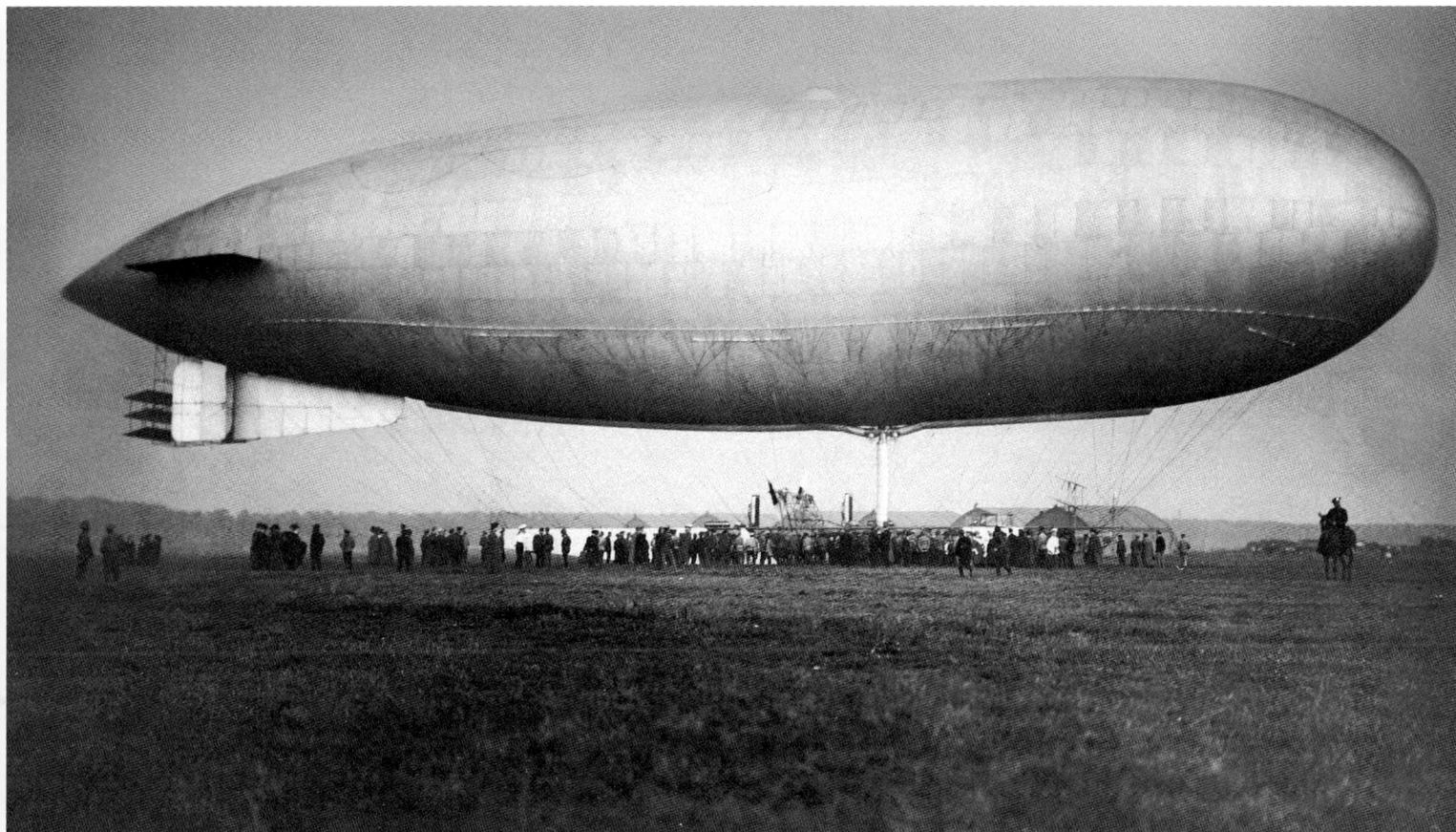

61. Military dirigible *Albatross*.

St. Petersburg. 1913

The Albatross *was built in Russia in 1912 at the Izhorsky Works. Capacity: 9,600 cu./m, speed: 68 km/hr.*

62. Cover of a dirigible without the frame for a motor bay.

Izhorsky Works. 1911

63. Building the dirigible *Albatross* **at the Izhorsky Works.**

1911–1912

The dirigible was built by designer B.V. Golubevy and D.S. Sukharzhevsky.
It took part in World War I and made some military flights dropping bombs on German fortifications..

63

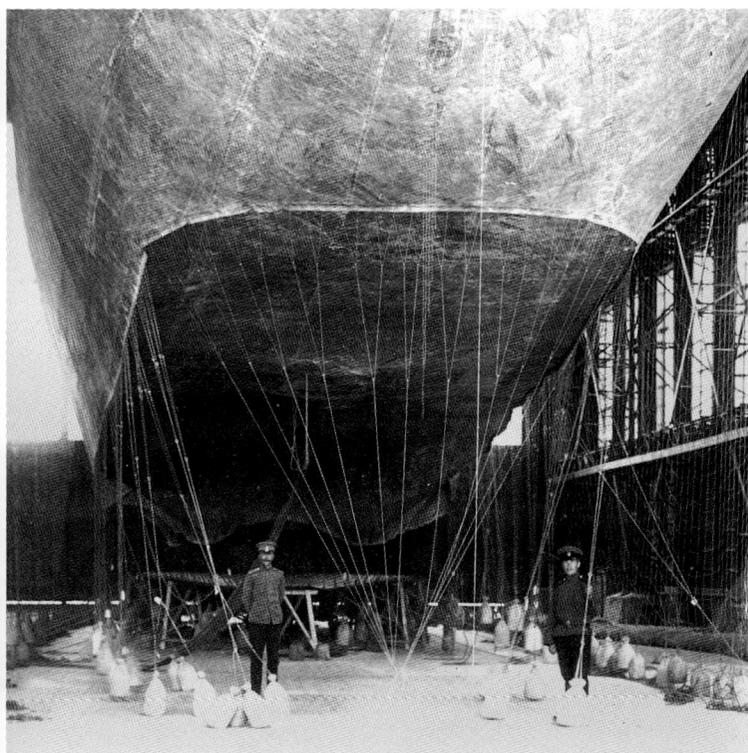

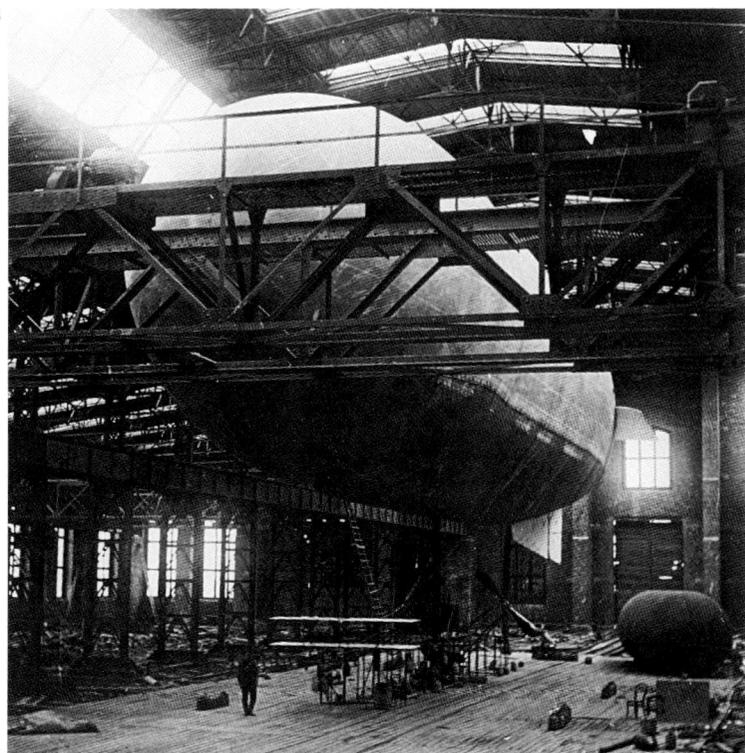

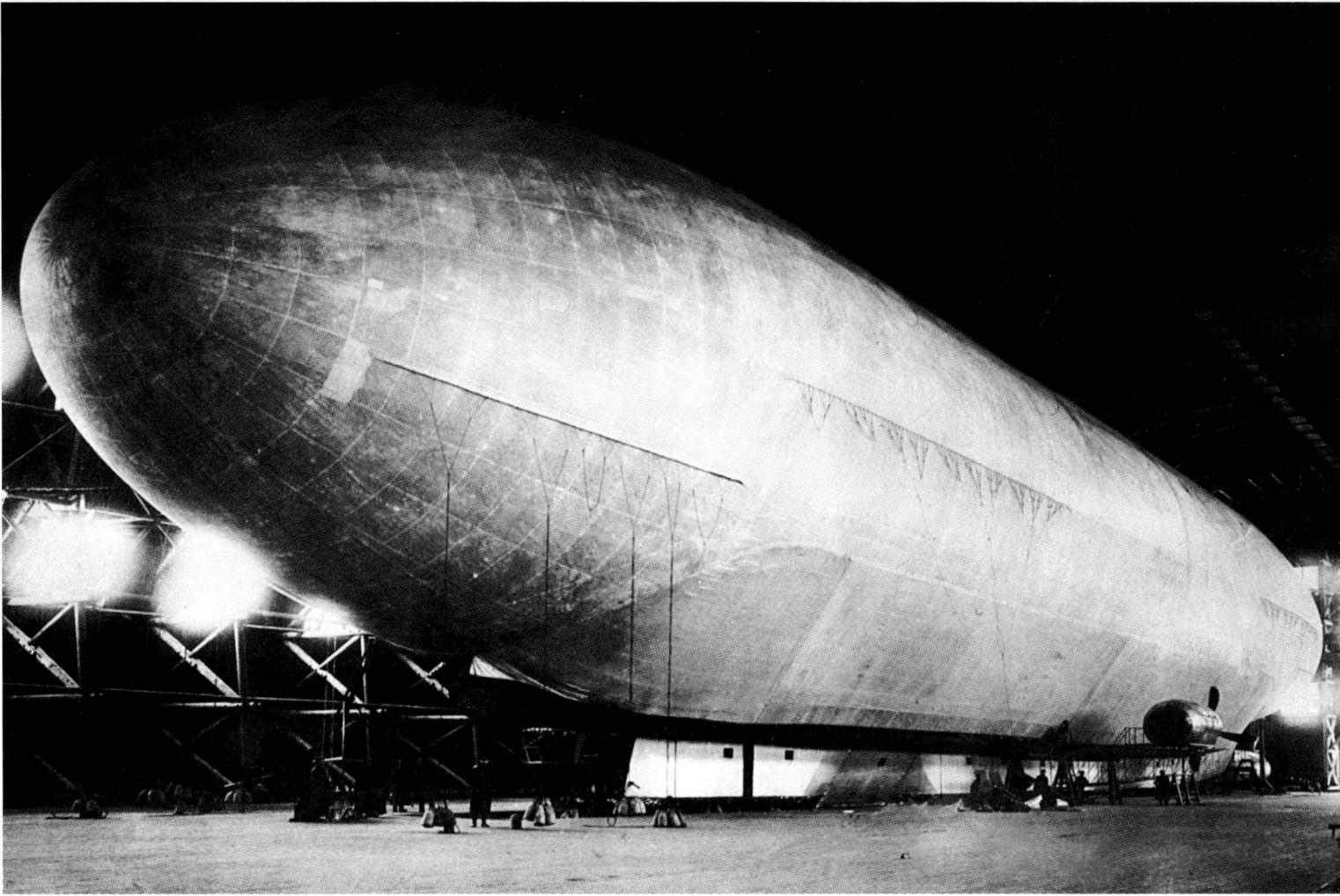

64. The largest dirigible in Russia - the *Gigant* (Giant) - in a hanger built specially for it.

Village Salizi. 1915

65. The dirigible *Gigant's* departure for the hanger. The dirigible was designed by A.I. Shabsky.

Village Salizi. 1915

66. The *Gigant* during an accident.

Environs of Gatchina. 1915

67. One of the motors of the *Gigant* while dismantling the body frame after an accident.

Village Salizi. 1915

65

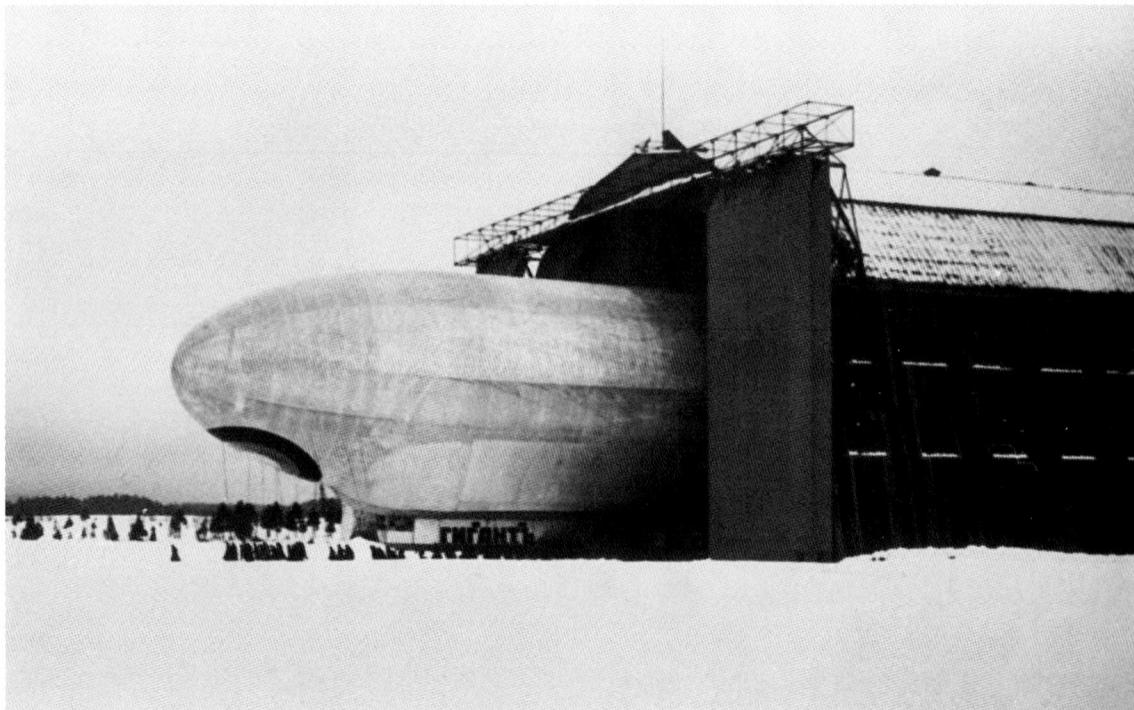

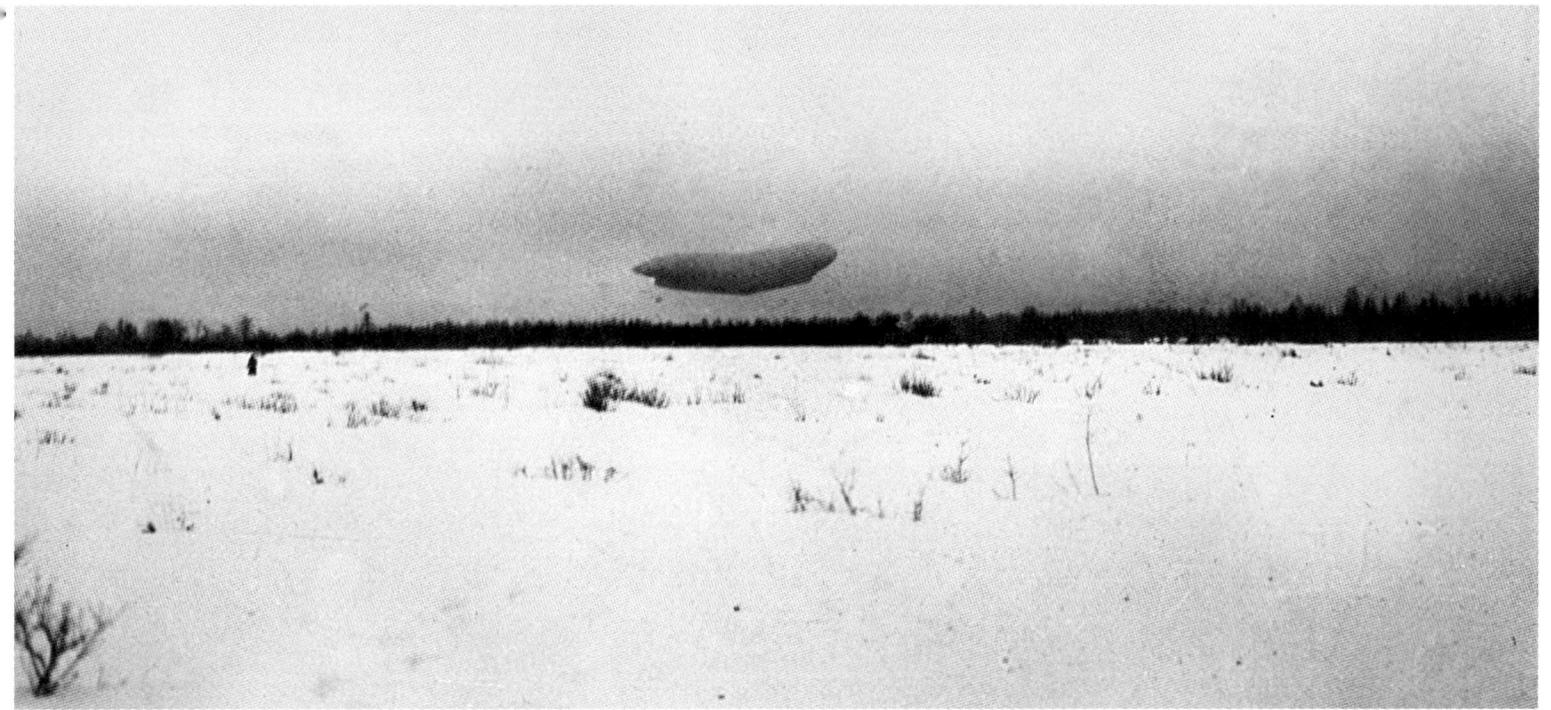

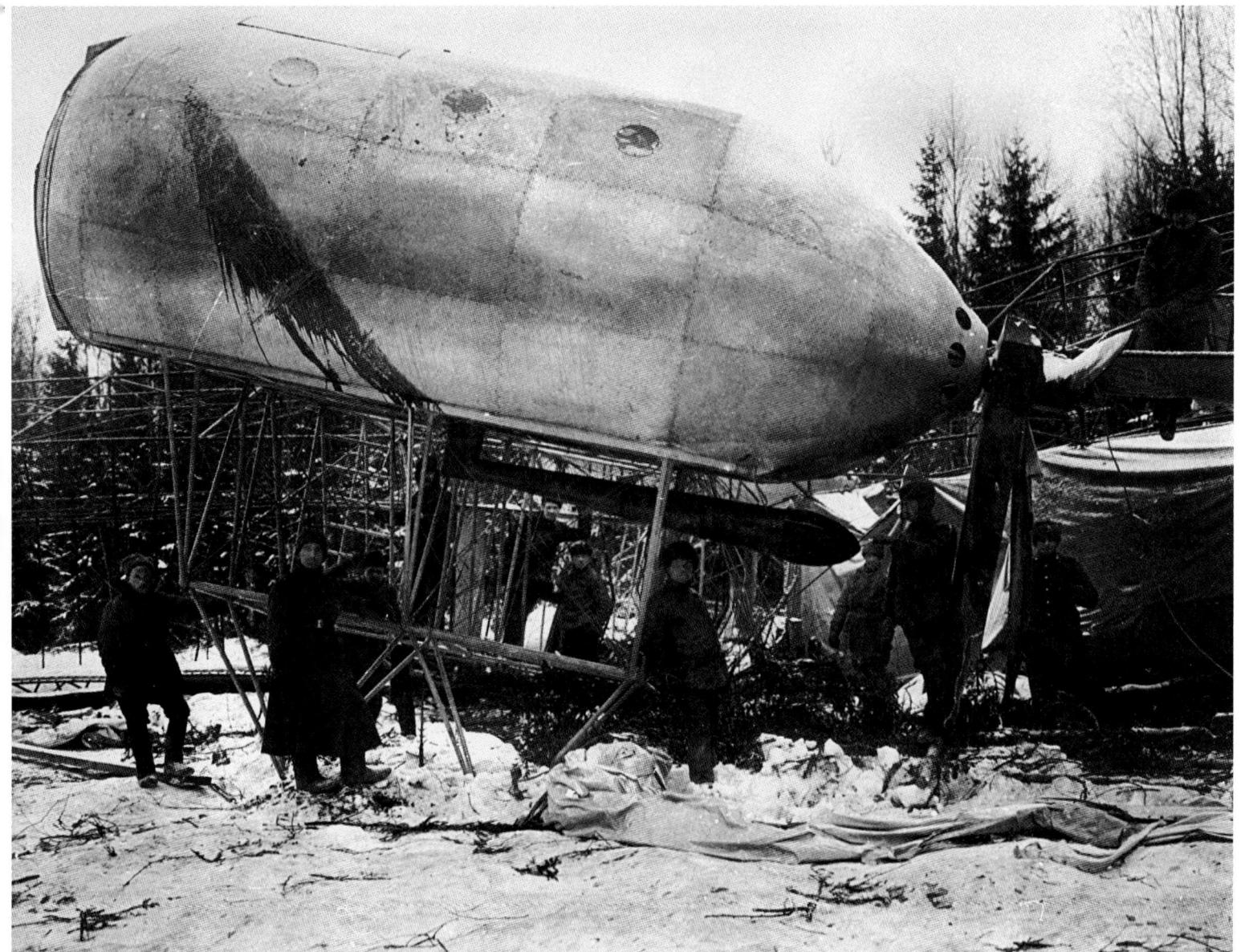

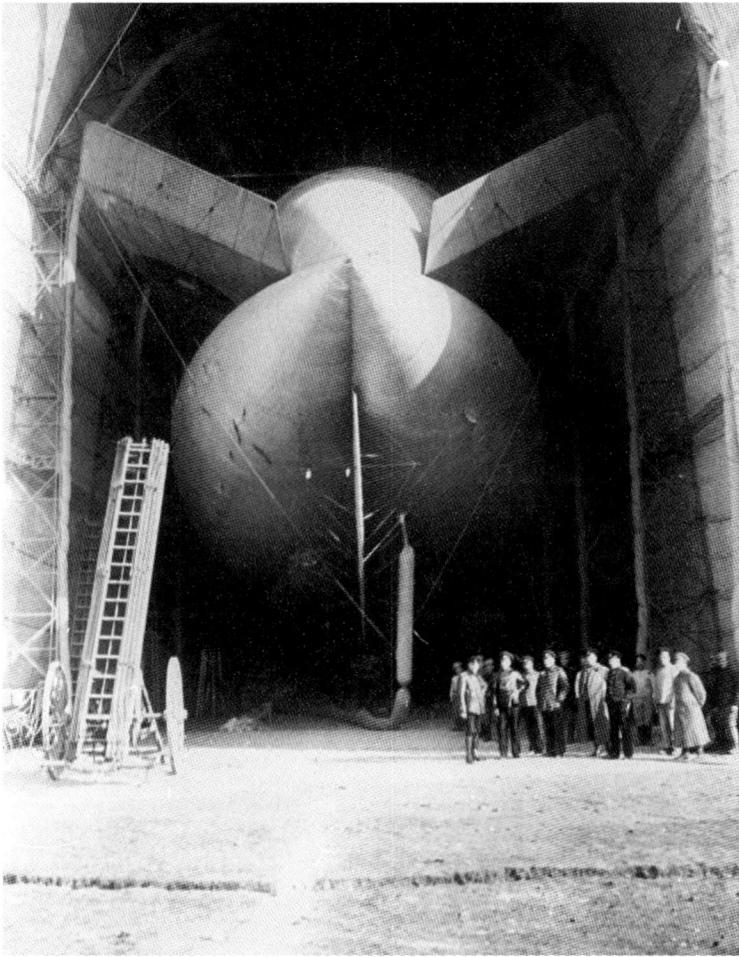

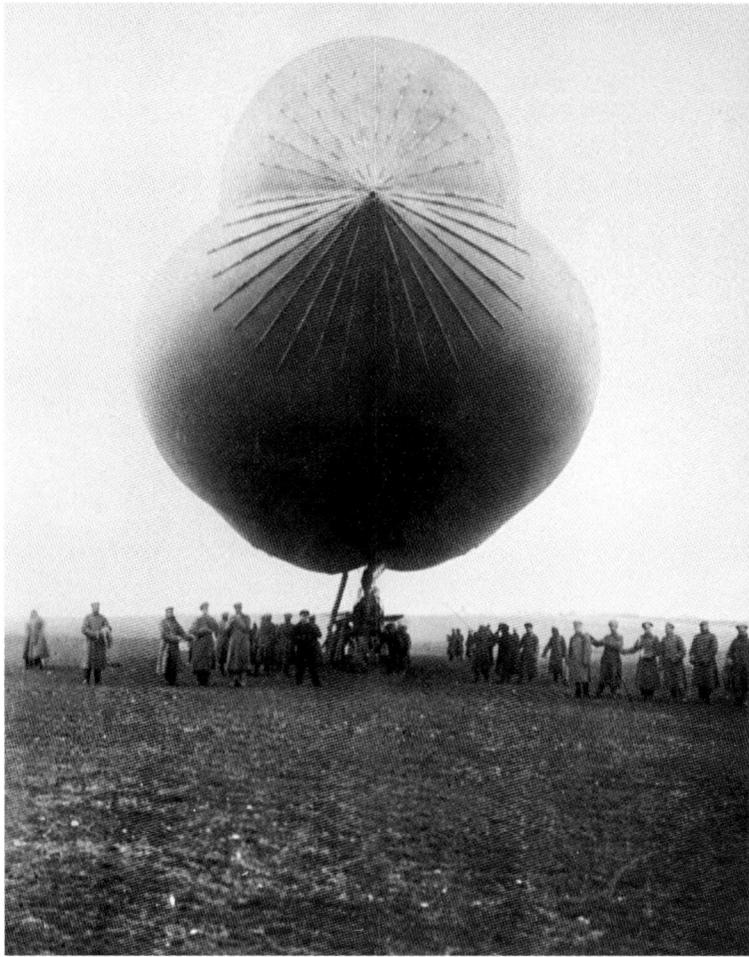

68. The dirigible *Cheornomor*.
Black Sea Fleet. 1916
Built in England. Capacity:
4,500 cu./m, speed: 80 km/hr.

69. Dirigible *Cheornomor-2*.
Black Sea Fleet. 1916
Built in England in 1916. Capacity:
4,500 cu./m., speed: 80 km/hr.

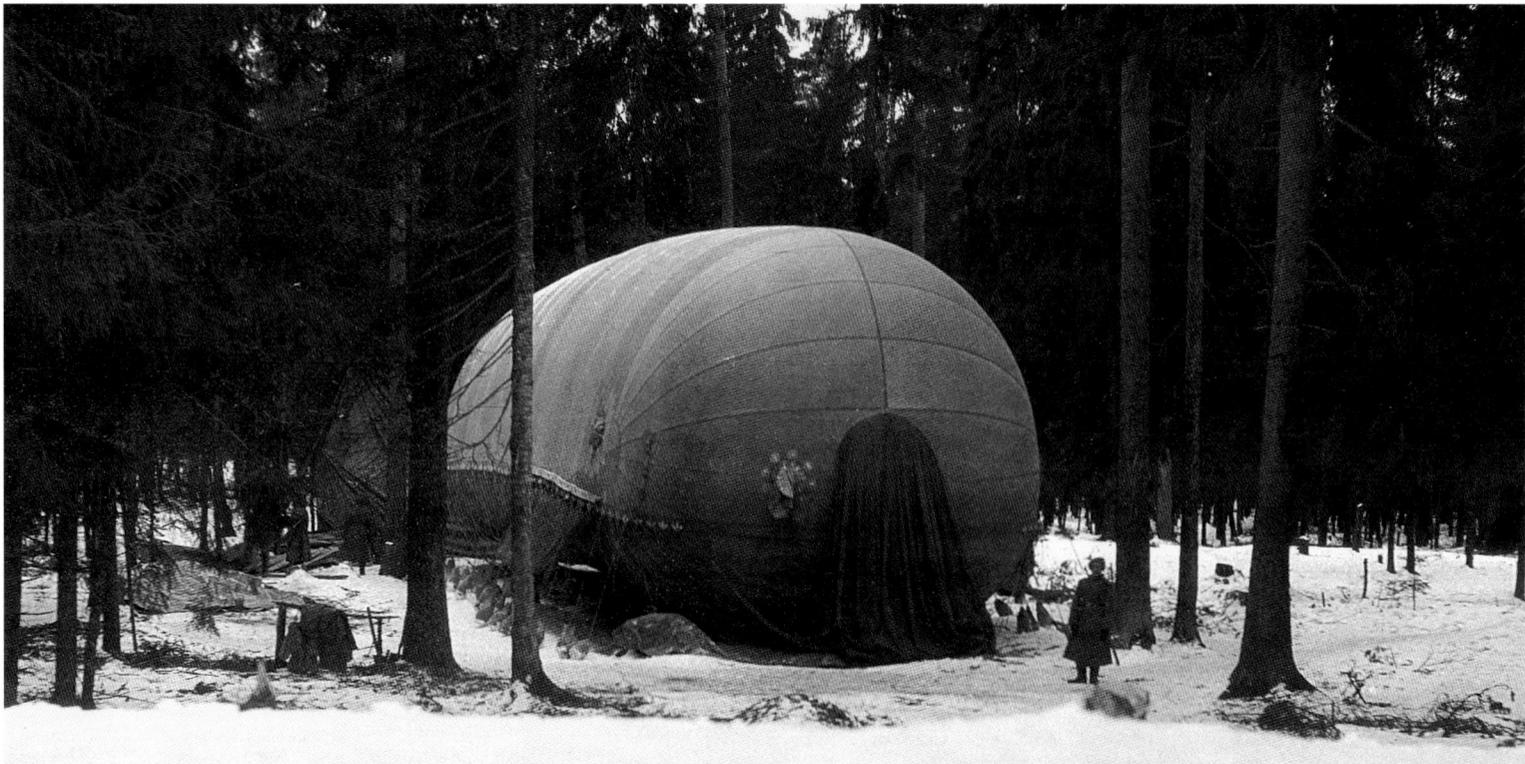

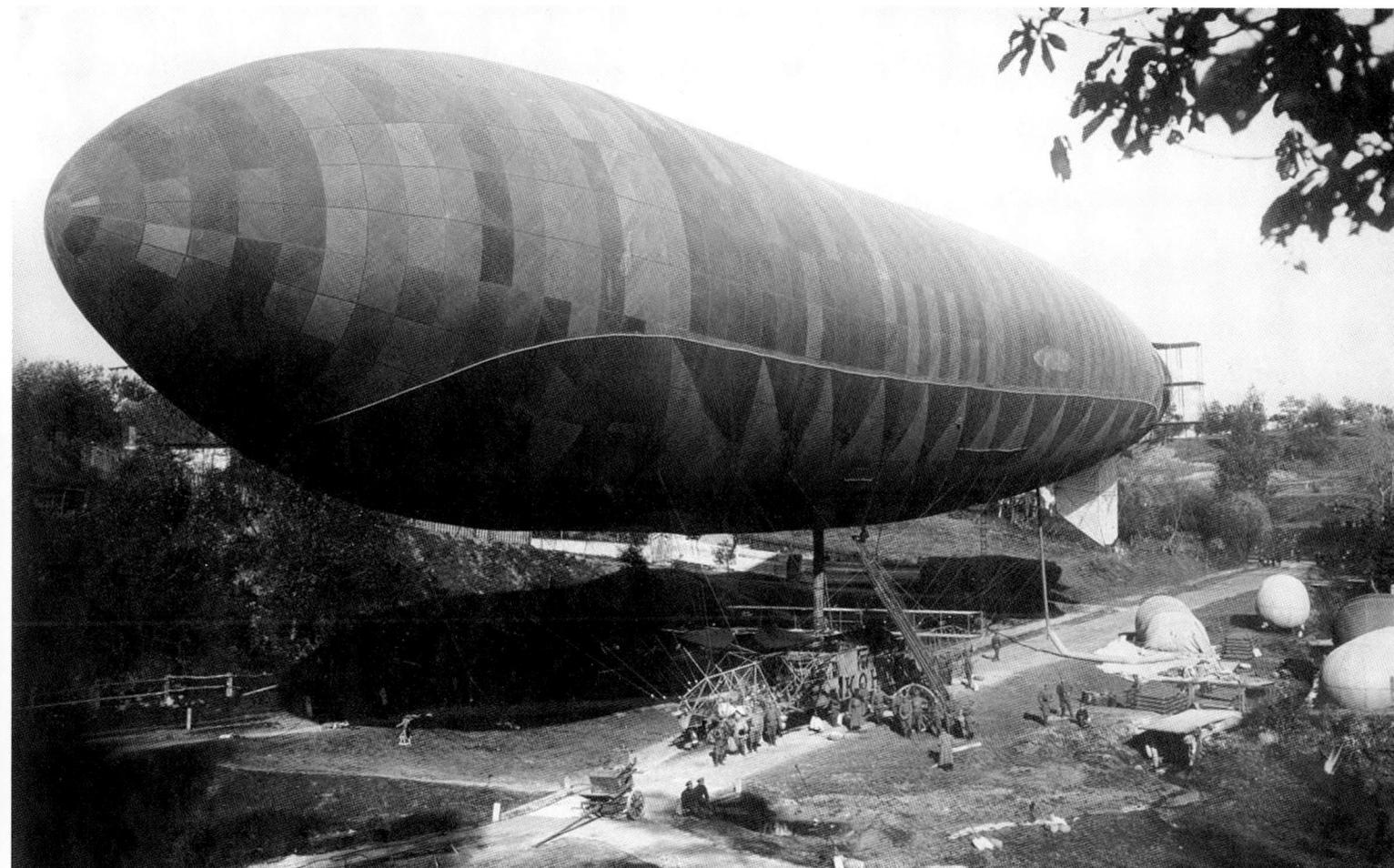

71. The dirigible *Condor.*

Lvov District. 1914 — 1915

Built in France in 1913. Capacity: 9,600 cu/m., speed: 55 km/hr, crew: 7-10 people. The Condor was added to the 2nd Aeronautical Company in Brest-Litovsk, then in Lvov. It took part in military actions during World War I.

70, 72. A tethered aerostat of the Percival type, meant for correcting artillery fire, is camouflaged in a forest.

Southwestern Front. 1916

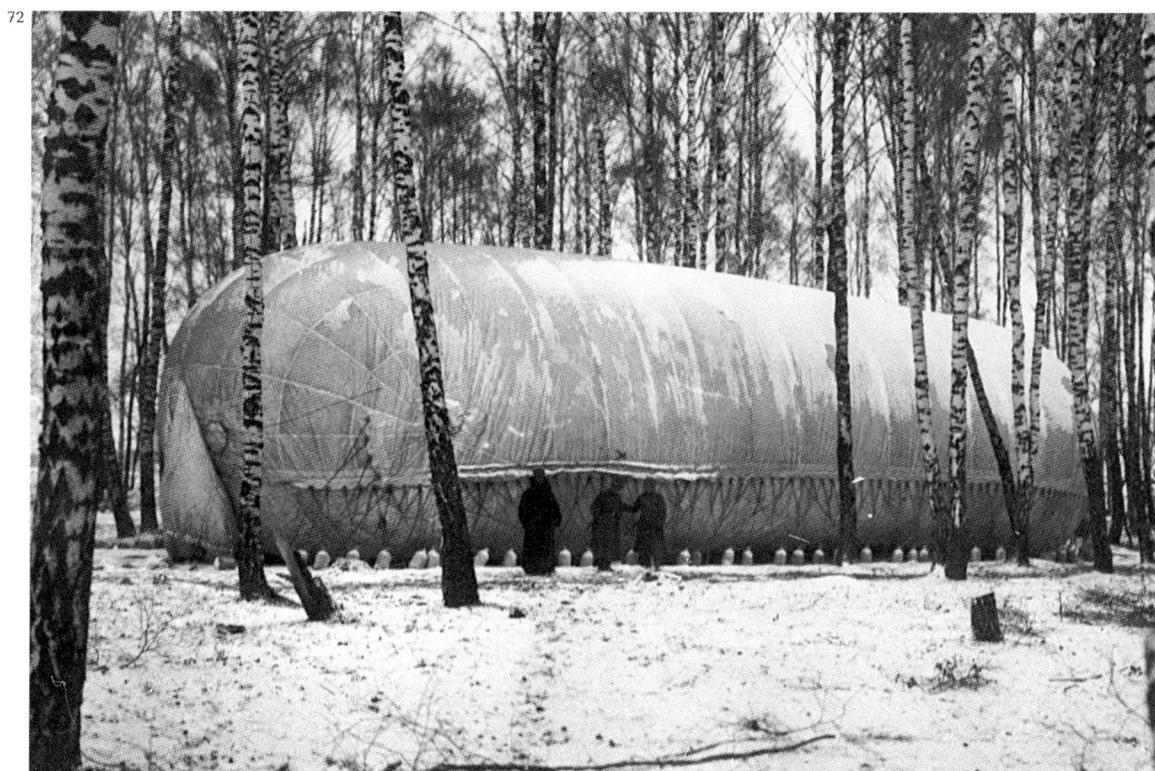

72

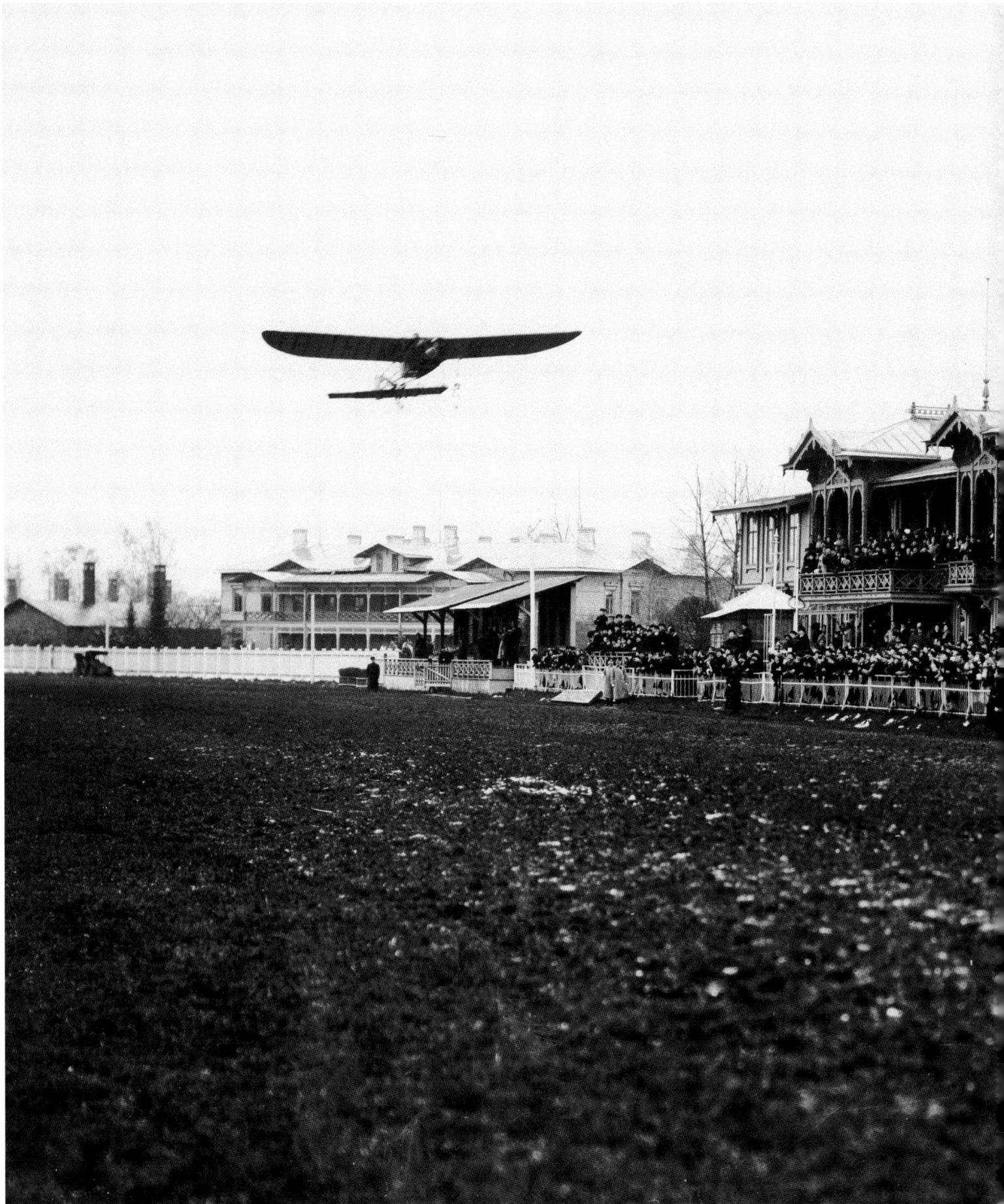

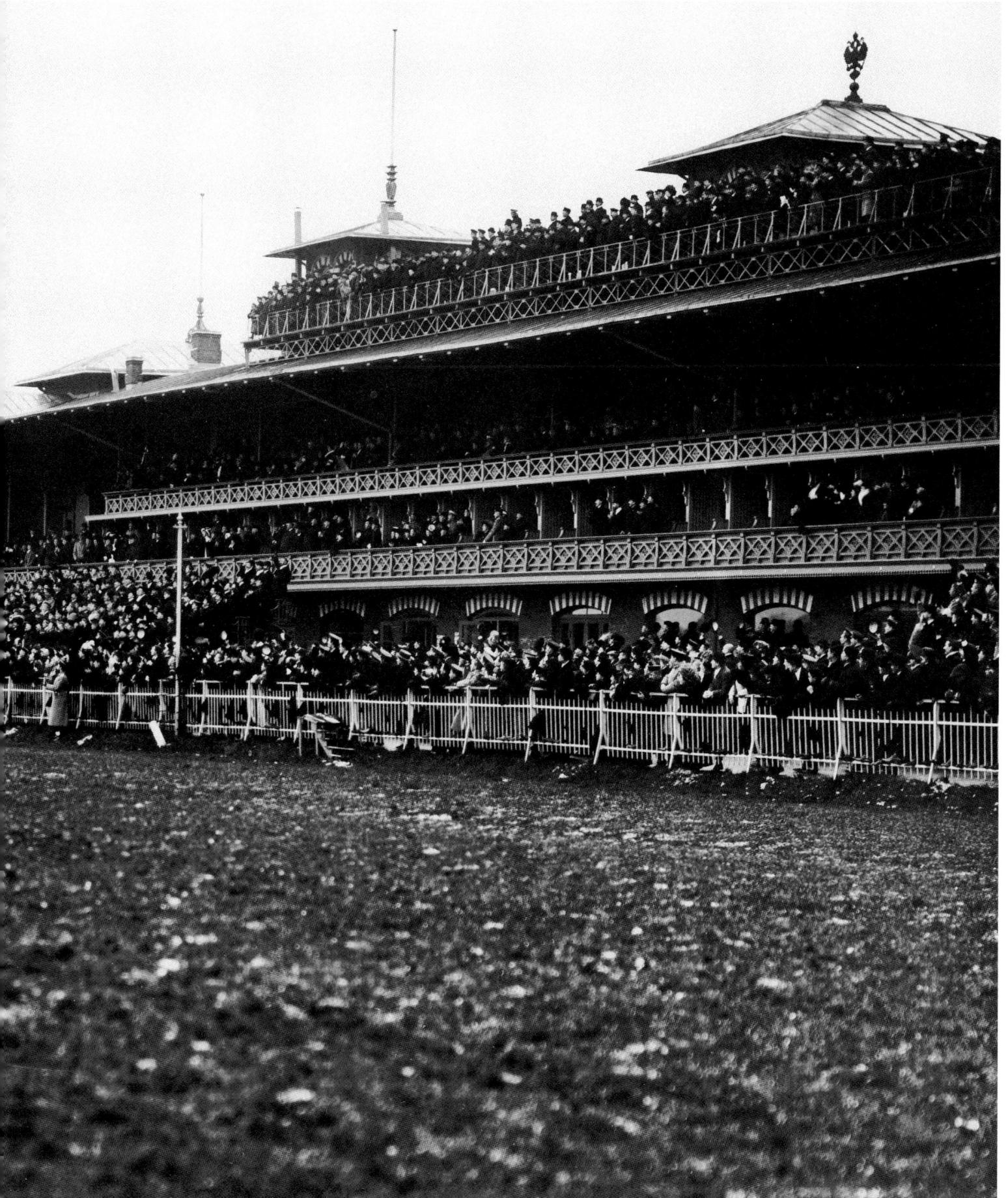

73. Flight of Albert Guillot.
Kolomyazhskyi Racetrack. Fall 1909

Developments in aviation led to increasing competition among both designers and pilots: which pilot in which apparatus could fly farther and higher and could lift a heavier weight? A new past time soon appeared in many countries - aviation festivals.

The first such Russian festival, called the «Aviation Week», took place on April 25-May 2, 1910. The event attracted a lot of interest. Earlier in 1909 the press had written about flights by foreign aviators happening in various Russian cities. Now for 8 days the capital watched the events unfolding at the Kolomyazhsky Racetrack, refitted as an airfield. On a given day of the festivities 40,000-80,000 spectators gathered there.

The first Russian aviator Nicholai Evgrafovich Popov, flying beautifully in a device built by the Wright Brothers, especially distinguished himself in competitions with foreign participants, and the press enthusiastically chronicled his feats. After an unsuccessful landing, ending in a plane crash, about 2,000 rubles were gathered to procure a new plane for the universally beloved Popov. N.E. Popov walked away with a majority of the prizes from these competitions and broke more records than anyone, receiving, among others, the major prize - a silver cup.

Because of the Aviation Week's success, the Pan-Russian Aeroclub decided in September of that year to sponsor a Russian aviation festival in St. Petersburg at the Komendantskyi Field from September 8 to October 1. Russian pilots M.N. Efimov, E.V. Rudnev, S.I. Utochkin, L.M. Matsievich, and G.V. Piotrovskyi, returning from training in France, showcased their skills in the sky. Enthusiasm for aviation was so high that even Russian Prime Minister P. A. Stolipin flew in the air, on the airplane Farman IV on September 23, 1910 with aviator Lev Makarovich Matsievich.

This festival also had balloon flights, including long-distance ones. S. I. Odintsov in a balloon from the Treugolnik Works flew 40 hours and 30 minutes to Taranrog, and later on September 21 he rose to a height of 6,400 meters in the same balloon with N.A. Ruininuim, breaking a Russian record.

The Aviation Festival was overshadowed by aviator L.M. Matsievich's death, when he fell from his plane on September 24. This tragedy was most likely caused by technical design faults. A large mass of people followed the hero on his final journey to the Nikolsky Cemetery at the Saint Alexander Nevsky Monastery.

In St. Petersburg in 1911, the Mikhailovskyi Riding Academy, under the auspices of the Imperial Russian Technical Society, presented the First International Aeronautical Exhibition, which lasted two weeks. Full-scale models of aviation and aeronautical technology were showcased there, among which was the famous Blerio plane, a Wright Brothers' plane from the Brege Company, and the domestic design of a flying device with accompanying motor.

At the same time as the exhibition, the First Pan-Russian Conference of Aeronauts took place from April 12-17, moderated by N.E. Zhukovskyi, at which prominent scientists, designers, and developers shared their achievements with their colleagues. At the Komendantskyi Airfield in St. Petersburg on May 14th a series of Aviation Weeks opened, where already famous Russian aviators demonstrated their professionalism: M.N. Efimov, A.A. Vasiliyev, V.A. Lebedev, A.N. Sredinskyi, A.A. Kuzminskyi, and M.F. de Campo Scipio. New records were also made: A.A. Vasiliyev flew to a height of 1605 meters, and V.A. Lebedev broke the Russian record for length of a flight with a passenger - 1 hour, 29 minutes, and 16.2 seconds, receiving the special prize for a take-off with the maximum weight of 138 kg.

On May 22, the St. Petersburg Aviation Week came to an end, and right after it another one opened in Moscow, where Efimov, Vasiliyev, de Campo Scipio, and also A.M. Gaber-Vlynskyi and B. I. Rossinskyi showcased their talents. The Moscow competitions had their own unique aspects. The tasks were harder and introduced war-like elements: missile launches, the use of powder magazines (with training equipment), and delivery of dispatches and weapons (guns).

On June 30, also in 1911, the Sevastopol Military School of Aviators held their own festival on their camp field: the Aerial Parade, in which 15 planes participated. After a month, on the birthday of Heir Tsesarevich Alexsei Nikolaevich, another aviation parade was held. In front of a large crowd encircling the airfield the pilots demonstrated their achievements in the planes Farman IV and Blerio.

June 30, 1911 was also a famous day in Russian aviation history for the fact that it was the first time a woman, Lydia Vassarionovna Zvereva, flew. She had received her pilot's license at the First Russian Association of Aeronautics School. Other representatives of the "weaker" sex followed her: in 1911, Liubov Galanchikova, Evgeniya Shakhovskaya, and Evdokiya Anatra received their licenses. Many other women also did the same, becoming aviatrices.

The most famous aviation event of 1911 was the Pan-Russian Aeroclub's organized flight from St. Petersburg to Moscow (July 10-11). The very fact that it happened vividly demonstrated both the possibility of long flights and the Russian aviators' skill level, as well as the high quality of different types of planes. However, only one out of the ten participants made it to the goal: Alexander Vasiliyev's entire

flight took 24 hours, 41 minutes, and 14 seconds, though he was only in the air for 4 hours and 42 minutes.

Long-distance flights continued into 1912. Air Force Lieutenant Viktor Vladimirovich Dyibovskyi completed a flight in May from Sevastopol to Kharkov to Moscow to St. Petersburg. The public and St. Petersburg officials greeted the intrepid aviator, who went a distance of 2,500 miles. In June, Dmitryi Georgievich Andreadi completed a longer flight over a distance of 2,900 miles.

The first Russian aviators demonstrated their skills in many Russian cities, but Alexander Alexeevich Kuzminskyi glorified Russian aviation in the Far East, touring from Fall 1912 to Summer 1913 in China, Hong Kong, Cambodia, and Singapore. His flights in Manchuria, China, Vietnam, Cambodia, Indonesia, and Persia clearly showed man's ability to master the airplane, and he amazed thousands of people with a hitherto unseen spectacle.

Tsarsckoe Selo hosted an Aviation Week from August 15-21, with the aviators M.N. and T.I. Efimov, G.V. Alekhnovich, M.F. de Campo Scipio, and G.V. Yankovskyi. G.V. Yankovskyi made a flight to Krasnoye Selo and back in 20 minutes and 21 seconds, considered a great result at the time!

Military planes had their own competitions similar in many ways to the aviation festivals. These competitions helped determine which firms would supply arms for the imperial army.

The first such competition was held in St. Petersburg at the Korpusnyi Airfield from September 1 to October 9, 1911. Although three planes took part, only one - the Gakkel VII, built and piloted by Y.M. Gakkel, - actually completed all of the tasks, but it was a start. In a sense, this was the first military festival that demonstrated that the army and naval leadership saw the potential of flying devices to become new kinds of weapons.

The second competition of military planes lasted almost 40 days, from July until August, 1912. 10 planes took part at the Korpusnyi Airfield, of which three successfully fulfilled the entire flight program: I.I. Sikorskyi's monoplane, V.N. Khioni's monoplane, and I.I. Steglau's bi-plane. A 30,000 ruble prize was given to the Russo-Baltic Railcar Factory for Sikorskyi's plane, and the other two prizes of 15,000 and 10,000 rubles went to the Moscow factory Dukes.

The already traditional «civilian» aviation festivals also continued, and as such the third Pan-Russian Aviation Week happened in St. Petersburg from May 14-23, 1913. It was organized by the Sport Committee without the involvement of private businessmen, and monetary prizes were given according to the percentage of points collected during competitions.

Naval aviators had their own first competition, showing their skills near the spit of Elagin Island. Three military pilots joined sportsmen-aviators. Moreover, V. Lebedev and A.A. Agafonov distinguished themselves in flight and received an award for their participation in the First Balkan War (1912-1913: Bulgaria, Serbia, Montenegro, and Greece against Turkey) from the Greek government. The pilots P.V. Evsiukov and F.F. Kolchin, who also participated in the war, were awarded with the Bulgarian Order «For Military Services».

At the opening ceremony of the competition the famous aviator A. Gaber-Vlynskyi broke the record for height, having risen to 2,250 meters. On the second day, he beat his own record, rising to a height of 2,500 meters, and monoplane pilot V. Garlitskyi astonished spectators by flying deep curves. On the last day of the Aviation Week on the spit of Elagin Island the pilots N.A. Yatsuk, G.V. Alekhnovich, and D. Alekcandrov showed their take-off and landings on the water with seaplanes (hydroplanes), which astonished the public.

On July 18, 1913, at Krasnoye Selo there was a military aviation parade, in which military aviators showcased the First Aviation Company. Flying in a group over the assembled spectators, they completed an entire array of difficult aerobatic figures.

In St. Petersburg from April 8-13, 1914, the third Pan-Russian Convention of Aeronautics took place. And, from April 29-May 6 at the Komendantskyi Airfield, was the Fourth Aviation Week, which was the final aviation festival in pre-revolutionary Russia.

The first day of the aviation week was memorable for all the wonderful sights - aerobatic figures done by G.V. Yankovskyi on I.I. Sikorskyi's «S-12», and also group flights. At a certain point there were 6-7 pilots in their planes at once, and each of them had a passenger on board. The competitions turned out to be very eventful: the fastest flight to Krasnoye Selo and back was completed (G.V. Alekhnovich won, flying the distance in 43 minutes and 46 seconds), and the pilots each tried to win the prize for the fastest flight. And, of course, every aviator tried to show deeper aerobatics or more perfect «loop-the-loops». On the last day, despite worsening weather, the aviators wowed spectators with real aeronautic balancing acts in honor of the end of the festival. Thus, Raevskyi in his plane completed in 14 minutes 9 loop-the-loops, doing the last of them about 40 meters away from the ground. It was very effective and dangerous; and the pilots, doing the same in the air, were called «loopers». In time, that which seemed so dangerous to the spectators, though in truth just a game, became a foundation for higher aerobatics, enabling successful aeronautical battles.

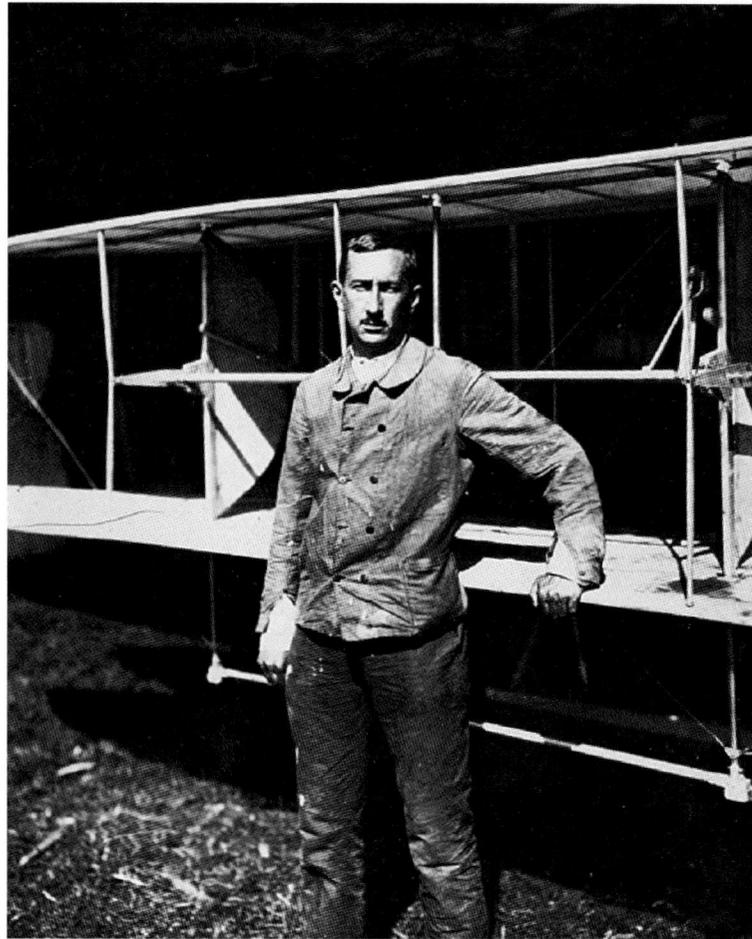

74. Nicholai Evgrafovich Popov - a hero of the First Aviation Week - next to his *Wright*.
Spring 1910

75. Flight on a hang glider, which lasted 3 minutes, from a personal design of famous aviator B.I. Rosinskyi.
Moscow region, river Kliazma.
November 24,1908

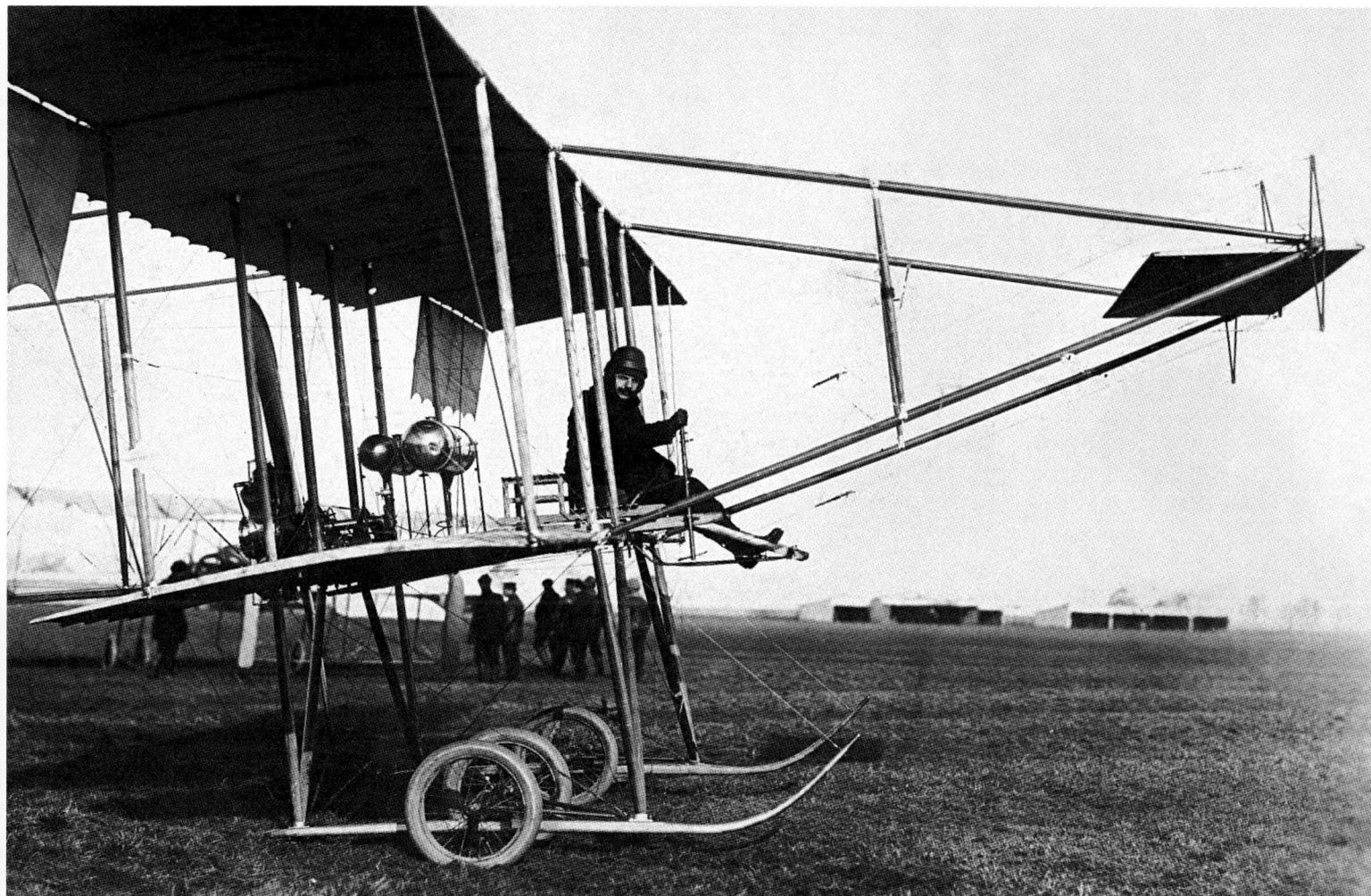

76. Pilot engineer G.P. Adler, a friend and colleague of I.I. Sikorskyi, on his *Farman VI.*
St. Petersburg. 1911

77. Lydia Vissarionovna Zvereva, the first Russian certified female pilot and a graduate of the flight school *Humayun* **in Gatchina - at the steering lever of the plane** *Farman IV.*
1910

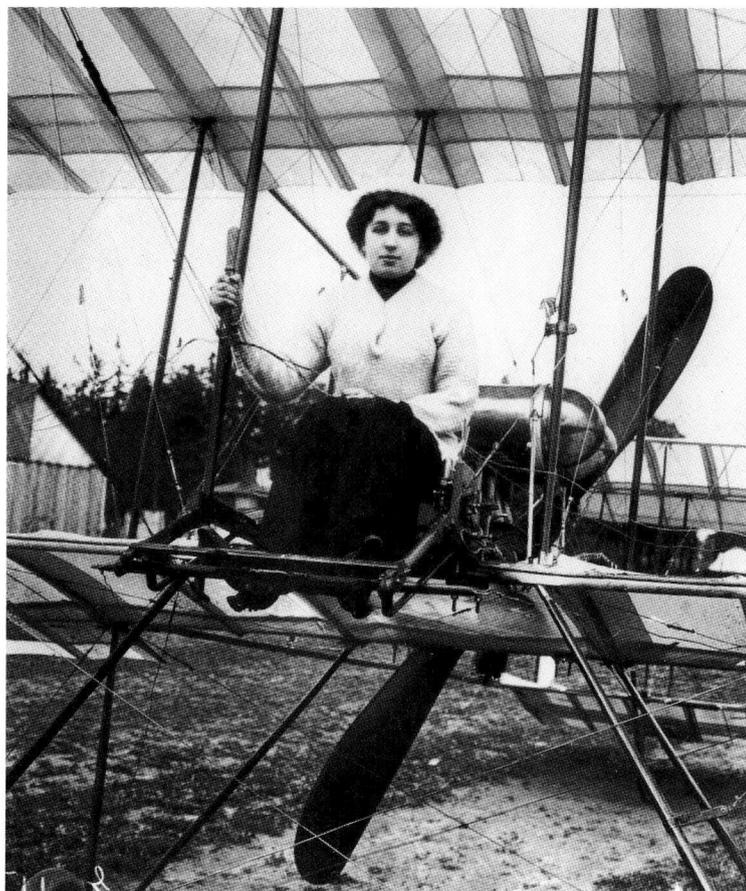

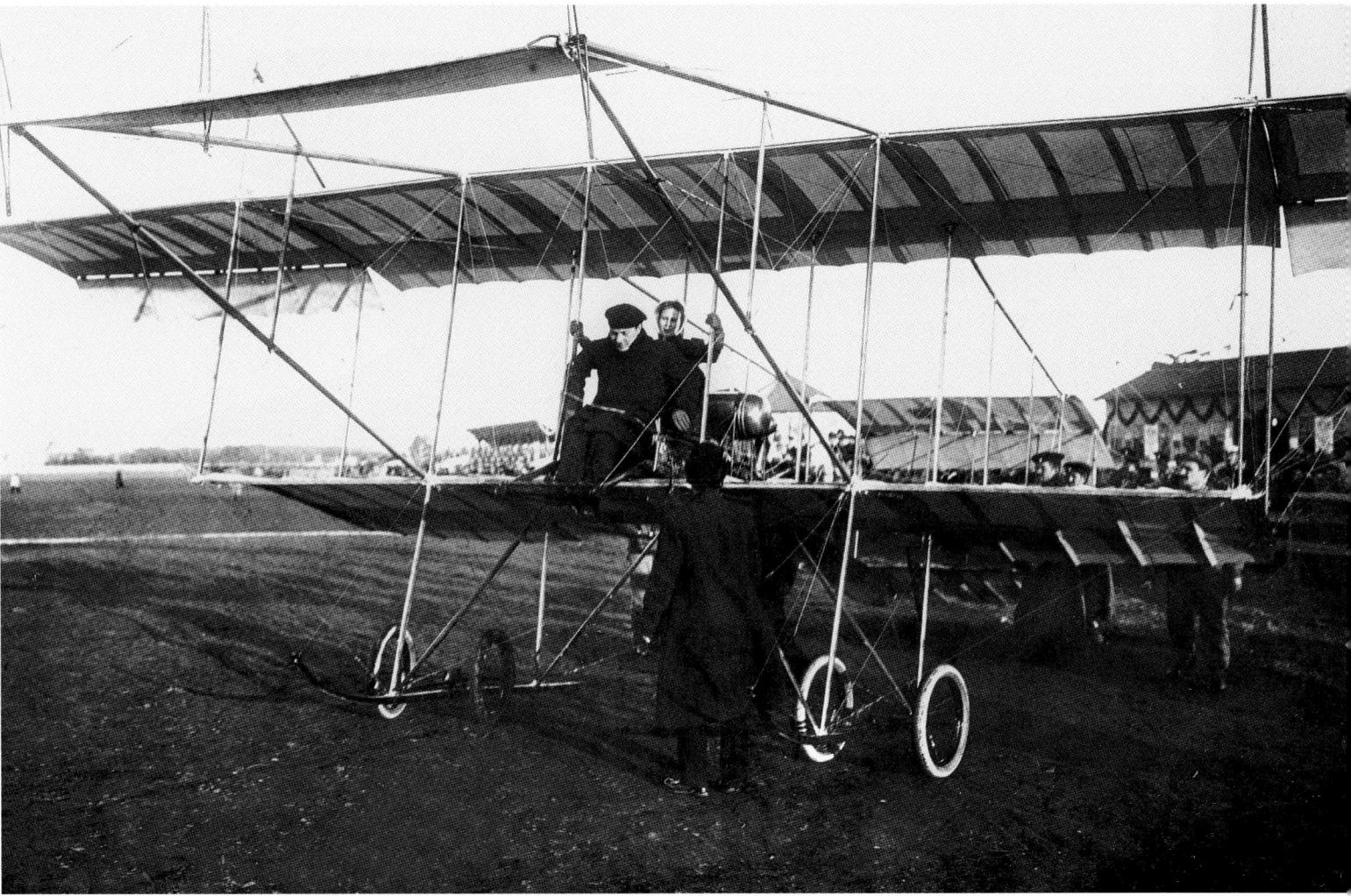

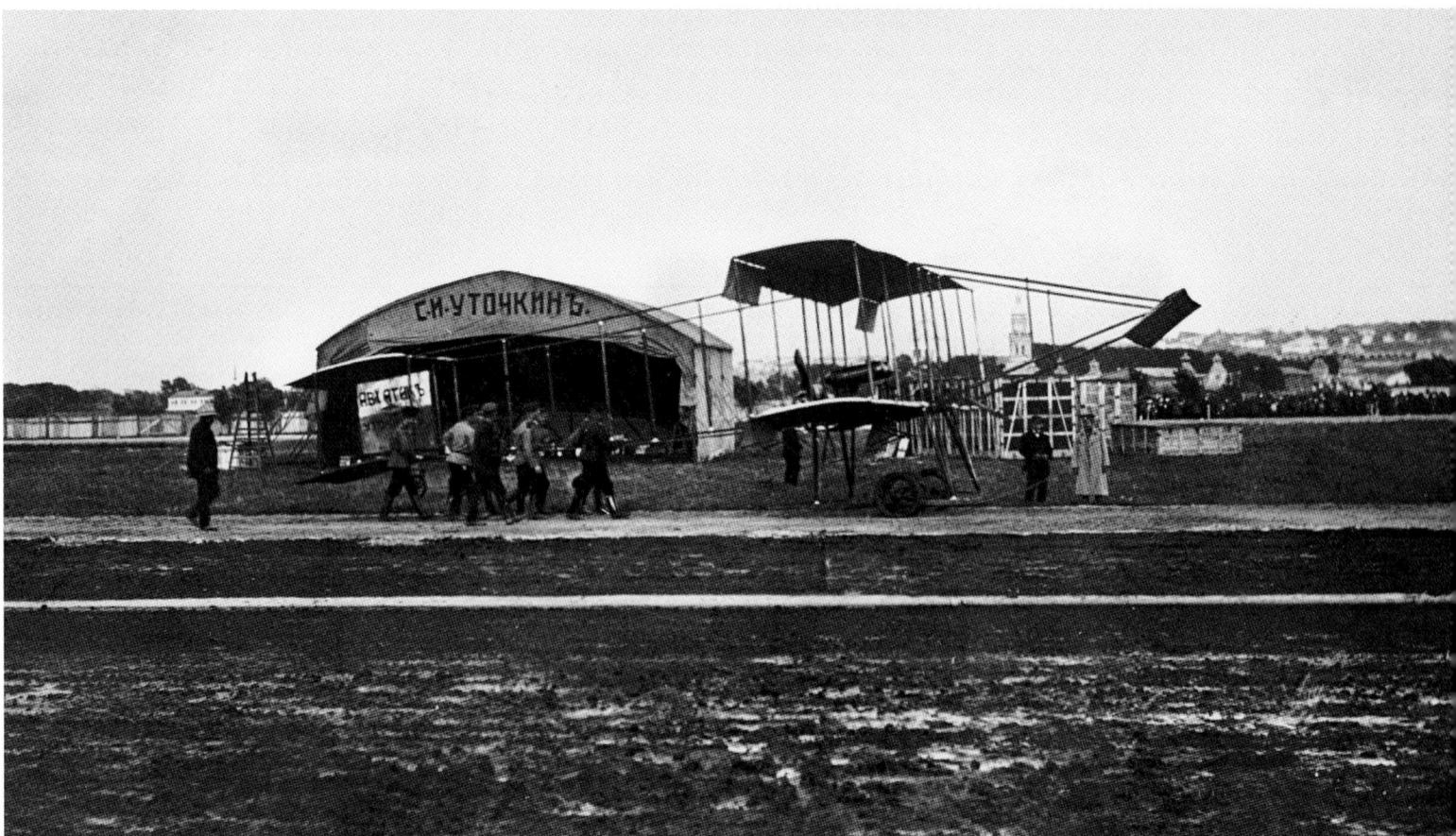

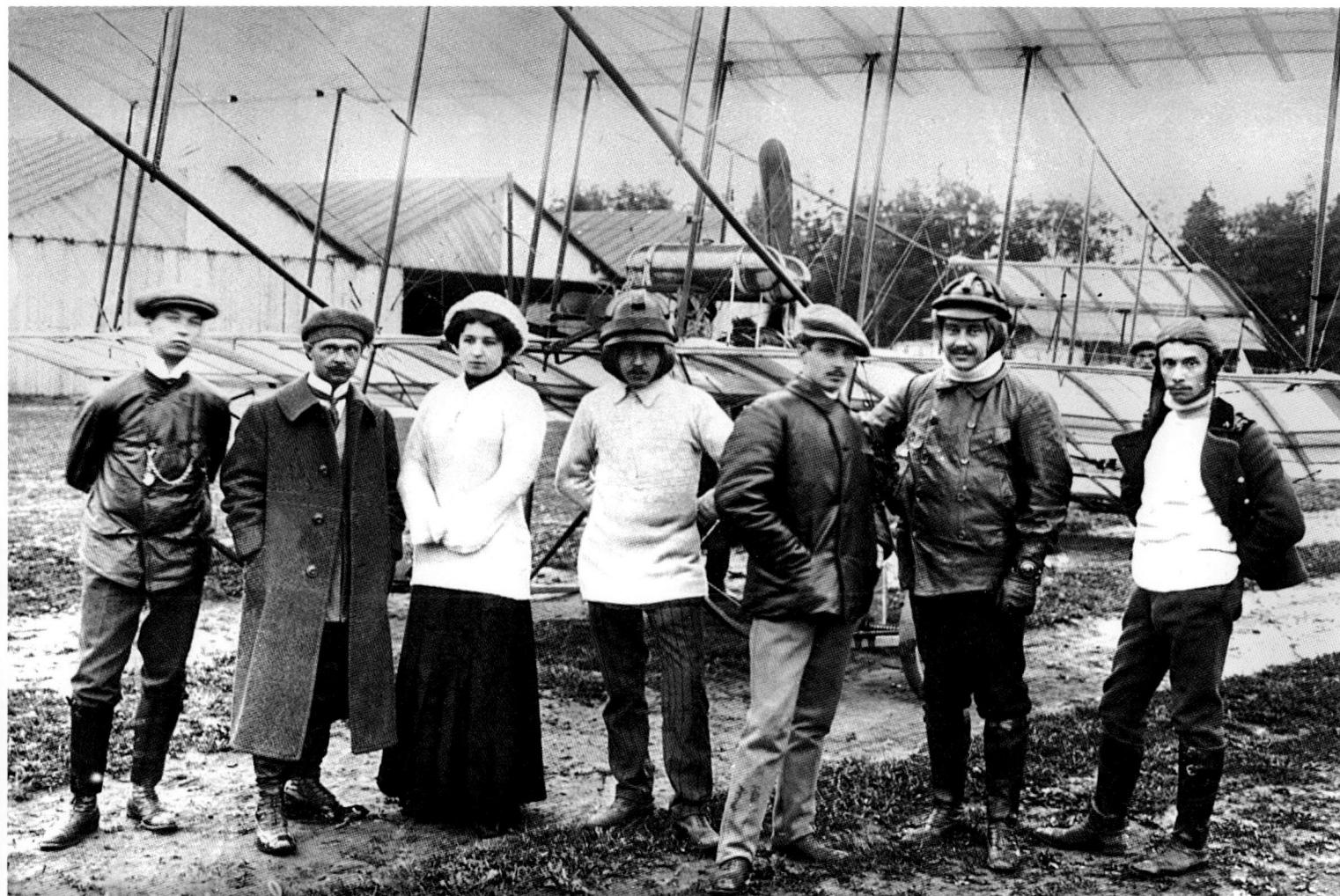

78. Aviator M.N. Efimov with a passenger on the starting line.
The First Aeronautical Week. Komendantskyi Airfield. St. Petersburg. 1910

79. Preparation of S.I. Utochkin's *Farman IV* for flight.
Komendantskyi Airfield. 1910

80. First Russian aviators (from left to right): F.F. Kolchin, K.N. Shimanskyi, L.V. Zvereva, P.V. Evyukov, A.A. Agafonov, N.G. Prokofiev-Severskyi, V.V. Slyusarenko.
1910

81. Transporting the plane *Farman IV*, carried to the station after a crash landing.
St. Petersburg. 1910

81

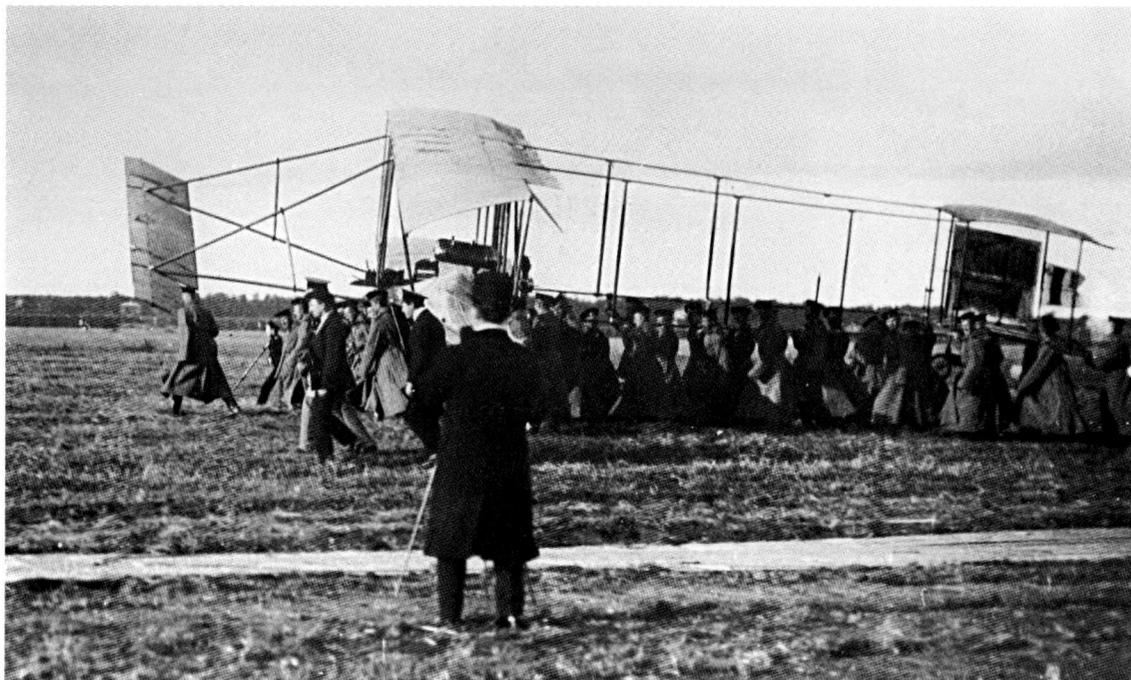

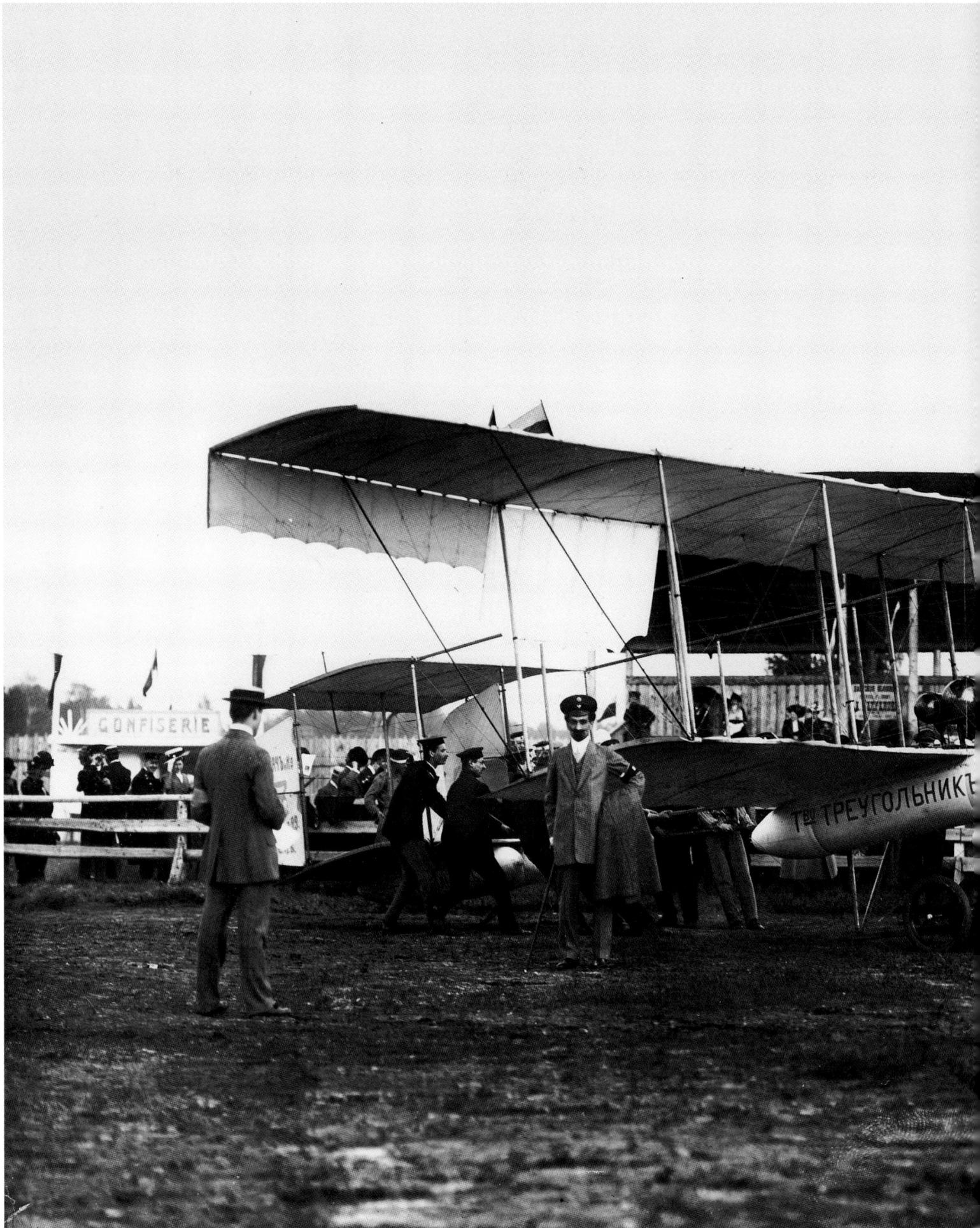

82. Aviator V.A. Lebedev with a passenger on the plane *PTA***.**
Komendantskyi Airfield. 1911
The plane had been fitted with inflatable air bags from the Treugolnik *Works, which were used for advertising and in the case of a necessary water landing.*

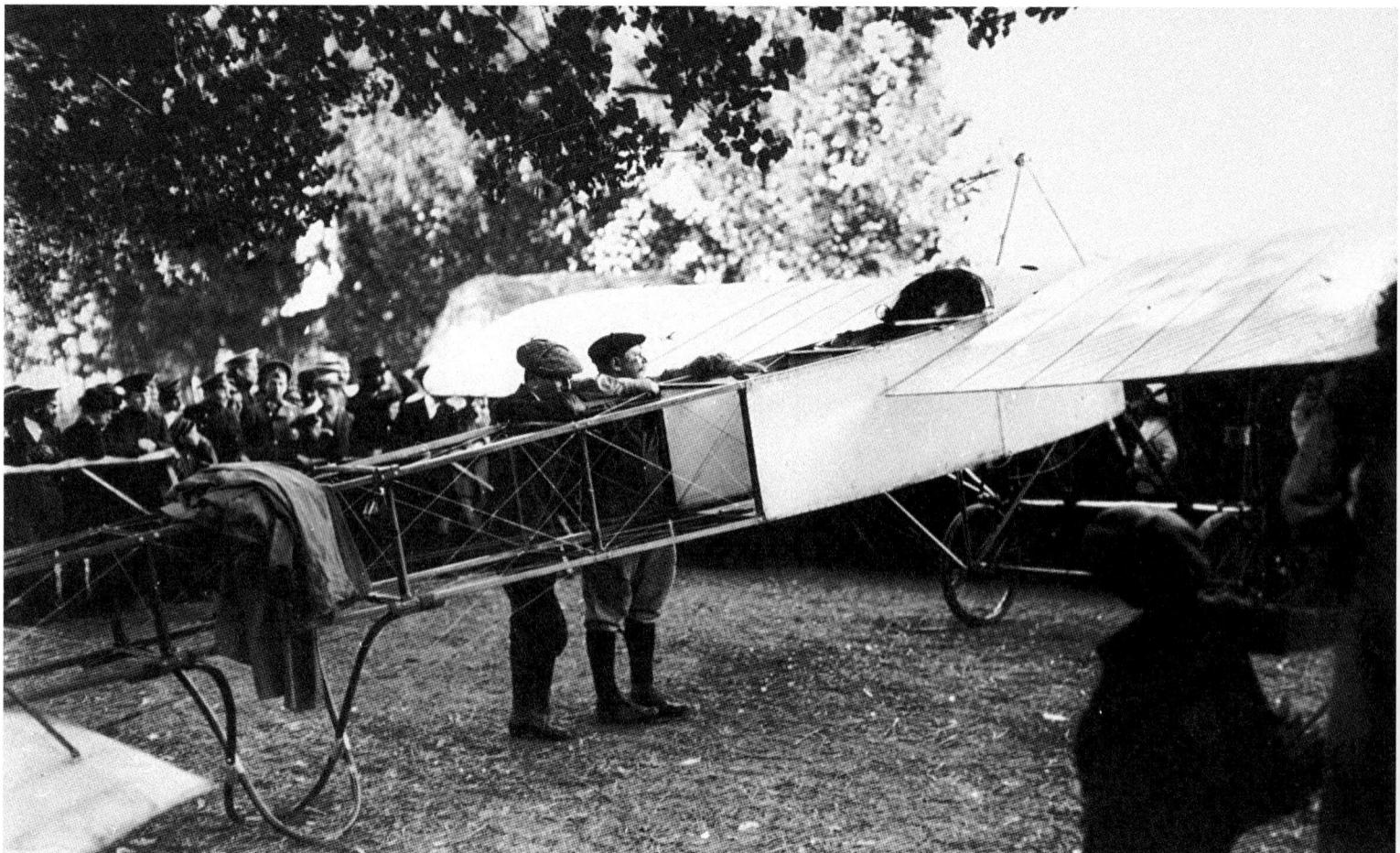

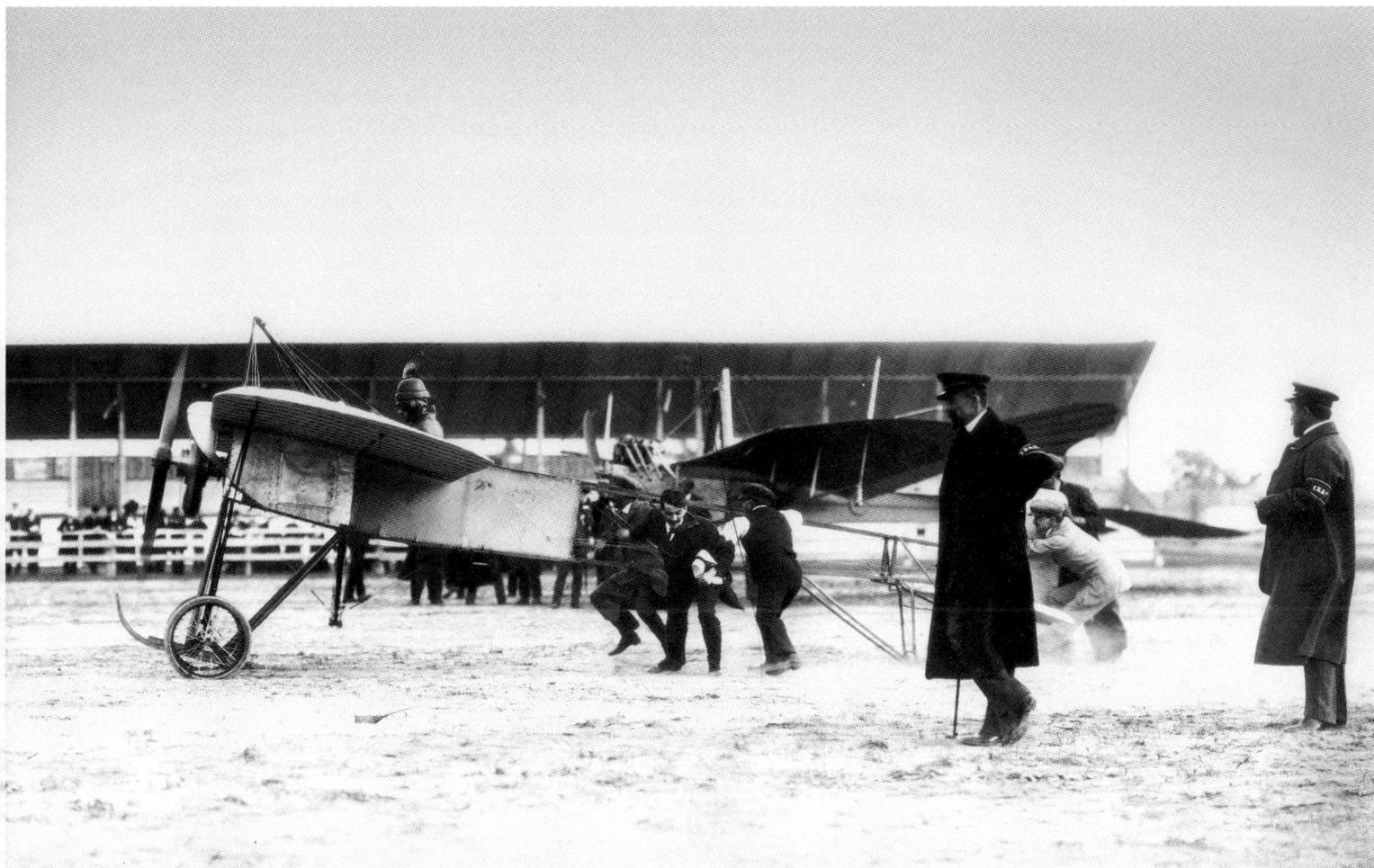

83. The world's first female pilot (aviatrice) Baroness Raymonda de la Rosh (having received a pilot's diploma on March 8, 1910) watches flights with the members of the committee for aviation festivals.

First Aviation Week. St. Petersburg. 1910

84. Preparation of airplane *Bleriot XI* **for flight.**

First Aviation Week. St. Petersburg. 1910

85. Takeoff of aviator M.F. de Campo Scipio on an airplane designed after the Bleriot.

Second Aviation Week. St. Petersburg. Komendantskyi Airfield. 1911

86. Demonstration flight of Lione Moran on the *Bleriot*.

First Aviation Week. St. Petersburg. 1910

86

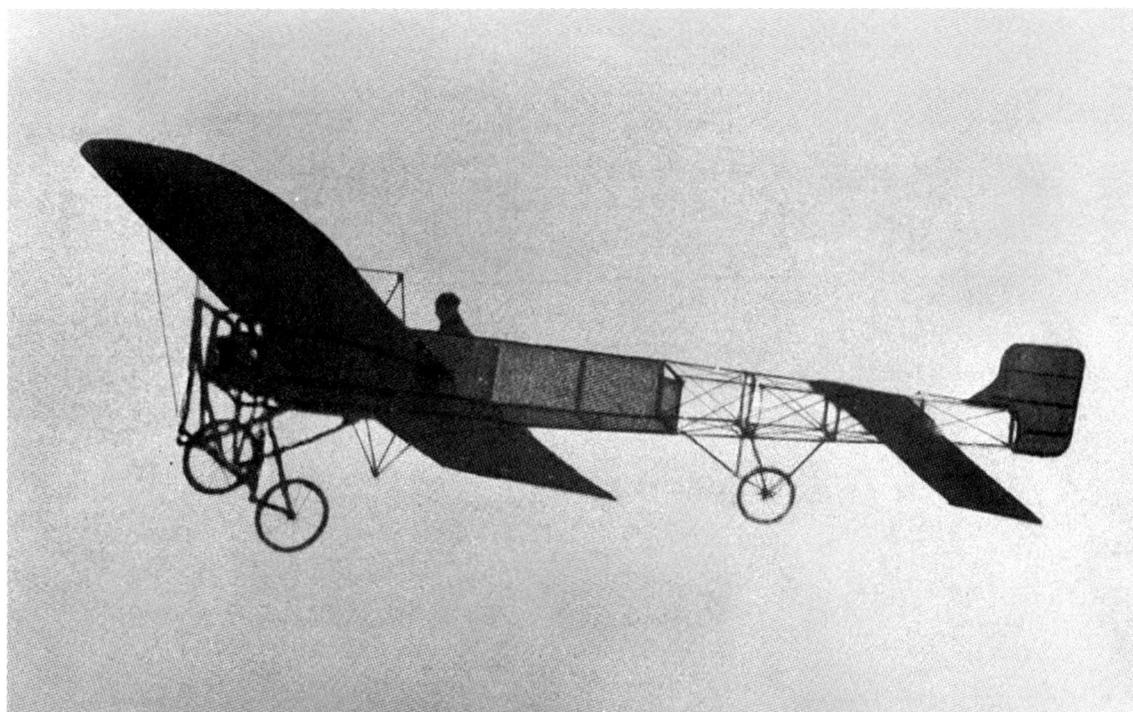

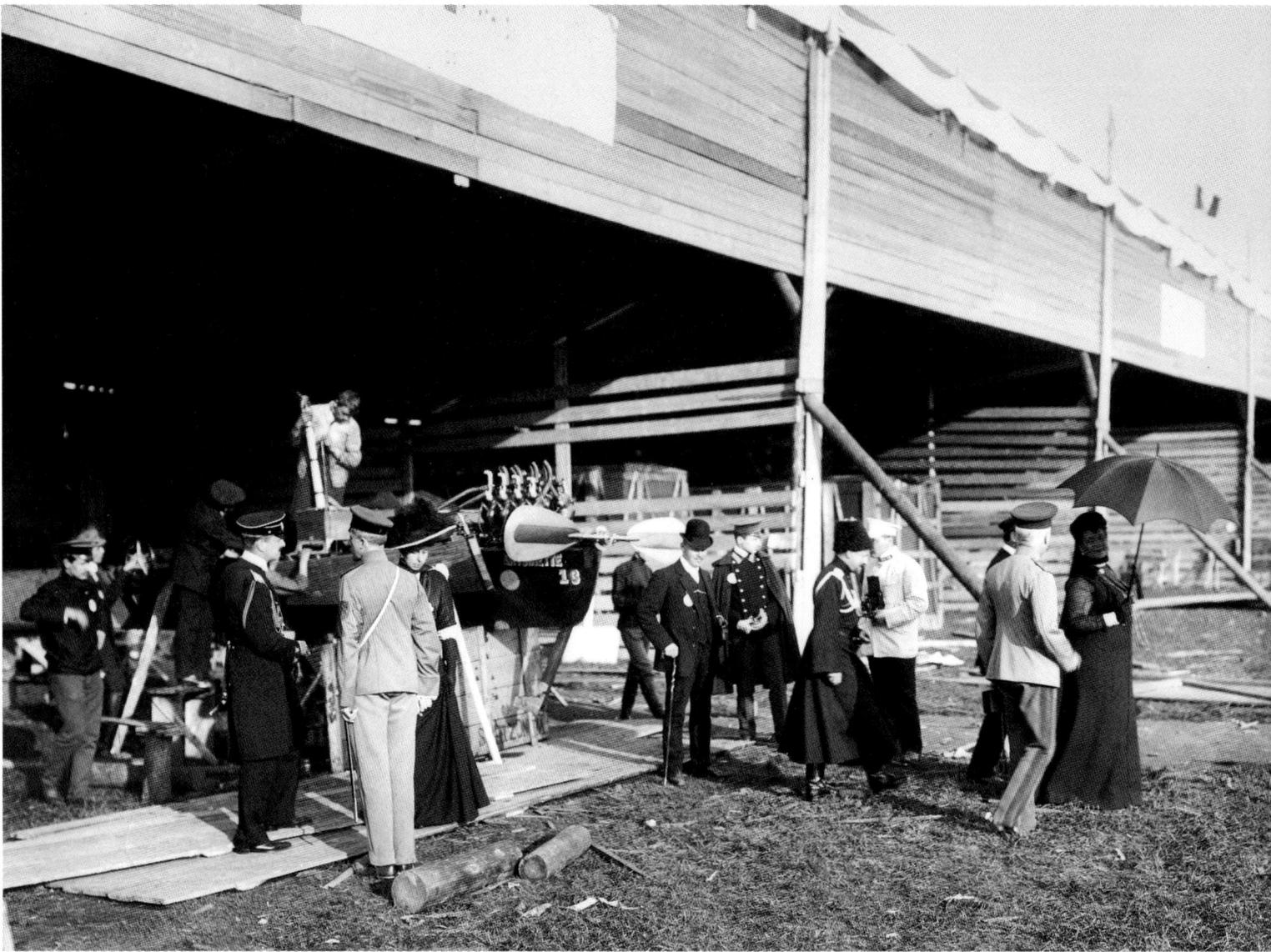

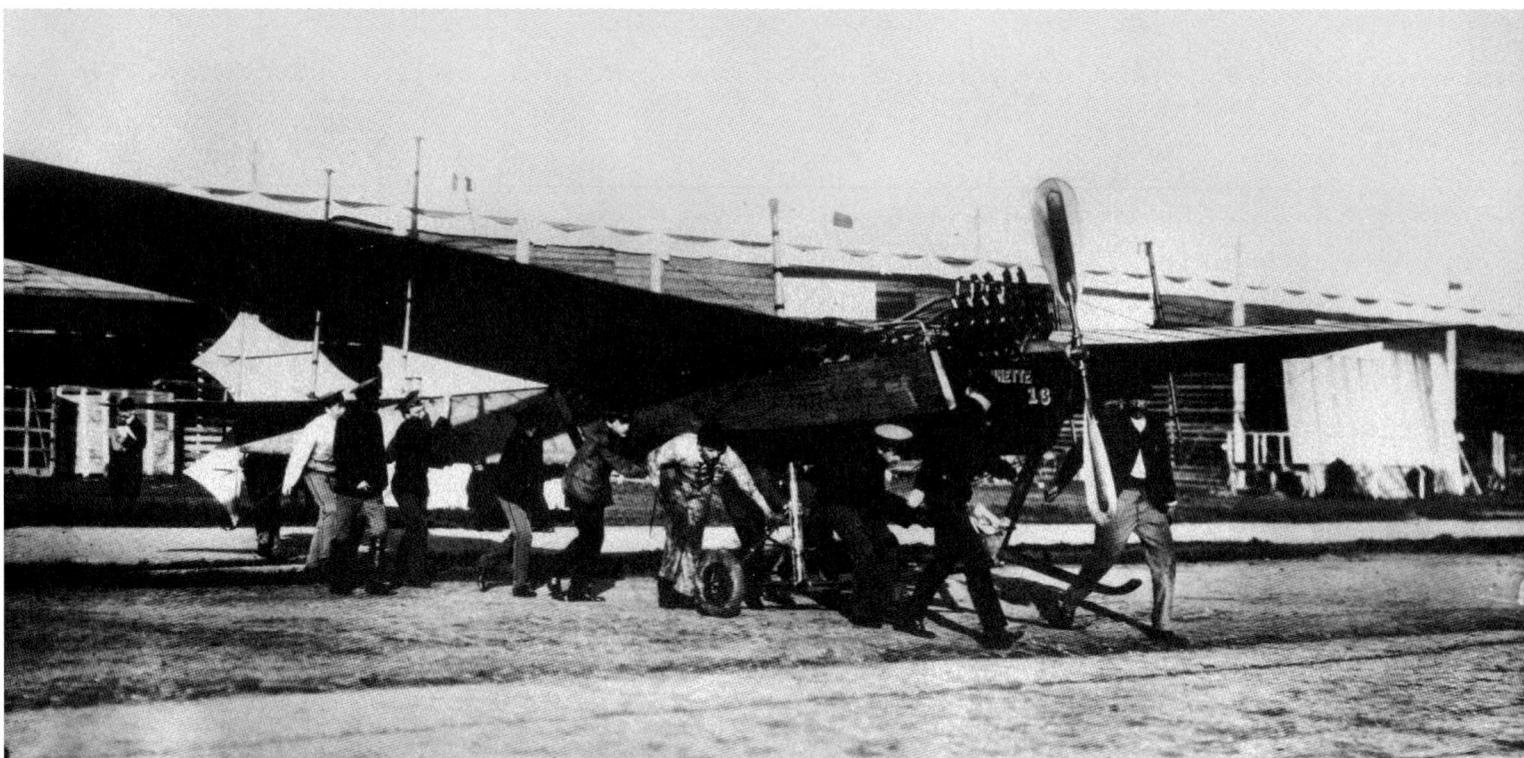

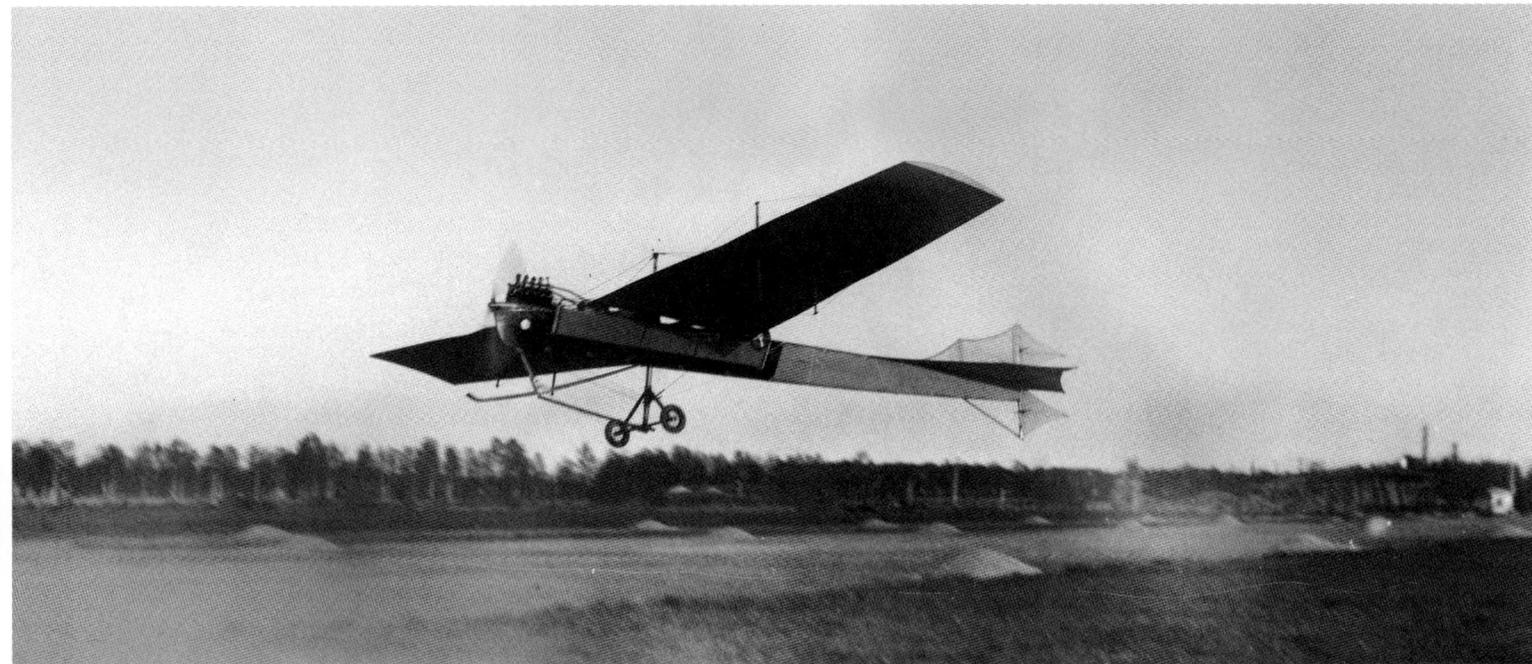

87. Assembly of the airplane *Antoinette's* system. On the right is **Grand Duchess Maria Pavlovna.**
First Aviation Week. Komendantskyi Airfield. St. Petersburg. 1910

88. The *Antoinette* **being led out to the starting line.**
First Aviation Week. Komendantskyi Airfield. St. Petersburg. 1910

89. The *Antoinette* **in the air.**
First Aviation Week. Komendantskyi Airfield. St. Petersburg. 1910

90. The airplane *Gakkel III* on the Gatchina Field. At the wheel is **Y.M. Gakkel, third from the left is aviator V.F. Bulgakov.**
1911 – 1912

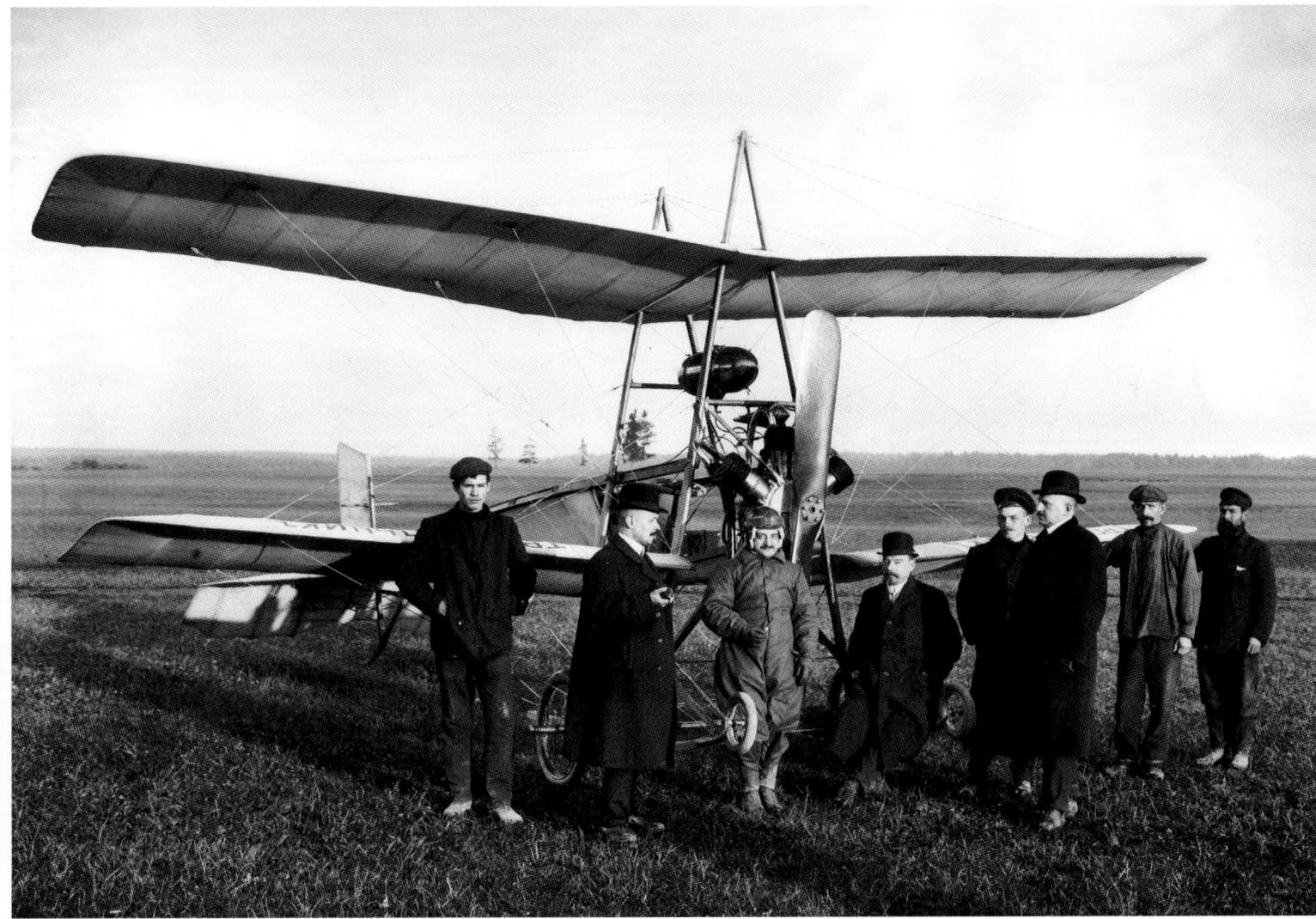

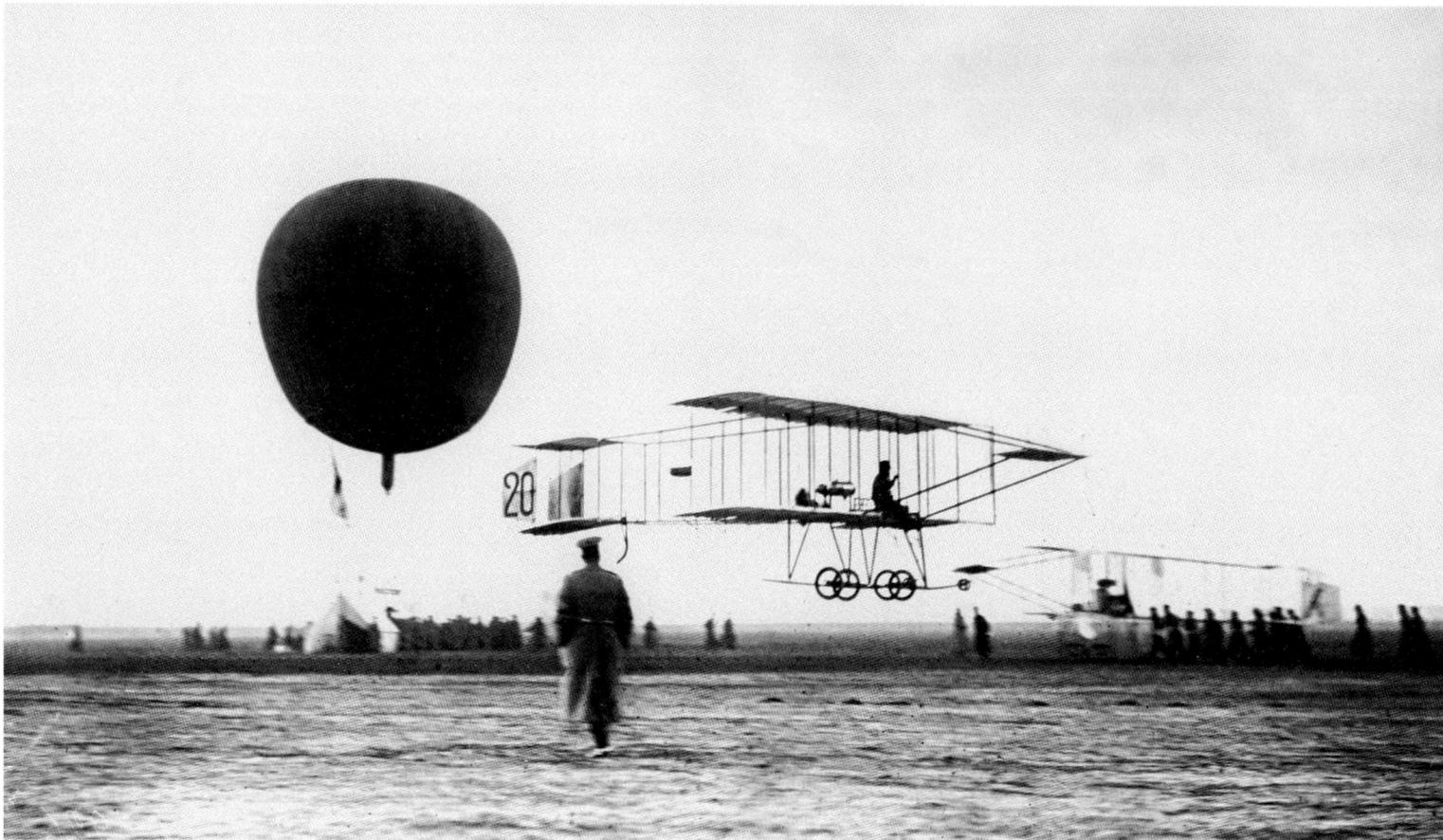

91. L.M. Matsievich flying the
Farman IV **as it lifts off.**
Komendantskyi Airfield.
St. Petersburg. 1910

**92. Lev Makarovich
Matsievich.**
1910

**93. A Group of student aviators near
the memorial marking the place
where L.M. Matsievich died, who was
the first victim of the young aviation
program in Russia. From left to right:
Shirinkin, Chamov, Gruzodubov,
Fufaev, Lohengrin, Gutcheno
(instructor), Novikov, Scherbinin.**
Komendantskyi Airfield. St. Petersburg.
1915

*The memorial (built by architect
I.A. Fomin) was placed by friends
of L.M. Matsievich from collected
donations (it has been preserved to
this day).*

**94. Funeral procession on Nevsky
Prospect for the burial of aviator
L.M. Matsievich.**
September 1910

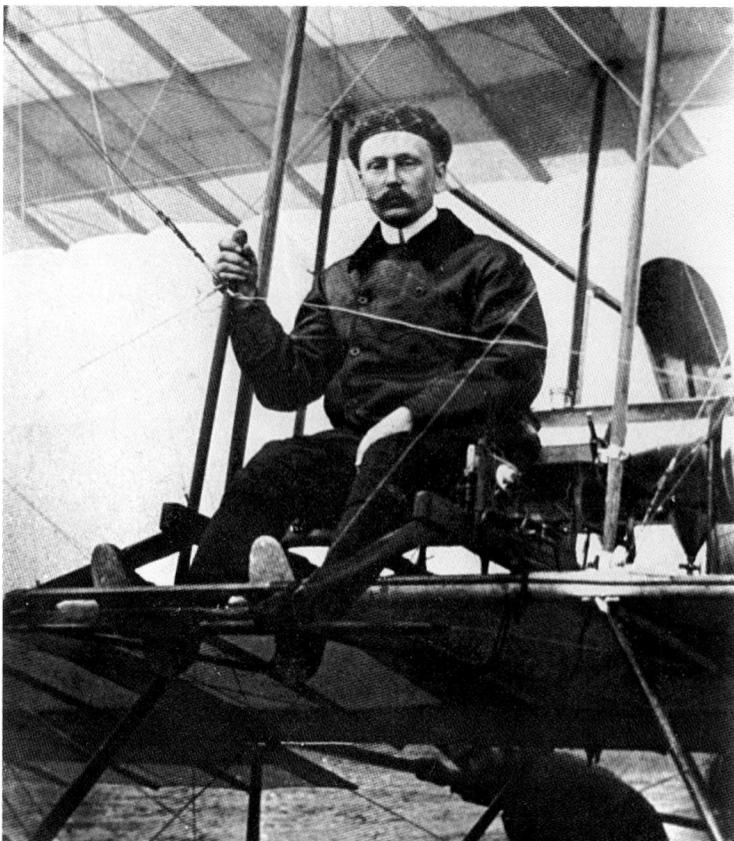

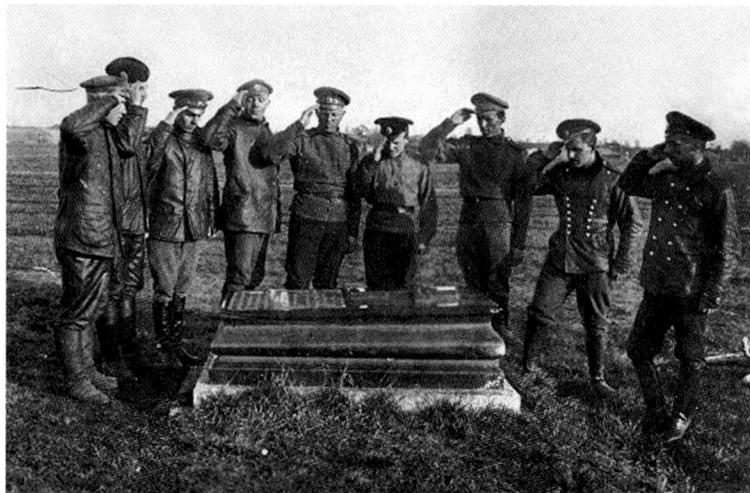

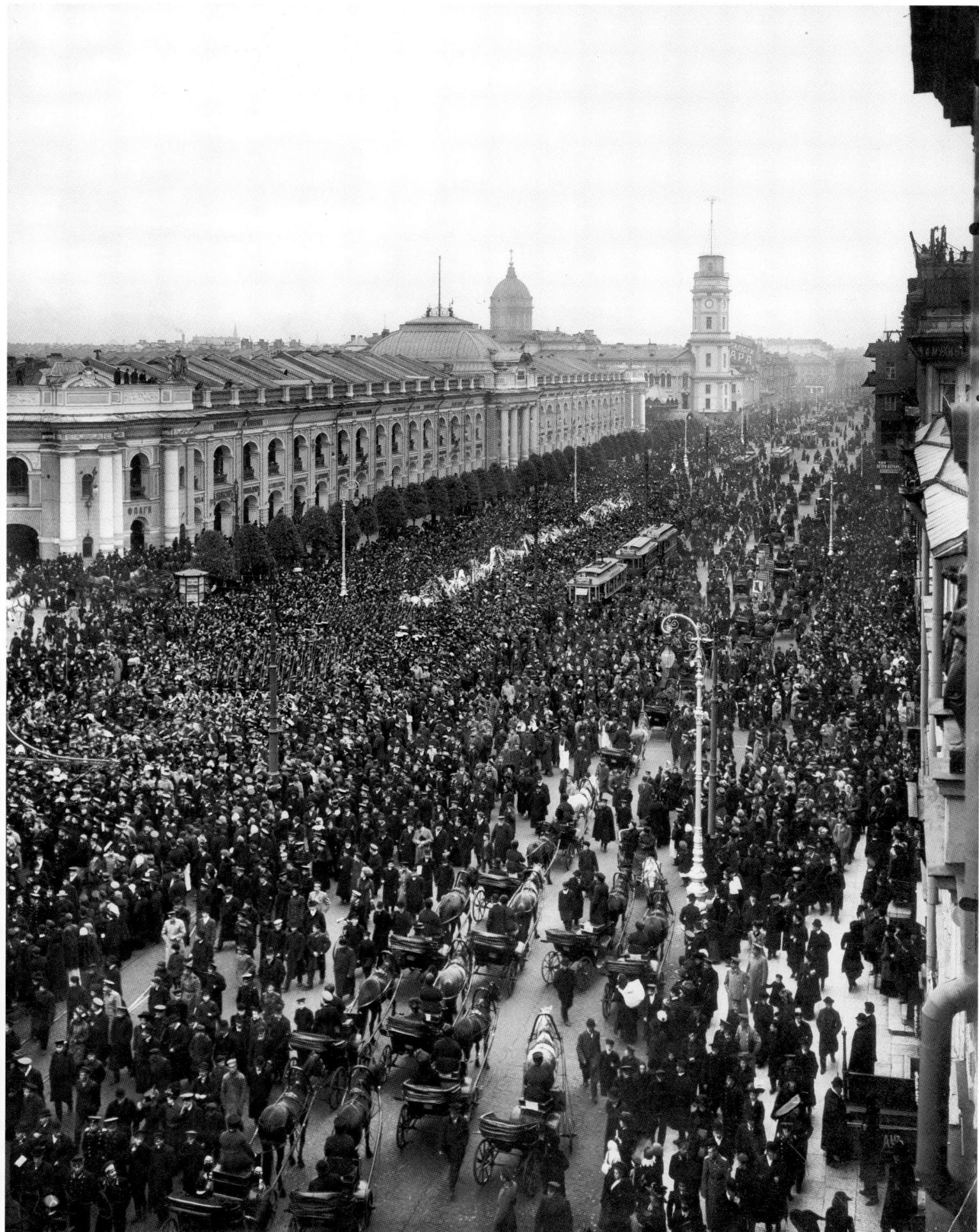

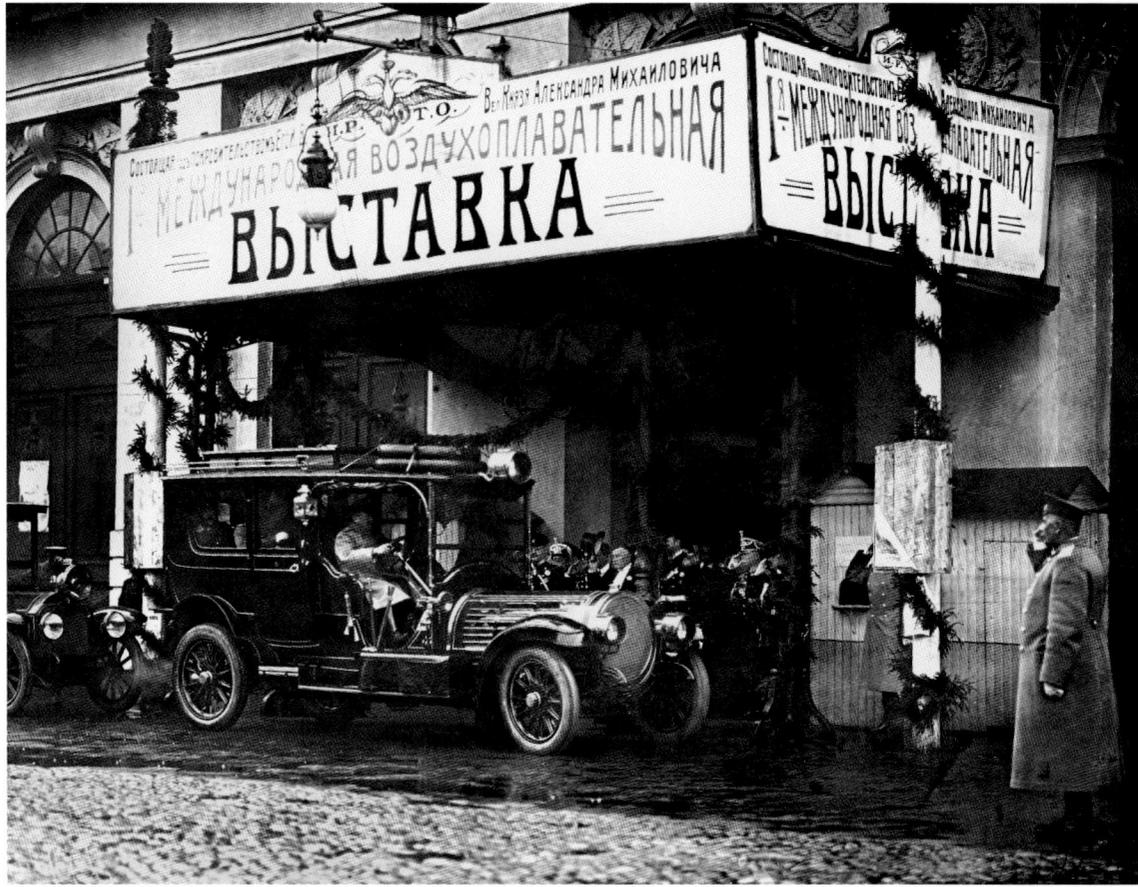

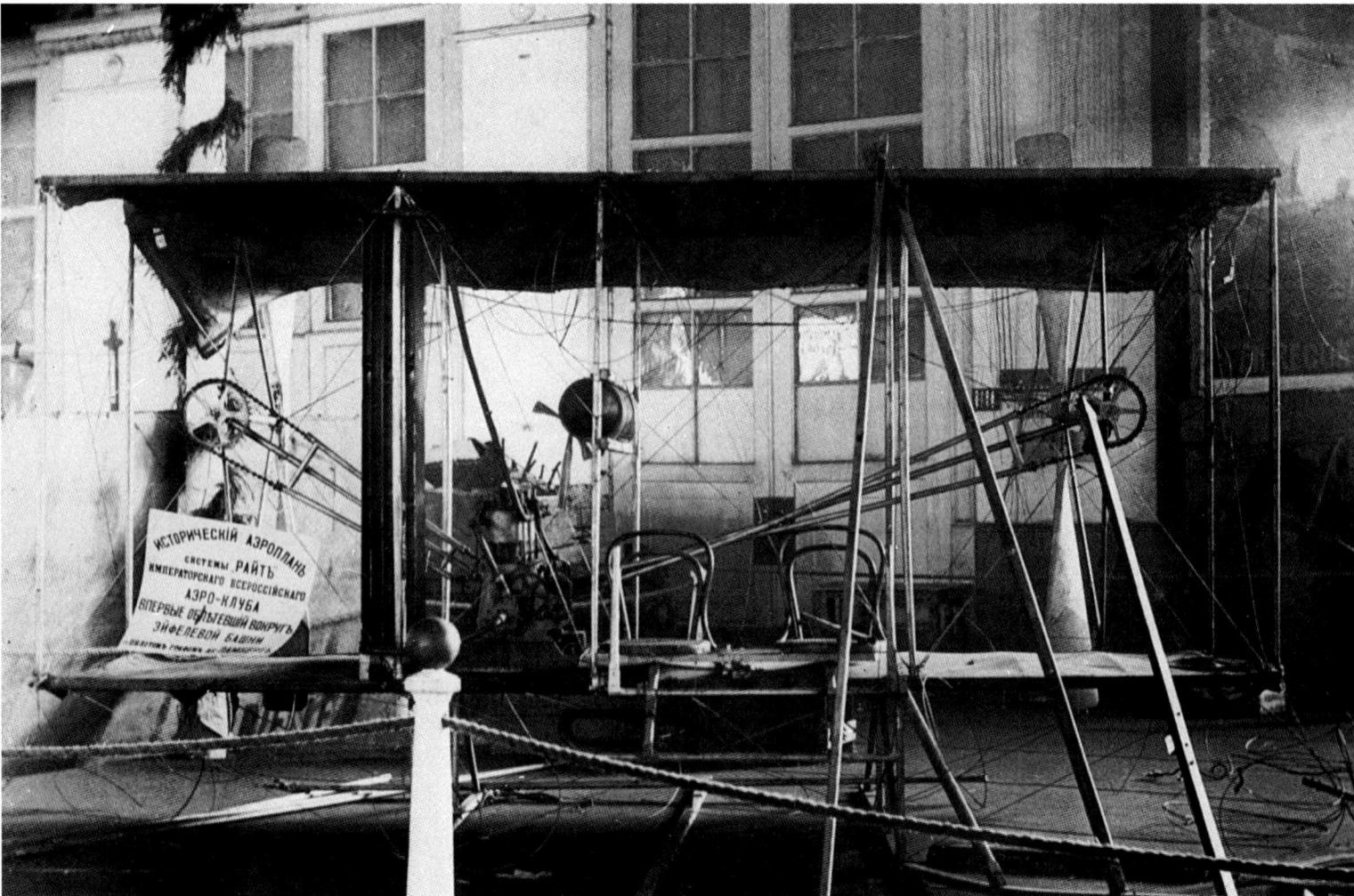

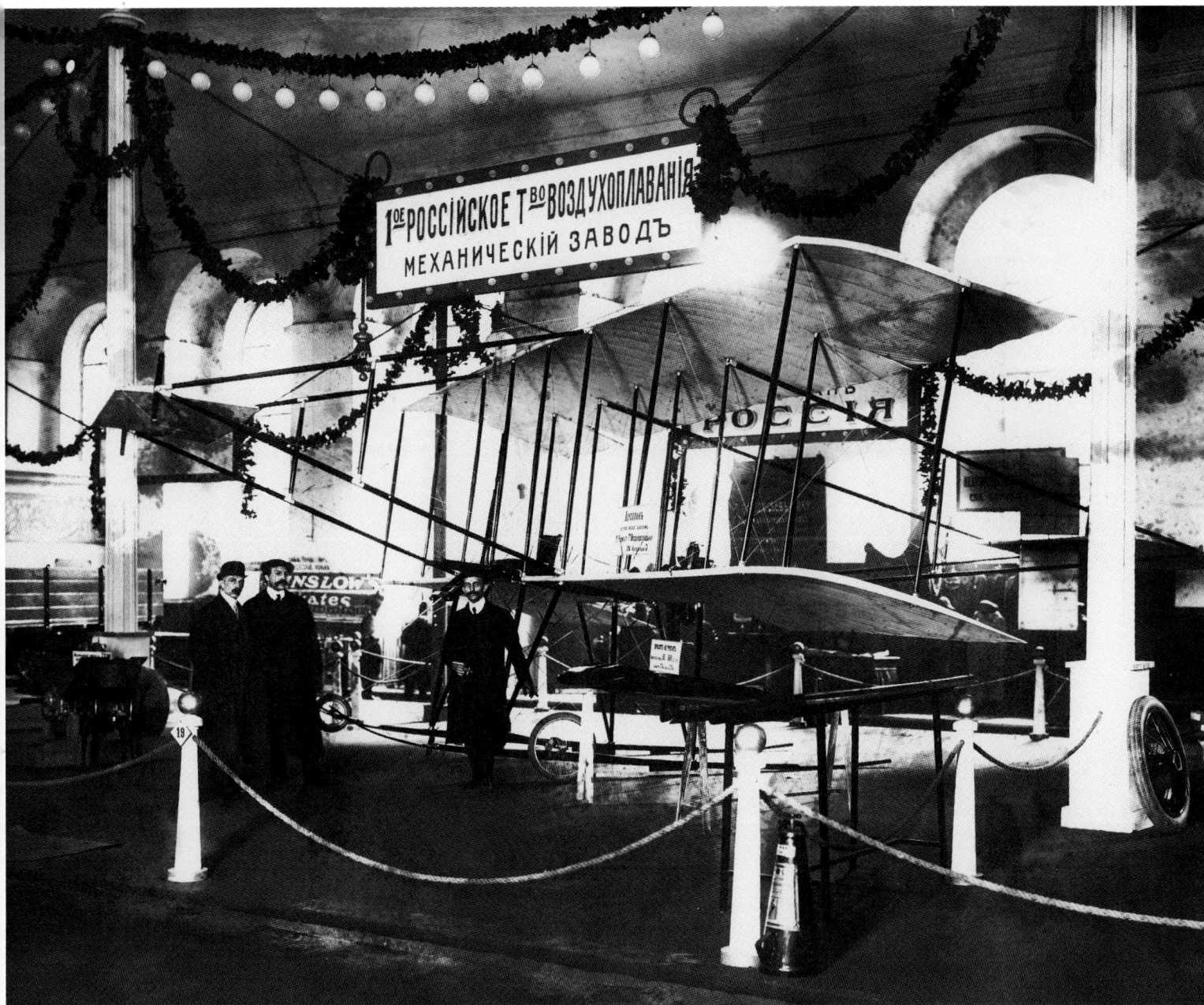

1ОЕ РОССІЙСКОЕ Тво ВОЗДУХОПЛАВАНІЯ
МЕХАНИЧЕСКІЙ ЗАВОДЪ

РОССІЯ

95. Advertising design of the main entrance of the Mikhailovskyi Indoor Arena at the First International Aeronautical Exhibition. In the foreground is the automobile of Emperor Nicholas II.

St. Petersburg. April 16, 1911

96. Fragment of the central part of the airplane *Wright*, on which in 1909 Count de Lambert flew around the Eiffel Tower in Paris.

97. Stand of the First Russian Association of Aeronautics.

Second Moscow Exhibition of Aeronautics. 1912

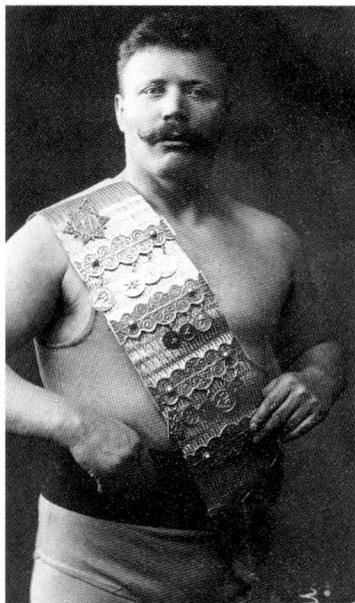

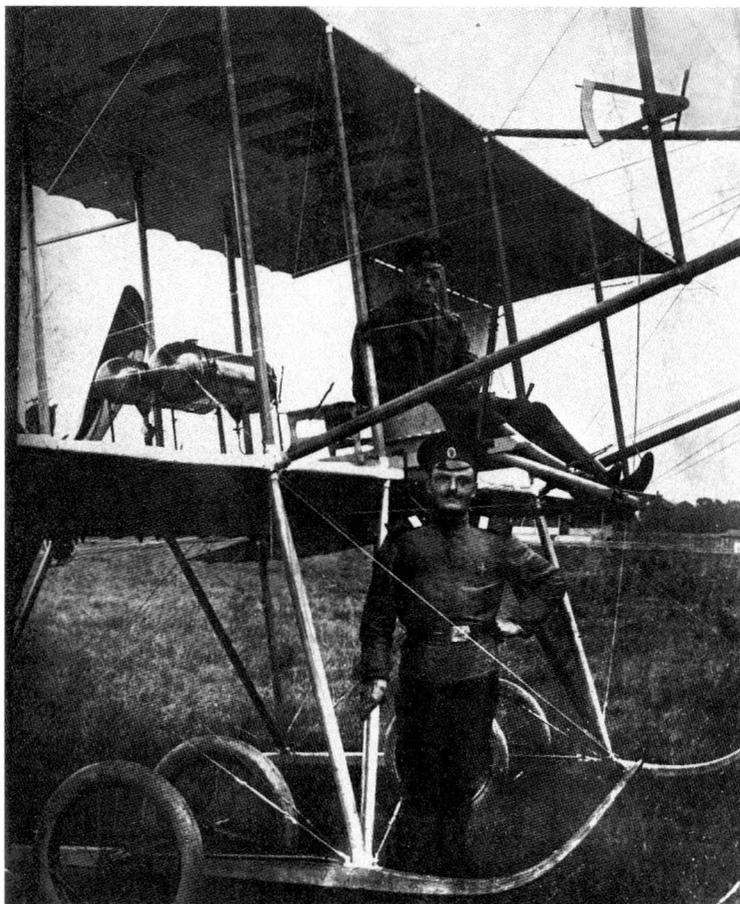

100

98. Professional fighter Ivan Mikhailovich Zaikin ("The Russian Bear").
1910 – 1911

A champion in Russia for weight-lifting (1904), student and colleague of I.M. Poddubnyi, I.M. Zaikin caught the aviation bug and graduated from the aviation school of Henri Farman in Mourmelon. He flew together with the famous pilots M.N. Efimov and M.F. de Campo Scipio.

99. The airplane *Great Novgorod.*
1911

plane had a 50 horsepower Gnome *motor, and was conceived by the initiative of Staff Captain L.E. Vamelkin with mechanic-carpenter Sergeant Major R. Apsov at the Nizhnyi Novgorod Department of the Pan-Russian Aeroclub.*

100. Aviators before a flight. First on the right – N.O. Volk, second on the right – G.P. Adler.
Komendantskyi Airfield. St. Petersburg.
1911 – 1912

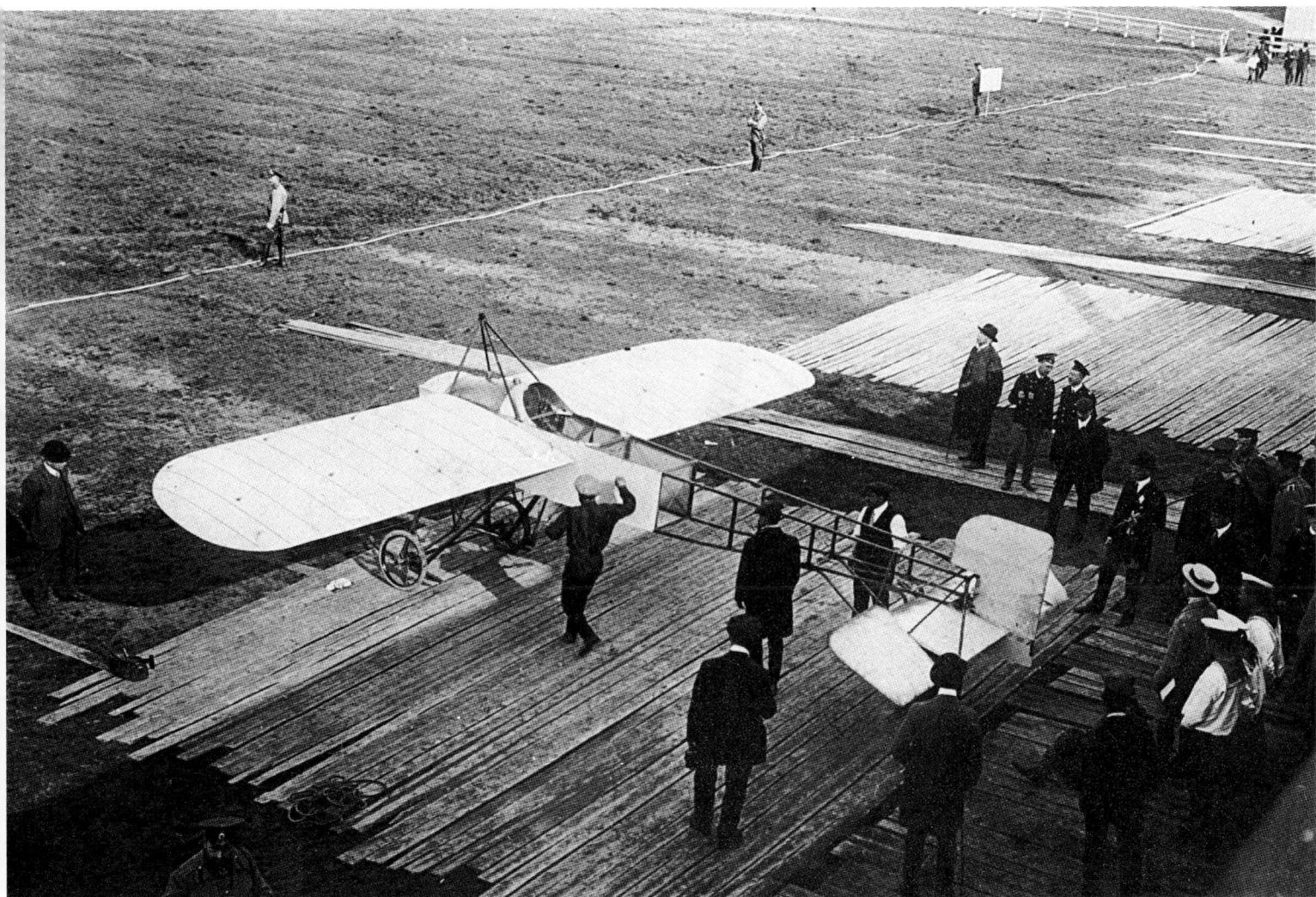

101. A plane after the style of the *Bleriot* **constructed by Moran. The pilot is G.C. Segno.**
Second Aviation Week. St. Petersburg. 1911

102. The oldest of a family of aviators: N.G. Prokofiev-Severskyi on the plane *Farman IV*.
St. Petersburg. 1911

102

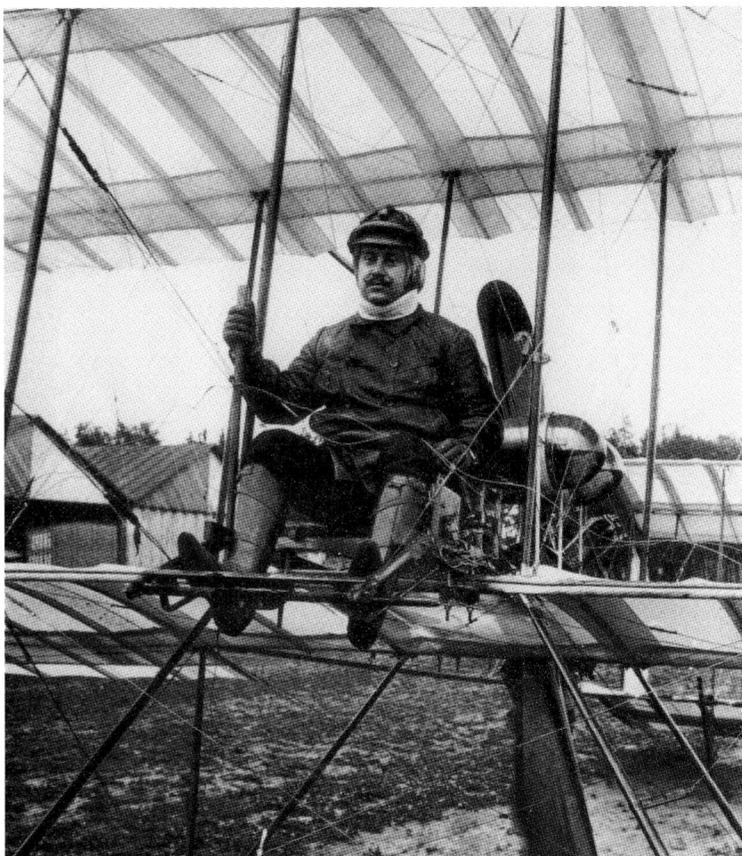

103. Ceremonial meeting of V.V. Dybovskyi after a flight on the plane Nieuport IV from Sevastopol-Kharkov-Moscow-St. Petersburg.
July 1912

104. Pilot-examiner G.V. Yankovskyi next to I.I. Sikorskyi's "S-11".
1912–1913
The plane was prepared especially for the large jubilee flight from Moscow-St. Petersburg-Moscow, dedicated to the 300-year anniversary of the Romanov House.

105. Staff Captain D.G. Andready (standing in the cabin of the airplane), having accomplished a flight from Sevastopol to St. Petersburg.
July 12, 1912

106. Next to the plane *Farman VII* is V.A. Youngmeister and A.M. Gaber-Vlynskyi before a flight from Moscow to Borgorodsk-Orekhovo.
September 1912

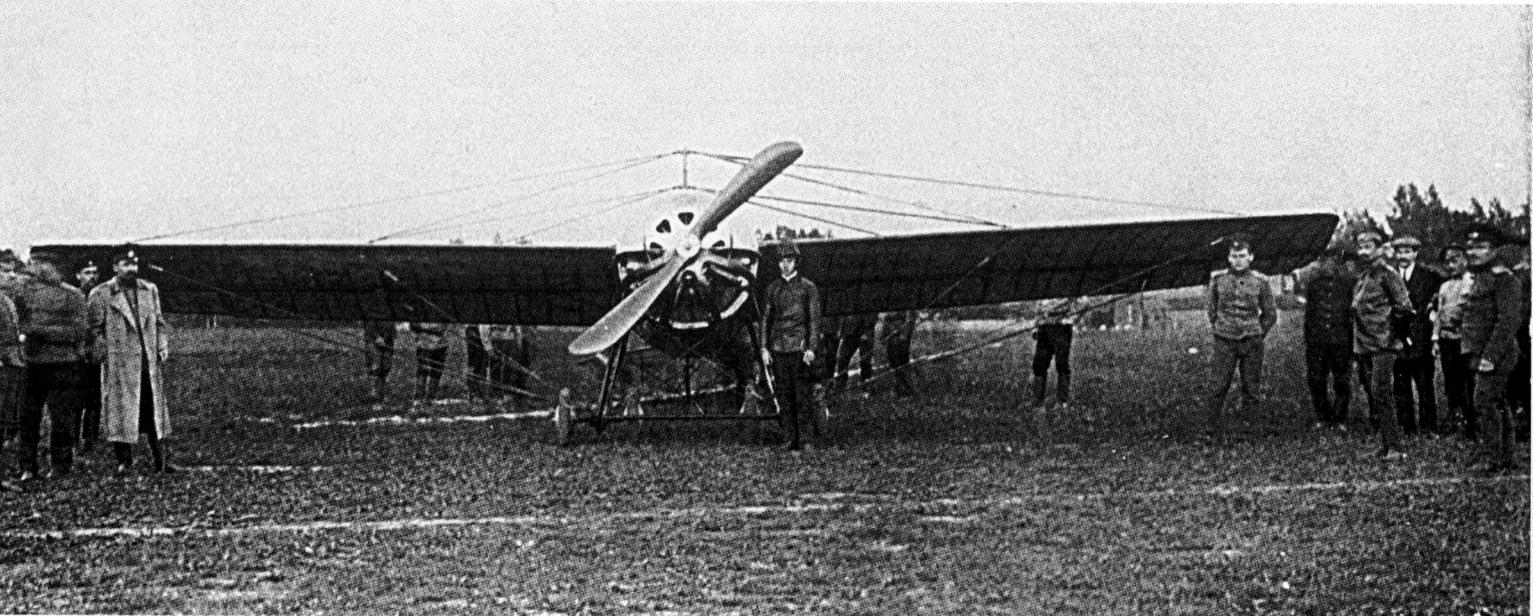

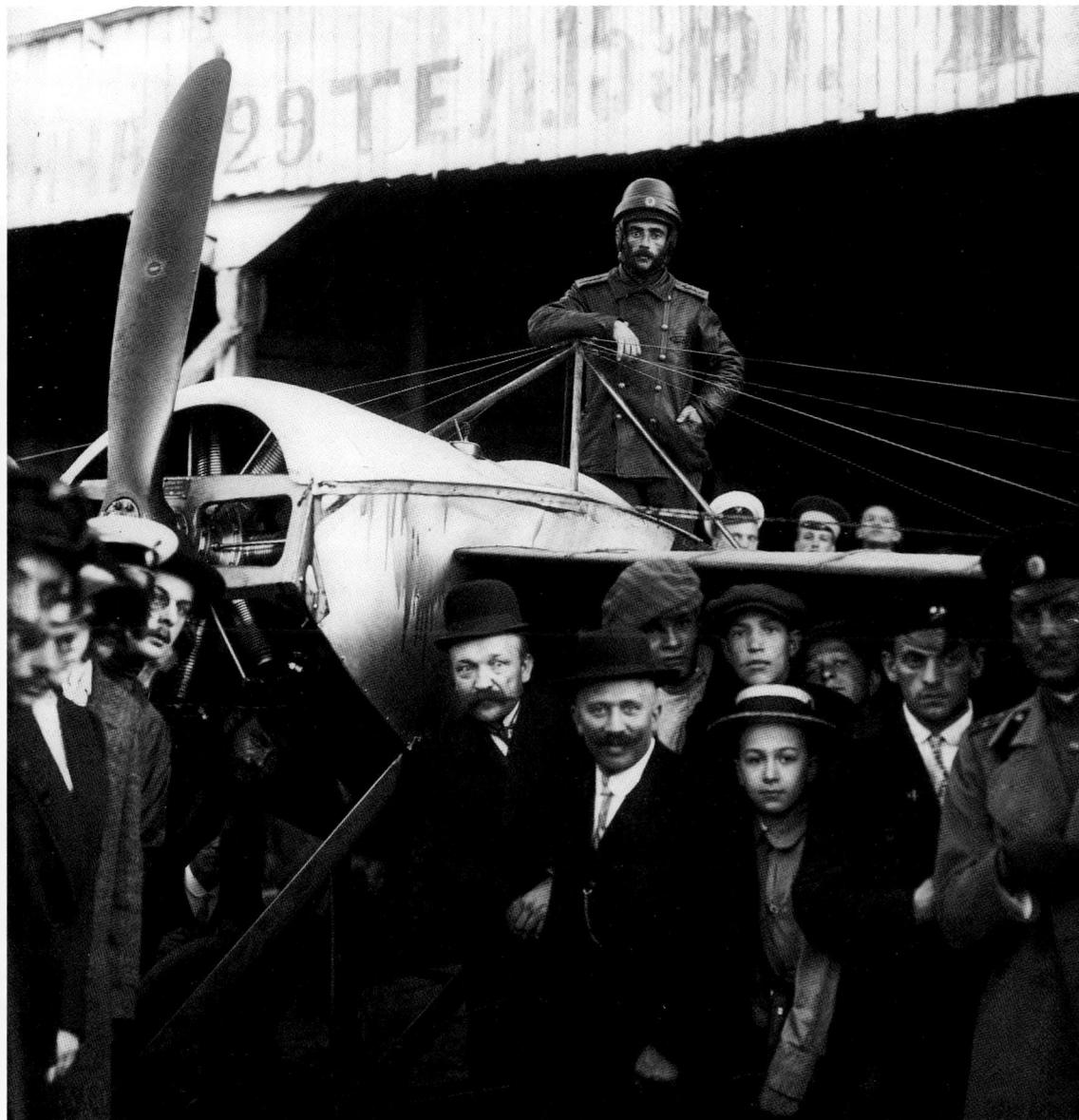

106

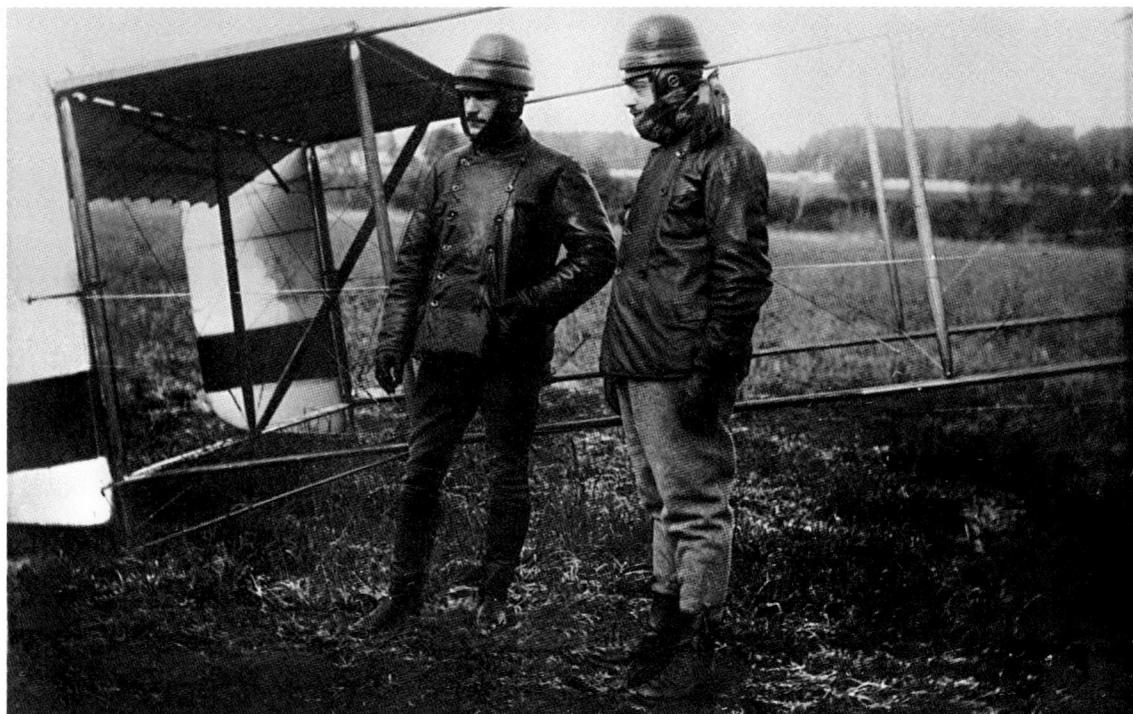

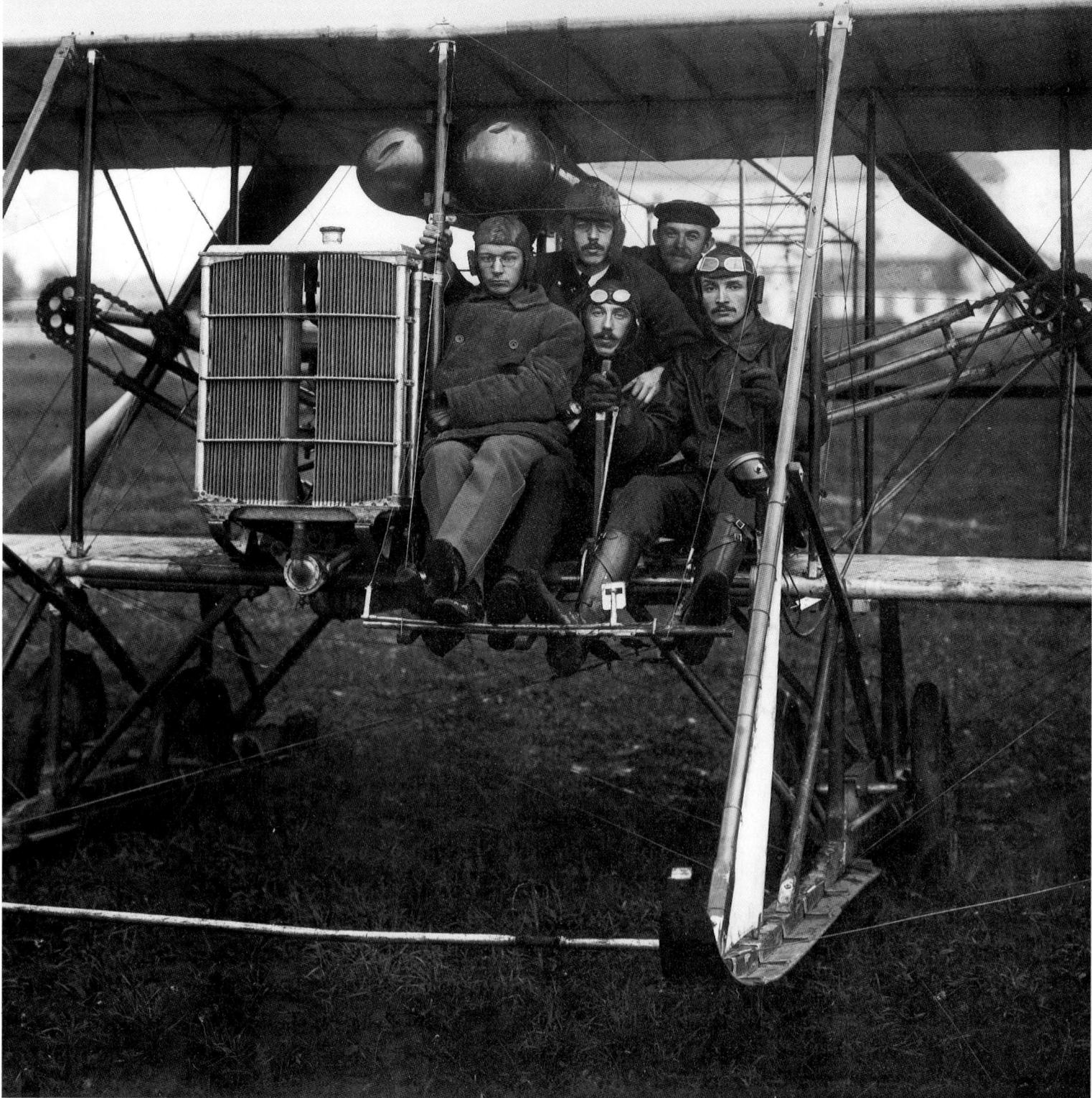

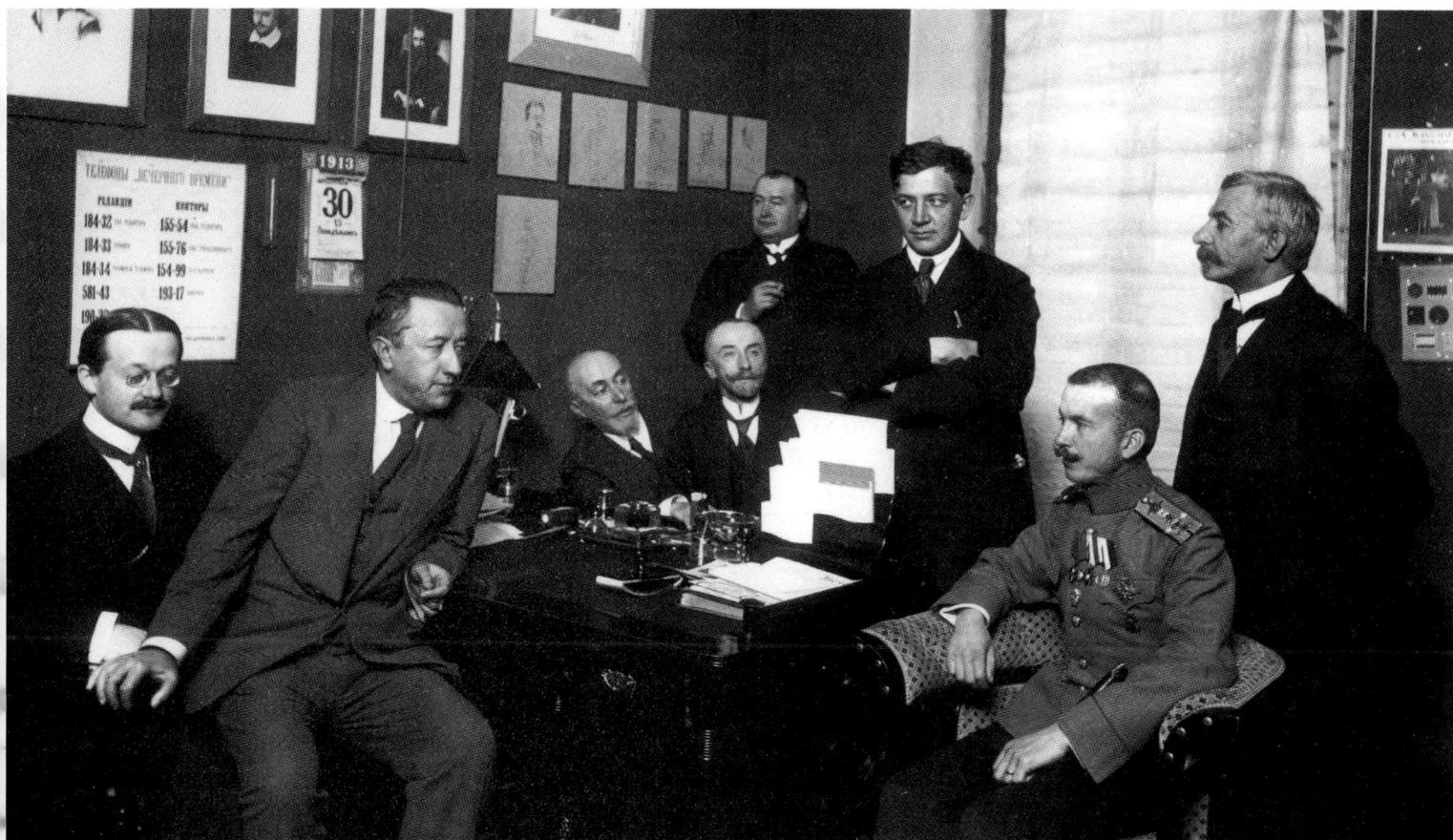

107. V.M. Abramovich with passengers on the plane *Wright.*
St. Petersburg. September 1912
This device, which was called the Wright of Abramovich, *placed the world record for flight length - 45 minutes and 57 seconds.*

108. Aviator P.N. Nesterov (second from the right) while editing the newspaper "The Evening Times".
1913

109.Pilot N.A. Yatsuk (standing in the center) with members of the Imperial Pan-Russian Aeroclub in front of the plane *Farman XVI.* **Third from right is G.P. Adler, second from right is A.A. Porokhovschikov.**
1913
In honor of the 300-year anniversary of the Romanov House, Prince S.S. Abamelek-Lazarev offered the Jubilee Romanov Goblet and a prize of 10,000 rubles for the aviator who flew from Odessa to St. Petersburg and back in less than 48 hours. The conditions of the flight turned out to be so difficult that the prize was never handed out.

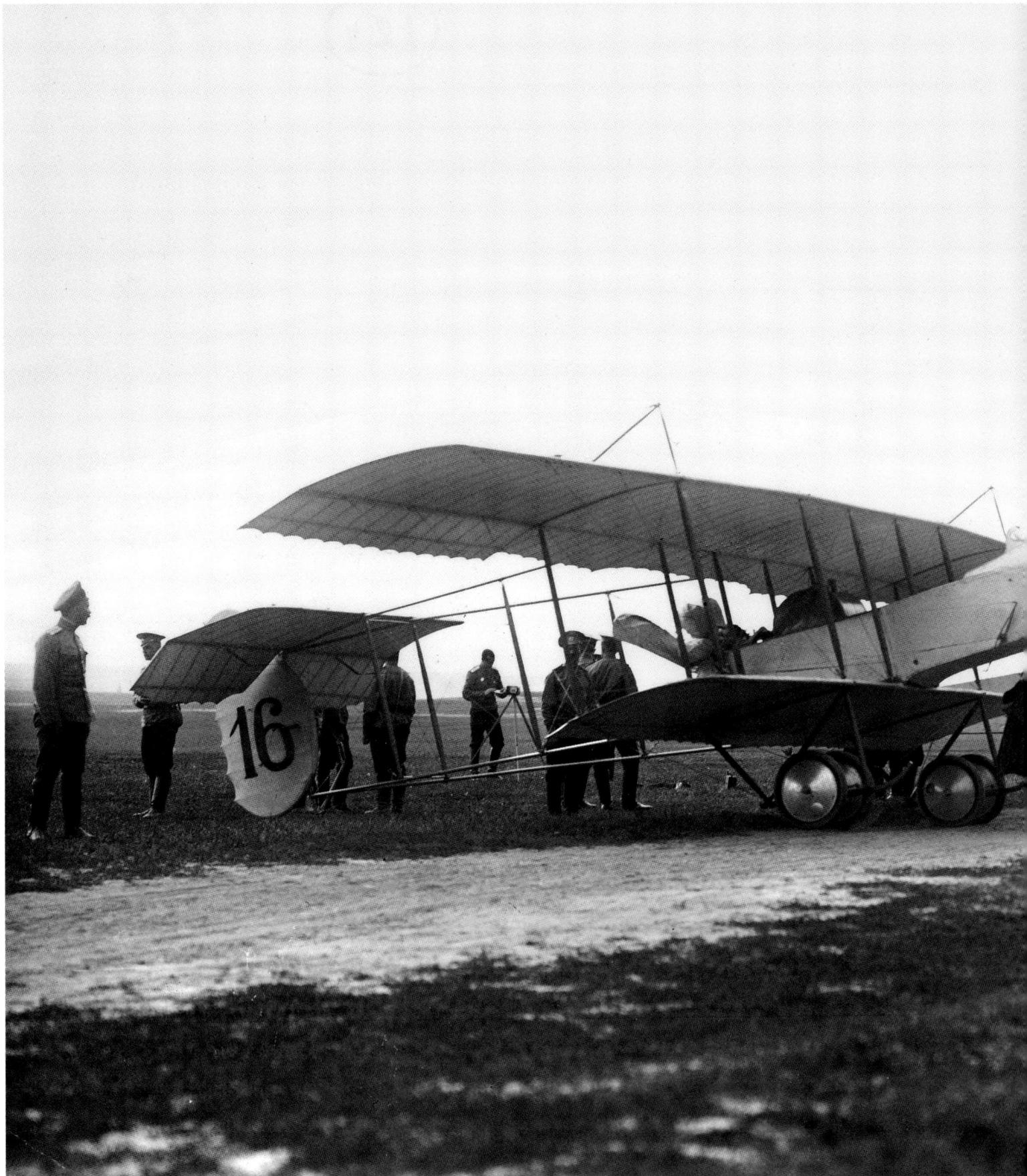

**110. Military airplanes at the airfield
of the 1st Aviation Squadron during
an aviation parade. In the foreground
is the** *Farman XVI*, **and behind it is the**
Nieuport IV.
Krasnoye Selo. 1913

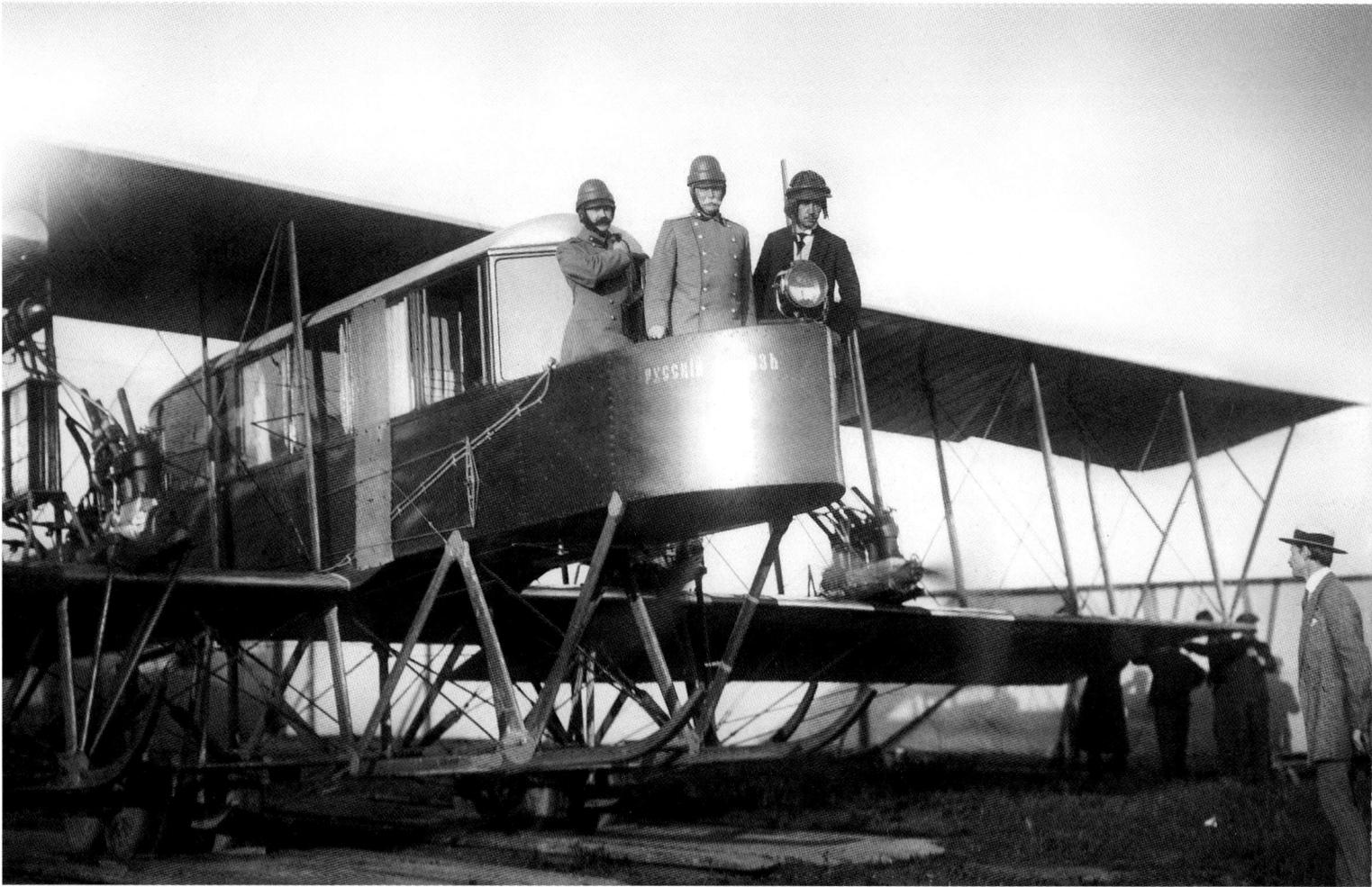

111. On the airplane Russian Hero. Right from left: I.I. Sikorskyi, General A.V. Kaulbars, Gener.

Military plane competition. Korpusnoi Airfield. St. Petersburg. 1913

112. A group of organizers of the Fourth Aviation Week. Third from left – Major General A.M. Kovanko.

St. Petersburg. 1913

113. Pilot and aircraft designer I.I. Sikorskyi (on right) with the aide-de-camp of Grand Duke Alexander Mikhailovich Captain First-Class N.F. Fogelem.

Military plane competition. Korpusnoi Airfield. St. Petersburg. 1914

114. The *Farman XX* flies over a signaling stand.

Комендантский аэродром. Санкт-Петербург. 1913 г.

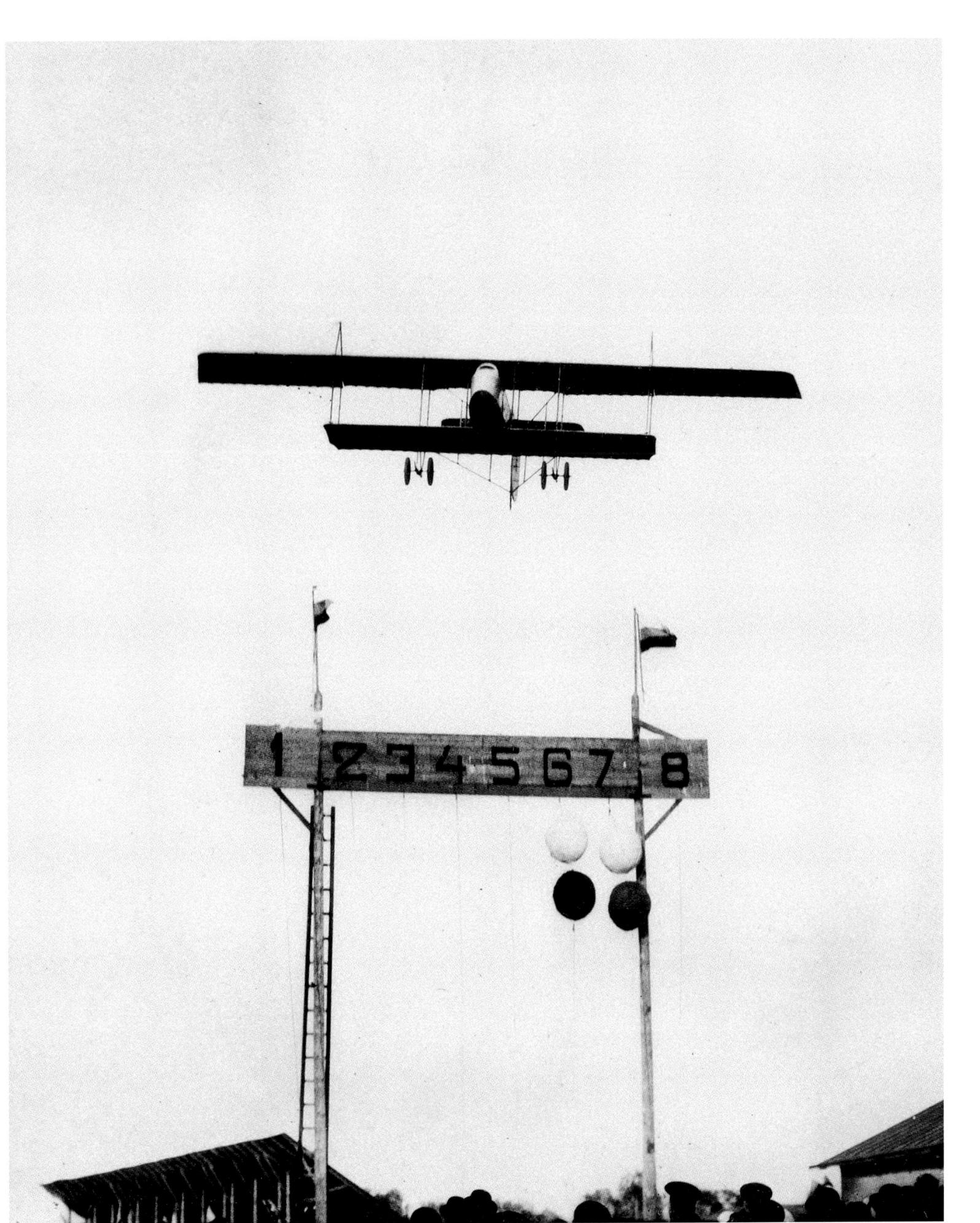

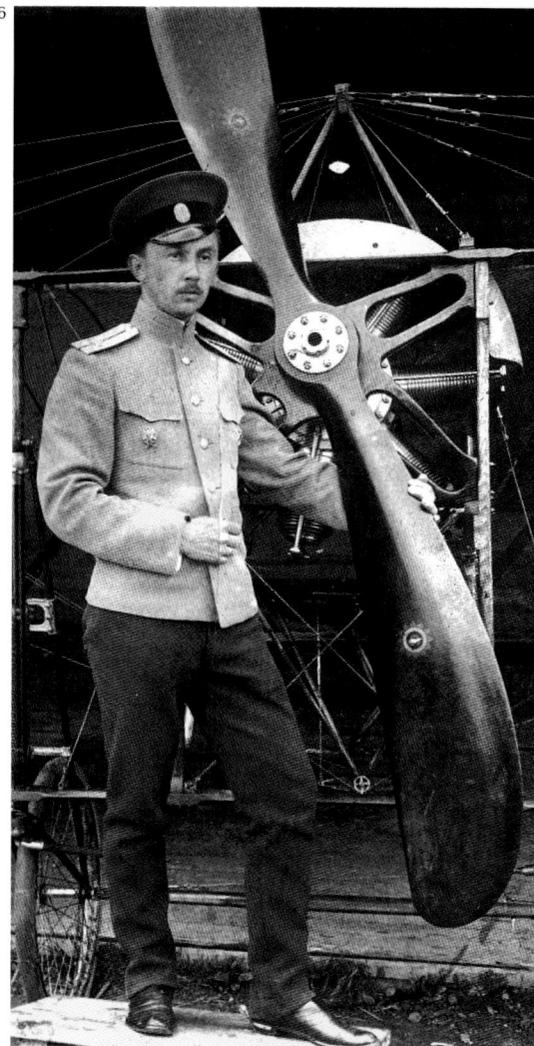

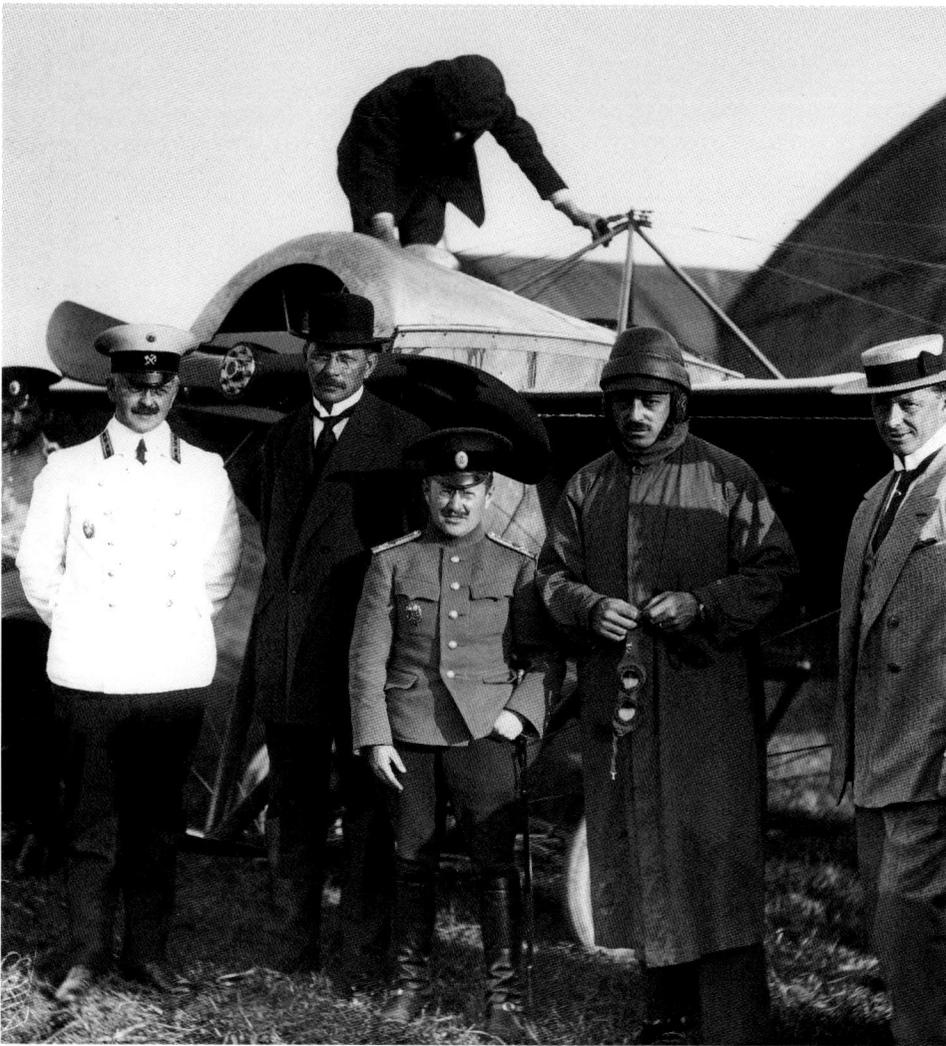

115. A group of participants at the military plane competition (from left to right): P.A. Kuznetsov, U.A. Meller, P.A. Samoylo, A.M. Gaber-Vlynskyi.
Korpusnoi Airfield. St. Petersburg. 1913

116. Aviator G. G. Gorshkov next to the airplane *Bleriot XI.*
1913
The pilot participated in tests to eject a mannequin with a Kotelnikov parachute.

117. Aviator G.V. Yankovskyi on I.I. Sikorskyi's *C-12.*
St. Petersburg. 1913
On this plane G.V. Yankovskyi more than once completed «dead loops», delighting the public and beginning pilots.

118. Assistant of the president of IVAK and colleague of Lifeguard Pavlovskyi, regiment aviator S.A. Mezentsev next to an airplane.
St. Petersburg. August 1914

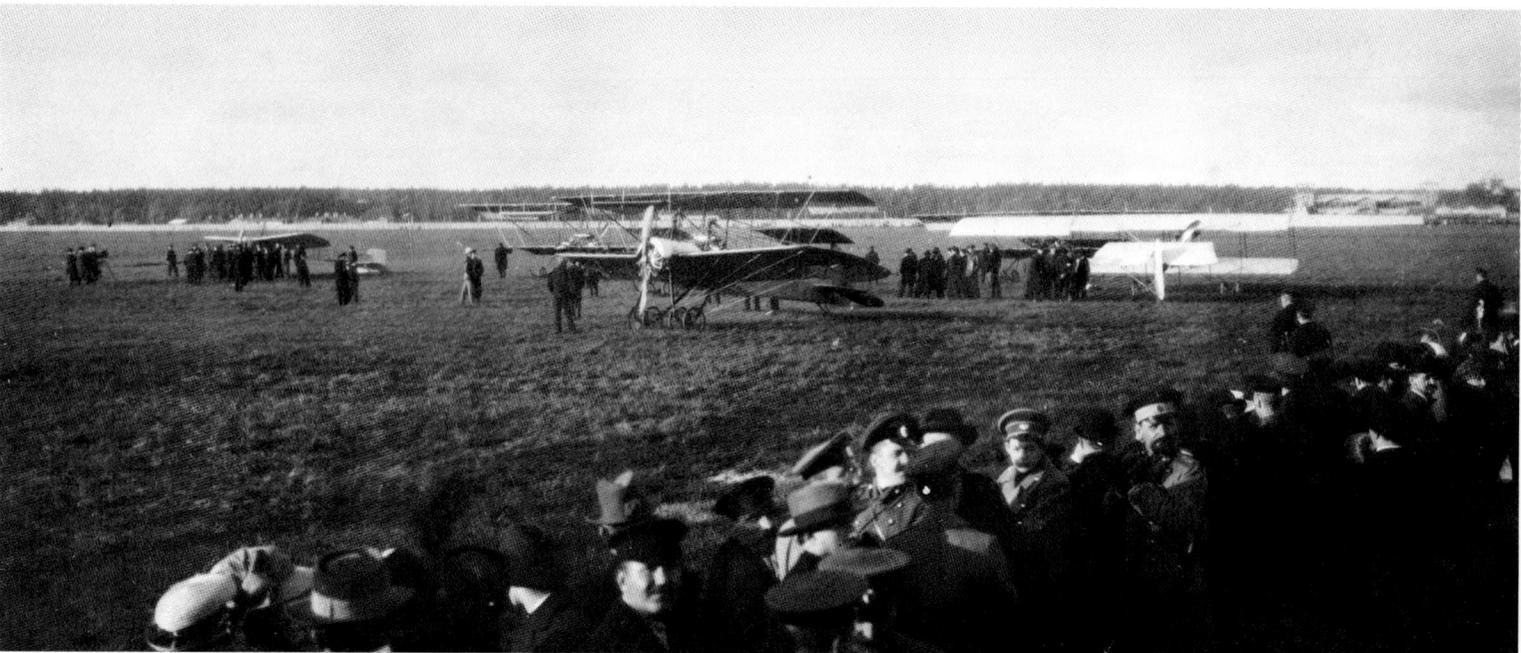

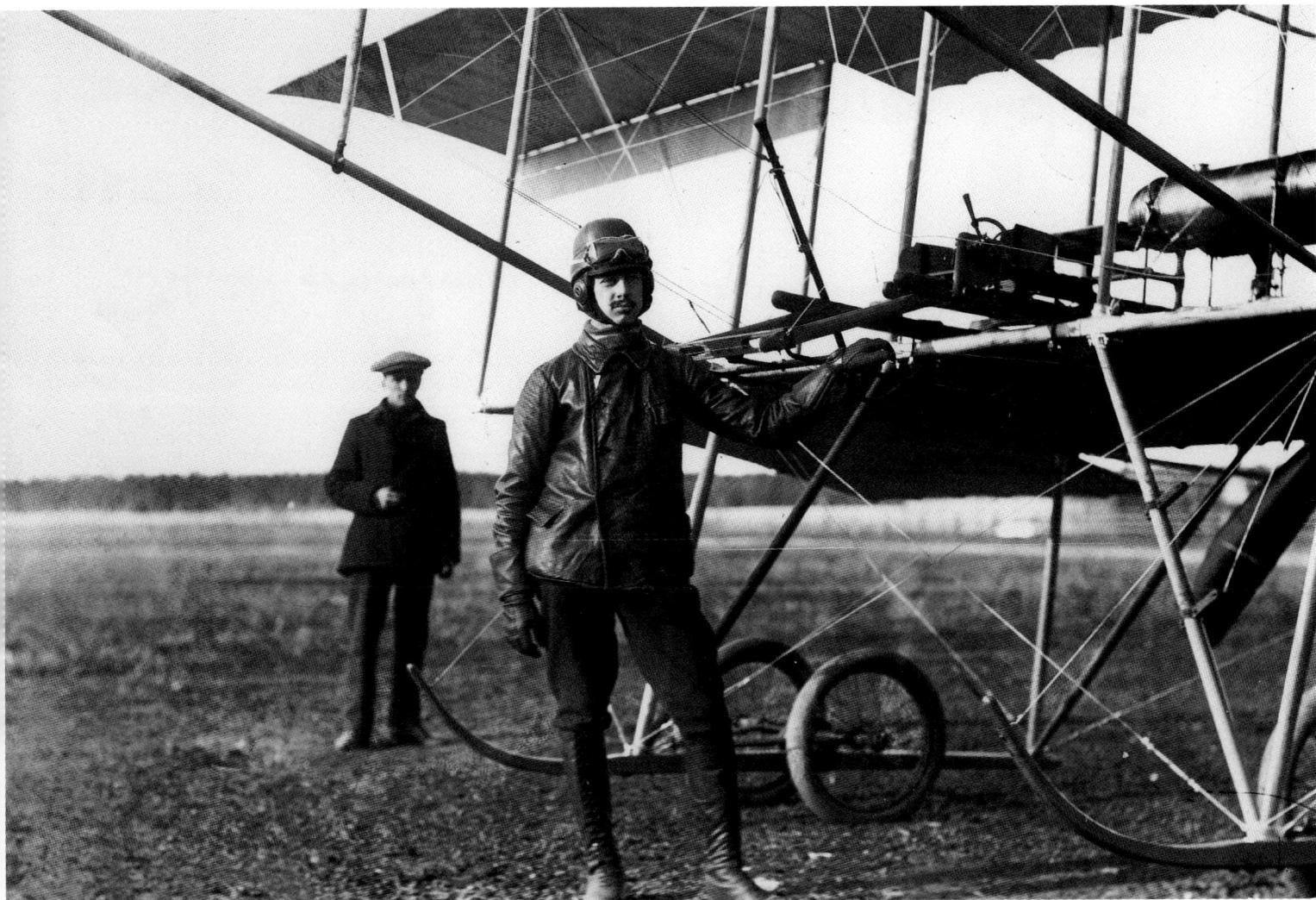

119. Pilot and designer of the Moscow Society of Aviation School Alexander Yakovlevich Dokuchaev on the plane *Farman VII*.
Moscow, Khodunskyi Field. 1915

119

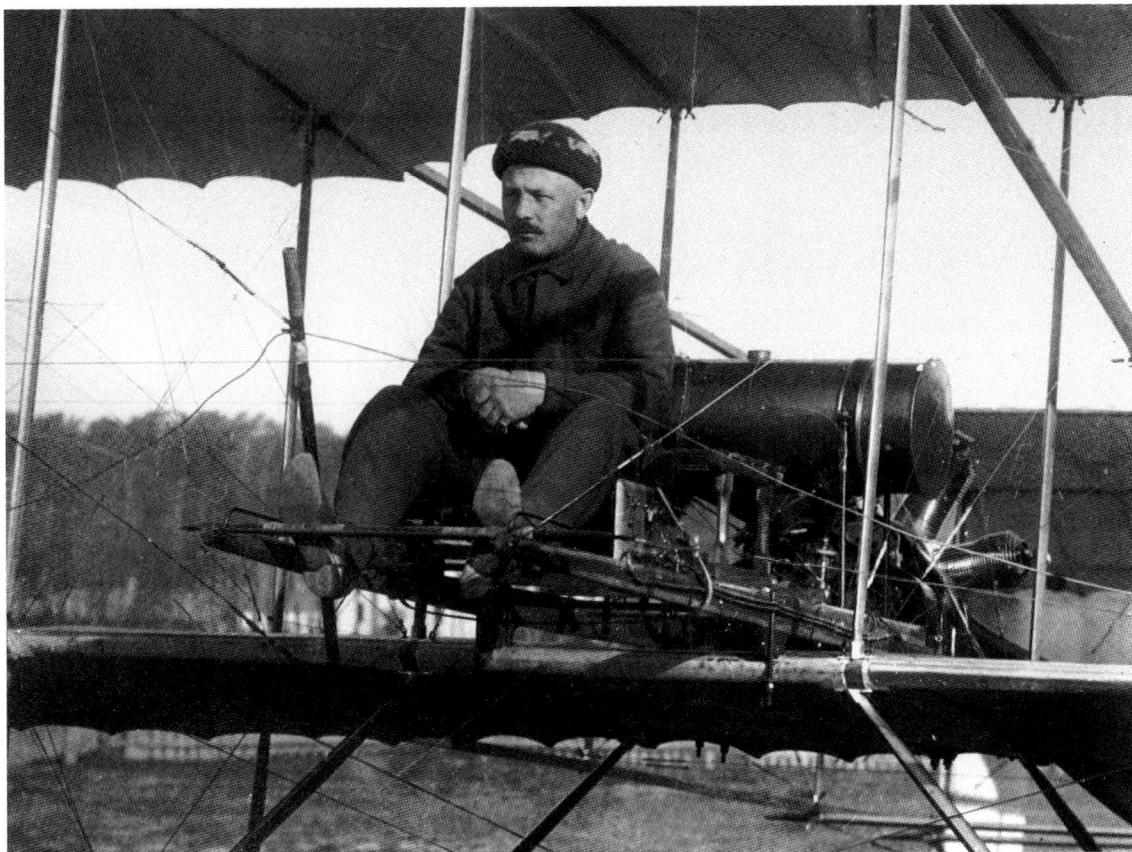

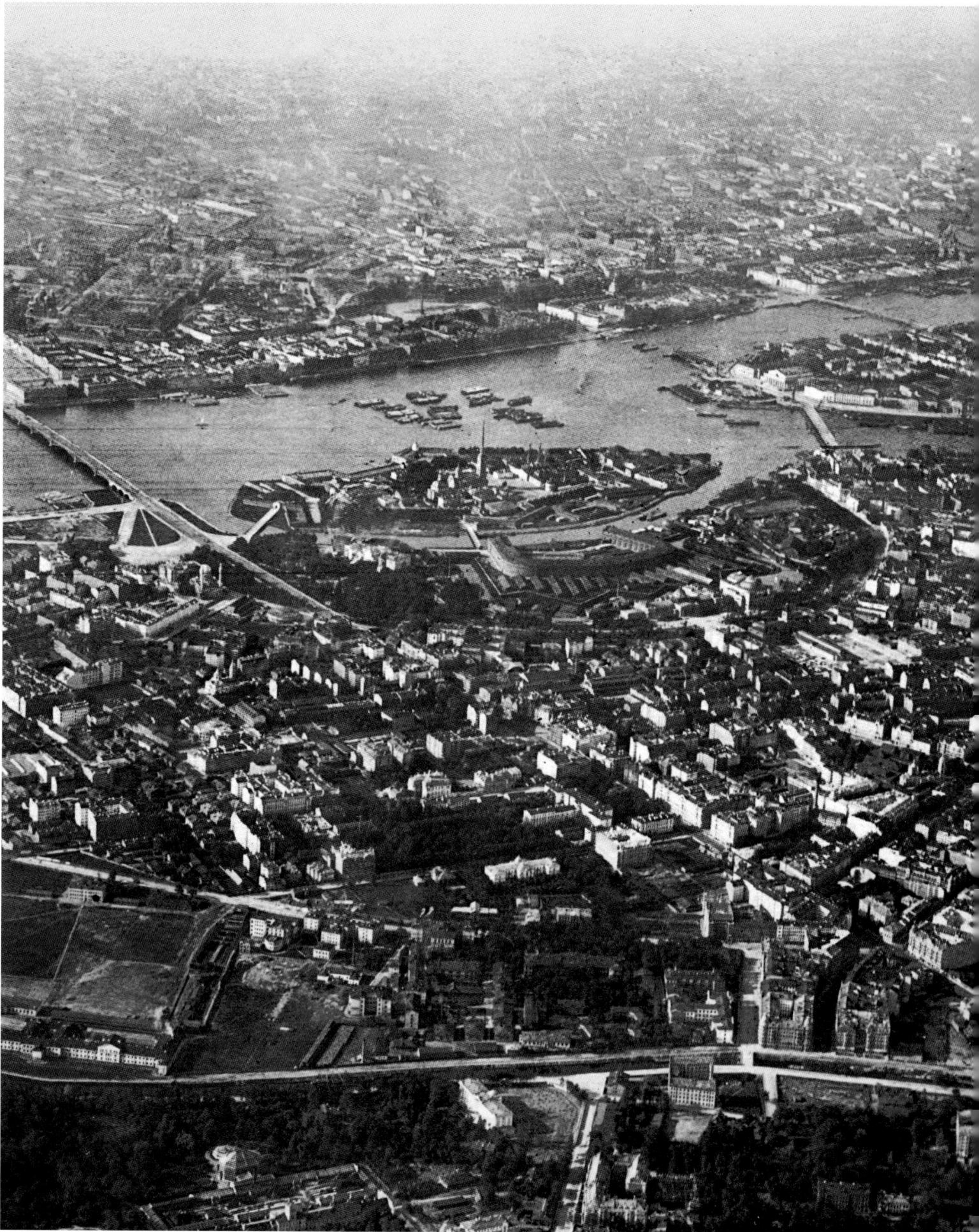

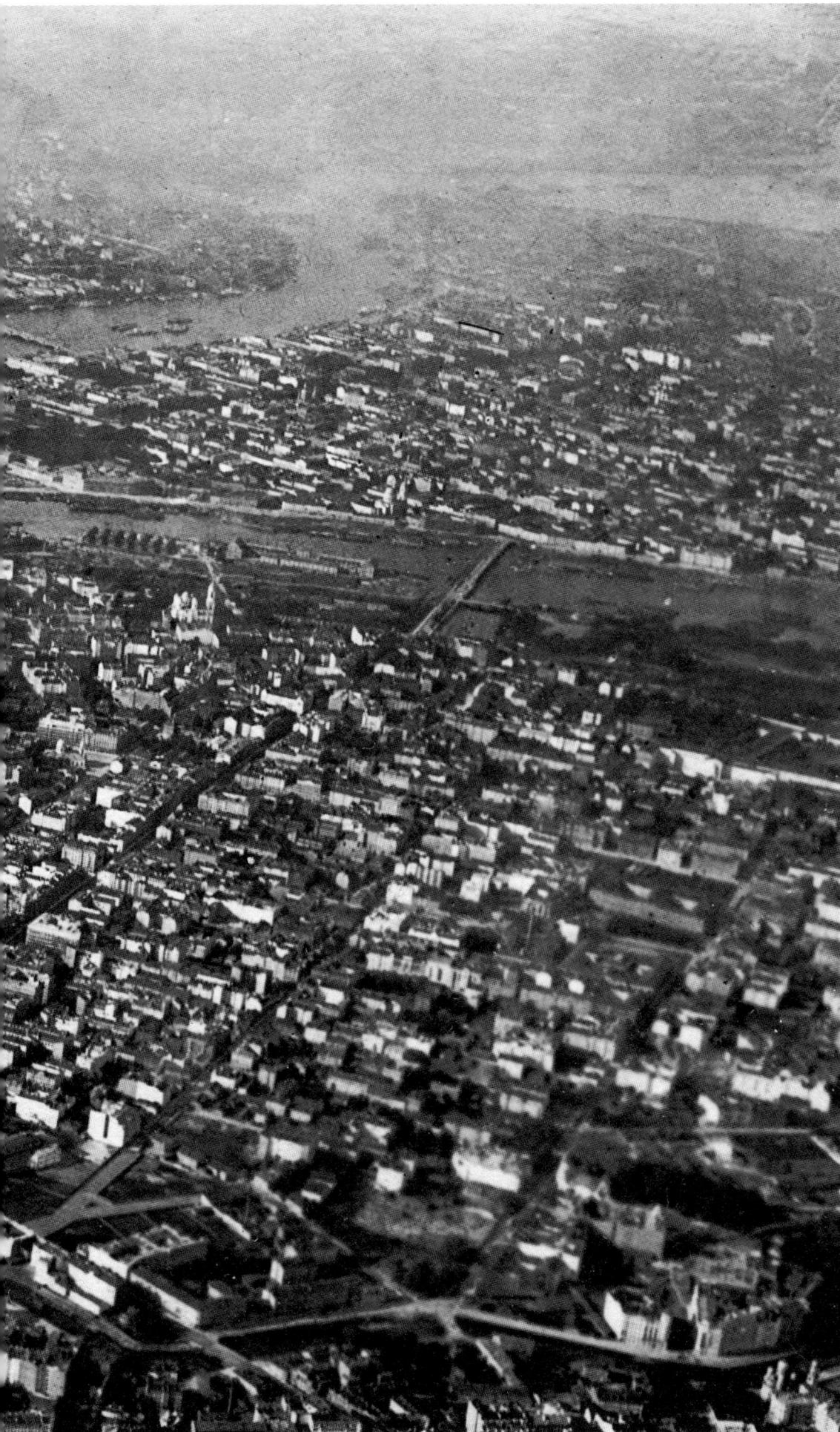

120. View from a plane from a height of 400 meters of the central part of St. Petersburg, including the Petropavlosk Fortress and Vasiliyevskyi Island.
1912–1913
A large part of the survey was done by either pilot P.N. Nesterov or the film operator who accompanied him.

121. Ms. E.A. Gurenkova - the fearless passenger of the french aviator A. Pierre, a figure known for his performance of the highest aerobatics.
St. Petersburg. May 1914

122. On the plane *Farman XVI* is pilot Alphonse Pierre with a passenger - the actress Liubov Galanchikova (who performed under the name Molly Morye).
St. Petersburg. May 1914

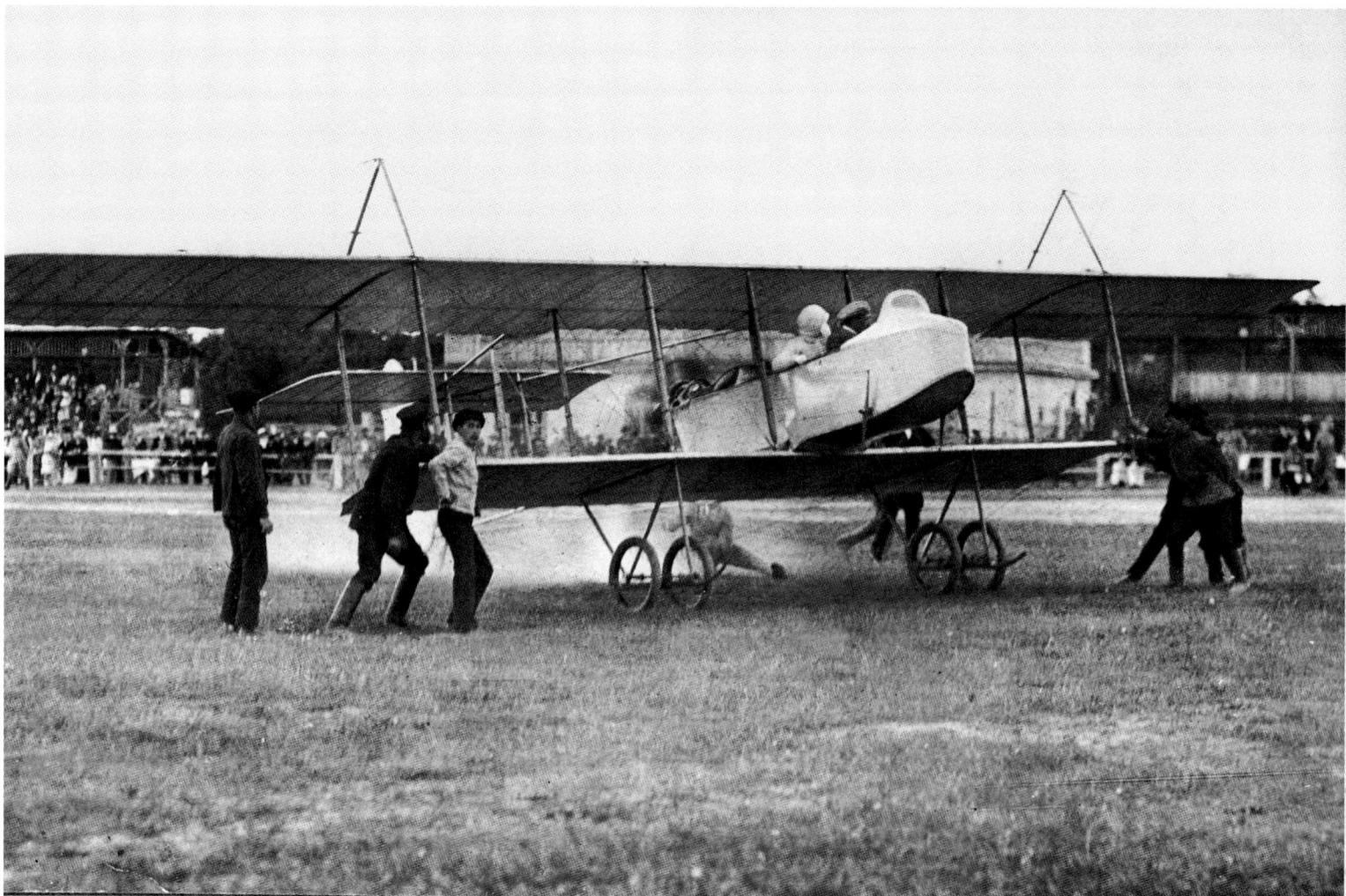

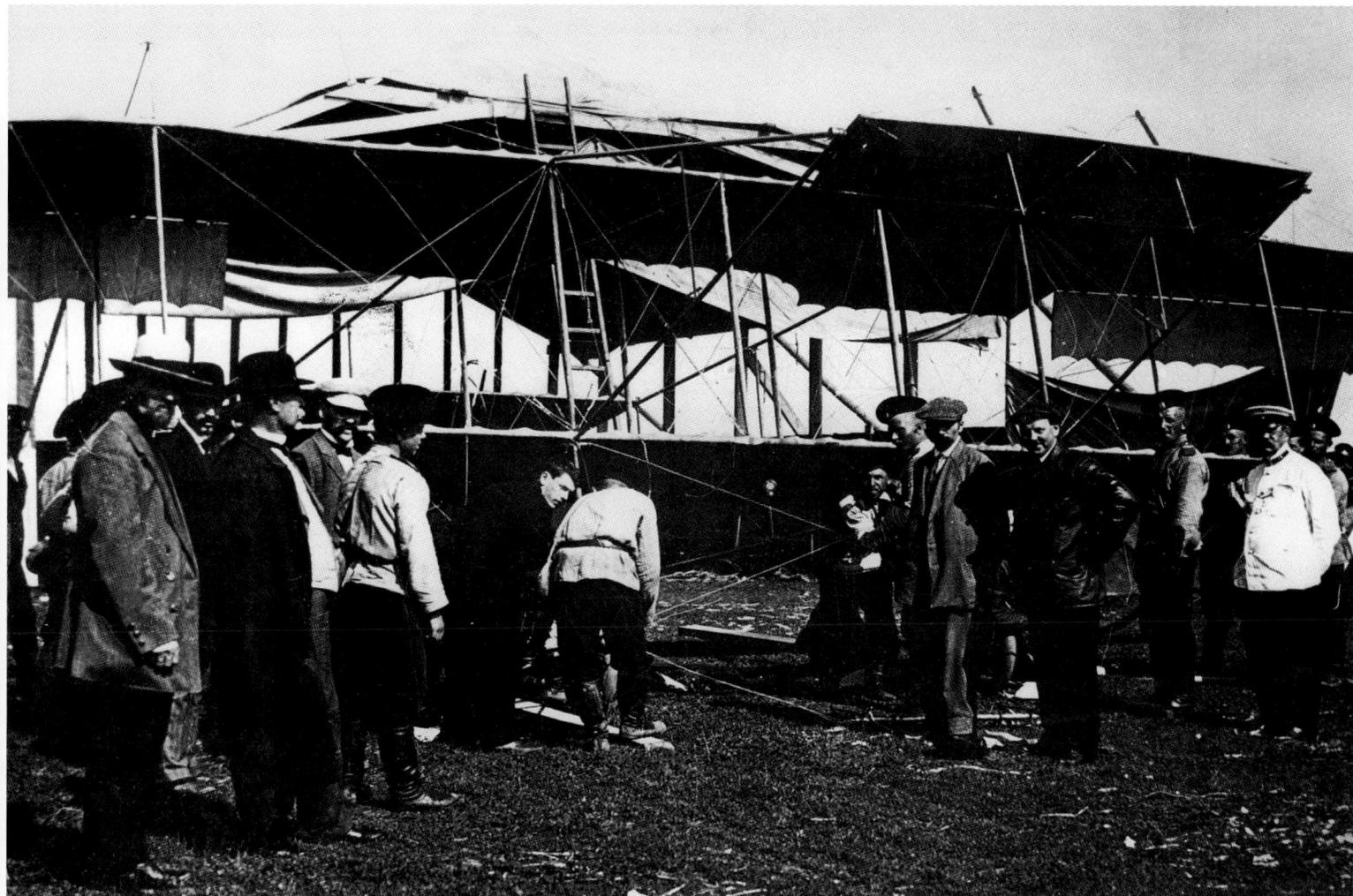

123. Curious spectators near the plane *Farman VII*, **preparing for flight.**
Moscow. 1913

124. Outfitting of the main entrance to the airfield of the Moscow Society of Aeronautics.
Moscow. 1914

124

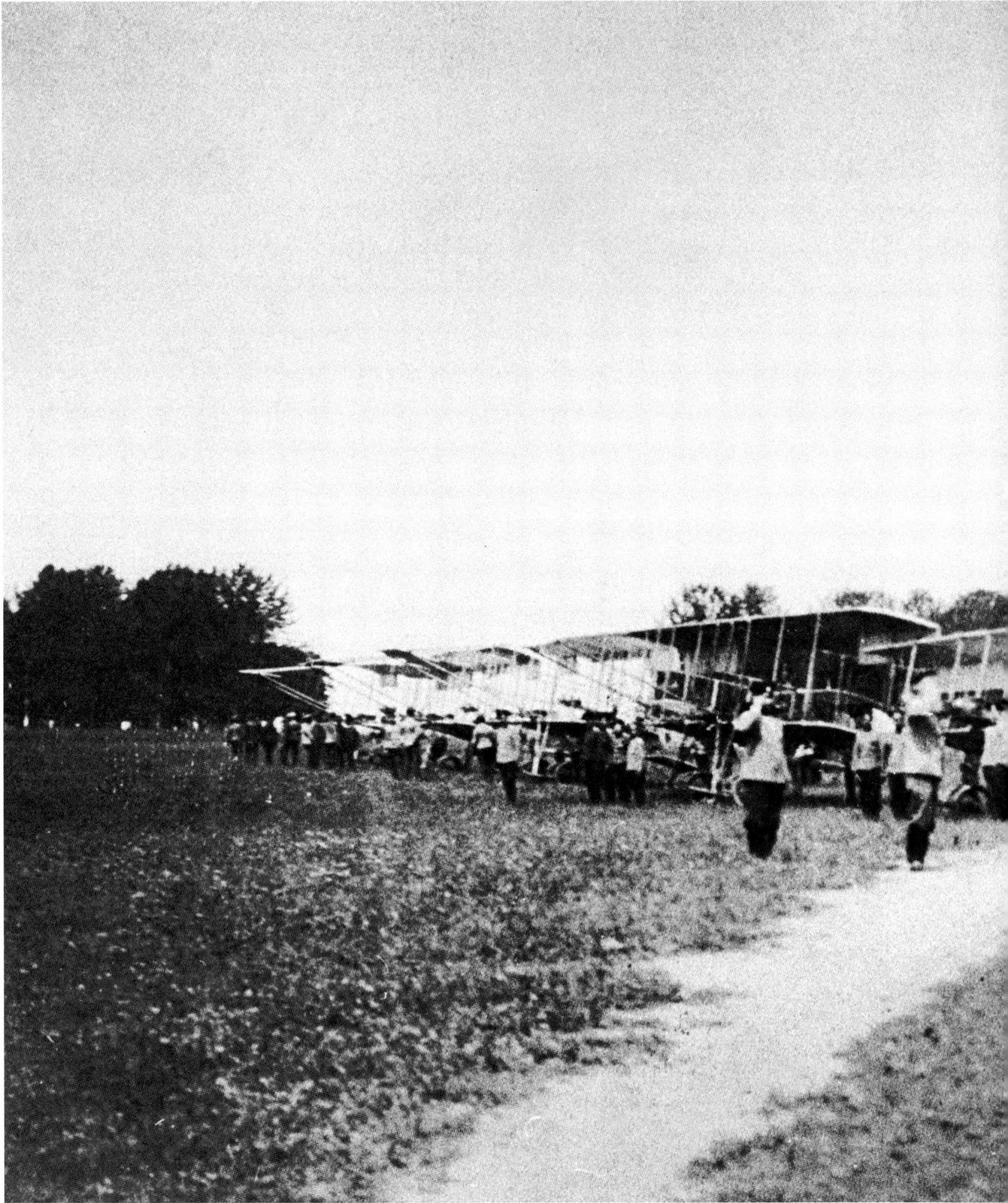

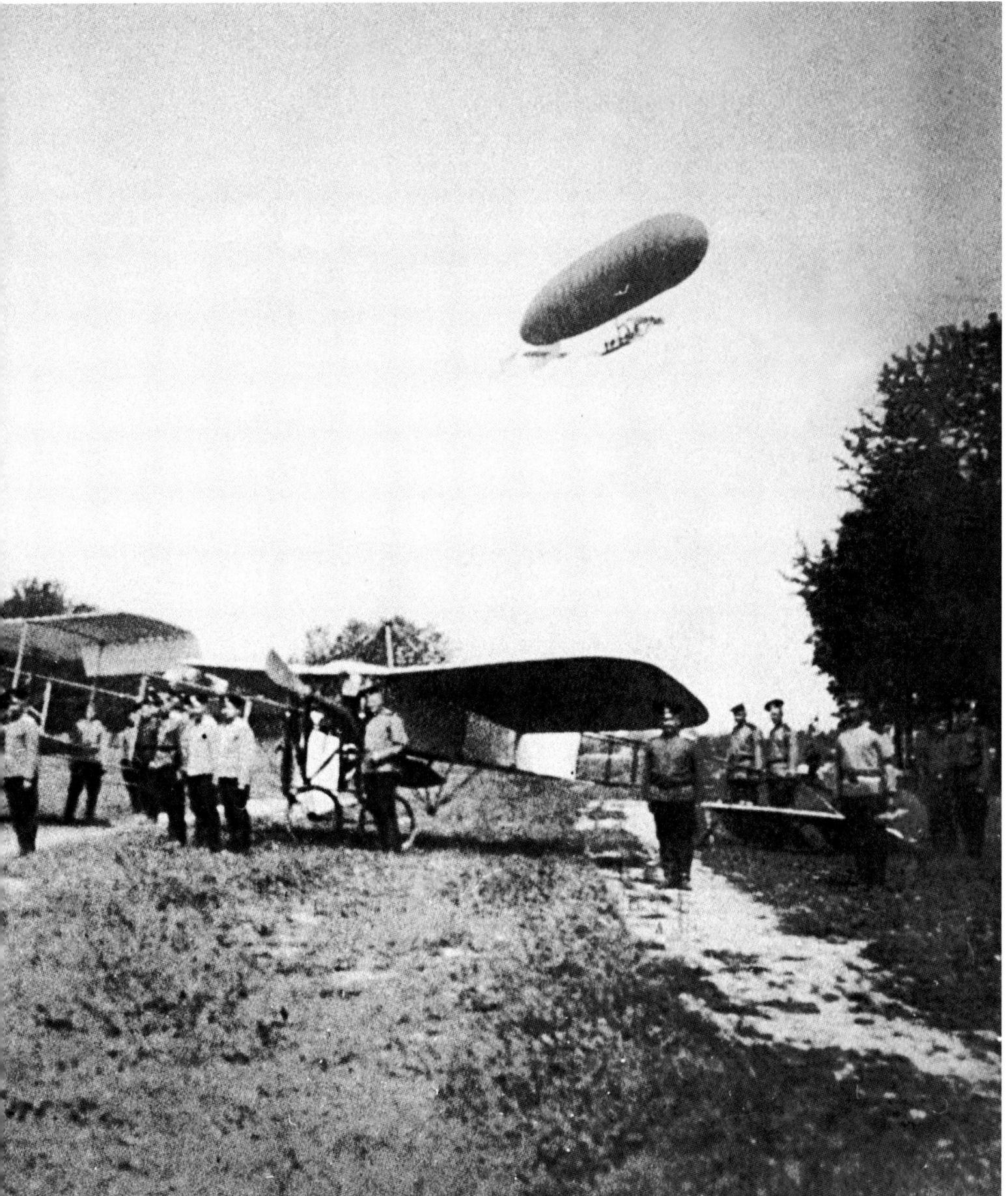

125. The head of the Officers Aeronautic School Major General A.M. Kovanko takes a report from the head of the squadron of the Aviation School. Joint maneuvers of the young aviators with military aeronauts.
Gatchina. 1910 — 1911

The training institution for the study of pilots, formed on May 3rd, 1910 in Gatchina, became the first aviation school in Russia and was officially called the Aviation Department of the Officers Aeronautical School (OAS). On July 19, 1914, the Aviation Department became the Military-Aviation School. The first instructors were G.G. Gorshkov, S.A. Ulyanin, and E.V. Rudnev. Moreover, the first private aviation school of S. S. Schetinin was opened in Gatchina, which was called "Gamaiun". Civilians interested in aviation, as well as women, could be taught aviation here. Also in 1911, still another school was founded in Gatchina - the First Russian Association of Aeronauts (FRAA). These schools all shared one airfield, which was the most convenient for the pilots.

On November 11, 1910, the Officers School of Aviation of the Department of the Air Fleet (DAF) was opened in Sevastopol on the Kulikovyi Field. Colonel S.I. Odintsov was appointed the head of the school, and one of the instructors was M.N. Efimov, who was quite famous in Russia. After a year, in November 1911, the first officer-pilots (30 people) graduated. In February 1912, the school moved to a new airfield near the river Kacha and became, thanks to its graduates, world famous under the name Kachinskyi. In May 1916, it was renamed The Sevastopol Aviation School of His Imperial Highness Grand Duke Alexander Mikhailovich. Other aviation schools were also founded elsewhere, such as a school for fighter pilots in Evpatoria and pilot-inspectors in Kiev.

In the Summer of 1911, to make officers from the Moscow Garrison into military aviators, a school of aviation was opened at the Khodunskyi Field (already being used for demonstration flights), which was subordinate to the military committee of the Moscow Society of Aeronauts (MSA). The first flying instructor at the Moscow Aviation School became A.M. Gaber-Vlynskyi. At the same time, by initiatives from aviators B.S. Maslennikov and A.A. Vasiliy, the private aviation school Oryol was opened in Khodynka.

In 1913, the main administration of the Joint Staff, in connection with an increased need for pilots, approved the creation of four private schools: the IPAC (Imperial Pan-Russian Aeroclub); the OAC (Odessa Aeroclub); the MSA (Moscow Society of Aeronauts), and the TSA (Turkestan Society of Aeronauts). At the beginning of the war, still one more private aviation school opened in Odessa, financed by banker A.A. Anatr. But the war demanded changes in the educational system in private and aeroclub aviation schools, and as a result they were militarized and reorganized to prepare flying cadres for the military air fleet.

Many graduates of the Russian aviation schools distinguished themselves in the beginning of World War I, and their names became famous in the history of Russian aviation.

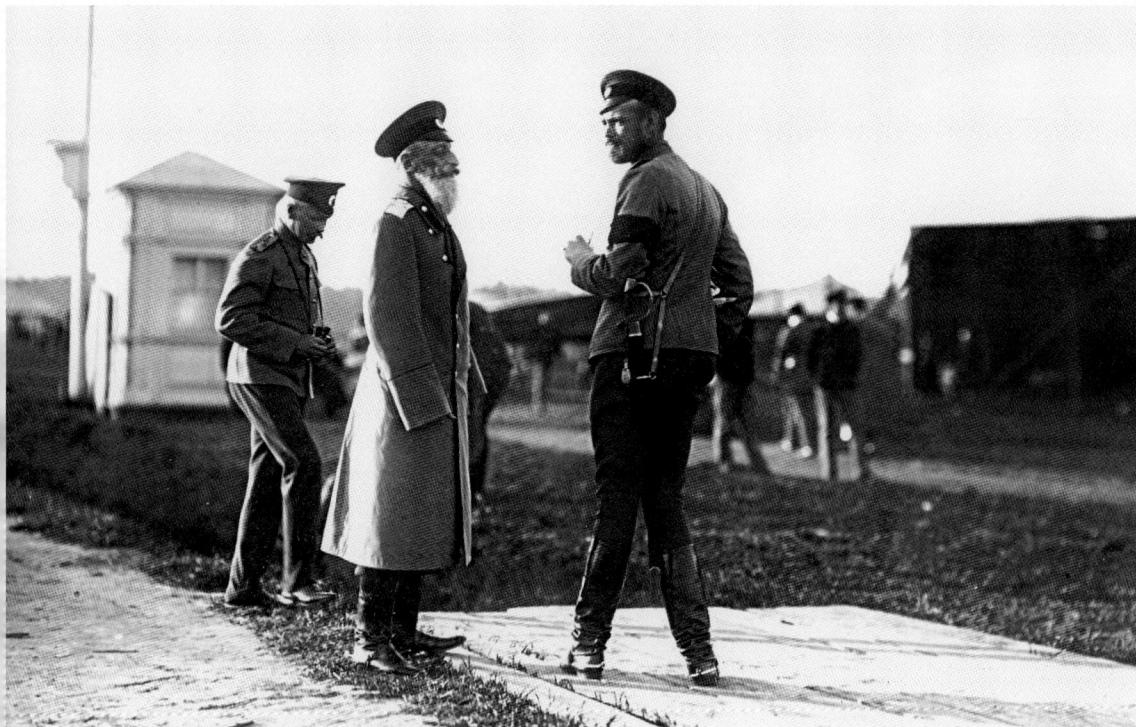

**126. General Major A. M. Kovanko
converses with Grand Duke
Sergei Mikhailovich, an honorary
member of IPAC.**

Komendantskyi Airfield. September 8, 1910

**127. Members of the Pan-Russian
Aeroclub. In the center is President
of the Aeroclub Count I.V. Stenbok-
Fermor. On his left is the head of
the aviation school IPAC Lieutenant
N.A. Yatsuk. In the cabin of the
Farman is Lieutenant S.A. Mezentsev.**

St. Petersburg. 1913

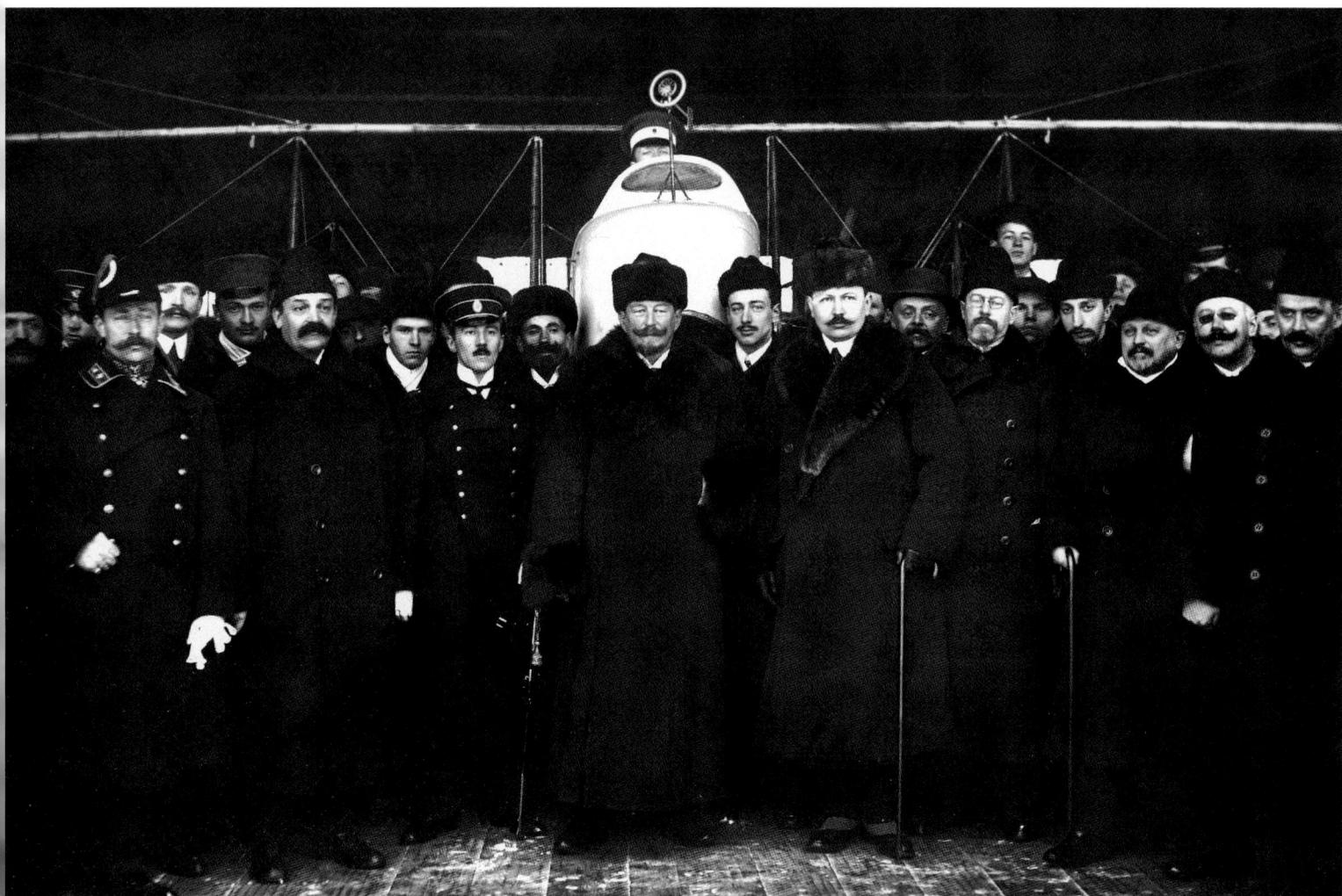

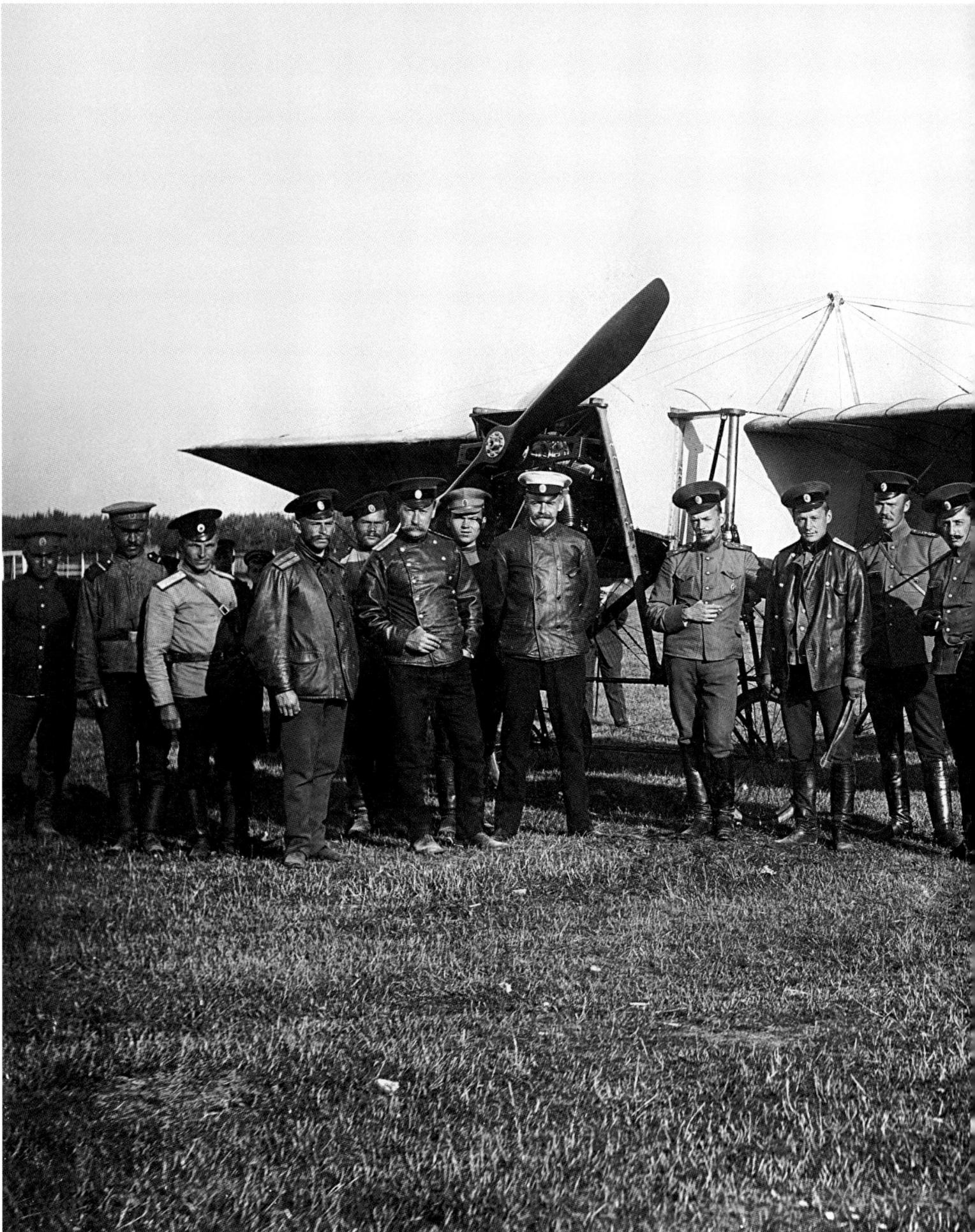

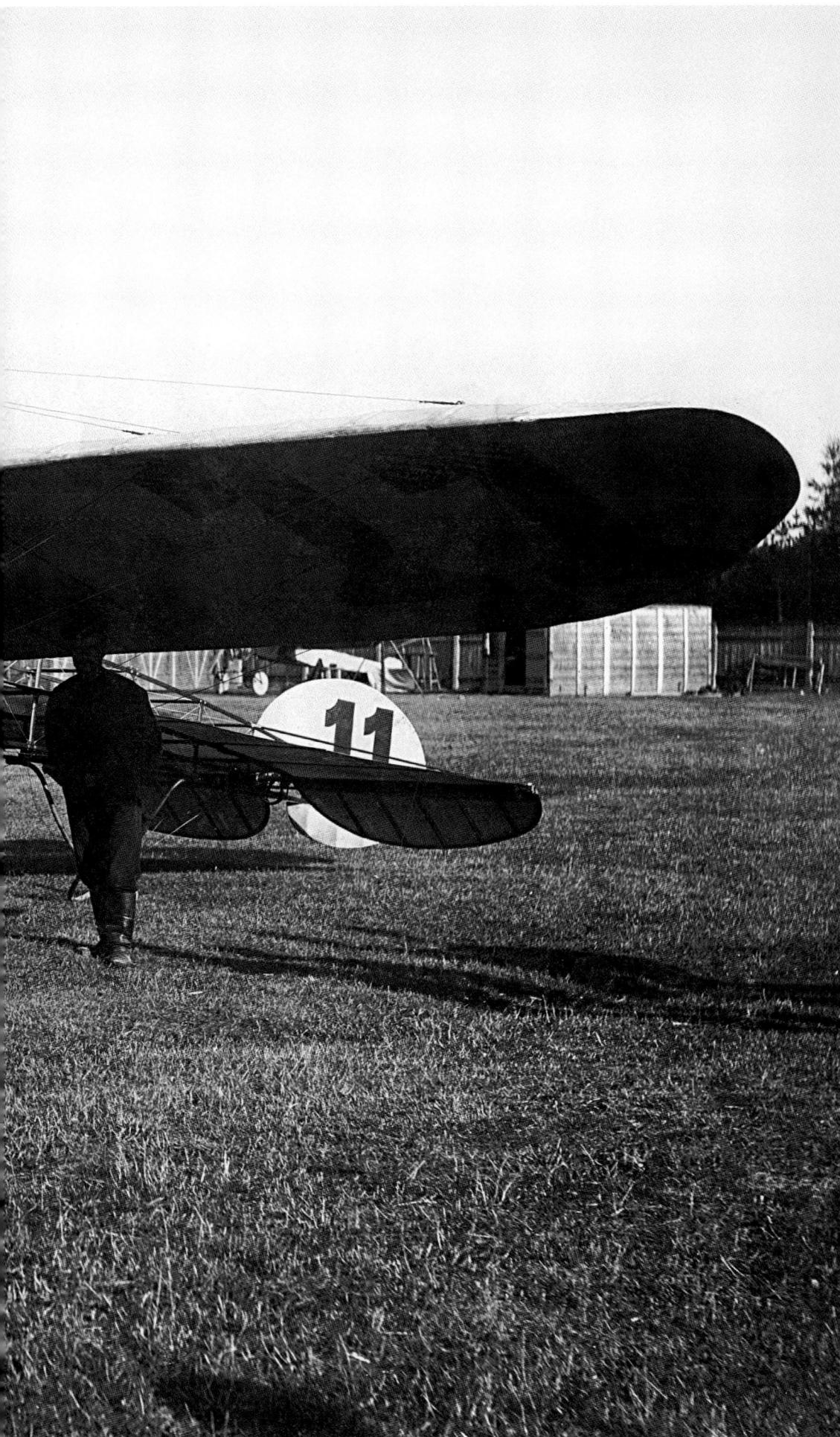

128. In 1911, the first flights at the Komendantskyi Airfield were done by the planes and aviators of the Sevastopol School. Trainees of the Aviation Department of the OAS and officer-gunners from the Novogeorgievskyi Fortress stand near the plane *Blerio XI*. Lieutenant of the Second Fleet Crew Baron G.O. Buksgevden stands in the center wearing a cap with a white covering. To his right are Lieutenant of the Novogeorgievskyi Fortress gunner Buikov (?), the pilot of the *Blerio*, and Lieutenant of the 11th Aeronautical Company V.A. Soloviev.
St. Petersburg. 1911

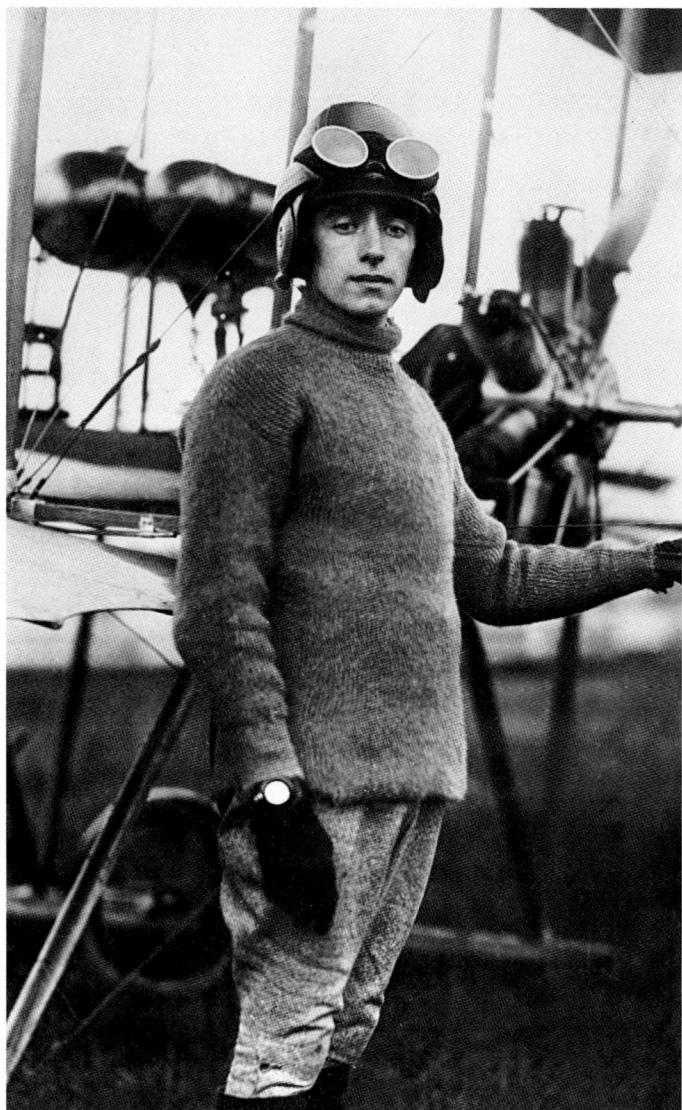

129. A pilot next to the plane
Farman IV.
Aviation School of the Pan-Russian Aeroclub.
St. Petersburg. 1911 — 1913

130. Panorama photo. In front of the *Farman IV* are graduates of the School of the Imperial Pan-Russian Aeroclub and students of the Aviation Department of the OAS. Pilots G.P. Adler and N.A. Yatsuk are in the plane.
Gatchina. 1913

**131. Grand Duke Alexander
Mikhailovich (in the center in the white
jacket) at the Sevastopol School of
the DAF. On his left is the head of the
school, I.S. Odintsov, and second to the
right of him in a cap is an instructor of
the aviation school M.N. Efimov.**
May 19, 1912

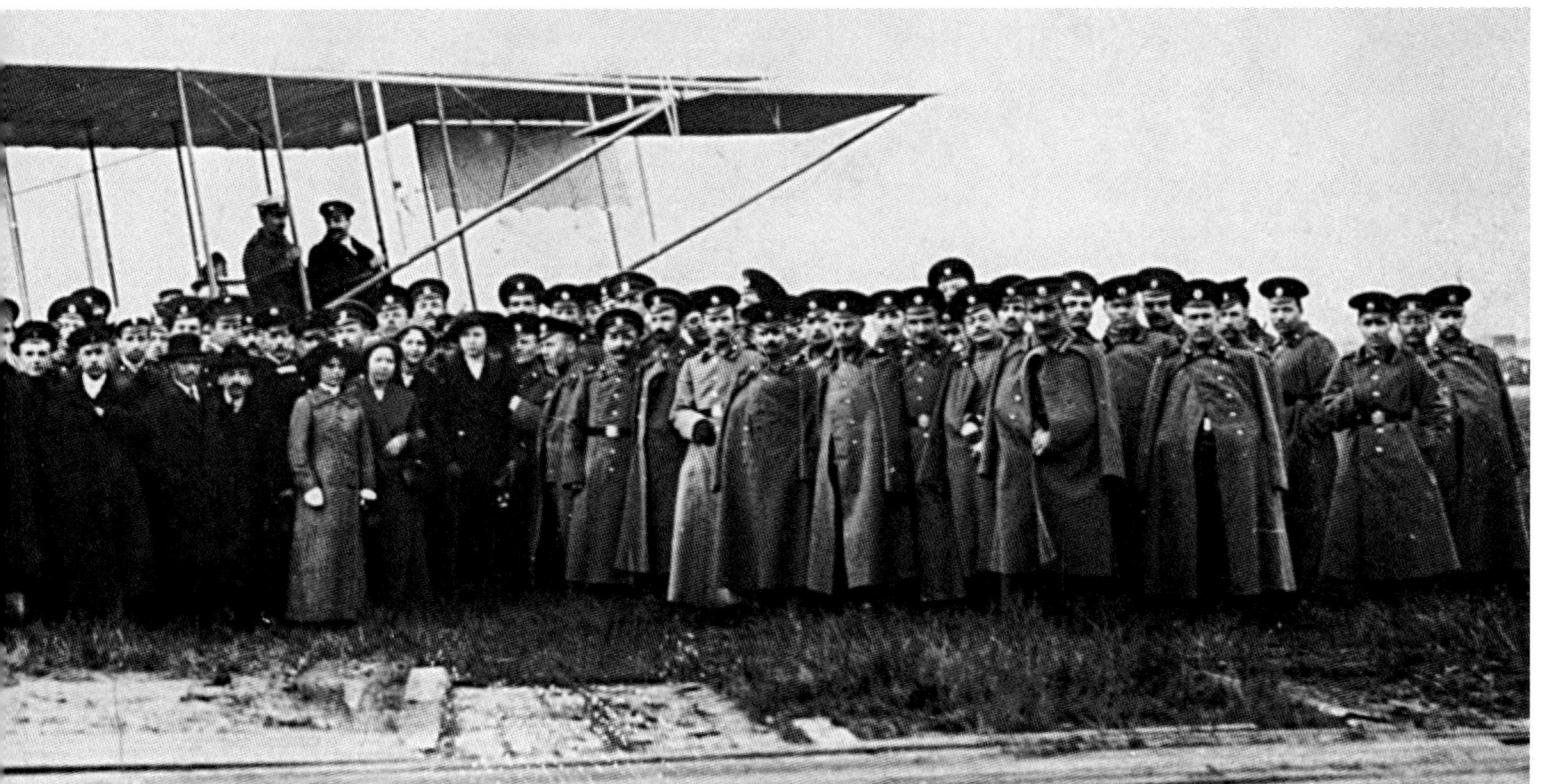

132

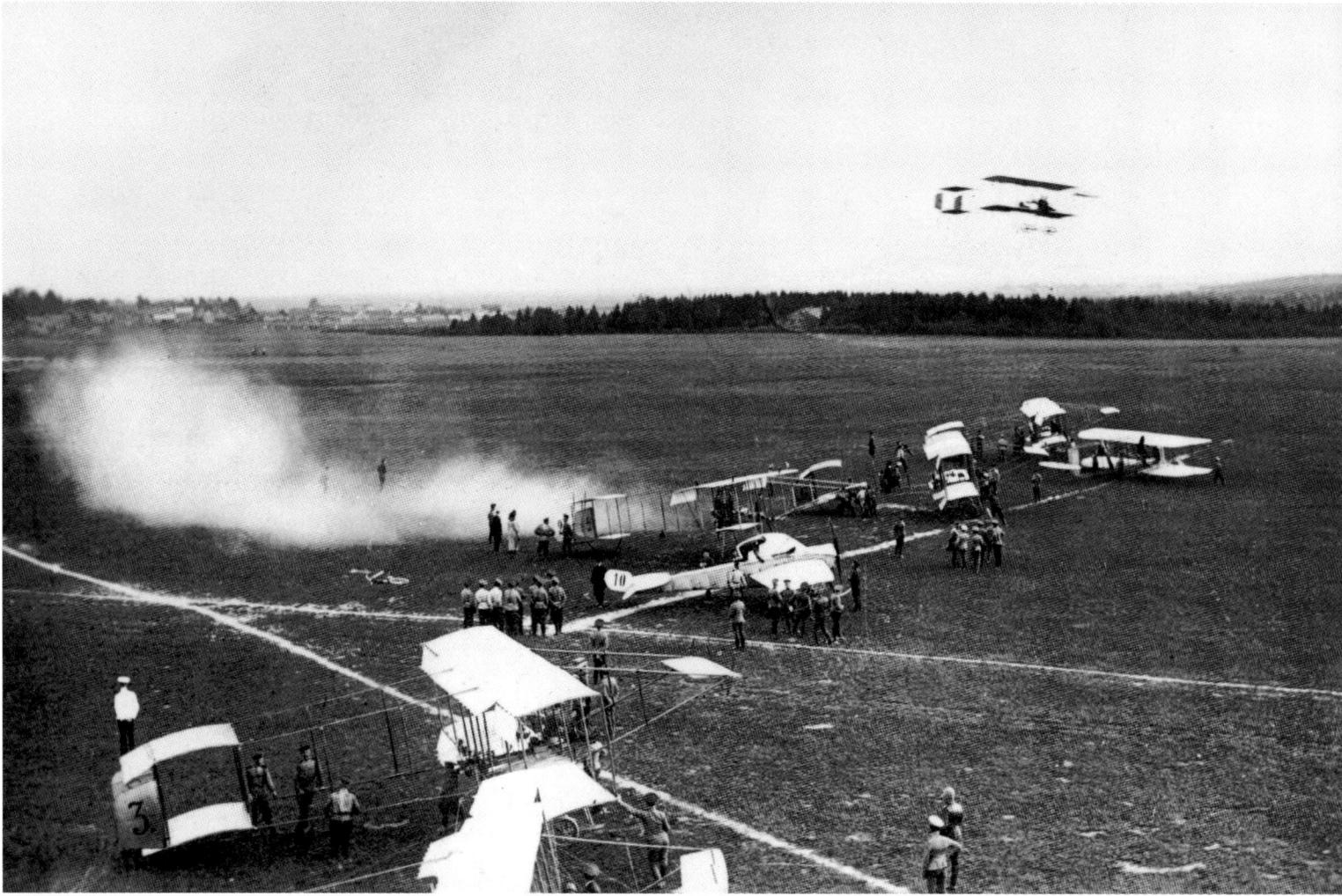

133

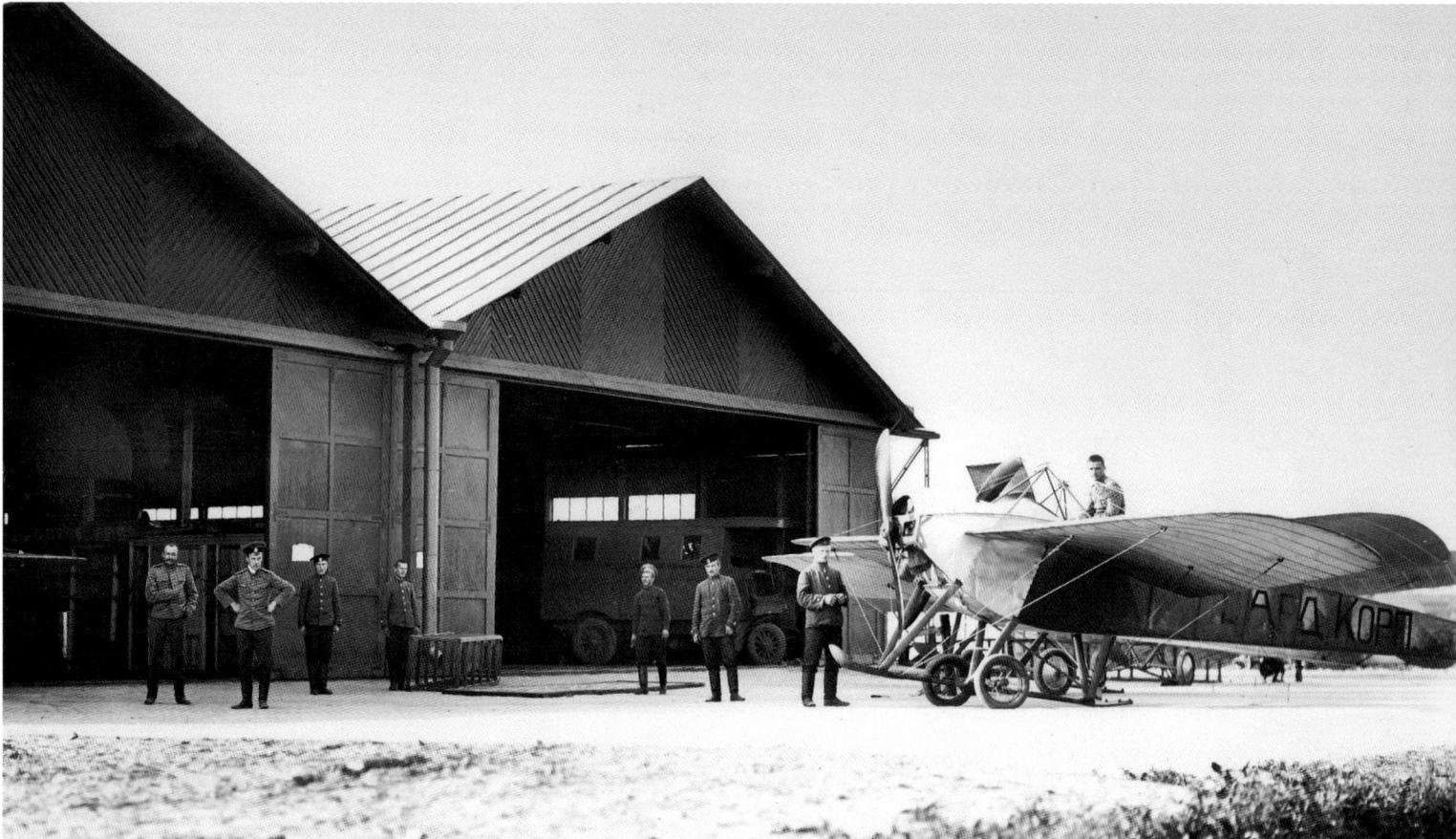

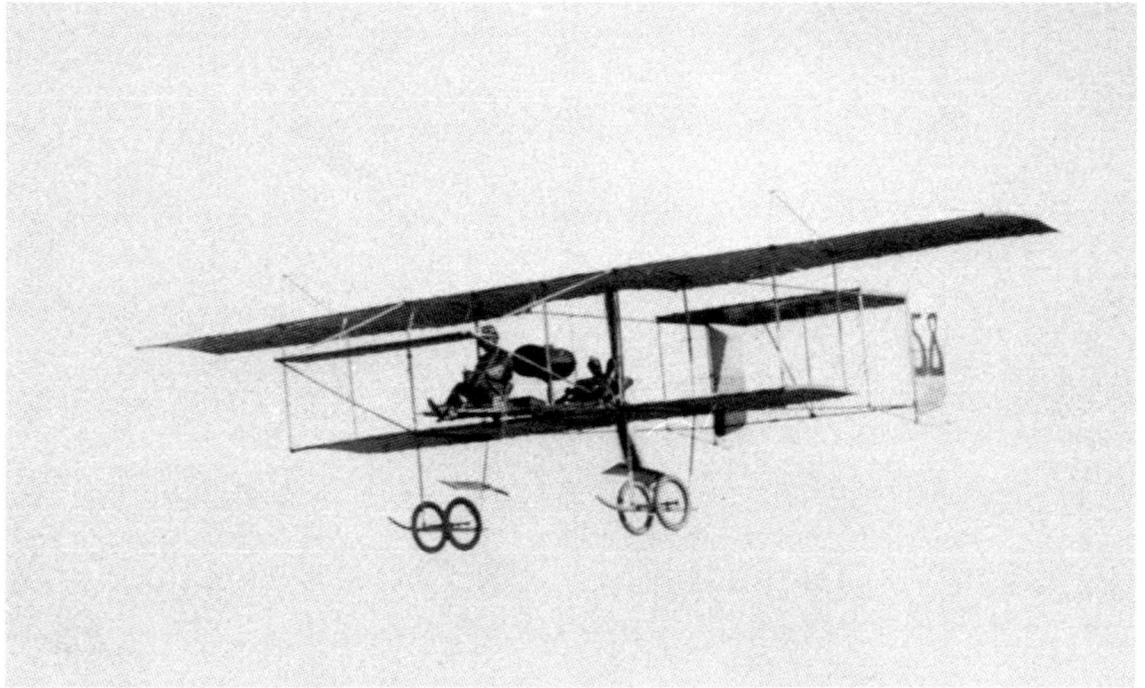

134

132. The airplane *Farman IV* on a flight.
Gatchina Airfield. 1912 — 1913

133. *Niupor IV* airplanes of the First Aviation Company near hangars.
Korpusnyi Airfield. St. Petersburg. 1913

134. One of the planes built in Russia - the *Farman VII* - as it lands after a demonstration flight.
Gatchina. 1910 — 1912

135. View from the heights of the Summer Field.
Gatchina Aviation School. 1910 — 1912

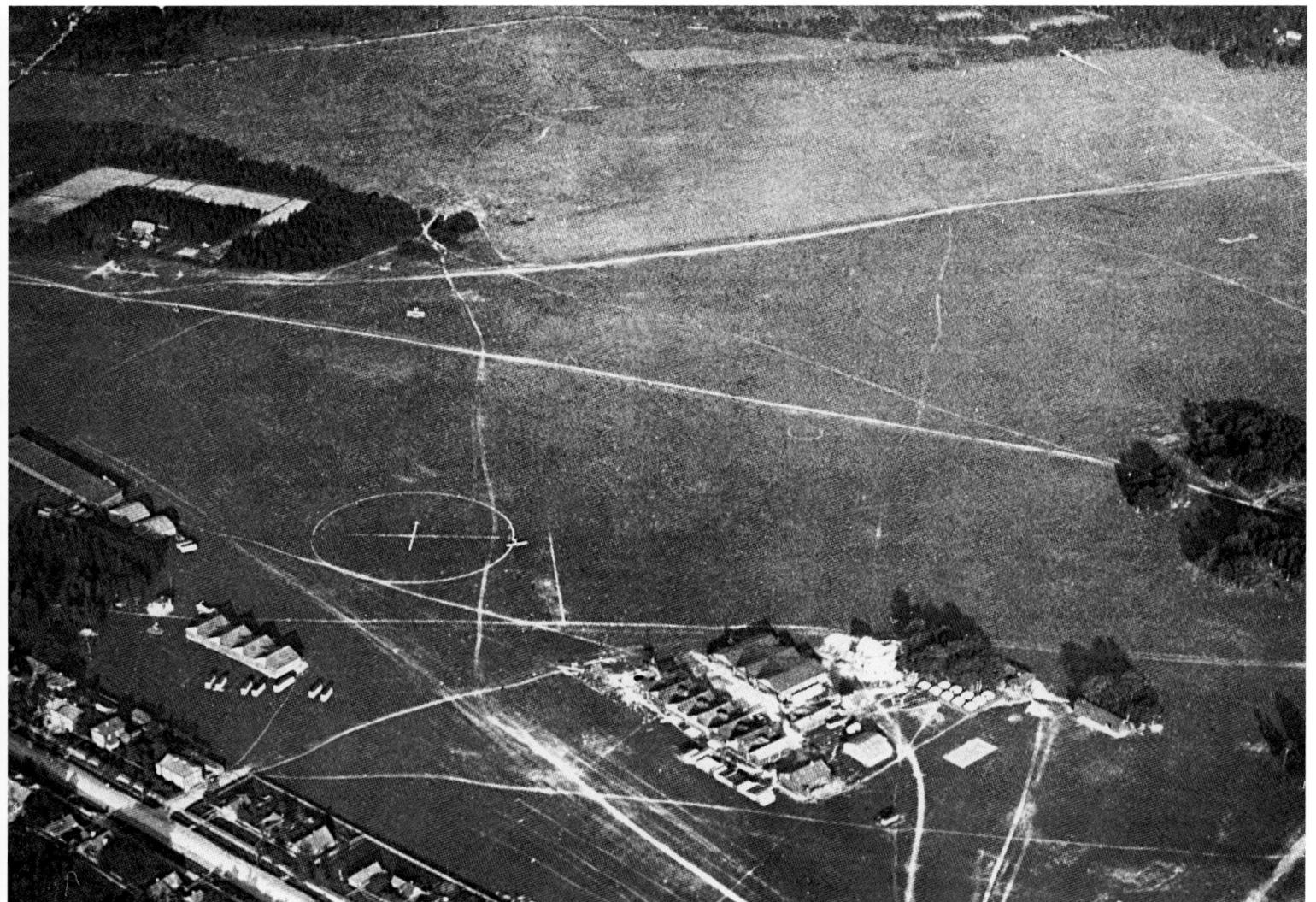

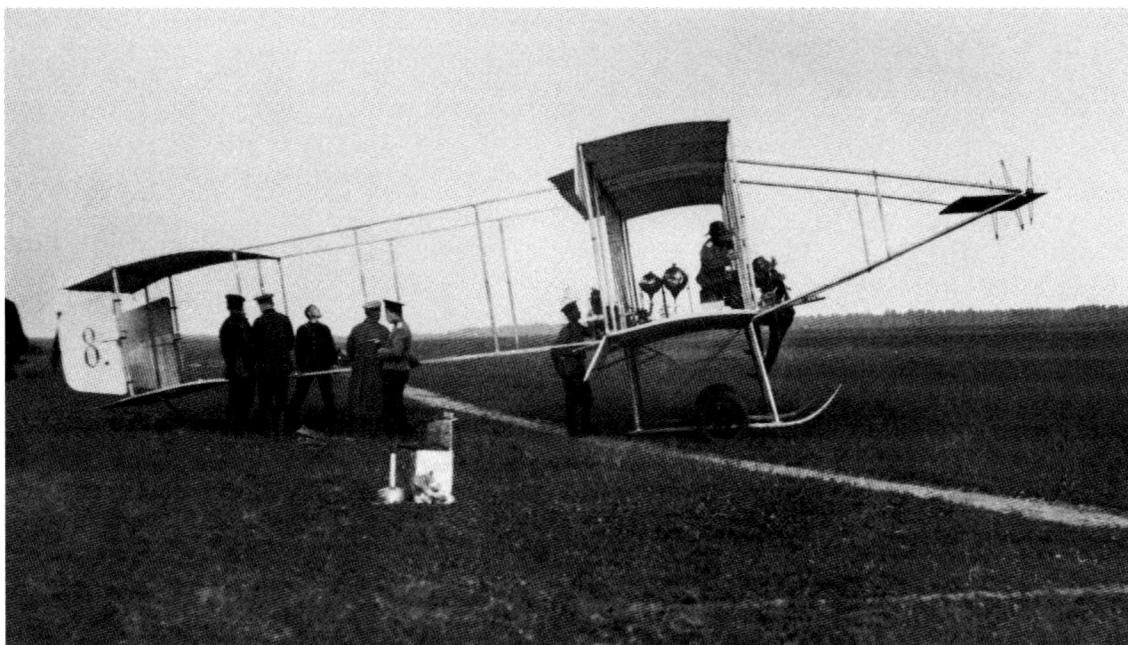

136. The *Farman IV*, the most popular training plane.

Gatchina. 1910 – 1912

The plane was built in Russia in 1910. After being modernized, it was renamed the Farman-Shinkova *and* Farman-Velikyi Novgorod, *among others.*

137. Training airplanes of the Aviation Department of the OAS.

Gatchina. 1912 – 1913

138. Instructor G.G. Gorshkov with passenger-officer on the *Farman IV* before a demonstration flight.

Gatchina. 1912

139. N.N. Danilevskyi, an instructor of the Aviation Department of the OAS, on a plane. His relatives and loved ones stand nearby.

Gatchina. 1913

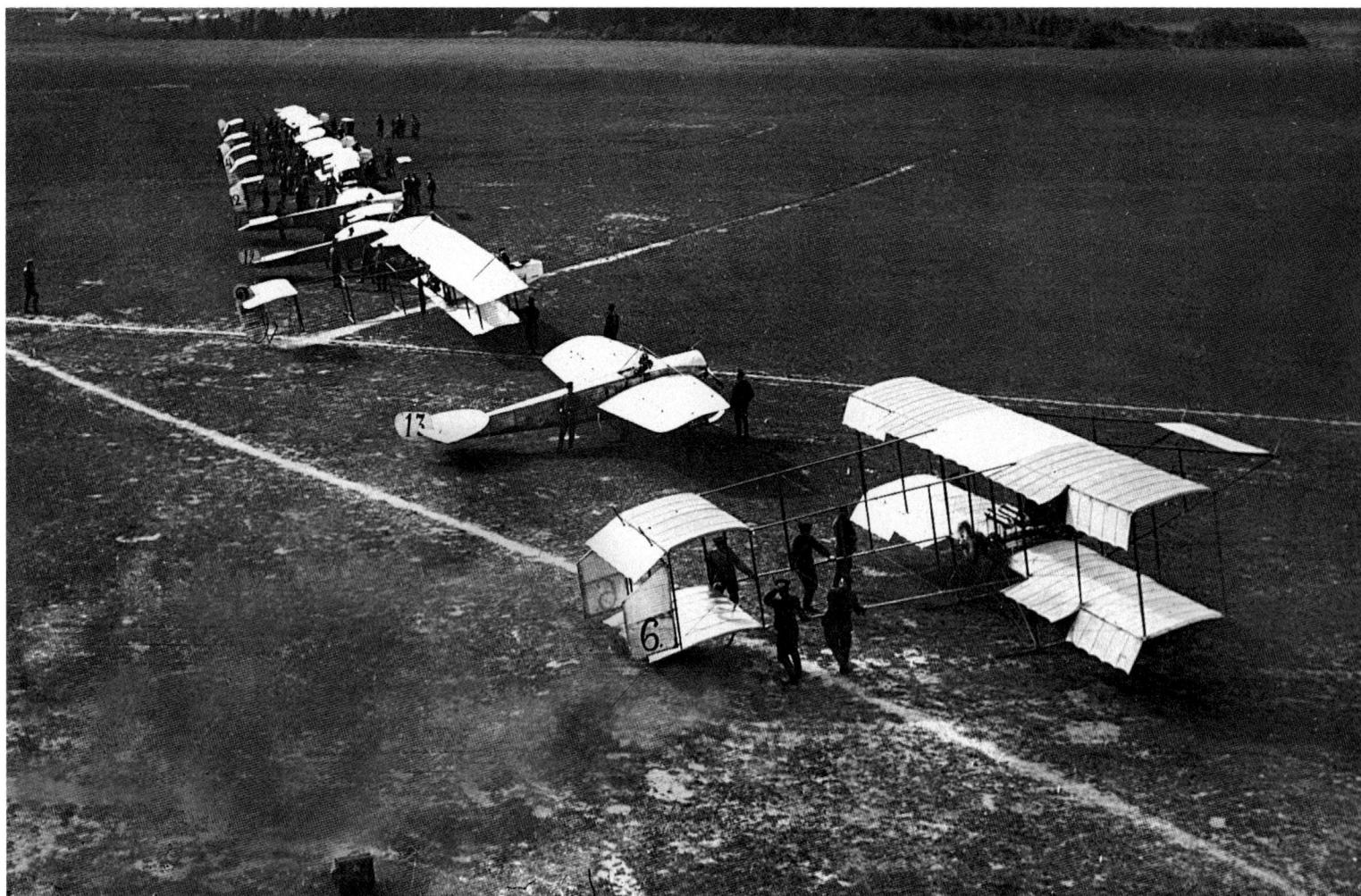

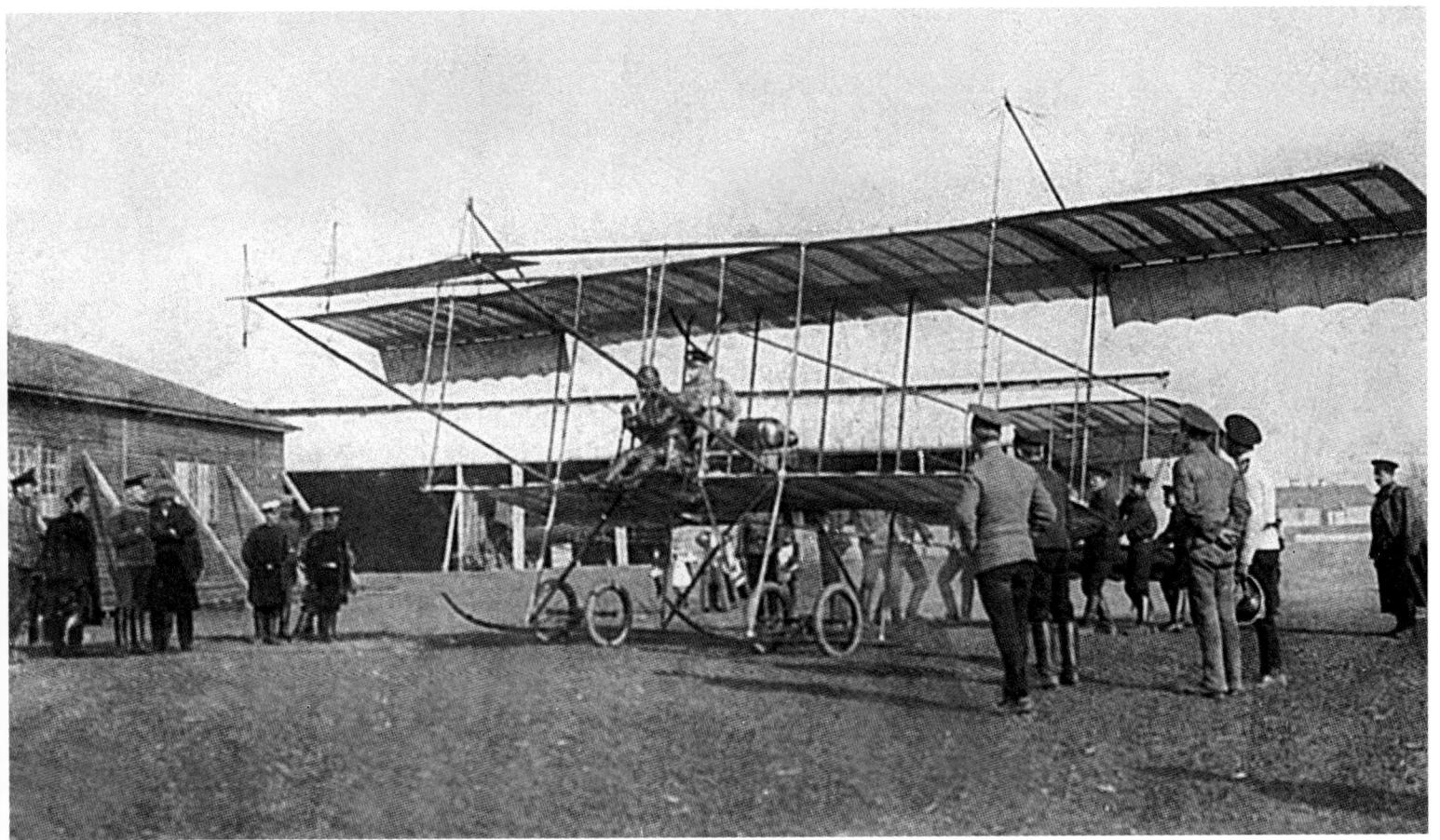

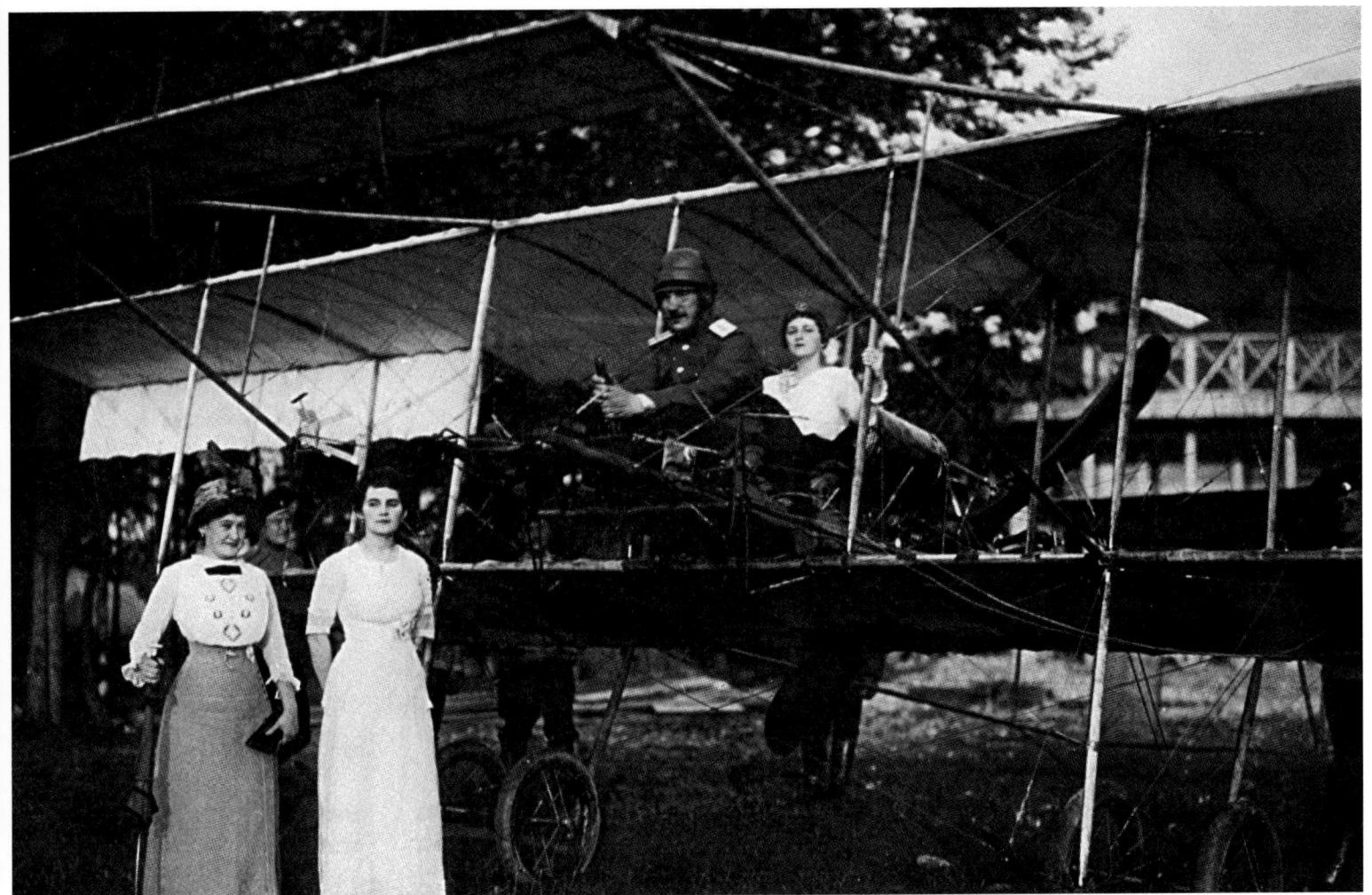

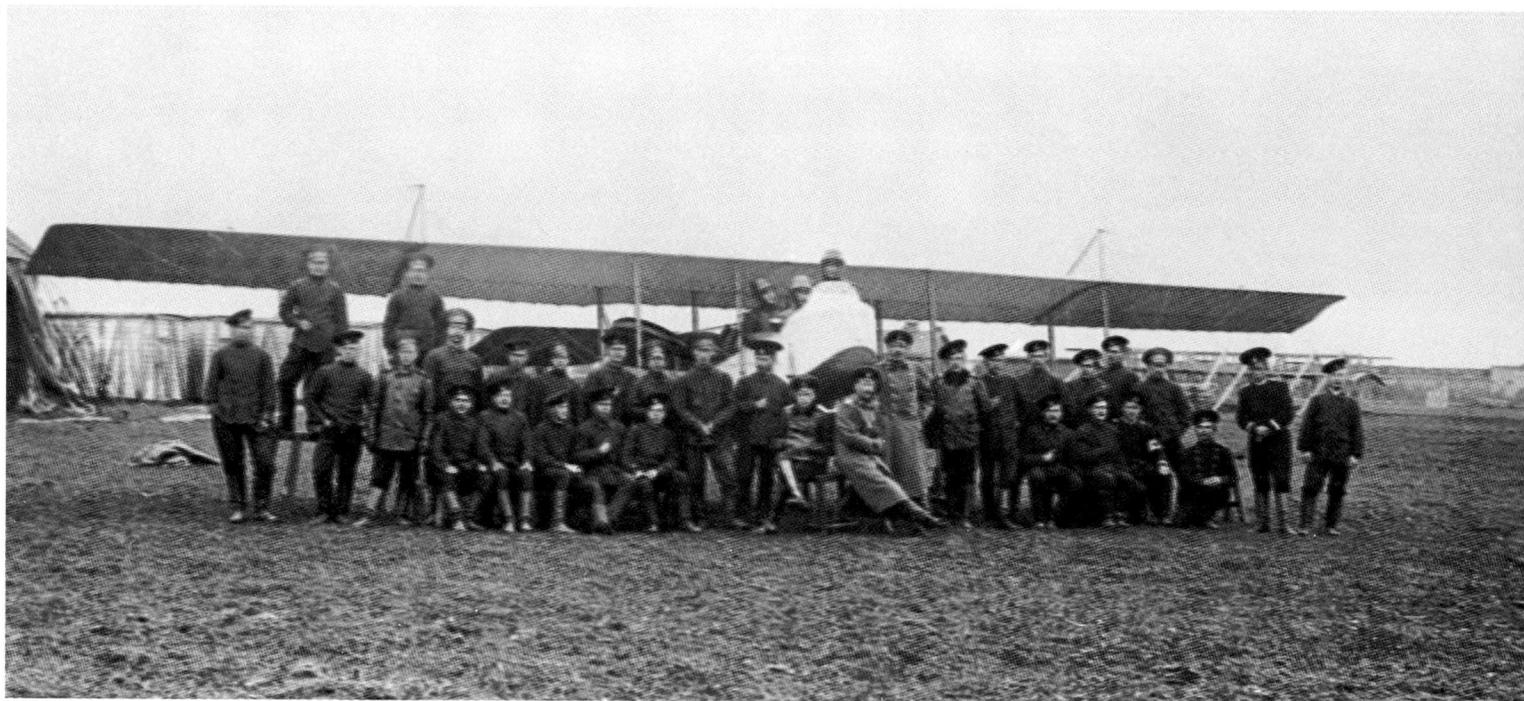

140. Aviators and mechanics near one of the *Farman XVI* **training airplanes of the Novogeorgievskyi Fortress Squadron.**
Maneuvers near Lublin. 1913

141. Military pilot trainees near the plane *Farman VII*. **Sitting second from the right is aviator-trainee V.G. Baranov, and standing is instructor N.N. Danilevskyi.**
Gatchina. 1911

142. Graduate of the IPAC school pilot L.A. Dunaev near the plane *Farman IV*.
St. Petersburg. June 29, 1913

143. The plane *Farman IV*, **also called** *Training*.
1911 – 1916

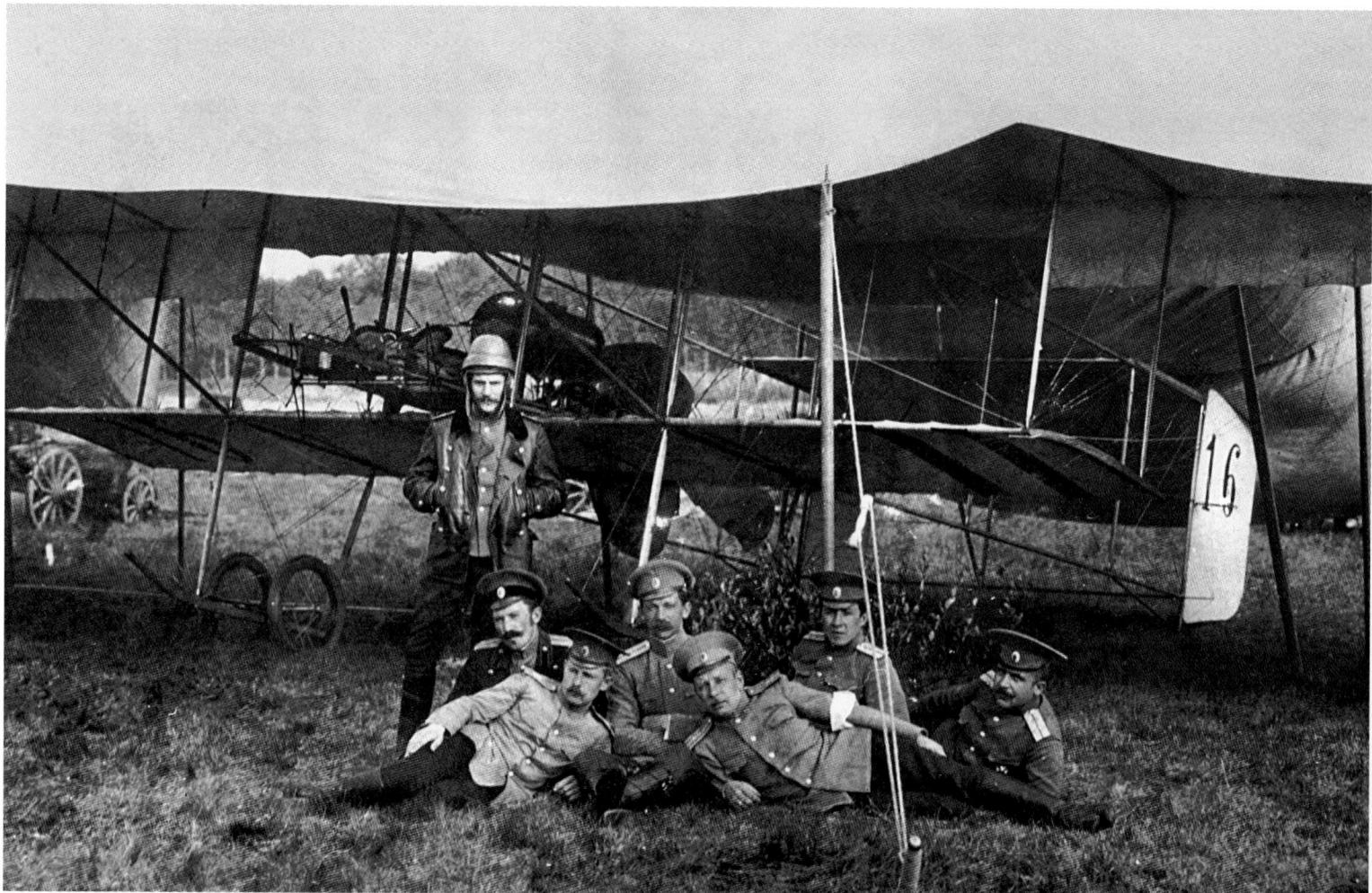

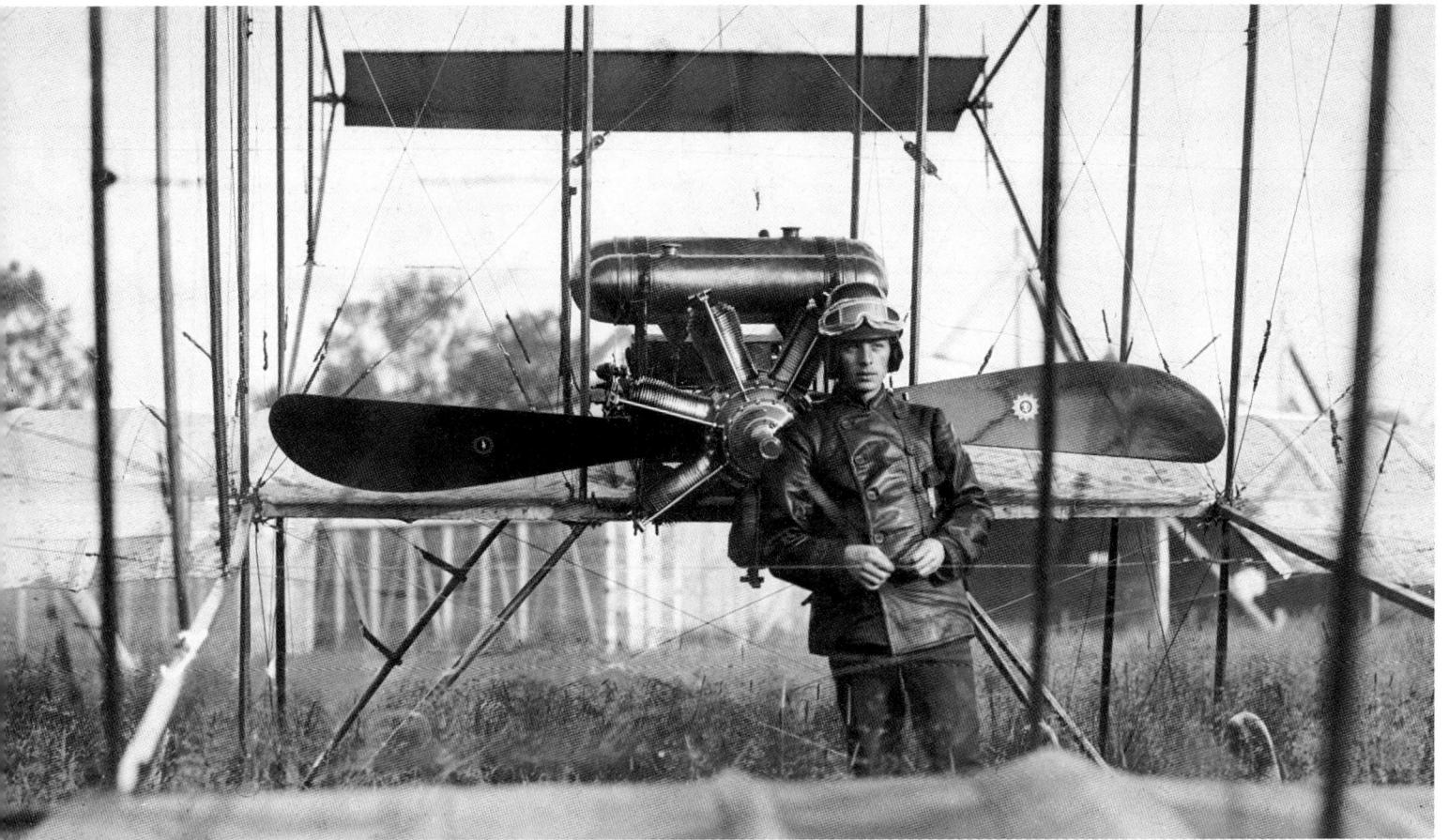

144. Instructor-pilot V.V. Sliusarenko with an officer of the Joint Staff on a fact-finding flight on the training plane *Farman IV*.
Gatchina. 1913—1914

145. Panorama taken from the training plane *Farman*. **The view is from the tail end of the plane.**
1912—1913

146. An aviator-trainee on the *Farman IV* **makes an independent flight.**
Gatchina. 1913

147. Summer training of military pilots.
Gatchina. 1913

145

Russian Imperial Air Force

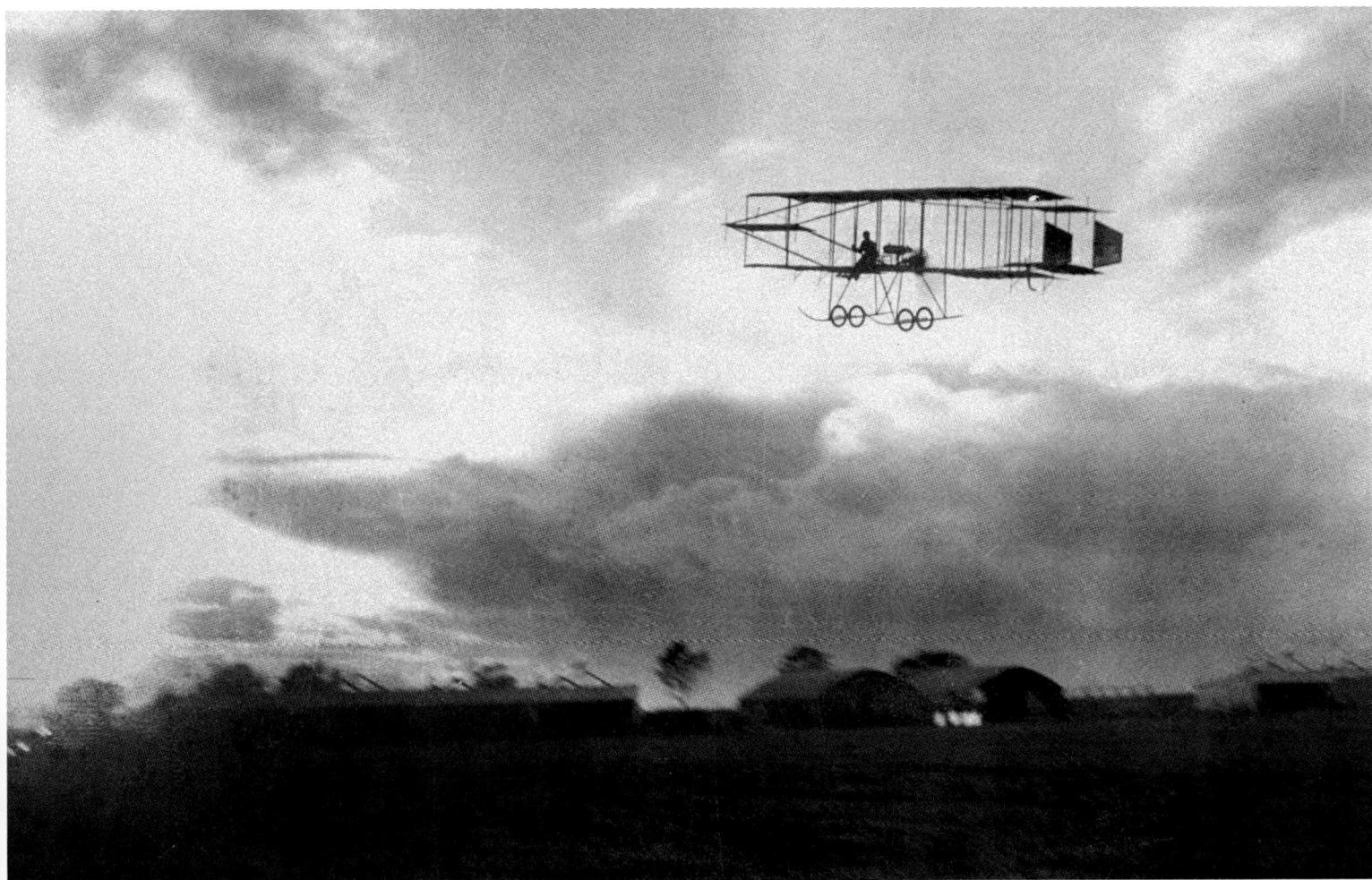

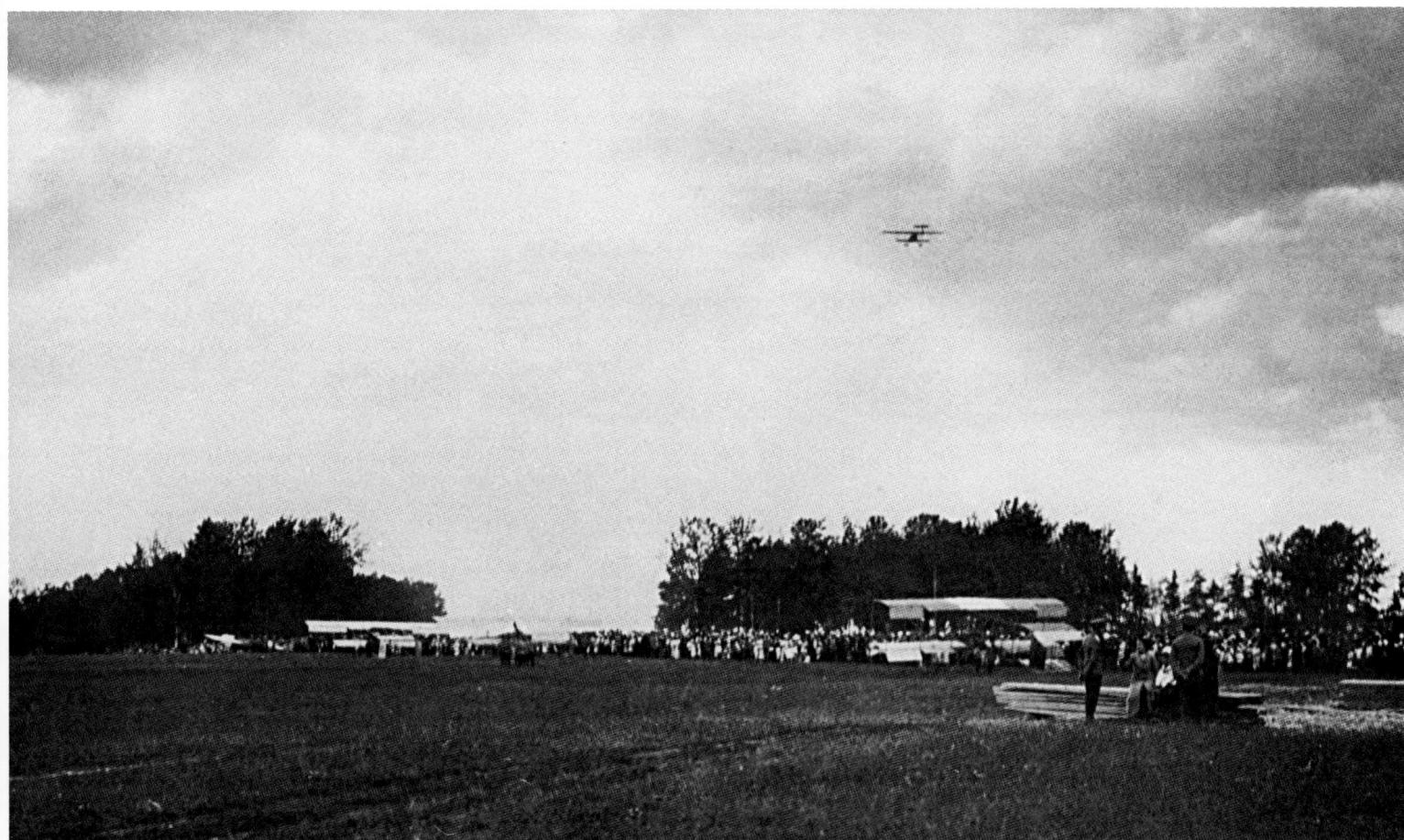

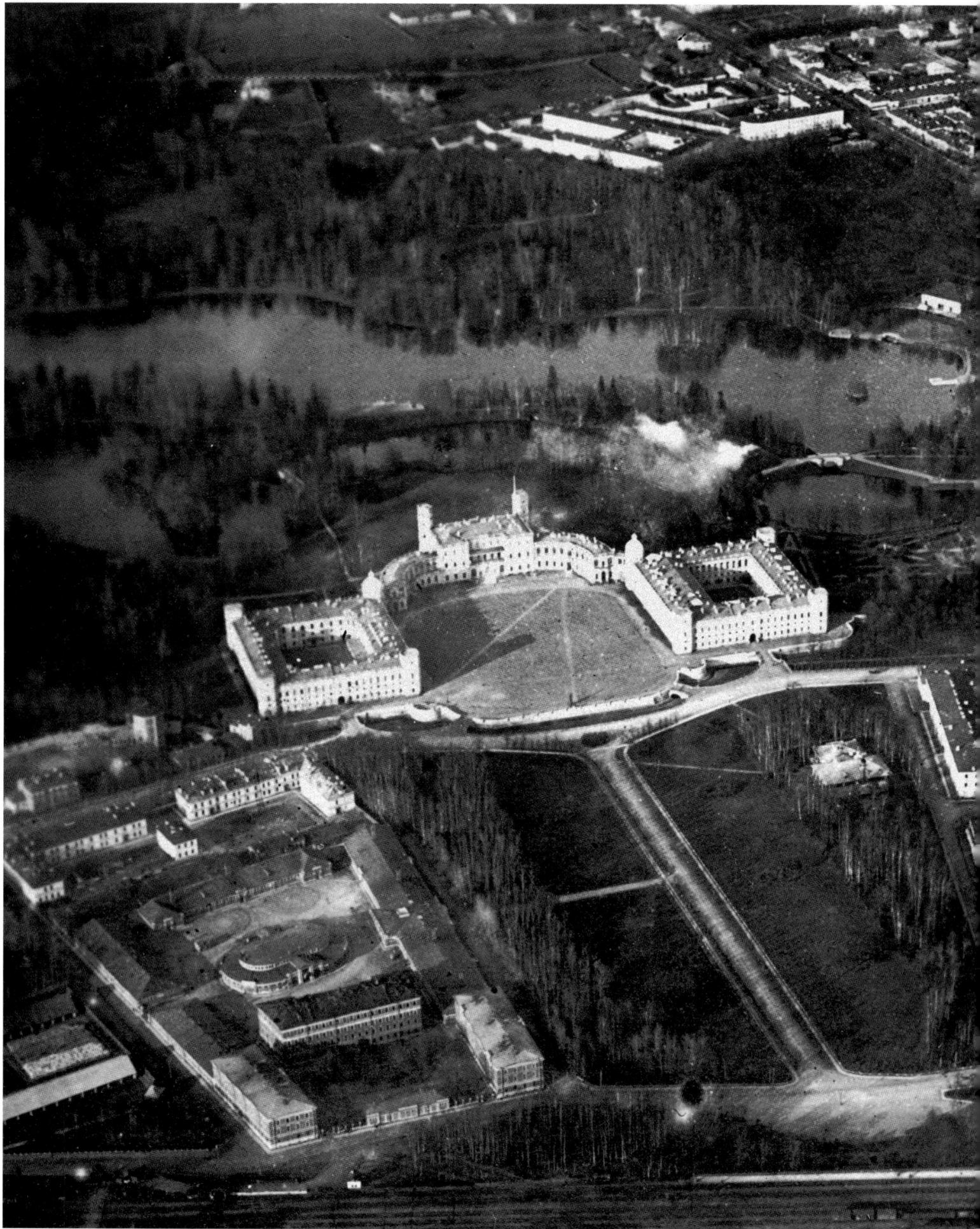

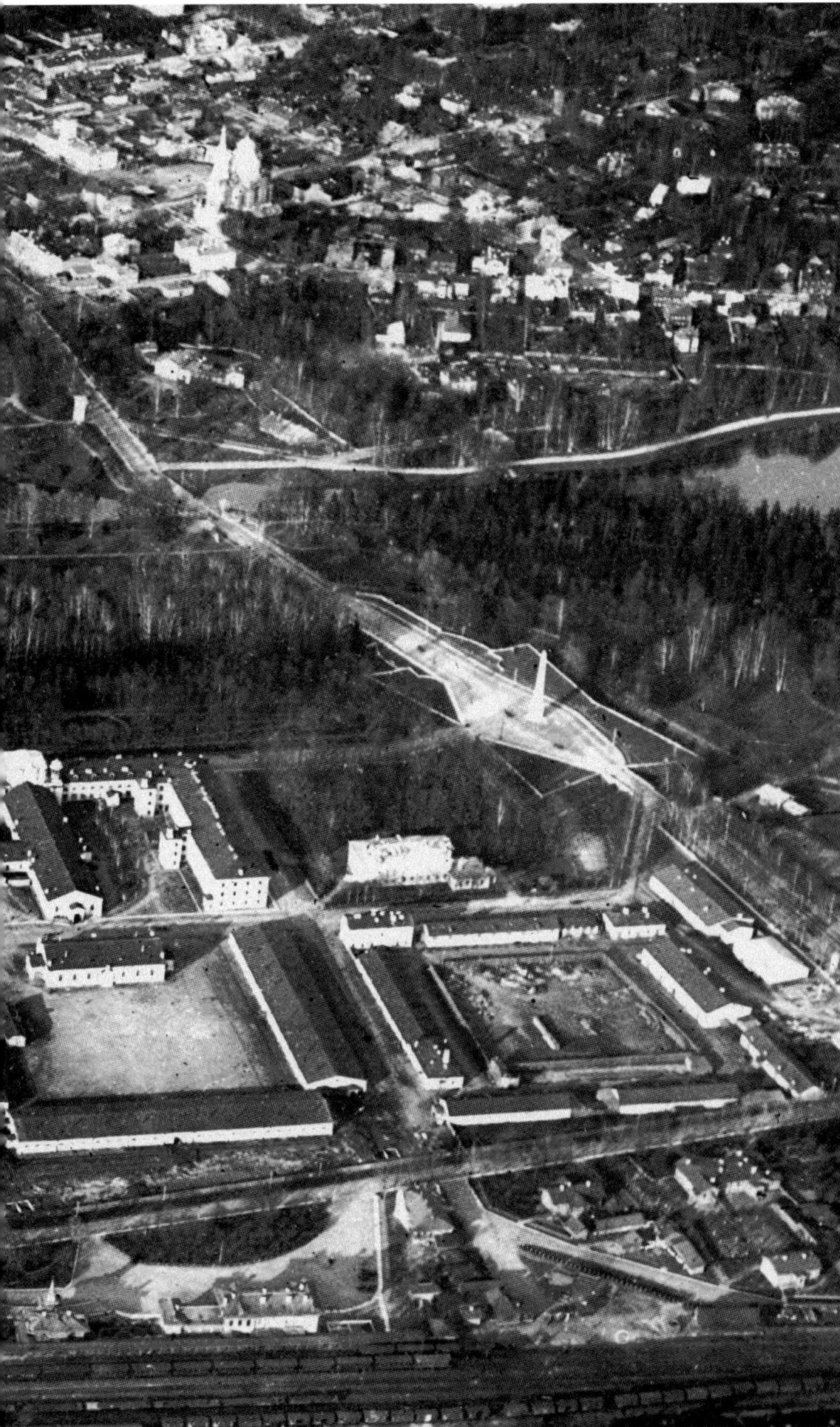

148. View of the Gatchina Palace.
1912
The photo was done by the aviator P.N. Nesterov, flying the two-seater Blerio *with movie camera operator V.P. Dobrzhanskyi.*

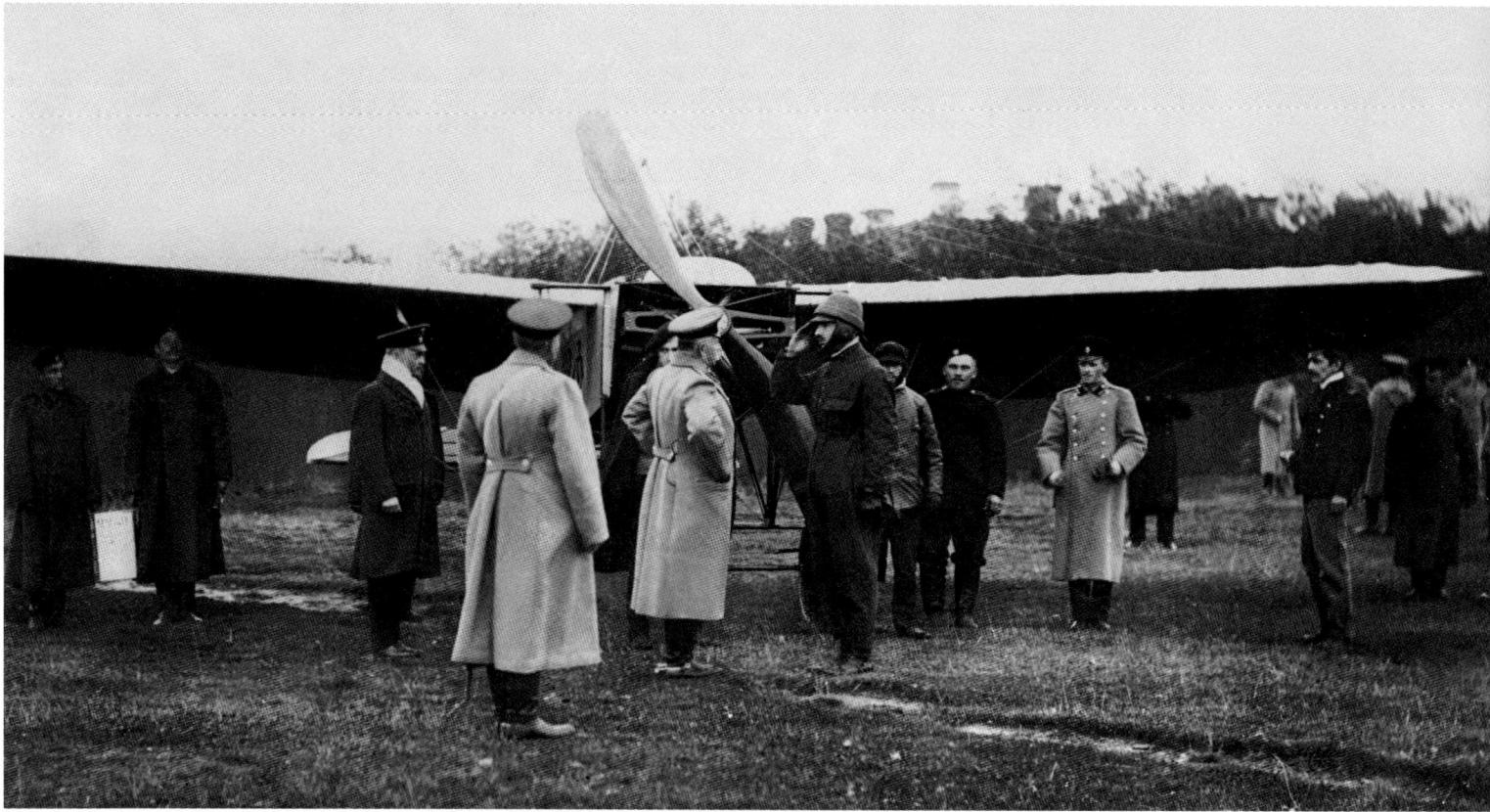

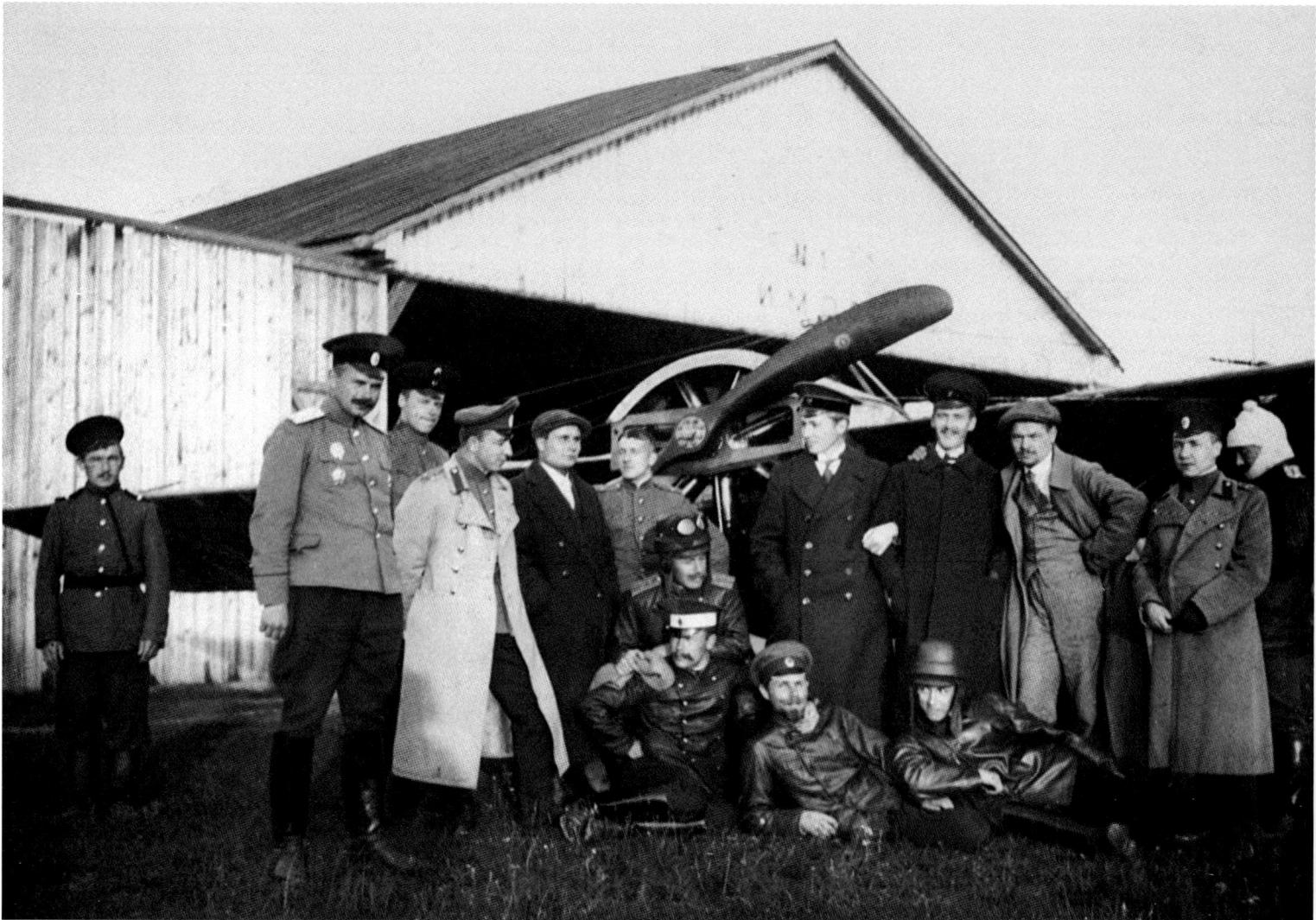

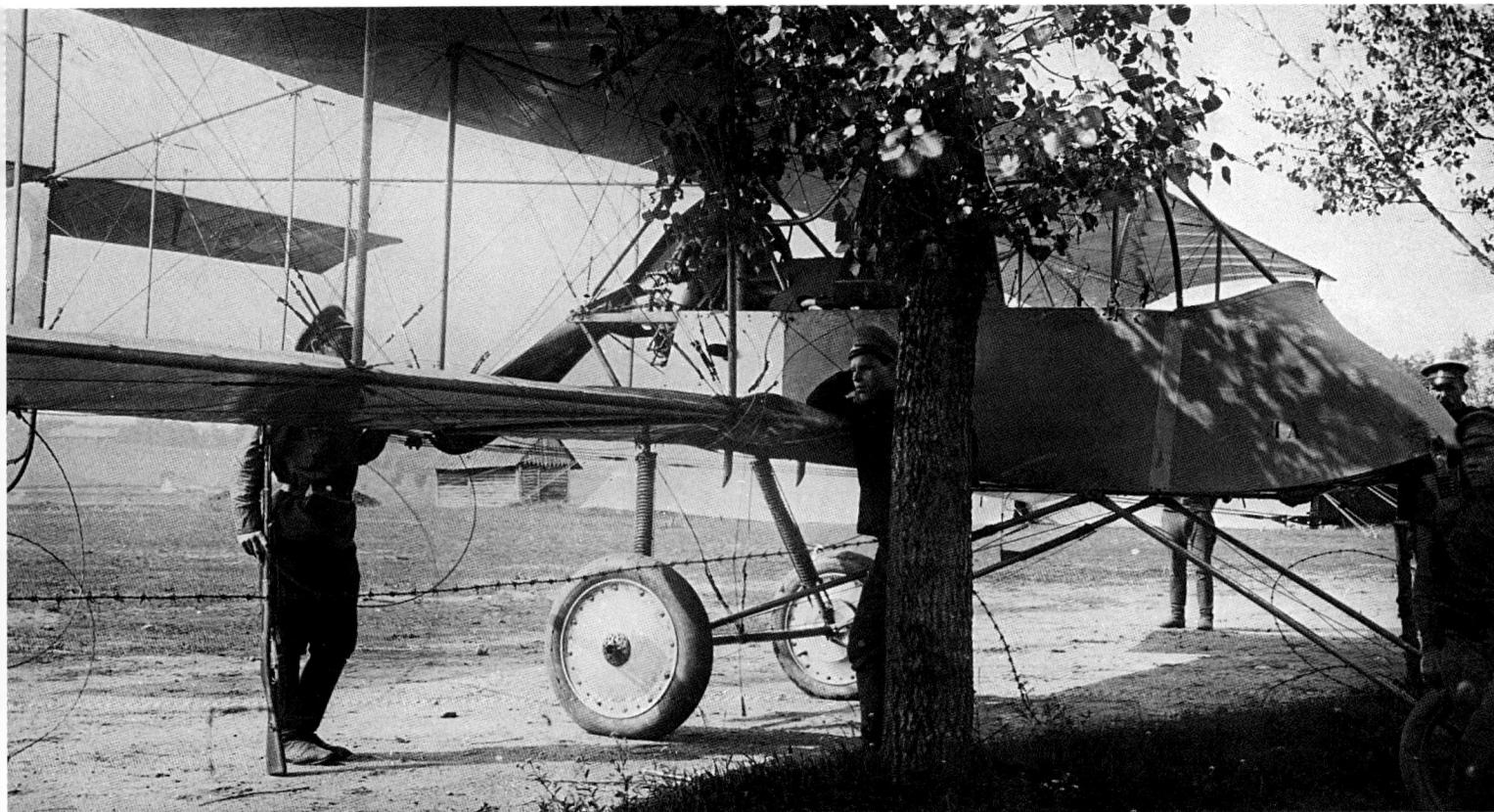

149. General A.V. Kaulbars takes a report from pilot-lieutenant S.A. Mezentsev about a flight done on the *Blerio*.
1913

150. Instructors and pilots of the IPAC near the *Niupor IV*.
Standing second from the right is T.N. Efimov, and laying second from right is I.S. Bashko.
Komendantskyi Airfield. St. Petersburg. 1914

151. Inspection of the *Vuazen* **after a crash landing.**
Gatchina. 1915

152. Mechanics of the Brest-Litovskyi Fortress Squadron near the training plane *Farman VII*.
Gatchina. 1913—1914
The model, also called Military, *was modified by Russian designers and manufactured at the aviation factory* Dukes *in Moscow.*

152

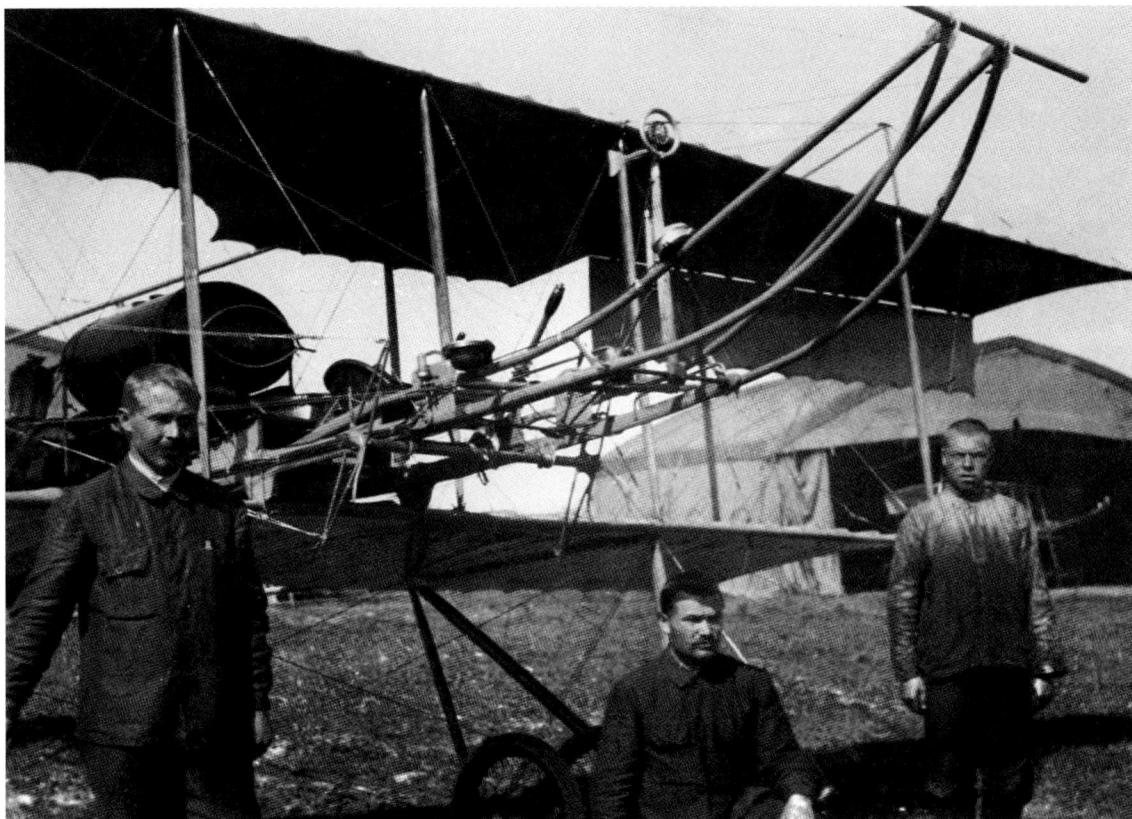

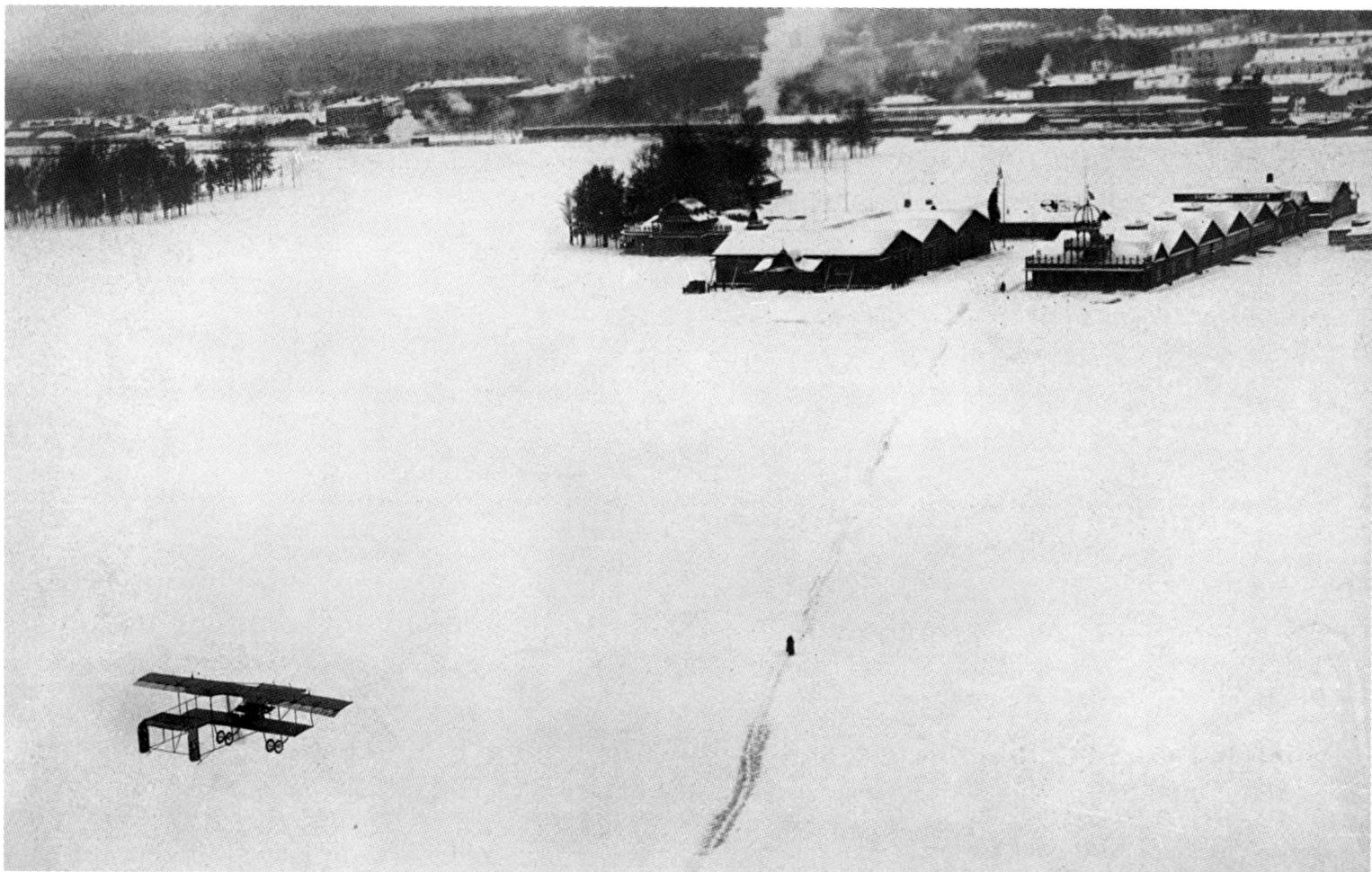

153. The airplane *Farman VII* **goes in for a landing.**
Gatchina. 1912

154. An aviator and mechanics in winter uniforms near the airplane *Farman IV.*
Korpusnoi Airfield. St. Petersburg. 1913 – 1914

Aviation schools also had a class in winter conditions. The pilots had winter apparel, and the planes were placed on skis.

155. *Farman XVI* **taking off.**
Gatchina Aviation School. 1915

156. *Farman VII* **from the Brest-Litovskyi Fortress Squadron on military maneuvers.**
Near Lublin. 1913

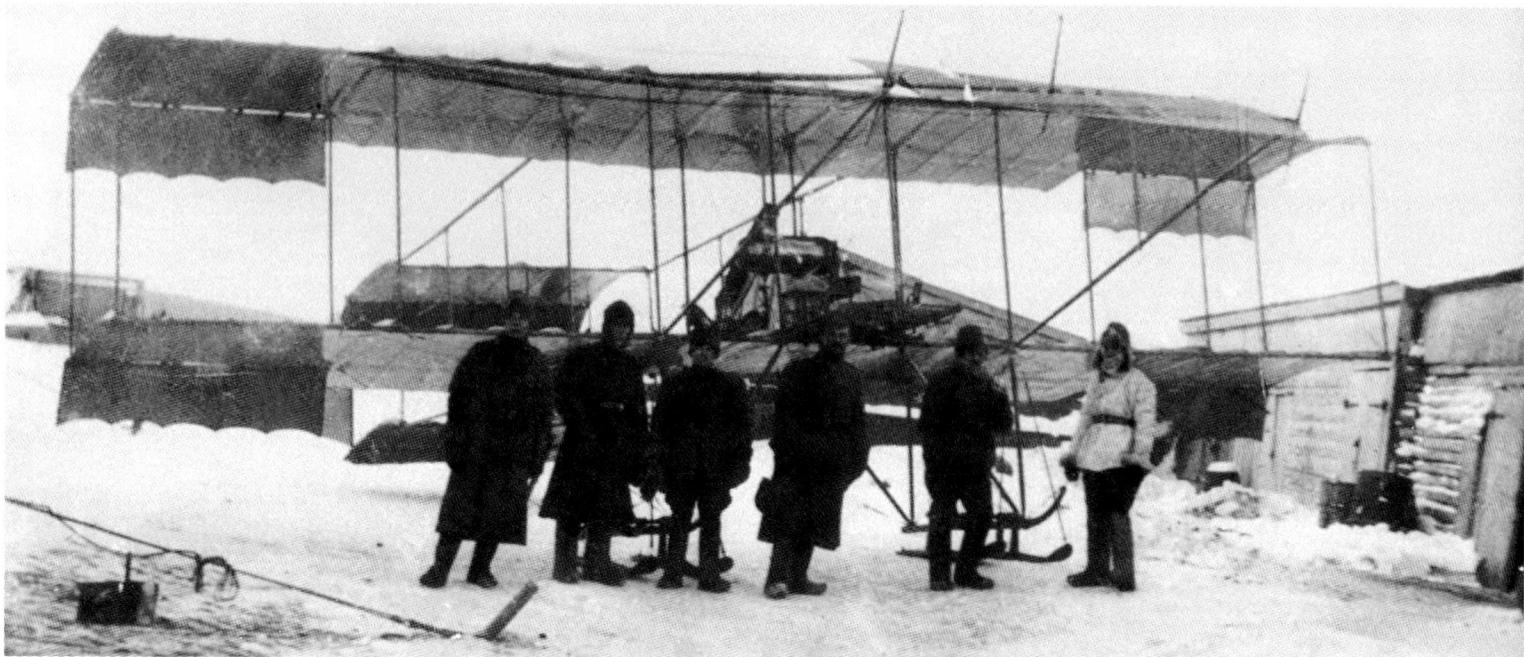

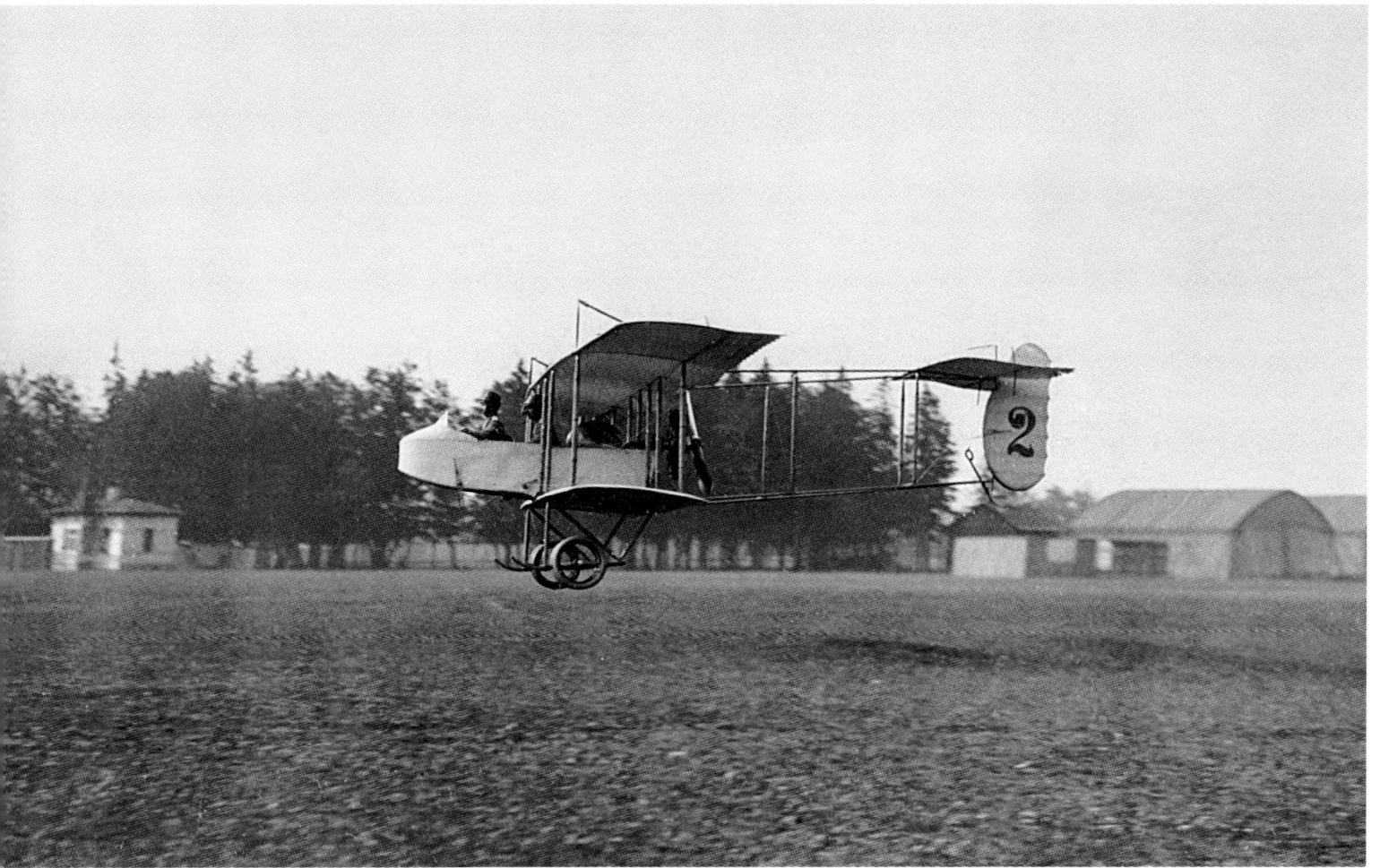

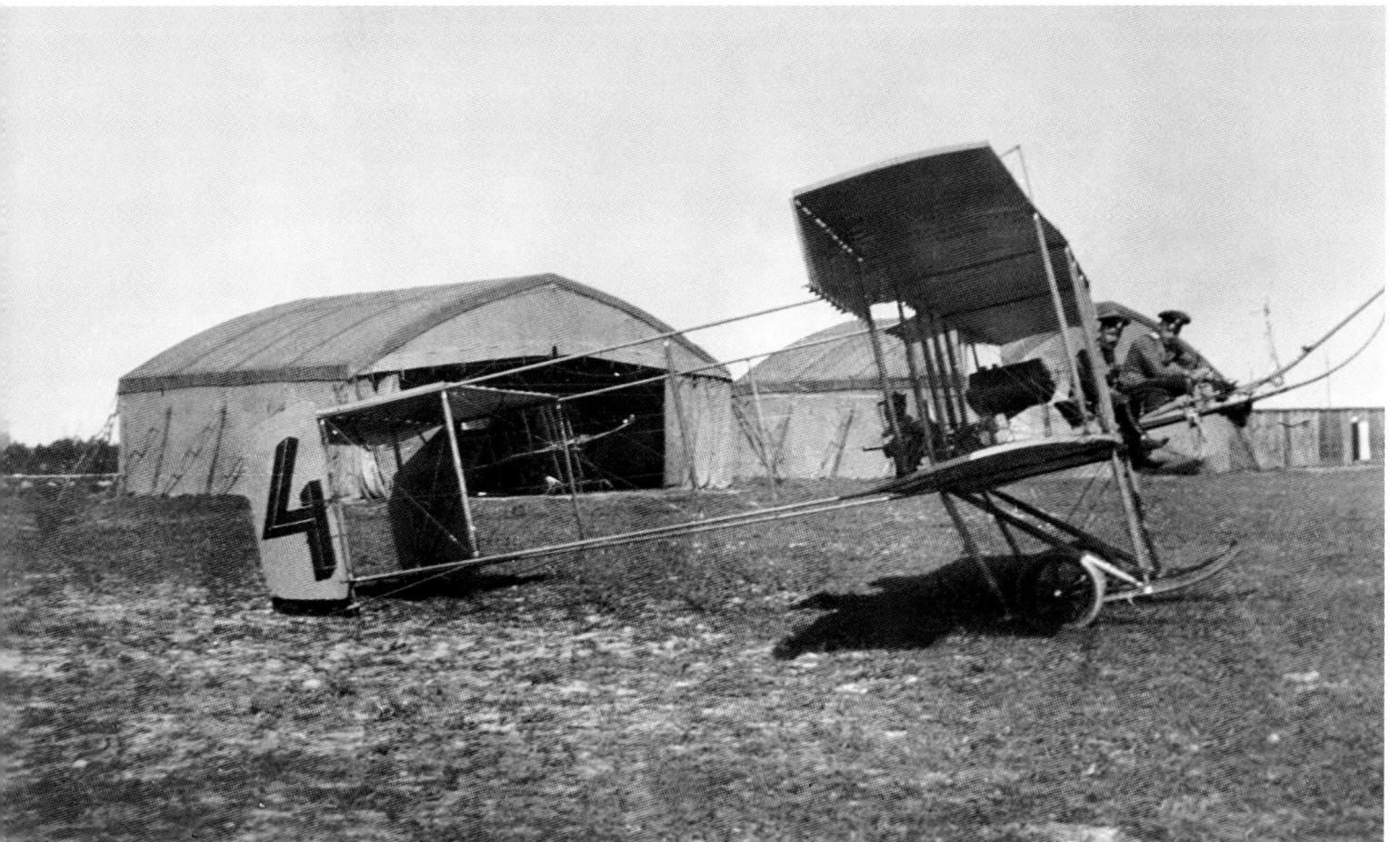

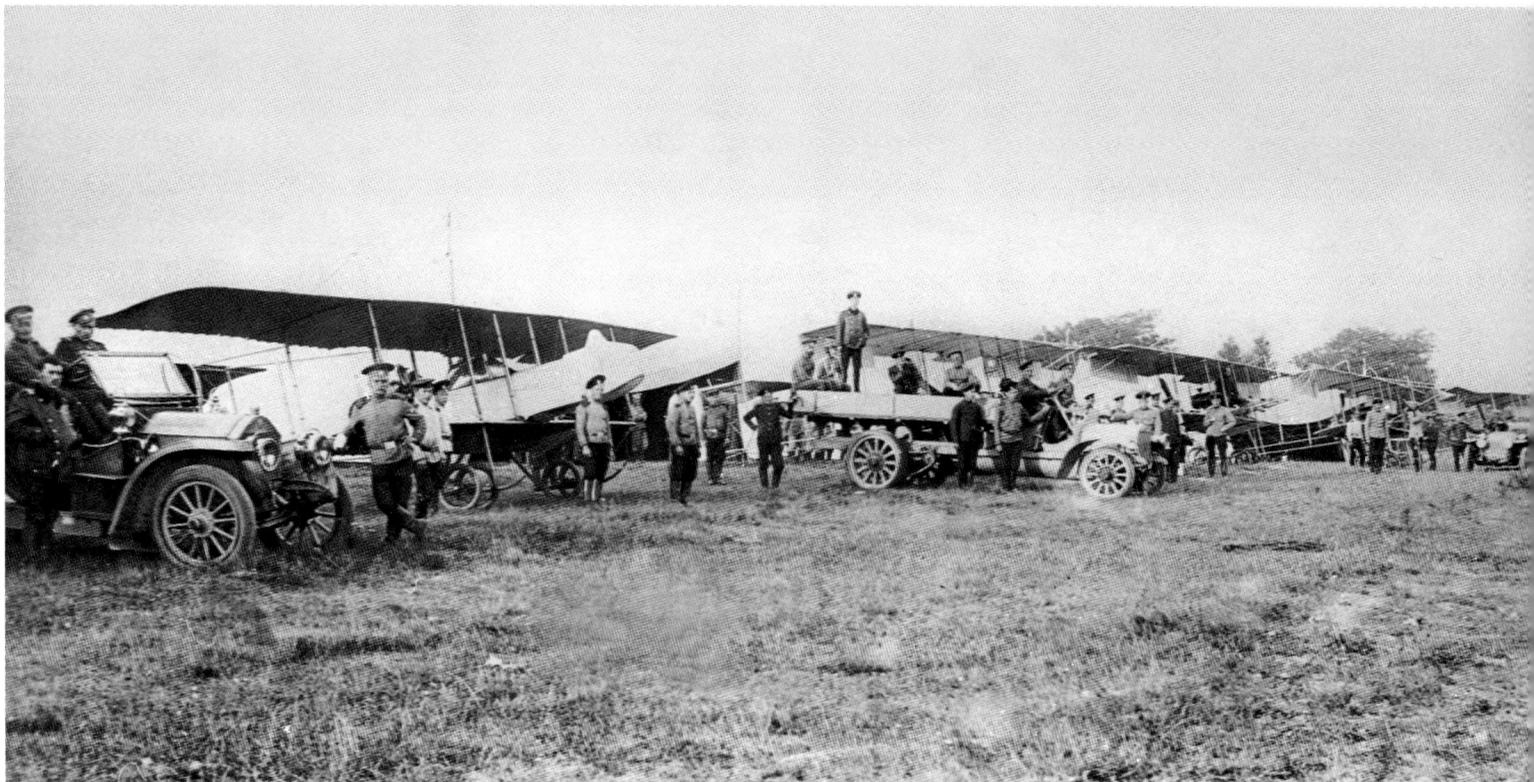

157. All ready on the Summer Field.
Near Lublin. 1913

158. Adjusting the motor in the workshops of an aviation school.
Gatchina. 1913—1914

159. The *Niupor IV* stowed in a special automobile for transport. Its aviator and mechanics accompany it.
St. Petersburg. 1913

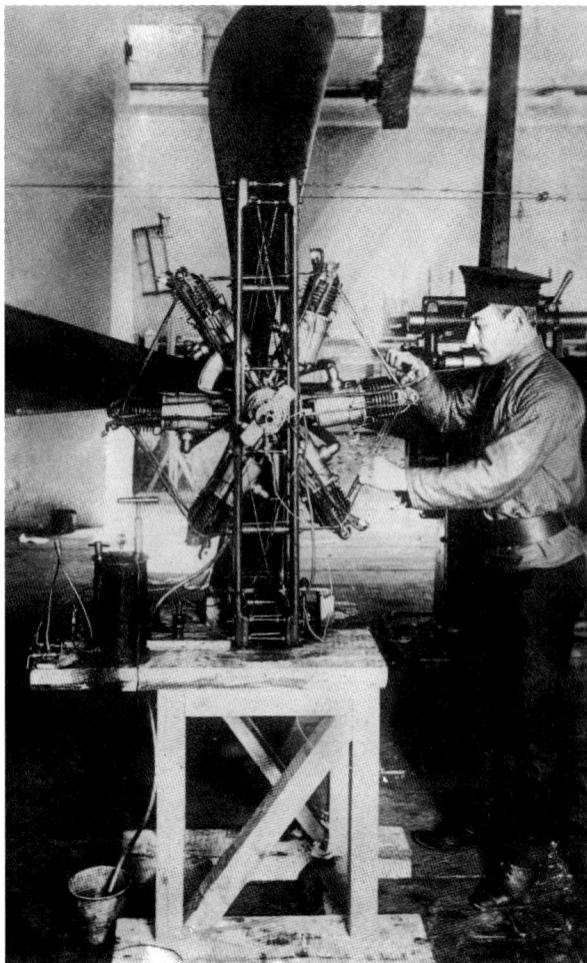

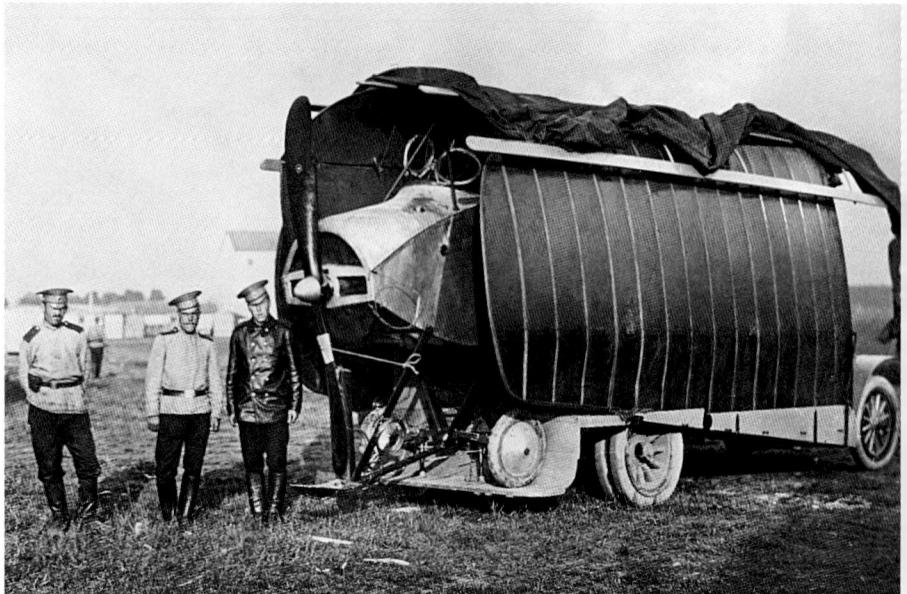

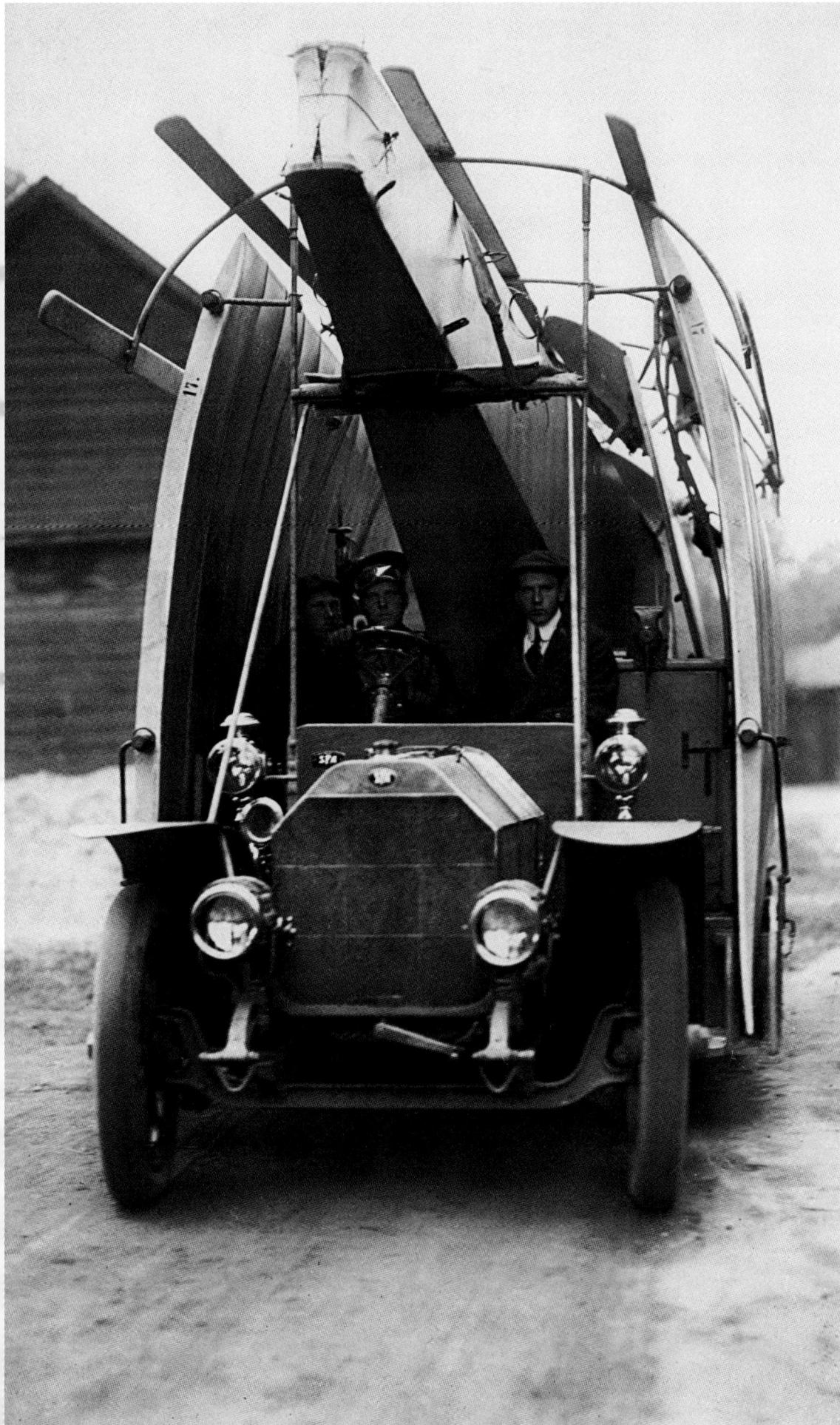

160. Pilot and designer
G.V. Yankovskyi (next to the driver)
in a special automobile
for transporting airplanes.
St. Petersburg. 1914

161

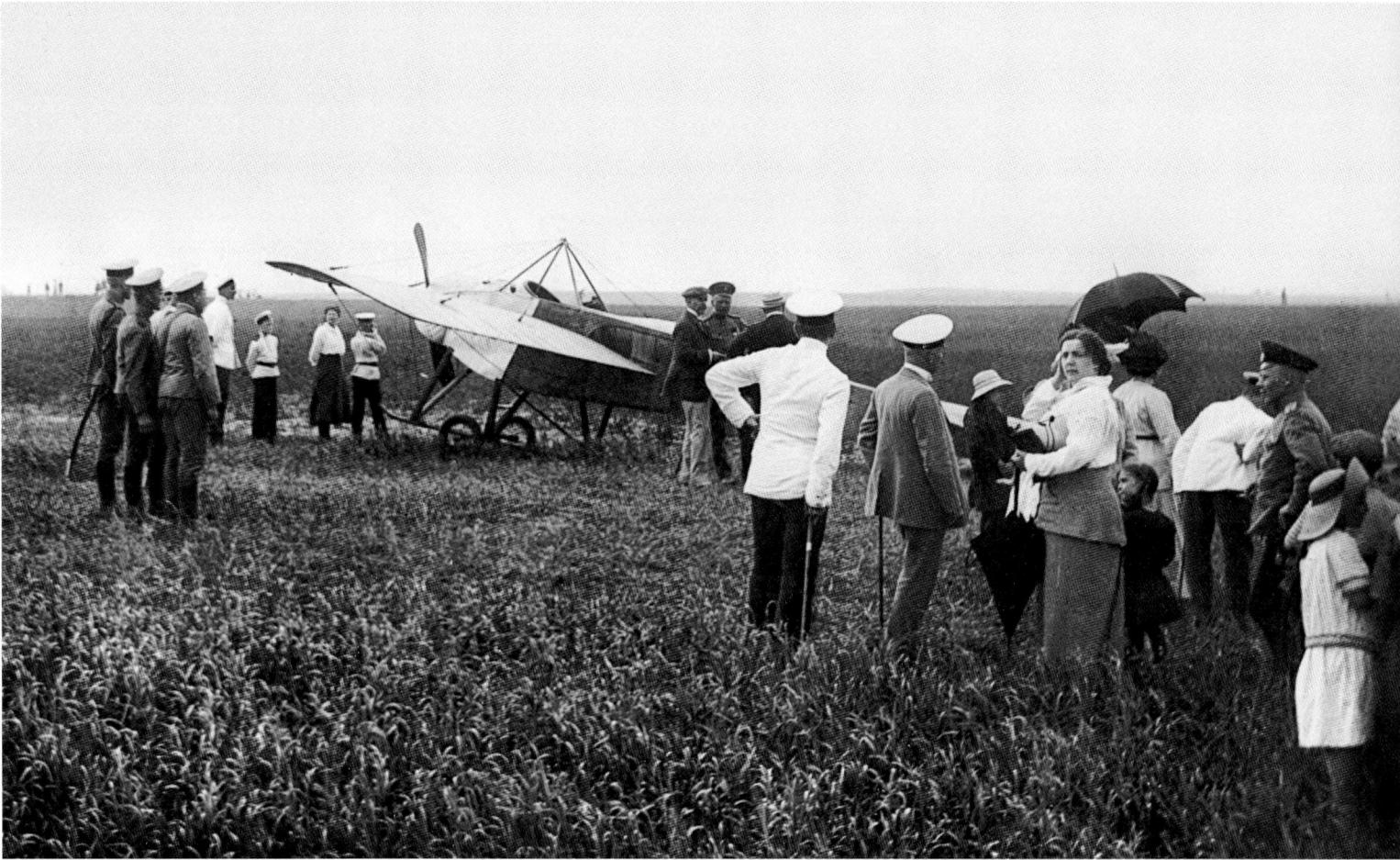

161. Emergency landing of the *Niupor IV*.
Near St. Petersburg. 1912

162. A trainee and instructor in the two-seater *Blerio*. **Training squadron.**
Korpusnoi Airfield. St. Petersburg. 1913

163. Aviator R.L. Nizhevskyi on the *Niupor IV* **being prepared for flight.**
Гатчина. 1913 г.

164. The *Niupor IV* **is taken from the hanger of the First Aviation Company.**
Korpusnoi Airfield. St. Petersburg. 1913

162

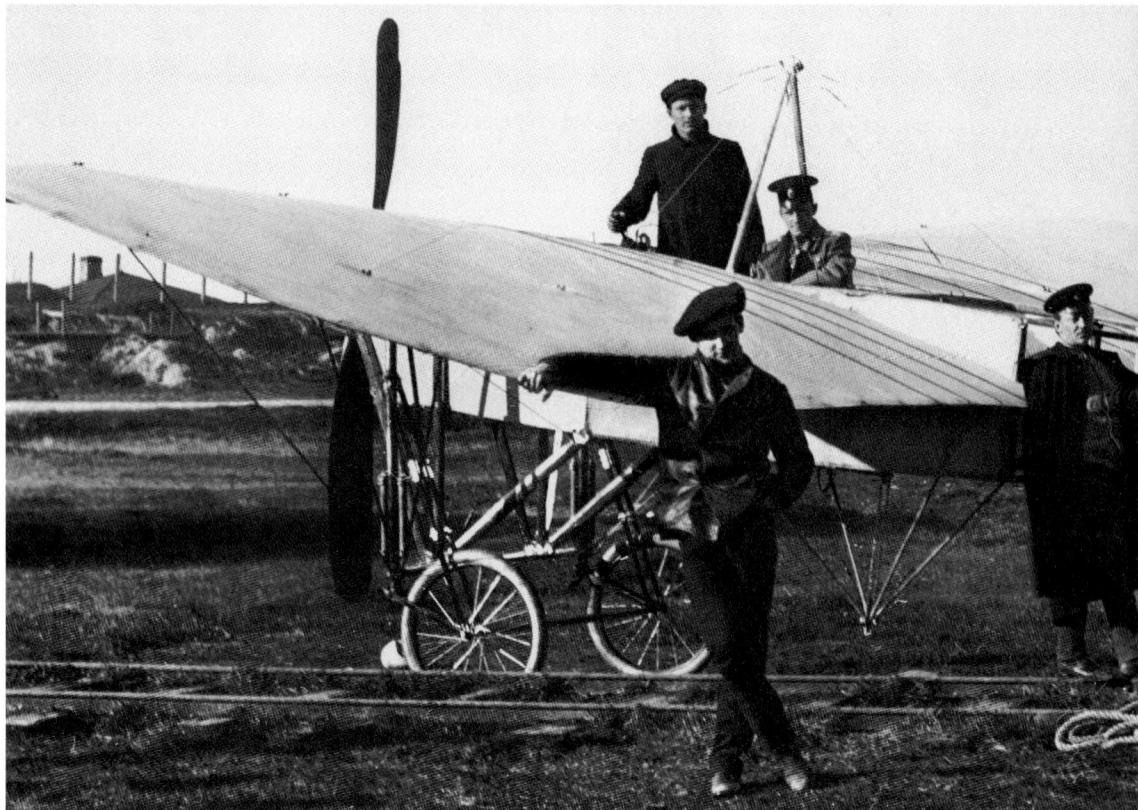

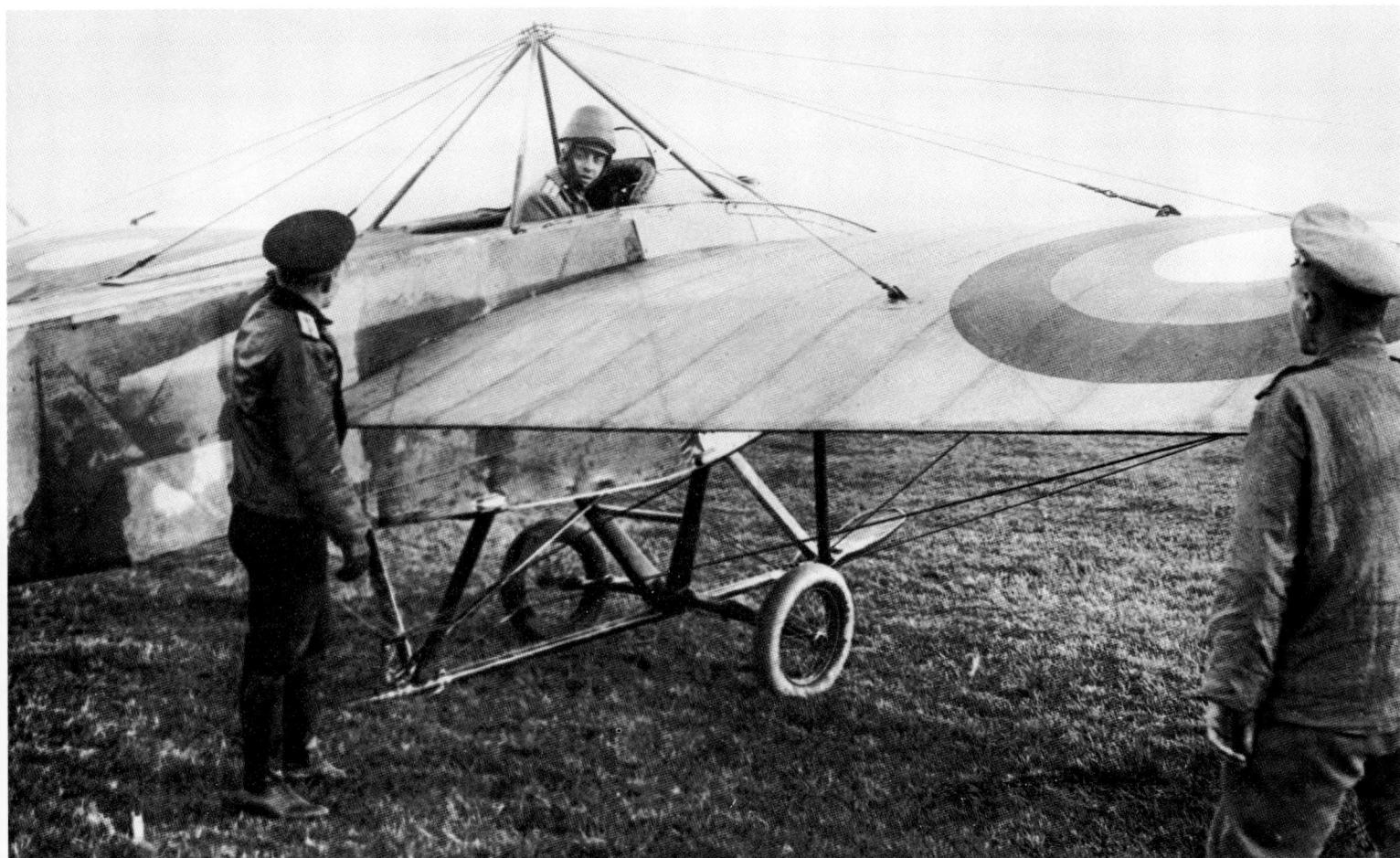

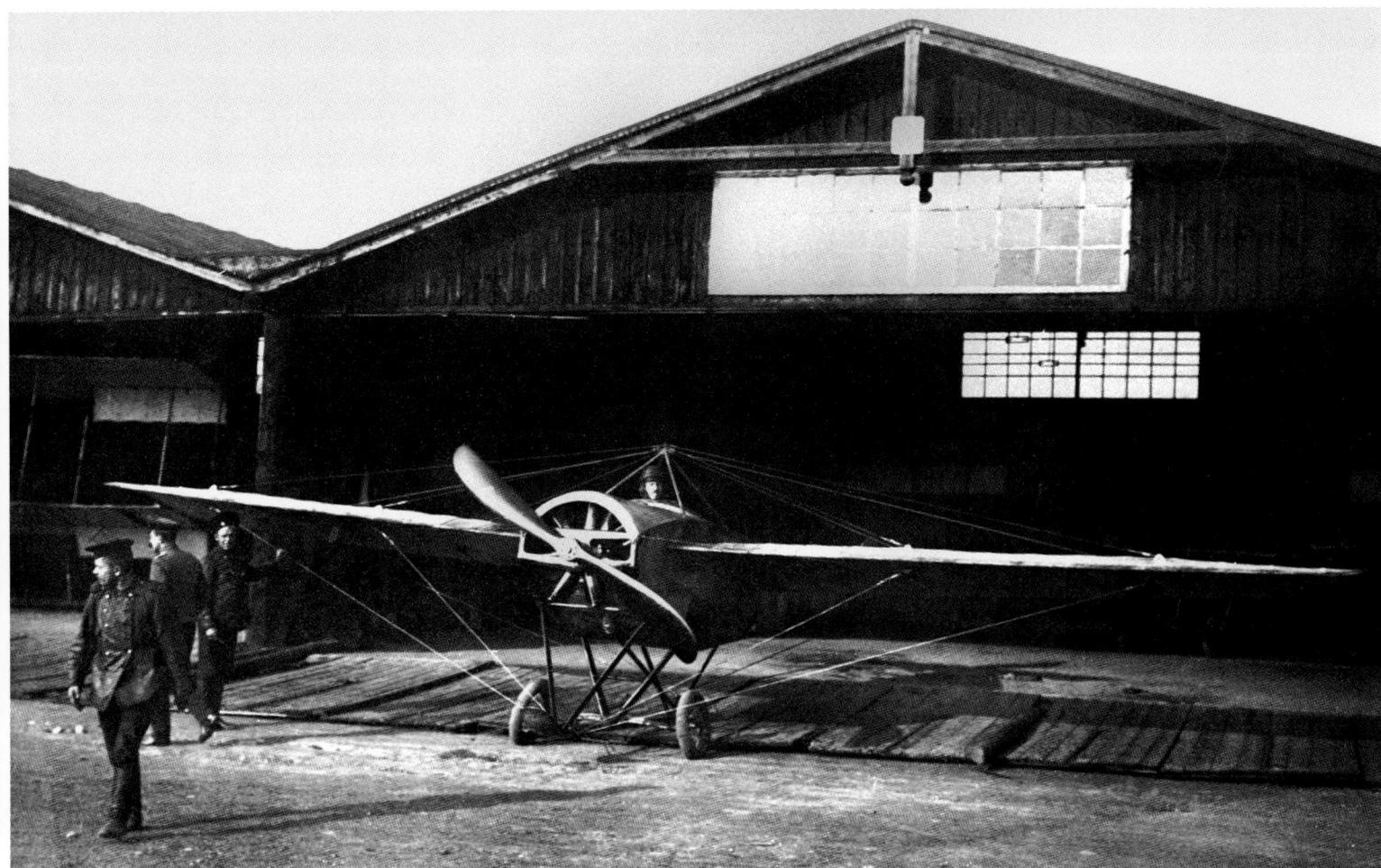

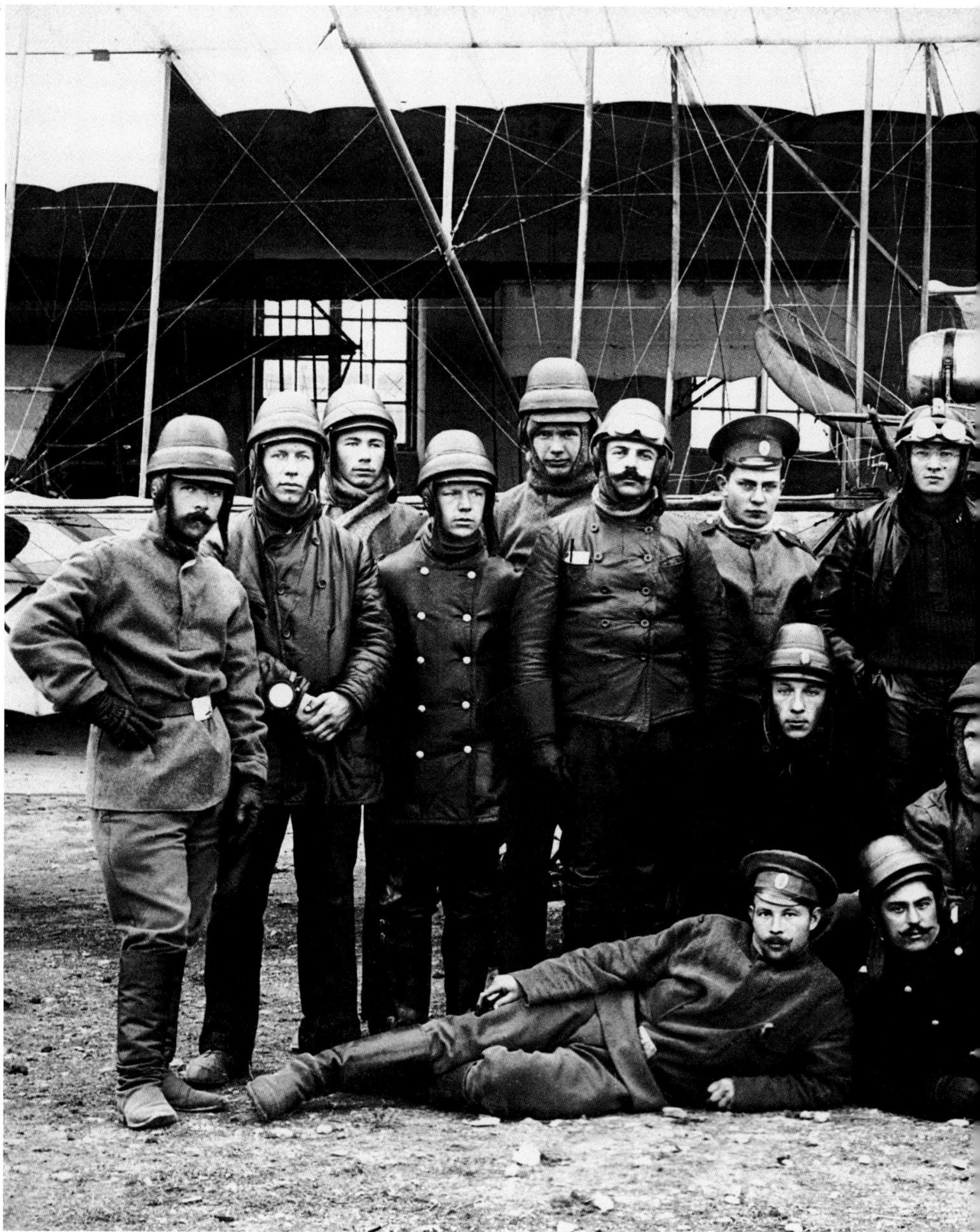

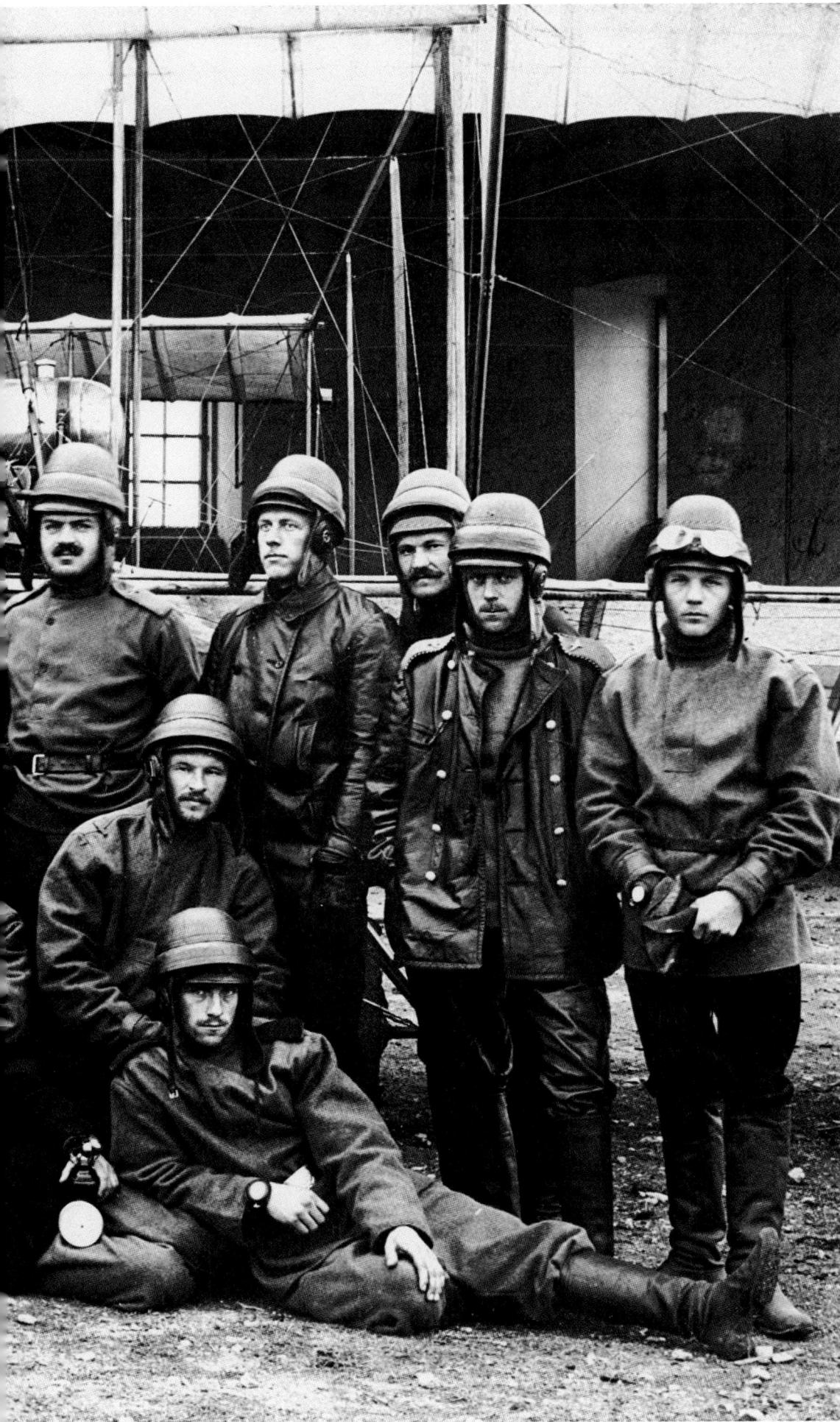

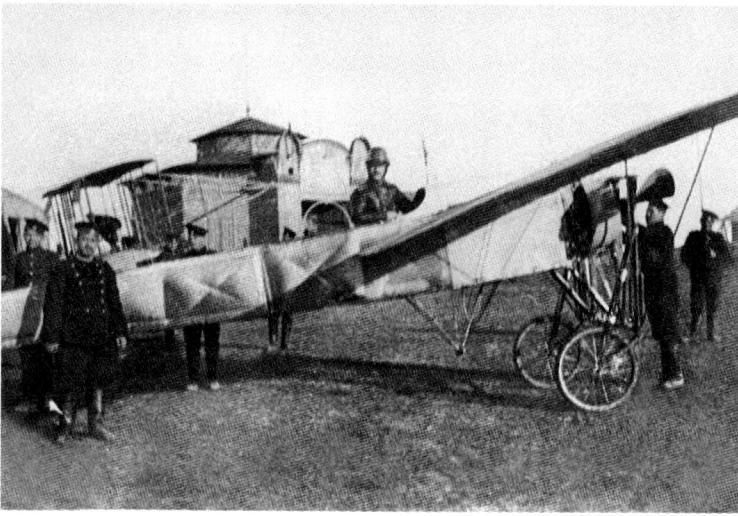

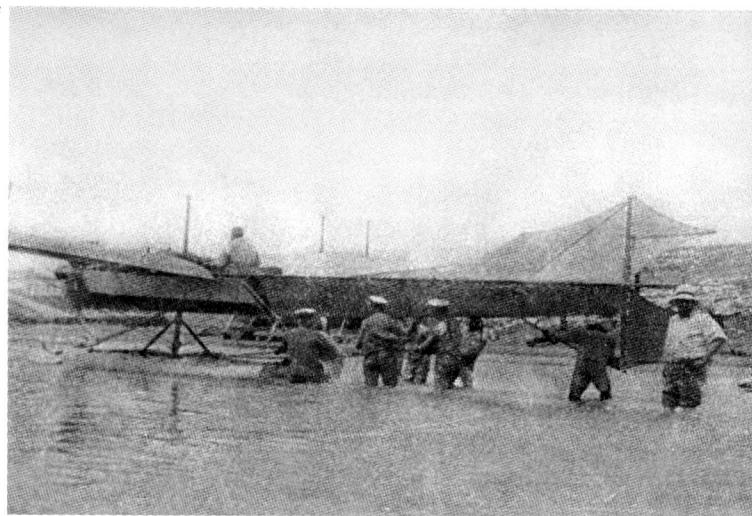

166. The airplane *Blerio*, **modernized according to M.N. Efimov's initiative.**
Sevastopol. 1912

167. The Black Sea *Antoinette* **in an unsuccessful attempt at a takeoff from the water.**
1911
The plane was placed on floats by Lieutenant S.F. Dorozhinskyi.

168. Sevastopol Officers School of Aviation.
1910
The School was formed in November 1910. In May 1912 it was moved to a more suitable place in the Kacha river valley to the north of Sevastopol.
The instructors of the School were D.G. Andreadi, K.A. Artzeulov, M.N. Efimov, A.E. Raevskyi, B.L. Tsvetkov, and others.

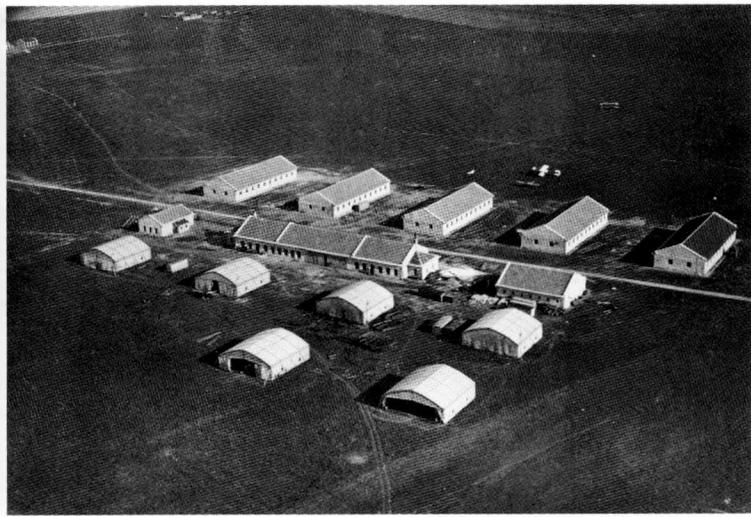

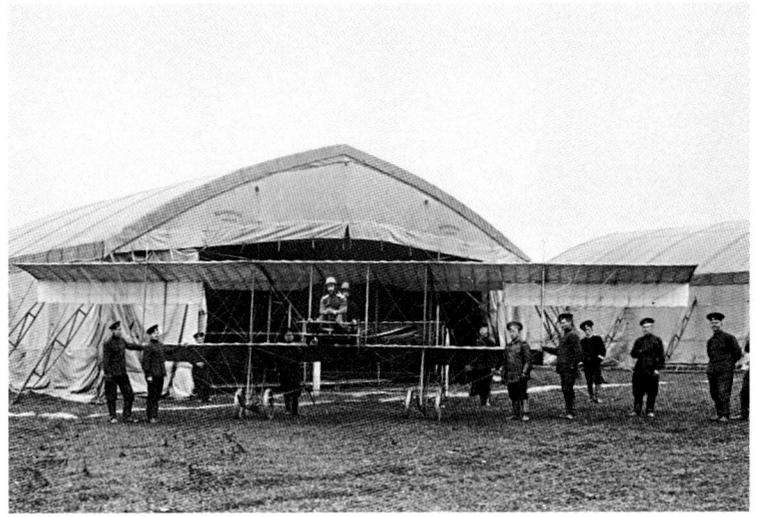

169. View of the Sevastopol Aviation School from a plane.

Sevastopol. 1912

In 1911, 26 planes were in use at the School.

170. An instructor and student take the *Farman VII* to the starting line.

Sevastopol Aviation School. 1913

171. The racing airplane *Blerio XI*. The pilot is V.F. Gelgar.

Sevastopol Aviation School. 1912

On November 29, 1910, V.F. Gelgar was the first person in Russia to take movie footage from a plane.

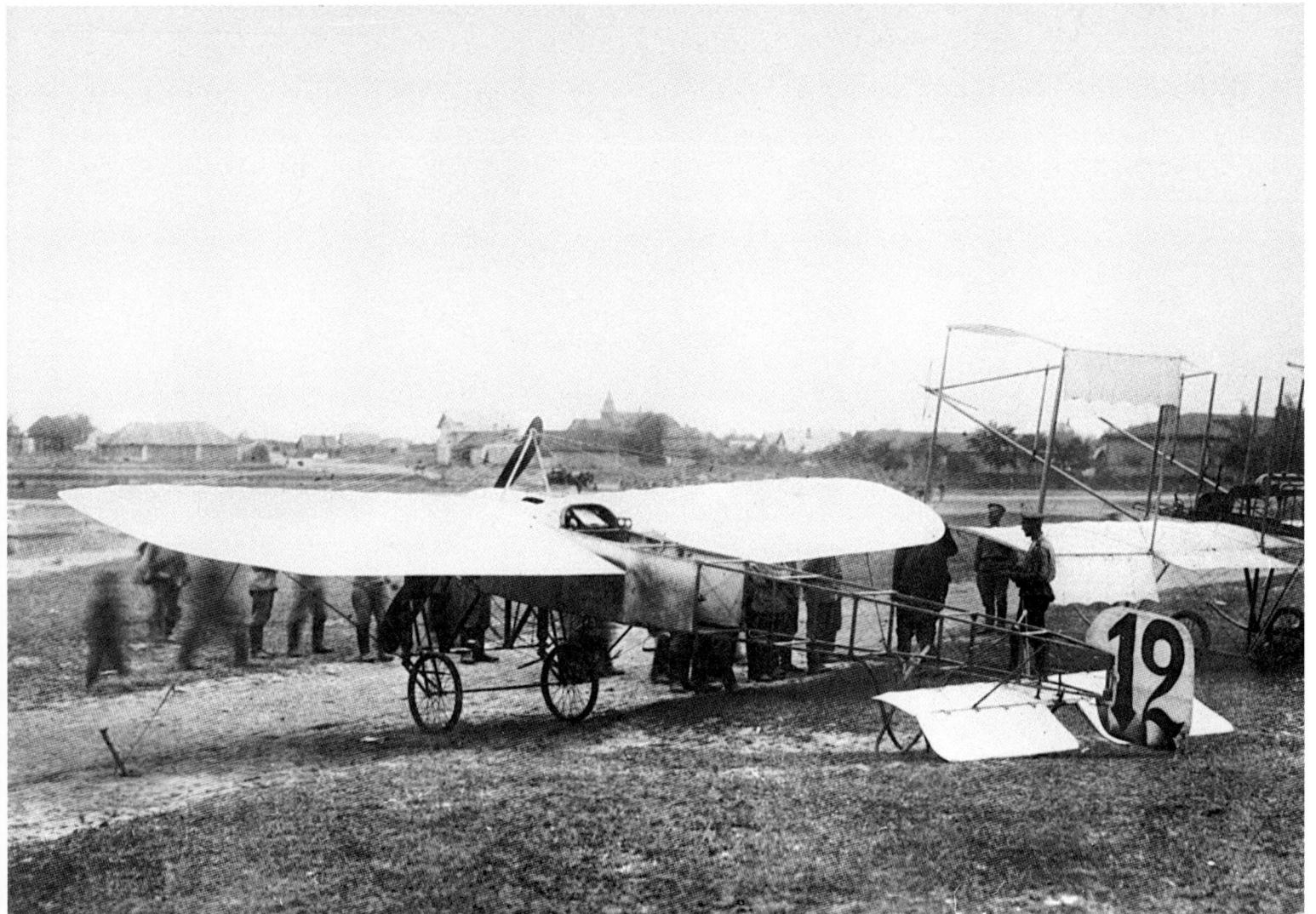

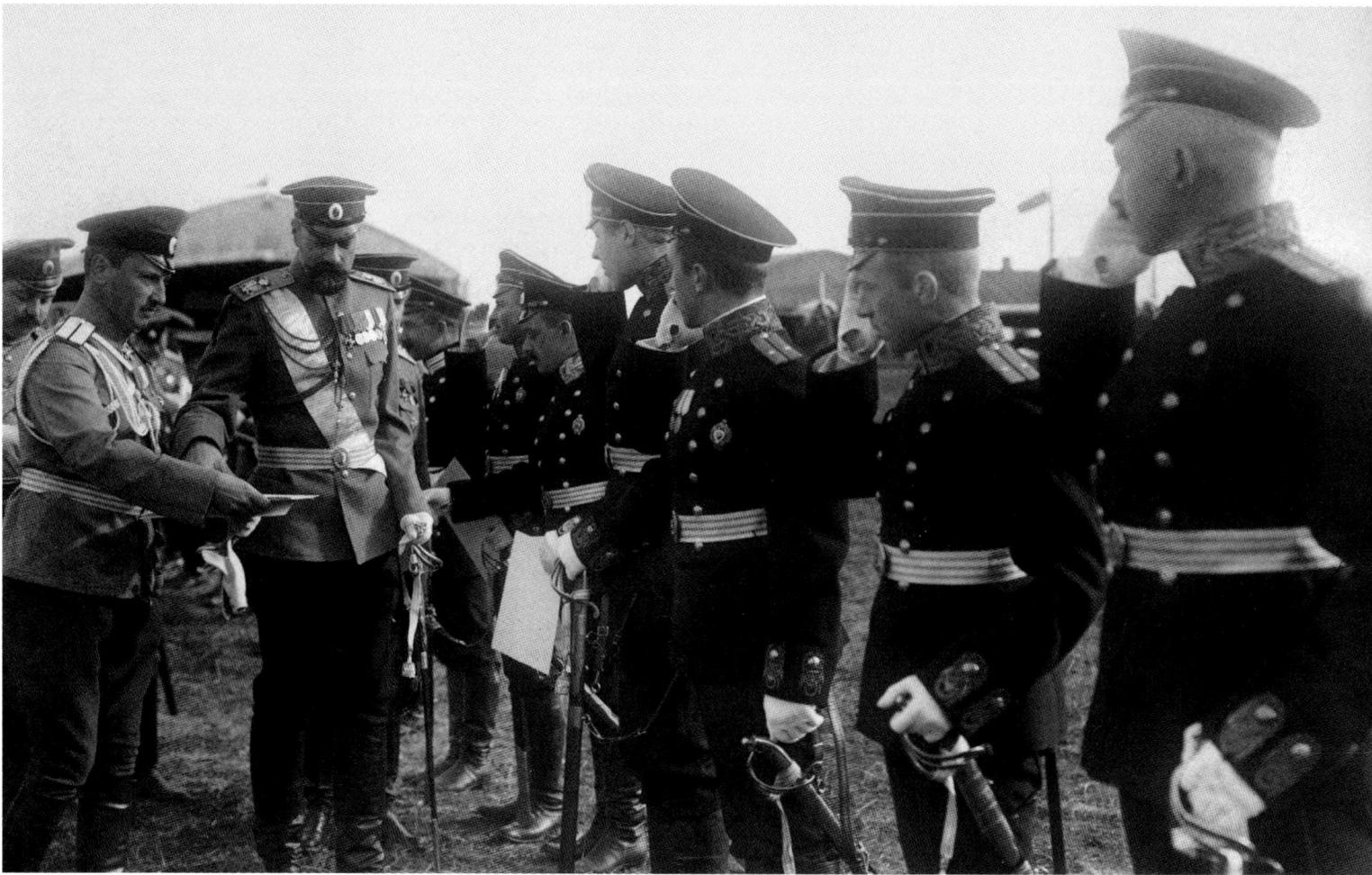

172. Grand Duke Alexander Mikhailovich (second on the left) gives diplomas from the aviation school to aviator-trainees Lieutenant A.E. Zhukov, Lieutenant N.R. Viren, Lieutenant N.L. Mikhailov, Midshipman V.V. Utgof, V.R. Kachinskyi, R.F. Essen, and E.E. Kovedyaev.
Sevastopol Aviation School.
October 8, 1912

173. Head of the Sevastopol Aviation School, Staff Captain I.Y. Zemitan, with passenger Lieutenant I.V. Podshivalov, after a record flight at a height of 3000 meters on the plane Moran**.**
1917

174. M.N. Efimov during a demonstration flight on the Farman IV**.**
1912
Well known to the public, M.N. Efimov became an instructor at 19 at the Sevastopol Aviation School.

175. Two-seater plane of the Blerio **type being taken to the starting line.**
Sevastopol Aviation School. 1913

173

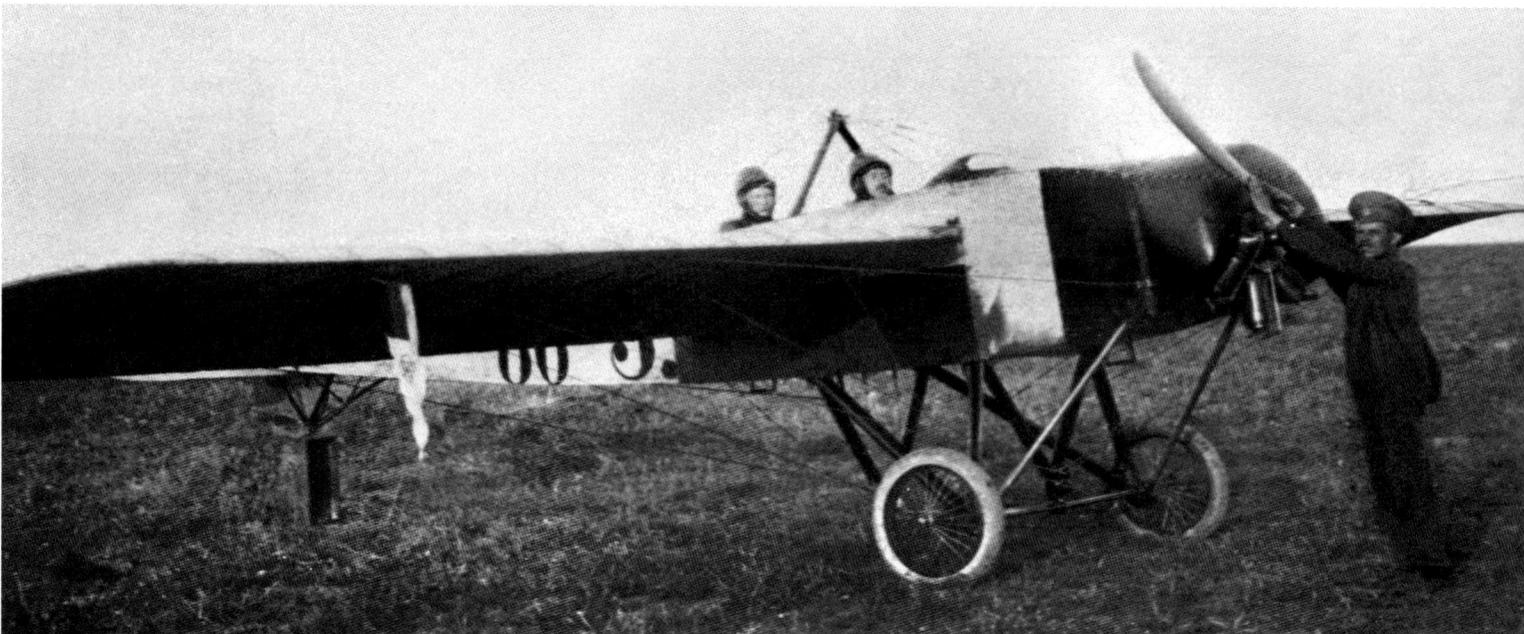

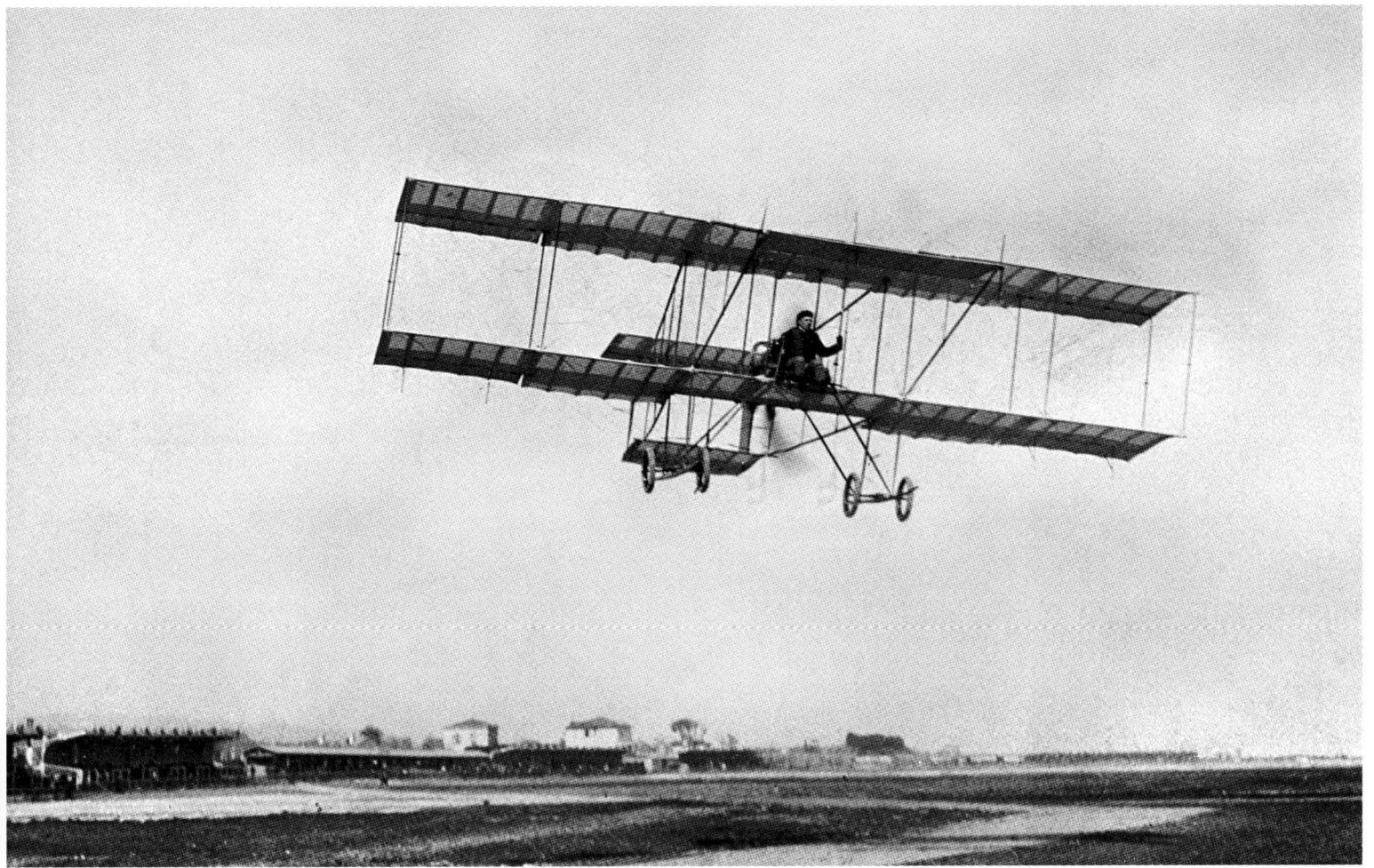

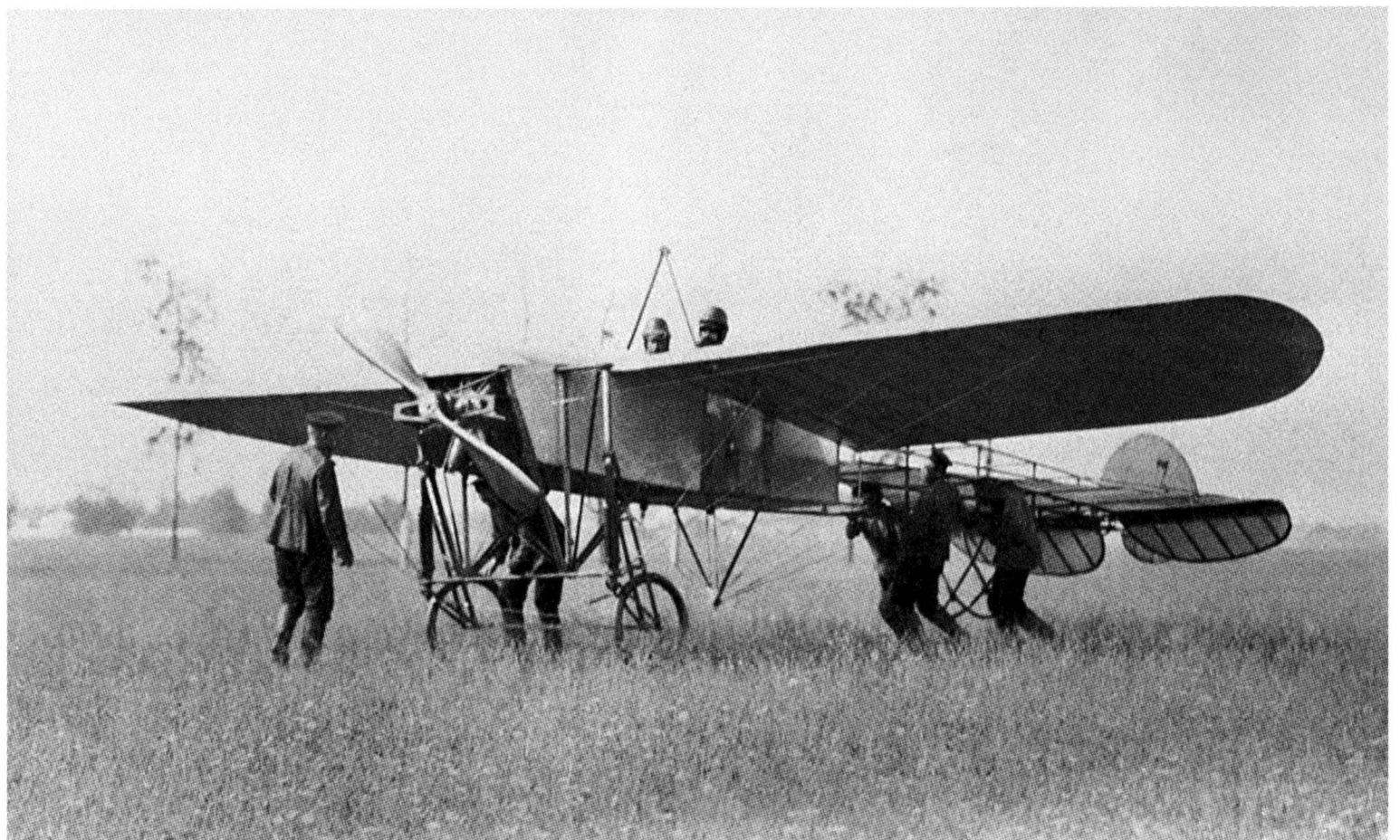

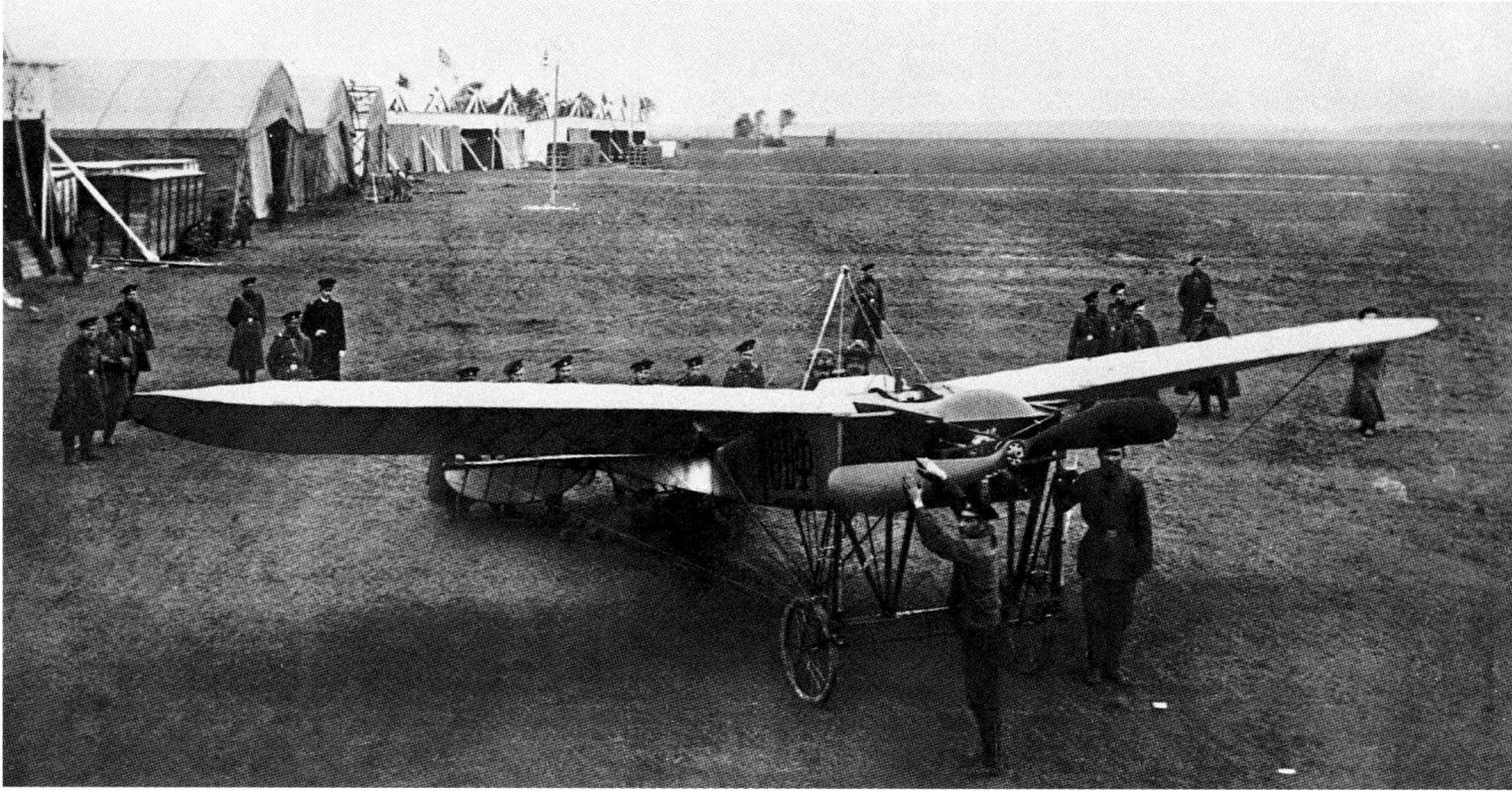

176. Pilot B.V. Matyievich-Matsievich (not long before his death) on the plane *Blerio XI*.
Sevastopol Aviation School. 1911

177. Aviator-instructor of the Sevastopol Aviation School with passengers before a demonstration flight on the training plane *Farman VII*.
1913

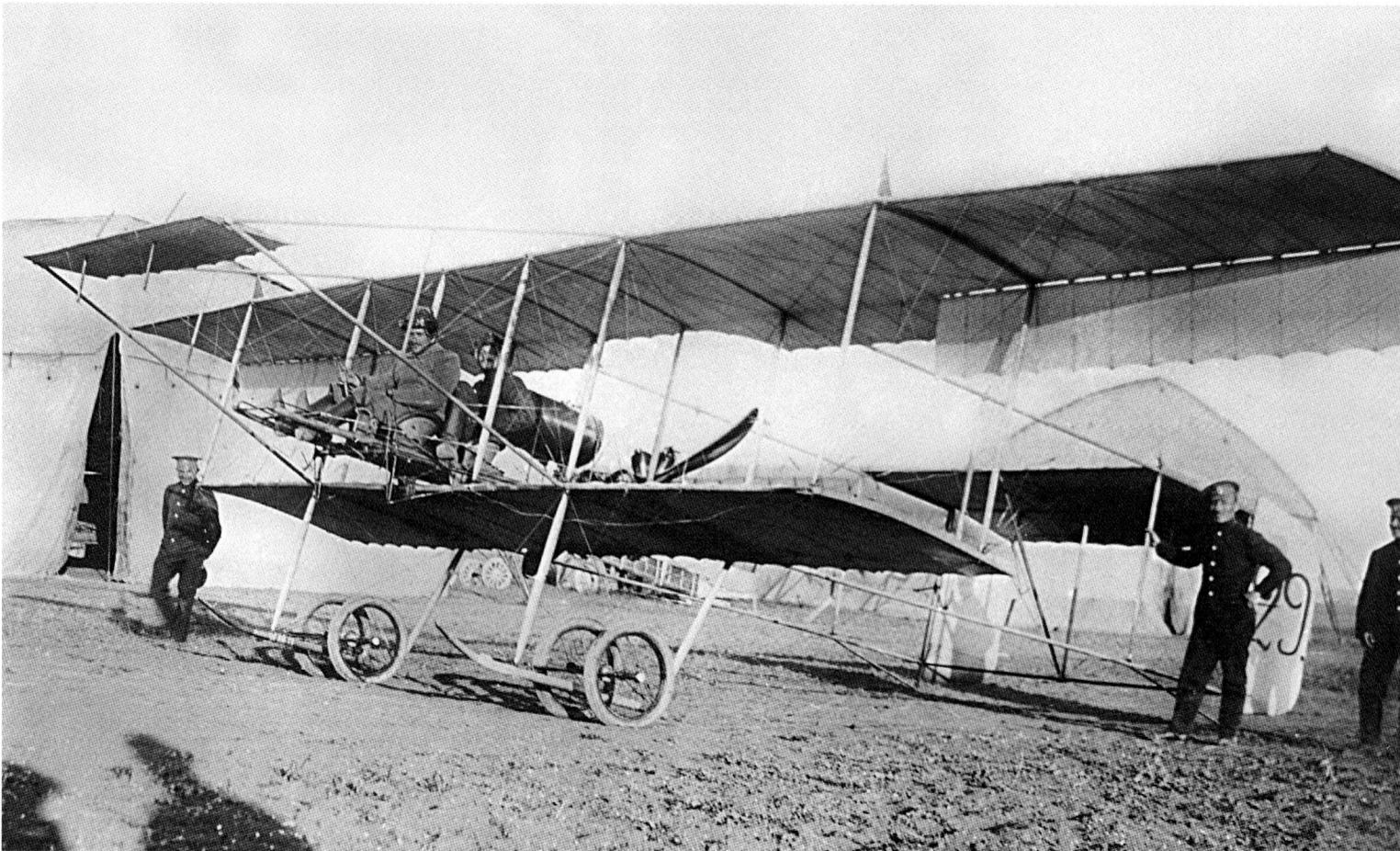

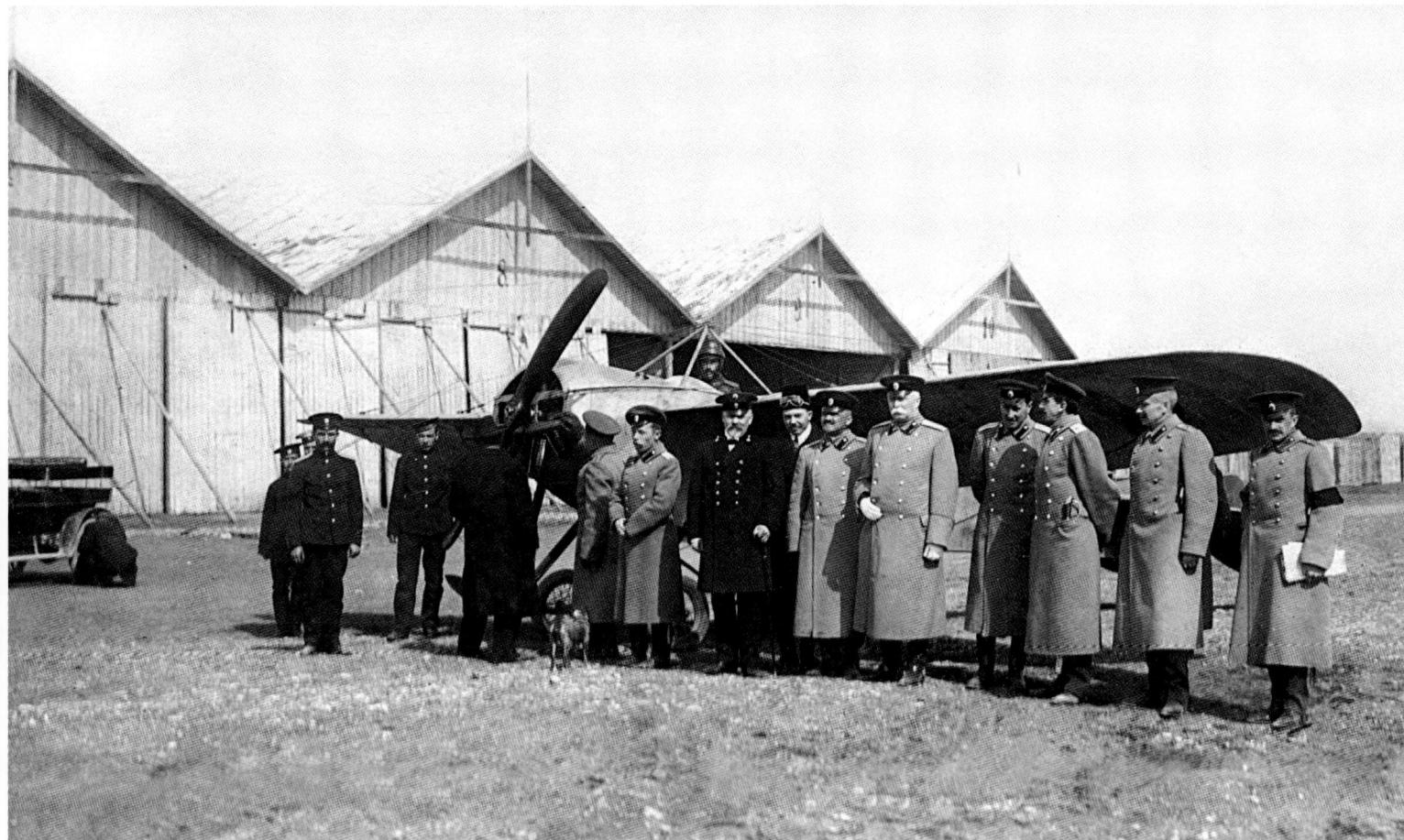

178. On the plane is aviator D.G. Andreadi. Near the *Niupor IV*, from right to left, are I.Y. Zemitan, P. Verkhovskoi, Lieutenant S.A. Uliyanin, Prince A.A. Muruzi, General A.V. Kaulbars, S.I. Odintsov, M.N. Efimov, A. Lenevich, I.N. Tunasheshenskyi, and S.I. Viktor-Berchenko.
Sevastopol Aviation School. 1914

179. Instructors and students in the hanger of the Sevastopol Aviation School. On the left in the cap is instructor T.N. Efimov.
Sevastopol Aviation School. 1915

179

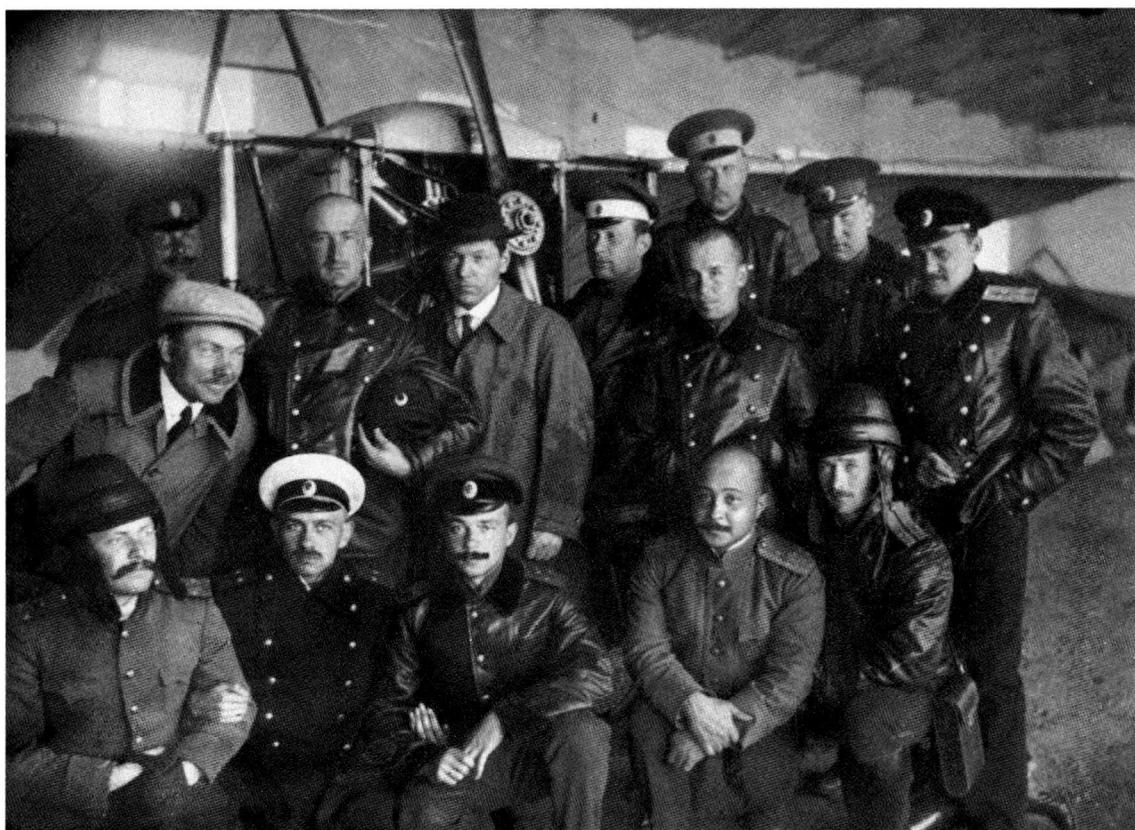

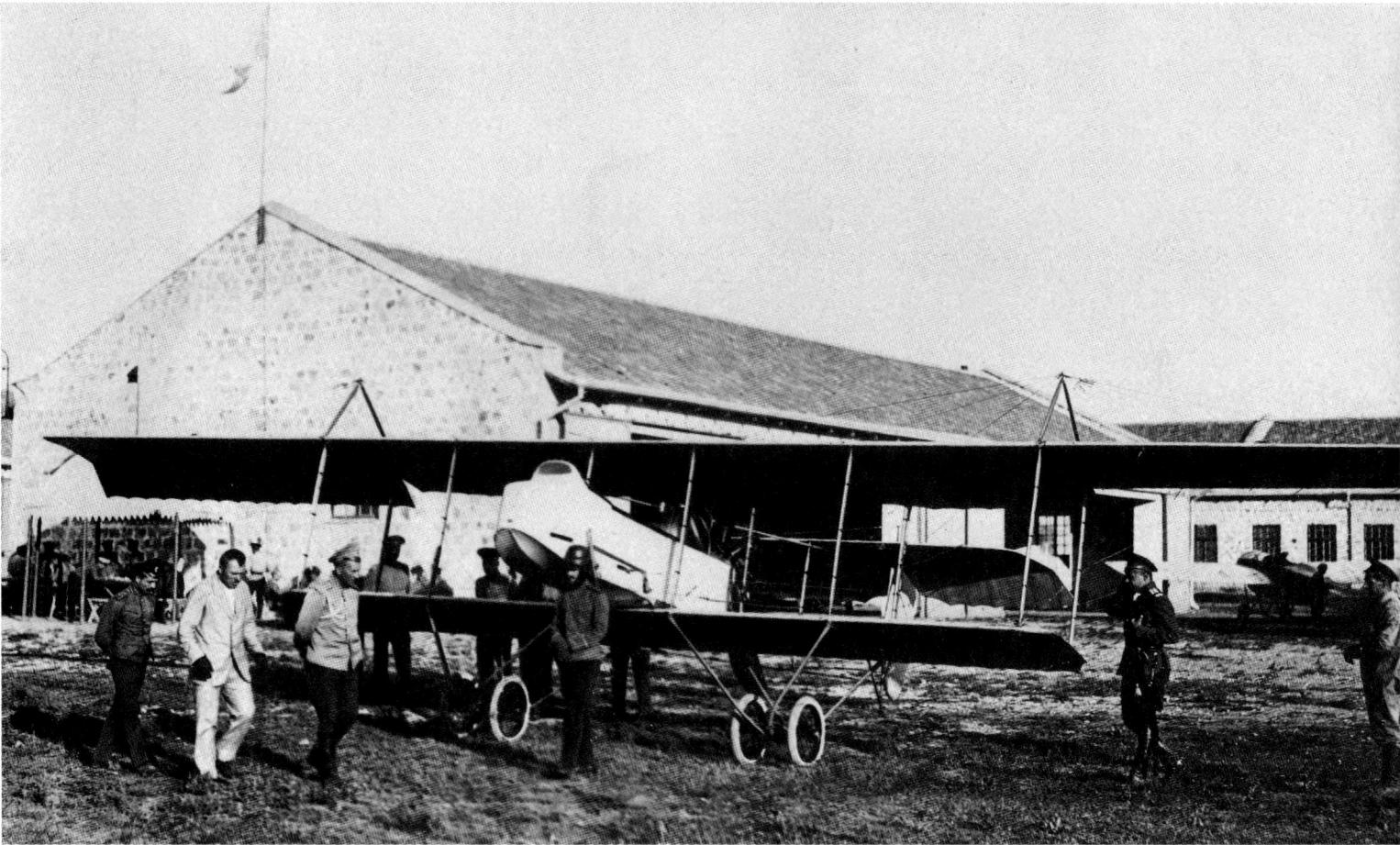

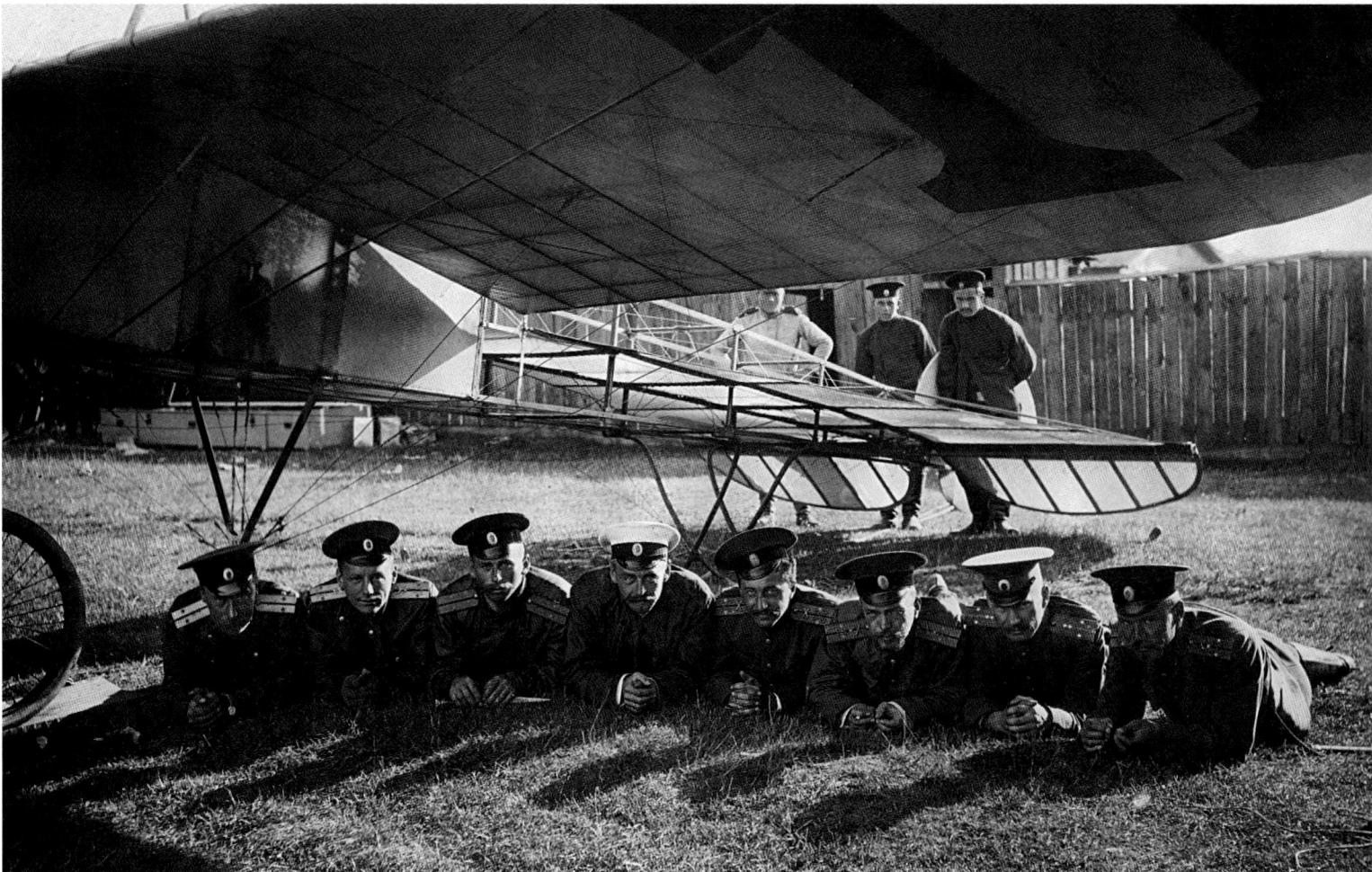

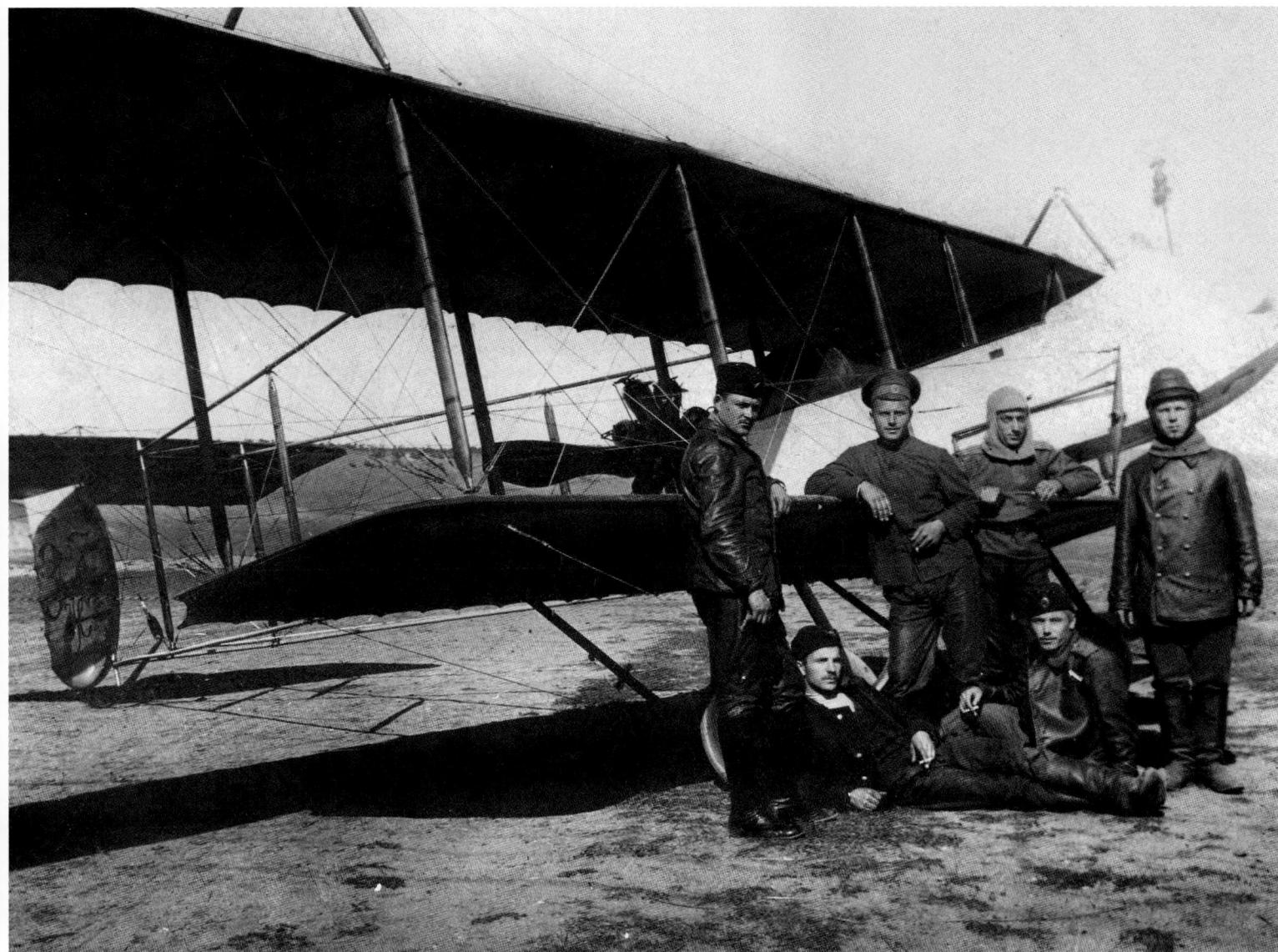

180. Instructor of the Aviation School M.N. Efimov (in the uniform) near the training plane *Farman XXII*. On the right is Lieutenant Prince A.A. Muruzi, the head of the Sevastopol Aviation School.
Sevastopol Aviation School. 1915

181. Pilots of the aviation school OAS and gunners of the Novogeorgievskyi Fortress near the plane *Blerio XI*. Second from the left is V.A. Soloviev, fourth is G.V. Buksgevden, sixth is Byikov, seventh is I.Y. Zemetan.
St. Petersburg. 1911

182. A group of pilots of the Sevastopol Aviation School near the *Farman XVI*. Among them is P. Vasitskyi, G. Tau, M. Plotnikov, and G. Pogoriletskyi.
1915

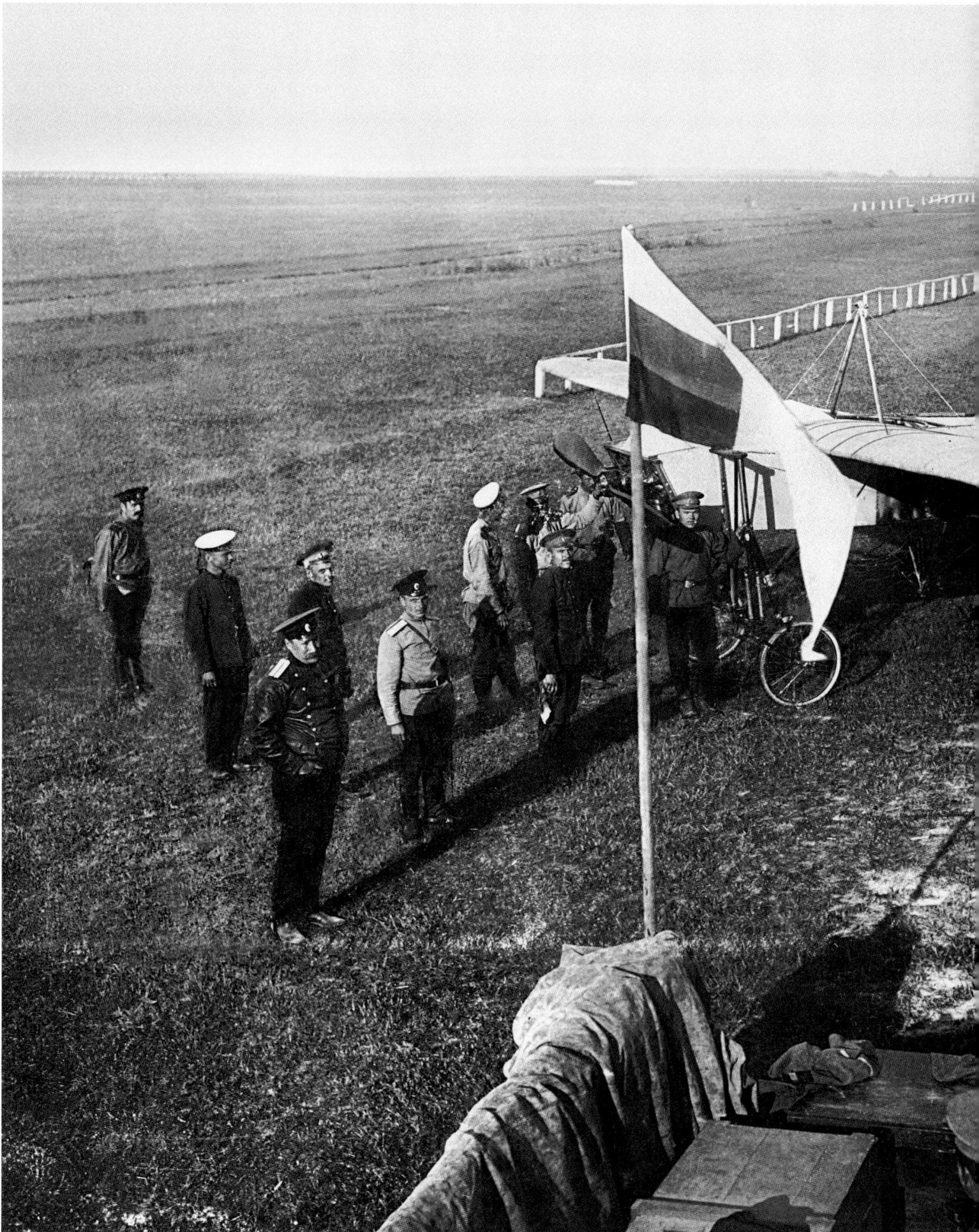

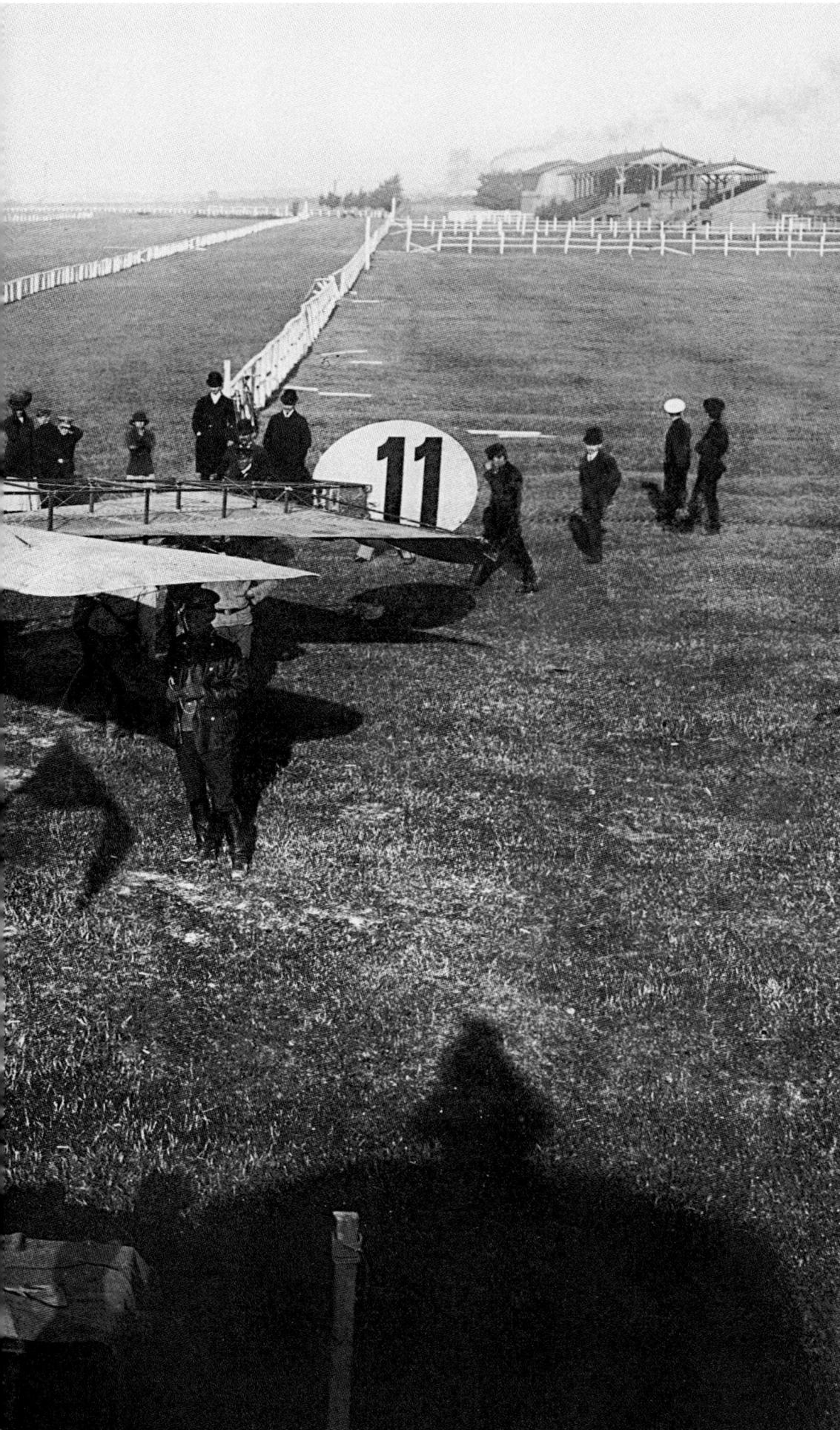

183. Baron G.V. Buksgevden's *Blerio XI* being led to the starting line.
Kolomyazhsky Racetrack.
St. Petersburg. 1913

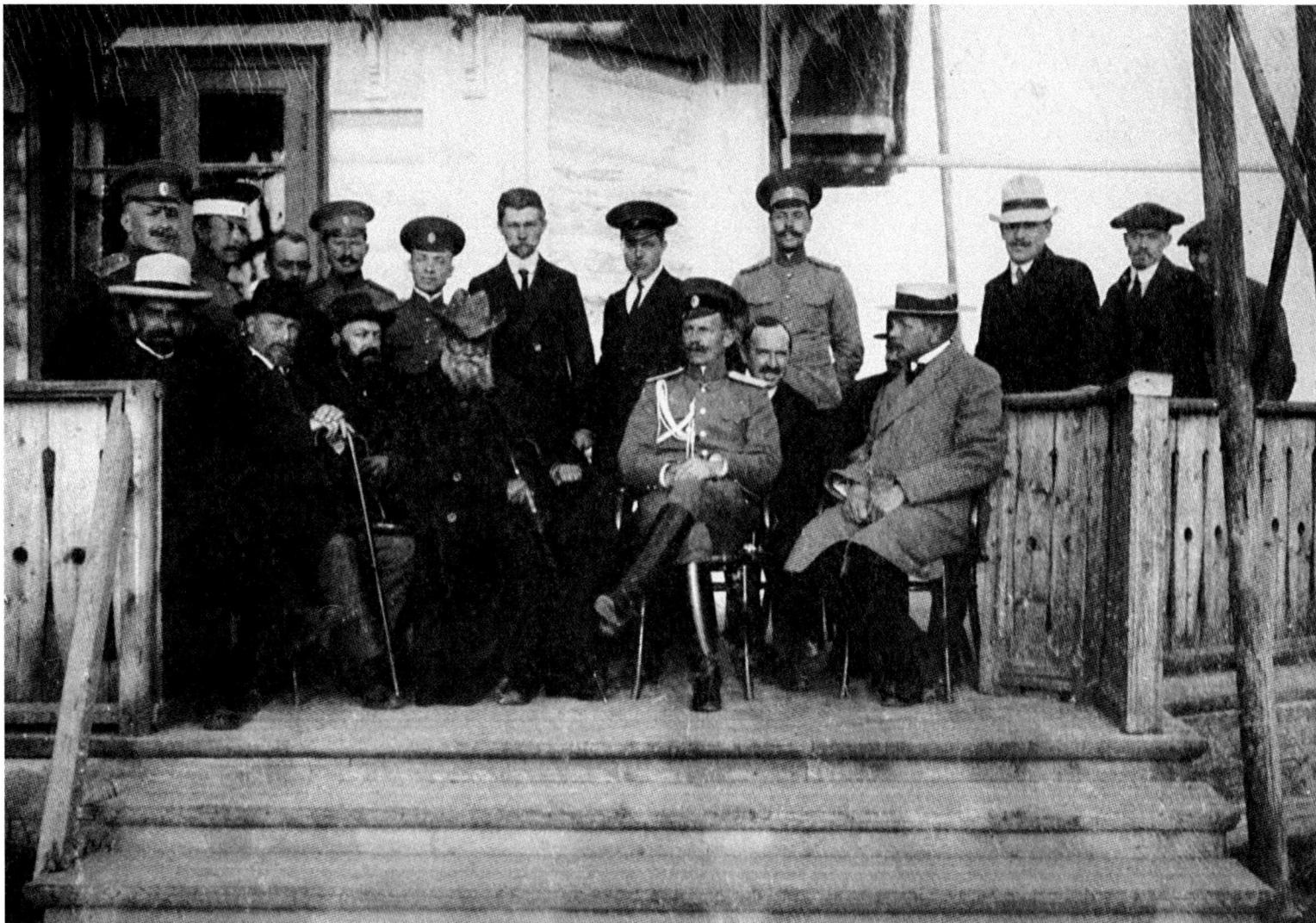

184. Overseeing the flights from the veranda pavilion of the Moscow Society of Aeronauts's (MSA) School of Aviation. In the first row sits (left to right): 1st − I.A. Meller, 4th −N.E. Zhukovskyi, farther down − Captain V.N. Gatovskyi, and G.I. Lukiyanov; in the second row stand (left to right): 1st − S.N. Voitzekhovskyi, 8th - Prince M.I. Massalskyi, farther − B.M. Bubekin, and N.R. Lobanov.
Moscow. 1915

185

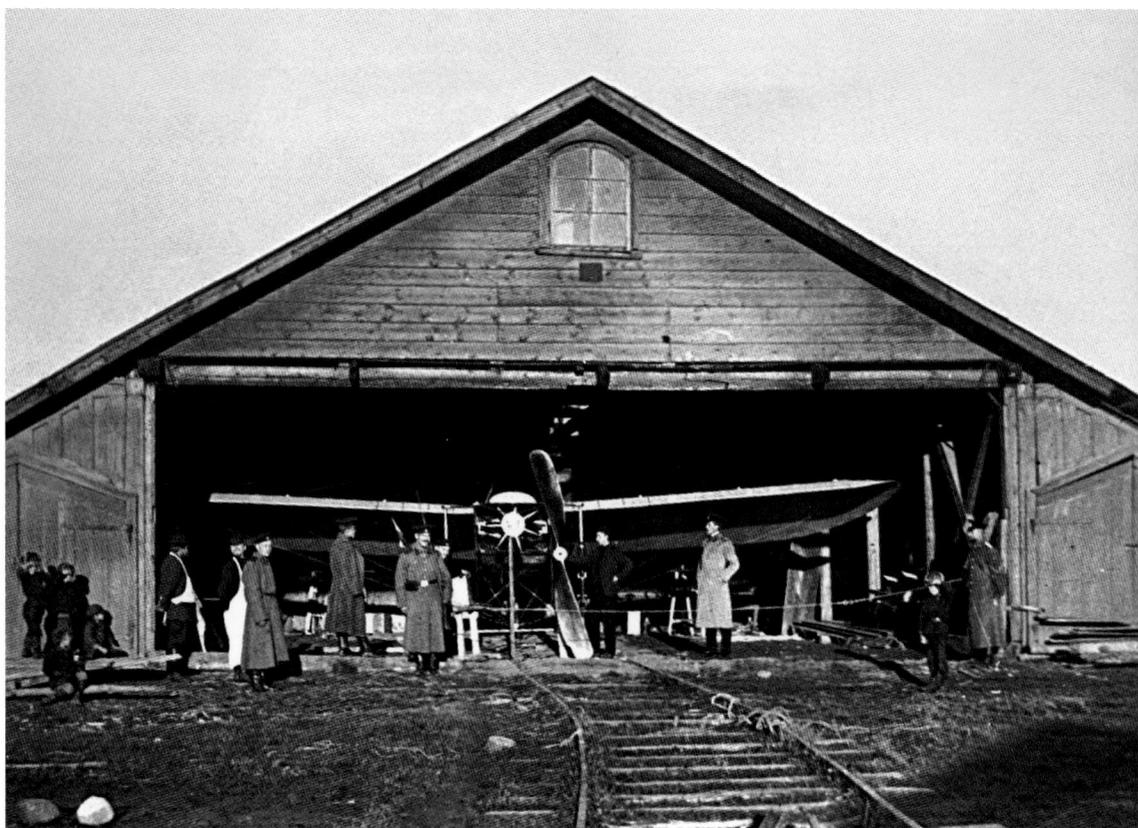

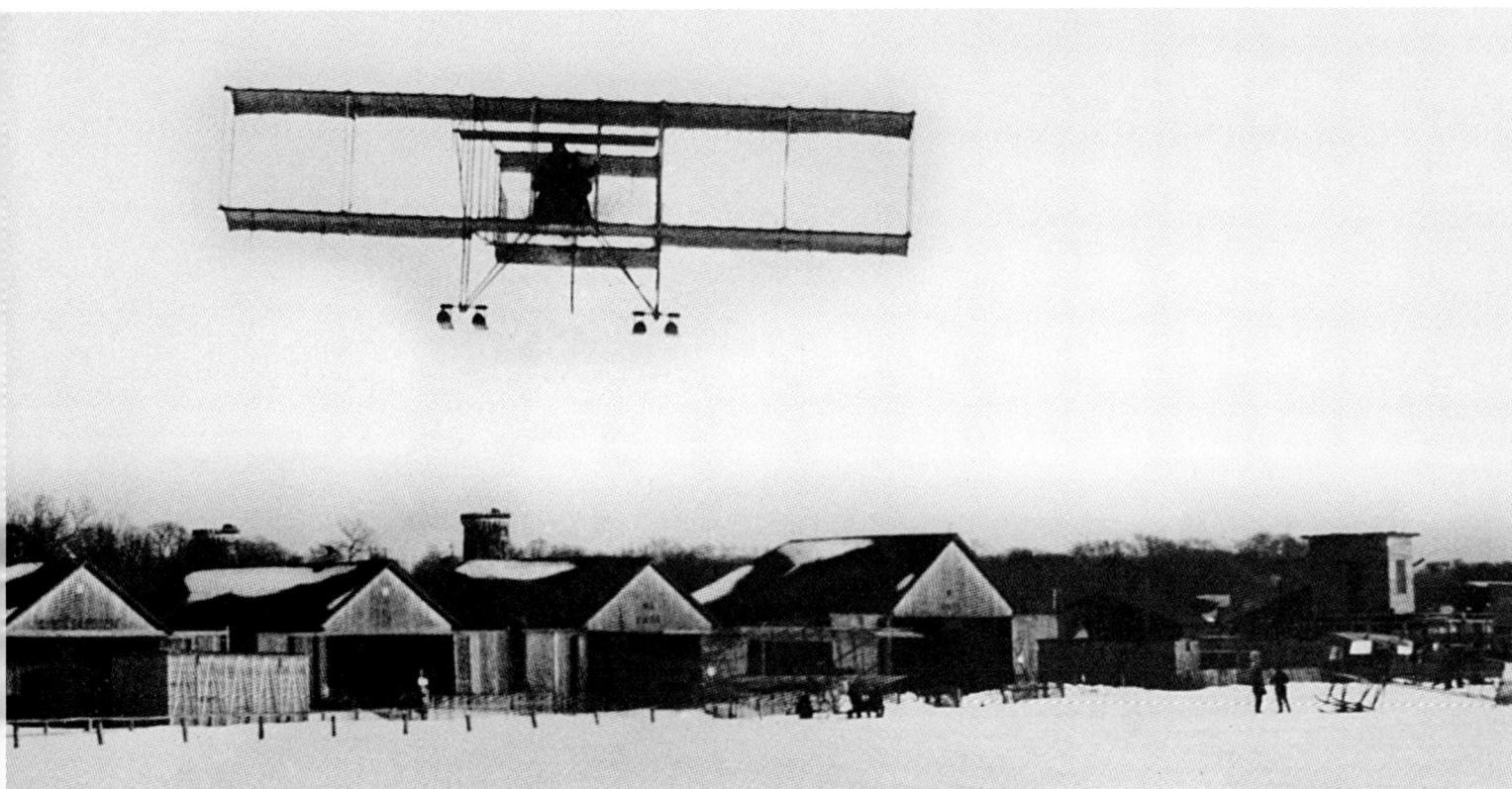

185. Preparing the *Blerio* for takeoff.
Moscow Aviation School. 1911 — 1912

186. Instructor A.M. Gaber-Vlynskyi with a trainee on the *Farman IV* (with Lobanov Skis) over the Khodynskyi Field, a training/ testing center for Moscow aviation.
1912 — 1914

187. The airplane Blerio in front of the Klementievskyi Range hanger near Mozhaiskyi. The plane *Ptenets (Chick)*, designed by A.N. Lobanov, sits in the hanger.
Maneuvers near Moscow. 1913

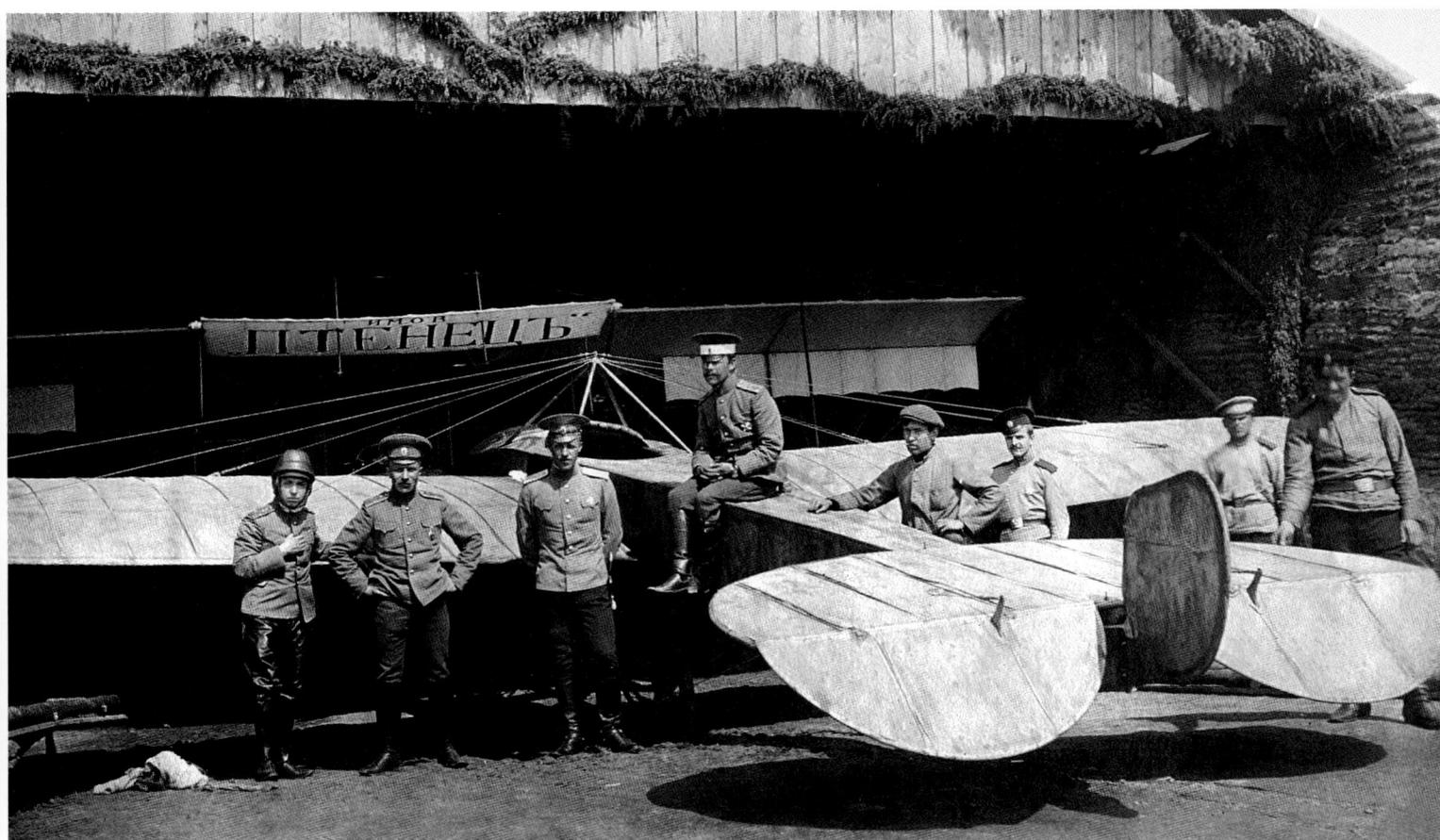

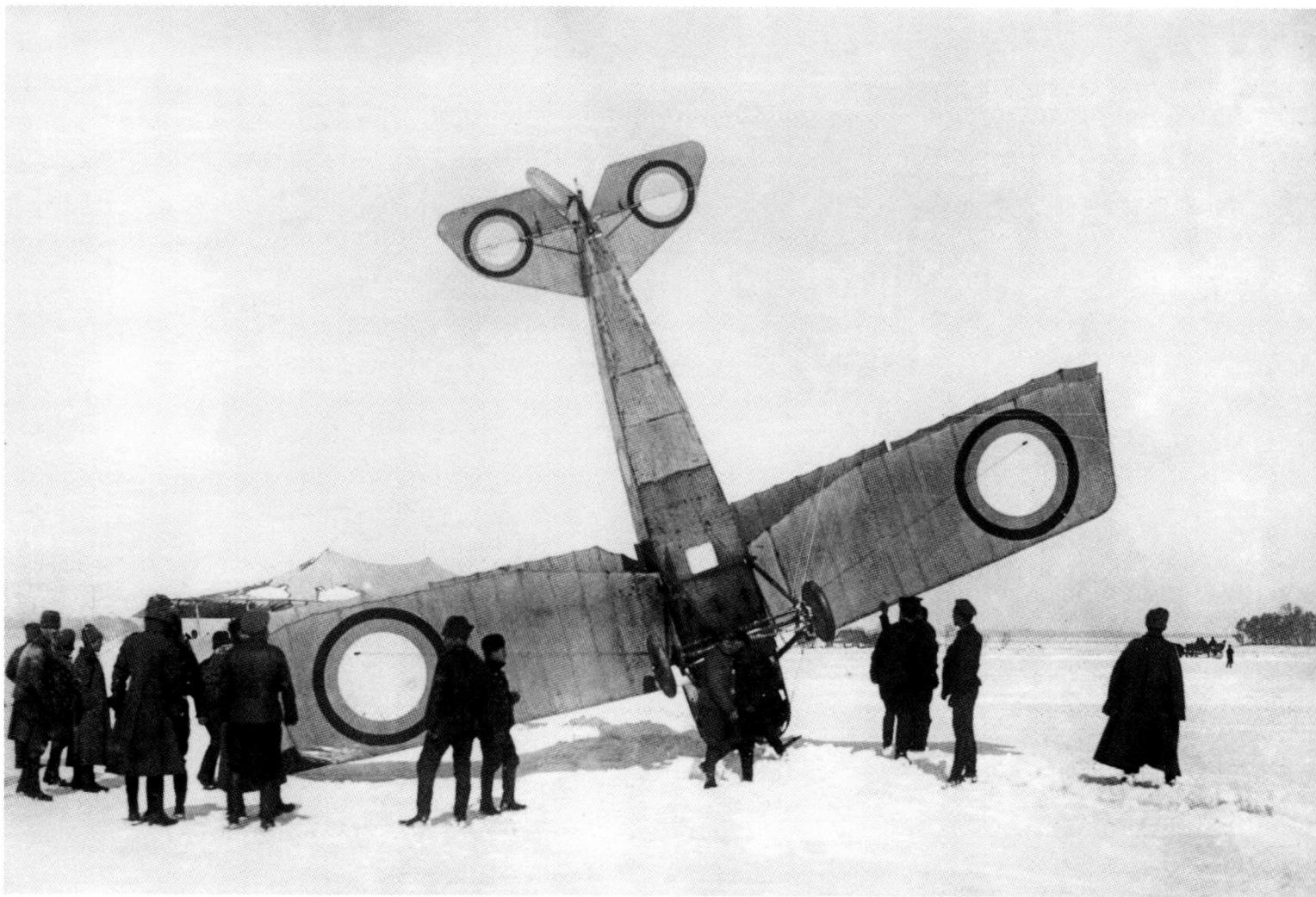

188. Crash of the plane *Anatra-Anade* **on the Moscow Aviation School field.**
Winter 1915—1916

189. Training plane *Moran-Parasol.*
1915
The partly-dismantled covering didn't allow the student to take off. Therefore, the student was taught to control the flight line in the airfield's territories.

190. Trainees of the Moscow Aviation School near the *Farman XVI.*
1916

191. P.N. Nesterov's "loop-the-loop", done by pilot A.M. Gaber-Vlynskyi.
Khodynskyi Field. Moscow. April 4, 1914

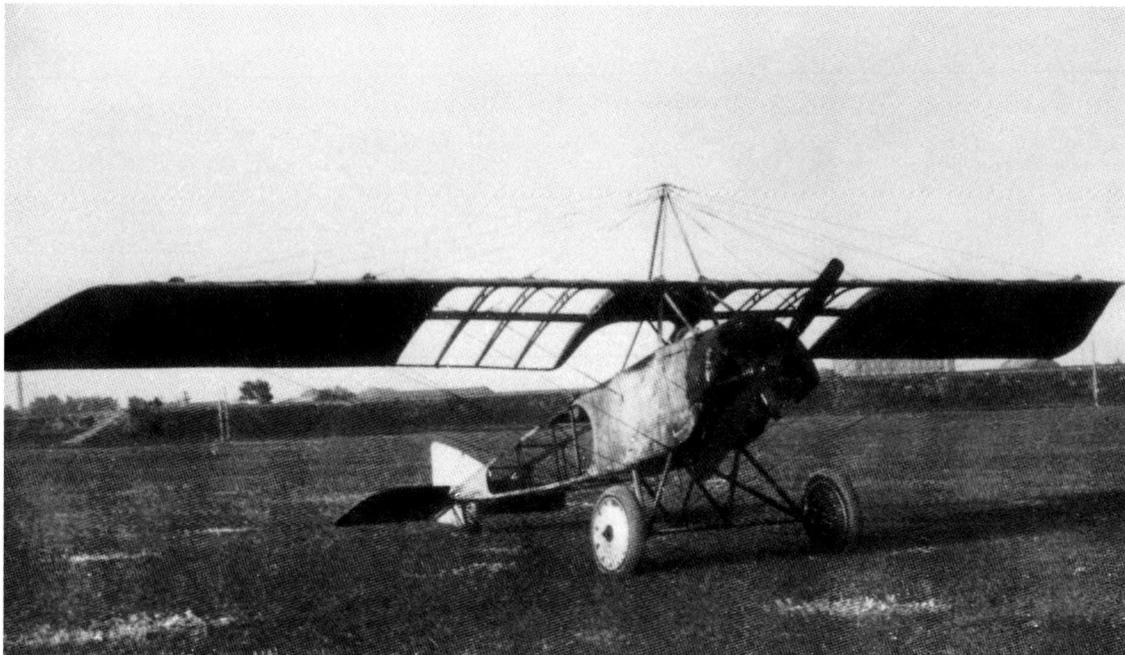

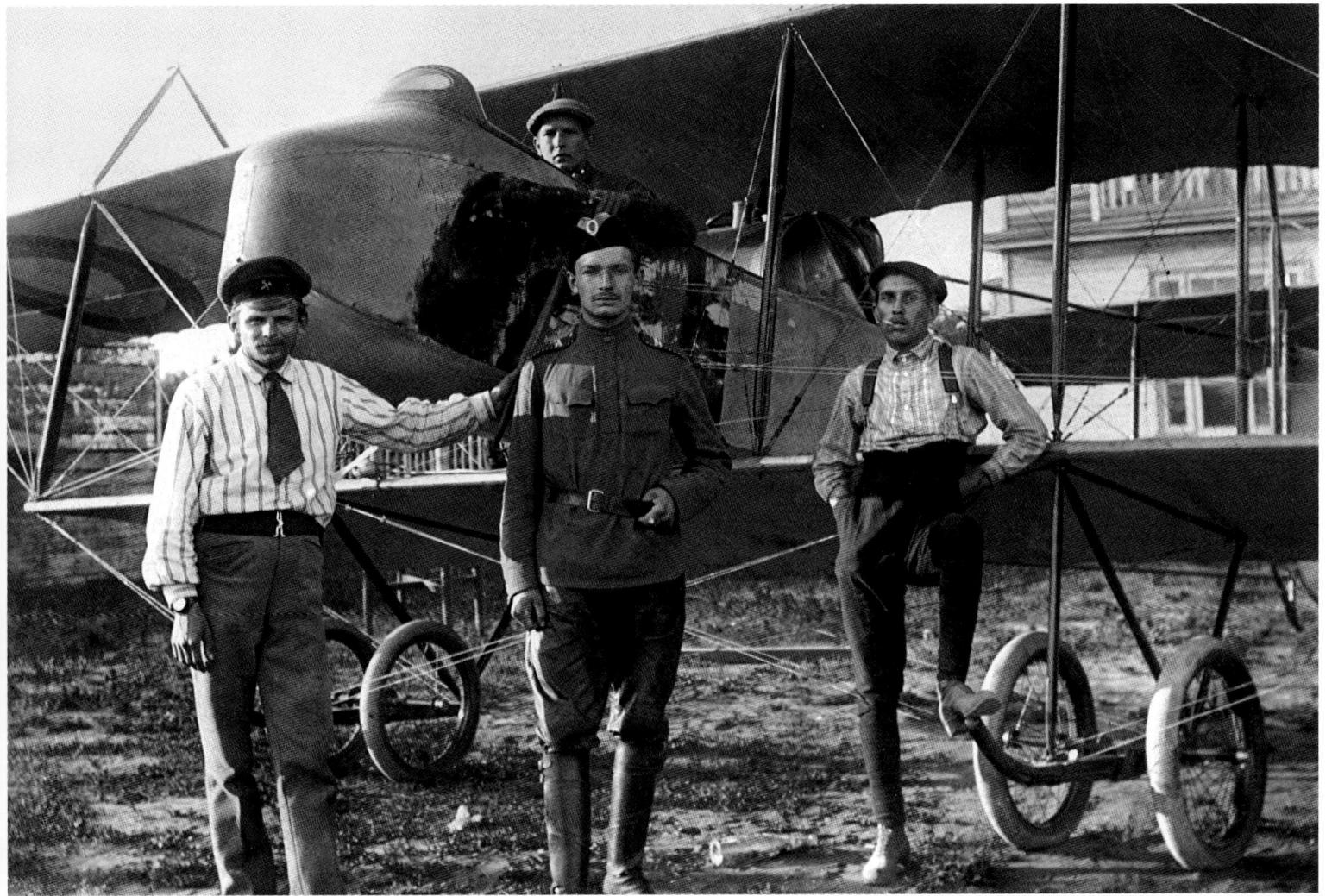

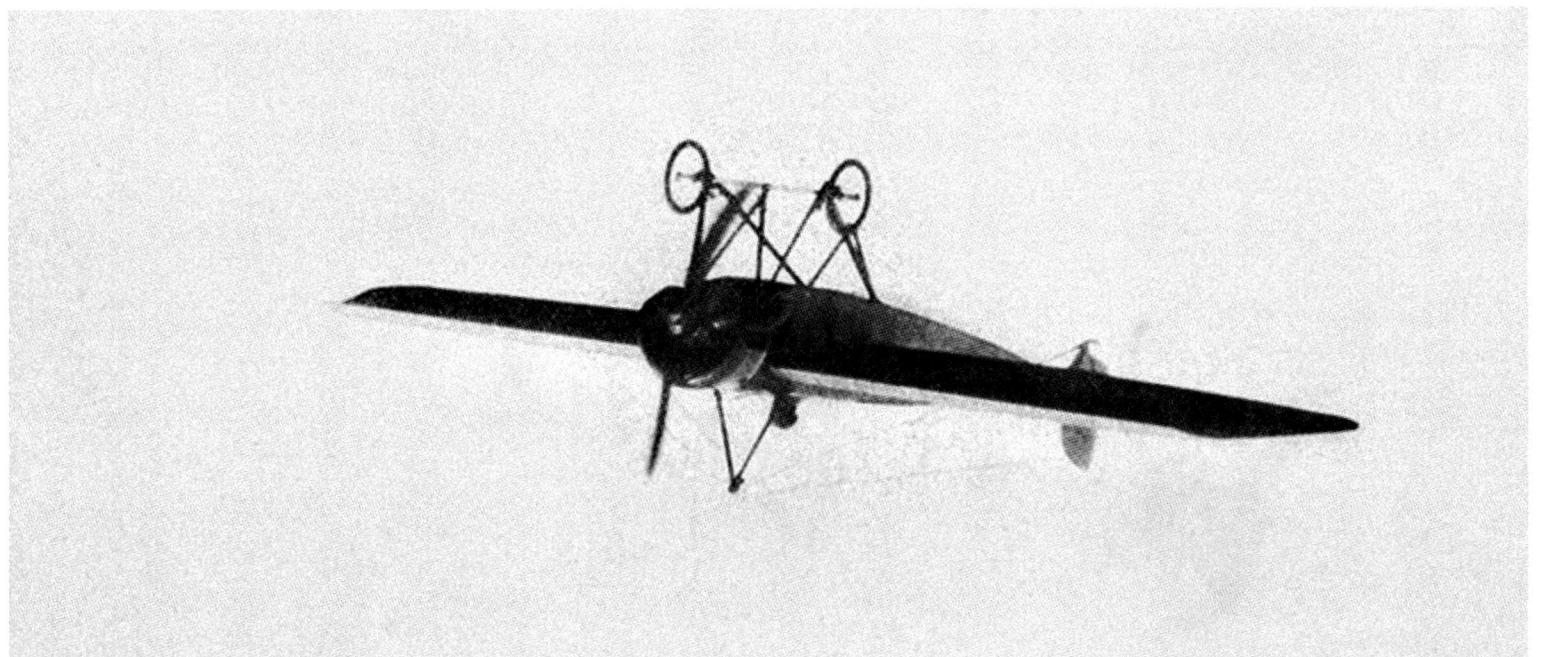

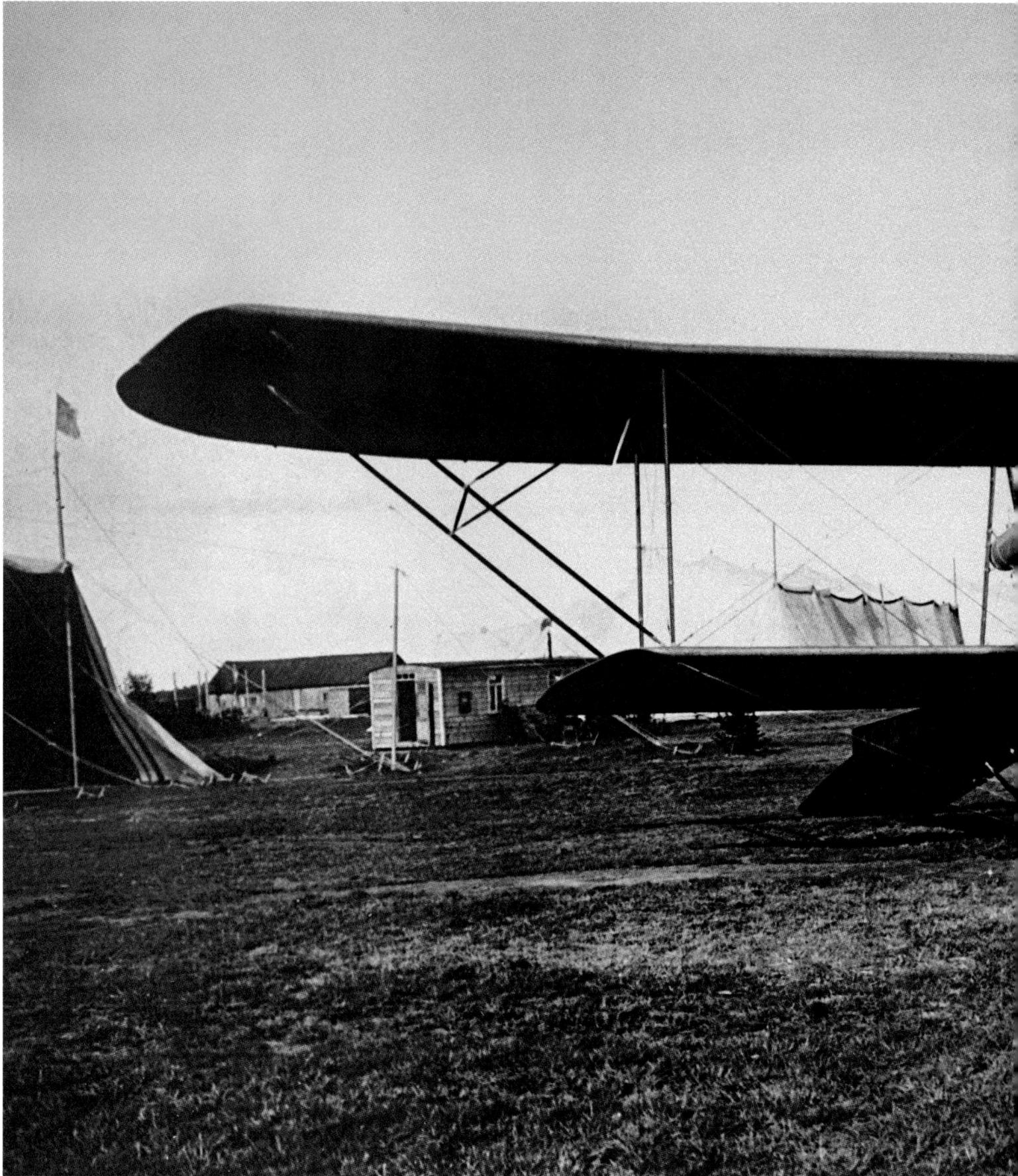

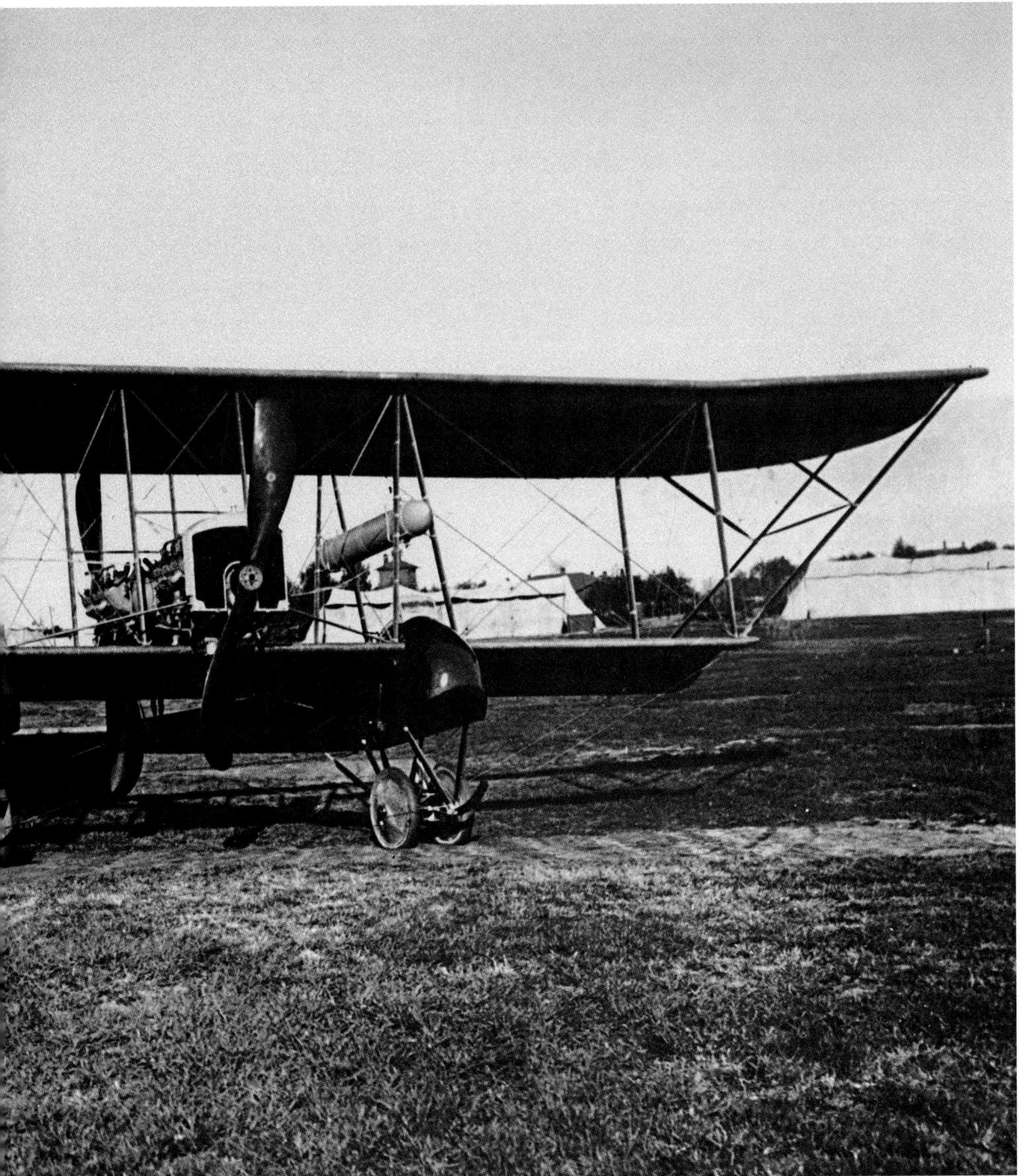

192. Designer I.I. Sikorskyi's *Diplura S-19* **before testing on the Korpusnoi Airfield.**
Petrograd. April 1916.

The first special businesses for building planes in Russia appeared in 1909. One of them, the First Russian Association of Aeronautics (FRAA), was based in the capital with workshops on Korpusnyi Street, and was owned by St. Petersburg lawyer S.S. Schetinin and plane builder Y.M. Gakkel, with participation from Moscow businessman M.A. Scherbakov.

Before long Gakkel left his companions and in 1910, opened his own workshop in Novaya Derevnya near the Komendantskyi Airfield. Over two years with his own money (while trying not to go broke) he tried to build airplanes of his own design. His story was not an exception, as other designers built and tried to commercialize their own planes, such as S.V. Grizodubov, A.A. Porokhovschikov, F.I. Bu-ilinkin, I.I. Sikorskyi, the brothers E.I., I.I., and A.I. Kasyanenko, G.K. Demkin, and E.P. Sverchkov.

Institutions of higher education held great significance in aeronautic circles, as many subsequently famous academics and designers in Russian aviation and aeronautics graduated from them. Factory owners like N.E. Zhukovskyi in Moscow made sure to employ these enterprising and talented students. As such, an entire «constellation of genius» among plane designers distinguished themselves: A.N. Tupolev, A.A. Arkhangelskyi, V.C. Stechkin, B.N. Uiriev, V.P. Vetchinkin and others.

At the FRAA factory in 1912 an order was placed for the French Farman and Blerio planes. In 1913, D.P. Grigorovich, a brilliant engineer and plane designer, arrived there. His first serious work was to understand the seaplane Donna-Leveque, which had been bought from France after a crash. Grigorovich designed and built the seaplane M-1 (Moscow 1) from its basis. This «aeroboat» became the first in an entire series of seaplanes - the more successful models of which even surpassed their foreign versions. Thanks to the young and talented plane designer, Schetinin's factory got a large order to produce seaplanes for the Naval Department.

Future plans for developing plane businesses, in part including opening FRAA branches in Yaroslavl and Sevastopol, couldn't be realized: the First World War and the events of 1917 disrupted these aspirations. D.P. Grigorovich tried to organize his own plane production for the Navy, having left the FRAA, but the start of the Civil War made this project unrealistic. Grigorovich only managed to partly realize his designing talents between 1920-1930, when he started building for the newly organized Soviet aviation.

In 1909, a workshop that built airplanes of foreign design was created from the overhauled Aeroclub in Odessa. In 1912, an aviation factory was founded on its basis with money from manufacturer A.A. Anatr (an Italian by birth). After receiving an order for building Farman type planes, the factory began its own production activities. The factory designed and built its own airplanes of the Anade, Anakle, Anasal, and Anadva types commercially, as well as licensing foreign designs. The talented Russian engineer Vasiliy Nikolaevich Khioni worked there to develop his own designs, and as such his planes were built commercially. In 1917, this factory had become a large business in the south of Russia, with a branch in Simferopol, where output was as high as 50 units a month (generally the land-based planes Anade and Anasal).

A new airplane factory appeared in Moscow in 1910, which evolved from the well-known Russian corporation Dukes. Up until that point, Dukes had issued bicycles, scooters and other devices. To begin building airplanes, Dukes, like all airplane factories, had to buy licenses to manufacture foreign planes like the Farmans and, later, Niupor IVs. The start of the war significantly increased production for the newly modified planes: the Farman XVI, Farman XX, Farman XXII and Moran. Dukes issued Niupors, Spads and other fighter aircraft. For the three years of the war, Dukes produced more than 1500 planes for the army, and the factory had its own designer-engineers, like F.A. Moska, N.N. Polikarpov and A.N. Tupolev.

Earlier in 1909, the Riga Russo-Baltic Railcar Factory (RBRF), the largest Russian producer of railway hardware, opened an aeronautic department (called Aviablat). Professor A.S. Kudashev from the Kiev Polytechnical Institute was the head, and he realized a few unique personal projects. In 1912, RBRF opened a branch in St. Petersburg and invited Ivanovich Sikorskyi to become the main

designer. He began with adaptations of the S-5A single motor planes as sea variants for the Naval Department, then followed with the S-10 (hydro), the S-6B in a land version, and also a few experimental planes. The S-16 was a more successful single-motor plane, which was built commercially and took part in World War I. Before 1913, I. I. Sikorskyi designed a completely new type of plane - a heavy multi-engine device that would be able to make long flights. As a result, the Russsky Vityaz (Russian Hero) and its «successor» the Iliya Muromets appeared.

In 1912, another aviation business under the control of the famous licensed pilot Vladimir Alexandrovich Lebedev was organized in St. Petersburg. He started his work producing plane propellers and replacement parts for planes like the Deperdiusen. In April 1914, he started to produce those very same planes along with the Vuazen, and towards the end of 1914 he prepared seaplanes (from the Franco-British Aviation Company or «FBA») for licensing. When the war started, Lebedev began to repair at the factory captured German and Austrian planes. After the repairs and modernizations, and with the new name Lebed, they were returned to the army. Thus, a few types of planes were built, from the Lebed VII to the Lebed XVIII, and then experimental work started for original designs, like the Lebed Grand and K-1, with participation from designer and conceiver L.D. Kolpakov-Miroshnichenko.

The war demanded that aviation design expand its production capabilities, which greatly widened the network of businesses connected with aviation. The largest of them was the Russo-Baltic Railcar Factory (that is, its aviation department Aviablat), the factories of S.S. Schetinin and V.A. Lebedev in St. Petersburg, and Dukes in Moscow.

In these years scientific research developed rapidly, as aviation businesses began to have their own designing departments, which studied modernization of foreign-bought planes, as well as re-working of domestic projects. I.I. Srikorskyi, D.P. Grigorovich, Y.M. Gakkel, A.A. Porokhovschikov, and V.N. Khioni especially distinguished themselves in this area.

Russian designers often proved that they could make planes better than the foreign-bought ones. An example of this is the seaplane M-9 of D.P. Grigorovich. The design turned out to be so successful, that the British government asked the Russians to grant them the licensing, so that they could use the plane for their own needs.

Unfortunately, not many Russian designers were adept at making planes that did not look Western and could also be commercially successful - the pull was too strong to be like the West, especially in governmental spheres. Many Russian factories obtained licenses for imported planes (almost exclusively French models), or they finished foreign planes for war needs, installing radio telegraph units, and different types of bombardment and rifle machine gun weaponry.

In 1917, V.A. Lebedev opened a branch of his business in Taganrog, which built seaplanes. Lebedev and Co. built designs from inventors G.A. Fride, A.U. Villish, and V.A. Slesarev.

Pilot-sportsman Vladimir Viktorovich Sluisarenko and his wife, aviator Lydia Vissarionovna Zvereva, also wanted to design planes. Having become famous for public flights in various Russian cities, they received an order from the War Department in 1913 to produce the Farman XVI. The pair founded an aviation business in Riga with their own flying school. At the start of the war, they received financial support from the military and moved their factory to Petrograd. At the start of 1916, their aviation factory grew larger due to an increasing number of orders for Moran-Parasol, Moran X, and Farman planes, as well as various experimental types of military planes.

Other aviation businesses also existed in Russia, and while not as large, they undoubtedly made their mark in developing Russian aviation. For example, there was F. Meltzer's factory in St. Petersburg, building by E.R. Engels' design a few original seaplanes, the F.E. Mosk's Moscow Aviation Factory, the A.A. Porokhovschikov's factory (in Petrograd), where a few of his projects were realized, the factory Salmson in Moscow, as well as factories that made the plane motors Gnome and Ron. Practically all plane factories and businesses were privately owned, and a few depended on foreign capital. The government also wanted to build a factory, but this idea remained unrealized.

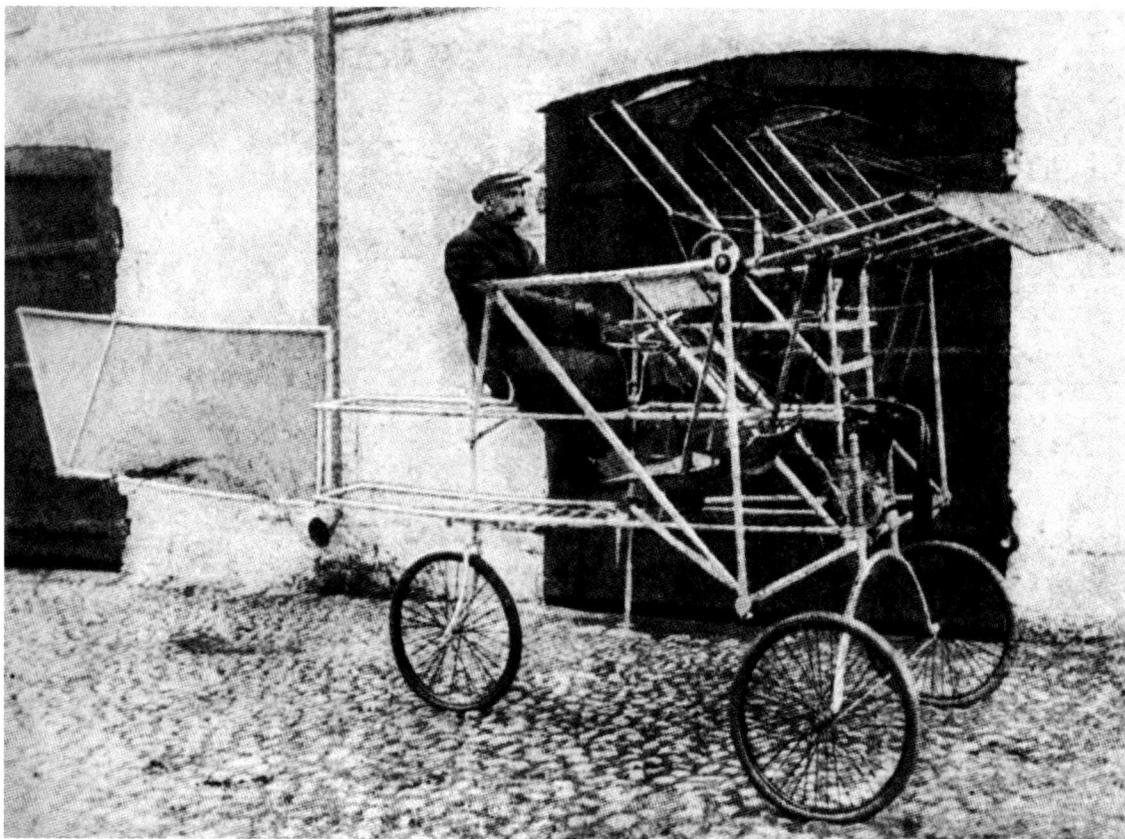

193

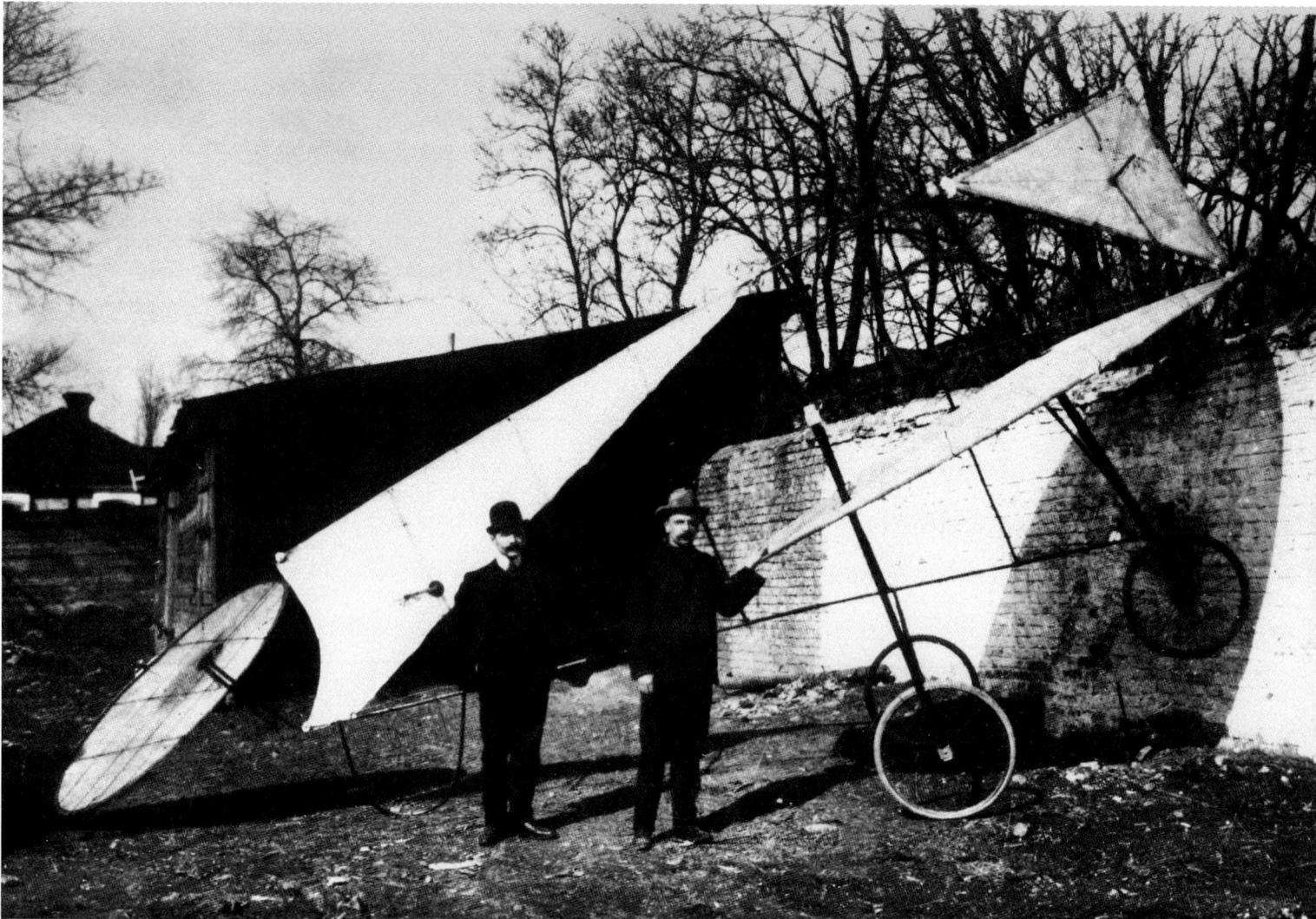

194

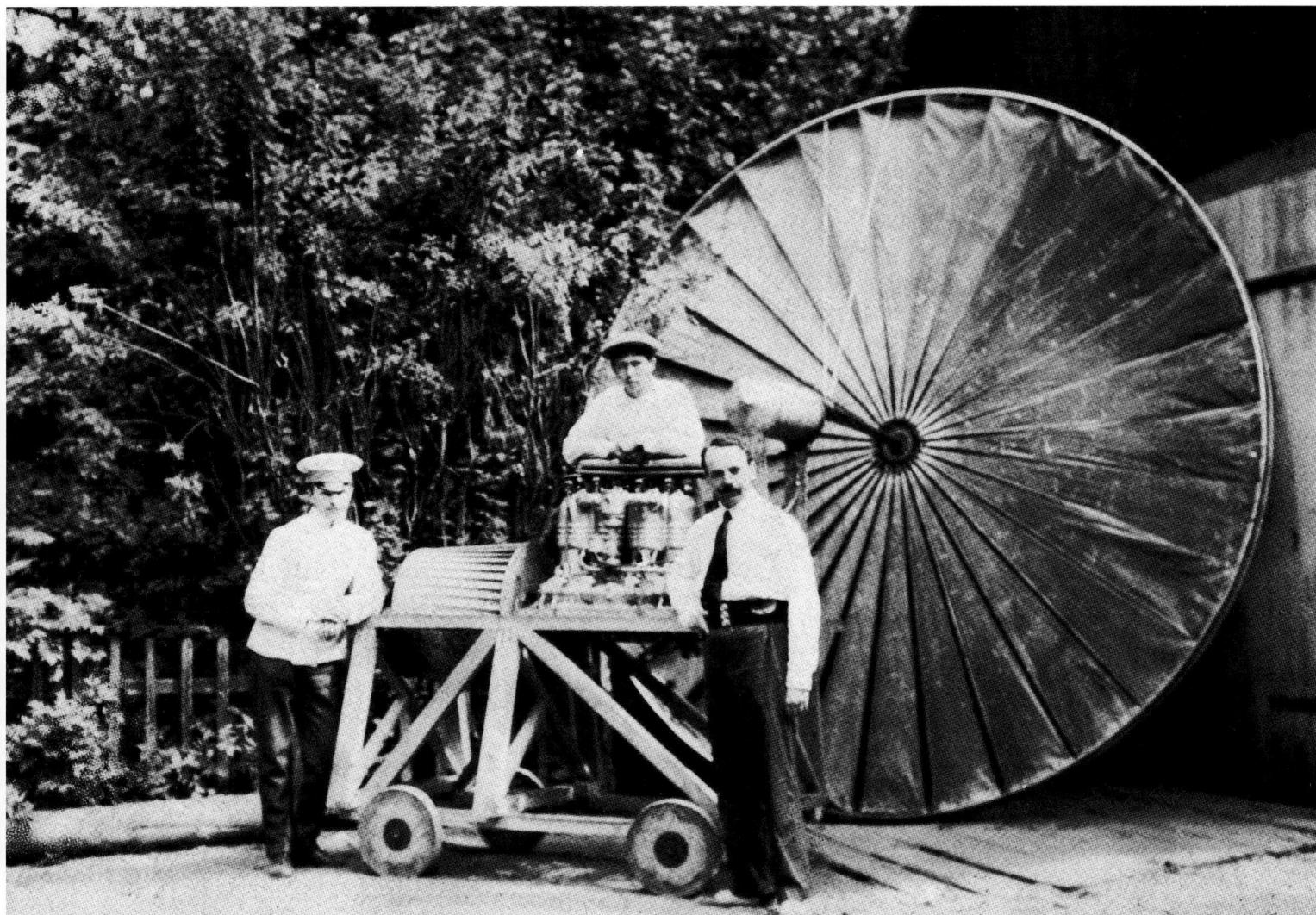

**193. Military engineer
E.P. Sverchkov's** *plane.*
1909
*Built with funds from the Main
Engineering Office in St. Petersburg.*

**194. The talented Russian innovator
and designer Anatolyi Georgievich
Ufimtsev (on the right), next to the**
Sferonlan-1 **without an engine.**
Kursk. 1910

**195. Designer-inventor N.I. Sorokin
(on the right) near the engine** *Argus*
and in front of a propeller-ventilator.
1012 — 1913

196. The *Sferoplan-2.*
1910 — 1913
*Built in 1910, it had an engine of 60
horsepower. During tests it was broken
down by a squally wind.*

196

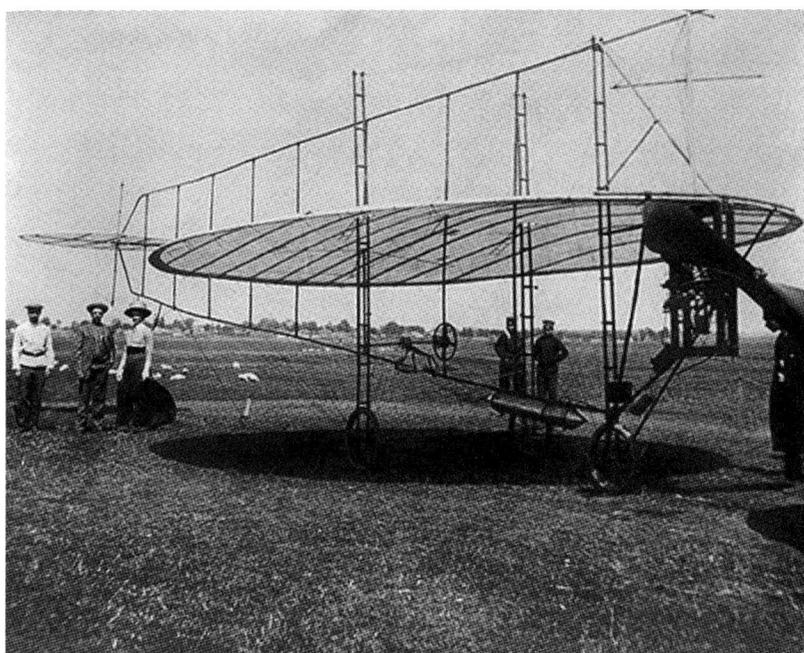

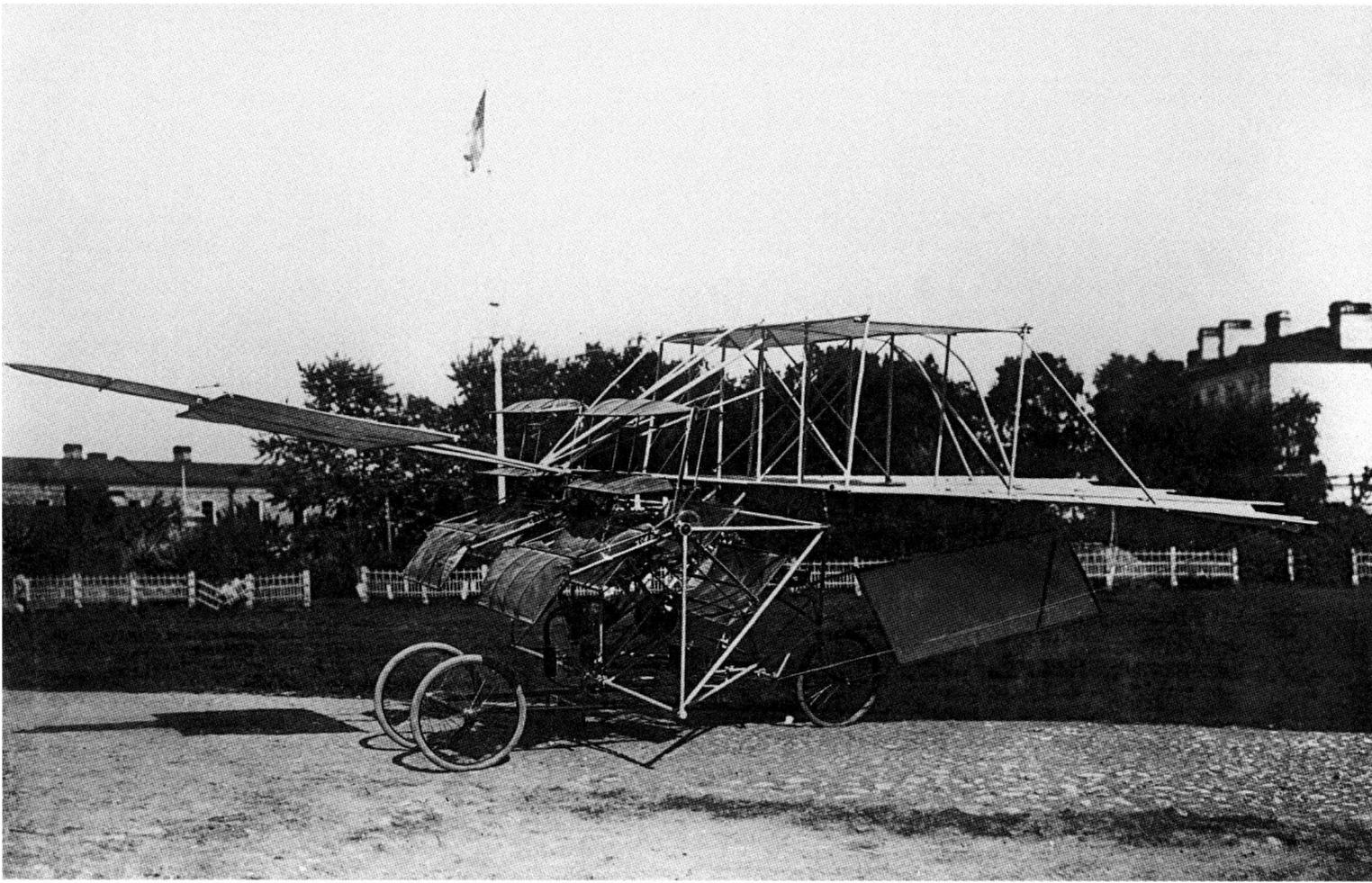

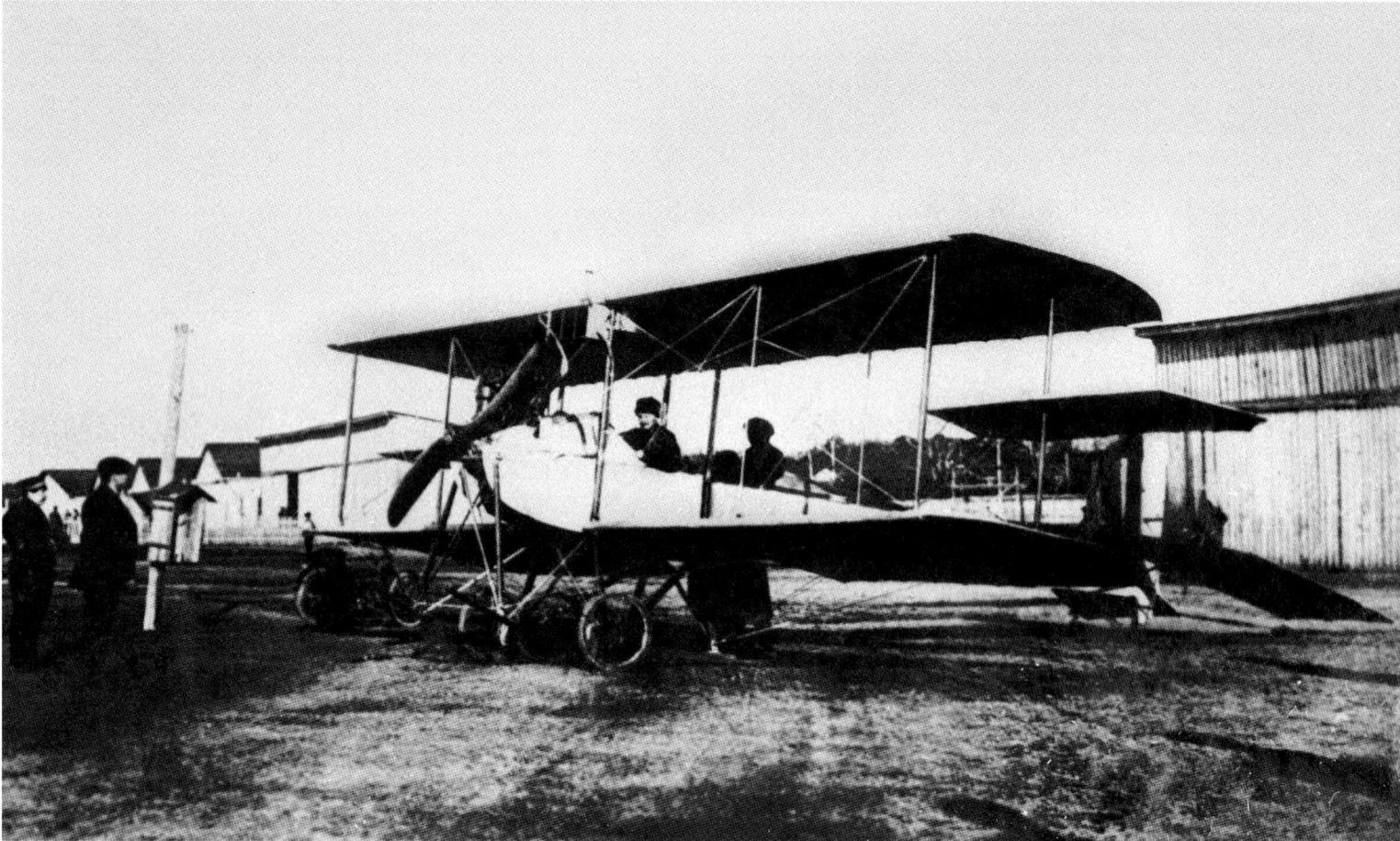

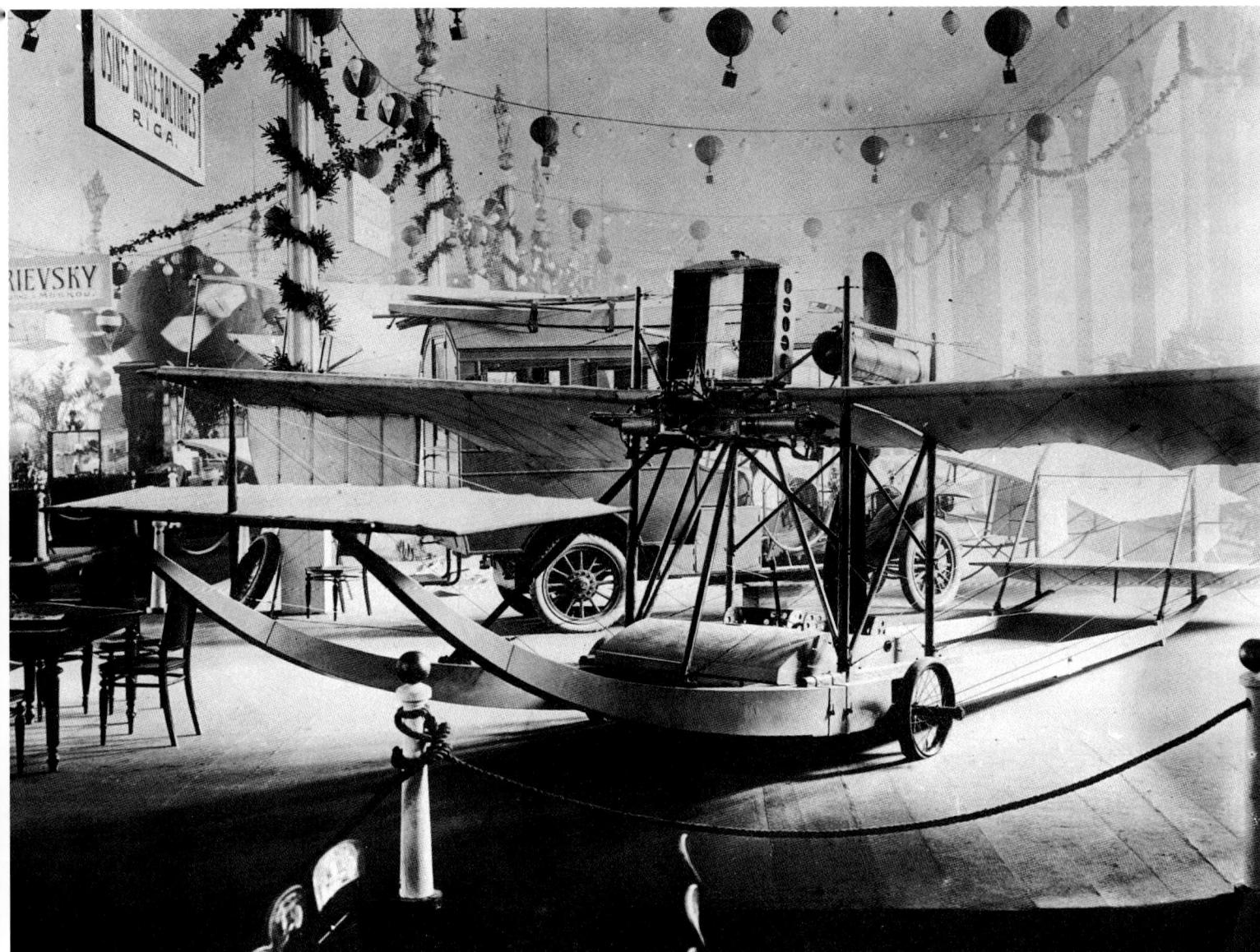

197. E.P. Sverchkov's *plane.*
St. Petersburg. 1910

It received a medal "For Original Design" on May 4, 1909 at an international exhibition of new innovations, which was organized by the Society of Military, Naval, and Farming Technology at the Mikhailovskyi Riding Academy.

198. The plane *Gakkel VIII* **during tests.**
Gatchina. 1913

In 1912, at the Second International Exhibition in St. Petersburg the plane received a gold medal.

199. Y.M. Gakkel's twin-float seaplane, the *Gakkel V.*
The First Aeronautical Exhibition.
St. Petersburg. 1911

The plane was awarded the Imperial Russian Technological Society's silver medal.

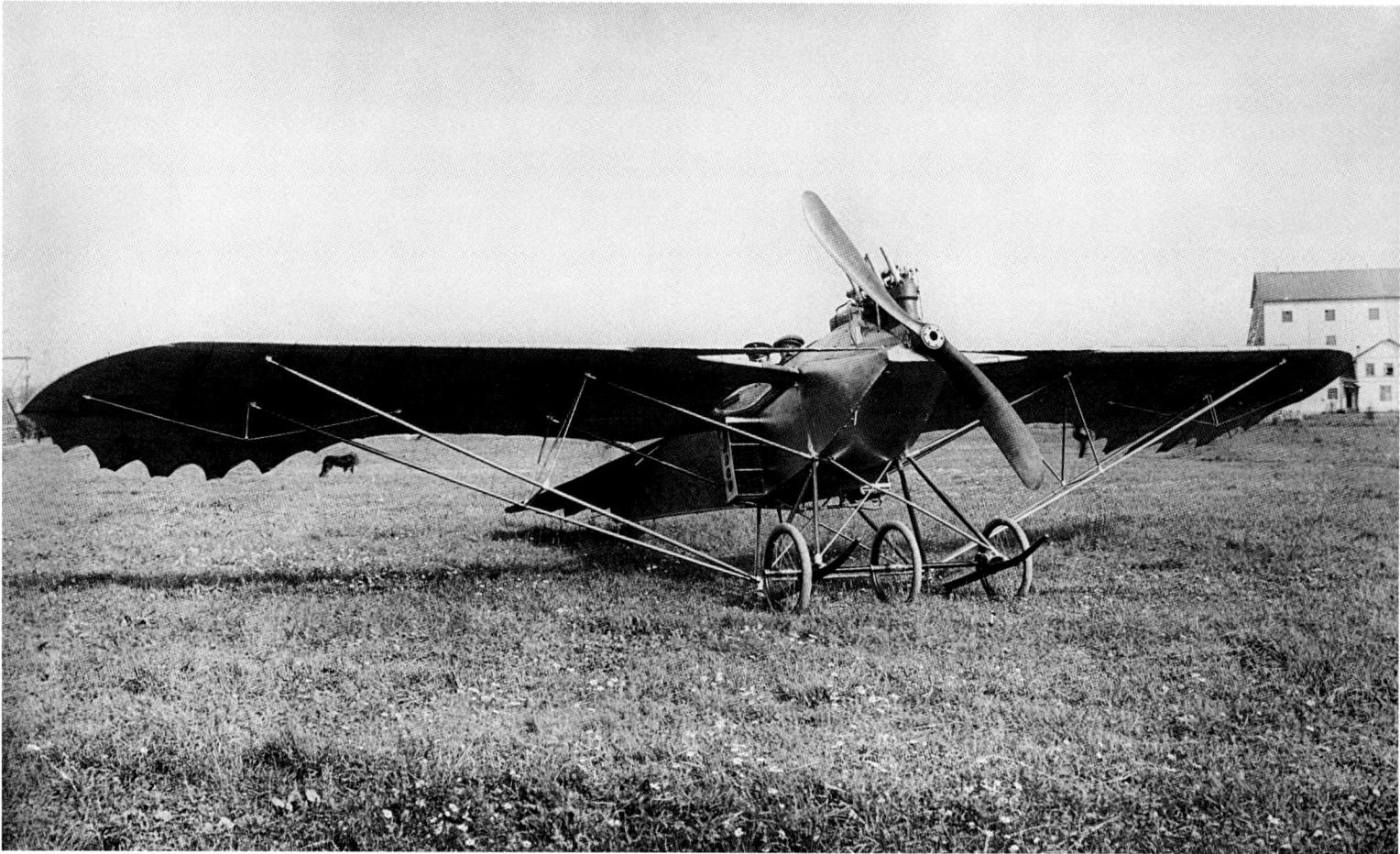

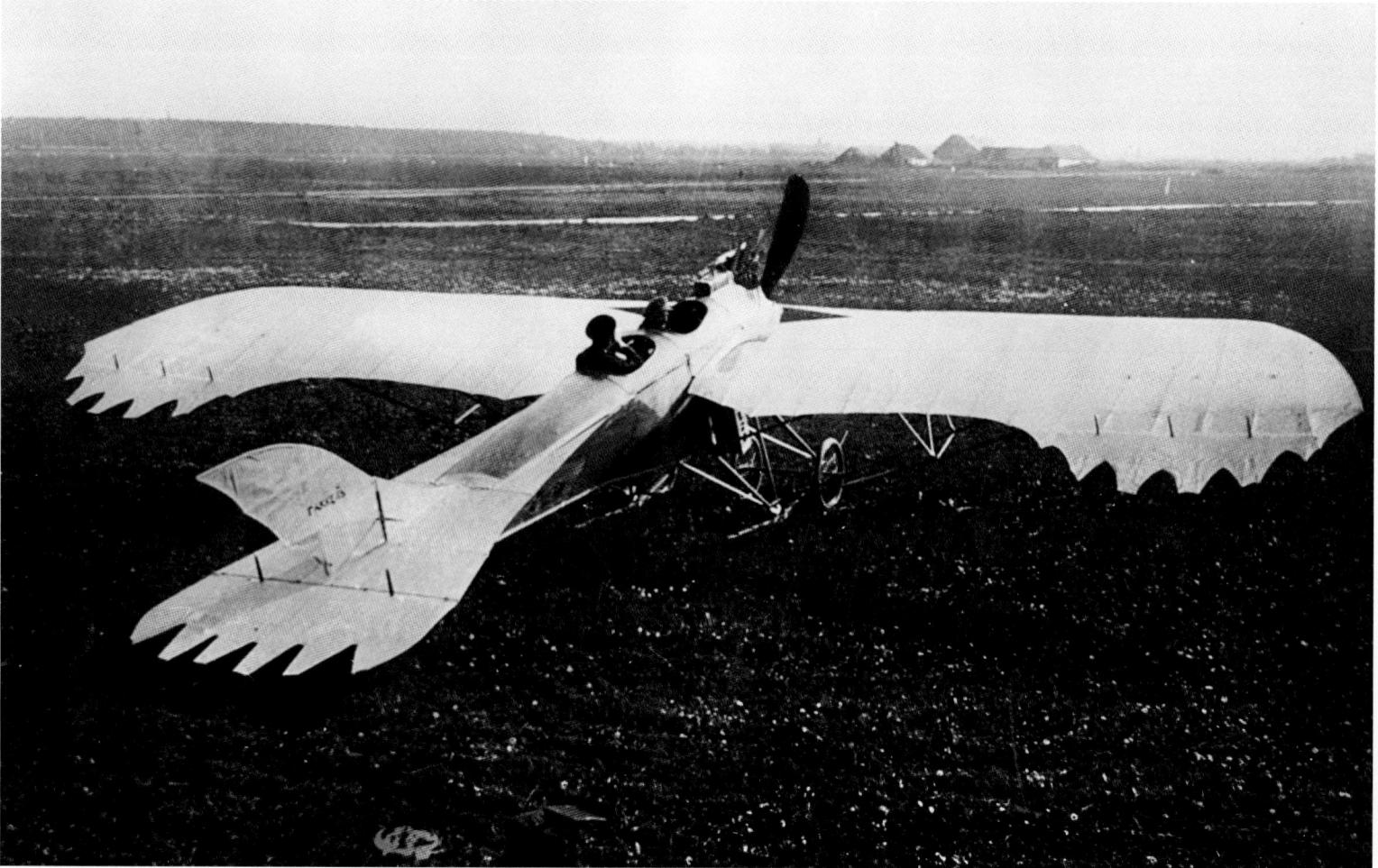

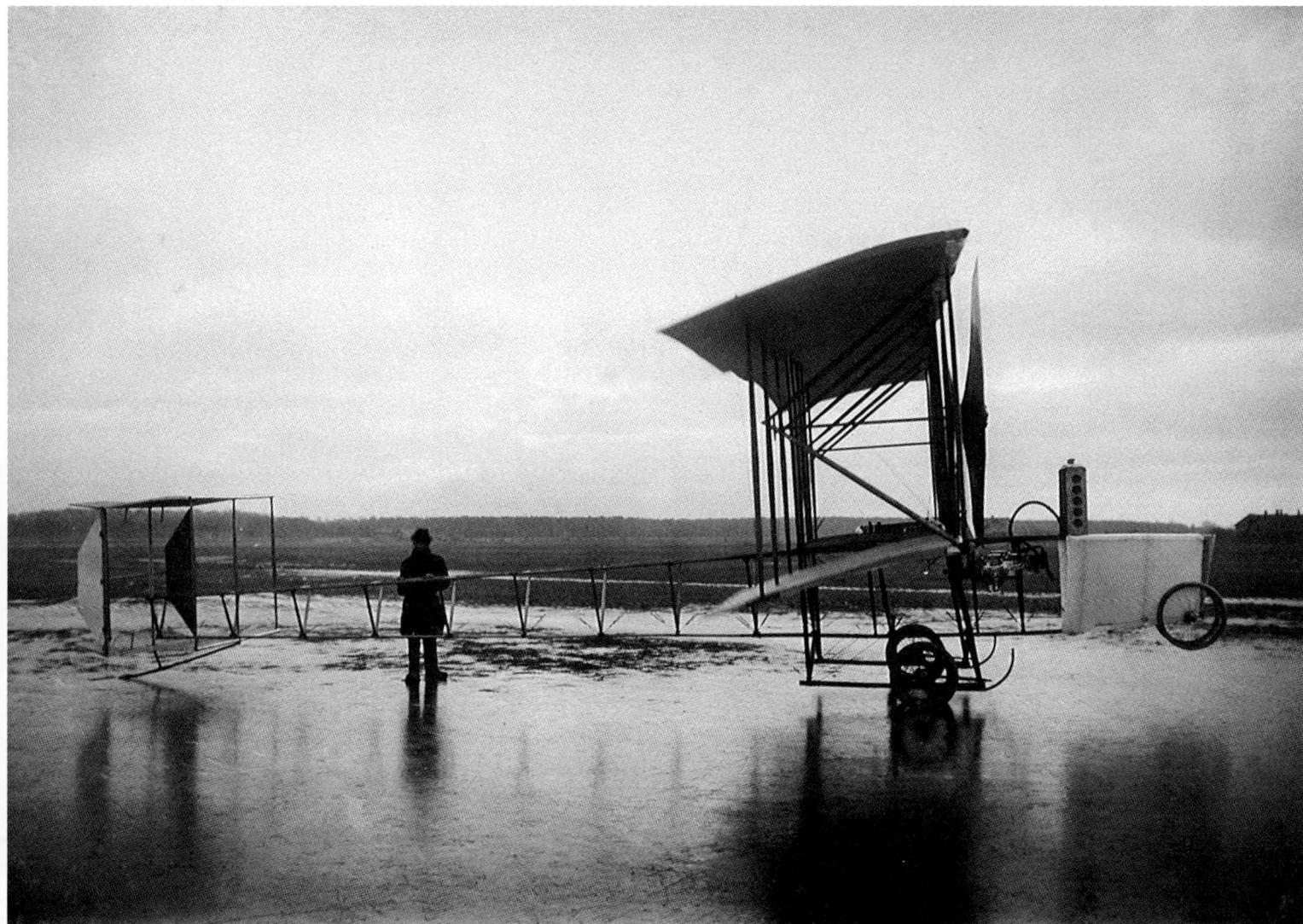

200. The original *Gakkel IX.*
St. Petersburg. 1912—1914
The device, with an Argus *motor of 80 horsepower, was built in 1912. It participated in a competition at the Third Aviation Week, but because of engine problems it could not complete the program.*

201. A plane of Yakov Modestovich Gakkel's design, copying the figure of a bird...
1912—1914

202. Airplane of the Kasyanenko Brothers, with an original system for the wings that changed their angle.
St. Petersburg. 1911
It was built in 1912 with an Arlikon engine of 50 horsepower that had a fuselage with a transfer on two propellers.

203. The two-seater-monoplane-tandem plane with a thrusting propeller and *Labor* **motor.**
1912
A plane by S.K. Dzhevetskyi's design with a 70 horsepower engine. Shown at the Paris International Exhibition in 1912.

203

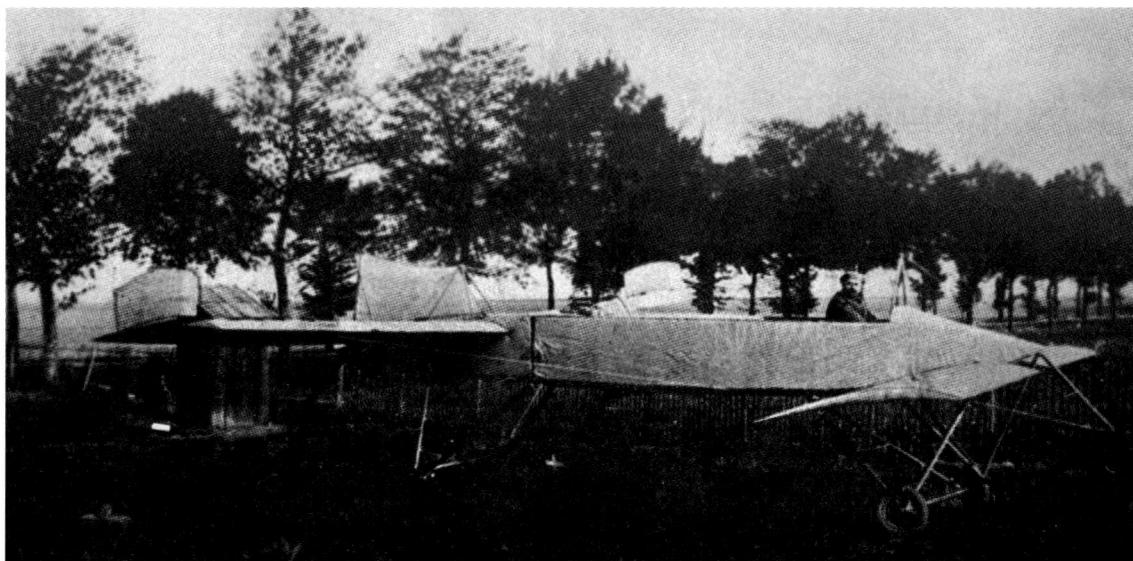

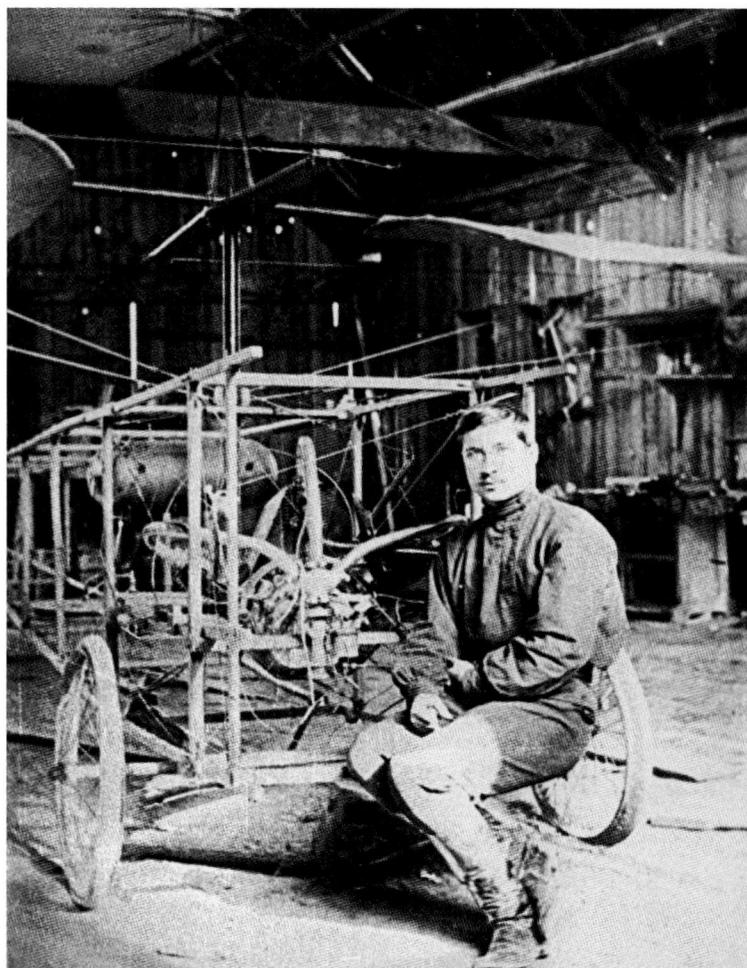

204. The young designer B.N. Iurer in a hanger near a full-scale miniature with a light motor of 25 horsepower.
Moscow. 1910

Boris Nikolaevich Iurev, a Technical Institute student, used his own theory of propellers to re-work the one-propeller device with a Gnome motor of 70 horsepower. Because of material difficulties and a lack of necessary engines, he had to build a helicopter with a weak Anzani motor of only 30 horsepower. The author received a writ of protection from the Patent Bureau of the Russian Trade and Manufacturing Department because of its design in September 1910.

205. View of the full-size helicopter of B.N. Iurev (on the left).
1912

Built by students of the Technical Institute in 1912, the helicopter received a gold medal at the Second International Exhibition of Aeronautics in Moscow. Its schematics became the model for practically all single propeller helicopters.

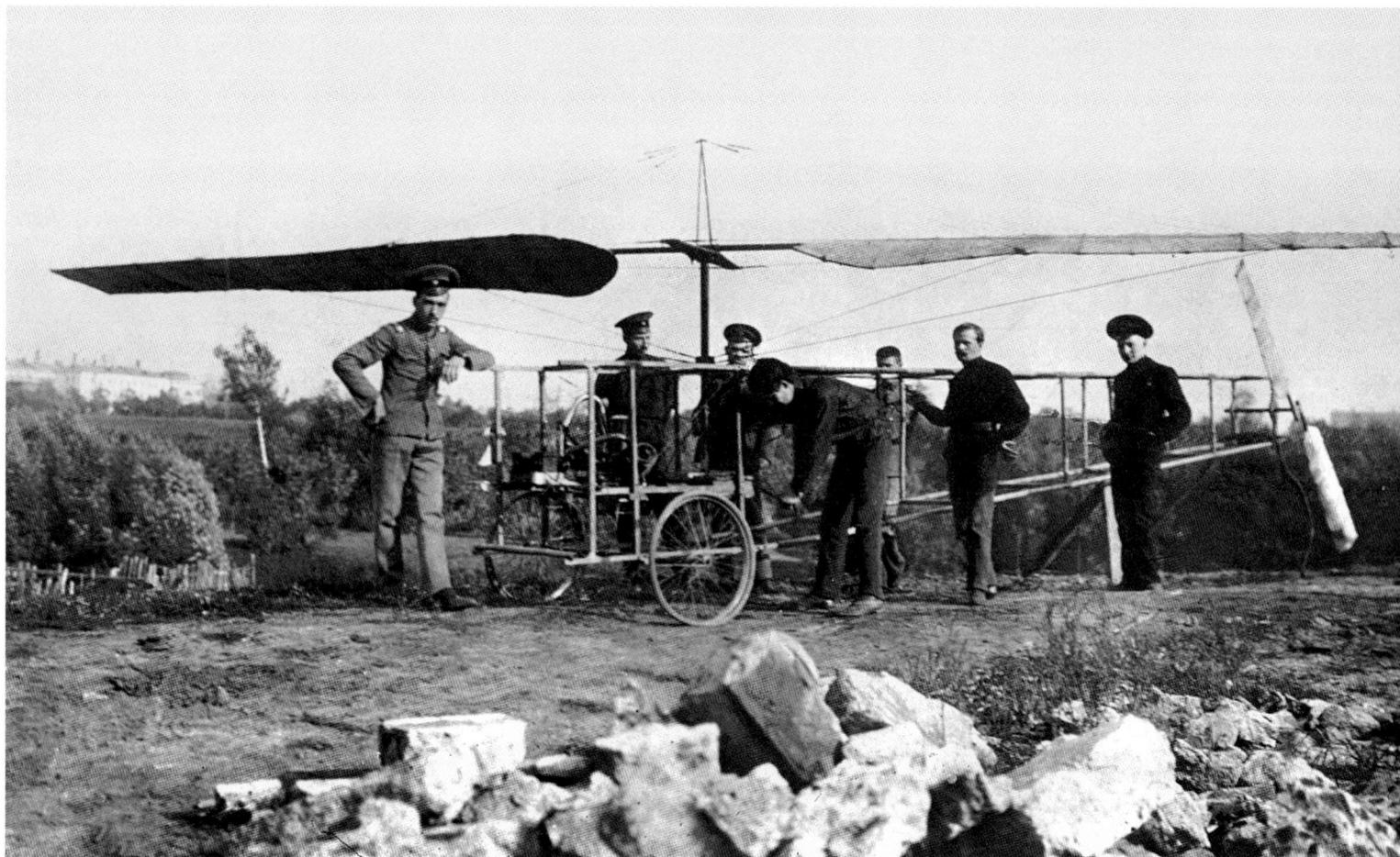

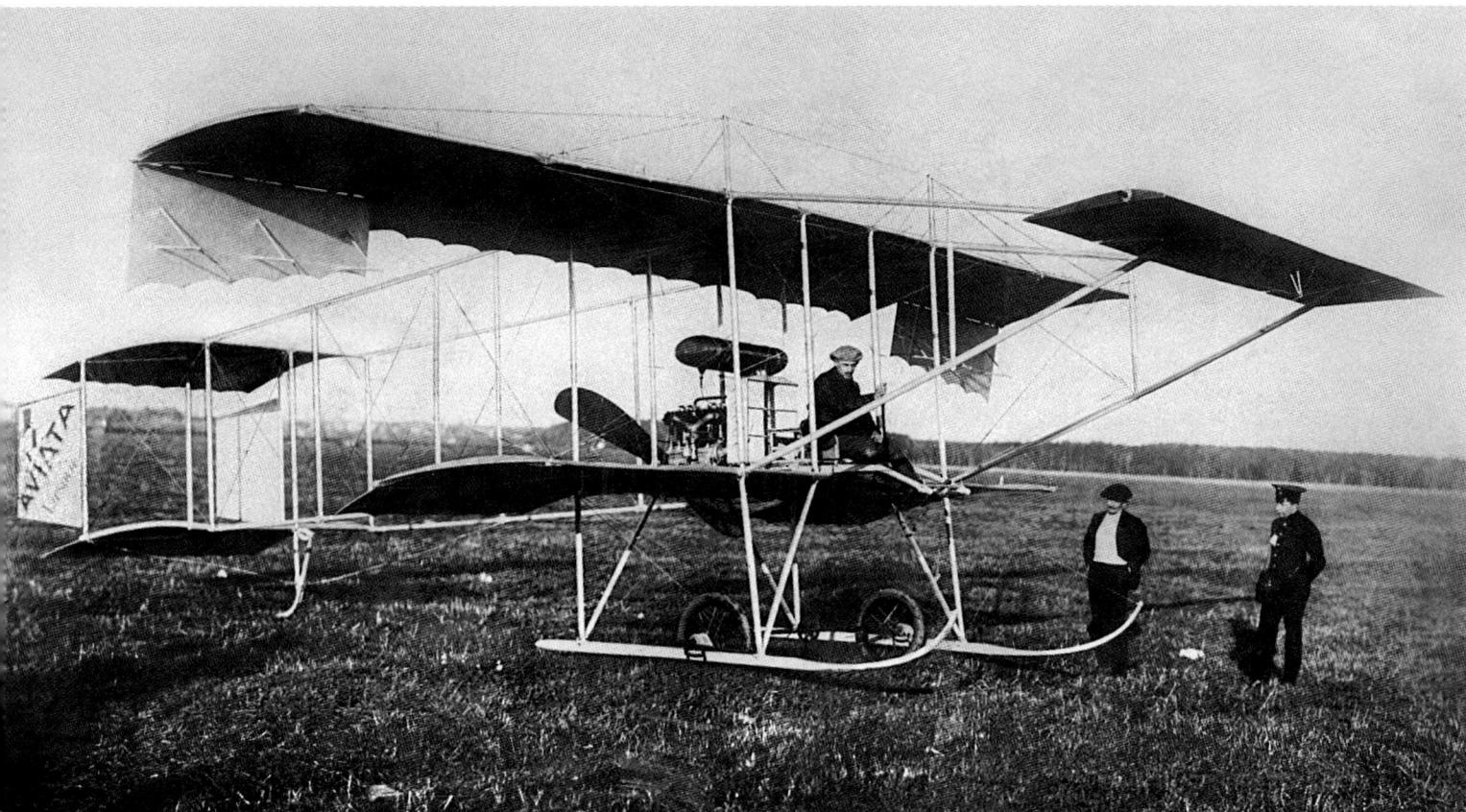

206. The airplane *Farman-Aviata.*
St. Petersburg. 1910—1911

Built at the Warsaw firm Aviata, *the War Department took a few types of the device for training purposes..*

207. The airplane *Kudashev-1.*
Prince A.S. Kudashev sits behind the steering wheel..
Kiev. 1910

The plane had an Anzari *engine of 35 horsepower. The flight was made May 23, 1910 at the Syretskyi airfield in Kiev.*

207

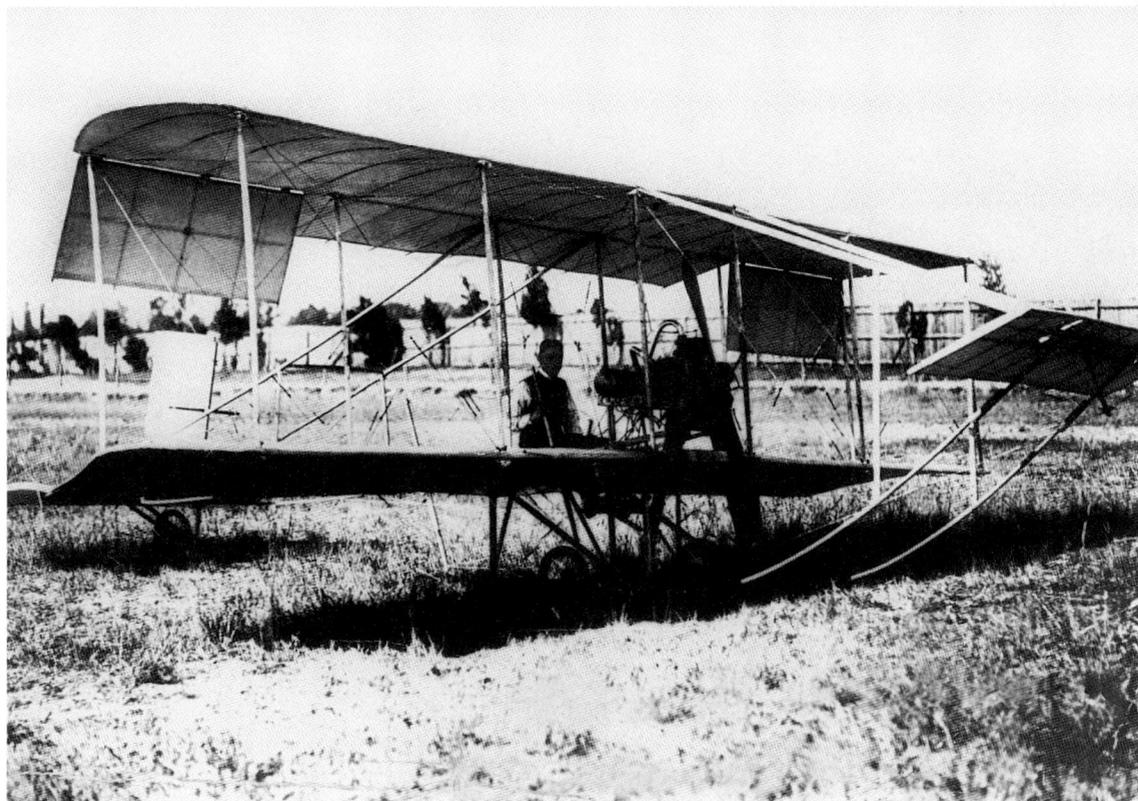

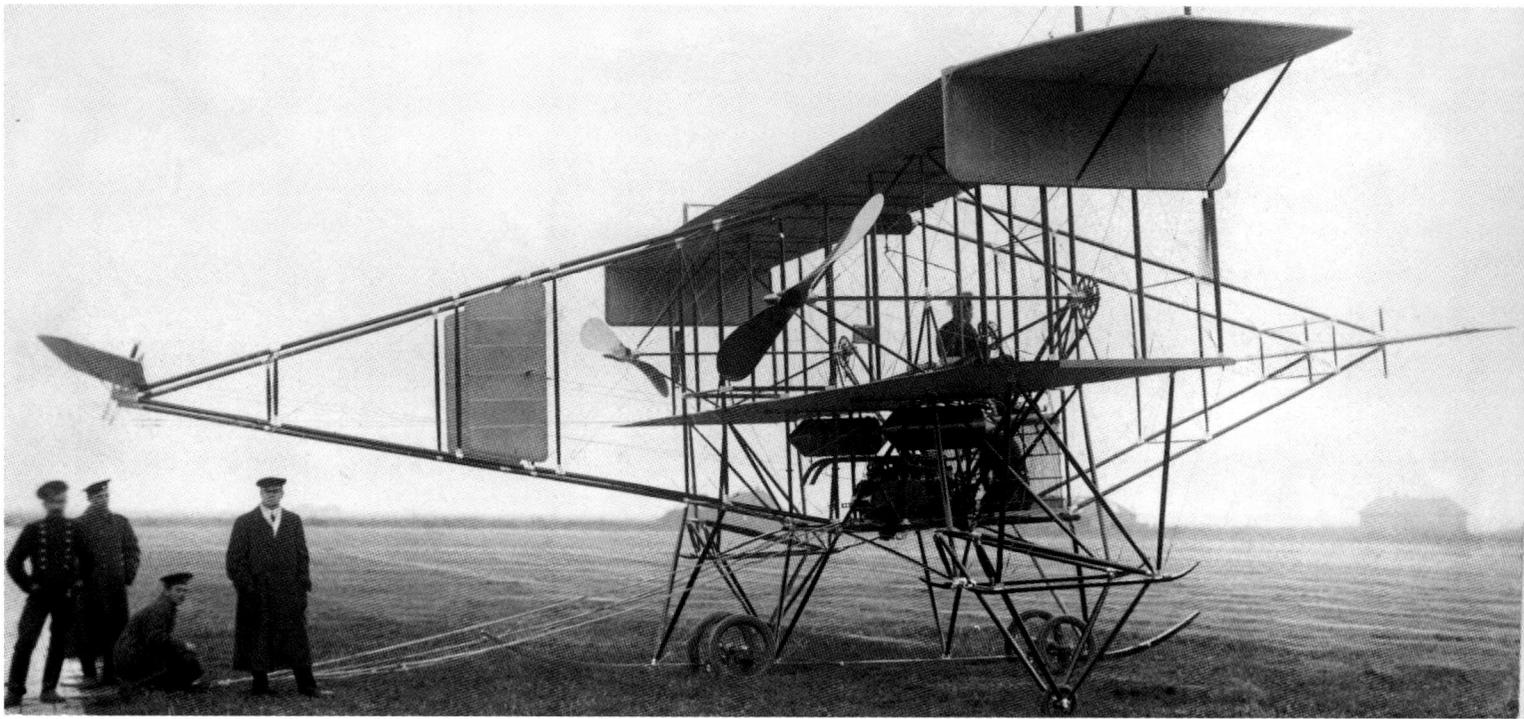

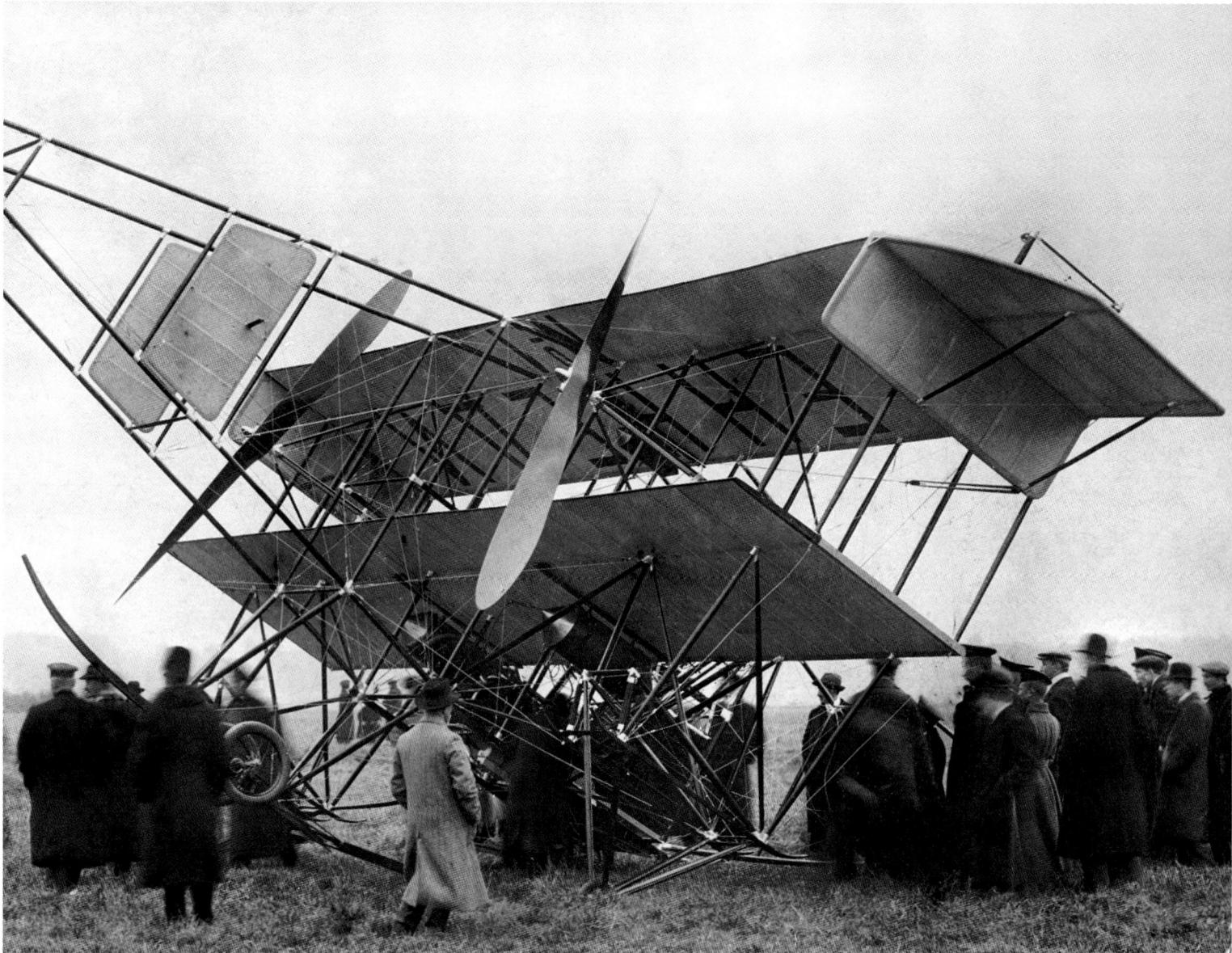

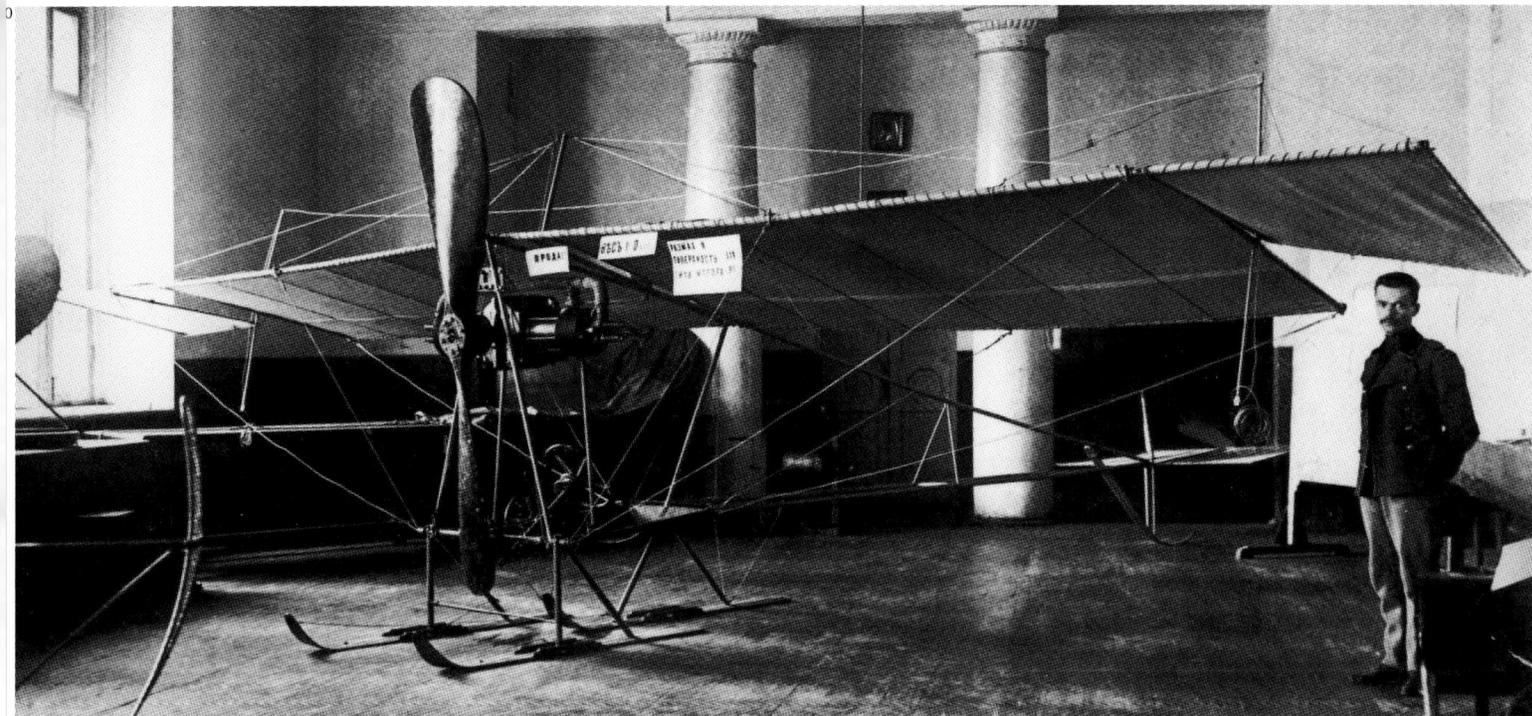

208. English engineer C.M. Kennedy's plane (one of the representatives of the famous Kennedy clan), at a competition of war airplanes.
1912

209. A plane that crashed, which was designed by C.M. Kennedy and piloted by N.A. Yatsuk.
1912
C.M. Kennedy's plane had a cumbersome truss design that was so different, aviators refused to test it. After the unsuccessful competition, the designer went home, taking with him Russian secrets.

210. Inventor U. Kemp's monoplane.
Moscow Aeronautical Exhibition. 1910

211. A plane of Alexander Danilovich Karpeki's design. *Biplane-1.*
Kiev. 1911

212. The plane *Grisodubov-3.*
Kharkov. 1910—1911
The designer took a risk and carried his year-old daughter on it, the future aviator and Soviet hero, Valentina Grizodubova.

212

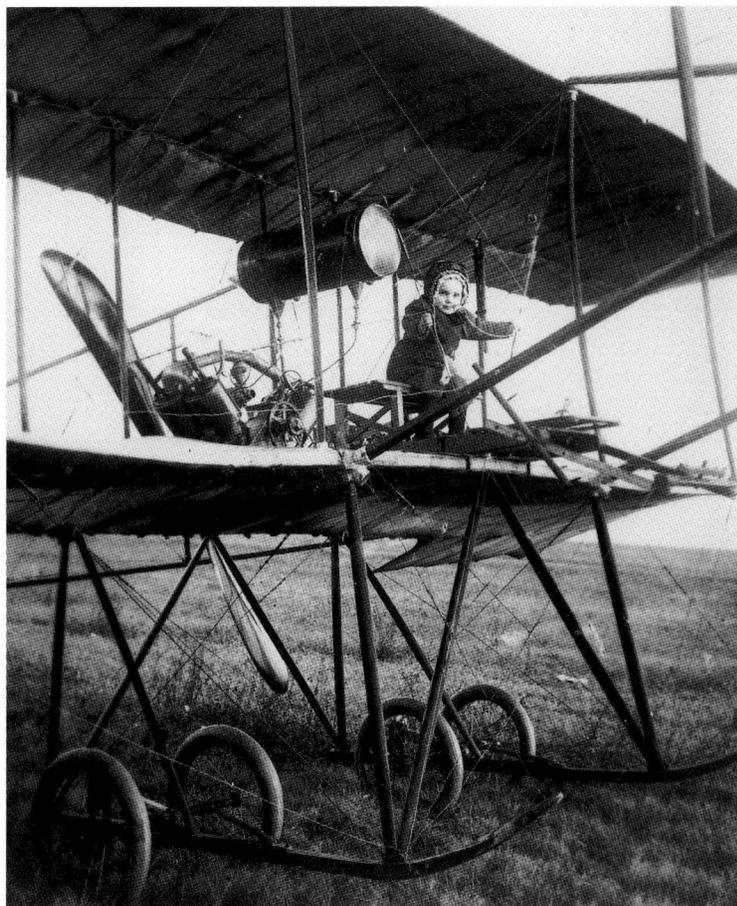

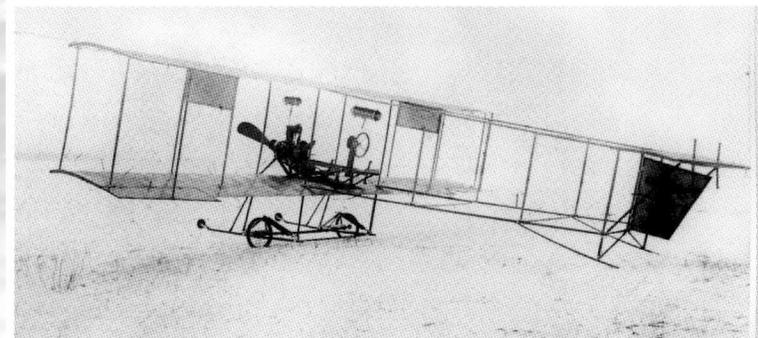

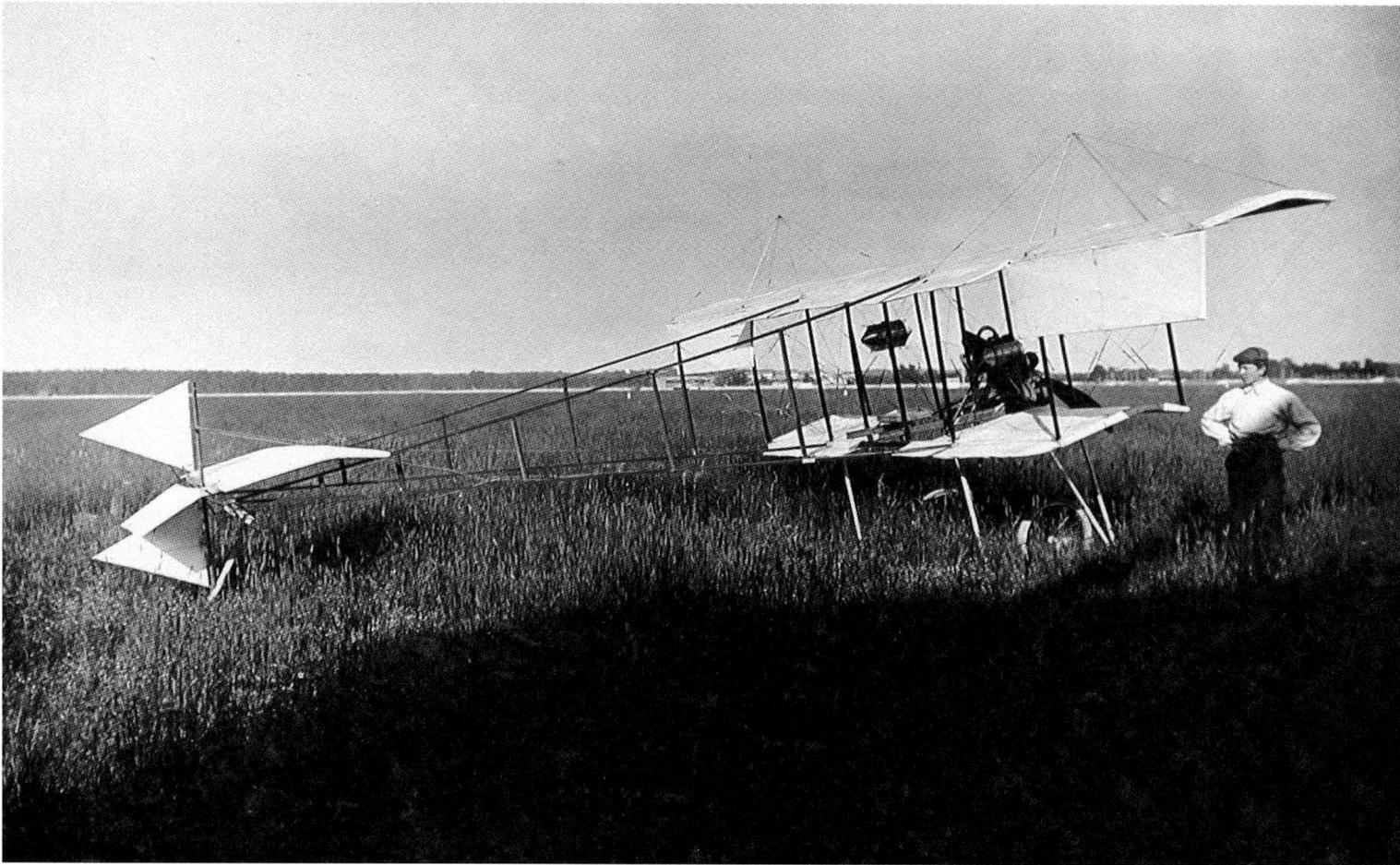

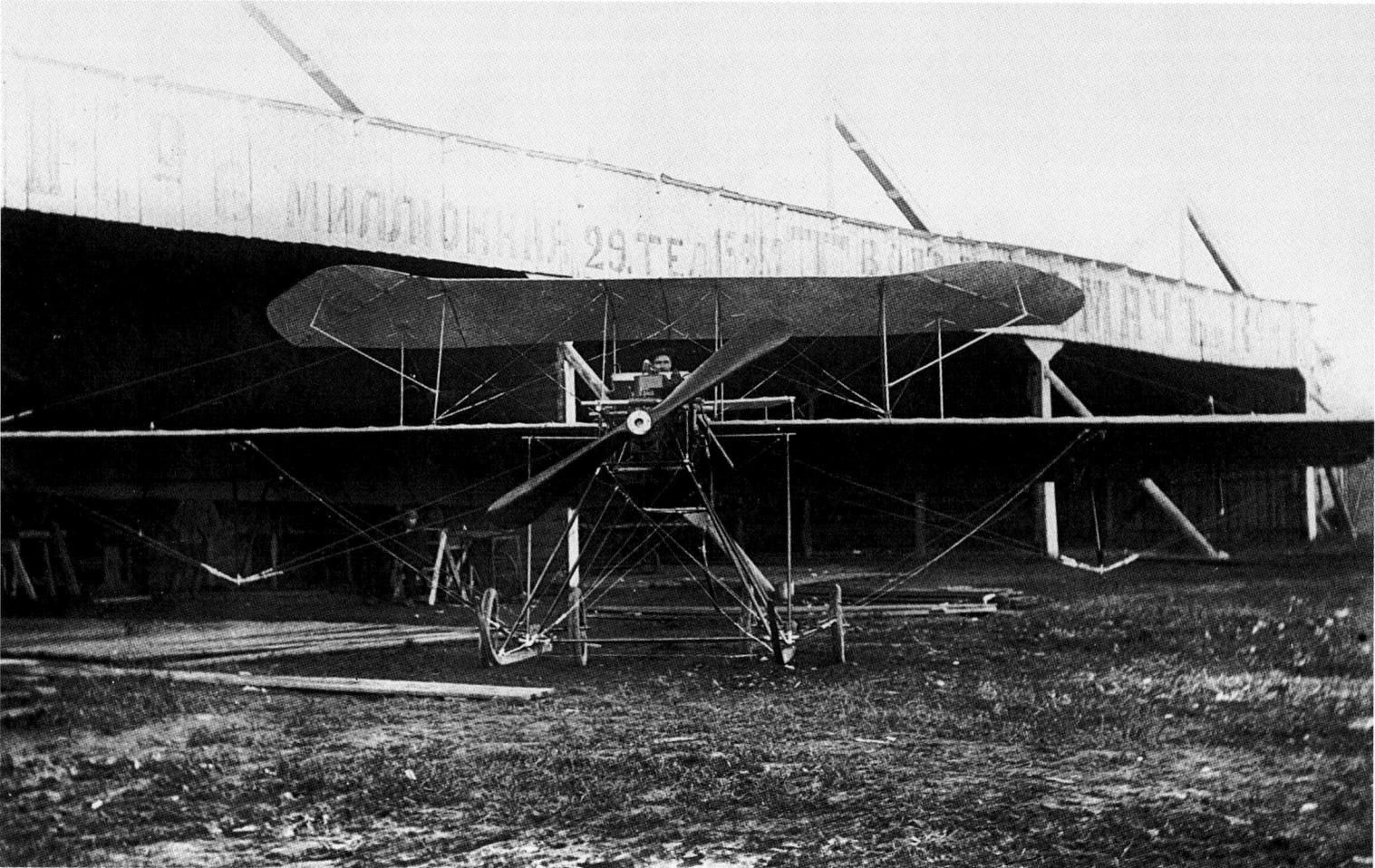

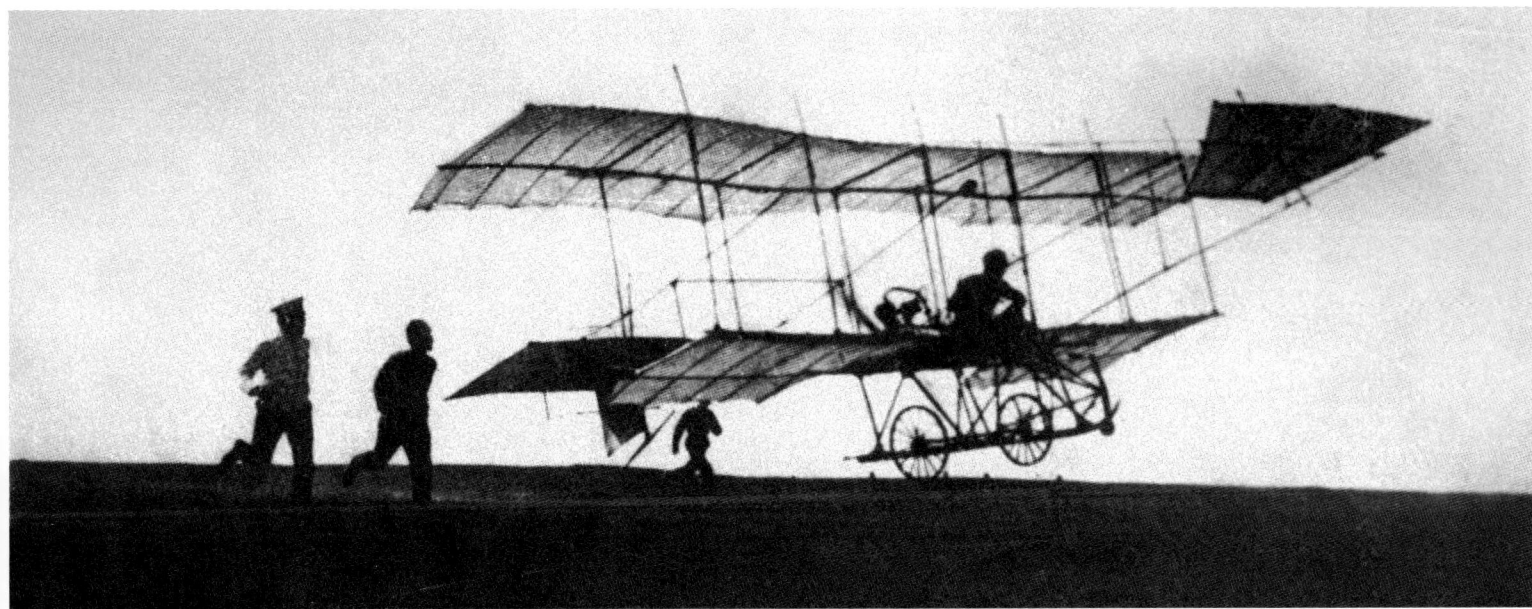

218. G.K. Demkin's biplane before takeoff.
Komendantskyi Airfield.
St. Petersburg. 1911–1912

219. The plane *CHUR-1.*
Komendantskyi Airfield.
St. Petersburg. 1911
Designer - N.V. Rebikov, inventor - G.G. Chichet. It was financed by M.K. Ushkov.
In 1912, the plane was shown at the Second Aeronautical Exhibition in Moscow.

220. The plane *Kasyanenko-1* **at take off.**
Cherkassy. 1910
It had a Anzani propulsion motor of only 15 horsepower, and was built by the Kasyanenko Brothers (Evgenyi, Ivan, and Andrei). Summer 1910.

221. The *Farman-Sommer,* **designed by M V. Agapov.**
1910–1912
It was a biplane with front arcs and a Sommer type chassis, but longer, which helped for better alignment. Its tail was like that of the Farman-3, and it had a Reno motor of 55 horsepower and a thrusting propeller. The airplane turned out to be successful, flying wonderfully, and eventually became a training plane at the Gatchina School.

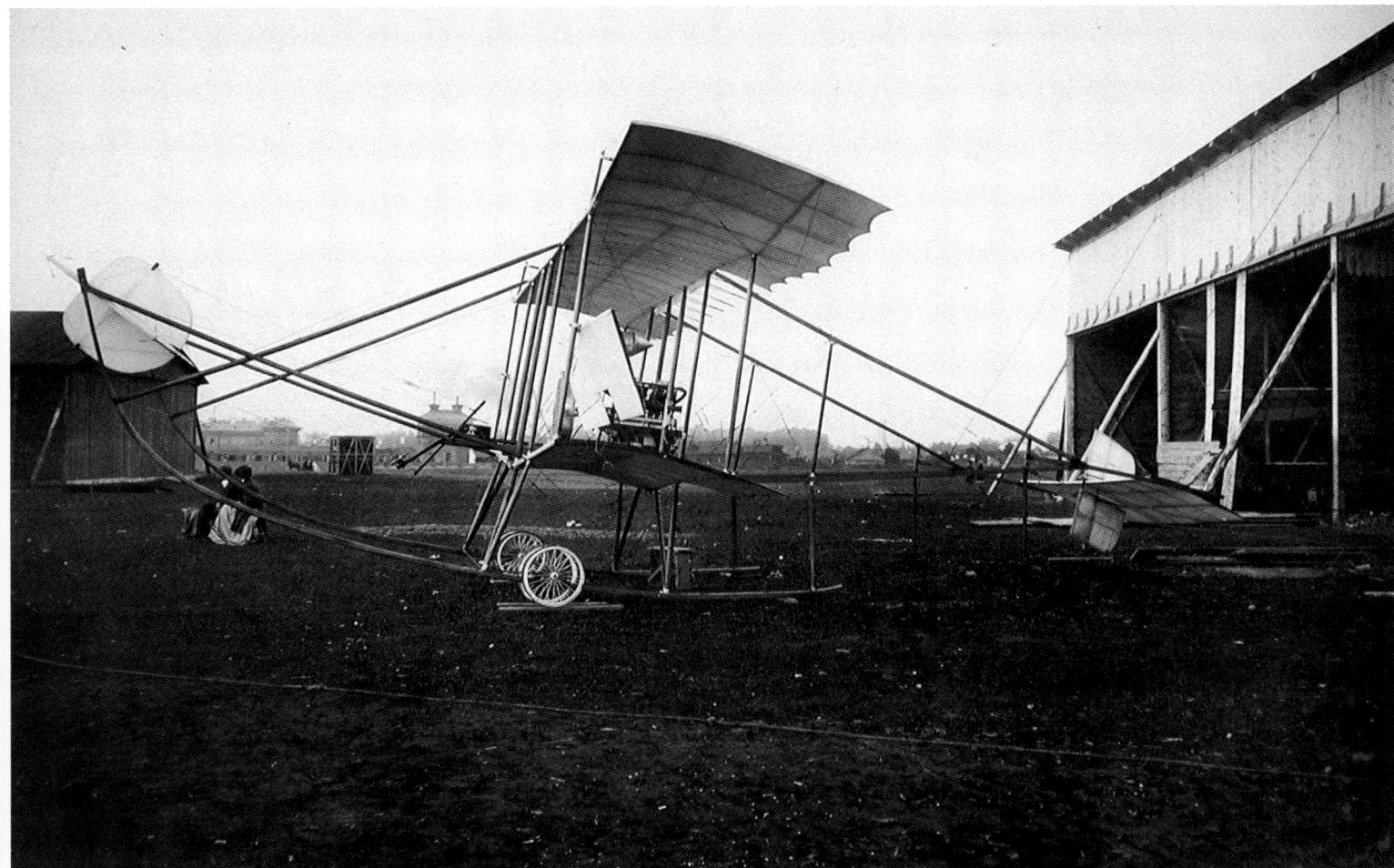

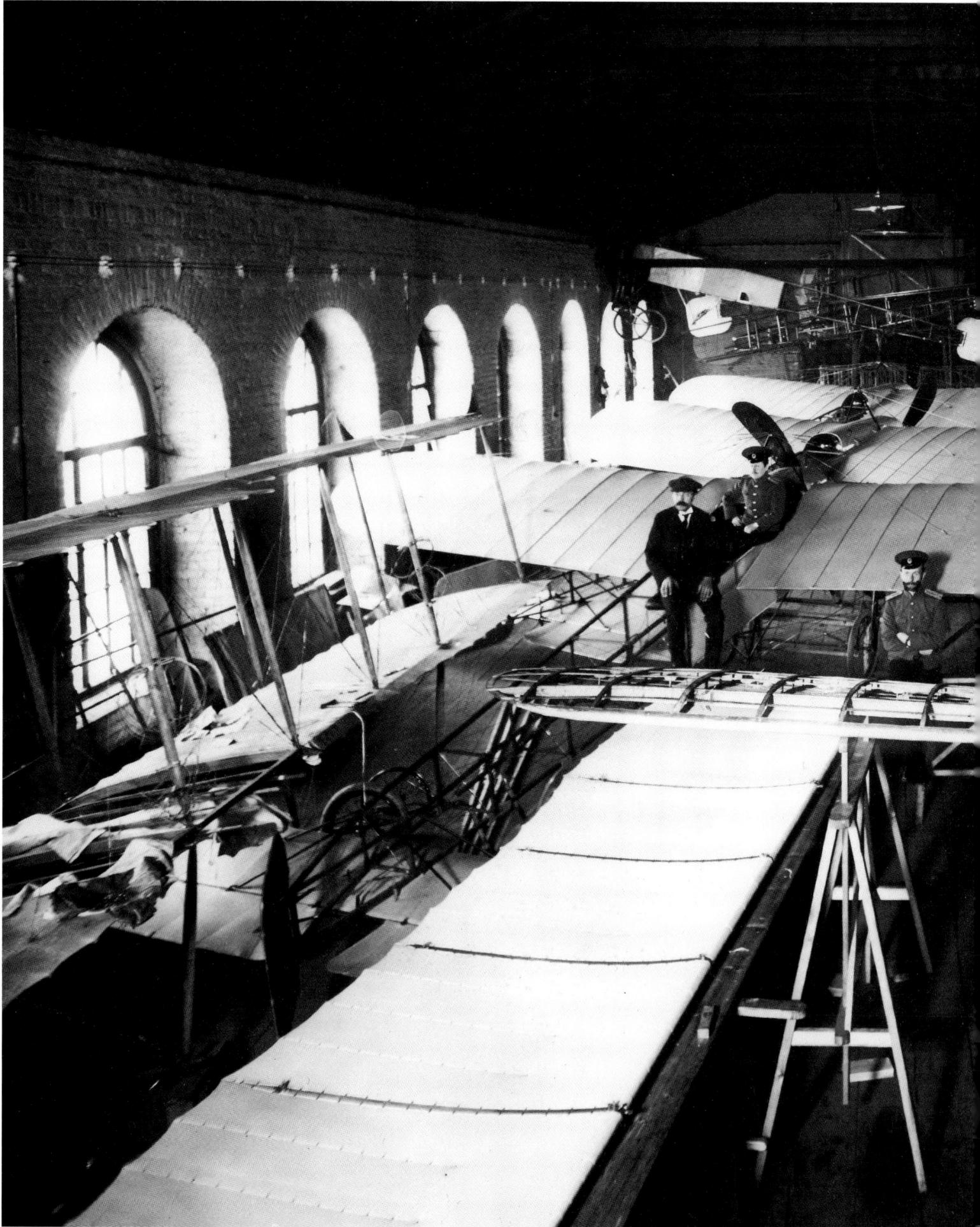

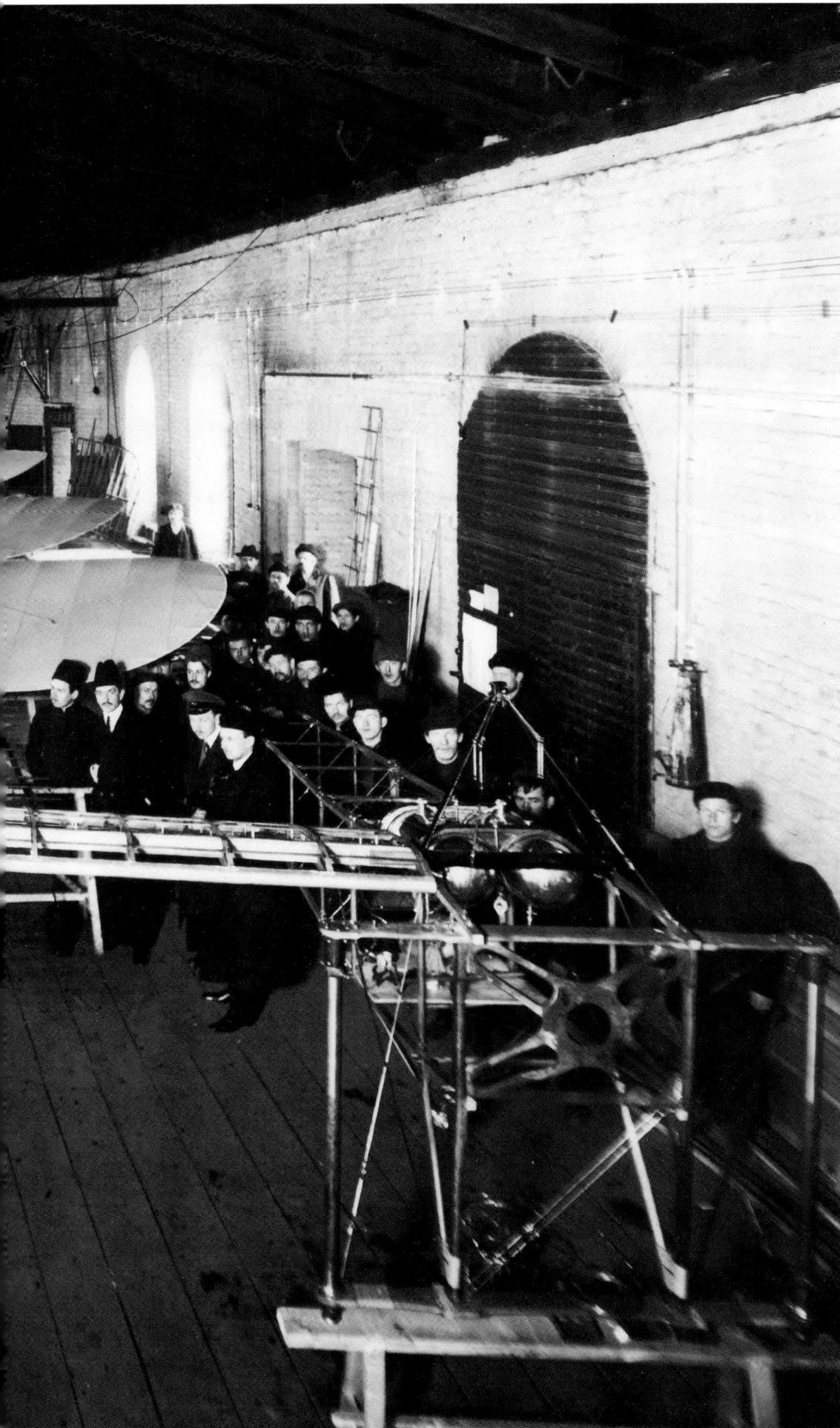

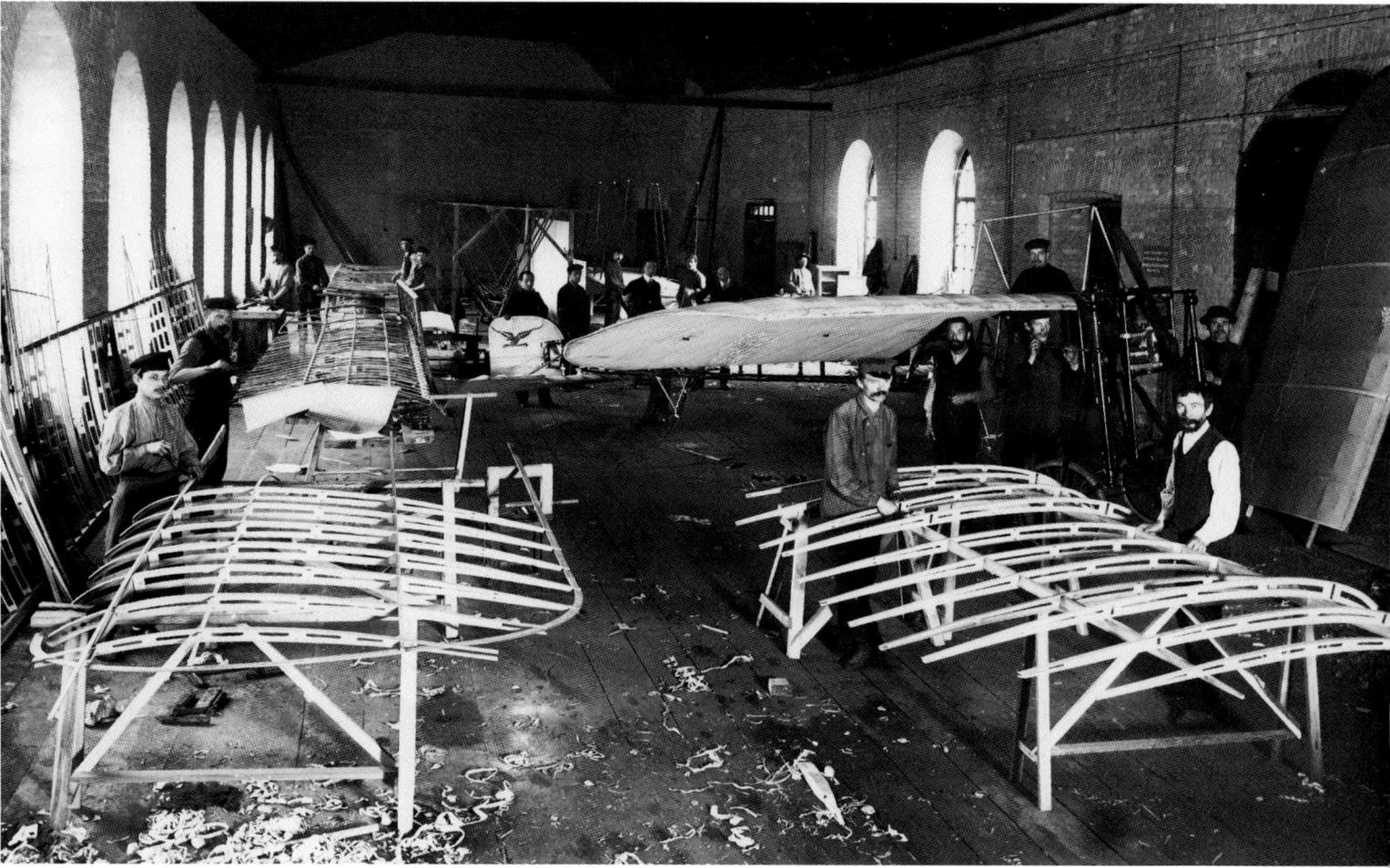

223. Stream-preparation of wing frames for a *Blerio* plane. At the far end is a finished plane with an emblem of the Imperial Pan-Russian Aeroclub.
FRAA Factory. St. Petersburg. 1912

224. *Blerio* planes being prepared for acceptance by the commission by members of the Imperial Pan-Russian Aeroclub.
FRAA Factory. St. Petersburg. 1912

225. French aviator A. Pierre's airplane of the *Blerio* type.
St. Petersburg. 1914

226. Pilot and designer A.V. Shinkov checks the attachment extensions of the constructed plane, which he designed, with an *Utka (Goose)* thrusting propeller and a *Gnome* engine of 50 horsepower.
St. Petersburg. 1912

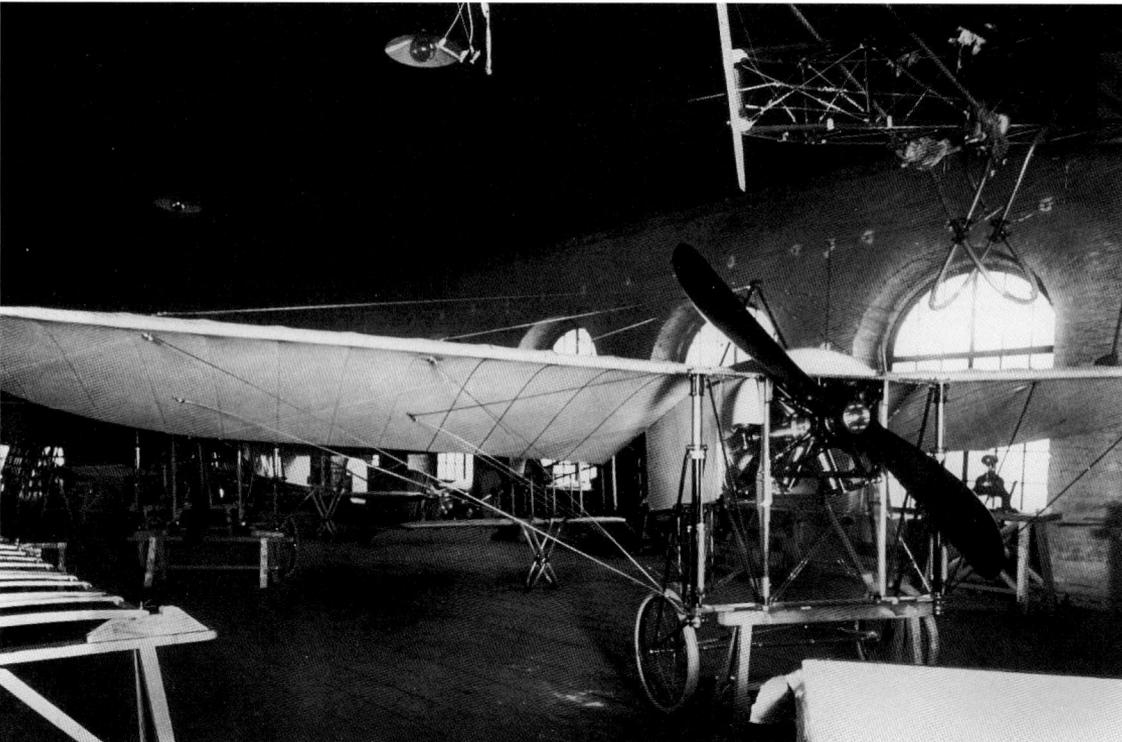

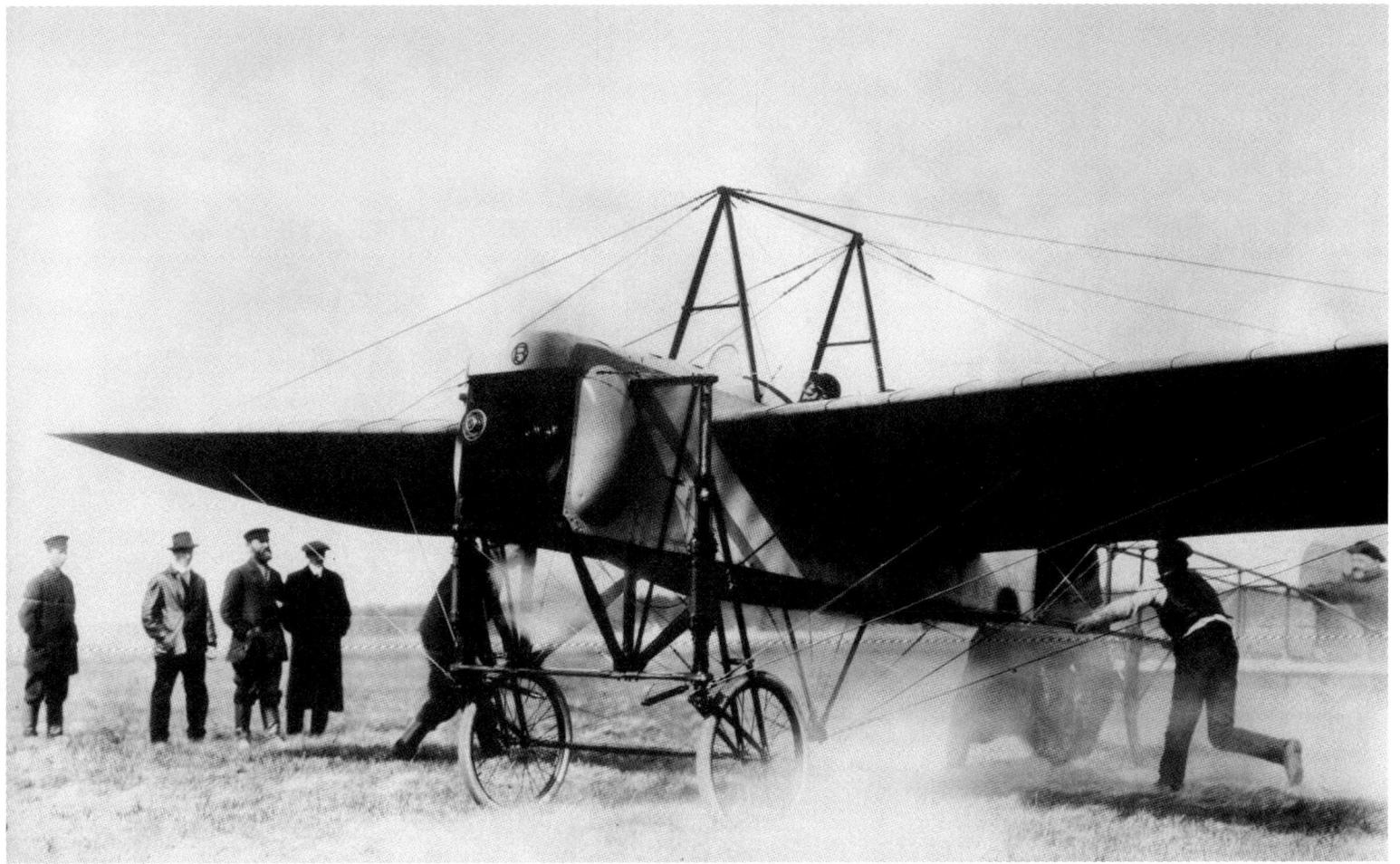

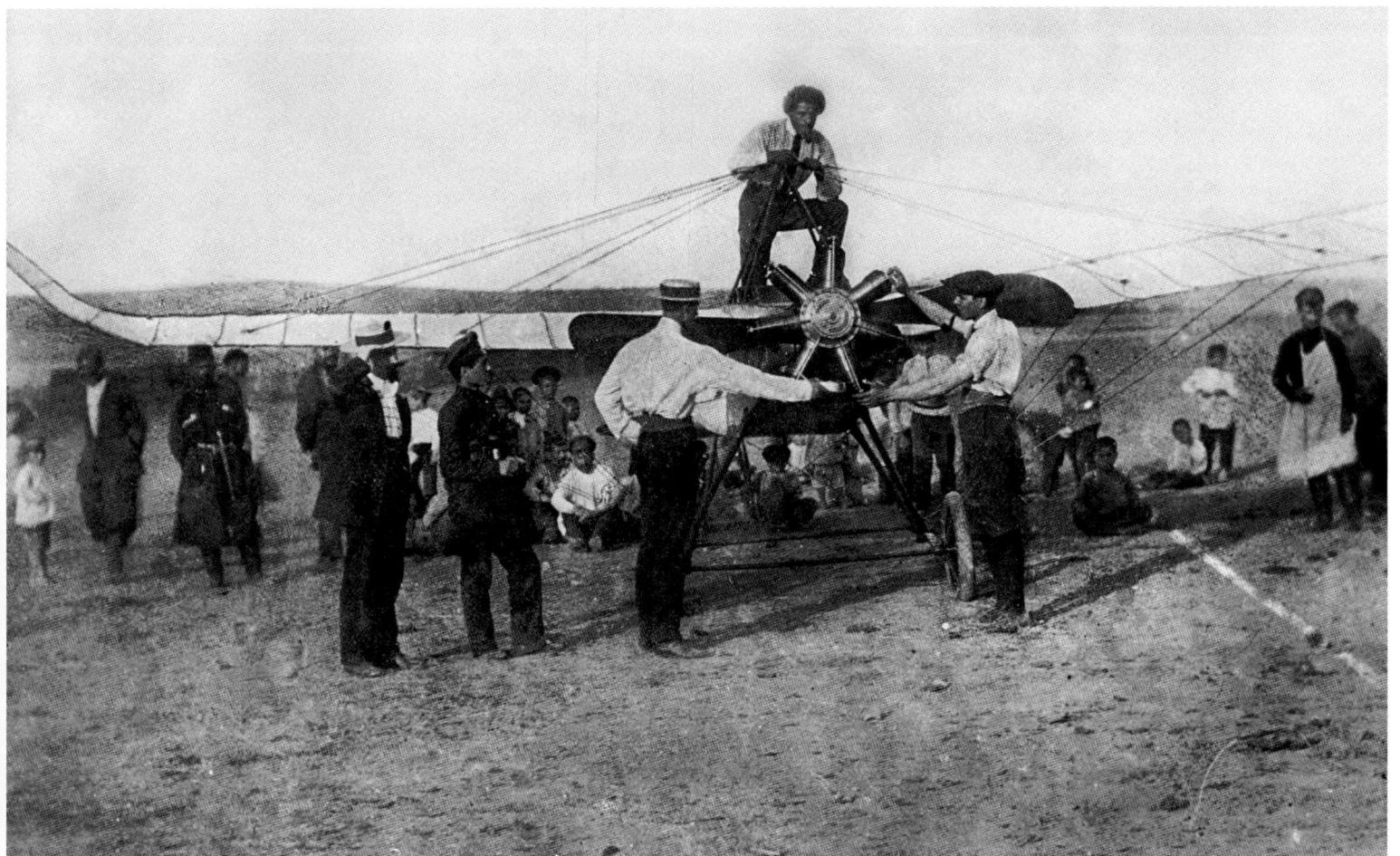

227

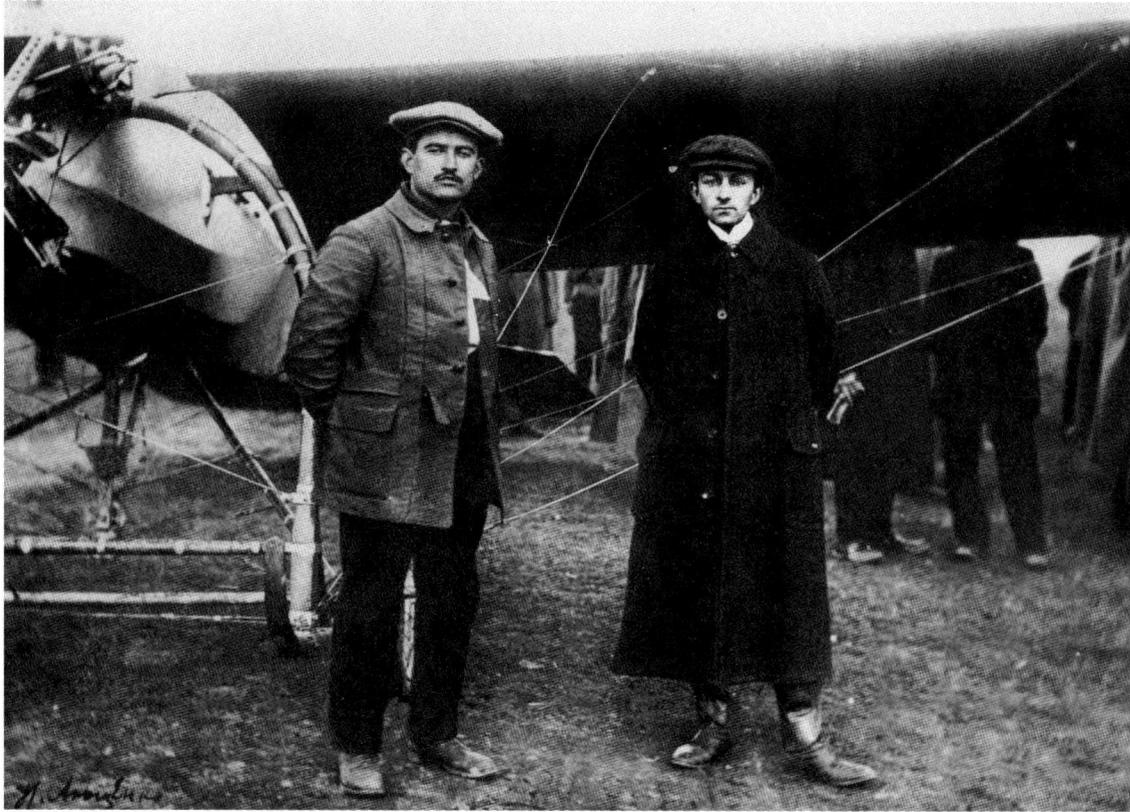

228

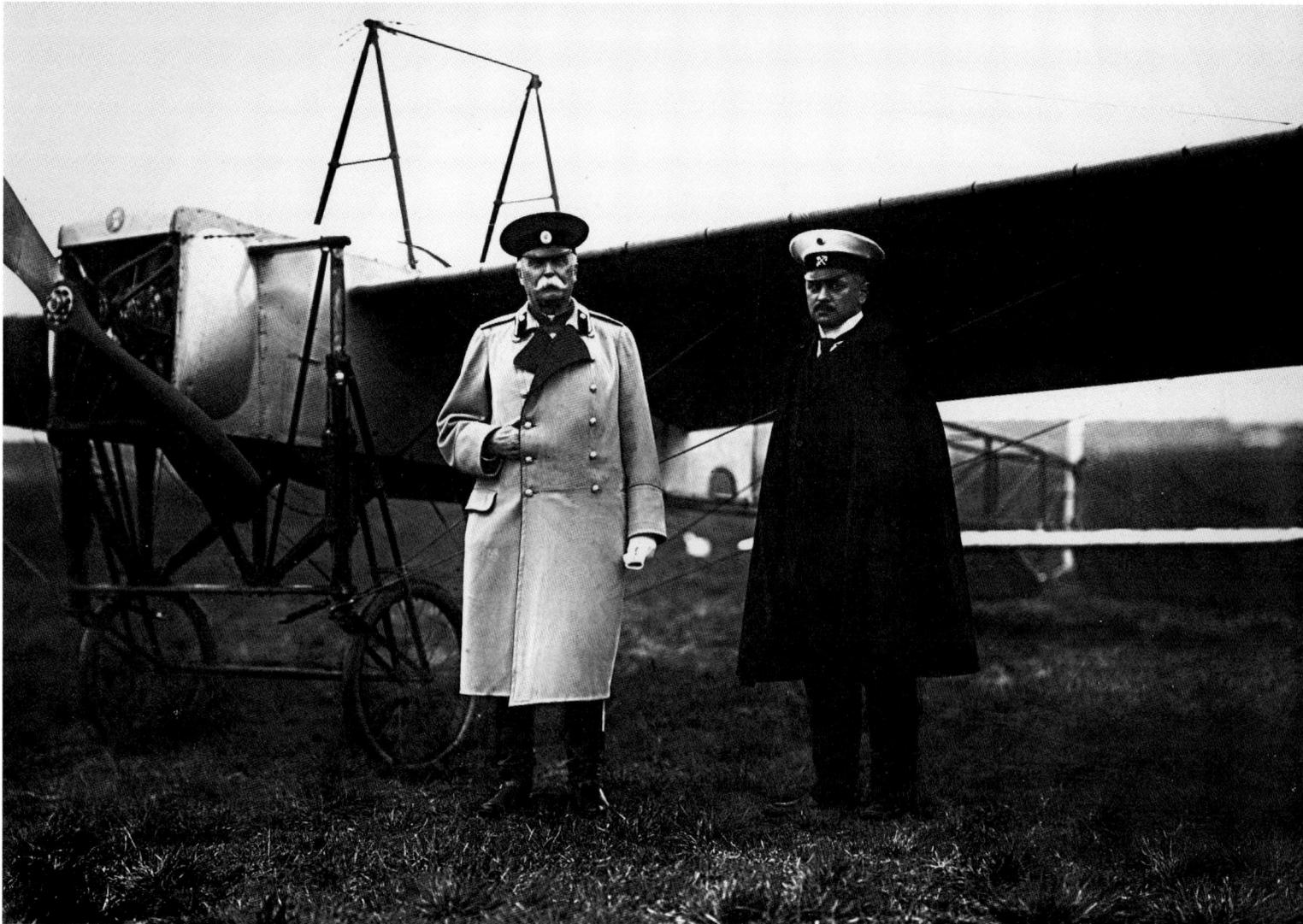

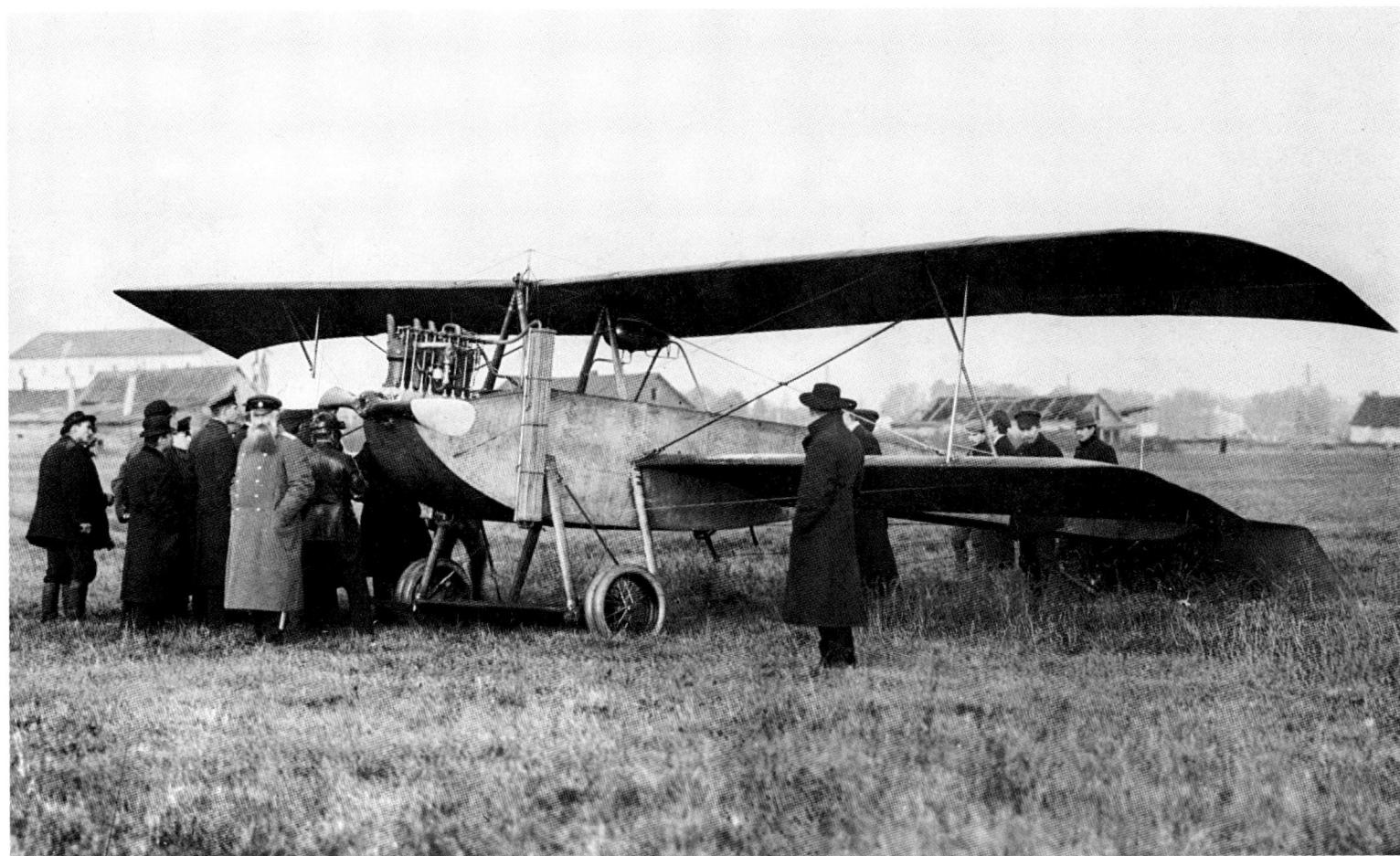

227. Aviator I.A. Blinderman (standing on the left) near the plane *Blinderman-4*, **which he designed, at a military plane competition.**

St. Petersburg. 1912

Because of his political beliefs, I.A. Blinderman emigrated to France, where he opened his own aviation school. After he become a French citizen, he visited Russia more than once.

228. Cavalry General A.V. Kaulbars and designer V.V. Kuznetzov near a plane, on which French aviator A. Pierre flew.

St. Petersburg. 1910

229. The plane *Steglan-2*, **reached a speed of 130 km/hr and was recognized as one of the best at a competition of war planes.**

Korpusnoi Airfield. St. Petersburg. 1912

230. I.I. Stegan's first plane.

St. Petersburg. 1911

Built in 1911 with a Vial motor of 50 horsepower, the plane fell apart during tests.

230

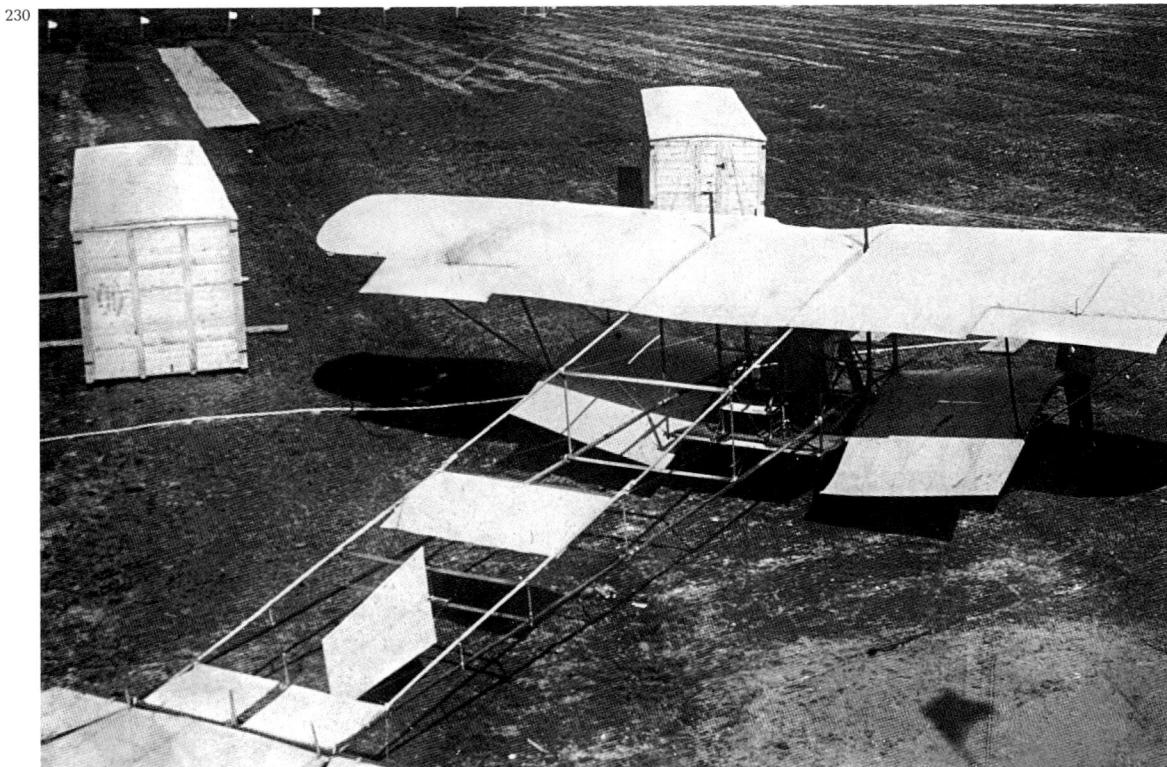

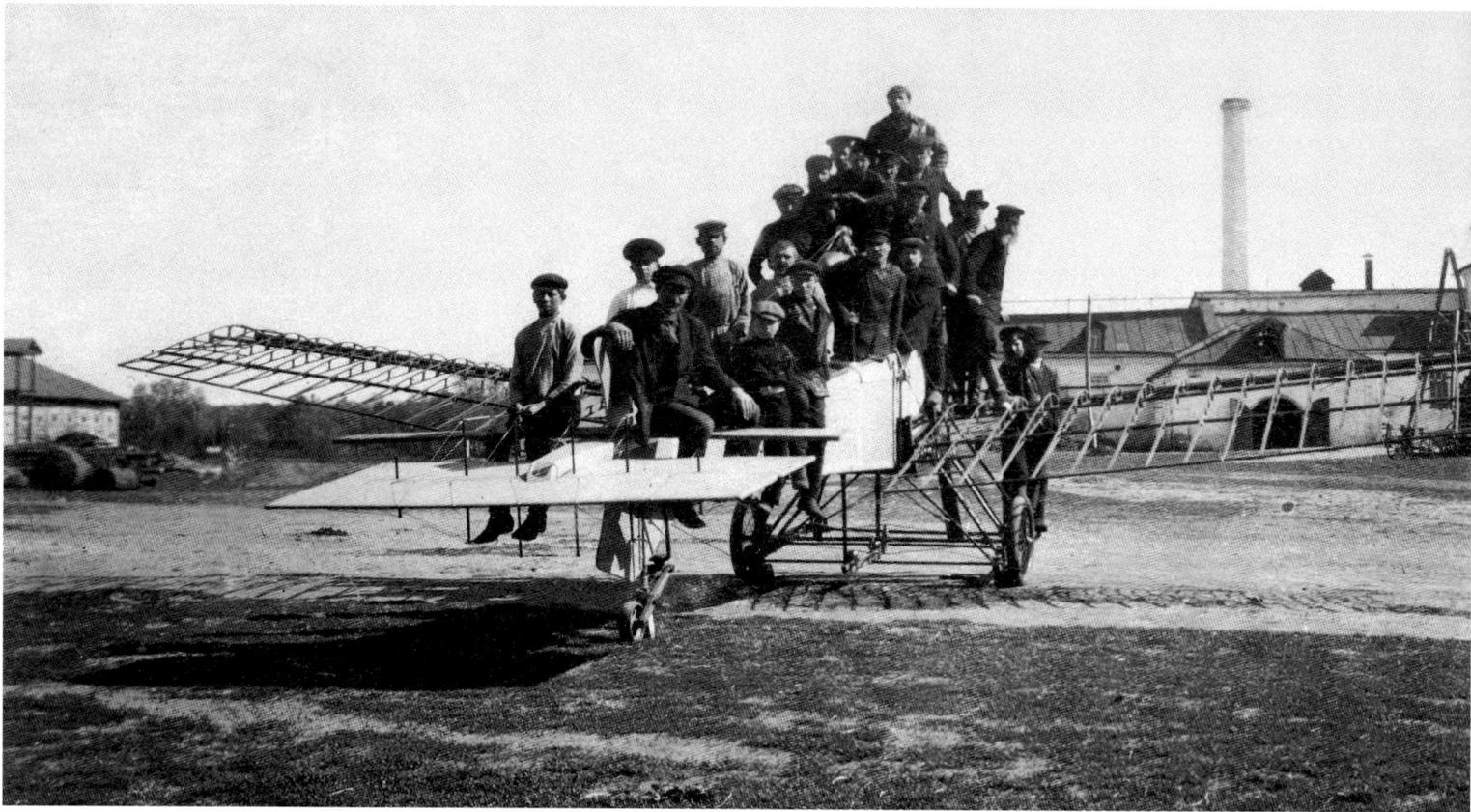

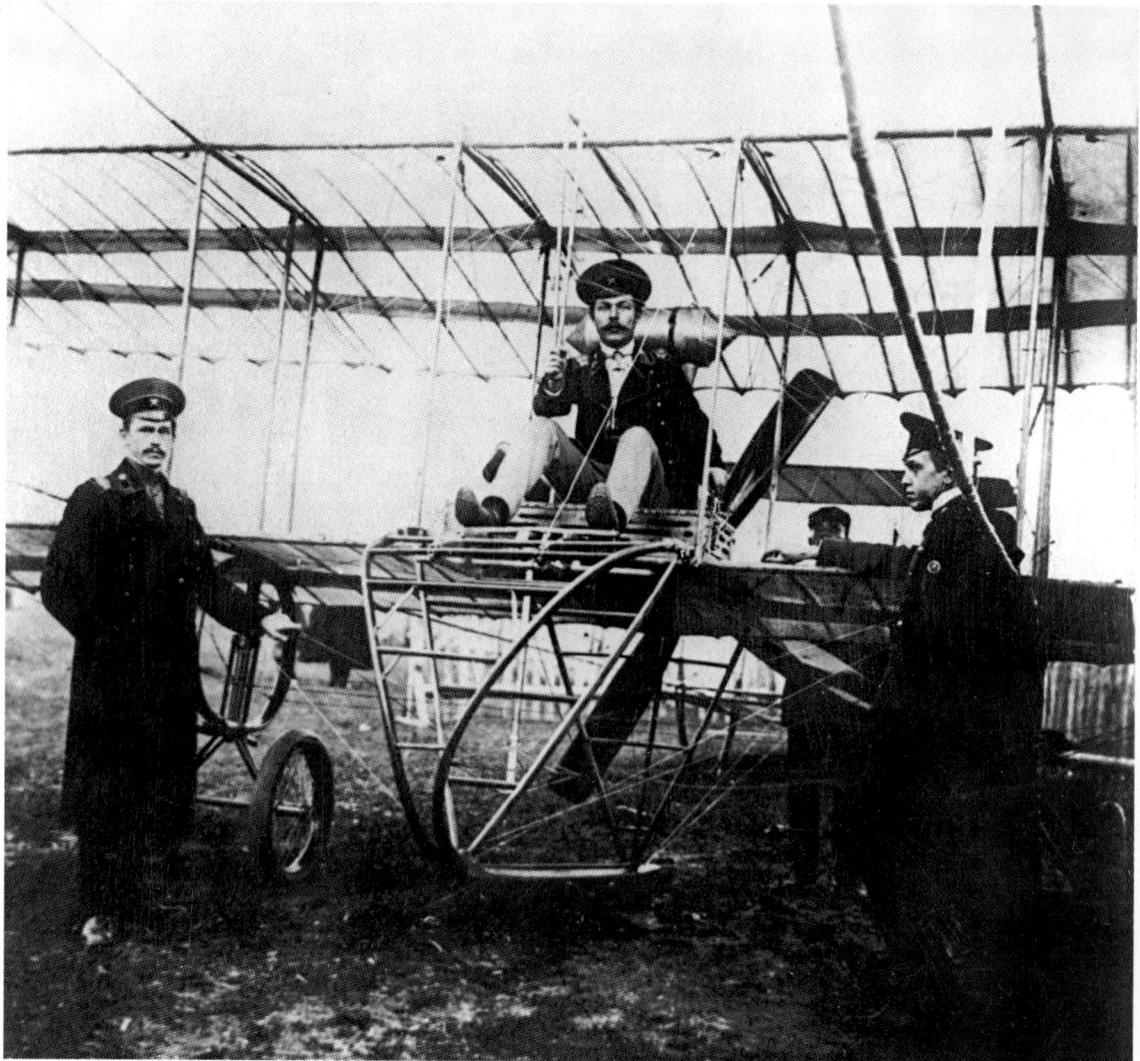

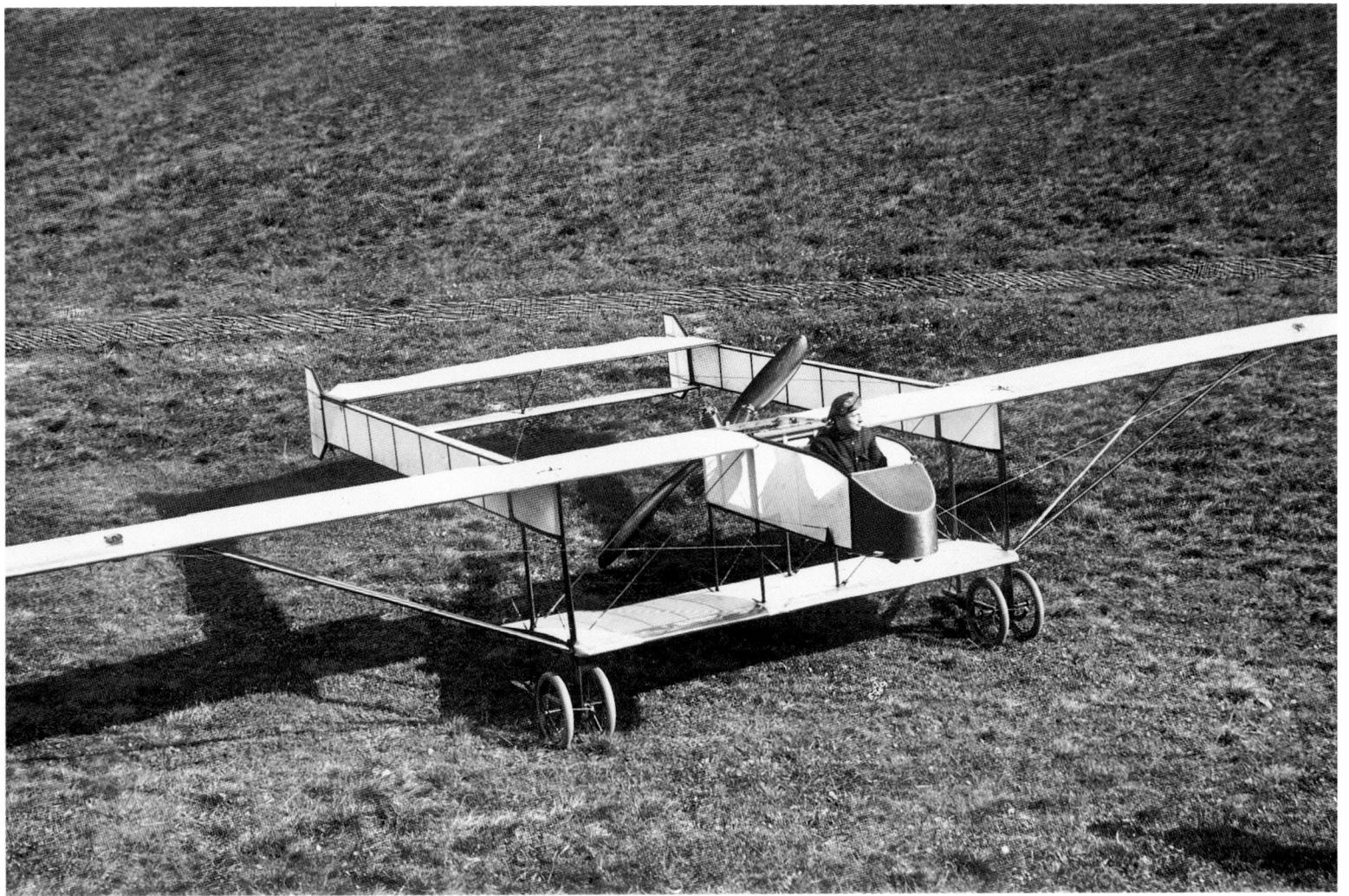

231. 3-seater plane of a design by P.V. Mozharov (subsequently a designer of motorcycles; in the photo he is at the very top) at the moment of checks of strength.
Krasivka village of the Tambovskyi Guberniya. Fall 1914

232. N.P. Lobanov, a student of the Moscow Technical Institute, on the plane *Ptenets (Chick)* that he designed.
Second International Exhibition of Aeronautics. Moscow. 1912

233. A.A. Porokhovschikov's original design for the *Bi-kok*. Testing done by aviator and future designer M.L. Grigorashvili.
Komendantskyi Airfield. Petrograd. August-September 1914

234. A plane built by P.V. Mozharovyi.
Tambovskyi Guberniya. 1914

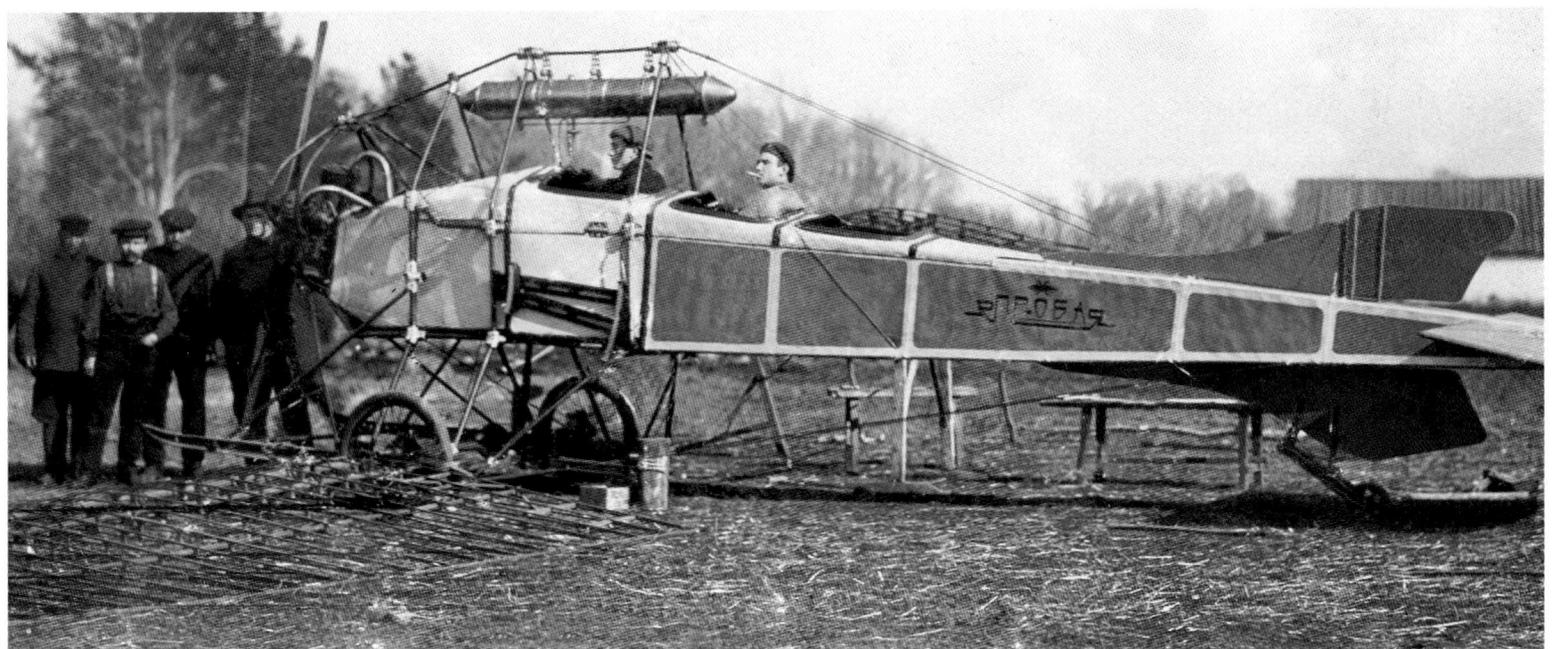

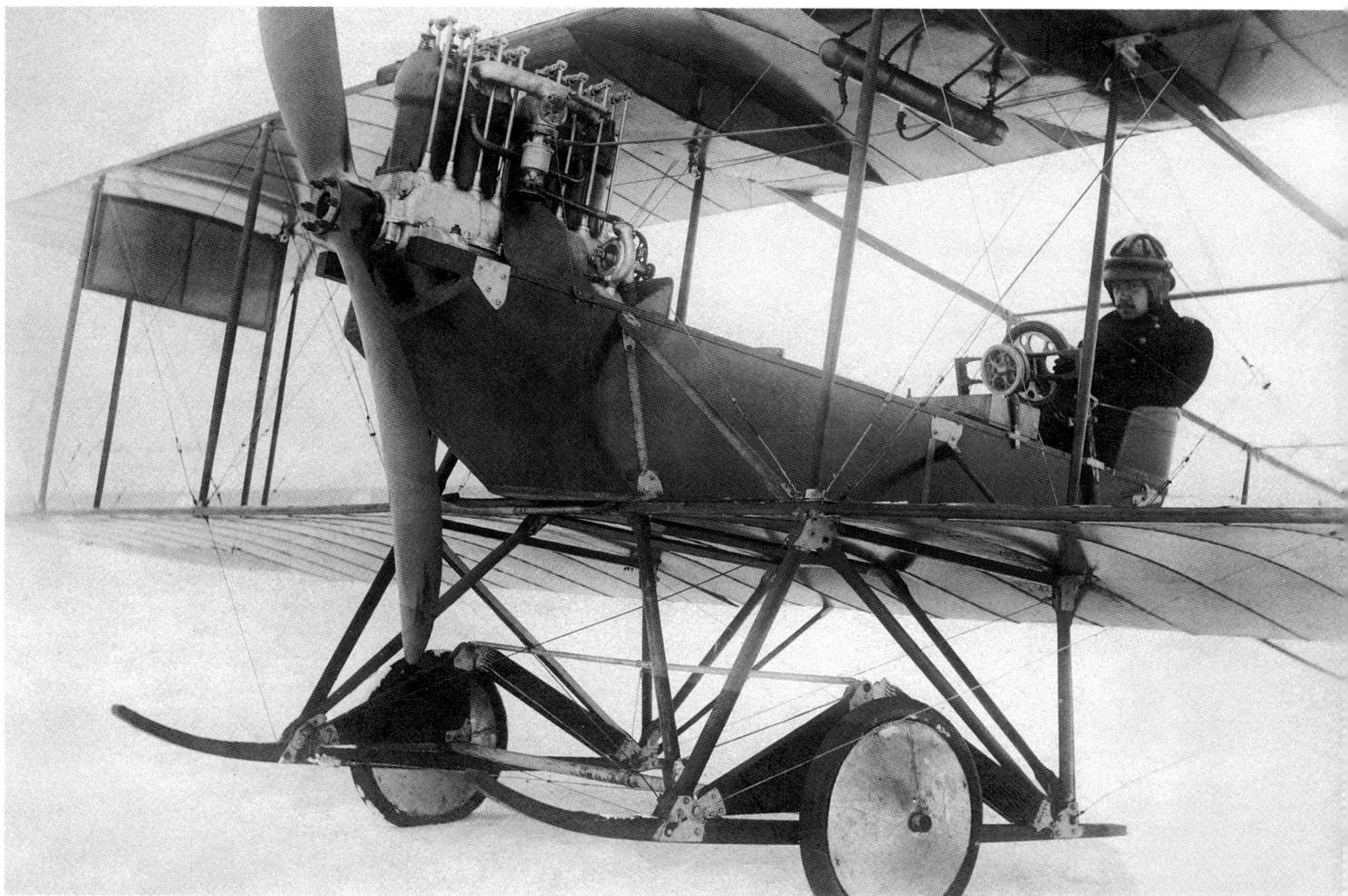

239. I I. Sikorskyi at the helm of the S-6, built in November 1911.
St. Petersburg. 1911

On December 29, I. I. Sikorskyi on this machine set the first Russian speed record - 111 km/hr.

240. I.I. Sikorskyi, pilot G.V. Yankovskyi (in the middle), and G.V. Alexnovich in the cabin of the S-11.
St. Petersburg. 1913

241. Two planes of I. I. Sikorskyi. In the foreground is the airplane S-11 (Round), and in the background is the S-10.
St. Petersburg. 1913

The first Russian monocoque S-11— a mid-wing monoplane with a Gnome engine of 100 horsepower, a round cross-section fuselage, and cabin for 3 people. It was built in 1913, and G.V. Yankovskyi first flew it in the beginning of July 1913.

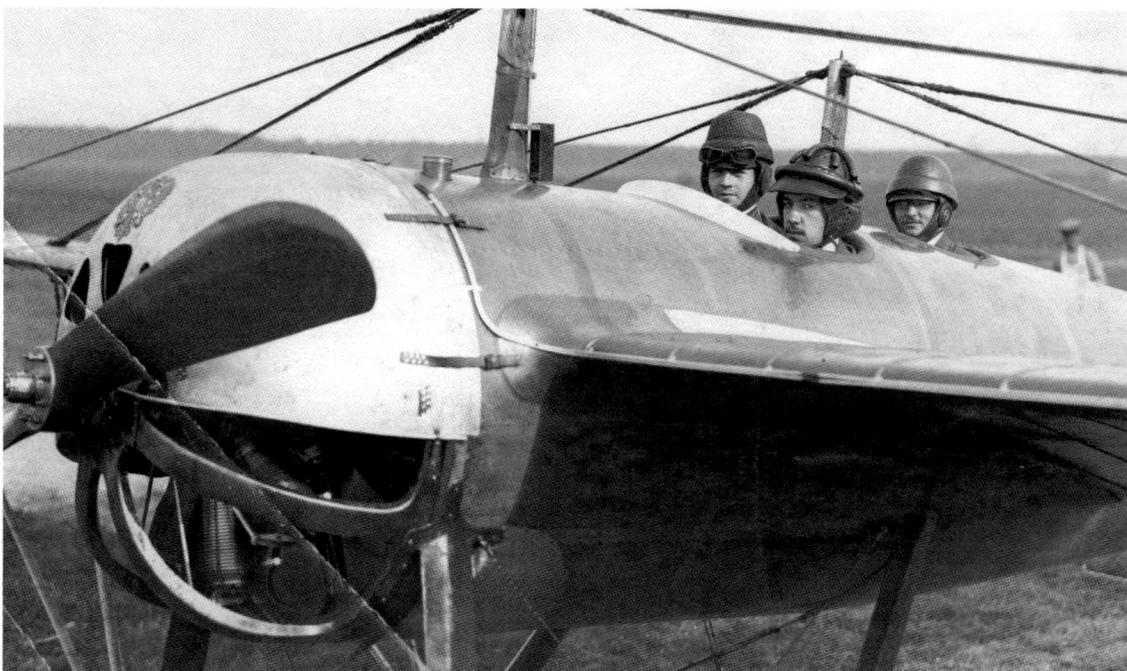

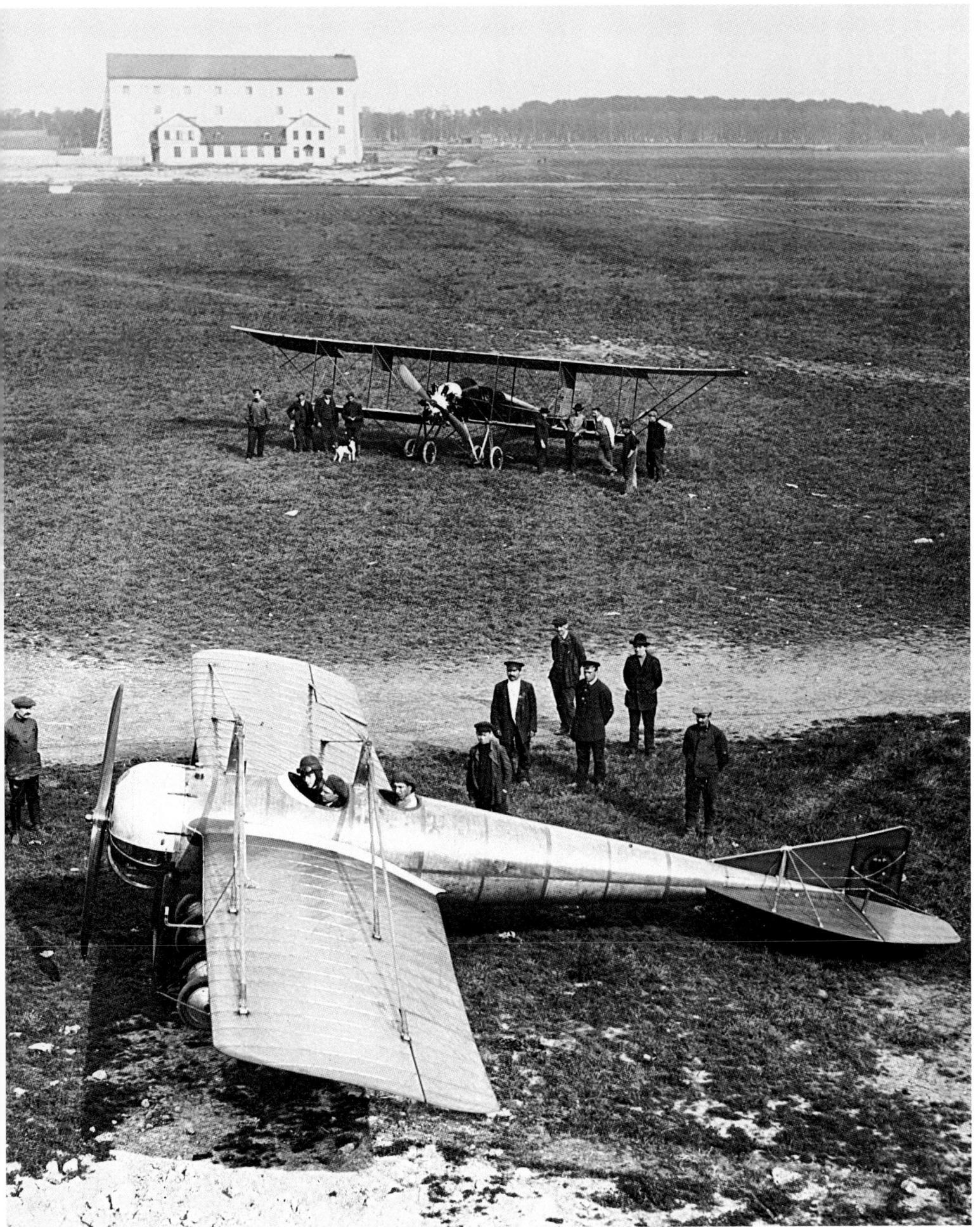

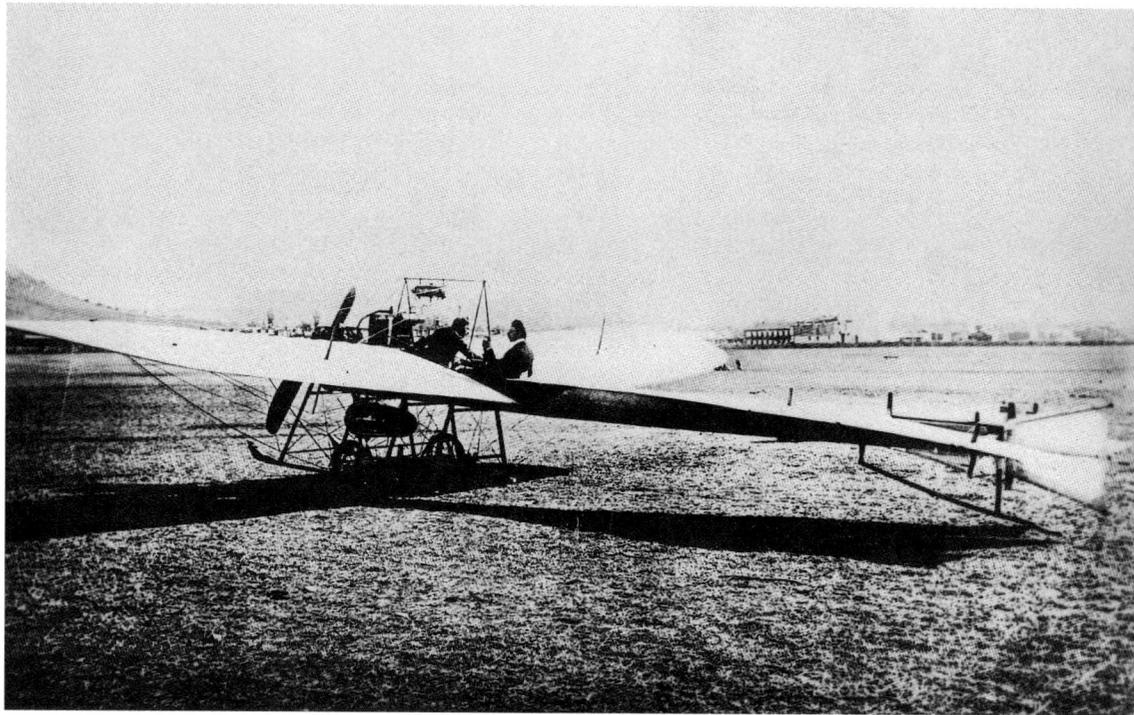

242. An *Antoinette* airplane of Russian design.
1912—1916

243. The designer S.L. Zhilber and F.A. Moska are sitting in the airplane *Mosca MB*. Nearby stands Captain V.P. Buistritzkyi, a war inspector of receiving at the factory, a collaborator, and a designer.
Moscow. 1912—1916

244. . Practical training on aircraft engines at the Polytechnic Institute. In the foreground, first from the left, is future famous aircraft designer N.N. Polikarpov, second is A.A. Bessonov, who had become a famous aircraft designer.
St. Petersburg. 1915

245. Aviator-examiner G.V. Alexnovich (on the left), mechanic Egorov near the plane *Gakkel VII*, at a competition of war planes.
Korpusnoi Airfield. St. Petersburg. 1911

243

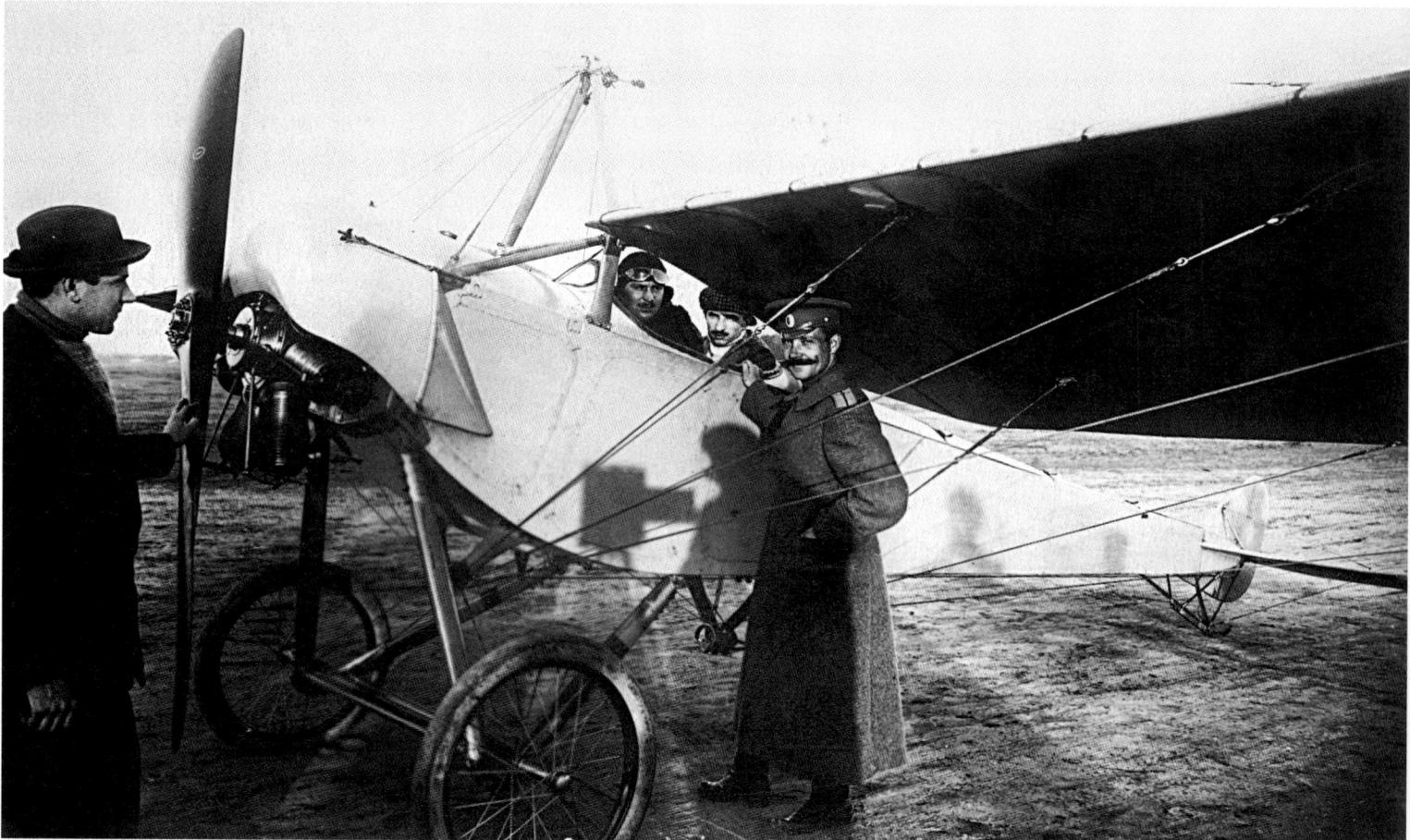

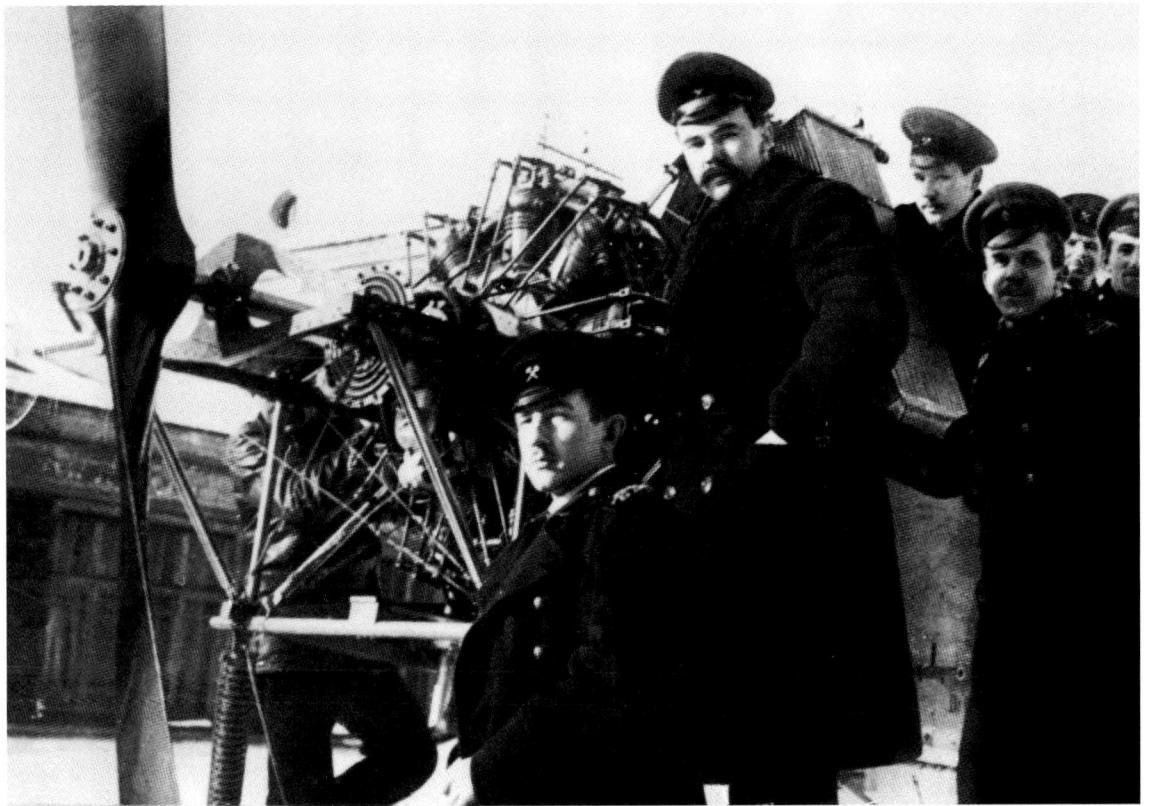

244

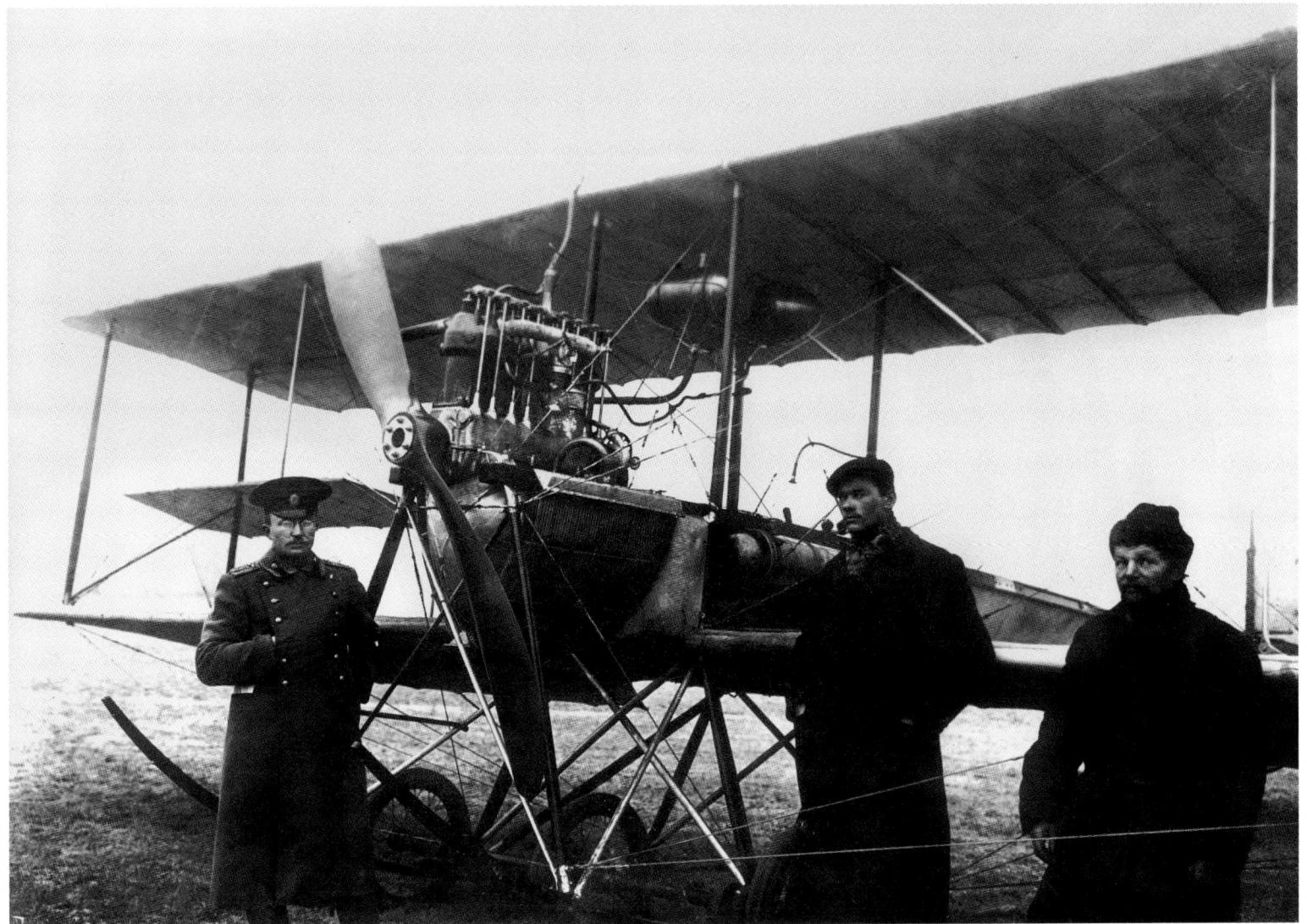

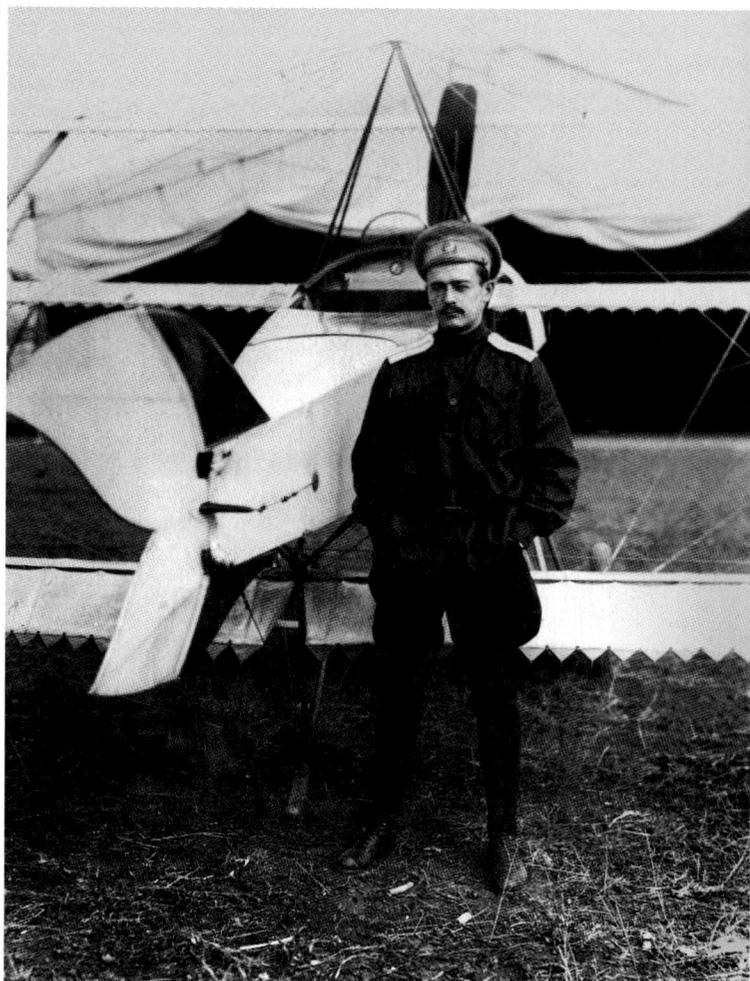

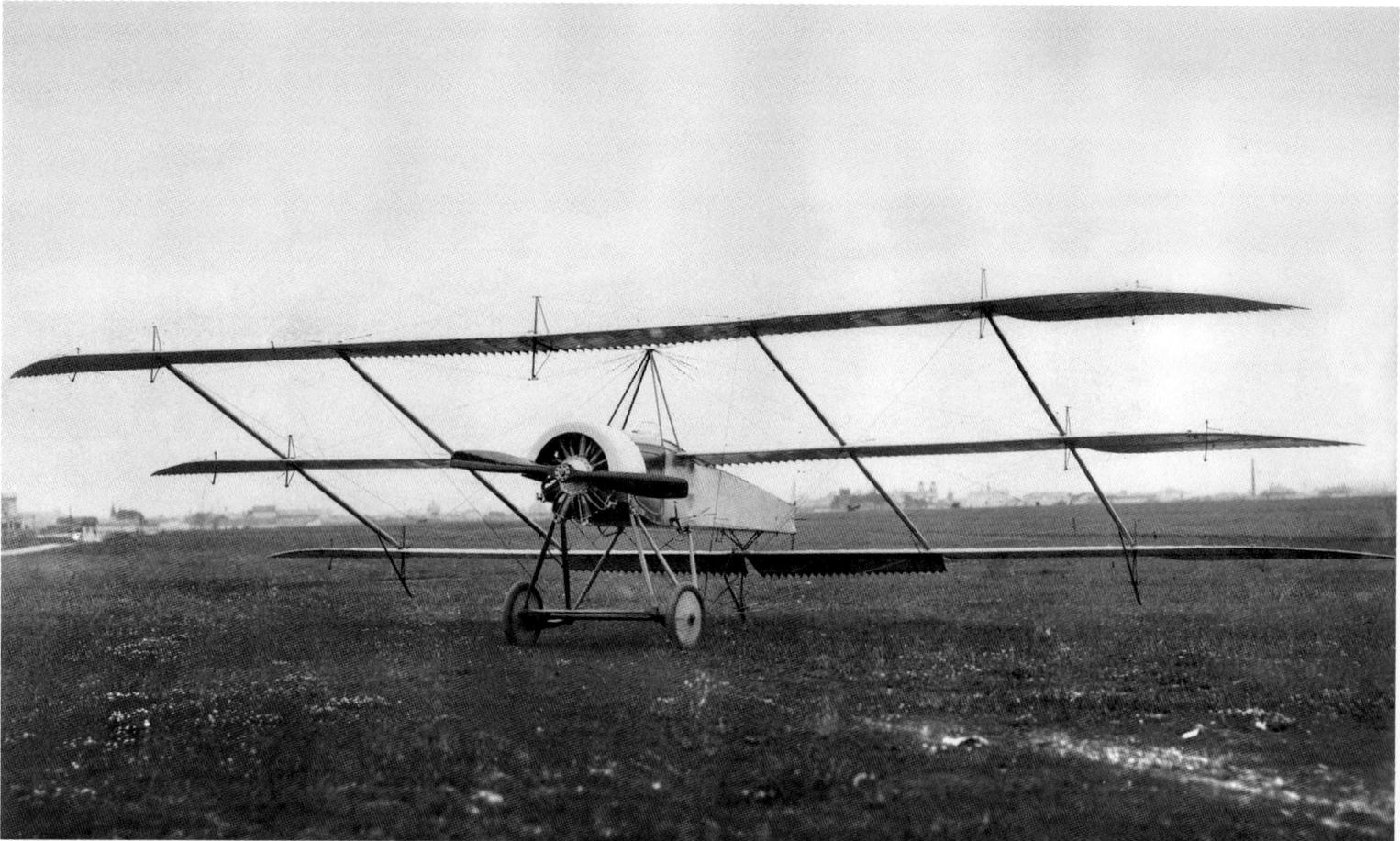

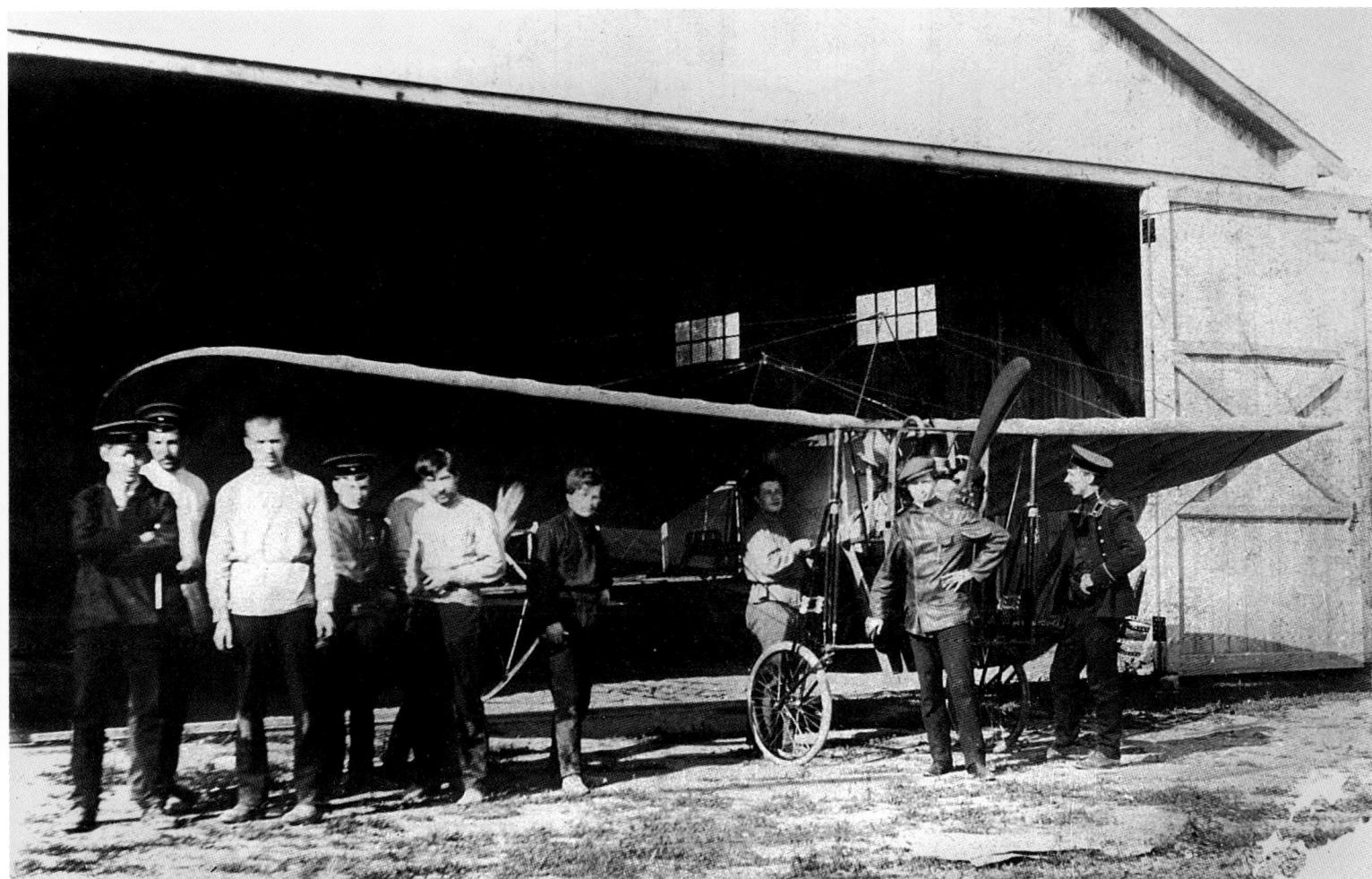

246. Pilot and designer
A.A. Faltzfein,who had become
a military aviator, during the war
in 1914-1917.
1913

247. Alexander Alexandrovich
Bezobrazov near the plane *Triplane*
of his own design.
1914—1916
*Built in 1914 in Moscow, the plane
was given to the Sevastopol
Aviation School.*

248. A.A. Bezobrazov's *Triplane*.
Moscow. 1914

249. Students near the planes they
designed of the *Blerio* type. Fourth
from the left is B.N. Iurev, a future
designer.
Moscow. 1912—1914

250. 2-seater reconnaissance plane,
a four-wing, built on the basis of the
French *Moran J* by V.F. Savelievyi
with engineer V. Zalevskyi.
Smolensk. 1916
*Military aviator V. A. Iungmeister
tested the plane.*

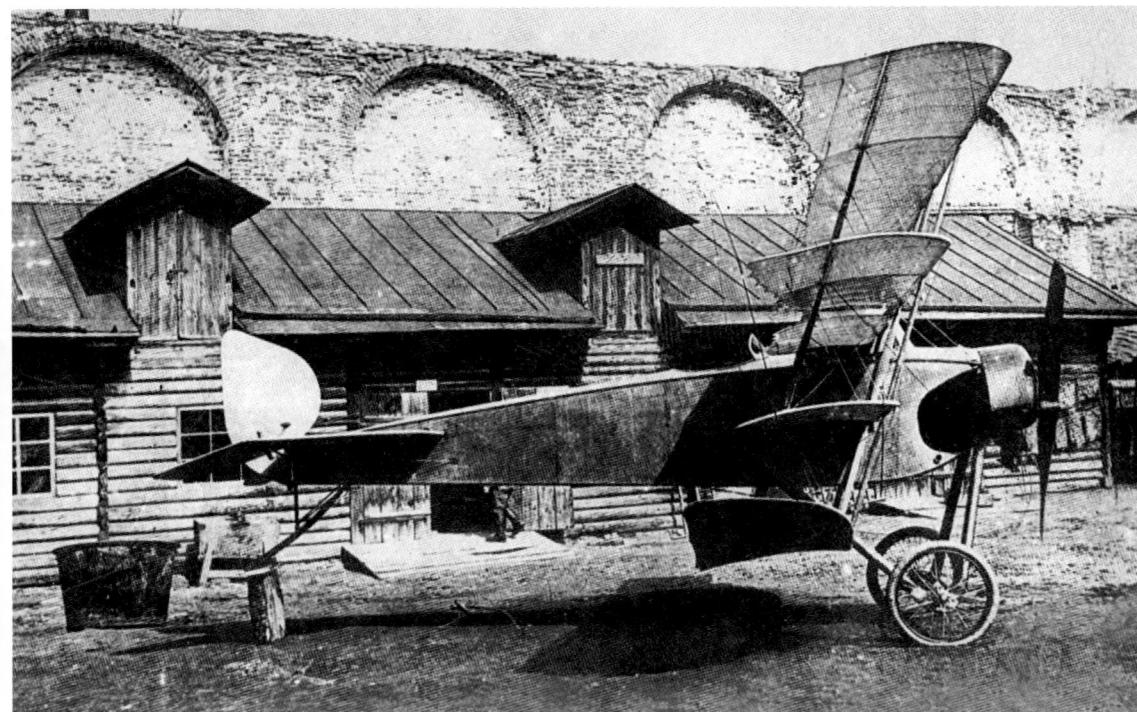

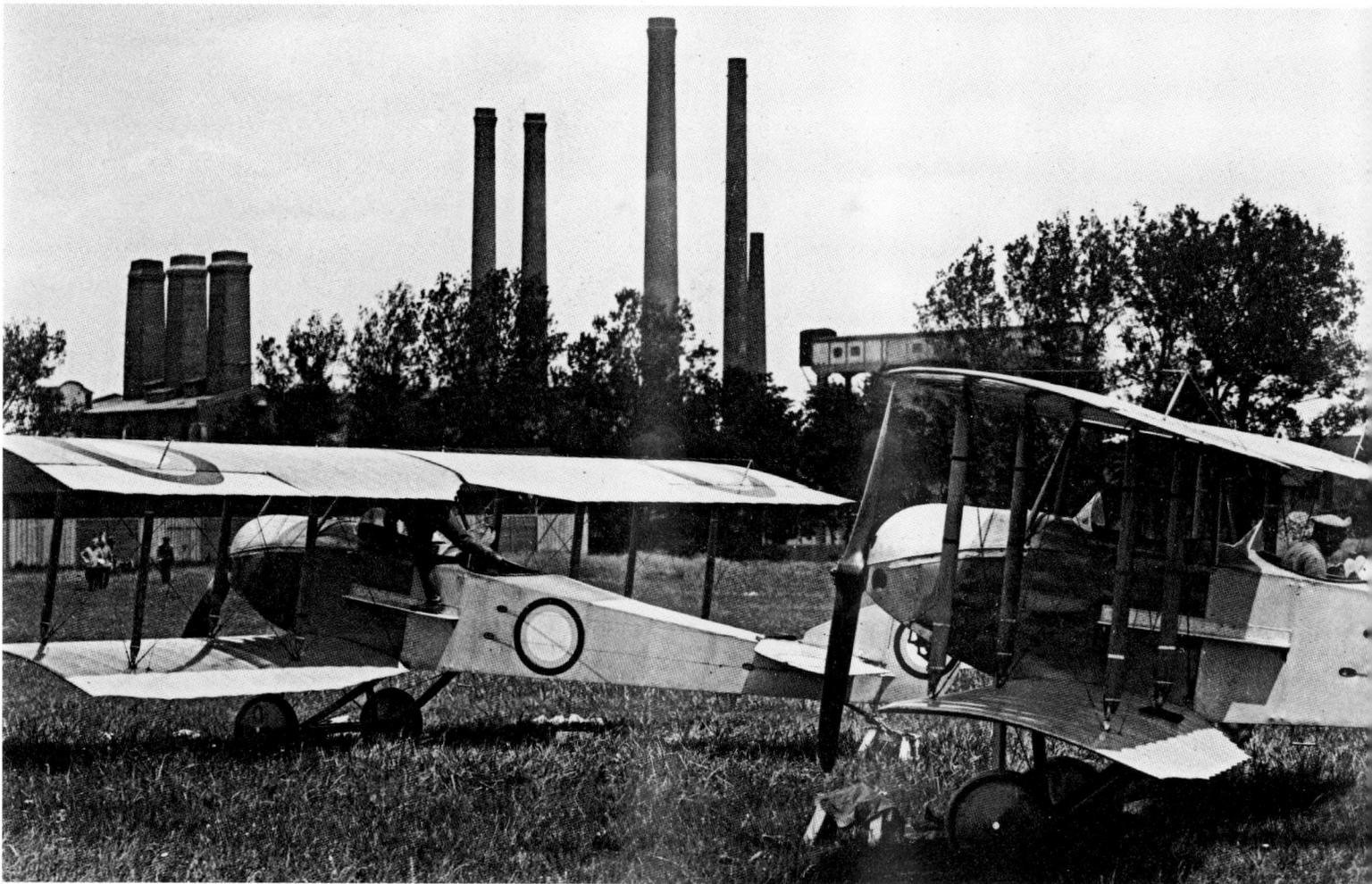

251. In the factory yard are the commercial planes of designer A.A. Anatr, preparing to be sent to the front.
Odessa. 1916

252. On aircraft designer V.A. Lebedev's ice boat.
Malaya Nevka. St. Petersburg. 1911 — 1912

An engine of 25 horsepower with an aerial propeller had been placed on it.

253. Aviator and aircraft designer V.A. Lebedev at the wheel of a car in front of the plane *Niupor X*.
Petrograd. 1914 — 1915

252

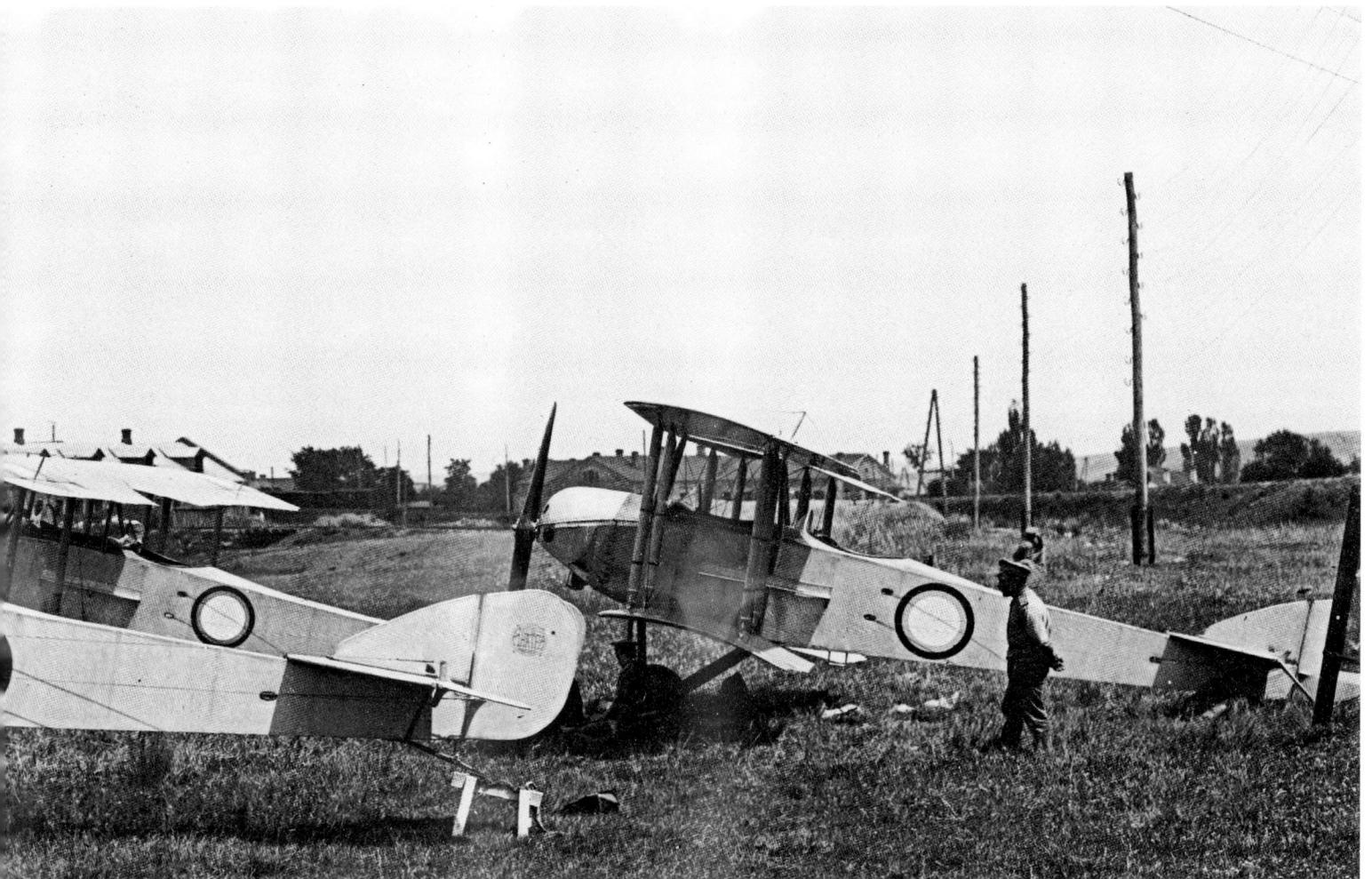

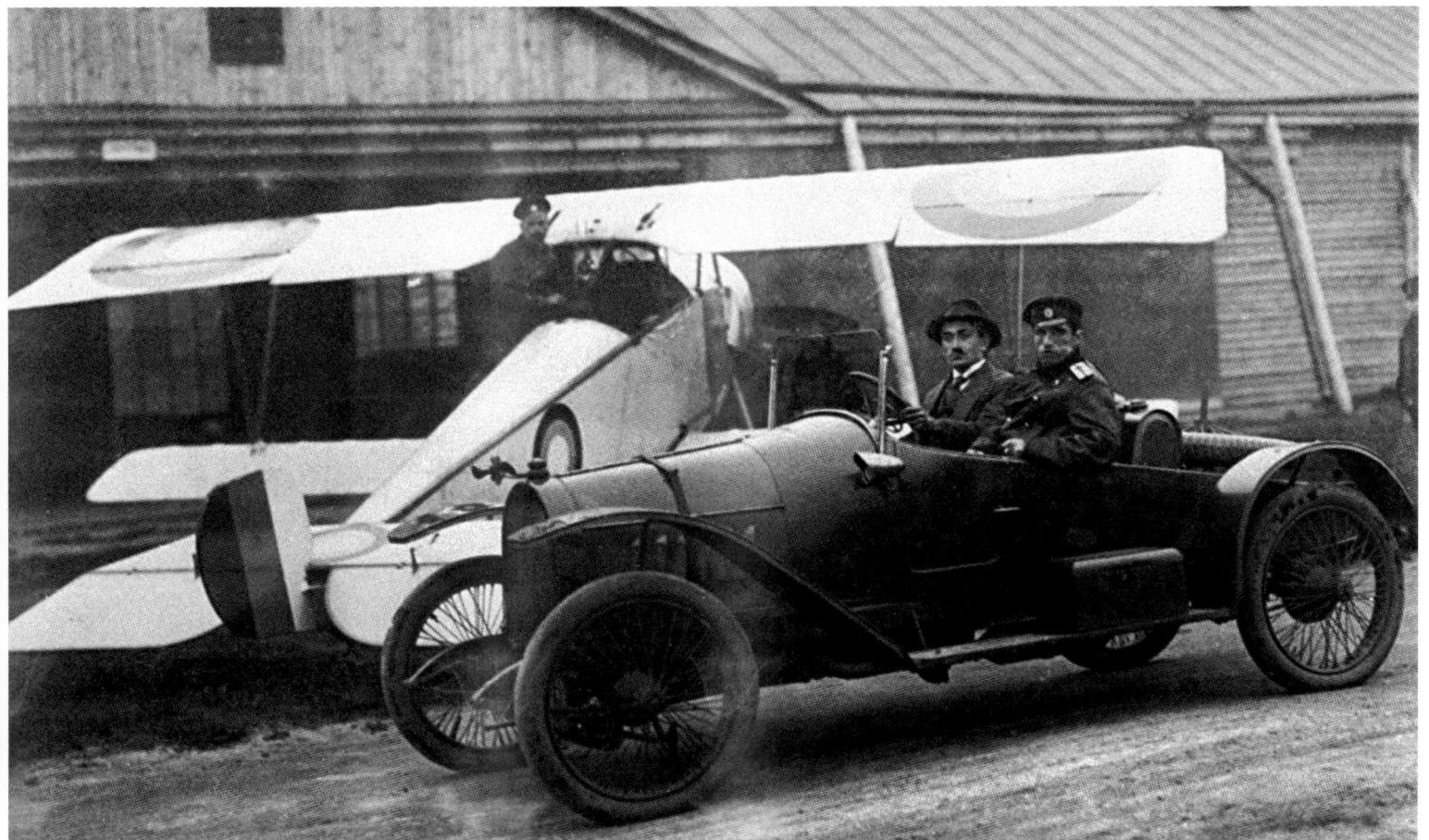

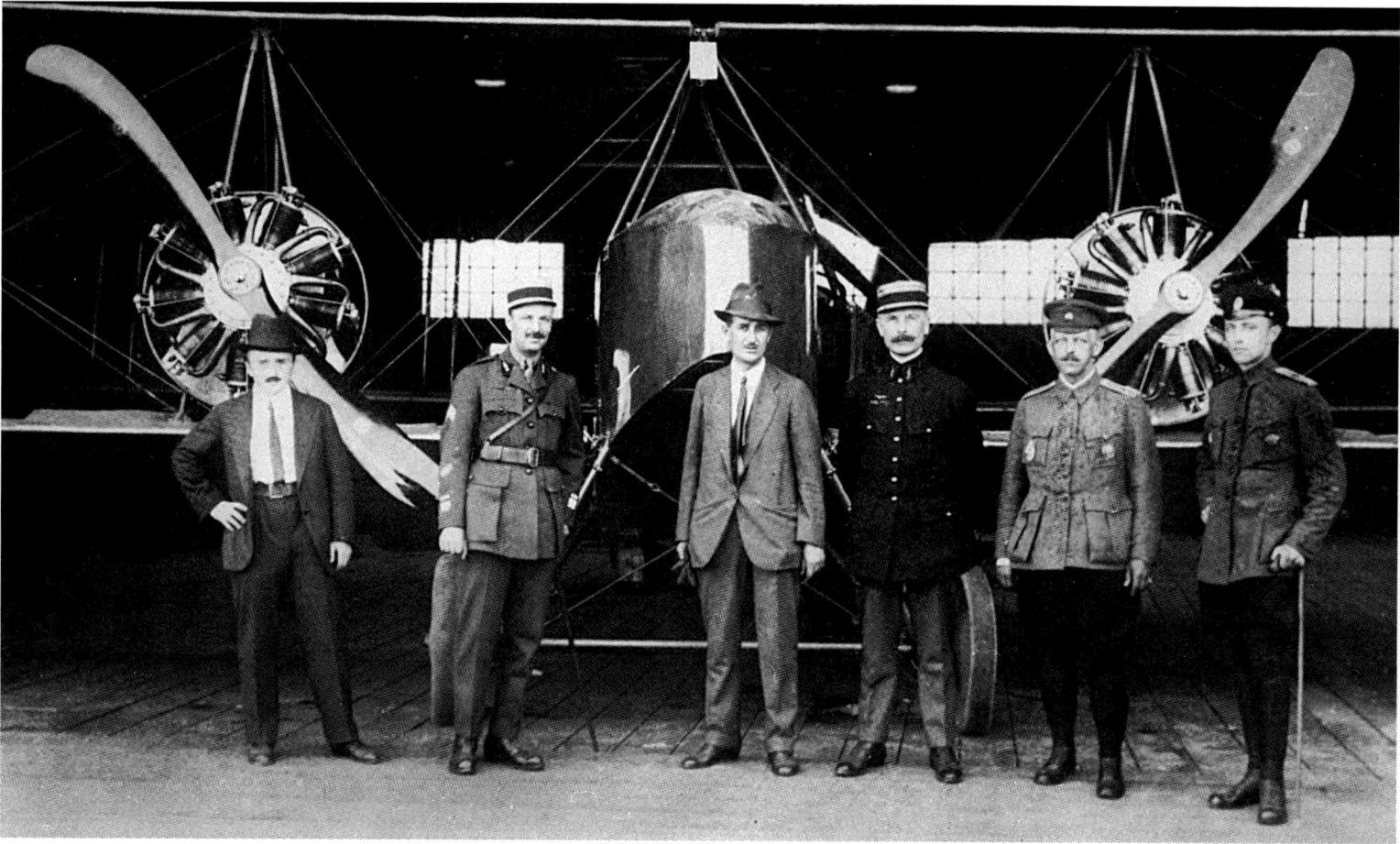

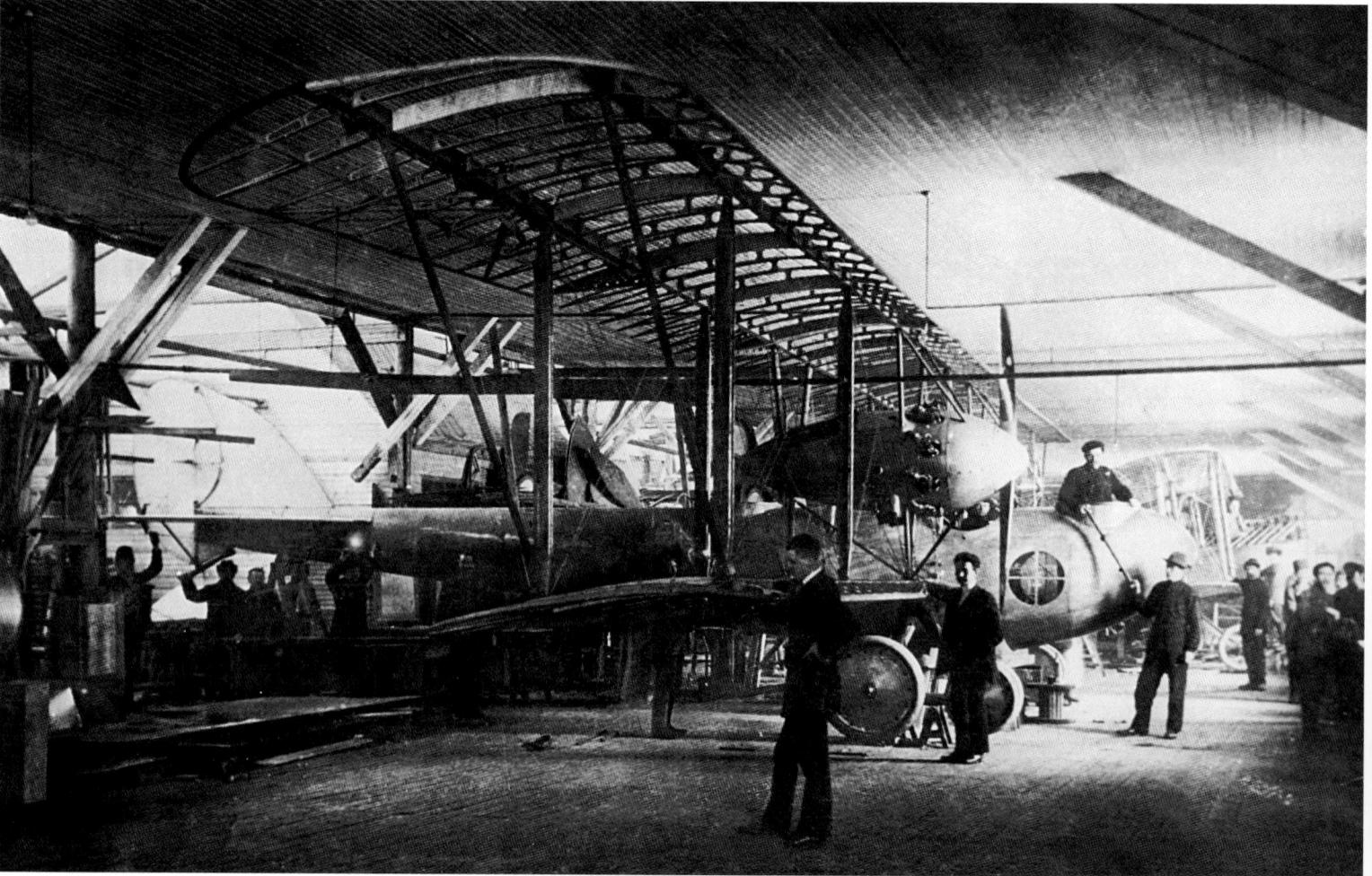

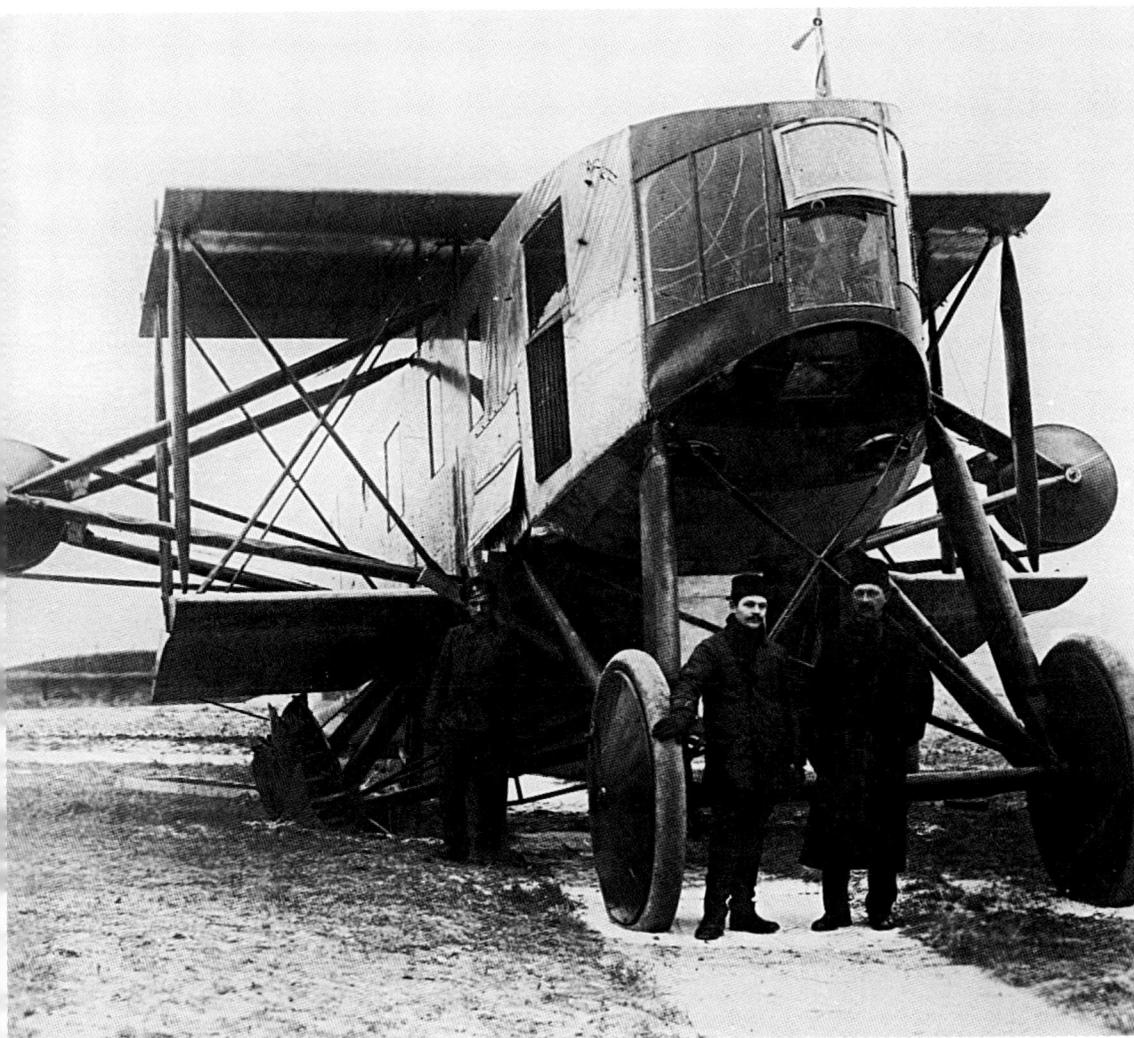

254. Aircraft designer V.A. Lebedev with French representatives near the plane *Lebed XVI.* **Third from the left is L. Shkulnik, an engineer and designer of weaponry.**

Petrograd. 1916

Aviator A.P. Goncharov tested the plane.

255. One of the original planes of aircraft designer V.A. Lebedev during assembly, which was named *Lebed Grand,* **or** *Lebed XVI.*

Petrograd. 1916 — 1917

Assembly of the plane remained unfinished.

256. V.A. Slesarev (on the left) near his *Svyatogor.*

Petrograd. 1916

257. The plane *Svyatogor,* **created by engineer-designer Vasilyi Adrianovich Slesarev, who experimented in aerodynamics.**

Petrograd. 1916

Construction on the plane began in December 1914 at the V.A. Lebedev's aviation factory. During war times problems with the plane surfaced, and only in March 1916 was a new type of bomber prepared for tests, during which the plane was damaged. Interest in the Svytogor waned in 1917 and it was no longer tested.

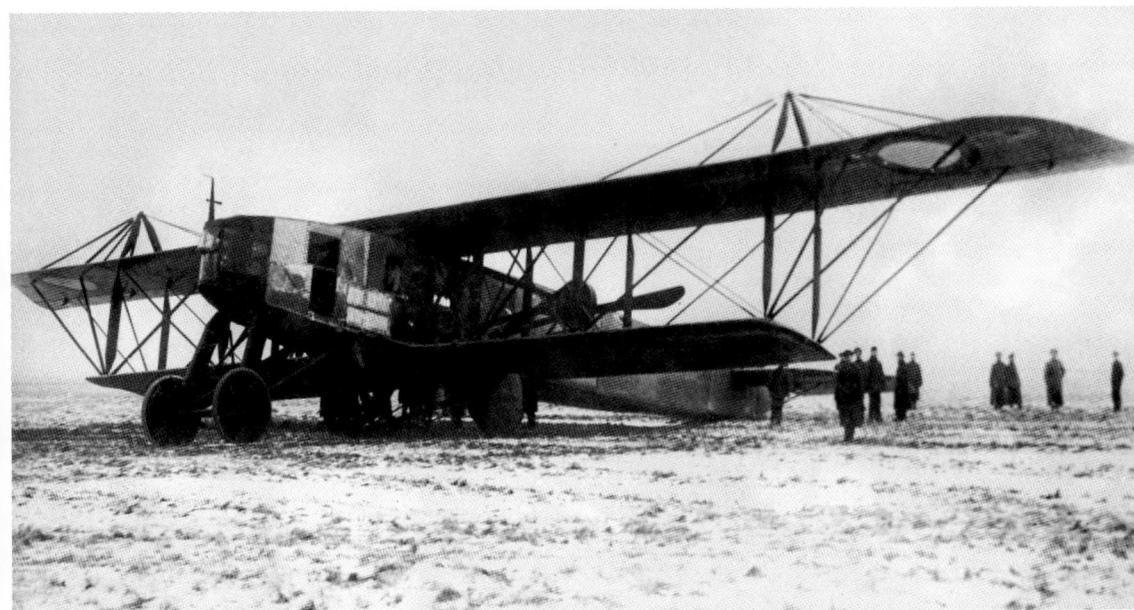

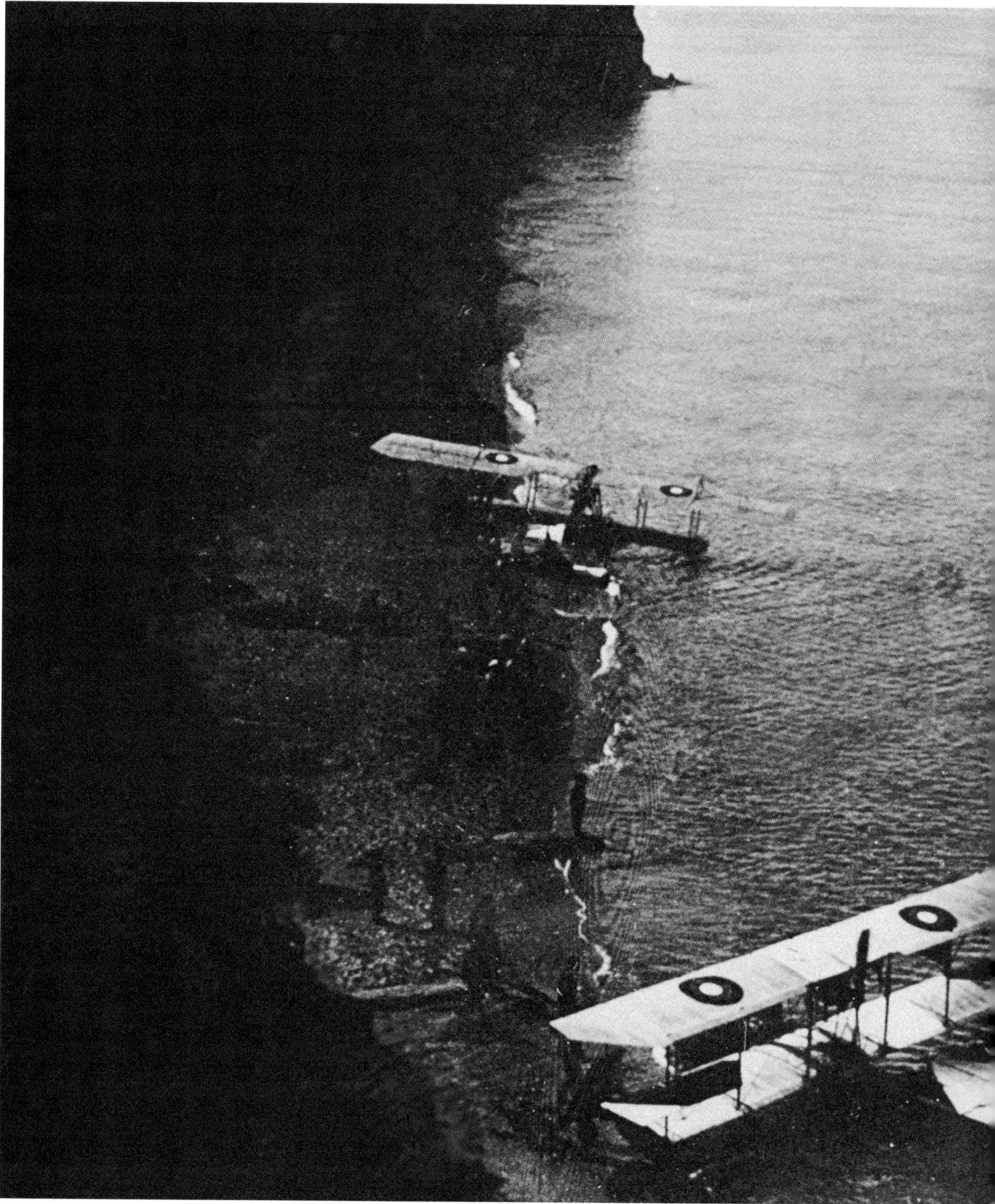

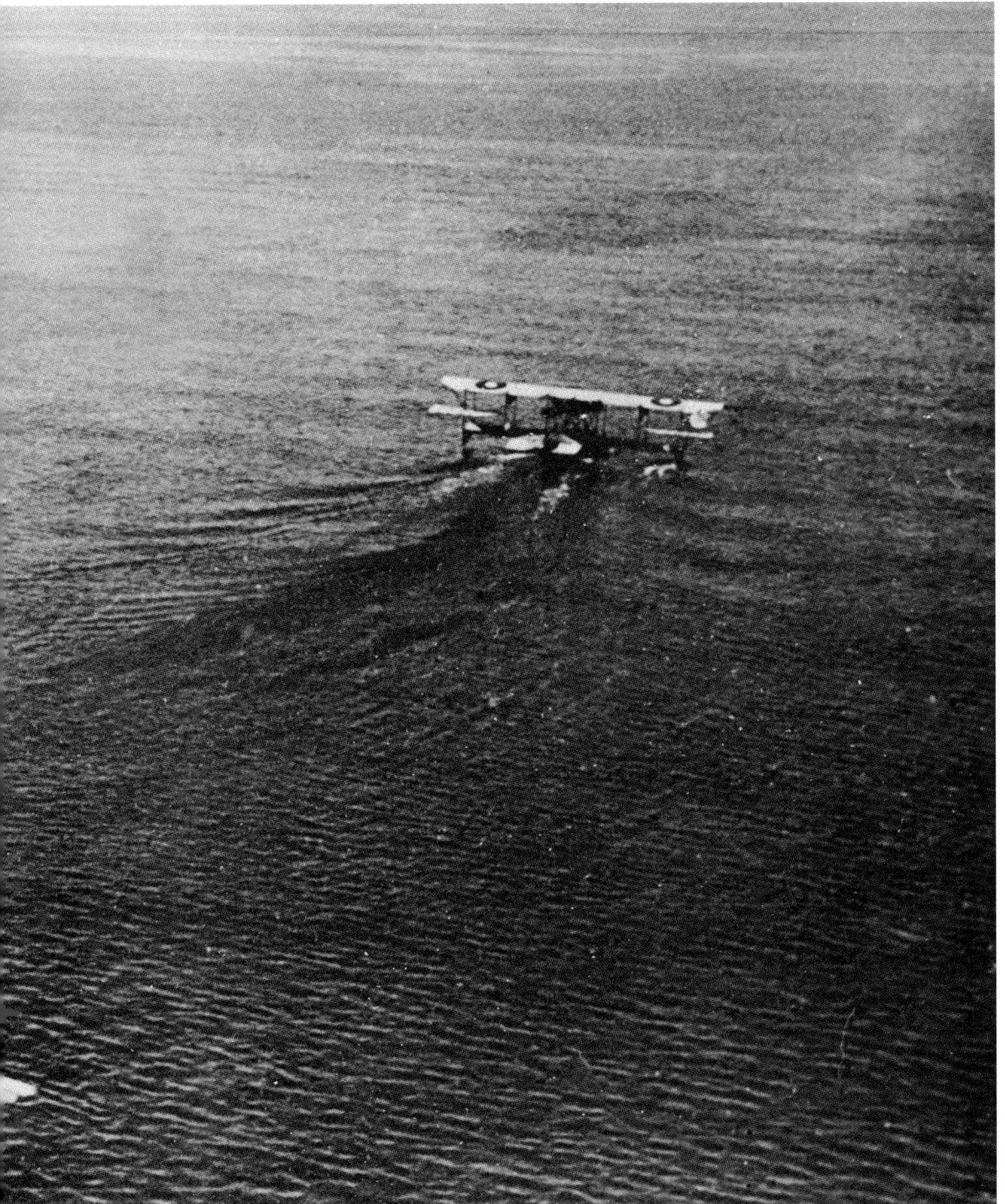

258. Seaplane squadron of the Black Sea Fleet: Curtiss planes and flying boats.
Near Sevastopol. 1915–1916

Seaplanes immediately attracted interest and were useful, especially in the navy. The Russian Empire's borders were near water in many places, and thus Russia saw the need to adopt this progressive new technology.

The first amphibious plane, which could land on both water and a regular airfield, was Y.M. Gakkel's seaplane the Gakkel V, a two-float single-wing of an original design. For this device Y.M. Gakkel received the silver medal at the First Aeronautical Exhibition in April 1911 in St. Petersburg. However, the Navy also bought a small amount of foreign seaplanes, such as the Vuazen-Canard and the floating Curtiss, used mostly in the Black Sea.

In 1912-1913, I.I. Sikorskyi worked seriously on seaplanes, designing and testing floating variants of his own dry-land models, like the dual-float S-5A, single float S-5A, and the hydro S-10. The Naval Department took the S-10 and built it in a small series.

In Summer 1913, work was also started on seaplanes at the Schetinin factory in St. Petersburg. A few achievements of engineer D.P. Grigorovich have already been discussed in the previous chapter, but his biggest success was the creation in 1915 of a seaplane, or, as they were called at the time - a "flying boat", the M-5, which became, in its time, the precursor to the more successful M-9. It was significant that Grigorovich's M-9 flying boat became the world's first seaplane, which could complete a "loop-the-loop" (by pilot Y.I. Nagurskyi and mechanic N.N. Godovikov with passengers on board), making a world record on November 12, 1916, thanks to the Imperial Pan-Russian Aeroclub.

Before the war, at the end of 1913, a consignment of flying boats from the FBA (Franco-British Aviation Company) was bought for the Russian fleet, and a small series of 30 planes was built at the Lebedev factory. They were like Grigorovich's M-5 in their parameters. At the beginning of World War I, the army bought the American seaplane Curtiss-F, which played an active role in Black and Baltic Sea military operations. Other floating seaplanes of the Farman-Moris and Sikorskyi S-10 types played roles as well.

Many aviation designers worked to develop the fleet: V.A. Lebedev built a few variants of his dry-land planes, fitting them to float; A.U. Villish also created a few seaplanes of the VM-1, VM-2, and VM-5 types; the talented designer and pilot E.R. Engels designed original flying-boat fighters; and pilot G.A. Fride built seaplanes of his own design. The famous plane designer I.I. Sikorskyi undertook an attempt to fit the plane Iliya Muromets for service in the fleet, readying it for floating and testing it in May 1914. The experiment turned out to be successful, but at the beginning of the war this Iliya Muromets was lost in Libau (the crew burned it on July 21, 1914 during evacuation, so that secret modifications would not reach the enemy).

Special ships able to carry seaplanes became a bright point in the history of naval aviation, the so-called "seaplane cruisers", "aviation ships", or "aircraft carriers". Here it needs to be noted that a few ships of the Russian fleet had already been refitted to carrying aeronautical devices, like tied aerostats, at the beginning of the 20th century. The most famous of such ships was the aeronautical cruiser Rus.

The question of basing planes on ships came up more than once before World War I. Thus, in 1913, the transport ship Dnepr of the Black Sea Fleet was refitted into an aircraft carrier, and on it seaplanes of the Curtiss type were placed in special wooden hangers. The next step was to alter the Black Sea cruisers Kargul, Pamyat Mercuria (Memory of Mercury) and Almaz (Diamond) into aircraft carriers. At the beginning of the war, the state ships Emperor Nicholas I and Emperor Alexander III became secondary ships, or plane transporters. After being rebuilt the Emperor Alexander III was renamed the Emperor Alexander I.

The plane transporters' first "trial by fire" happened in the Spring of 1915, when the Emperor Nicholas I of the Black Sea Squadron reached the Bosphorus. Here the ship-based "flying boats" did reconnaissance to find enemy positions.

From then on, plane transporters were actively used during attacks on Turkish fortifications. The most effective was the attack of 11 seaplanes on Zunguldak on February 16, 1916, when, because of bombardment of the port, a Turkish steamship was destroyed and a few other ships were damaged.

The Baltic Fleet had refitted its own aircraft carrier, the Orlitsa, into the transport Emperor Alexander, able to carry three seaplanes on a special deck with a hanger. In the Summer of 1915, the Orlitsa took part in military operations, ensuring reconnaissance and correction of artillery fire for the fleet. In 1916, more modern seaplanes like D.P. Grigorovich's M-9 were based on the Orlitsa. Notably, on July 4, these planes, fitted with artillery fire, destroyed two German planes.

In the Summer of 1916, one more seaplane transport, the Romania, went into construction, given to Russia by Romania, after the Empire went to war on the side of the Entente kingdom.

In November 1916, naval aviation was ended due to the fact that every sea had its own aeronautical division under the immediate supervision of the commanding fleet. On the Baltic such a division was made up of 2 brigades, with three airborne divisions in each, about 88 planes at the beginning of 1917. On the Black Sea there were 2 aviation brigades (with 5 airborne divisions), in which were 152 planes and 4 small dirigibles.

By the Summer, "Instructions for Military Actions of Airborne Divisions in 1917" came out, in which the main tasks of naval aviation were decided to be:

1. Aerial reconnaissance
a) watching the sea,
b) surveying areas of the sea and submarine battles,
c) watching the shore (photo-reconnaissance)
2. Aerial battles
3. Bombing

4. Correcting artillery on ships and on the shore.

In 1916, the Navy took an interest in using planes for torpedoing. Thus, the factory Gamaiun (a business created after the unification of the First Russian Association of Aeronautics (FRAA) with two other organizations) designed and built the torpedo carrier HPSU, a special-use two-float biplane seaplane with a dual motor, as conceived by D.P. Grigorovich, and ordered by the Naval General Staff. The torpedo was attached under the body of the plane on a special truss.

The Navy placed a lot of hope on this plane, planning to order 10 immediately. In August 1917, the plane first flew under direction from Senior Lieutenant A. E. Gruzinov, becoming the world's first special torpedo carrier. The Revolution didn't allow for the plane to be perfected.

Manning cadres were a particular problem for naval aviation. Initially, naval pilots were taught at the Gatchina Aviation School, but quickly found a new place in Sevastopol, in the south of Russia. However, both schools were not exactly oriented to prepare naval pilots, and fleet commanders decided to organize a special educational institution only for fleet officers. On July 28, 1915, on a base on Gutuevskyi Island, at the location of an experienced aviation station of the Baltic Fleet, the first Officers School for naval pilots was founded.

In order to teach pilots, a Baku branch of the Petrograd Aviation School was opened on November 22, 1915, and transformed in February 1917 into the Independent Baku School of Naval Aviation.

In general, from the results of hydro aviation in World War I specialists came to the conclusion that seaplanes had more potential than merely reconnaissance and bombardment. They could also place mines and torpedo ships.

At the end of 1917, Russian naval aviation became an independent type of warfare, able to complete a wide array of war tasks. Only political upheaval on a large scale negated these successes, which nevertheless were continued by the next generation of naval pilots.

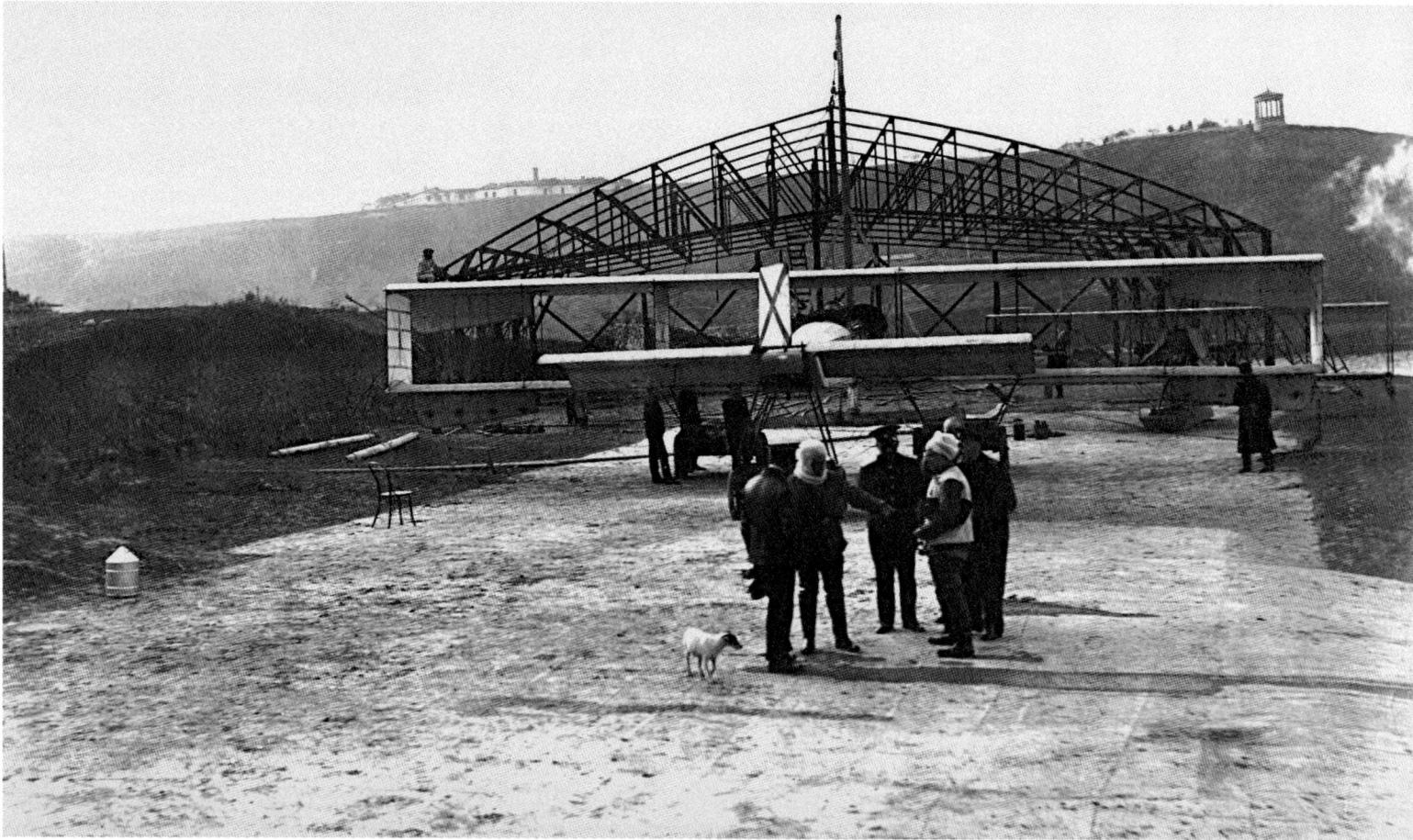

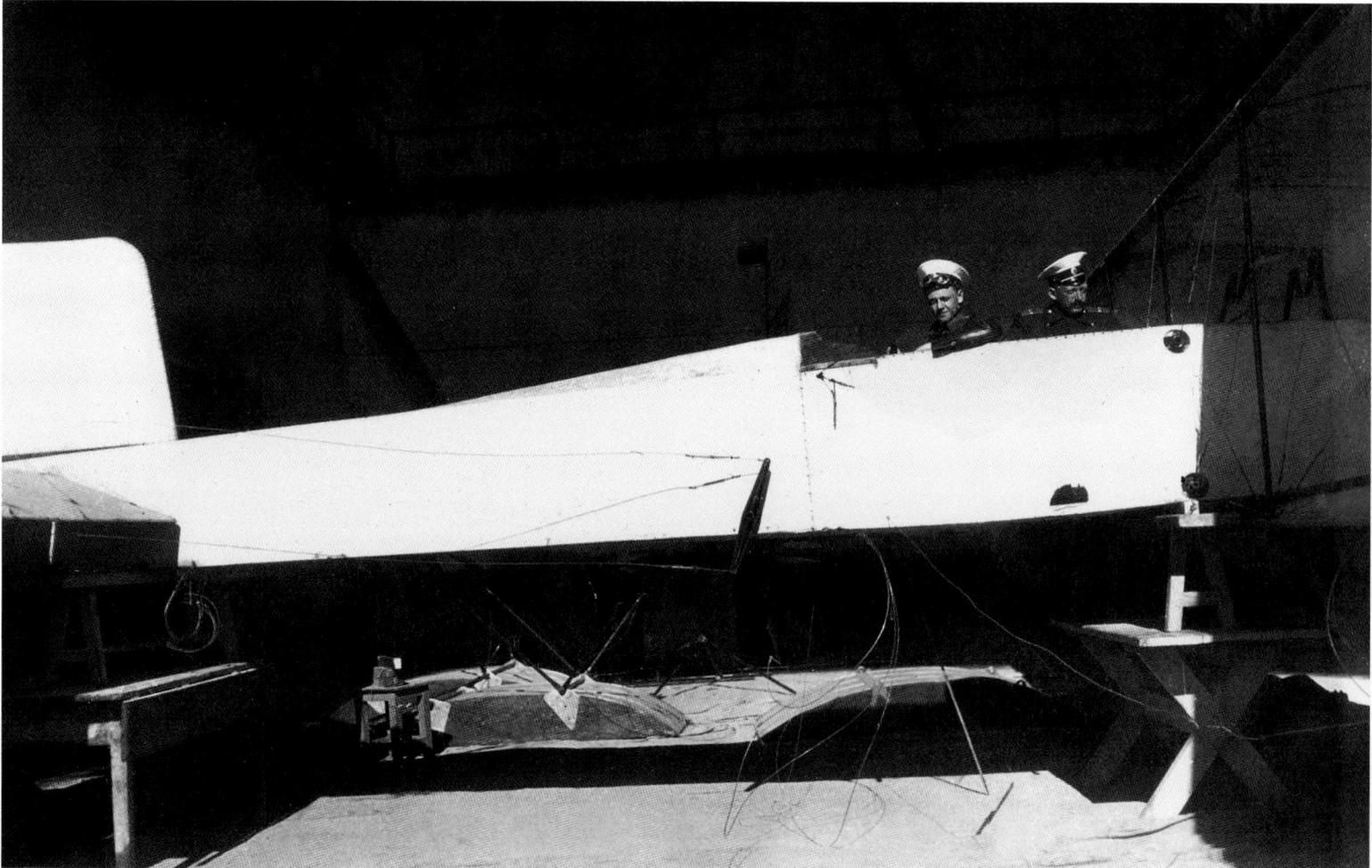

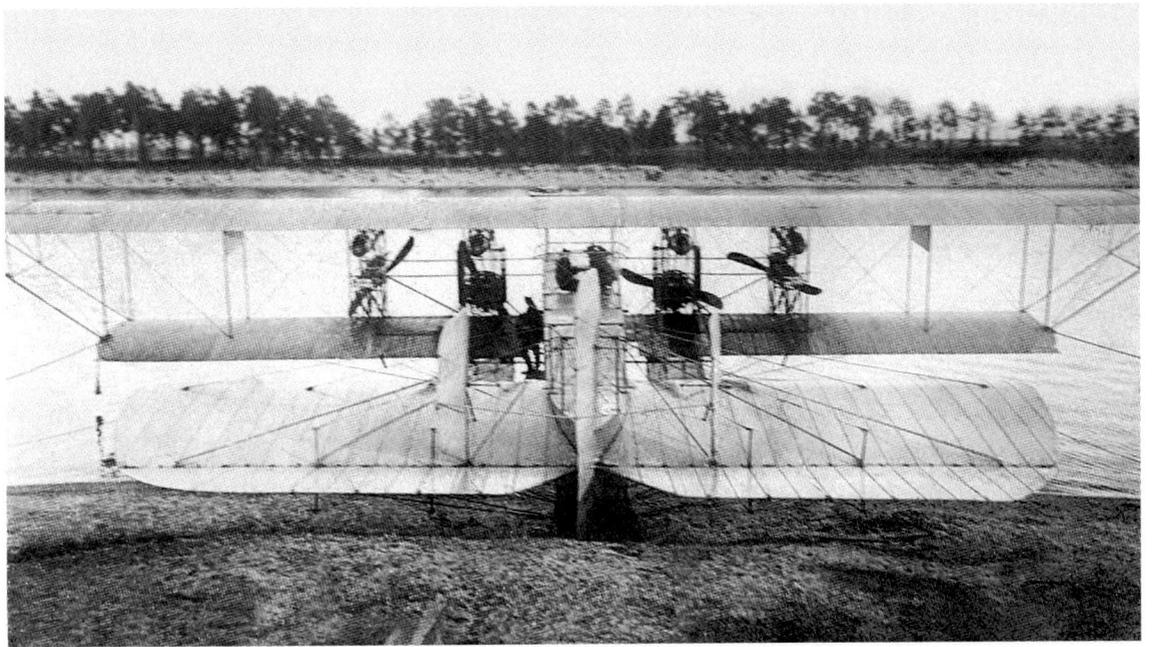

263. The *Vuazen-Canard ("Canard"* from the french for *"Duck"*), being prepared for flight. Future aviators would train on it.
Sevastopol. 1912—1913

264. The plane *Vuazen-Canard* during adjustment and alignment. On the left sits naval pilot M.A. Kovedyaev, the future head of the 2nd Airborne Squadron on the cruiser *Emperor Alexander I.*
Sevastopol. 1912—1913
Russia acquired 2 of these planes for the fleet.

265. The seaplane *Iliya Muromets* with commander G.I. Lavrovyi during a flight on the lake Ezel, where the plane station Kilkond was located.
Karanth Bay. July 1914

266. Assembly shop at S.S. Schetinin's factory. In the foreground is a seaplane of D.P. Grigorovich's *M-5* type.
Petrograd. 1915

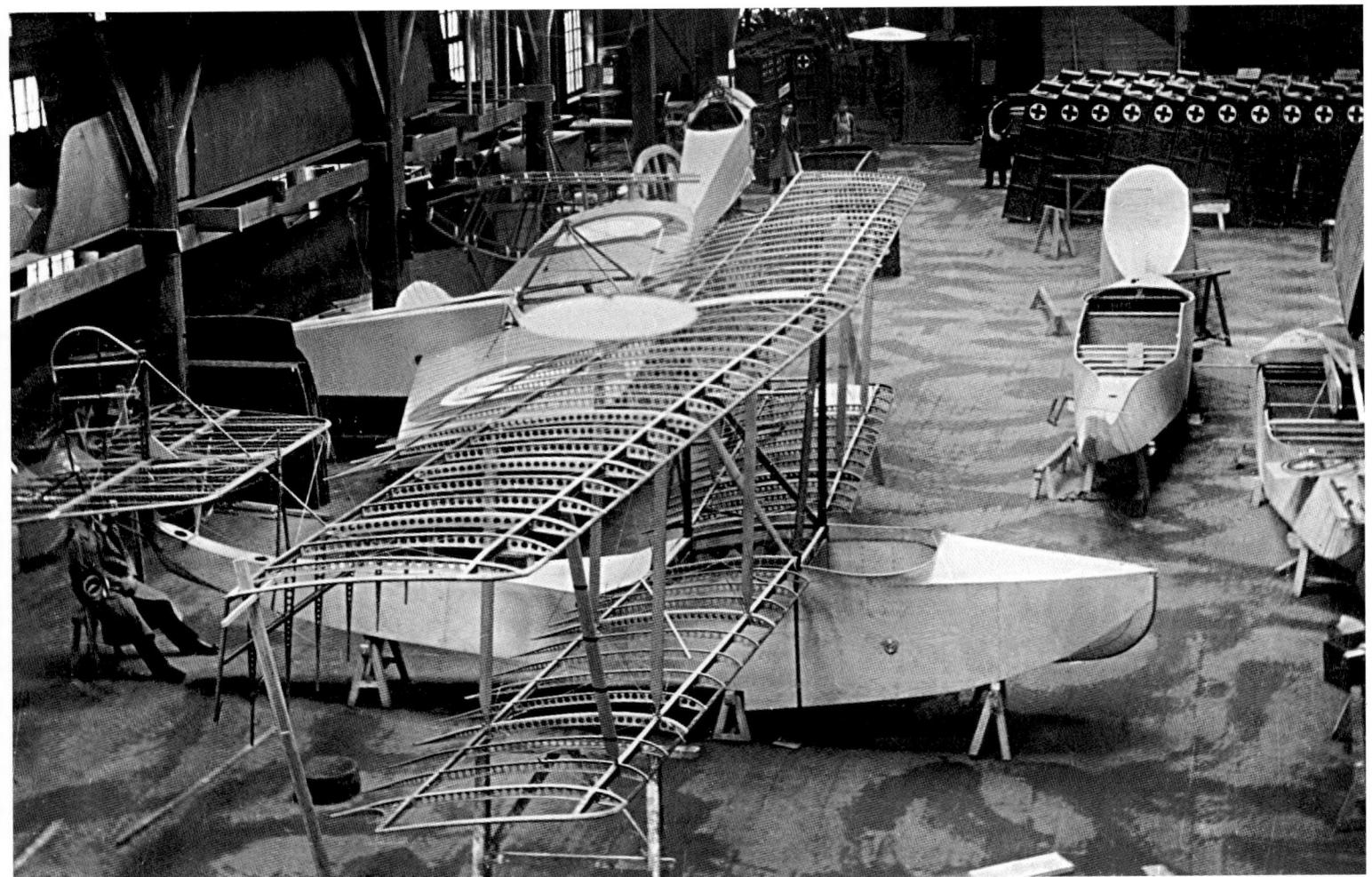

The Albatrosses of the Russian Fleet

267. Naval aviator and designer Lieutenant G.A. Fride next to the motor of the *Curtiss*.
St. Petersburg. 1912

268. Naval aviator and commander of an airborne division Y.I. Nagurskyi at the aviation base Lake Ezel of the 5th Airborne Division.
Baltic Fleet. 1915

269. V.P. Liubitskyi, an aviator and lieutenant of the fleet, on I.I. Sikorskyi's floating plane *S-10*.
Third hydro aviation station in Kilkond.
Baltic Fleet. 1915

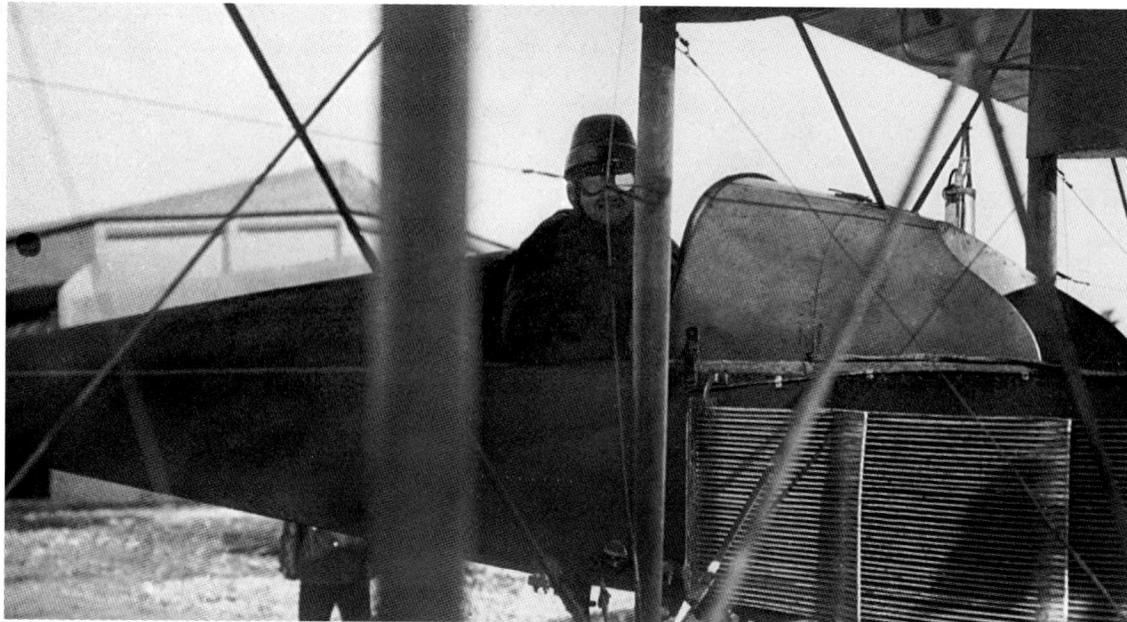

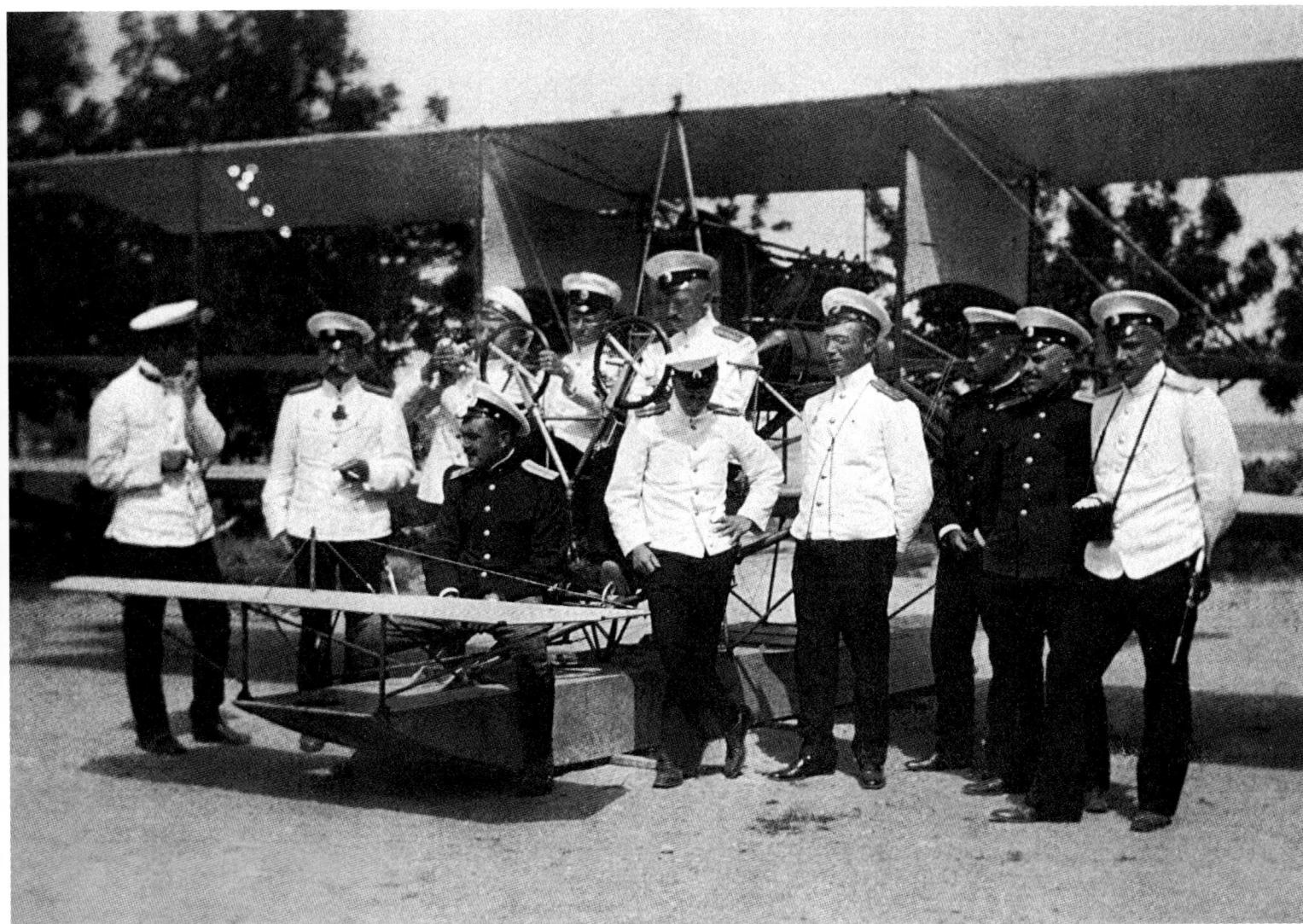

270. Near the floating seaplane *Curtiss* **are members of the selection committee for the title of naval aviator. Fourth from the right is Lieutenant V.N. Kedrib, fifth from the right is Lieutenant G.A. Fride.**
Sevastopol. 1913

271. Naval aviator Lieutenant G.A. Fride at the wheel of the seaplane *Curtiss*.
Sevastopol. 1913—1914

271

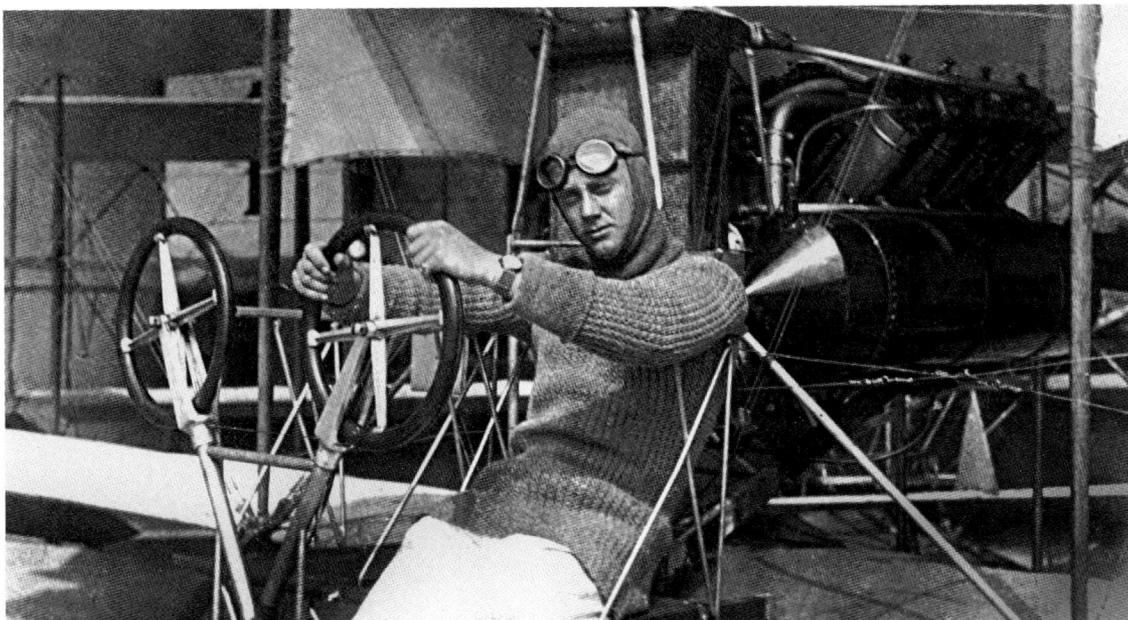

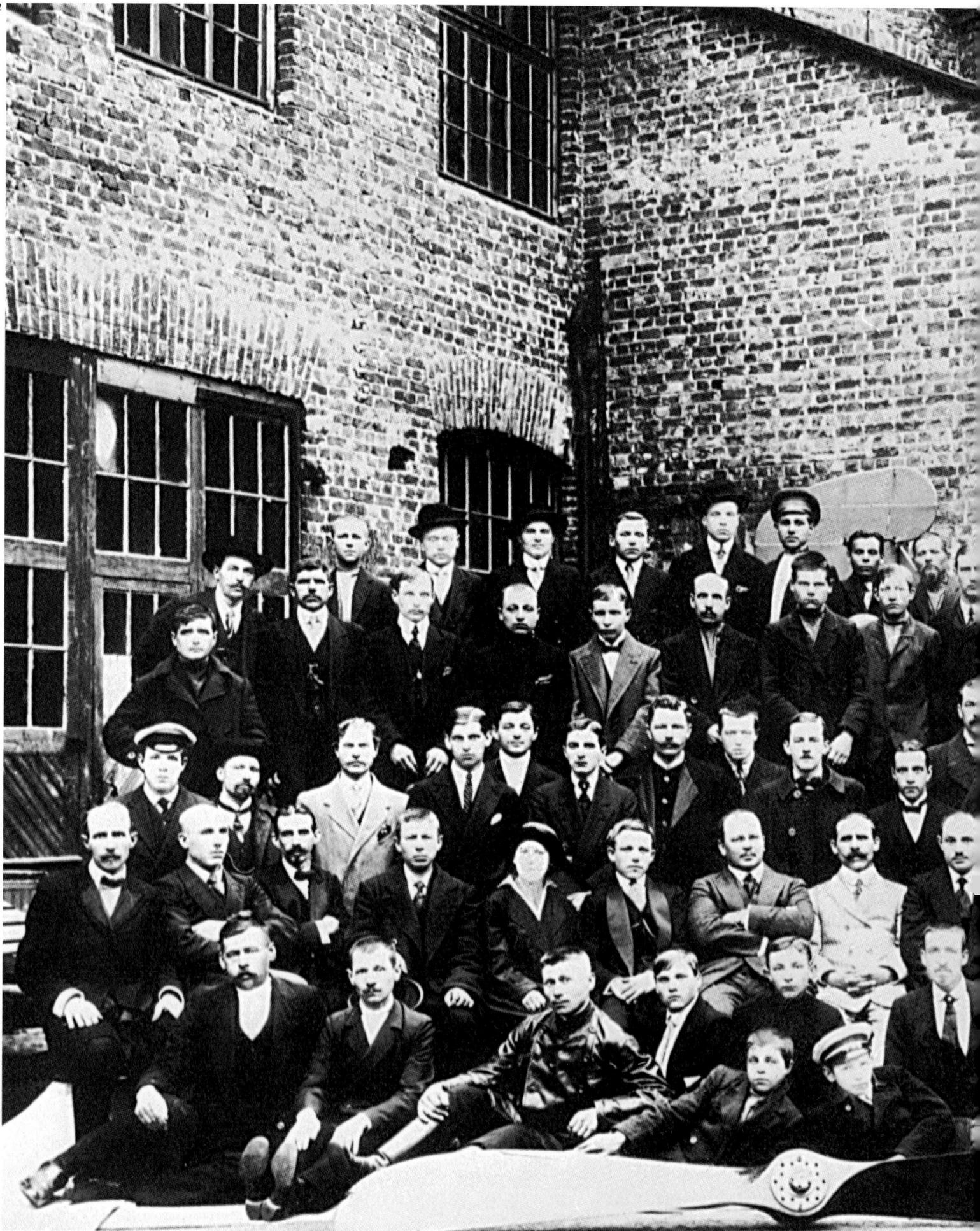

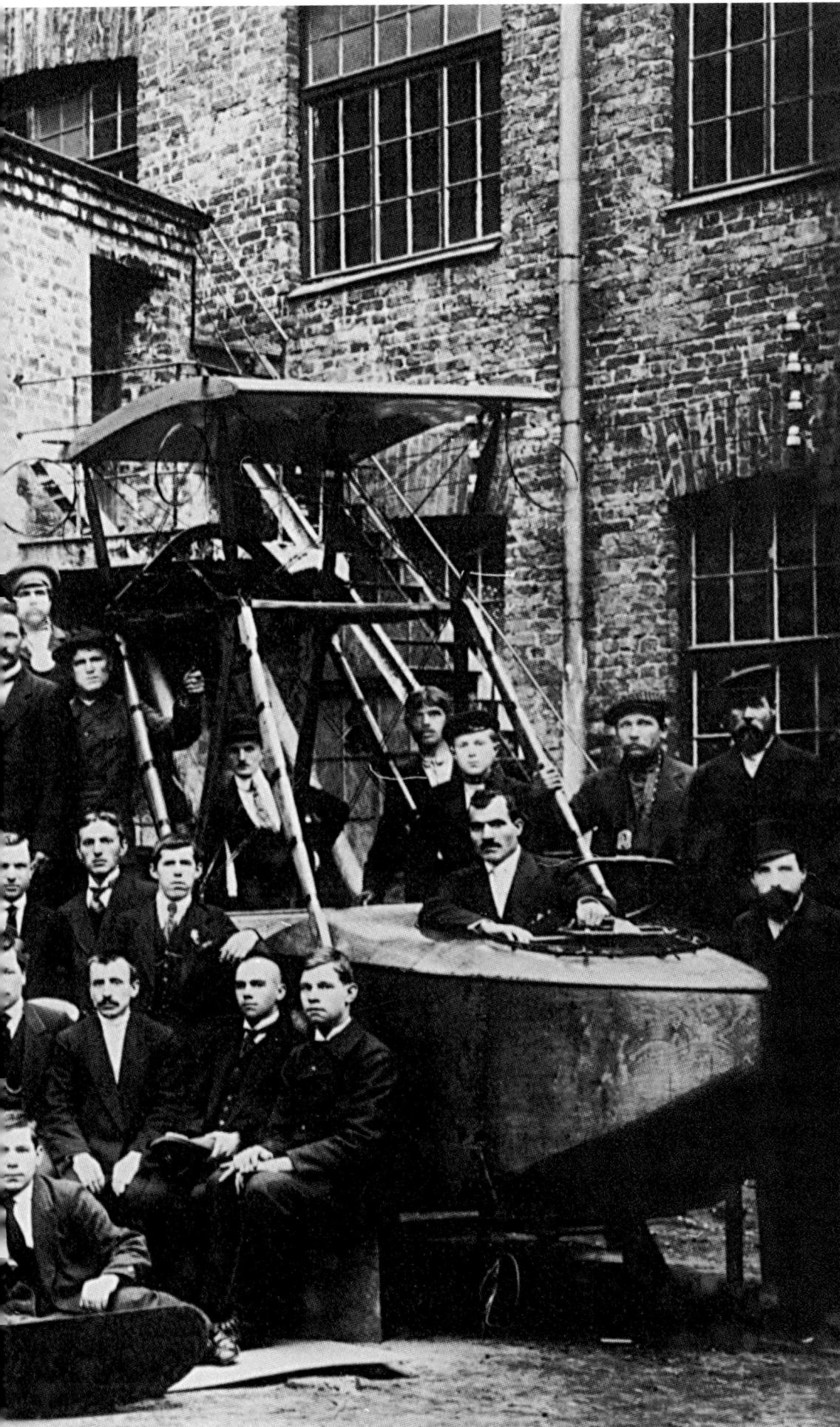

272. A group of workers from
S.S. Schetinin's aviation business
Gamaiun, where D.P. Grigorovich's
seaplanes were built (the *M-5* and
M-9). In the center in a white suit is
S.S. Schetinin and on the right next
to him is designer D.P. Grigorovich.
Petrograd. 1915—1916

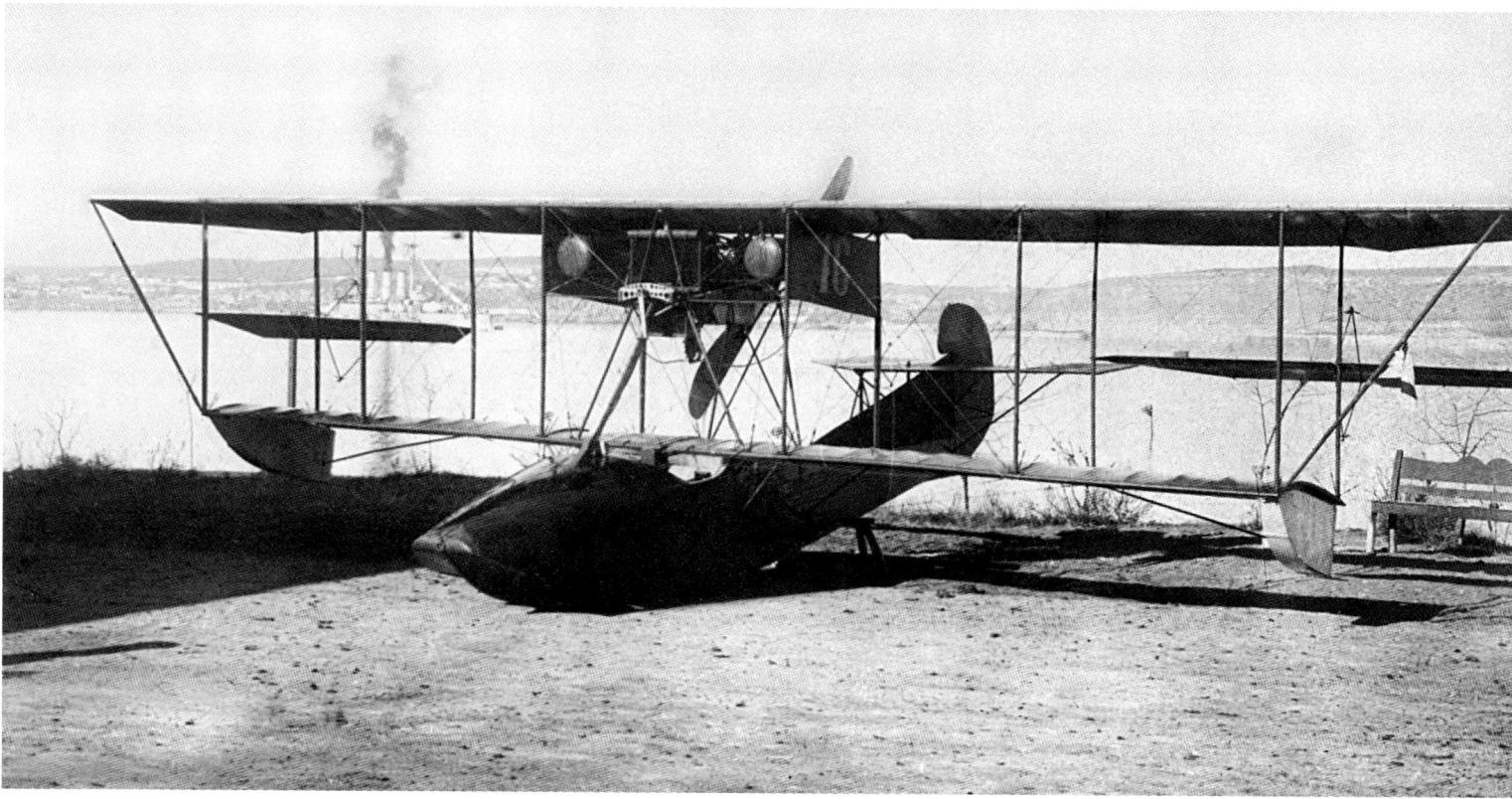

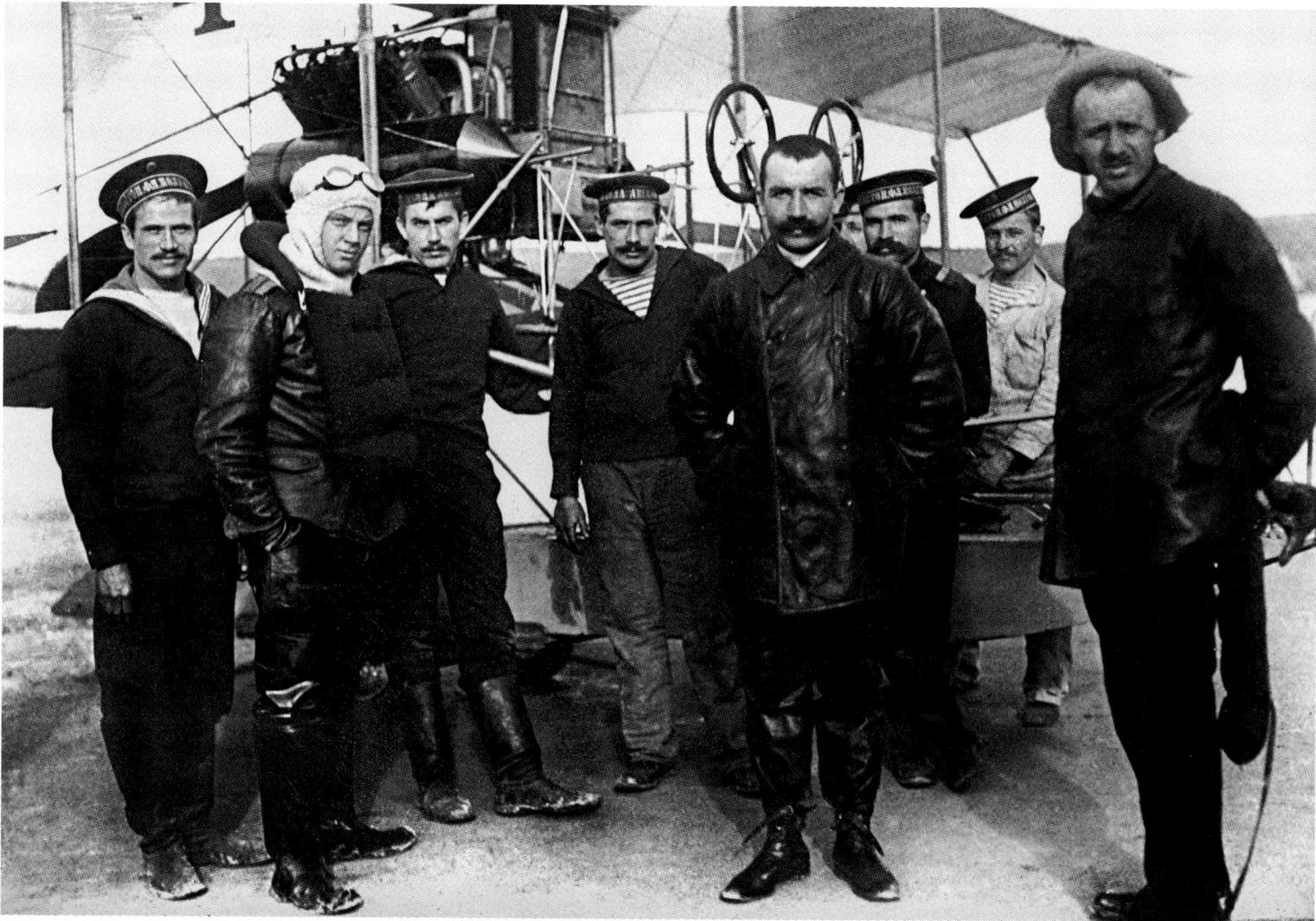

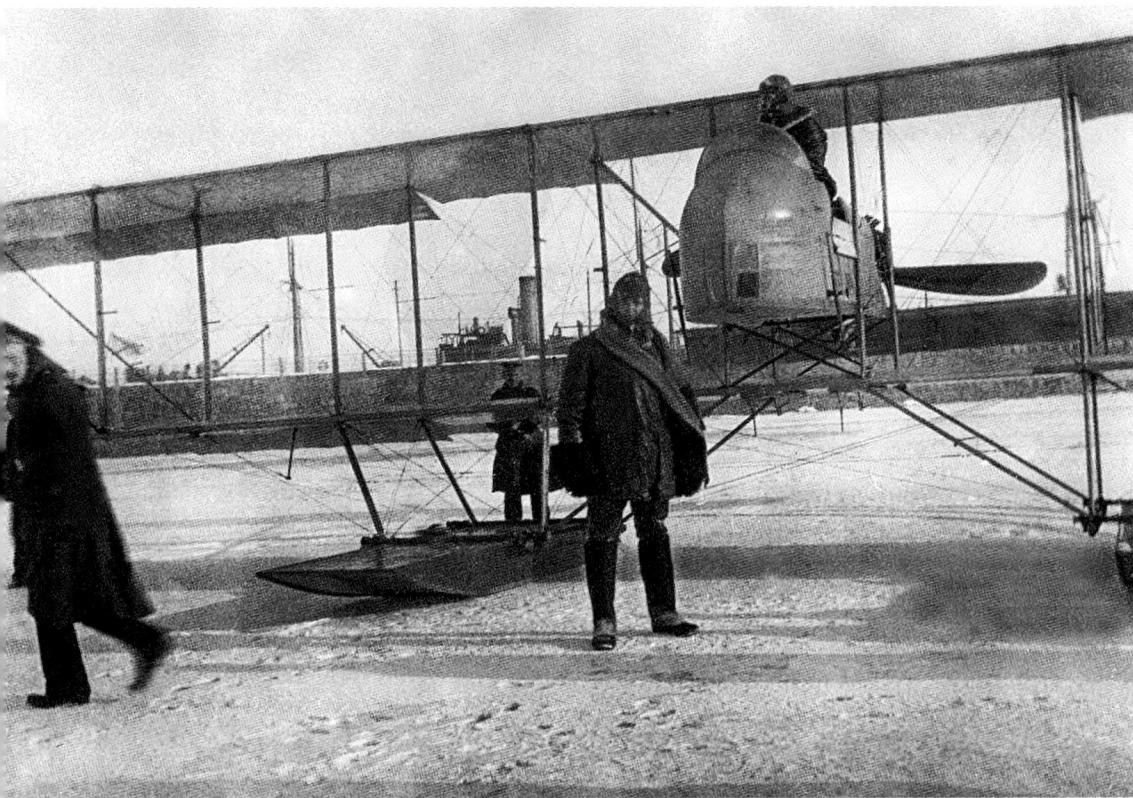

273. The seaplane *Curtiss*, a participant in military actions on the Black Sea.
Kilen Bay. Sevastopol. Fall 1914

274. Pilot G.A. Fride (in glasses and a life jacket) near the seaplane *Curtiss-Suchok* after a training flight.
Sevastopol. 1915

275. The seaplane *Farman-Moris* on float-skis preparing for takeoff from the ice.
Baltic Sea. 1915

Designer N.R. Lobanov worked with ski-snowflyers. A float chassis was ordered by P.V. Evsiukov for his colleagues and aviator Y.I. Nagurskyi.

276. Fuselage of a seaplane by designer G.A. Fride, a lieutenant of the fleet, equipped with underwater "wing-knives".
Petrograd. 1915—1916

276

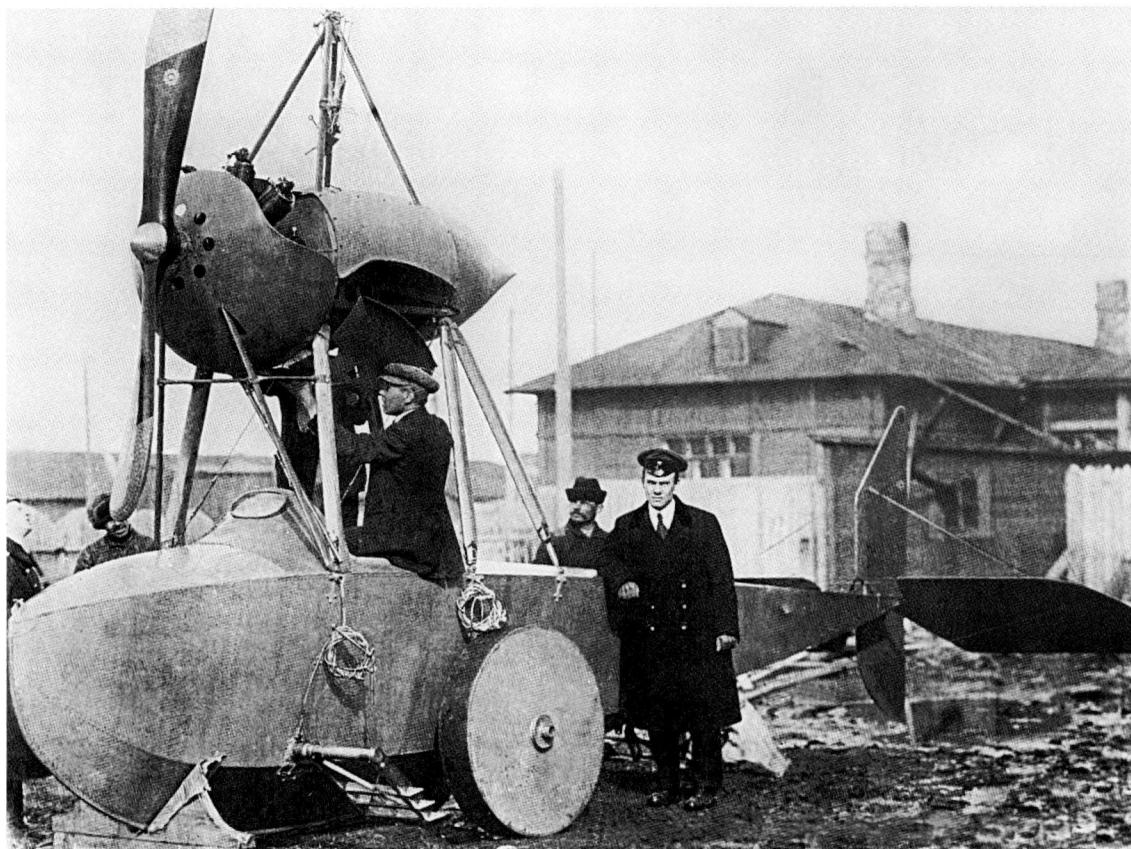

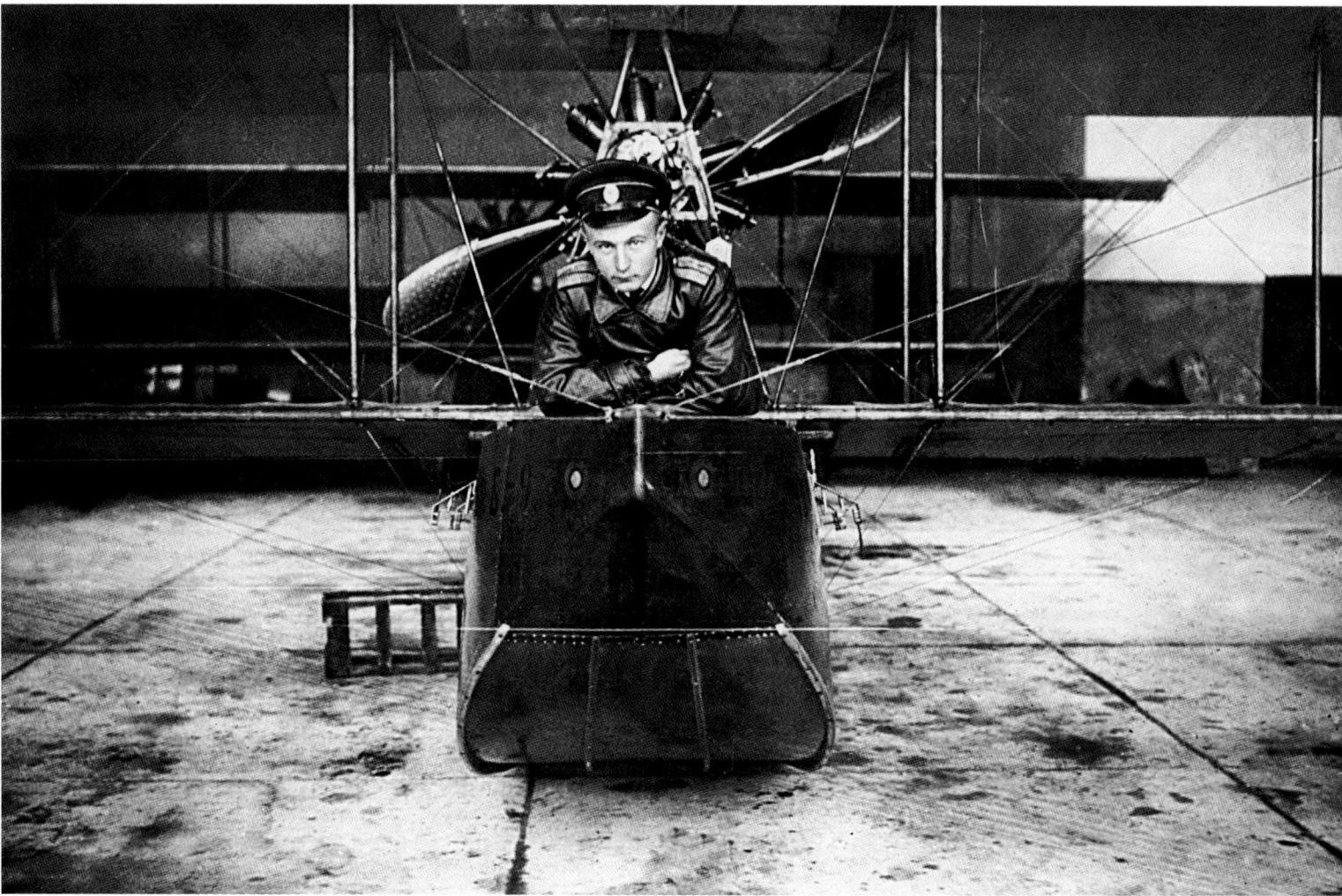

277. Midshipman V.A. Korolkov demonstrates his "FBA" seaplane.
Baltic Fleet. 1916

Such planes were created during World War I in France. There were 18 in all in naval aviation.

278. The naval plane *Farman-Moris* **while taking off from the water.**
Baltic Fleet. Winter. 1916

279. Naval aviator O. Zaitsevskyi near his *Farman-Moris* **at the plane base in the Alandskyi Islands.**
Baltic Fleet. 1917

280. The prototype of future aircraft carriers - the ship *Orlitsa* **(a** *"carrier of aircraft"* **as it was called in the Russian fleet).**
Baltic Fleet. 1916 – 1917

Planes of the 6th Airborne Division were based on the ship with aviators S.A. Petrovyi, B.A. Schepotievyi, L.V. Kovalevskyi, and V.L. Yakovlevyi. In the photo can be soon how the hangers of the planes were closed off with loose tents.

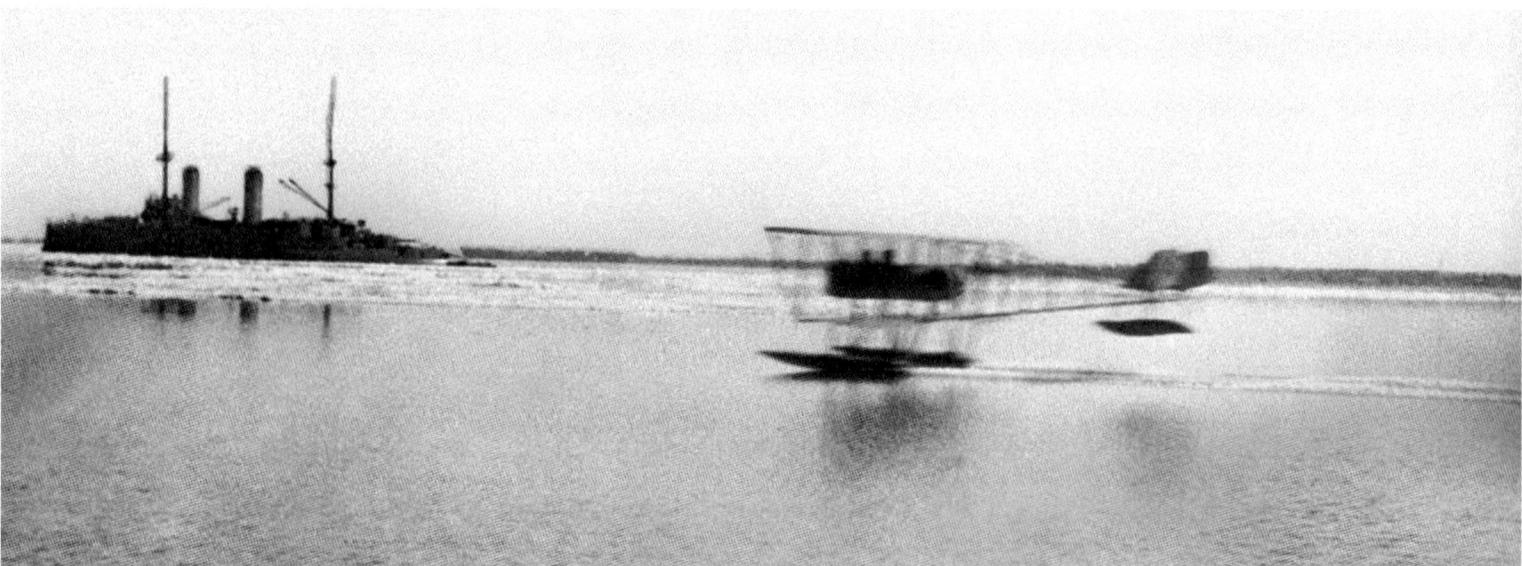

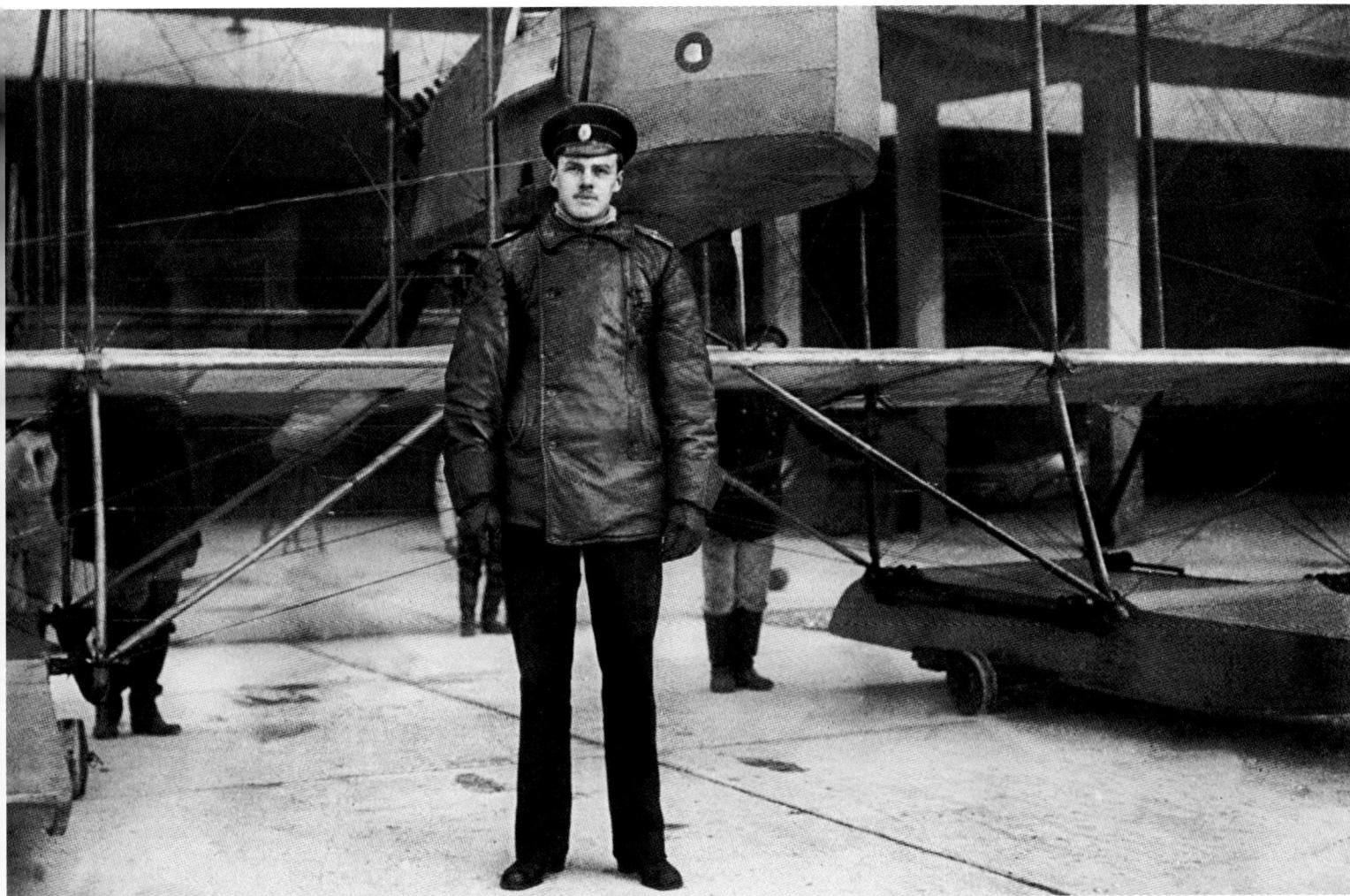

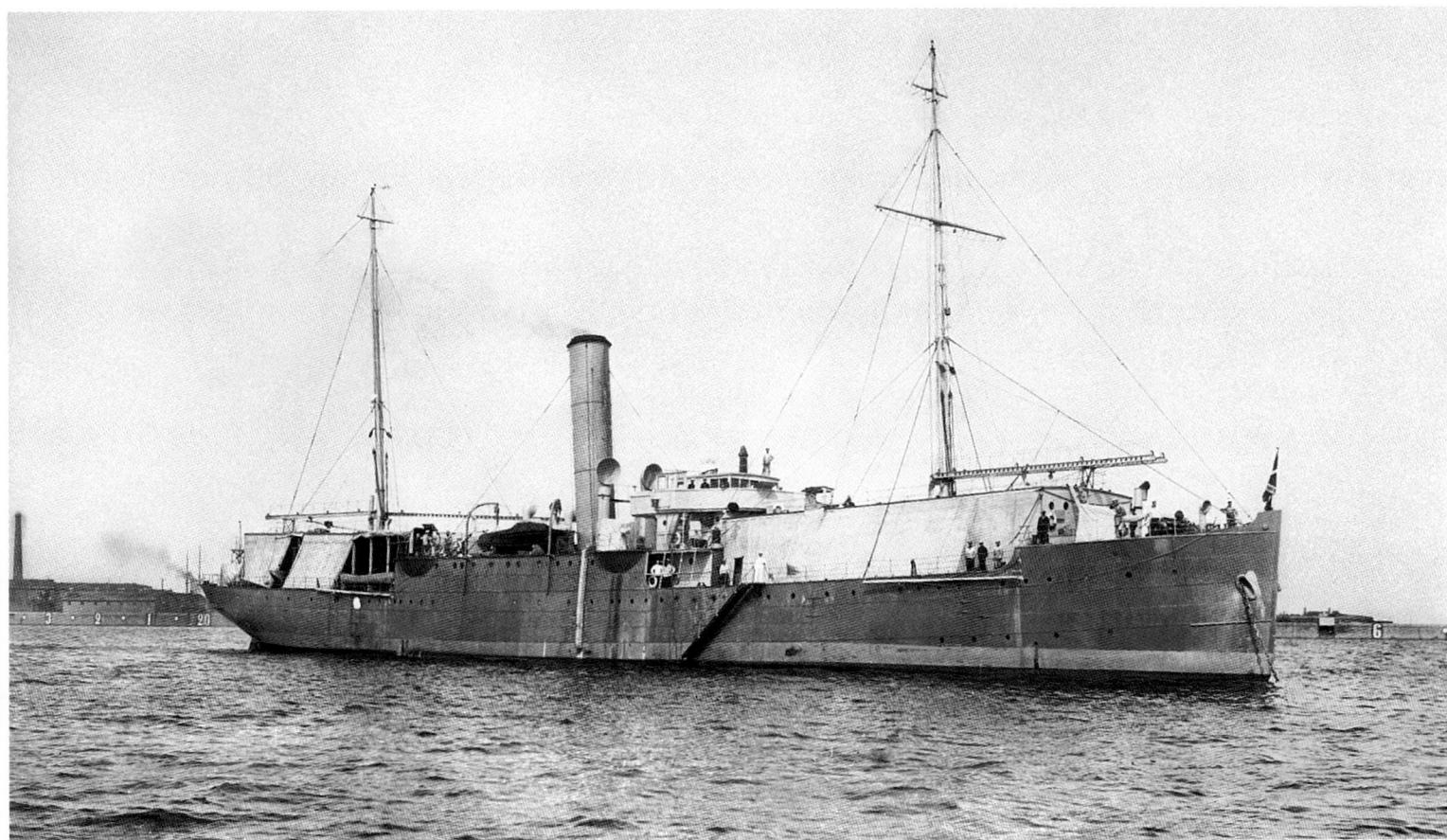

The Albatrosses of the Russian Fleet

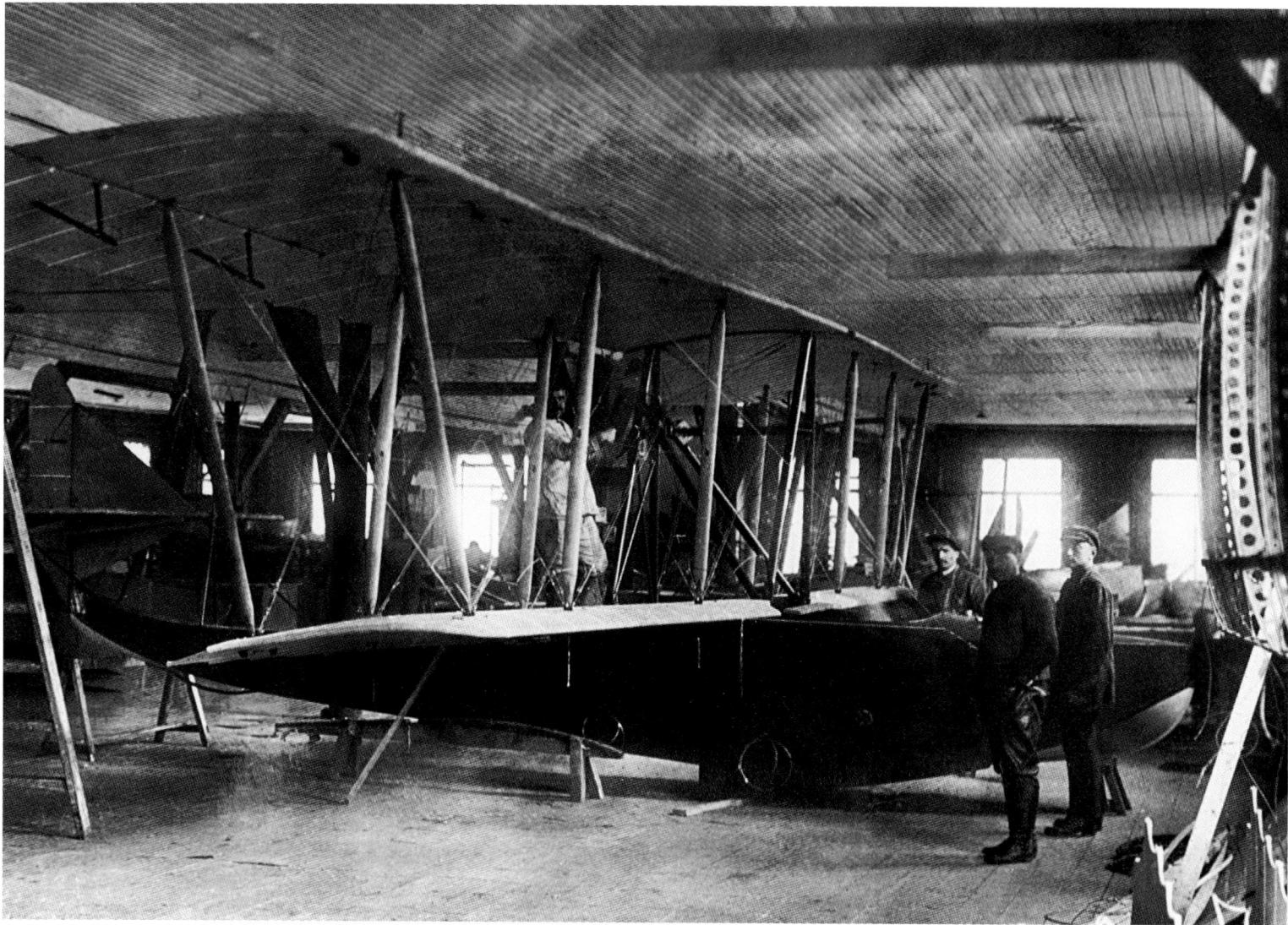

281. Seaplane _M-5_ in the hanger of a hydrostation.

Petrograd. 1916

282. Building inspection of the naval aviation station at the Sevastopol fortress by Emperor Nicholas II (standing in the center, and near him is heir Tsesarevich Alexei). Behind him in a combat uniform is Naval Minister Admiral I.K. Grigorovich, and to the left of him is Admiral A.A. Ebergard.

May 14, 1916

283. View from a neighboring ship on the carrier _Orlitsa_.

Baltic Fleet. 1914 – 1917

The tent has been pulled back and there's a good view of how the "FBA" seaplane was placed on the deck in 1914-1917. The ship took part in military actions up until 1917.

284. One of the first flying boats, the _M-9_, on the Black Sea.

Circle Bay. May 1916

Such boats were built in a large series and put in both the Black Sea and Baltic fleets.

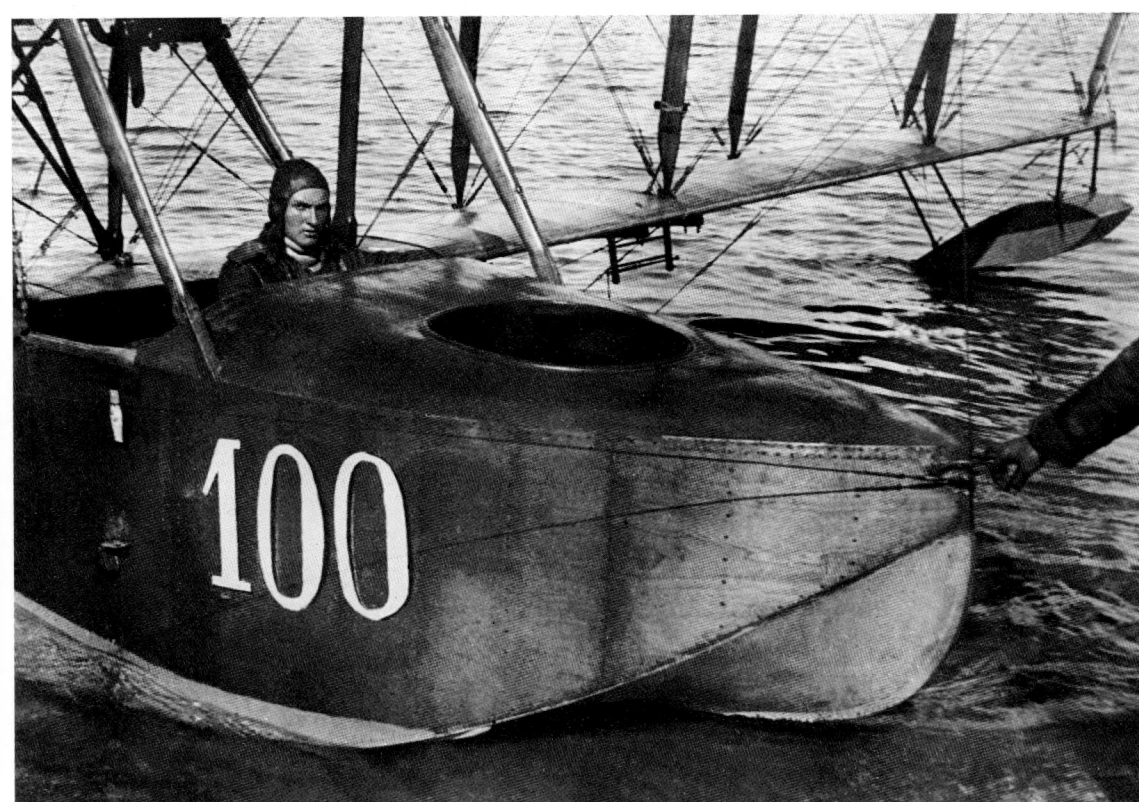

285

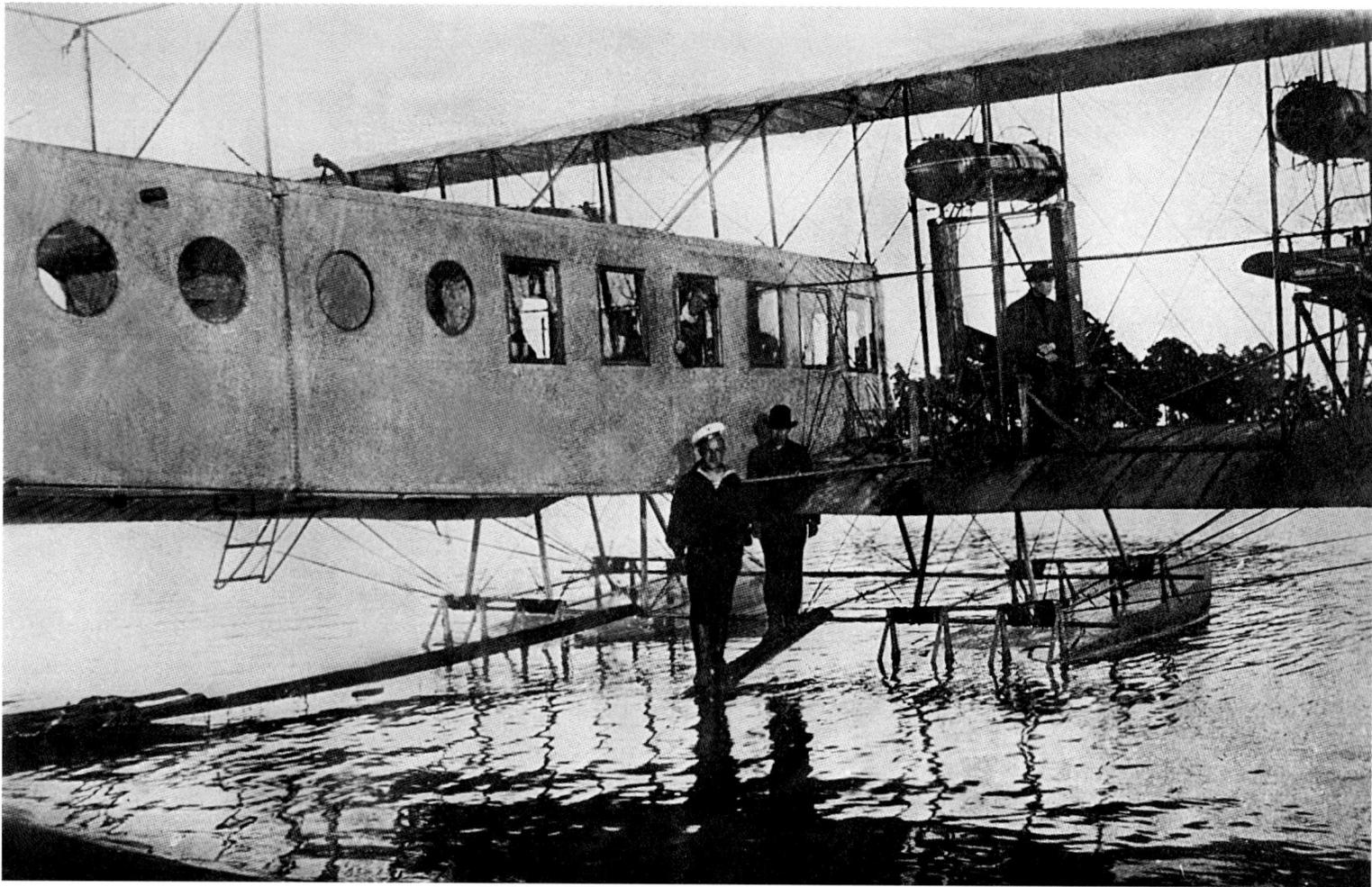

286

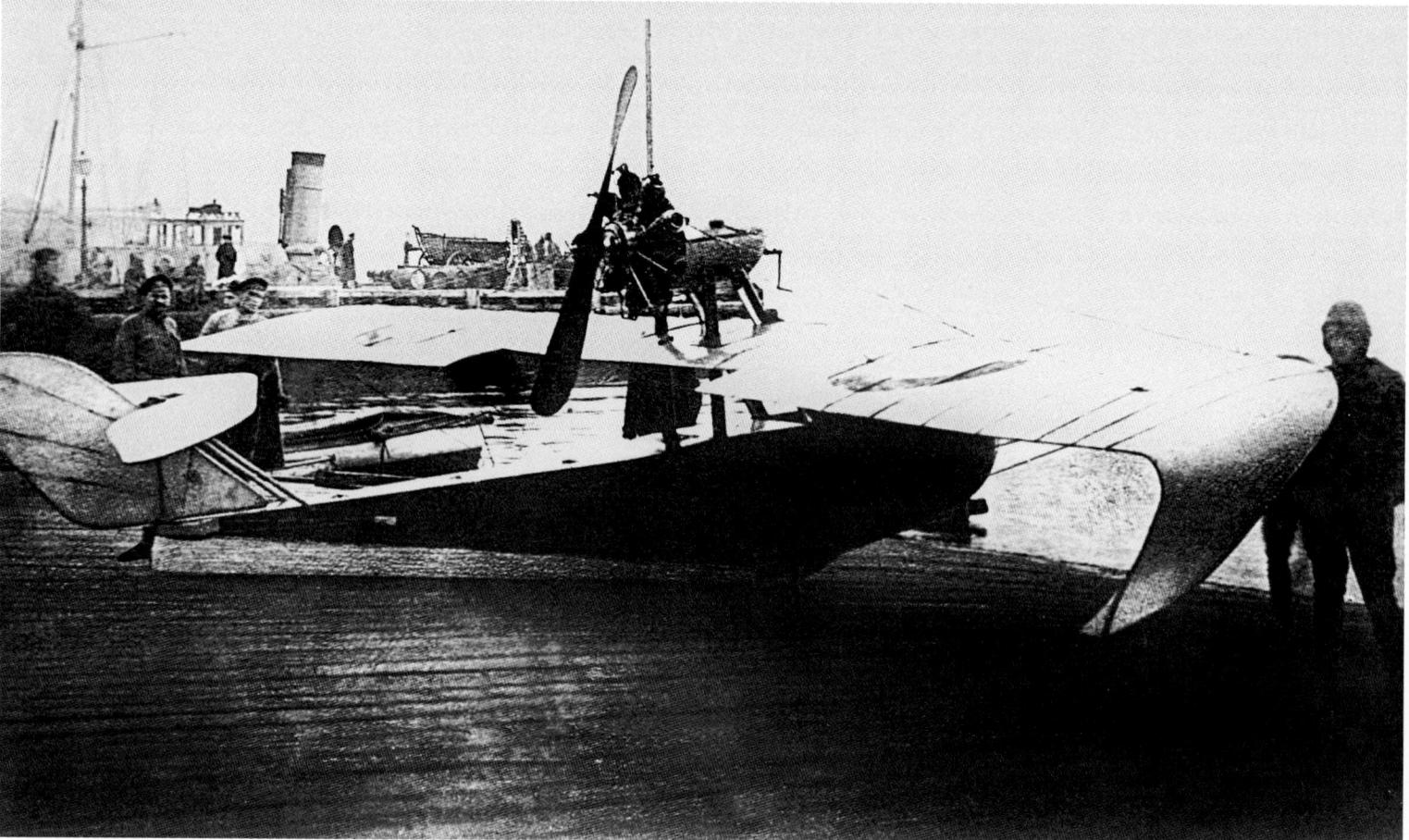

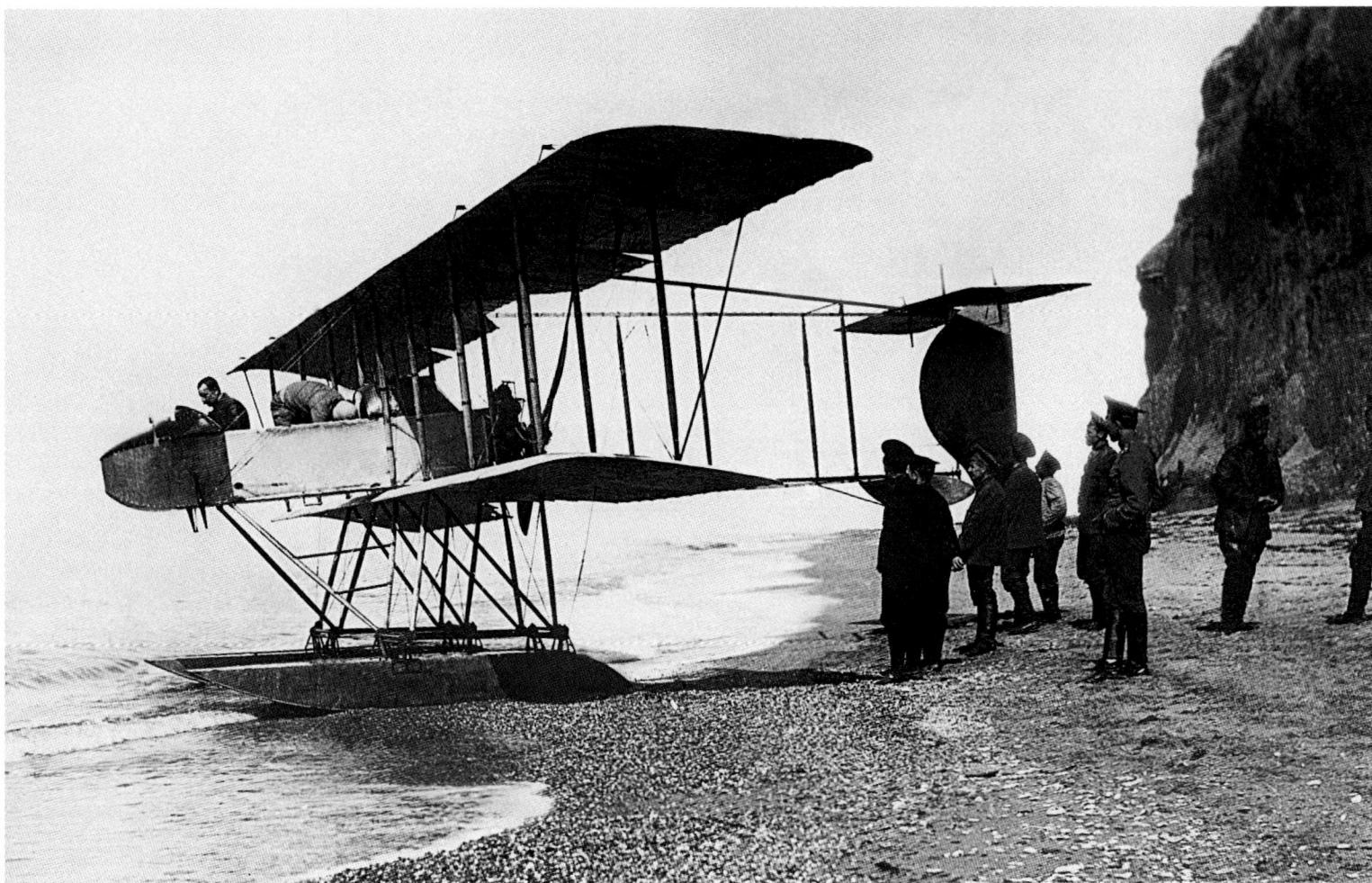

285.The *Iliya Muromets*, **mounted on floats and sent for carrying anti-ship torpedoes, during tests in Riga.**
1916

286. Seaplane-destroyer designed by E.R. Engels, during tests achieved a record speed of 170 km/hr.
Aviation School in Baku. 1916

287. Training seaplane *Moran-Solnie* **parking on the shore in Sevastopol.**
1915

288. Seaplane *M-9* **over Palace Square.**
Petrograd. 1917
In the picture is the upper part of the Alexander Column.

288

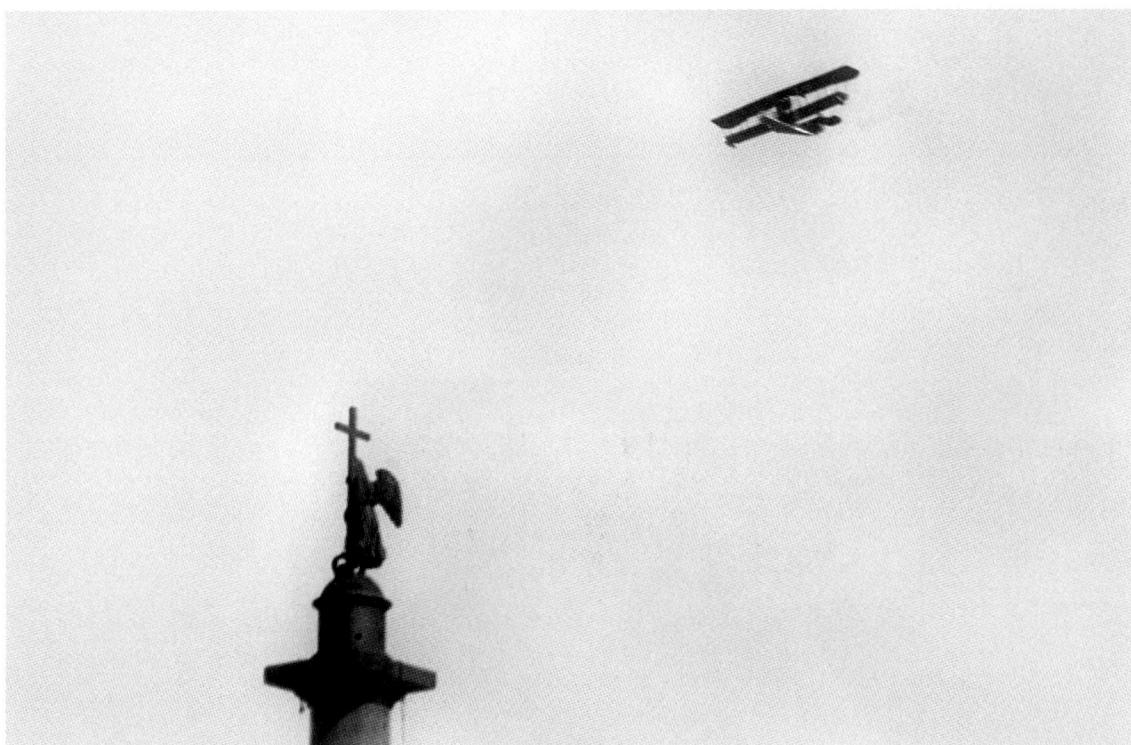

The history of many-motored bombers was unique not just in Russia, and dated back practically to the very start of the development of aviation.

At the end of 1911, Igor Ivanovich Sikorskyi began to develop a plane with more than one engine. The increase in the number of motors also increased the length of the flight, and Sikorskyi planned to include a closed, comfortable cabin for a few people that would ensure their security.

In Spring 1912, the idea of such a plane was formalized, and in the Summer, the project was realized. Thanks to active support from the president of the joint-stock company «Russo-Baltic Railcar Factory» M.V. Shidlovskyi, I.I. Sikorskyi's new plane was built and given the serial number S-9 and its own name, Grand. On March 4, 1913, it was first taken from the hanger, and I.I. Sikorskyi himself taxied it around the airfield. On Mach 15, the plane took off under direction from the designer, and in April it was tested at the Korpusnoi Airfield.

The plane had two Argus engines of 100 horsepower, and after fitting it with two more, it was given a new name, the Grand Baltic. After going through a number of tests, the gigantic plane was first demonstrated on May 10 to all of St. Petersburg, flying over the city at a height of 400 meters.

In the Summer of 1913, I.I. Sikorskyi also made another revolutionary step: he fit all four engines in one line on the lower wing for the first time in the world (up until then they were installed in united pairs, one thrusting and the other pulling). According to Baron A.V. Kaulbars, the creation of such a device became a turning point in military affairs.

The plane was given still another, more lofty name - the Russian Vityaz (Russian Hero) - and on July 25, 1912, it was shown to Emperor Nicholas II. The Tsar personally flew on board the plane, inspecting the well-made interior of the cabin. His sympathetic attitude to I.I. Sikorskyi influenced the designer's future plans.

In September 1913, at a competition of military planes taking place at the Korpusnoi Airfield, an engine crashed into the Russian Vityaz, which fell from a plane flying over it. I.I. Sikorskyi then began work on a new, more modern many-motored device. The military wanted the new plane to carry artillery, which had not even been considered for its forerunners (which, interestingly, was also the reason that the Russian Vityaz was refused for restoration).

Initially, this model, called the Iliya Muromets, was built for long-distance flights. The design was considered to be the best and most expedient for during 1913-1914, as well as quite simple to produce. In November 1913, the Iliya Muromets (factory number 107) was built, and on December 10 it took its first flight from the Korpusnoi Airfield. On December 12, the plane, piloted by I.I. Sikorskyi himself, took off with 10 passengers on board, which was a new world record for capacity.

However, this record was surpassed on February 12, 1914, as Sikorskyi managed to take off with 16 passengers (and a dog called Shkalik in freight) - a genuinely phenomenal achievement for the young 25-year old plane designer!

The Naval Department expressed great interest in this plane, and it was decided to change it into a seaplane and fit it with floats. On May 14 in Libau, the new device completed its first test flight under the direction of I.I. Sikorskyi himself and Lieutenant G.I. Lavrov.

In April 1914, the second Iliya Muromets, type B, was built with stronger engines and a slightly smaller frame. The plane flew on May 29, and it broke a few new records for flight height and capacity practically right away.

The Department of the Army had already put in an order for 10 of these aeronautical giants on May 12, 1914, but I.I. Sikorskyi continued to test the abilities of his darling. On June 5, 1914, the Iliya Muromets took off from the Korpusnoi Airfield with a crew of 5 people and made a circle flight of 6 hours and 33 minutes, flying 650 miles, which became a world record. On July 16, the Iliya Muromets, number 128, made a new longer flight with a distance of 2500 km: from St. Petersburg to Kiev to Novo-Sokolniki and back to St. Petersburg. After this the plane began to be called the Iliya Muromets - Kiev. Planes appeared using this aeronautical giant as a model for projected passenger lines from St. Petersburg to Moscow; there were even talks about flights to the Arctic Circle and to America. However, the beginning of the war caused the need for different plans.

The military deservedly valued the Iliya Muromets as a plane of strategic importance: it had a large radius of action, the ability to carry large loads (up to 10 pounds of bombs), and there was the possibility of arming it with artillery weapons. The head of the General Staff suggested to the military ministry that 10 ordered planes should be distributed into squadrons. Later, in October, the Department of the Army ordered 32 more type B planes, although at the time I.I. Sikorskyi had already conceived of a new modification, the type C, as a purely military variant.

The president of Russo-Baltic M.V. Shidlovskyi, along with the supreme commander Grand Duke Nicolas Nikolaevich, decided to form separate squadrons filled with Iliya Muromets planes, which were part of the «Squadron of Flying Ships» (SFS). The decision delighted the Tsar, and on December 10, 1914, he signed an order to form the leading squadron. This day became the birthday of Russian strategic aviation.

Structurally, Russian aviation was separated into «heavy» aircraft, under the command of the Staff of the Supreme Commander, and «light» aircraft, joining the army under the command of Grand Duke Alexander Mikhailovich.

10 military Iliya Muromets «ships» went into the SFS (they were not mistakenly called ships: the crew from 5-6 people, strong armaments, and even the dimensions of the planes made them seem more like ships than planes) and two training models. M.V. Shidlovskyi led them and was given the assignment of General Major. At first the aviation part in the military had been headed by the aviation general.

At the end of December 1914, the squadron started its activities near Warsaw, not far from the city Yablonna, all of 40 km from the front lines. Here were gathered the best cadres - aviators as well as the technicians, which allowed for independent decisions on many difficult problems connected with fixing and modernizing the Muromets in field conditions. At the Yablonna base installations to outfit bombs and add defensive shooting armaments were created. Also, every plane had photo equipment to focus on bombing targets and record using panoramic aerial photography in deep reconnaissance of enemy positions. Experiments were even undertaken to attach cannon gunnery similar to the 37-mm cannon Gochkis, which was used against German Zeppelins. But these cannons was rejected in favor of stronger cannon gunnery. In general, it is acknowledged that during World War I the Iliya Muromets planes were the strongest combat unit not only in Russian aviation, but also in the whole world.

The first military flight was made on the Iliya Muromets-Kiev (the same that made the flight from St. Petersburg to Kiev; it was the only device that didn't have a serial number) on February 14, 1915, under the command of aviator G.G. Gorshkov. Then a longer flight was taken for reconnaissance into the deep back land of the German army; it lasted 5 hours and managed to find out the enemy's plans. As a result of these flights, Captain Gorshkov was awarded St. George weaponry for bravery and promoted to lieutenant colonel, with other members of the crew also being recognized.

After the first airstrikes, the Germans began to hurriedly strengthen their anti-aircraft cannons and redeployed fighting groups from the Western Front to fight the seaplanes. The Iliya Muromets' first air battle against German fighters took place in July 1915. Aviator I.S. Bashko attacked two German «hunters» on Brandenburg. The plane was damaged and Bashko himself was wounded, but his plane landed successfully, although not in its own airfield. This battle showed the high durability of the plane. In May 1916 the SHS already had 20 Muromets with experienced aviators, and all of them took an active part in the famous Brussels Offensive.

Military achievements of the squadron were widely reported in Russia's press and abroad, and the Allies began to dub the detachments «Muromets» and use the experience of the Russian aviators. By Spring 1917, the SHS had expanded into 30 units and was made up of 4 detachments, with commanders A.V. Pankratievyi, G.I. Lavrovyi,

I.S. Bashko, and R.L. Nizhevskyi. I.I. Sikorskyi continued to elaborate on the design of the Iliya Muromets, and thus were built the C, VK, G-2-bis, D-1, D-2, E, and NE (226).

Planes of the E type were considered to be a little more modern, and were basically flying fortresses, able to carry up to 800 kg of bombs. Its defensive equipment was made up of eight firing points, ensuring complete spherical firing. The pilot's cabin was fitted with glass and had good visibility, and the number of the crew grew to 7-8 people. For guarding and convoying the Muromets, I.I. Sikorskyi built special fighter planes, the S-16 and then the S-20, which then went into the SHS for tests.

Revolutionary upheaval sharply diminished the squadron's military activity. On April 28, 1917, a Iliya Muromets crashed along with all the crew (commanded by G.I. Lavrov) because of sabotage from soldiers not wanting to fight. By demand of the army minister A.I. Guchkov, M.V. Shidlovskyi had to hand in his resignation, and was replaced by the commander of the SHS G.G. Gorshkovyi. Designer I.I. Sikorskyi also left the squadron and returned home to Kiev.

By Summer 1917, the squadron's main base became Vinnitsa, where all its force was focused on preparing for a Summer offensive. However, this offensive ended in catastrophe: the army collapsed, as well as the entire government.

New planes built at Aviablat didn't go into the fleet. By Fall, the Petrograd factory completely stopped production.

In 1914-1917, the army received 60 Iliya Muromets seaplanes, and only one of them was downed by the enemy and lost - in November 1915 in the area of Baranovich (the Iliya Muromets III under command of Staff Captain D.A. Ozerskyi). Three other planes were shot down, but survived and could fly to their own territory.

After Russia left the war and the once united government fell, the planes located in Vinnitsa were partly pilfered for parts, and partly taken by the enemy. The famous Iliya Muromets-Kiev, for example, was hijacked by I.S. Bashko's crew at the Polish corps of I. Dovbor-Musnitskyi, but because of engine failure had an accident near Smolensk and was dismantled for spare parts (Bashko himself served in the Red Army, then commanded aviation in free Latvia, dying in 1946). There were a few of the Muromets in the Red Army (under commander A.V. Pankratievyi, who was killed in 1923 during a test flight), and in the army of the Ukrainian Central Legislative Body (under commander G.G. Gorshikov, who was shot in 1919 by the Odessa KGB), but they didn't play a serious role in the Civil War.

However, in spite of this sad epilogue, it can be said that I.I. Sikorskyi's Iliya Muromets became a real symbol of Russia's technical power and had a large influence on the general development of world aviation.

290. Igor Ivanovich Sikorskyi (also called "*Muromets***") - an engineer and designer of a few types of planes.**
1913

In 1912, he created a many-motored giant that was called the Grand Baltic, *and later -* Russky Vityaz (Russian Hero), *which made him world famous.*

291. Students from aviation courses at the St. Petersburg Polytechnical Institute. In the upper row, sitting in the Grand is V.A. Slesarev (second from the left), and Colonel-Engineer V.F. Naidenov (third from the left). In the lower row is aviator G.V. Alexnovich (fourth from right).
Russo-Baltic Factory. St. Petersburg. 1913

292. On the balcony of *Russky Vityaz* is writer M. P. Artsuibashev (second from the right).
St. Petersburg. 1913

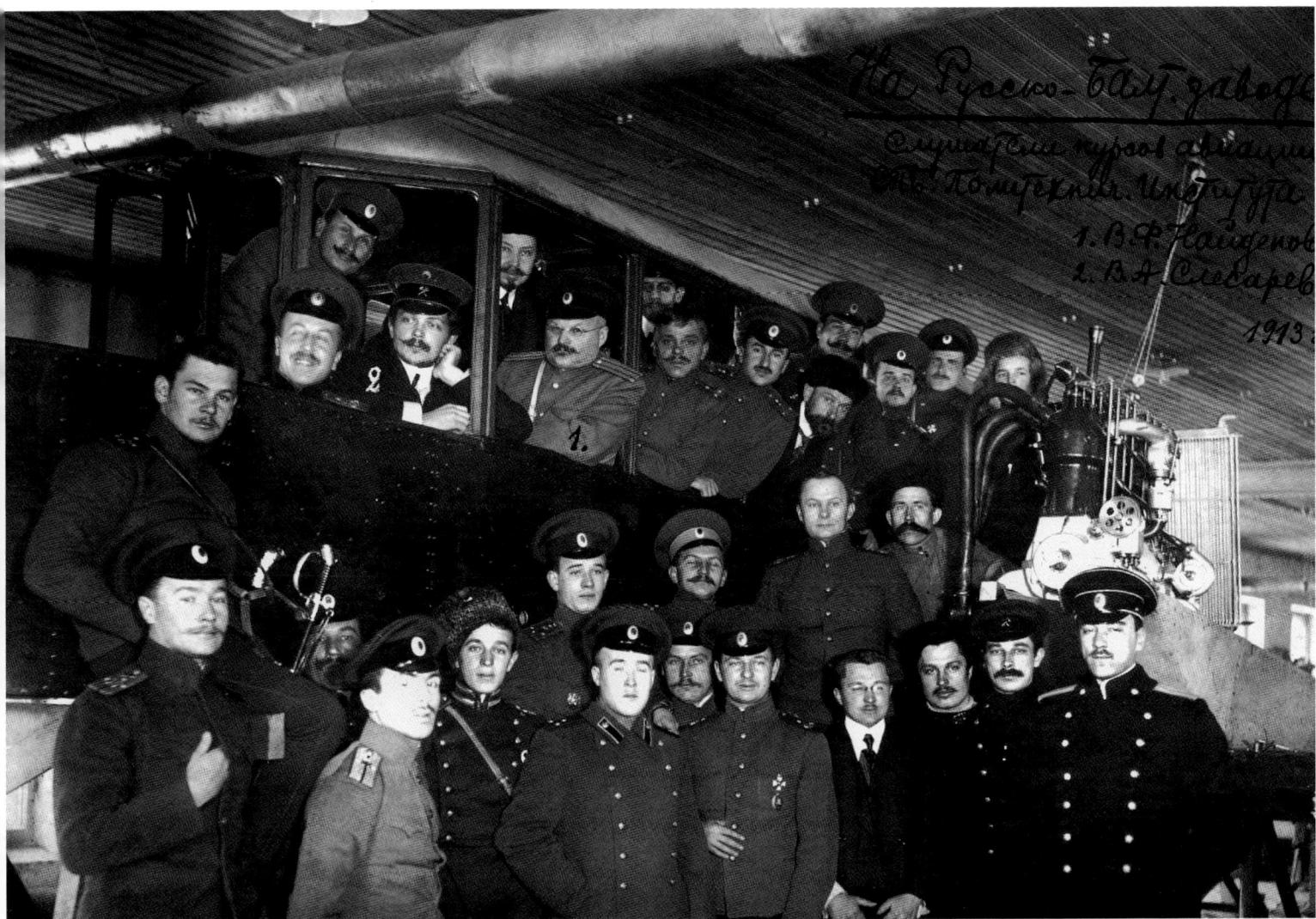

На Русско-Балт. заводе
Слушатели курсов авиации
при Политехнич. Институте
1. В.Ф. Найденов
2. В.А. Слесарев

1913 г.

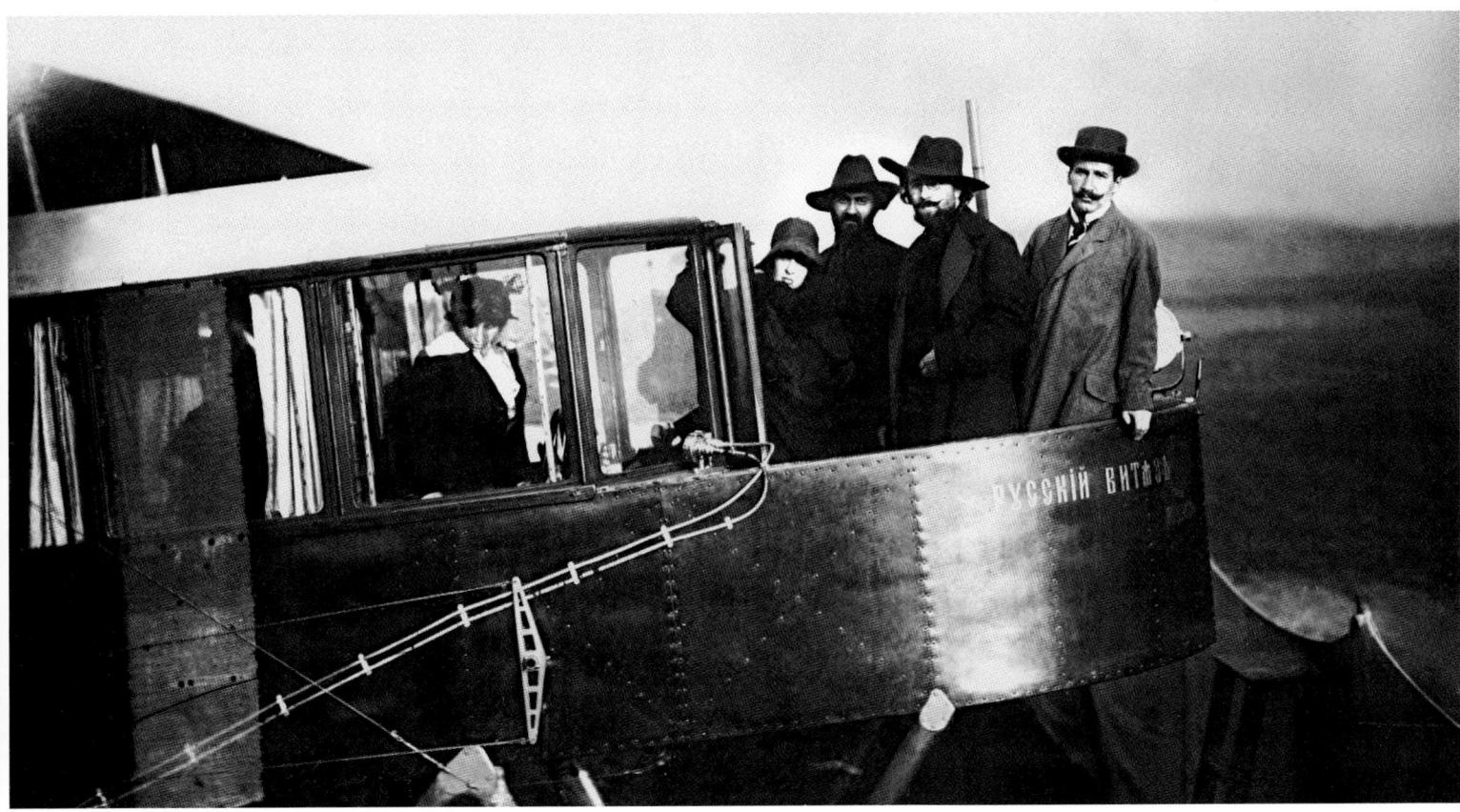

293

294

293. I.I. Sikorskyi on the balcony of his first giant plane, while below stand his sister and brother.

1913

Thanks to a spotlight, the plane could fly until night fell and have a means of illuminating a place to land.

294. The first variant of the *Grand* with two motors. On the right is the mechanic's assistant, and on the left of the plane is mechanic V.S. Panasiuk, who, together with designer I.I. Sikorskyi, participated in flights.

St. Petersburg. 1913

295. I.I. Sikorskyi near the plane *Grand* in a Summer field.

Komendantskyi Airfield. St. Petersburg. March 4, 1913

Some called the Grand *a "flying street-car" for its spacious cabin.*

296. Mechanic V.S. Panasiuk stands near the plane Grand, while I.I. Si-korskyi sits behind the wheel, and G.V. Alexanovich stands behind him.

St. Petersburg. 1913

296

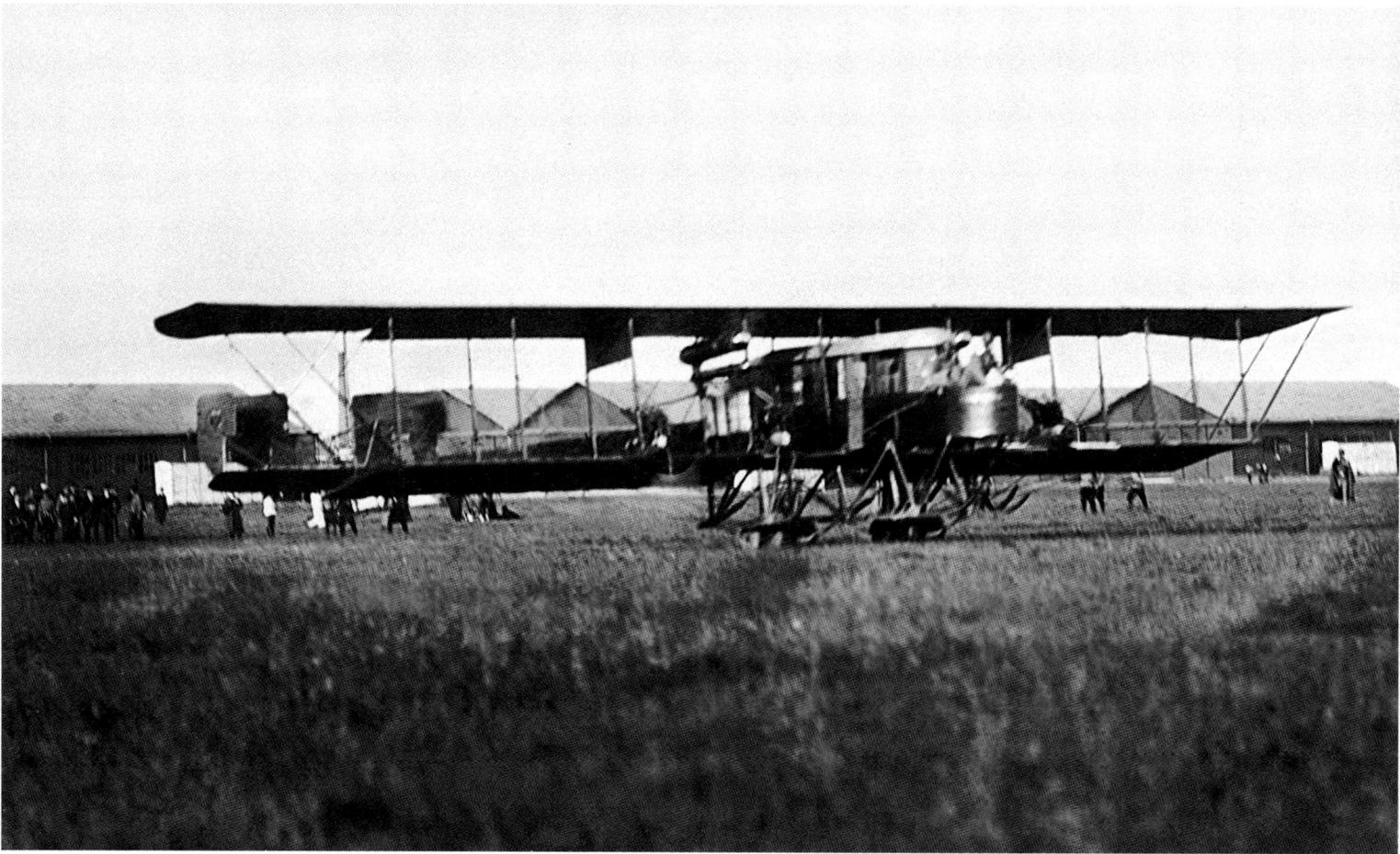

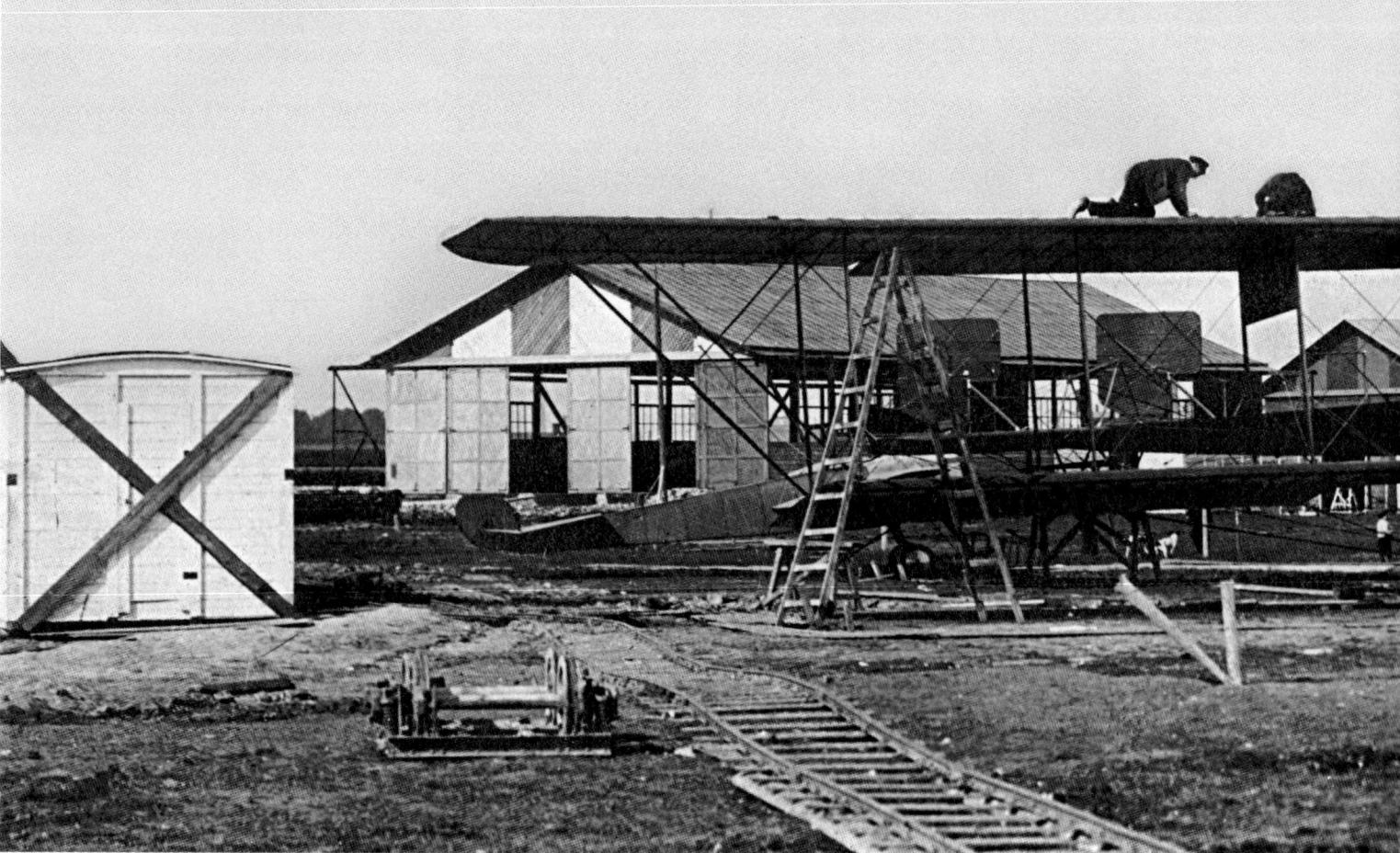

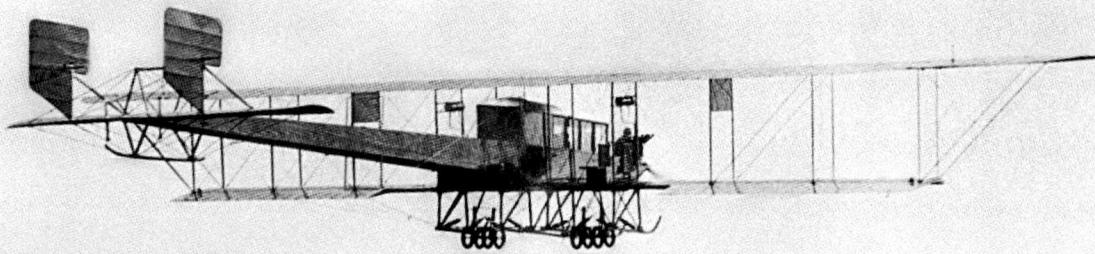

297. The first run through with the plane *Russky Vityaz.*
Korpusnoi Airfield. St. Petersburg. 1913

298. The *Grand Baltic* **prepares for takeoff. The engines were fitted to work in-tandem with a "push-pull" system.**
Korpusnoi Airfield. St. Petersburg. July 1913

299. The first flight of the *Grand* **under the command of I.I. Sikorskyi.**
Korpusnoi Airfield. St. Petersburg. July 18, 1913

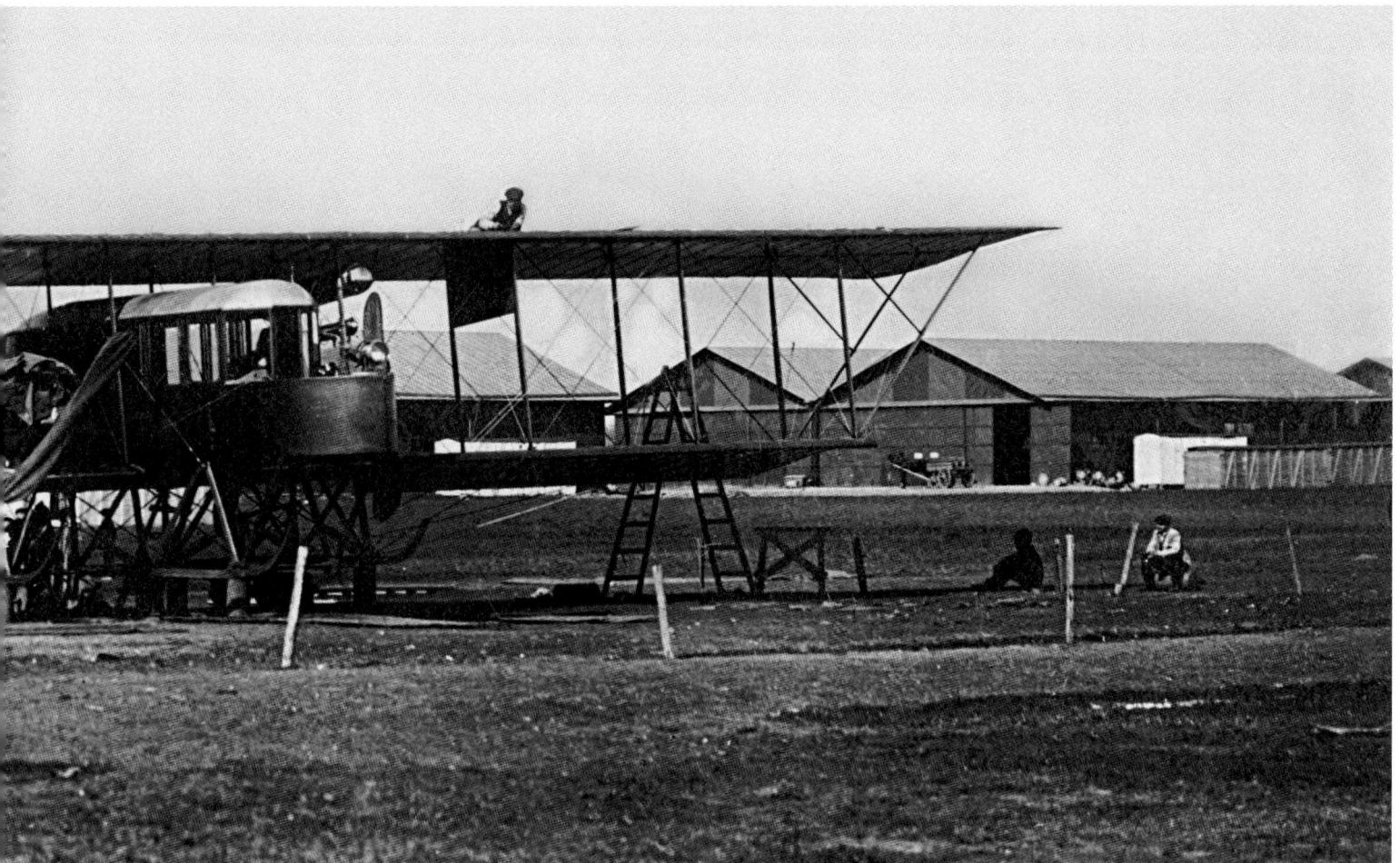

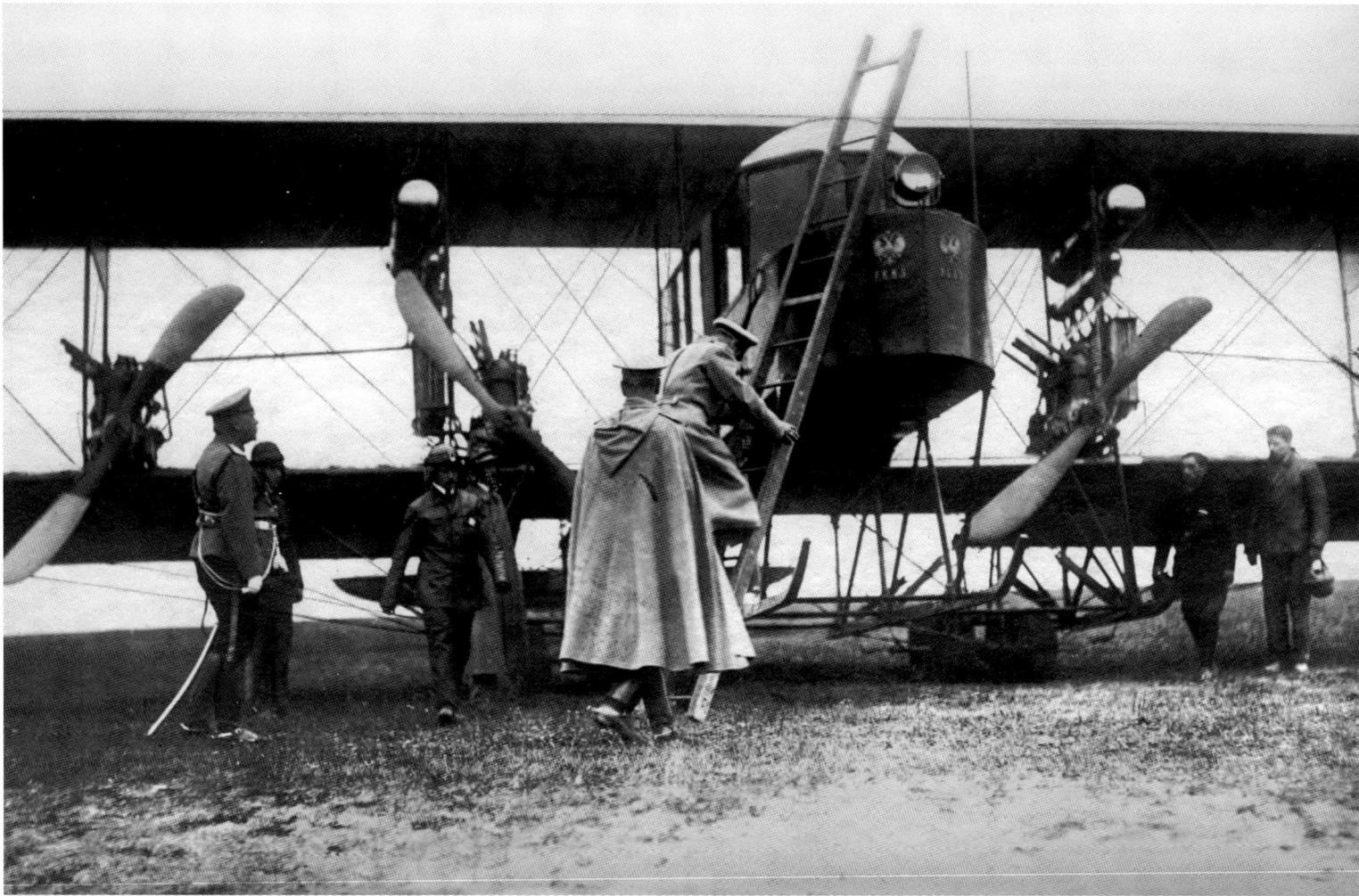

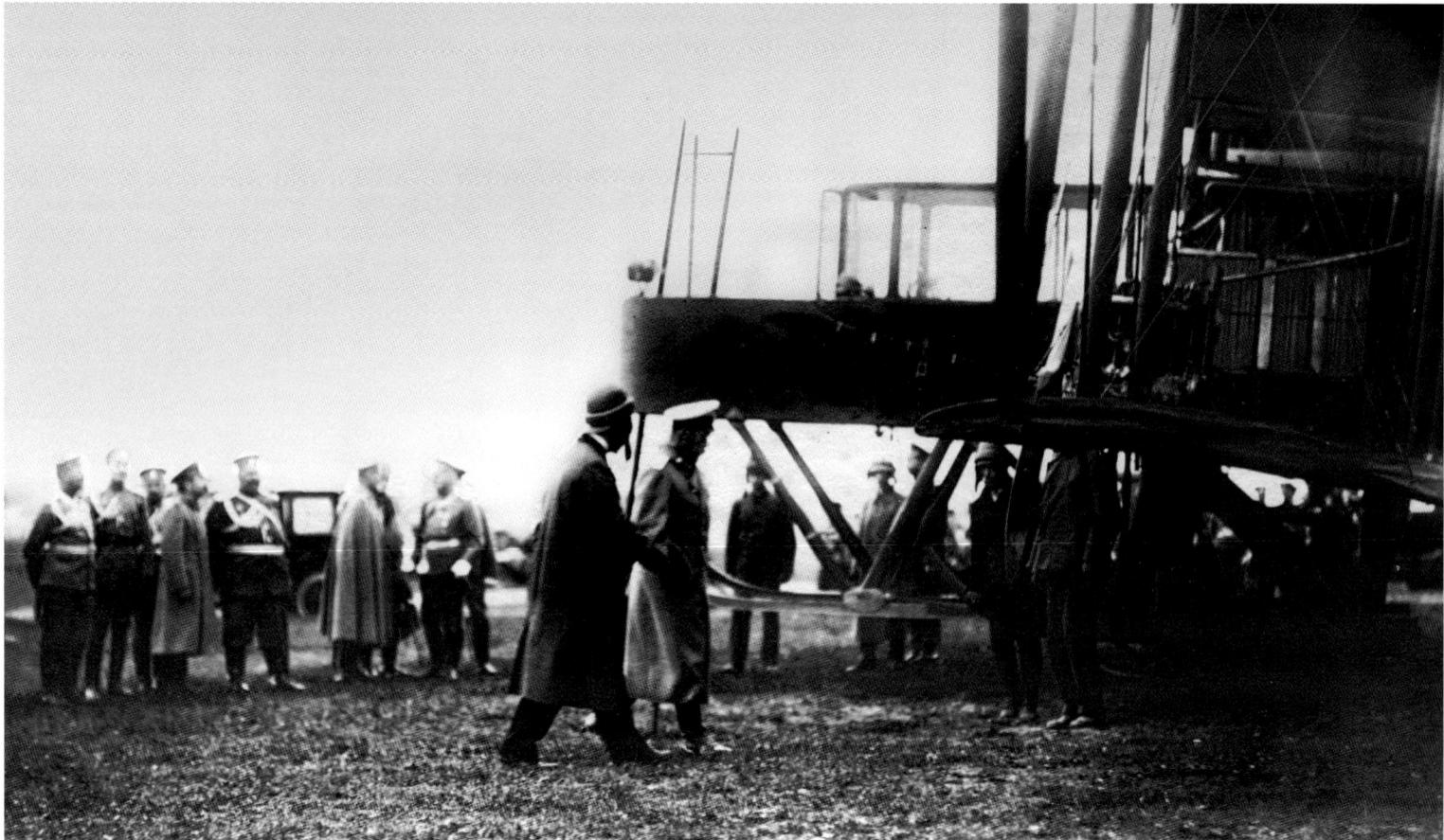

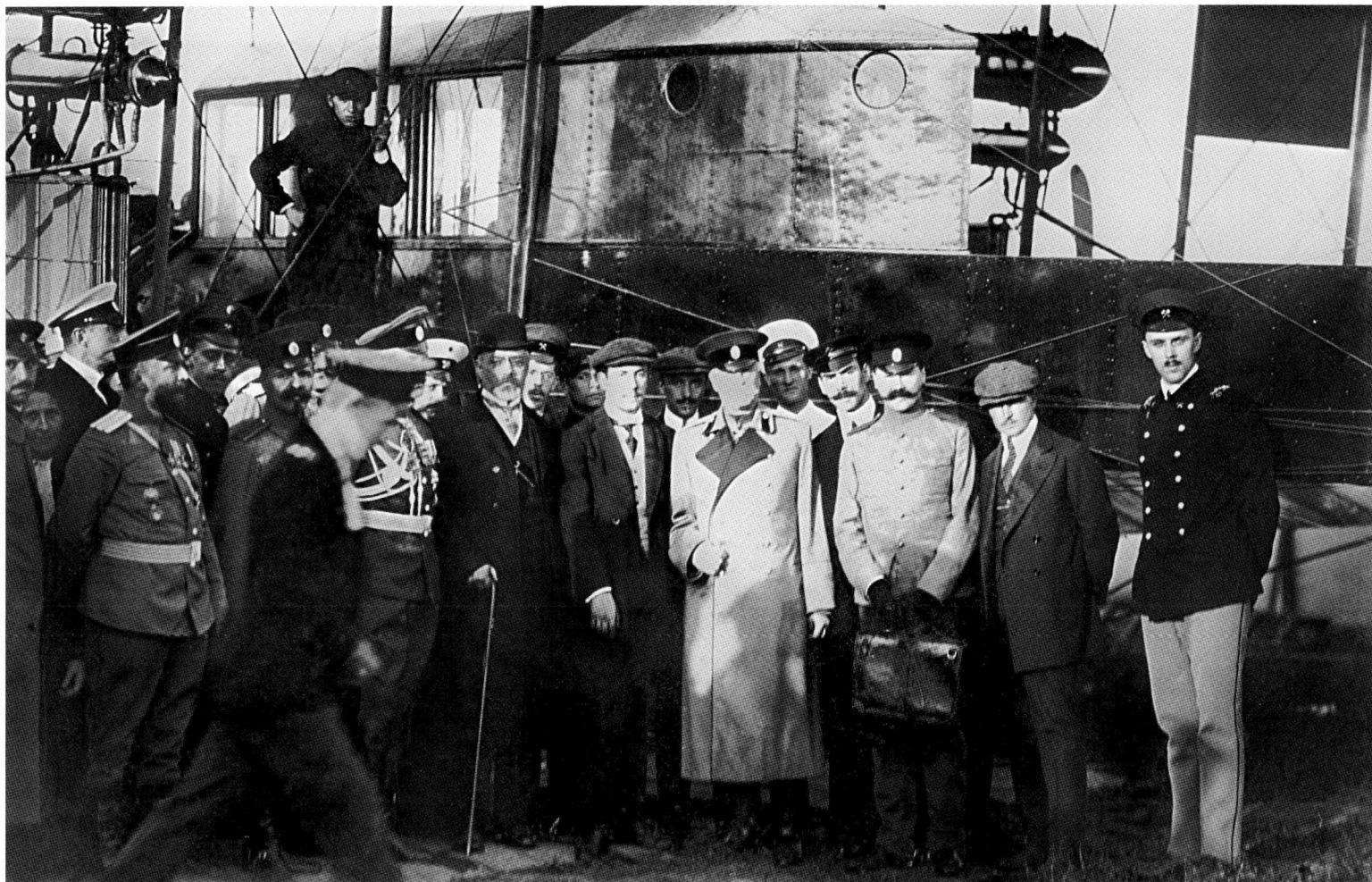

300. Nicholas II goes up in the plane *Russky Vityaz*, which had arrived on the Krasnoselskyi Grounds, so that the emperor could inspect it.
July 25, 1913

301. I.I. Sikorskyi and Nicholas II going to the hanger to inspect the *Russky Vityaz*.
July 25, 1913
On this day the plane was tested at the Korpusnoi Airfield.

302. A group of famous guests near the *Russky Vityaz*. Near I.I. Sikorskyi (fourth from the right), in a coat is the Baron A.V. Kaulbars, and second from the right is G.V. Alexnovich.
1913

303. A famous guest getting to know miraculous technology, with the plane *Russky Vityaz*.
St. Petersburg. 1913

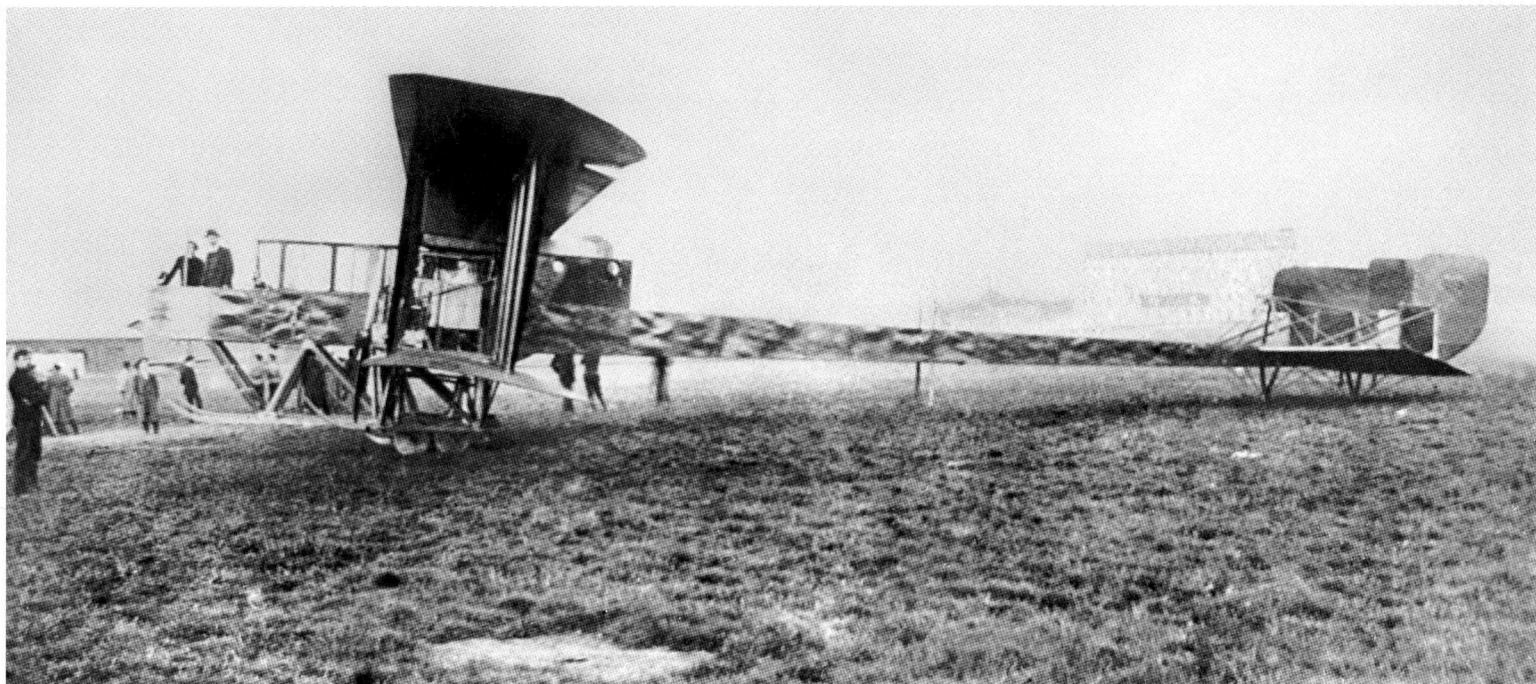

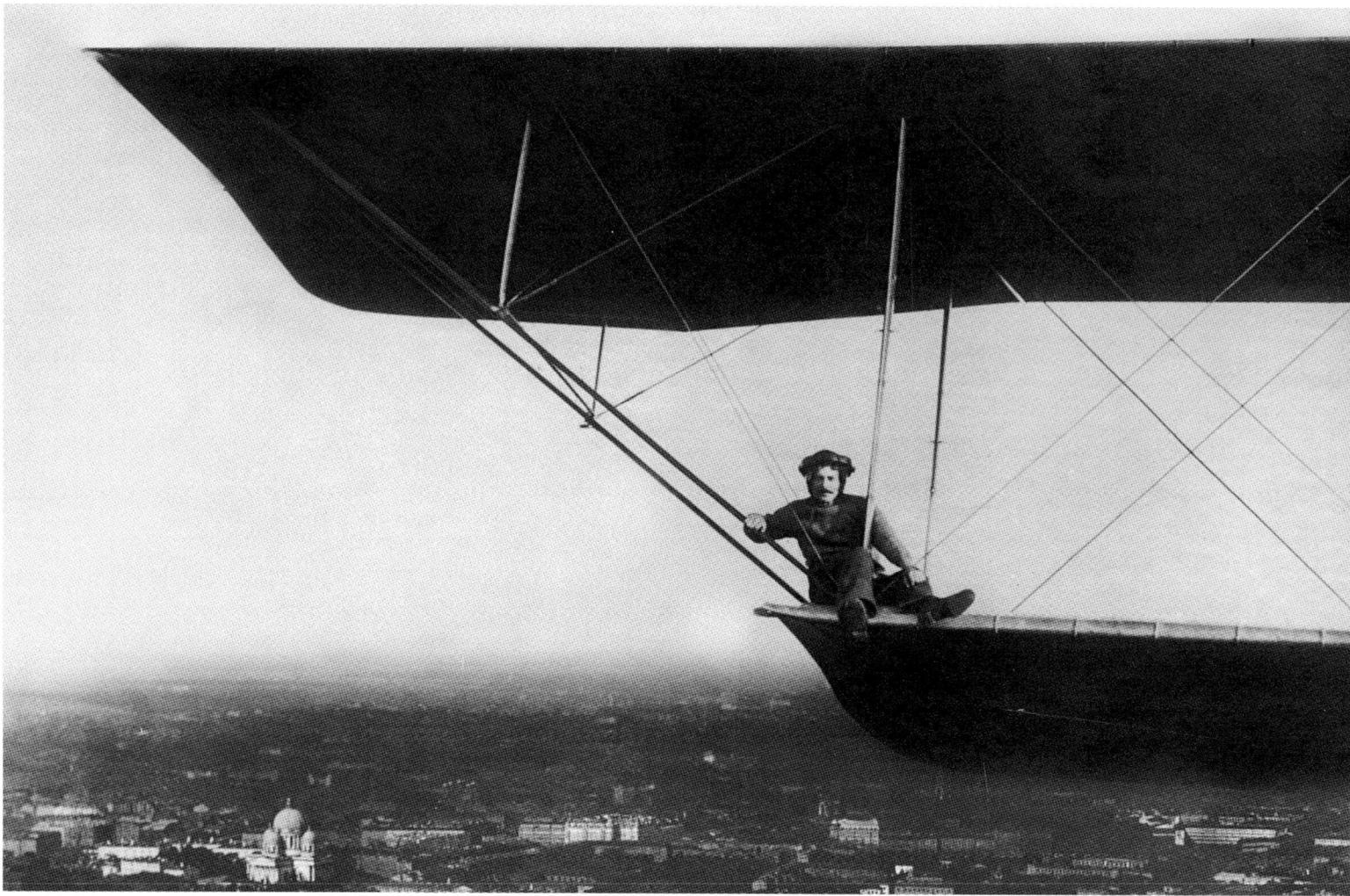

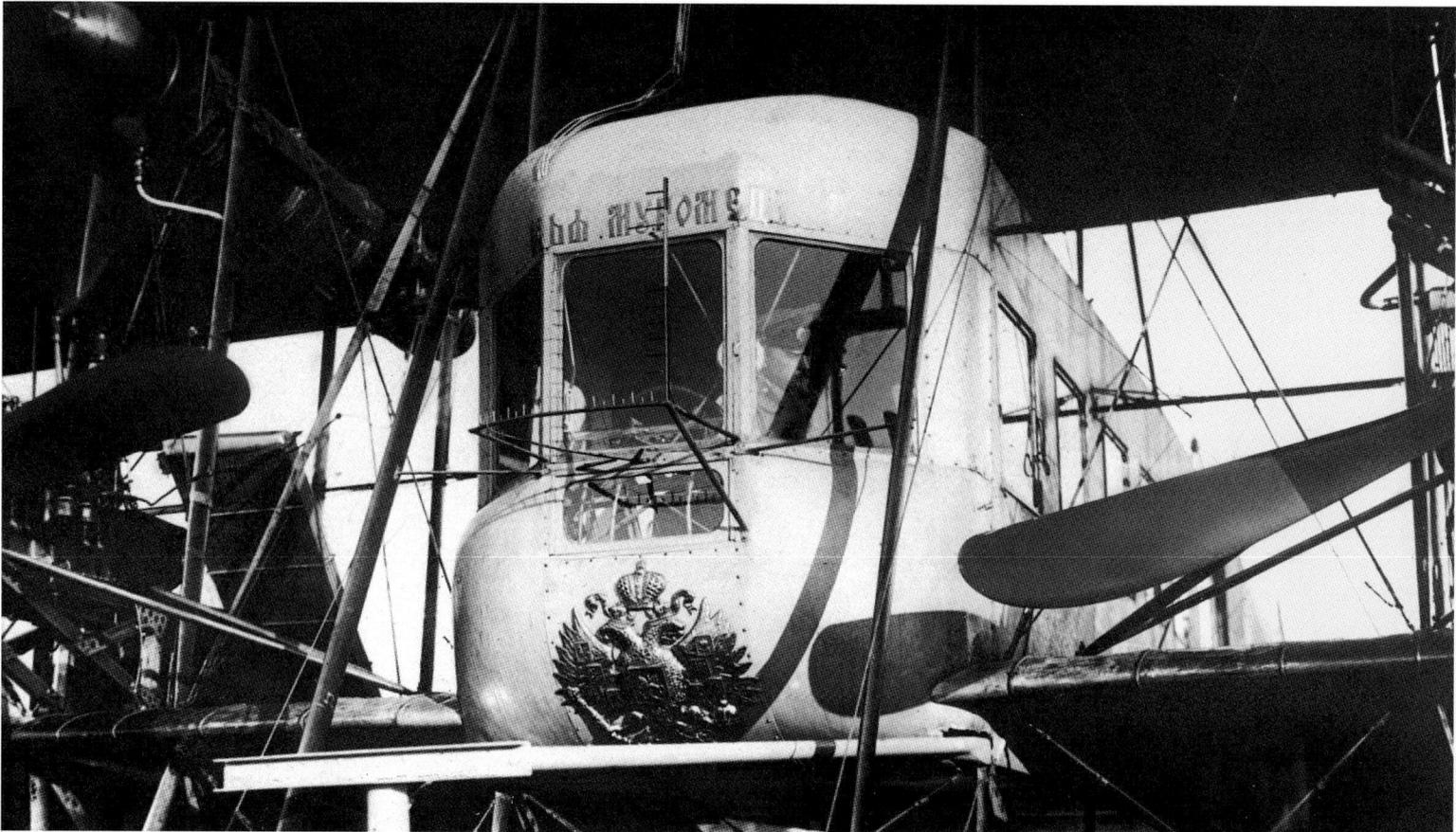

309. A dangerous trick, or a demonstration of the hope and stability of the *Iliya Muromets*: on a flight over St. Petersburg, a mechanic walked along the wing and sat at the edge.
1913

310. The second *Iliya Muromets* (with factory number 128). In the cabin is Captain G.G. Gorshkov.
Korpusnoi Airfield. St. Petersburg. 1914

311. A view of the Zabalkanskyi (today Moscovskyi) avenue from the cabin of the Iliya Muromets.
St. Petersburg. 1914

312. A group of workers of the RBRF, making a record flight on the *Iliya Muromets*. The plane took off with 16 people and reached a height of 300 m. Fourth from left is I.I. Si-korskyi, being carried by the person on the second from the right is Shkalik, the beloved dog of the RBRF.
February 12-25, 1914

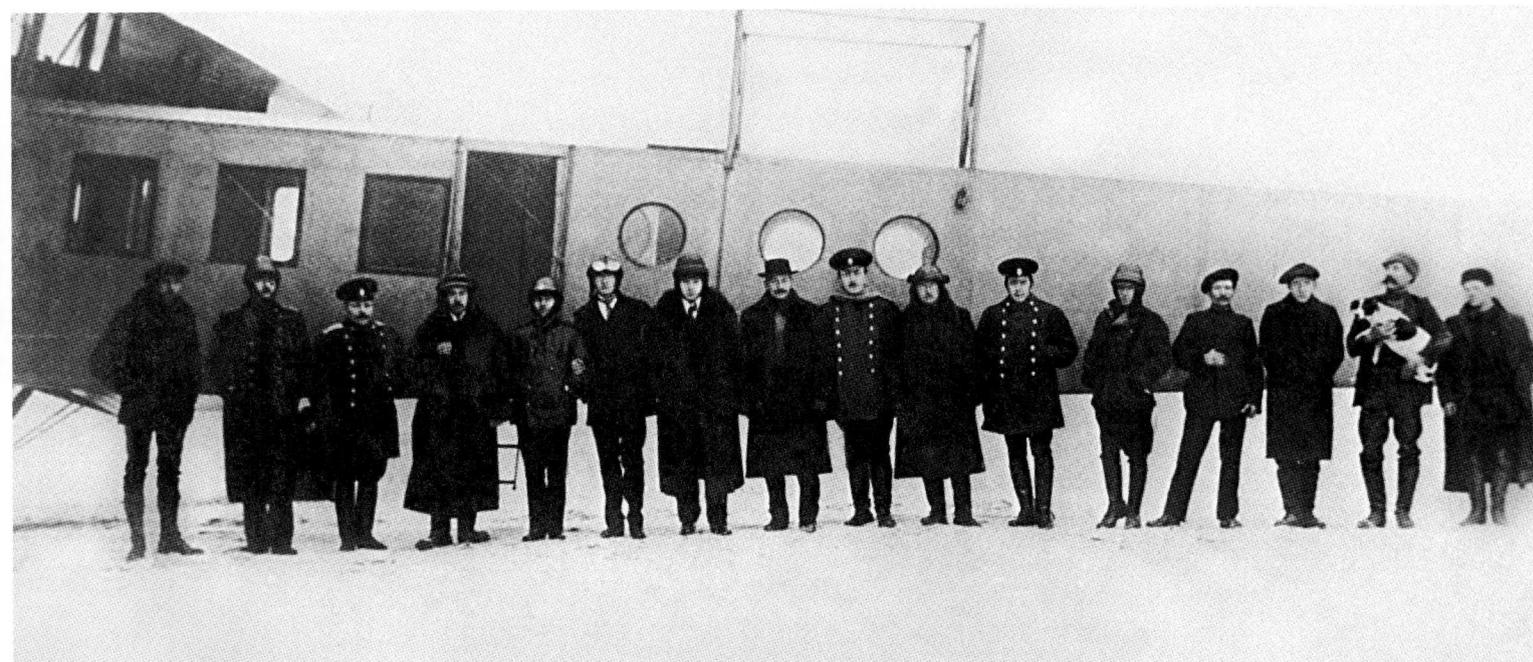

313

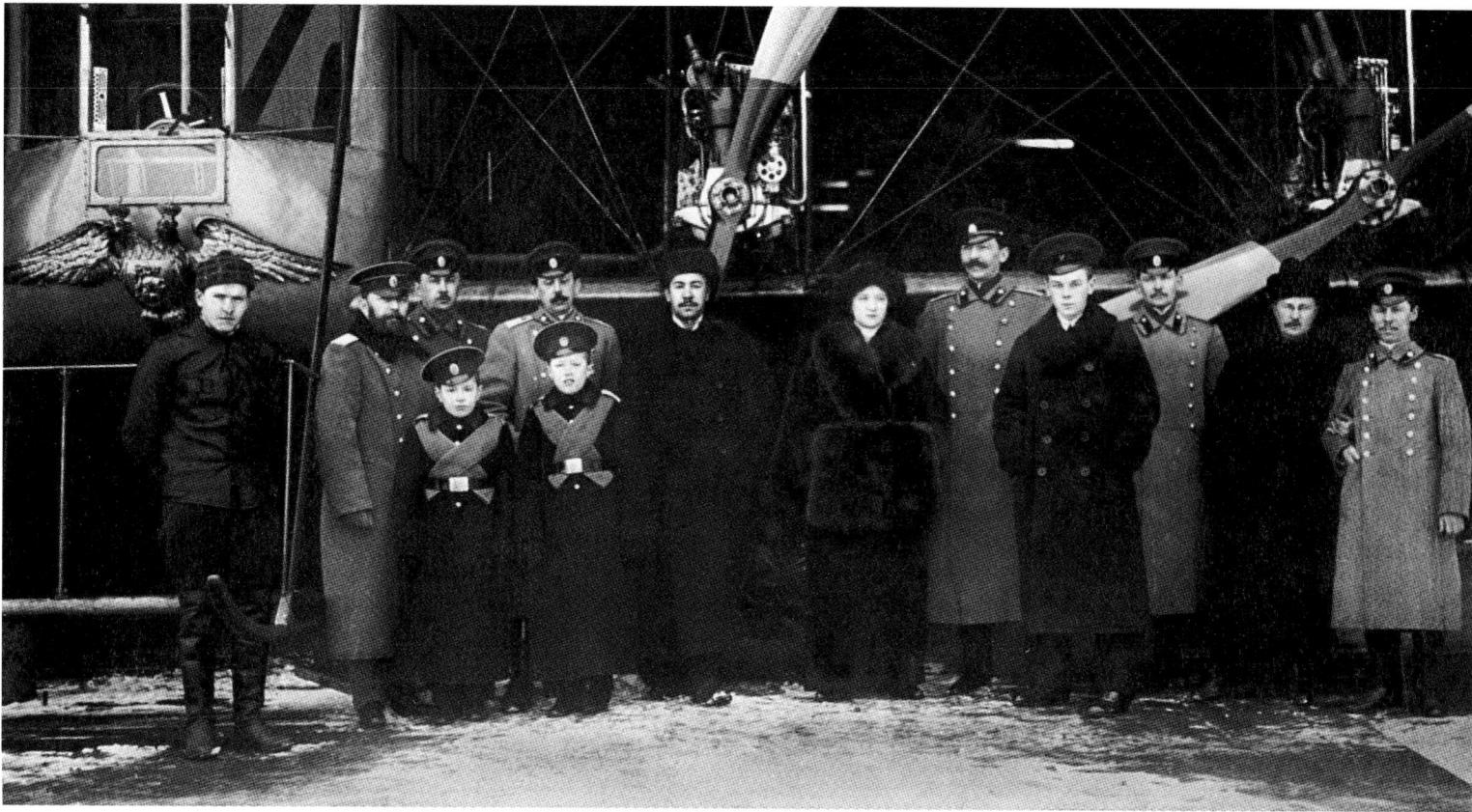

314

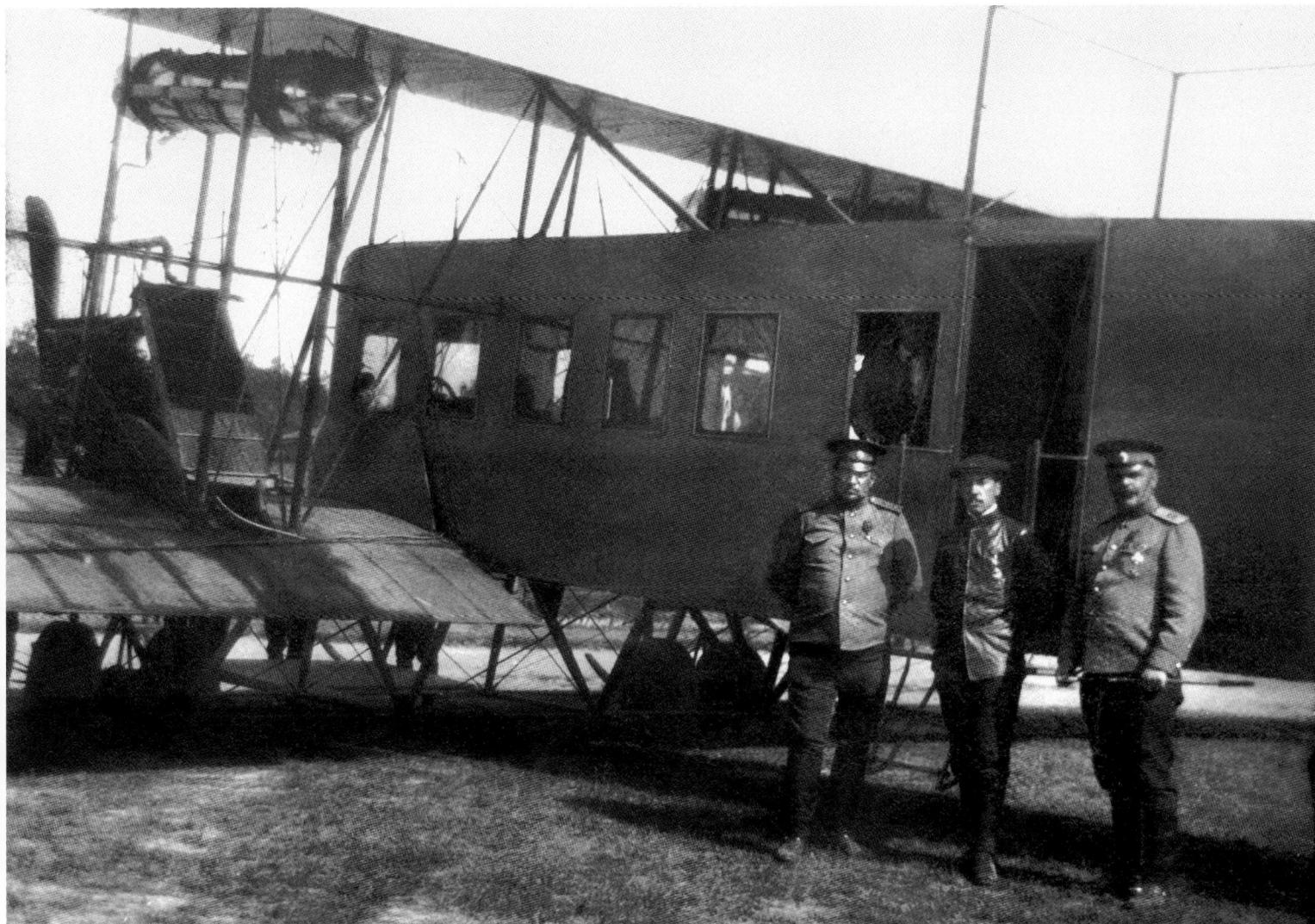

313. I.I. Sikorskyi (in the center) near the *Iliya Muromets*, and next to him is S.A. Ulyanin.
St. Petersburg. 1914

314. View of Gatchina from the *Iliya Muromets*, while checking photo equipment.
1914

315. I.I. Sikorskyi (in the center) with staff officers near the *Iliya Muromets-Kiev*.
1914

316. Lieutenant G.G. Gorshkov, pilot of the *Iliya Muromets-Kiev*.
1915

316

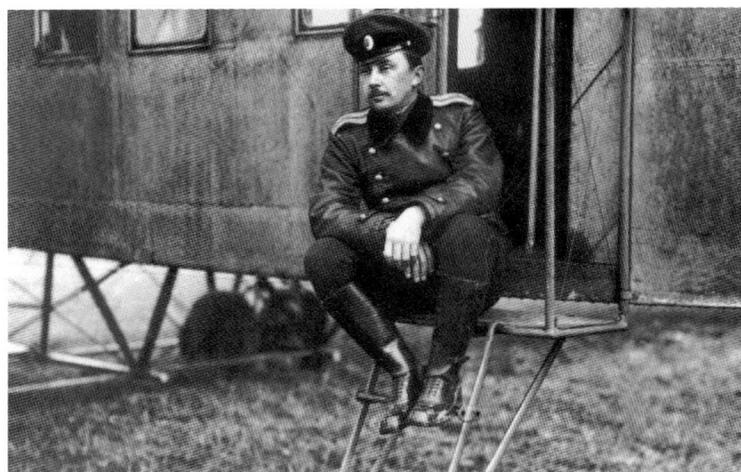

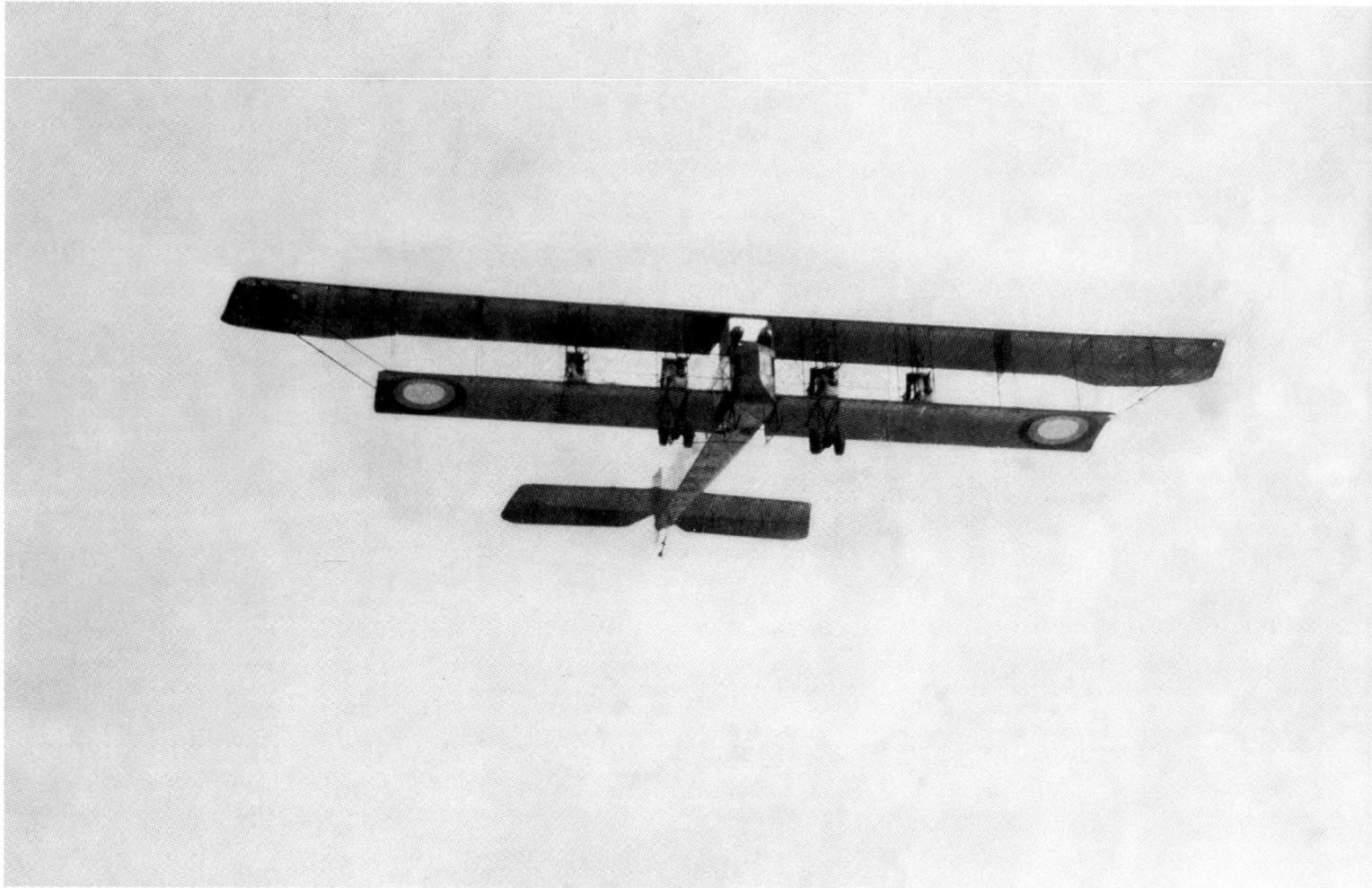

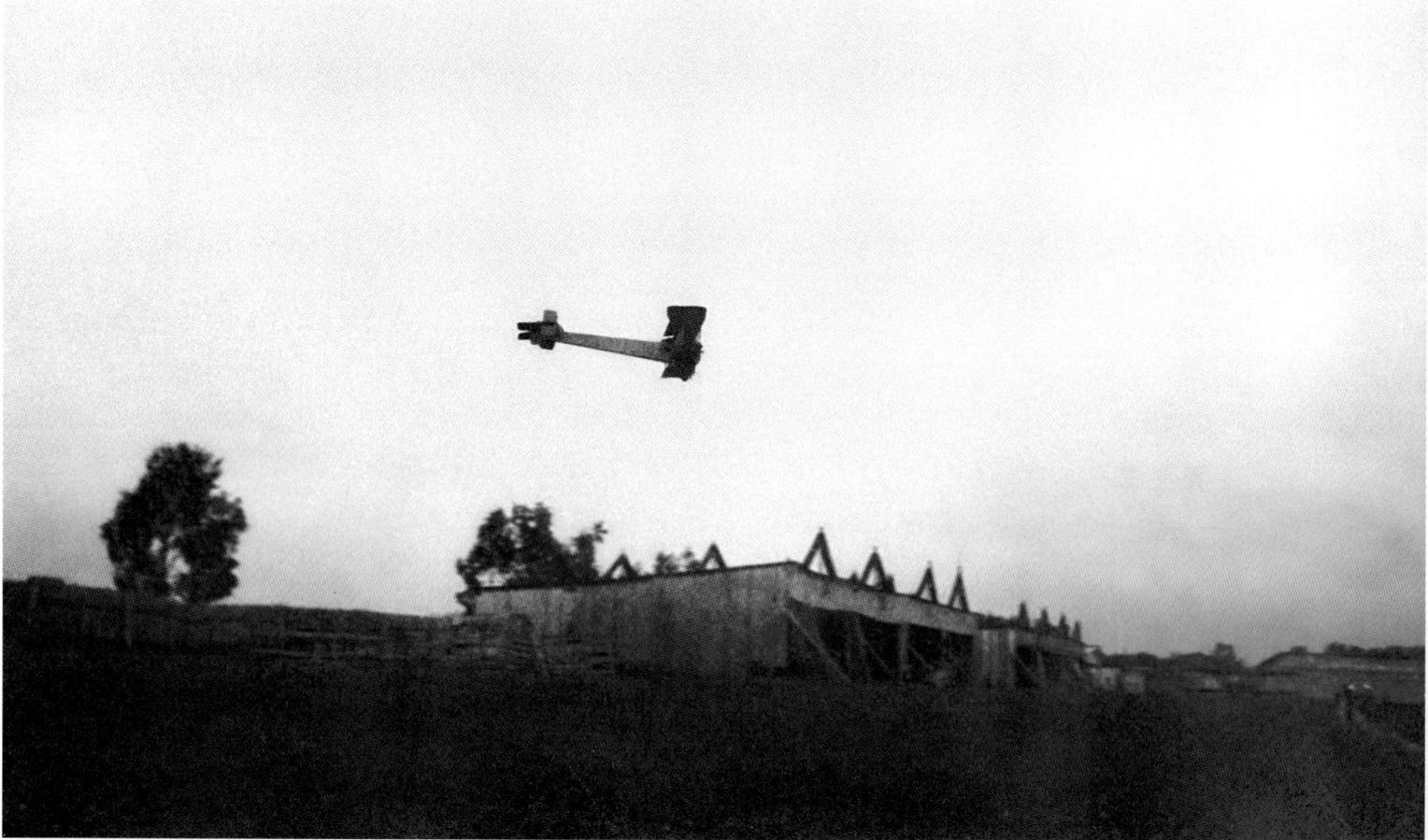

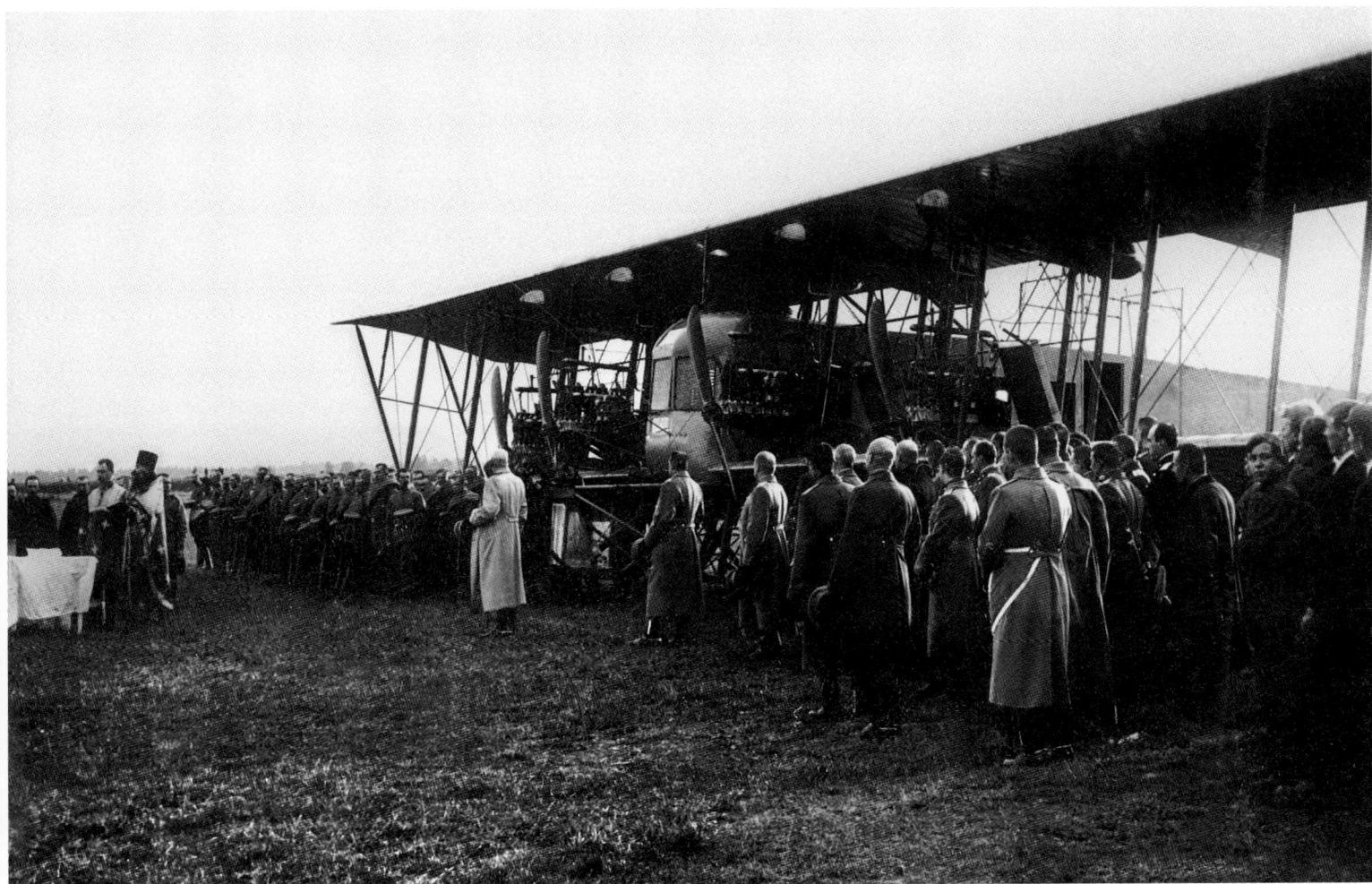

317. The *Iliya Muromets-Kiev* **on a curve after takeoff.**

Airfield at Yablonna near Warsaw. Spring 1915

318. The *Iliya Muromets, G-3,* **making a landing.**

Gatchina. 1917

319. Lighting up the *Iliya Muromets* **(commander - E.V. Rudnev), before sending it to the Front.**

Korpusnoi Airfield. Petrograd. September 1914

320. The *Iliya Muromets* **while landing.**

Airfield at Yablonna . 1915

320

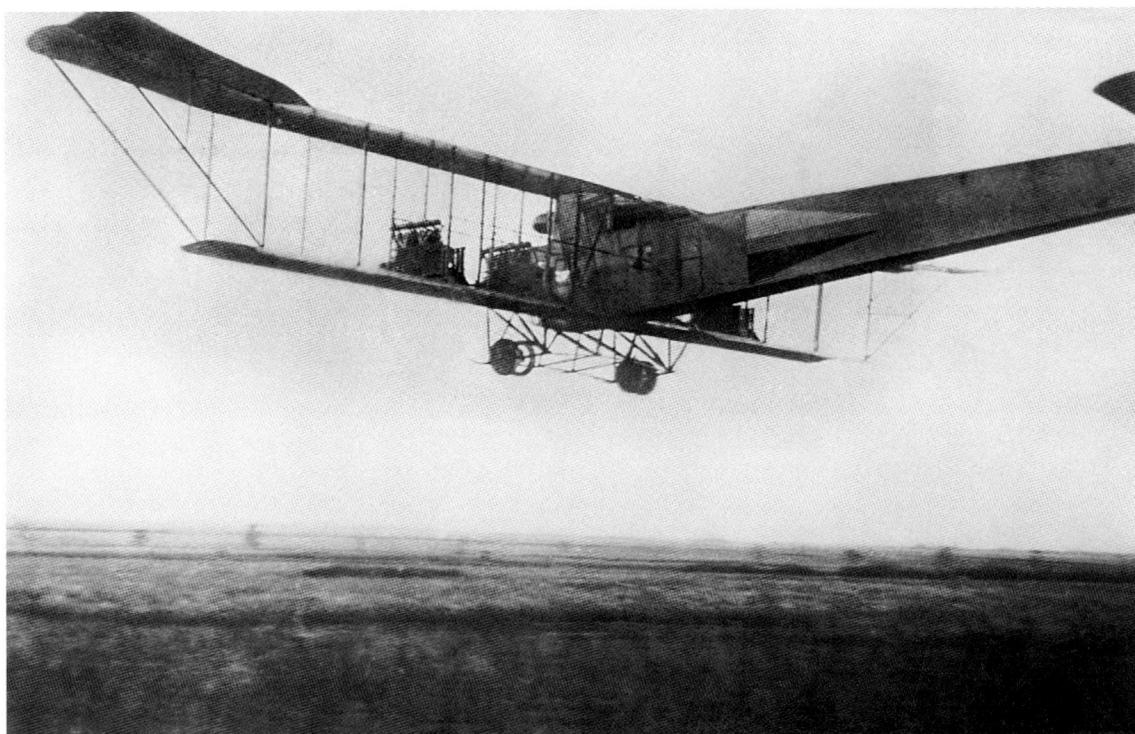

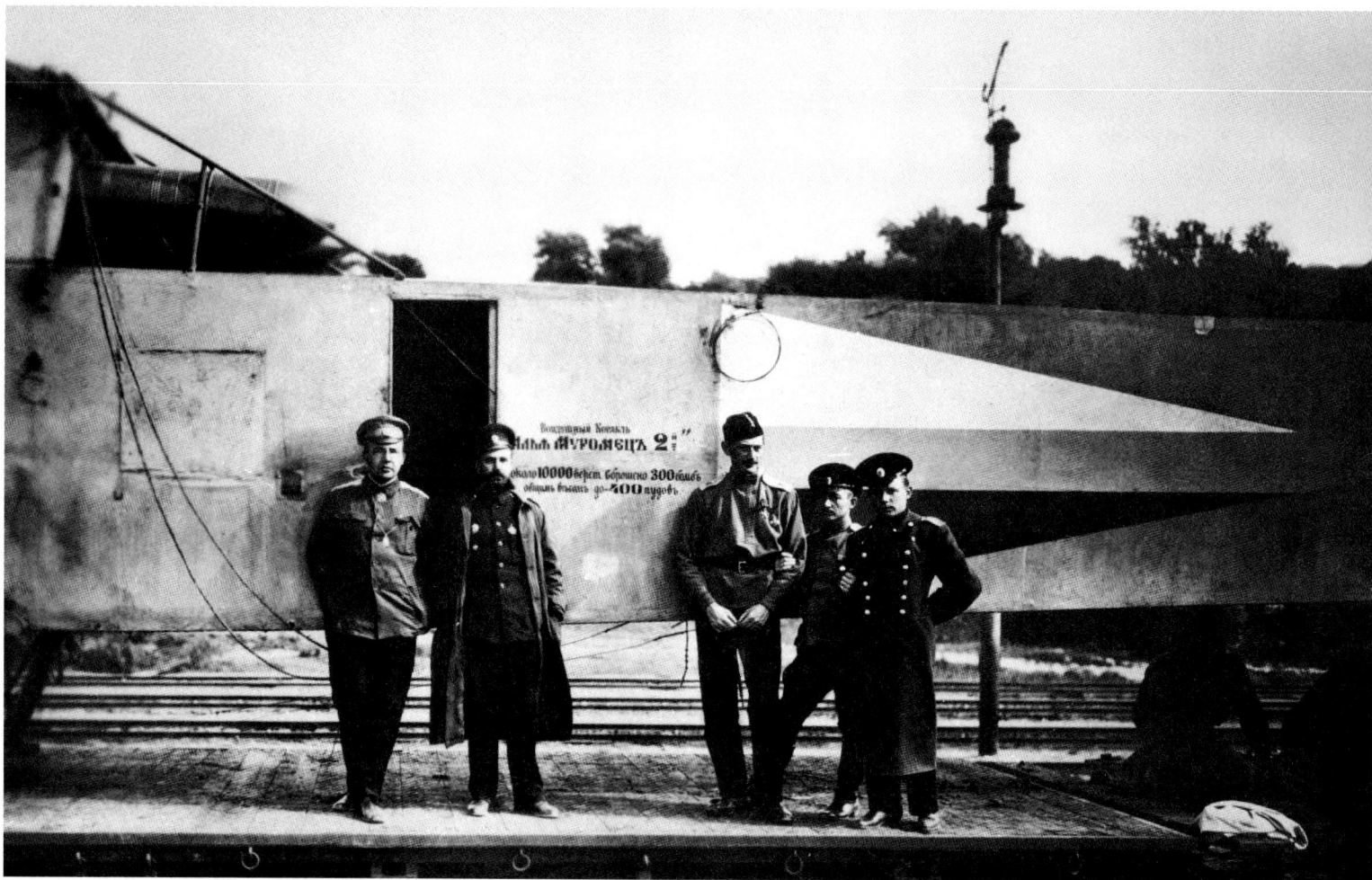

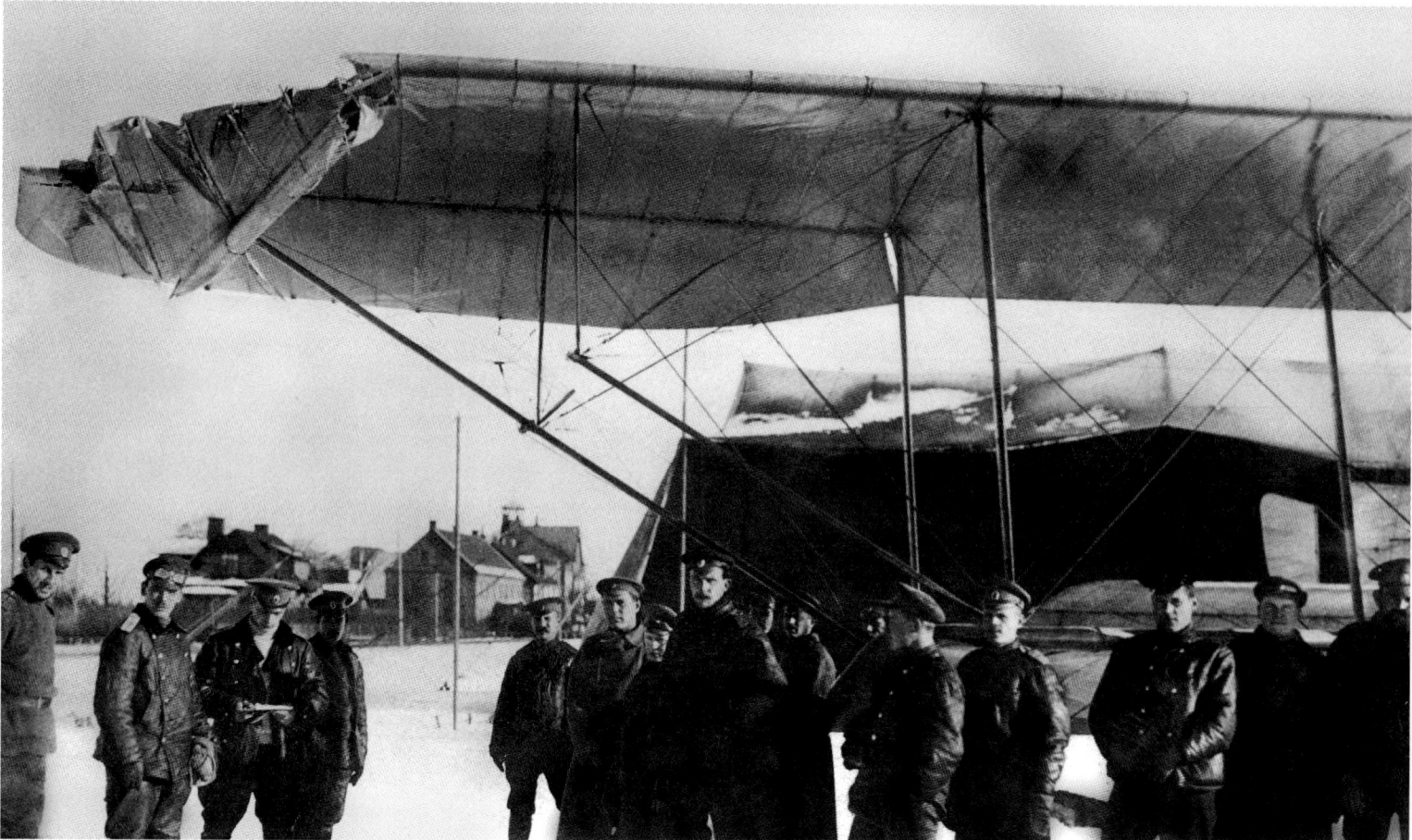

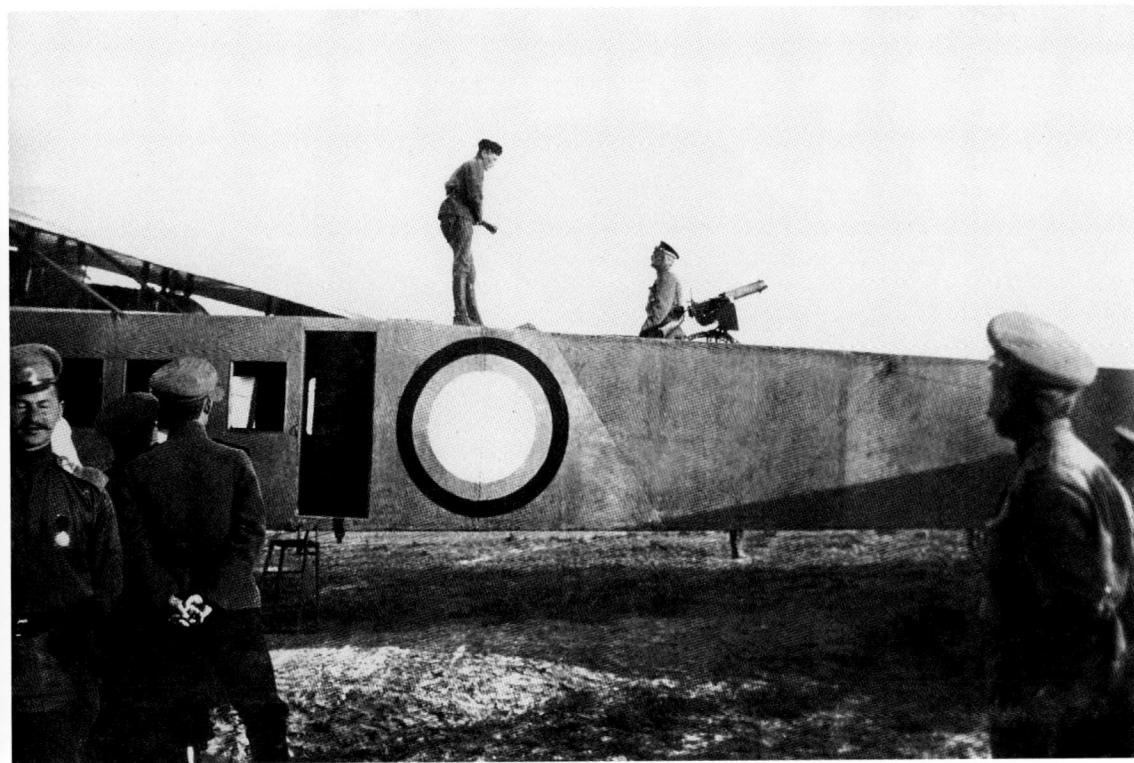

321. Squadron aviators near the plane Iliya Muromets II before it was sent for repairs to Petrograd. Left to right: A.M. Kolyankovskyi, A.V. Pankratiev, M.N. Nikolskoi, S.V. Fedorov, and G.V. Pavlov (nicknamed "Kewpie Doll").
August 1916

322. Near the *Iliya Muromets*, which had been damaged in battle.
1916

323. Grand Duke Kirill Vladimirovich examines a Maxim gun on the roof of the *Iliya Muromets-II.* Pilot M.N. Nikolskoi gives an explanation.
Airfield at Yablonna. 1915

324. The *Iliya Muromets, G-3,* on a flight.
Airfield at Yablonna. 1916

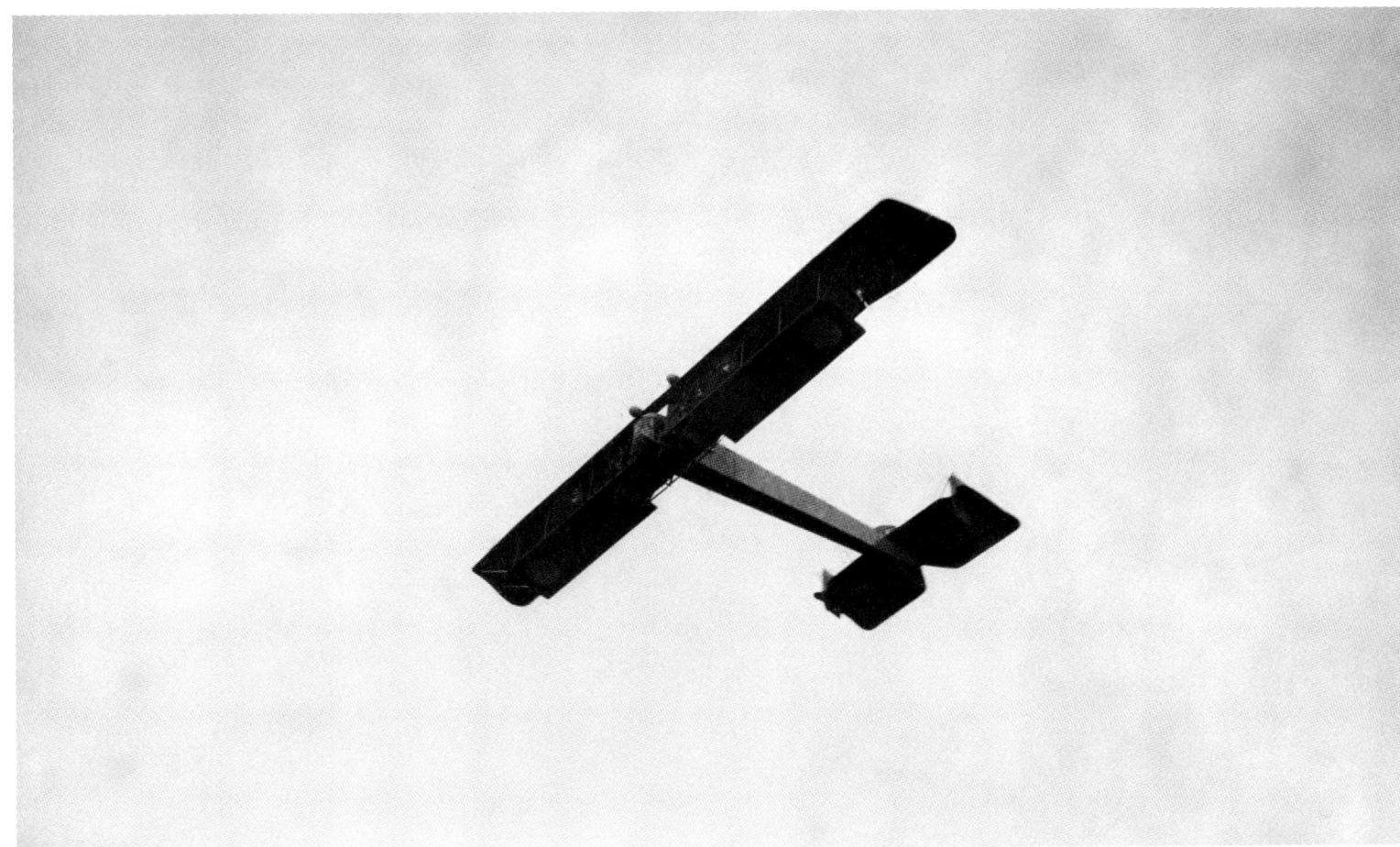

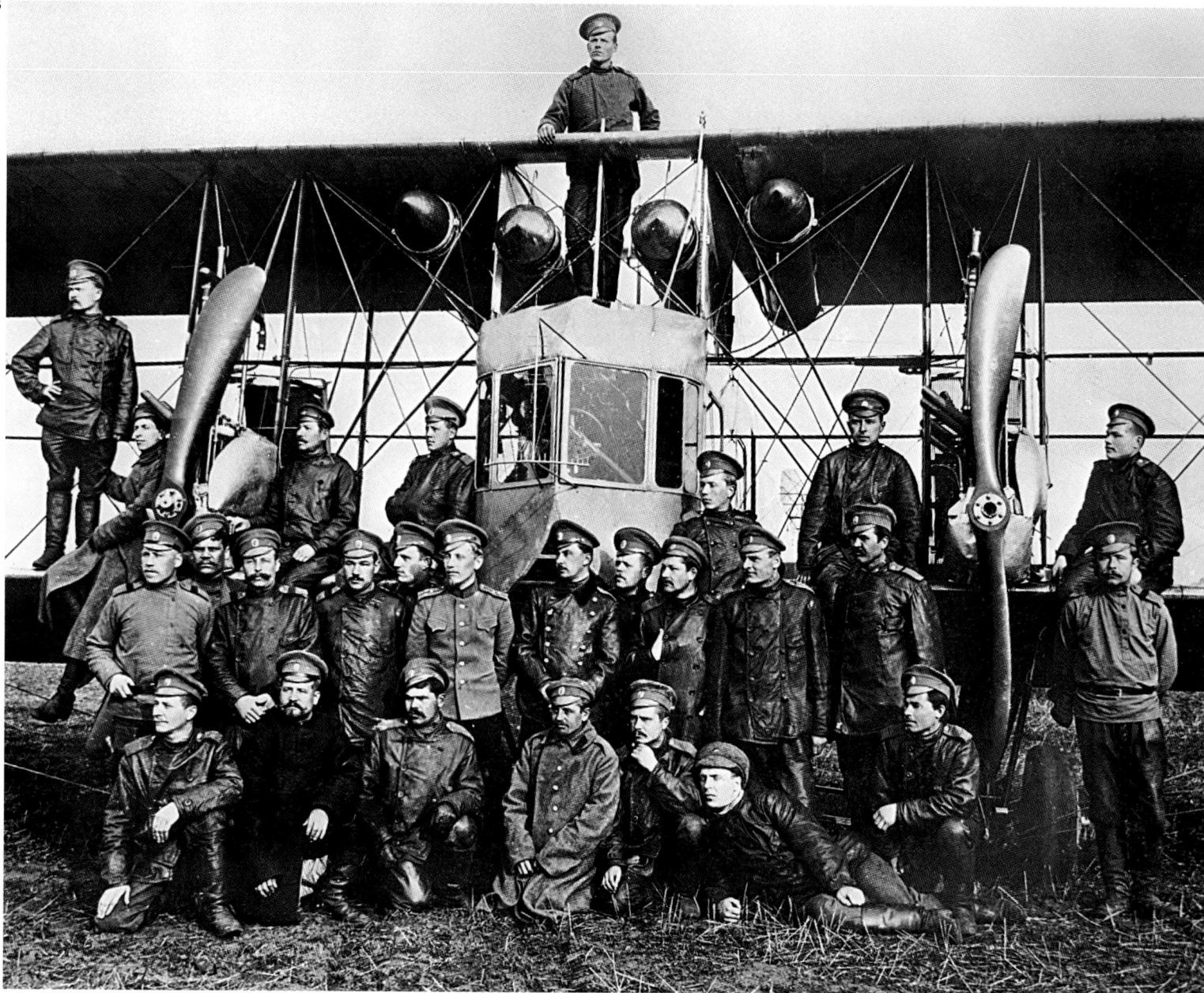

325. Military aviators with the world's first bomber plane, the *Iliya Muromets*, **type B. In the second row stand: I.S. Bashko(fourth from right), and G.G. Gorshkov (fifth from right).**

Pskov region. 1914

326. Aerial bombs being tested in an aerodynamic tube, with (from left to right): G.M. Musinyants, K.A. Ushakov, V.P. Vetchinkin, N.E. Zhukovskyi, and G.I. Lukiyanov.

Moscow. 1915

Research continued by order of the Head Military Technical Office (HMTO)

327. Ammunition placed in a special location - inside the cabin of the *Iliya Muromets*.

1914 – 1917

328. The interior of the fighter *Iliya Muromets*.

1914 – 1917

The pilots placed aerial bombs on board higher than normal and put them into the passage.

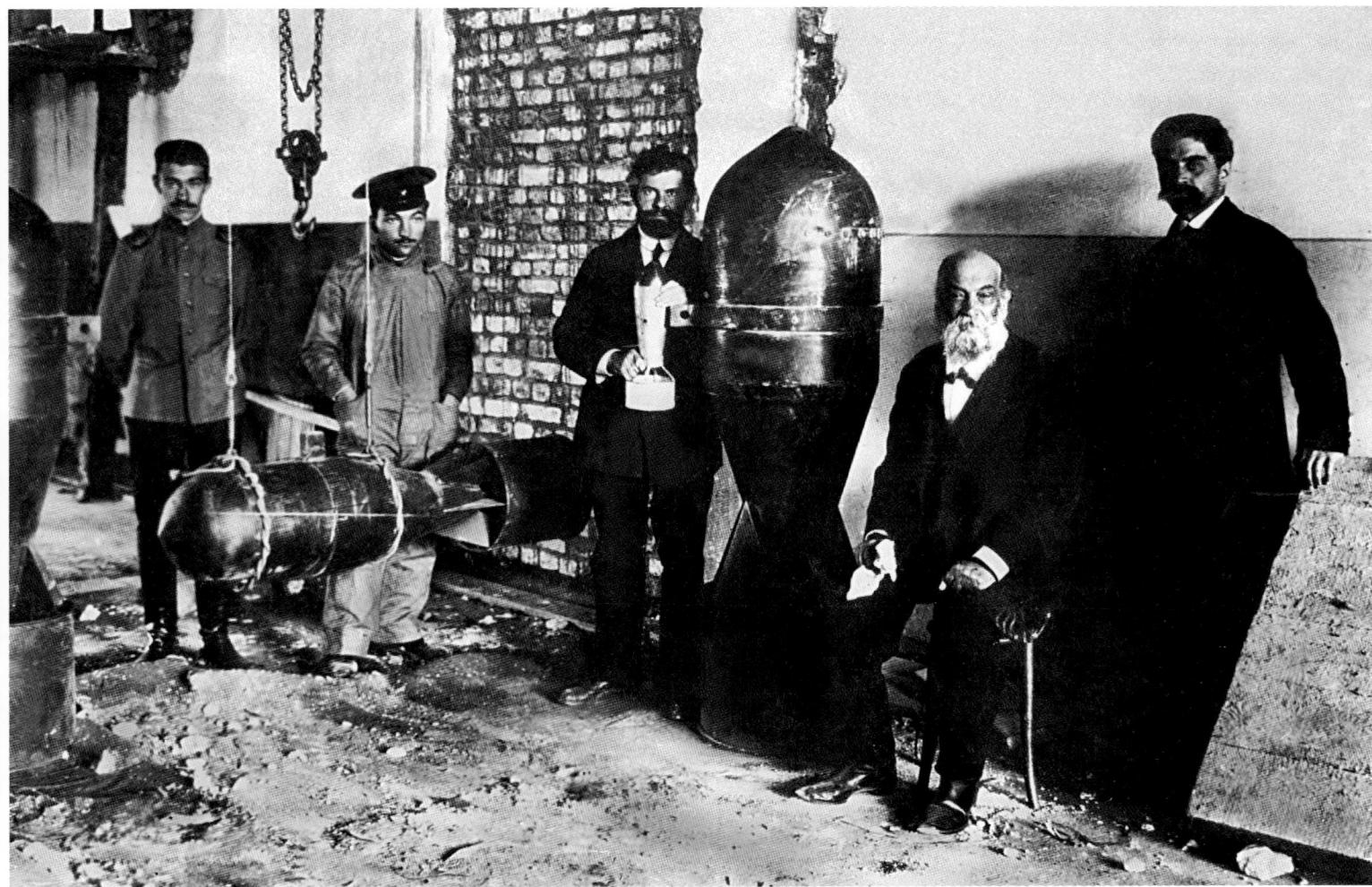

328

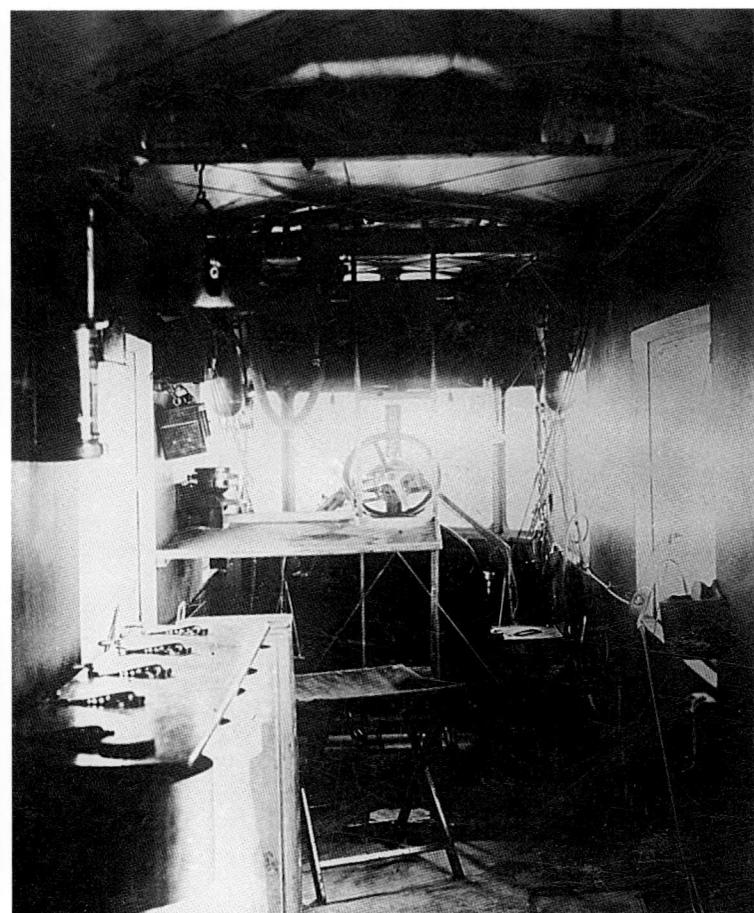

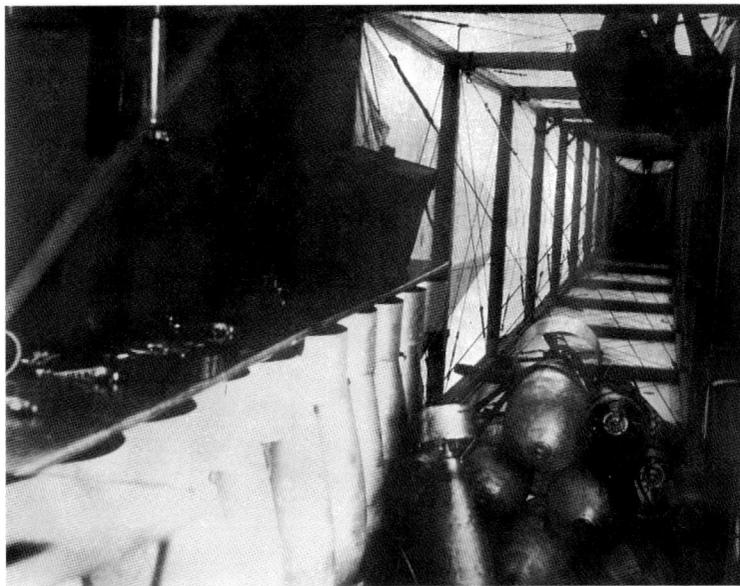

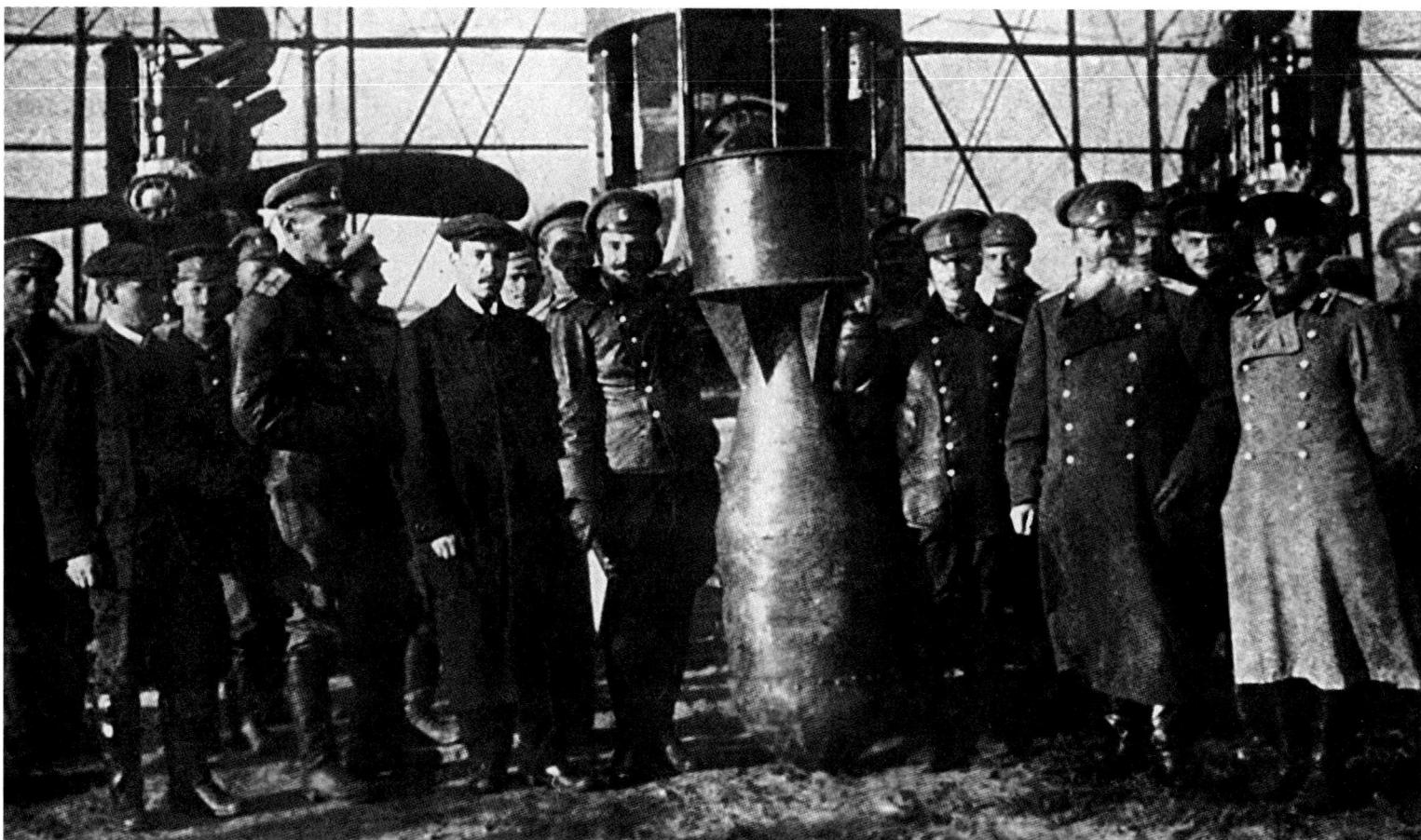

329. I.I. Sikorskyi (in the first row, third from the left). Next to him (fourth from the left) is A.V. Pankratiev, M.V. Shidlovskyi (second from right), and M.N. Nikolskoi (third from the left), all in a group of soldiers near an experimental 25-pound aerial bomb.
Airfield in the city Lida. 1915

330. Result of a night bombing strike from the *Iliya Muromets* along the Przhevorsk Railway Station in Galitsiya (to the south of Yaroslav).
June 27, 1915
The commander of the plane is I.S. Bashko, together with Staff Captain Naumovyi were awarded the order of St. George, 4th class, for this operation.

331. Grand Dukes Mikhail Alexeevich and Alexei Mikhailovich inspect the Iliya *Muromets-I* in a light hanger of the 6th Aerial Company.
Lember Airfield. Lvov. 1915

332. The Iliya Muromets returns from a military flight.
Western Front. 1915

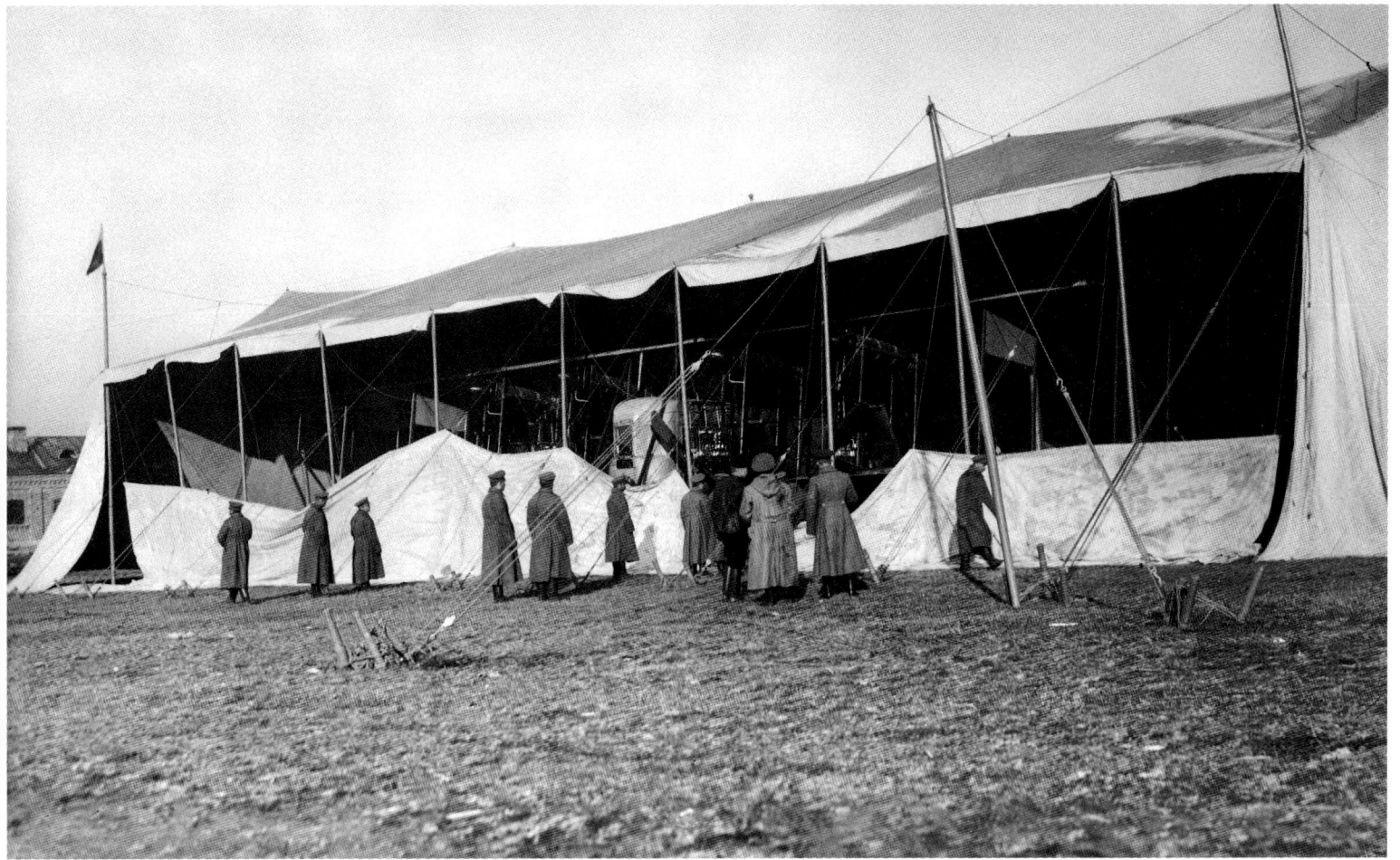

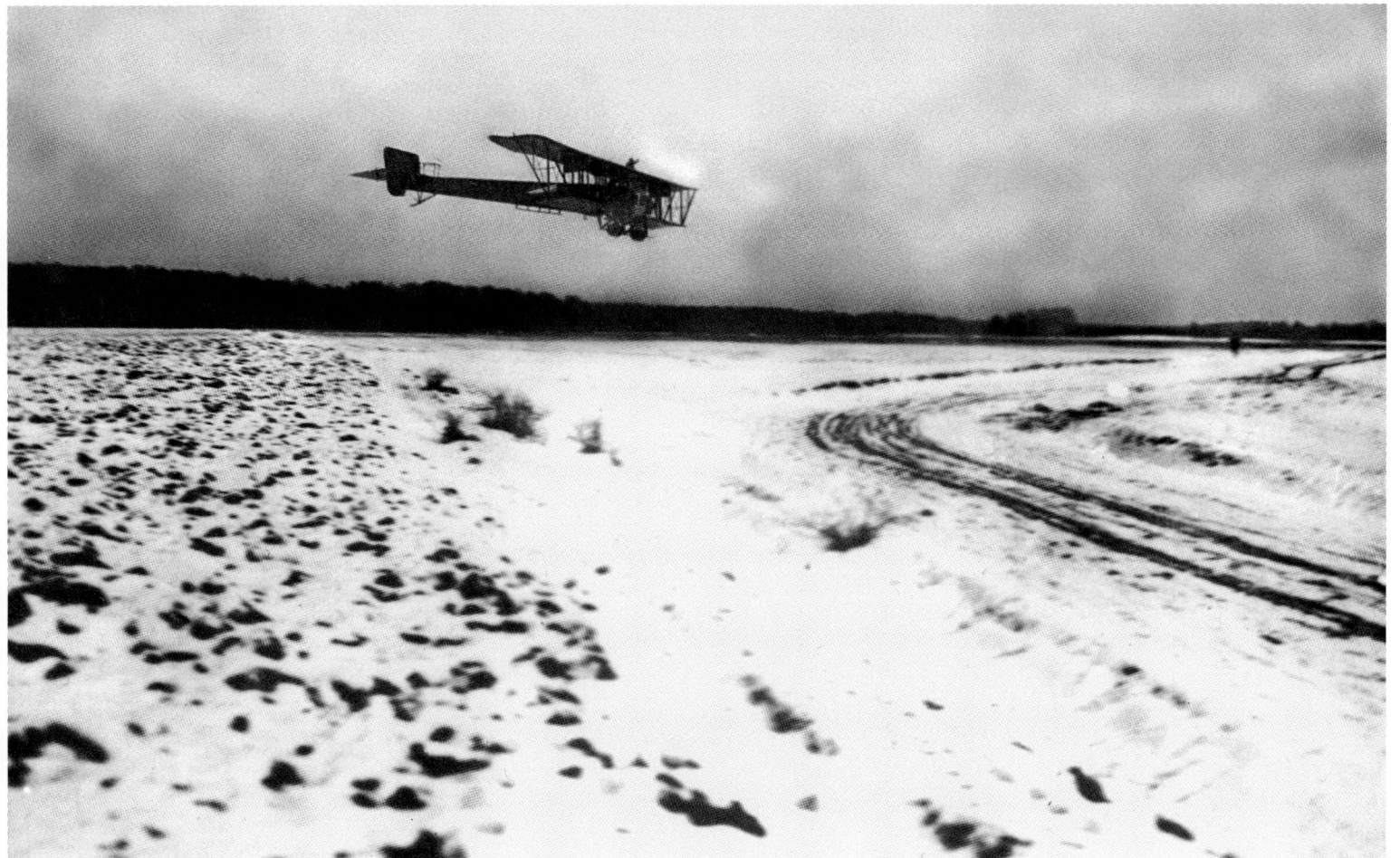

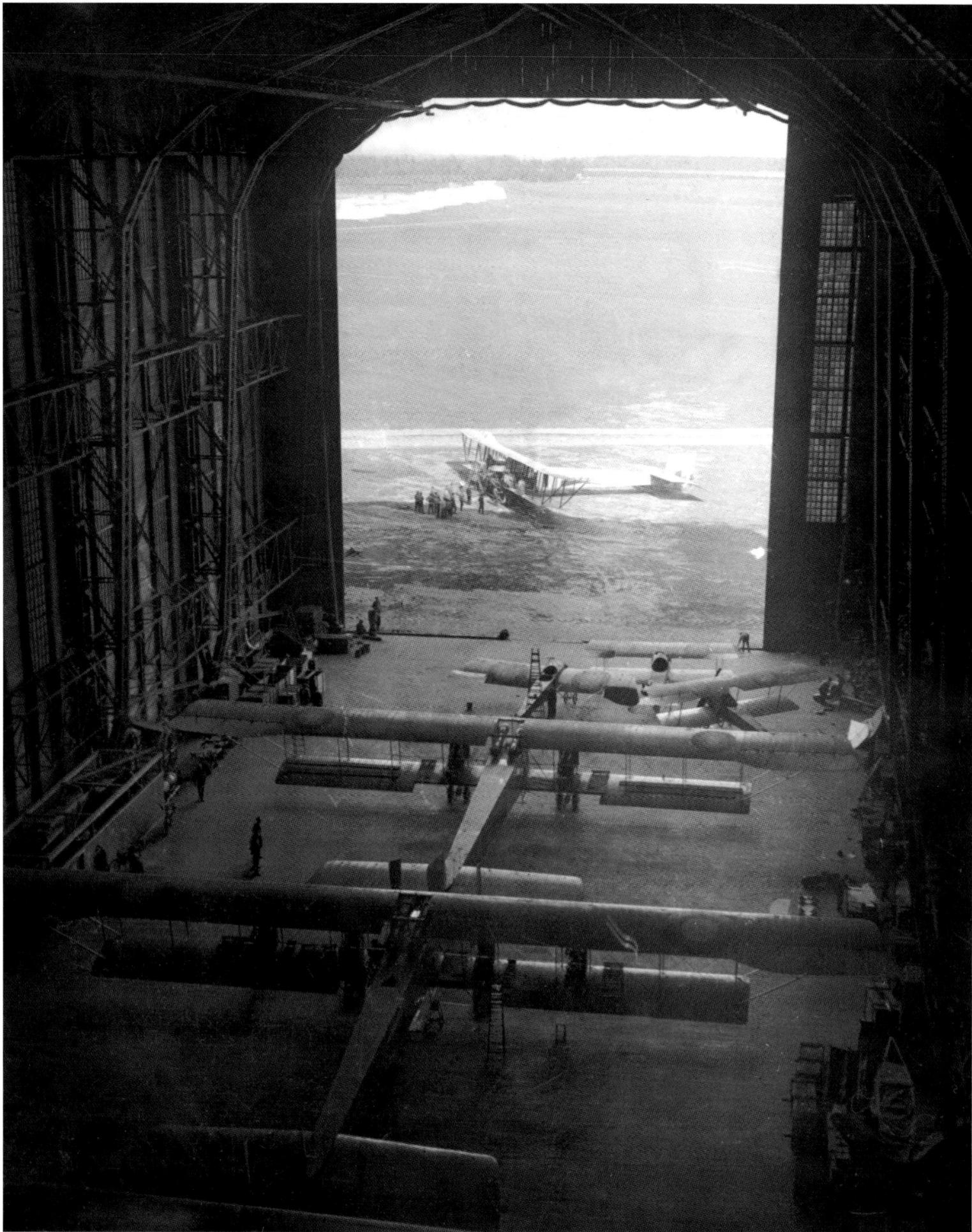

333

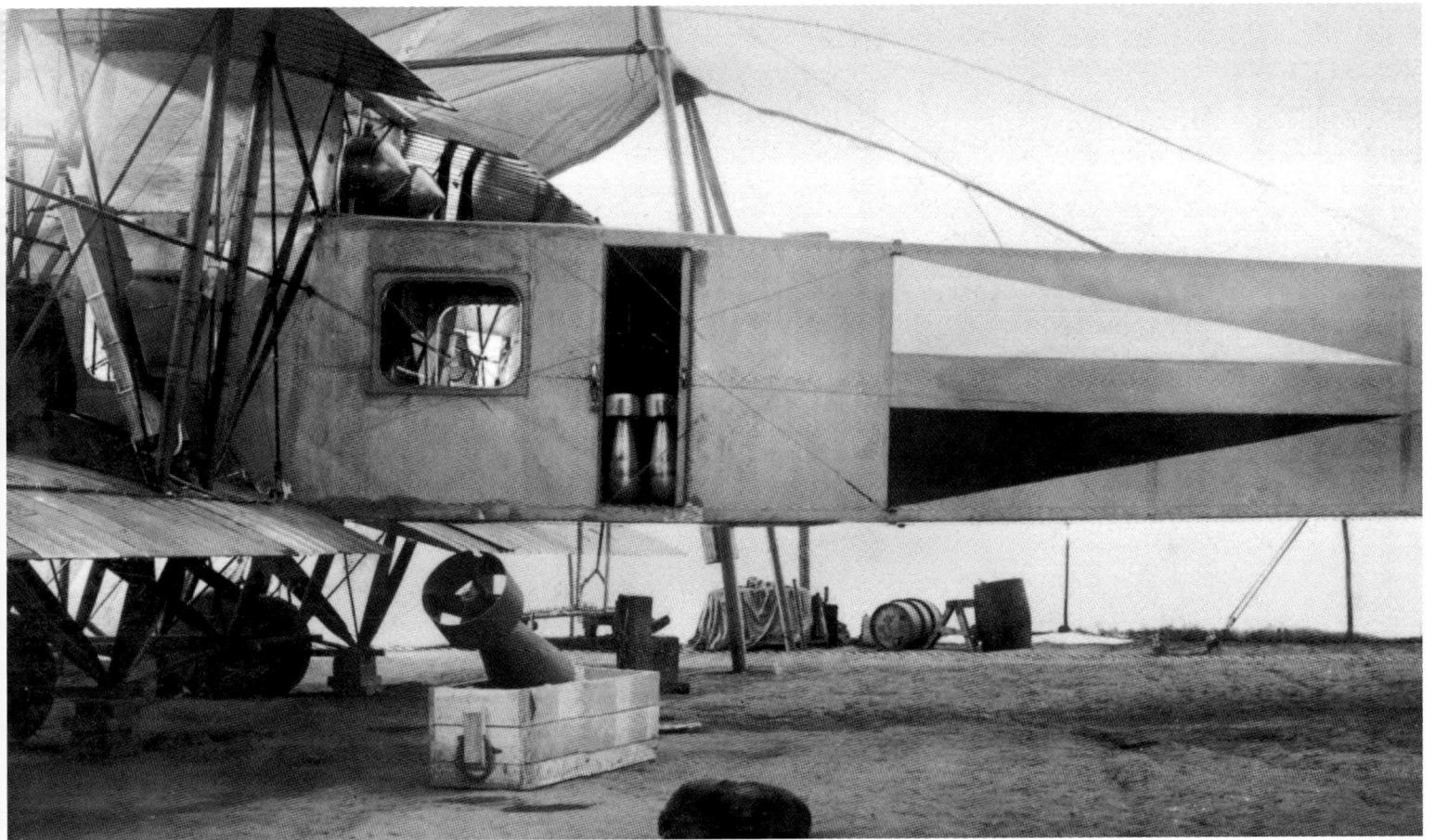

333. *Iliya Muromets* **planes and bombers of the Aeronautical Ship Squadron (the** *S-16* **and** *S-12* **types) designed by I.I. Sikorskyi in the hanger that had been made earlier for the dirigible** *Albatross.*

Yablonna. 1916

334, 335. Loading ammunition onto the plane *Iliya Muromets.*

Airfield at Yablonna. 1915

An identification mark - the three-colored pennant or Russian tri-color - can be seen in the upper photo. In the box are 10-pound aerial bombs.

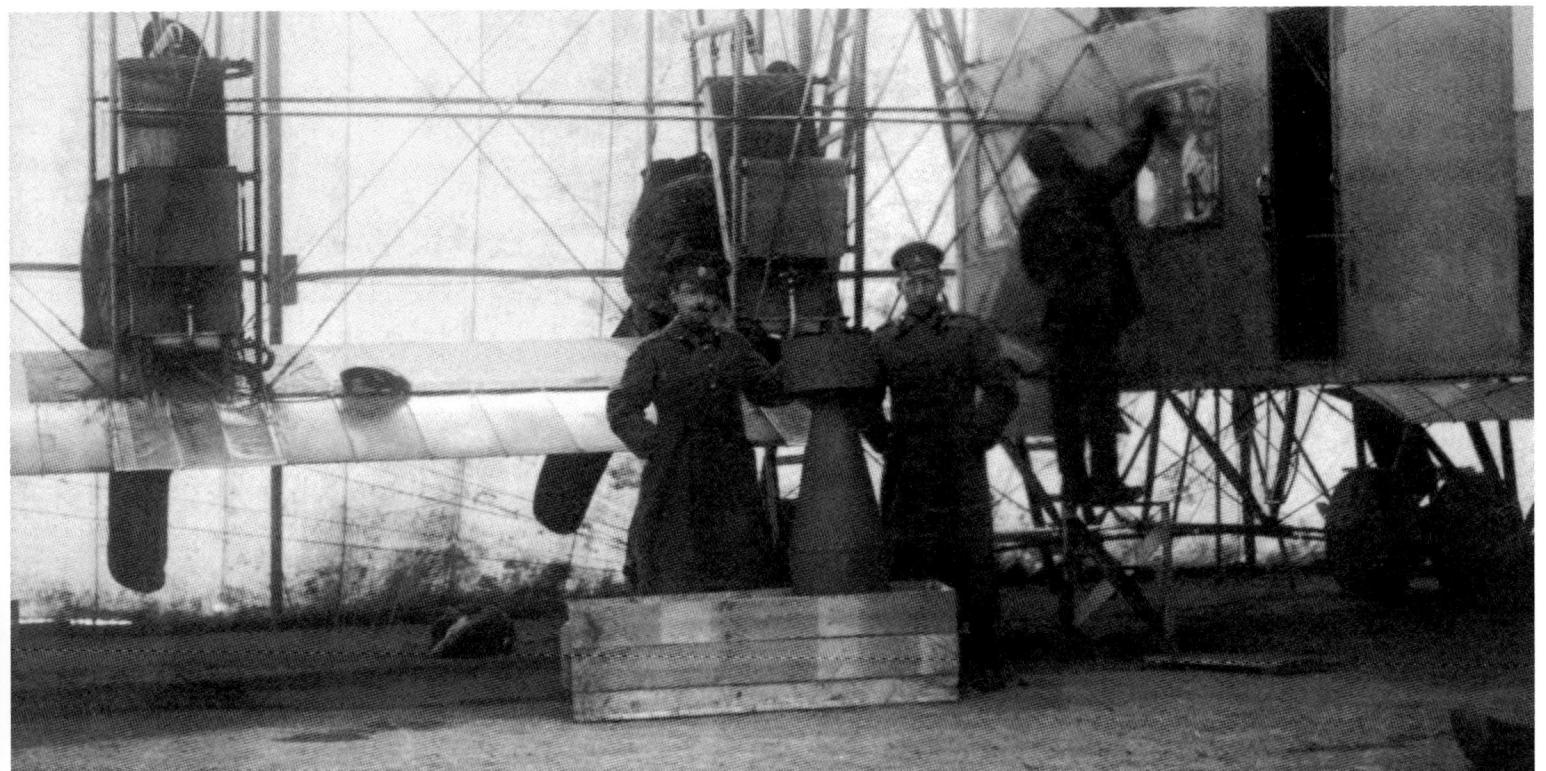

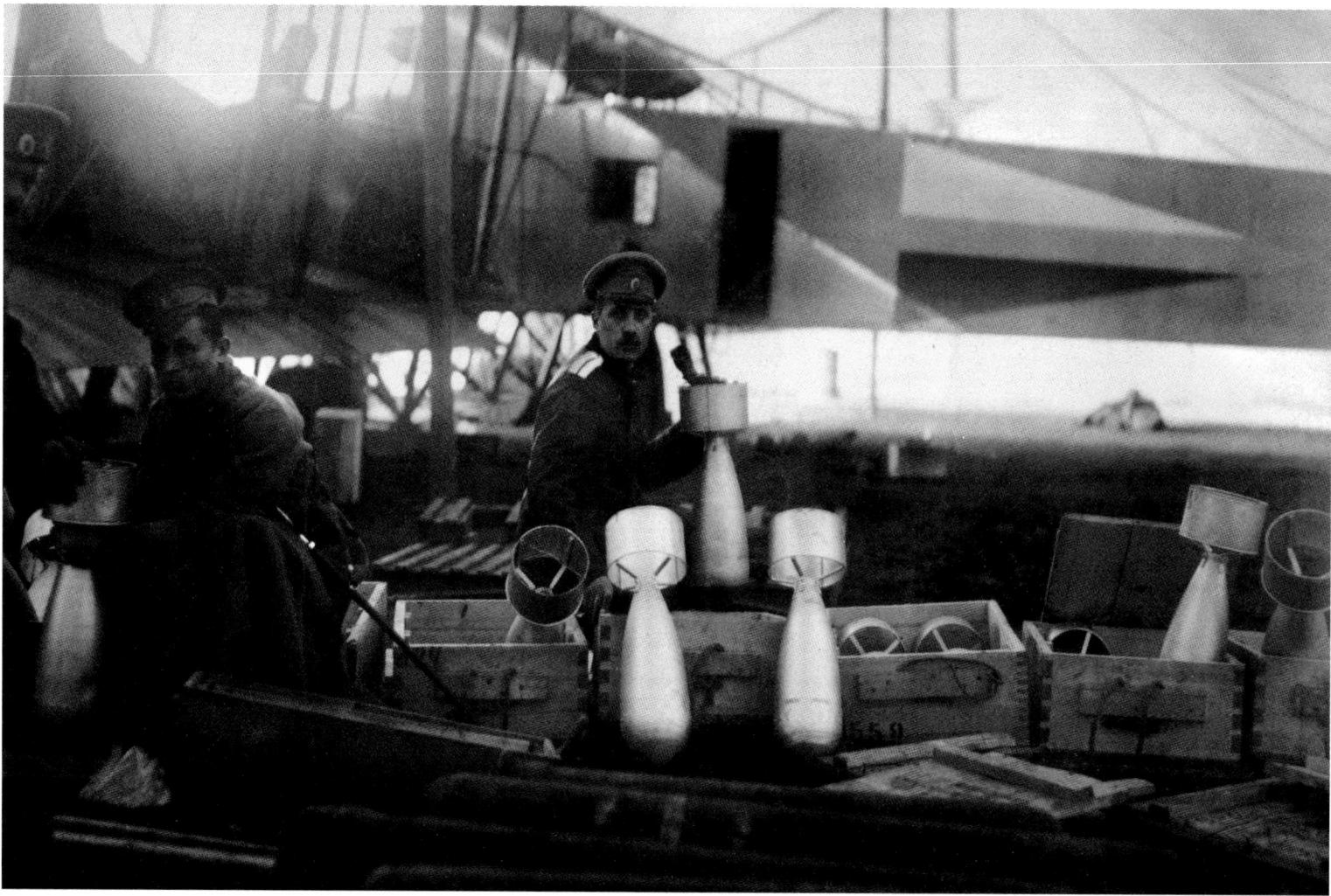

336. Staff Captain R.L. Nizhevskyi (on the right) preparing an aerial bomb to load onto the Muromets.

Airfield near Zegevold. Kurlyandia. October 1915

337. The *Iliya Muromets* after an emergency landing. The pilot is Staff Captain G.V. Alexnovich.

Yablonna. 1915

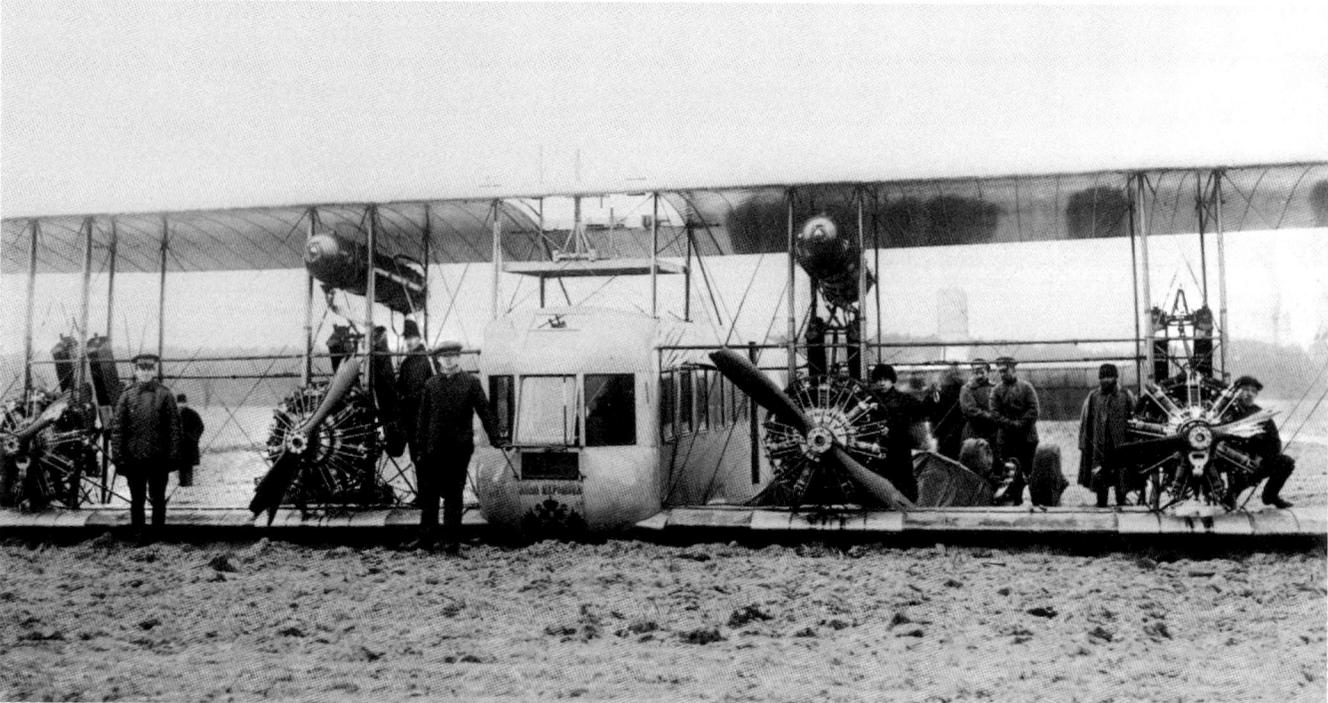

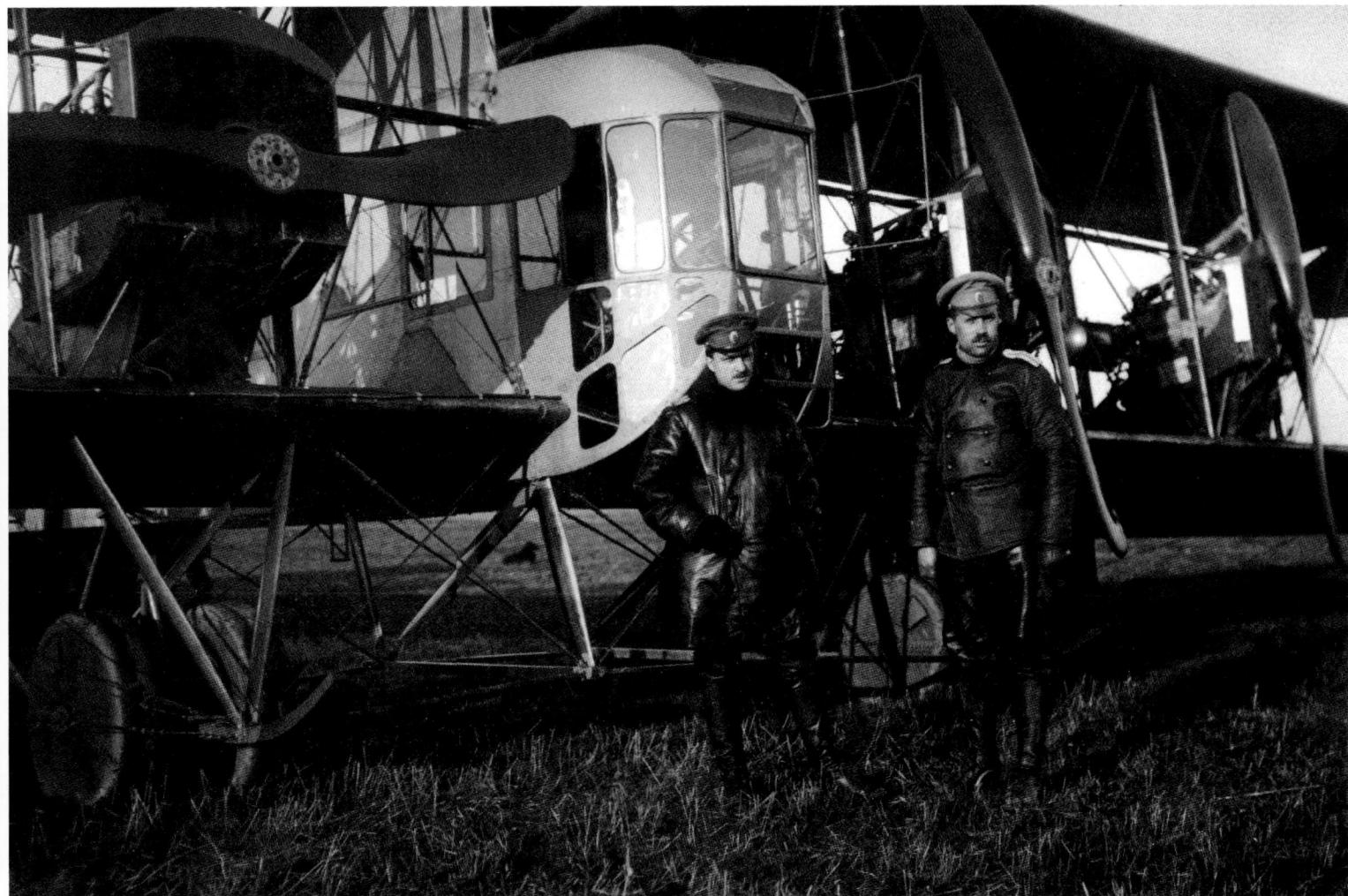

**338. Staff Captain R.L. Nizhevskyi
(on the left) in front of his** *Muromets,*
after an emergency landing.
Pskov. September 1915

339. The plane *Iliya Muromets.*
1914 — 1917
During a military takeoff the mechanics could walk along the wing to the engine and repair them.

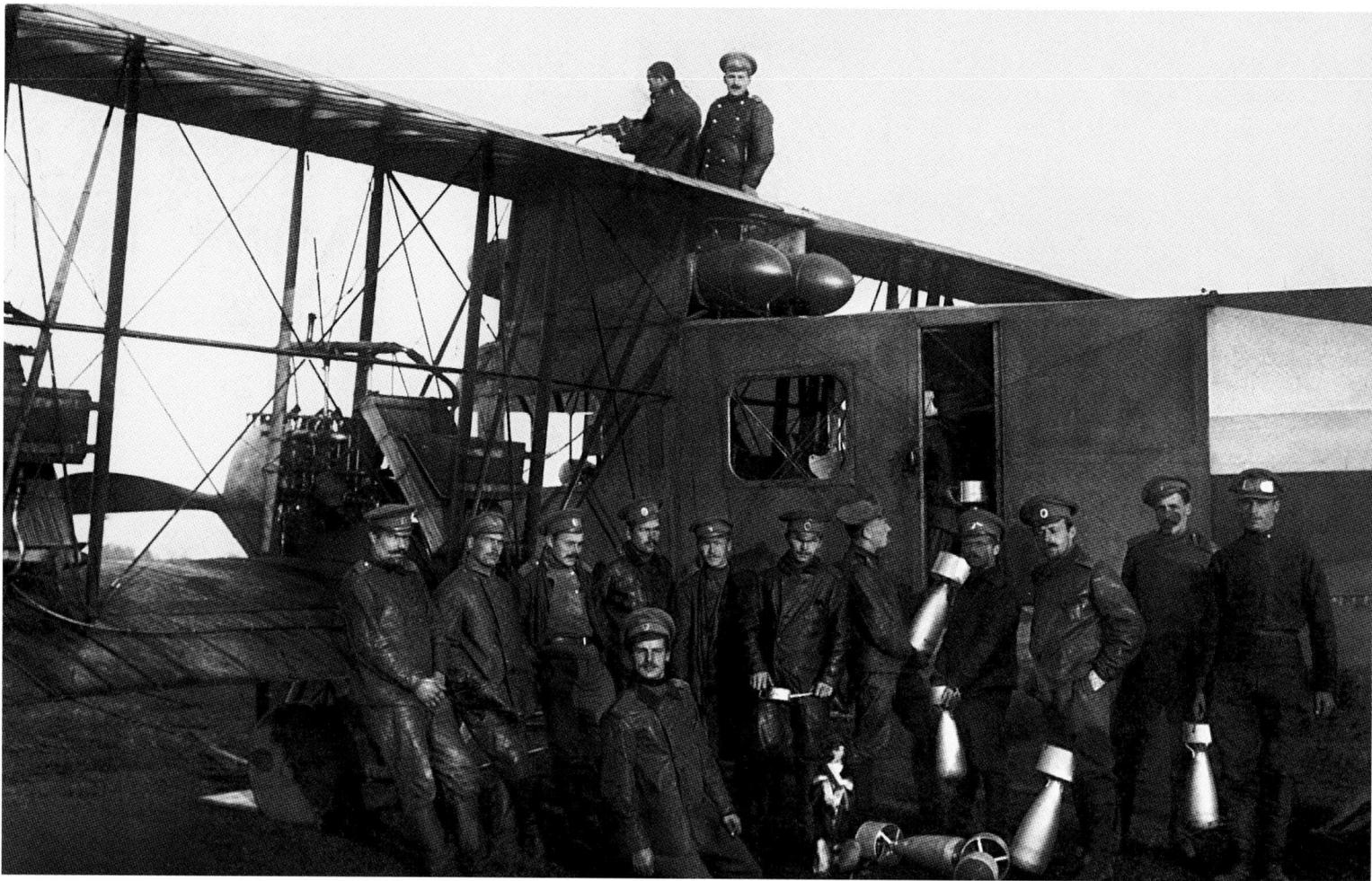

340. Loading aerial bombs in to the *Iliya Muromets-III*. The bombs' general weight was around 19 pounds, or 300 kg.
Yablonna. July 1915

341. The *Iliya Muromets-II*. A.V. Pankratiev's crew. During hard braking, the wings came apart and covered the cabin.
Selo Rezhitsa. September 24, 1914

342. A.V. Pankratiev's crew mechanics while regulating the motors of RBRF-6 on the *Iliya Muromets-II*.
1914

343. Squadron common room decorated for the New Year.
Yablonna. 1915 – 1916

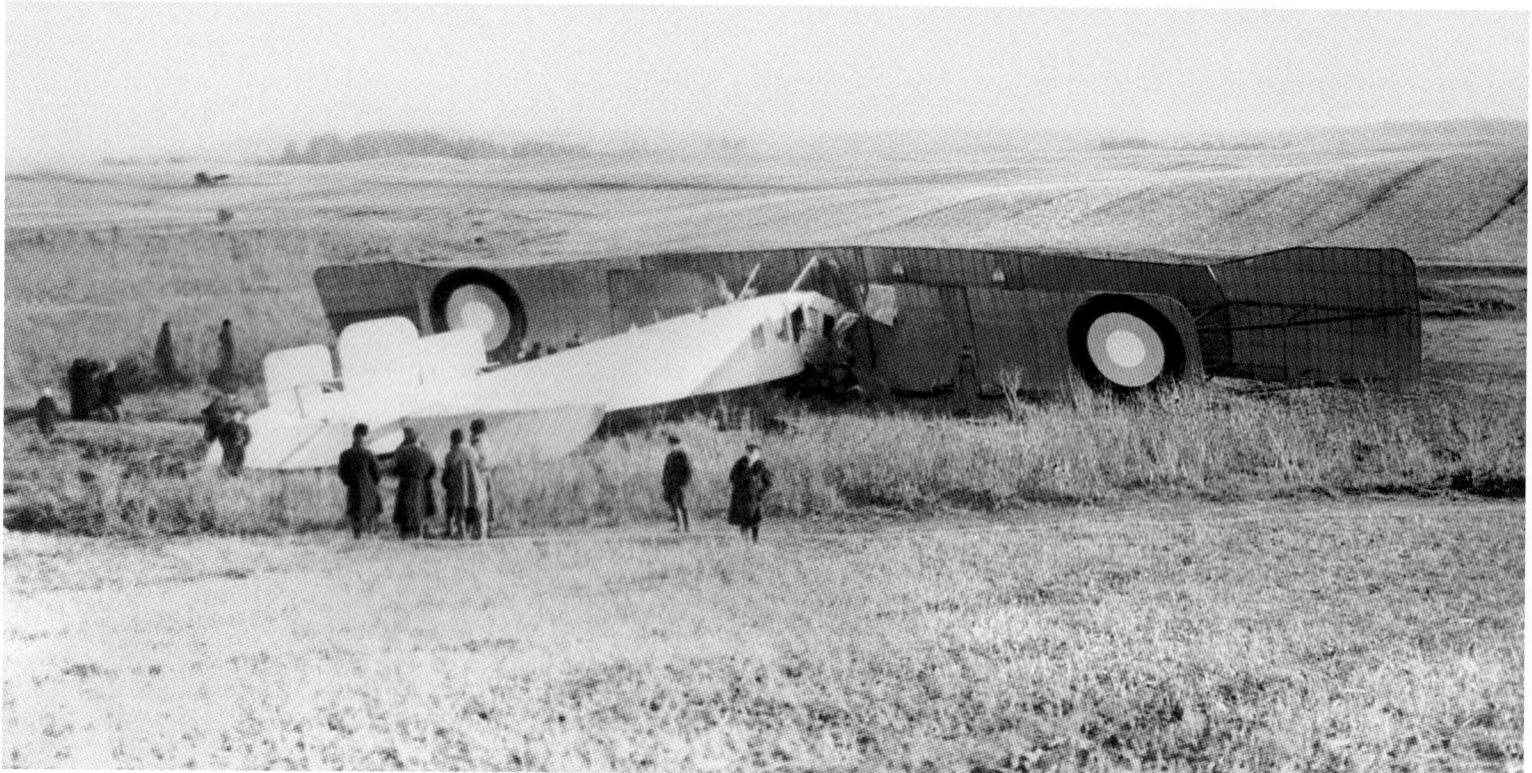

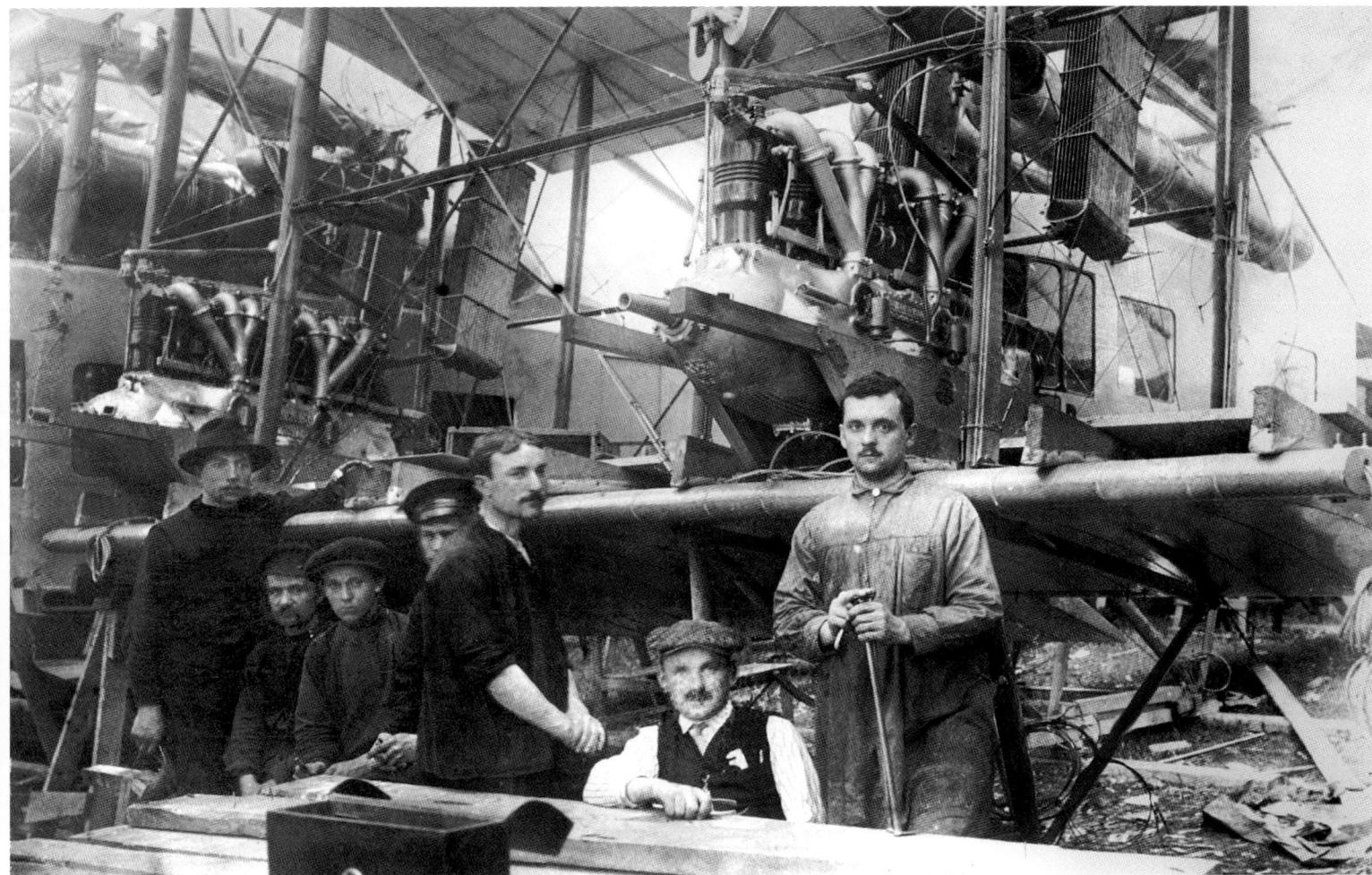

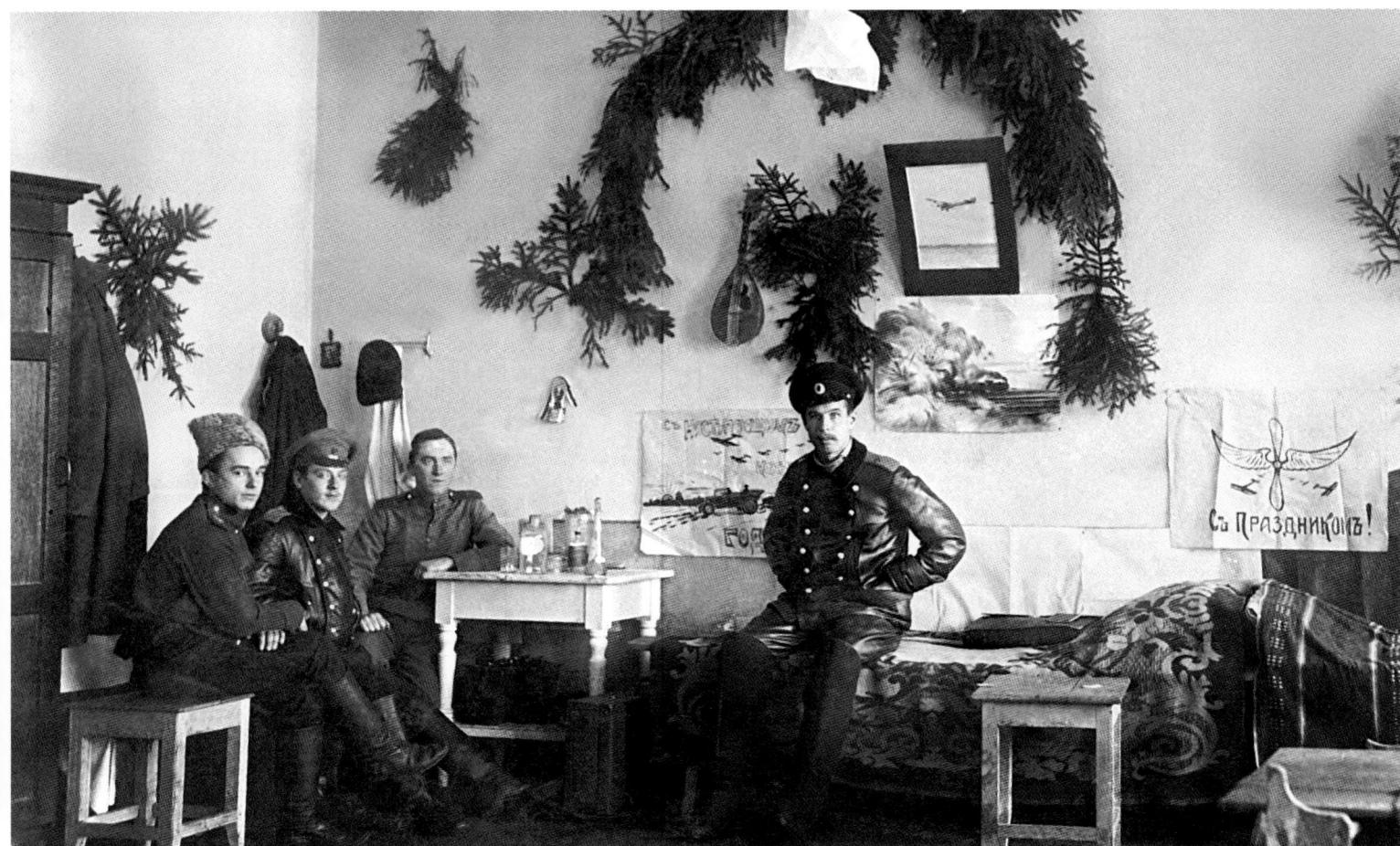

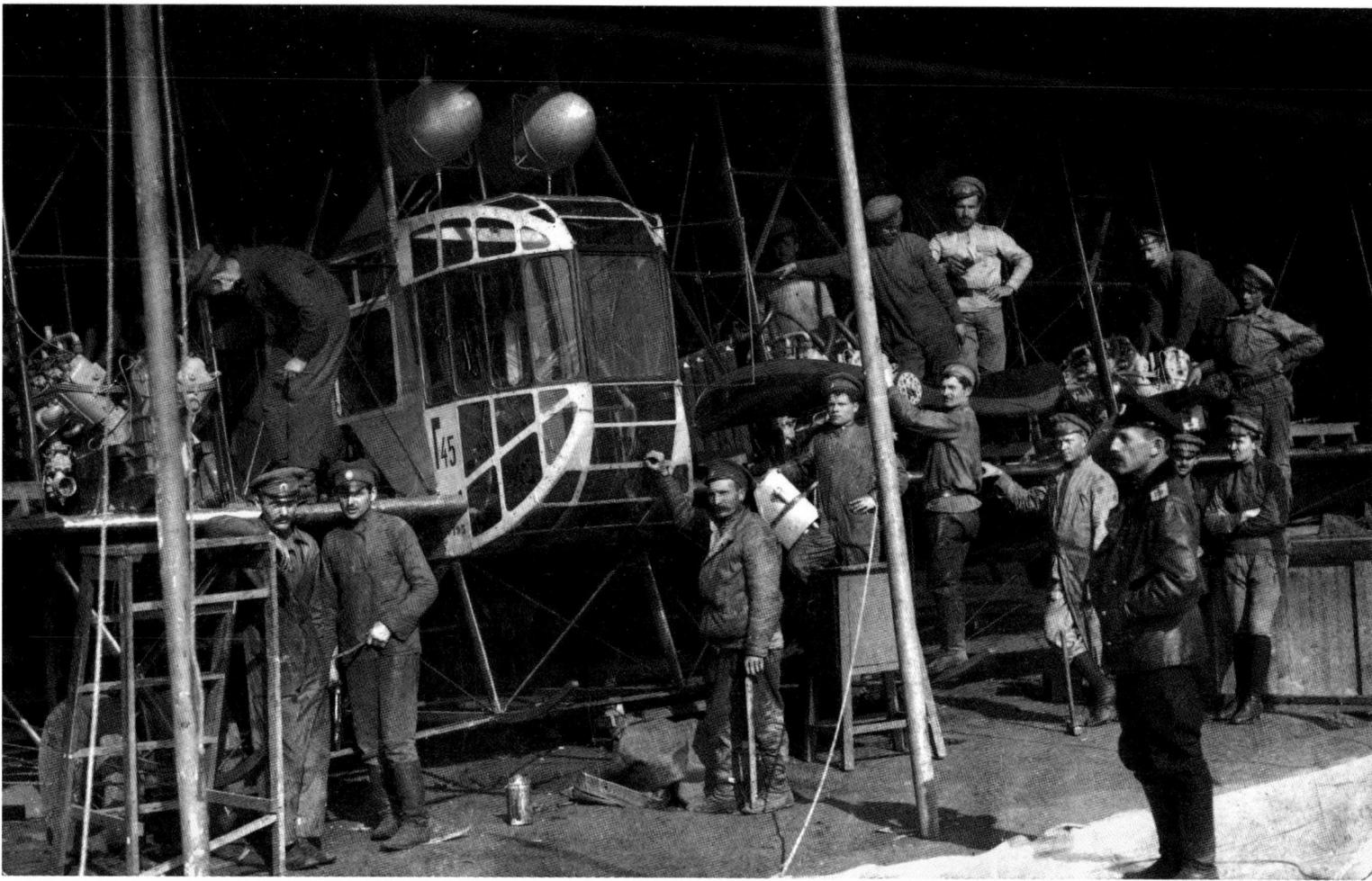

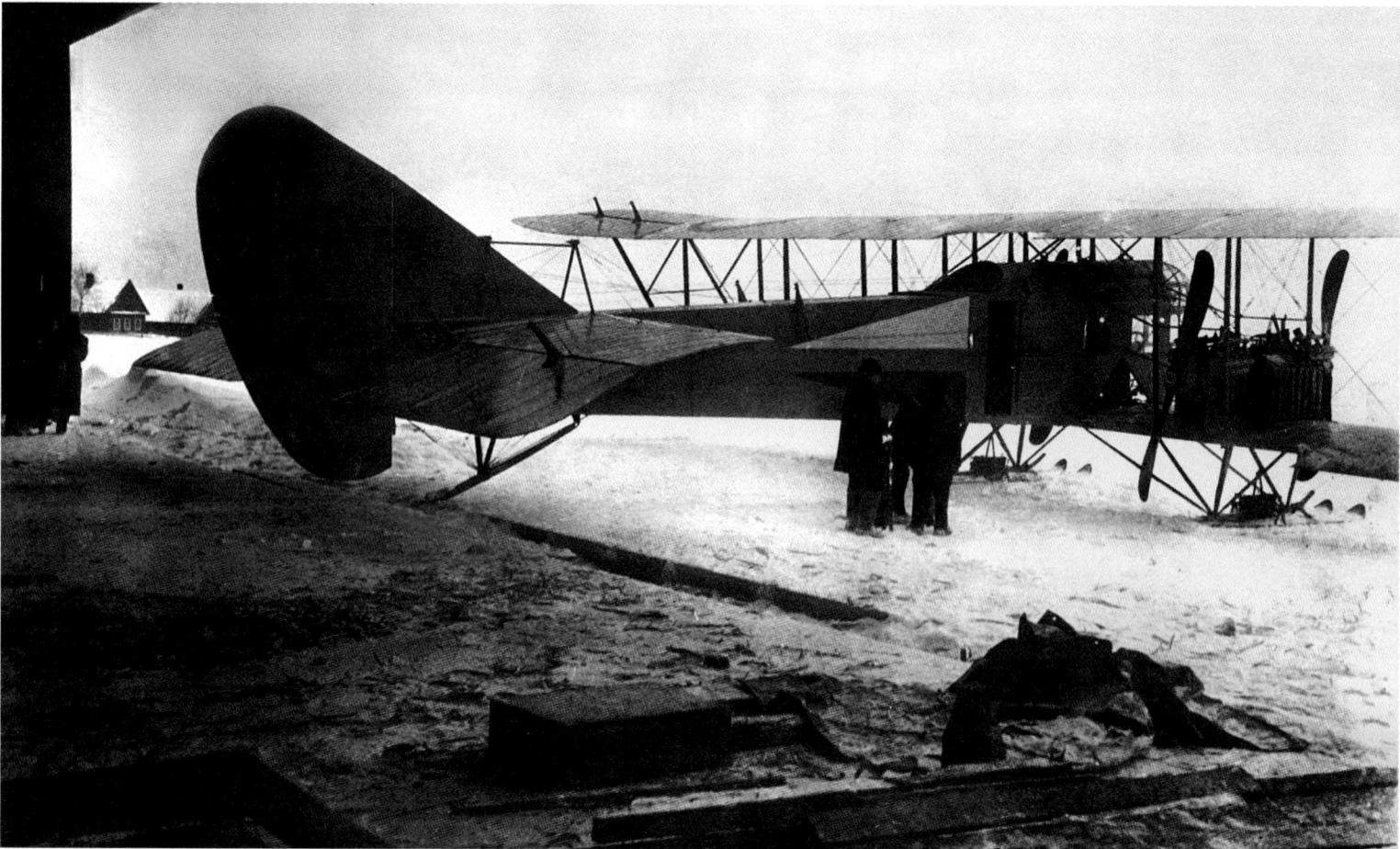

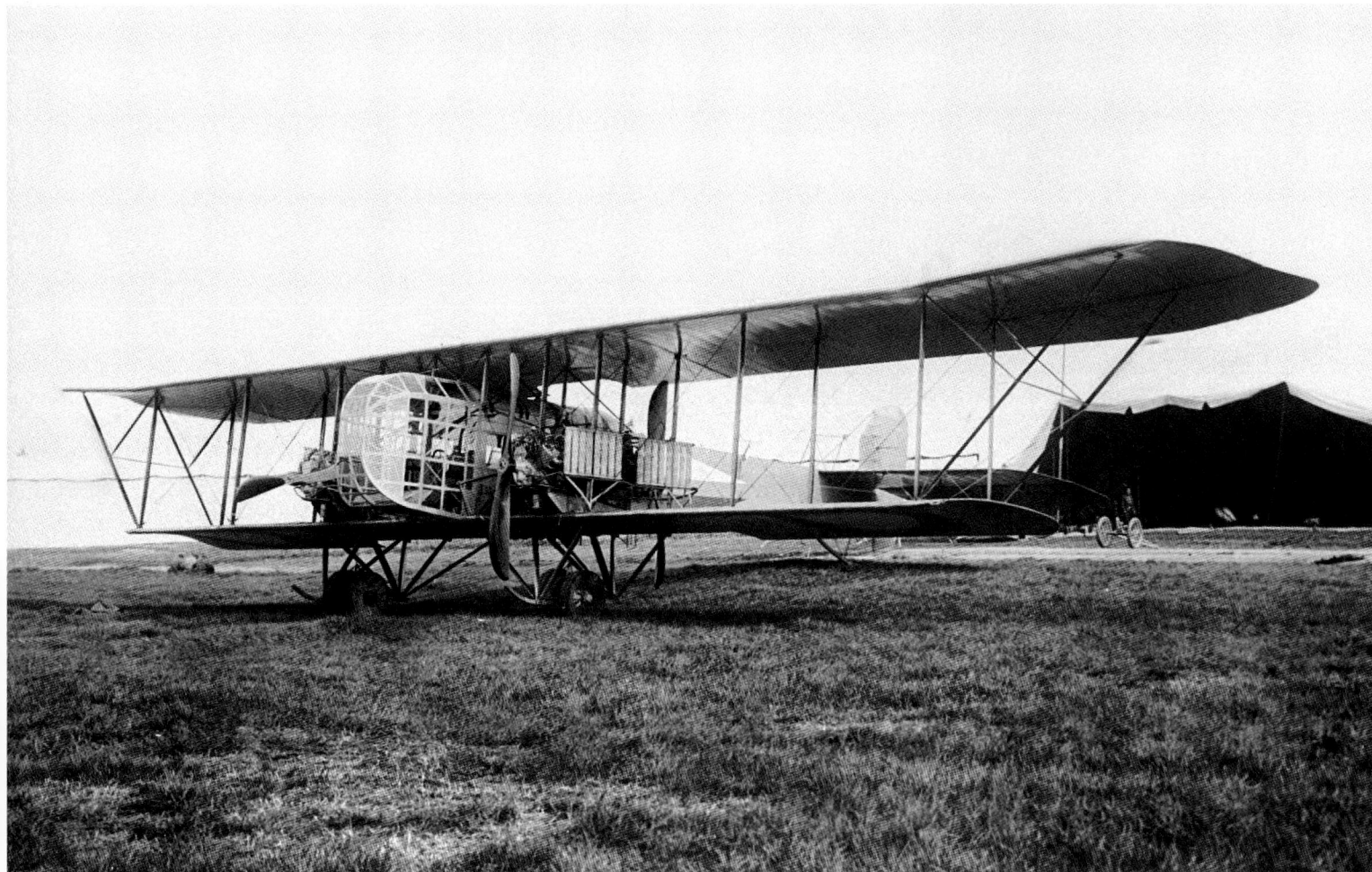

344. Repairing the Iliya *Muromets-XII* **type** *G* **in a front-field tent. Second from the left is mechanic P.V. Kudryashov.**
Summer 1917

345. The plane Iliya *Muromets-DIM* **in front of a hanger during preparation for tests.**
January 1916

346. The *Iliya Muromets* **type** *D-1* **after being modernized into a bomber and going through military tests.**
Pskov. Summer 1916

347. The *Iliya Muromets -III* **type** *B* **on the front airfield.**
Vlodava. June 1915

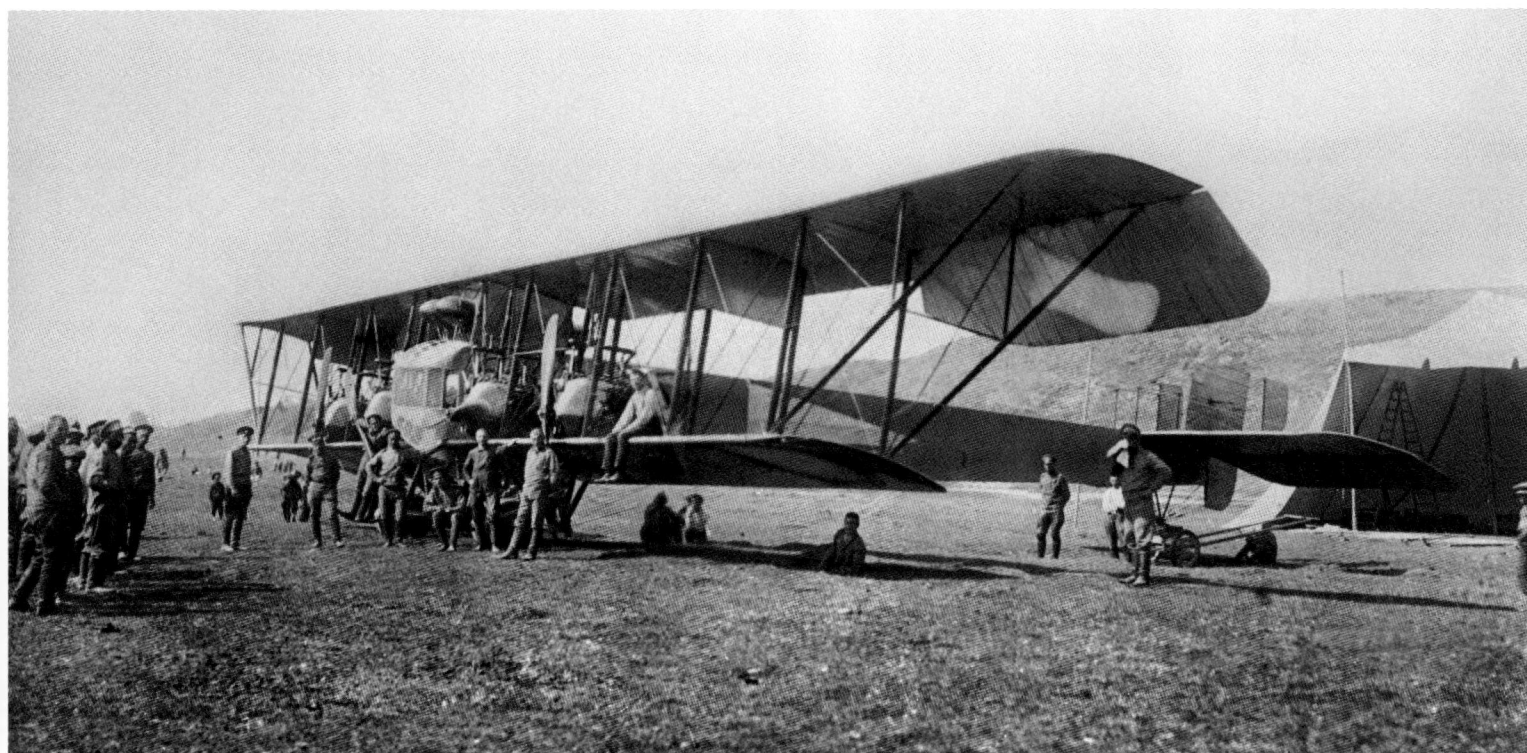

348. An aviator on the plane Moran-Parasol flying off on reconnaissance.
1915

When Russia joined World War I, all military planes was placed in airports, which were under the military command staff and were broken into detachments. In total there were 39 airborne squadrons: 25 of them were corps based: the guards, grenadiers, third field, the first, fourth and fifth Siberian, and eight bondsman squadrons (in Brest-Litovsk, Kovno, Grondno, Ossovets, Novogeorgievsk, Sevastopol, Kars, and Vladivostok).

Fully equipped fighting squadrons turned out to be not so full: instead of the supposed statewide 234 airplanes in stock, there were from 180 to 220. There was also a significant shortage of pilots, in both officers and enlisted men. However, even being so «incomplete», the Russian Air Force was if not first, than probably second according to the number planes it had (Germany had 232 airplanes, Austria-Hungary had 48, France had 165, England had 63, and Belgium had 16).

The weakest areas in military aviation was the underestimation from higher army commanders of the role of airplanes in future wars, and their inability to clearly understand the possibilities of aviation except in reconnaissance and correcting artillery fire. An important fact as well was that airplane crews, for the most part, were represented by members of the privileged classes, many of whom viewed aviation as a sport, having little knowledge of technical aspects, which were considered «dirty».

However, when the Tsar's war manifesto was published, many aviators filed petitions to enroll as volunteers in the acting army, which provided a kind of influx of «fresh blood». All of them as «hunters» were enrolled into Air Force squadrons with their own personal planes, in which they had already made many sporting flights. Thus, the aviators A.A. Kuzminskyi, A.A. Vasiliyev, I.A. Orlov, F.F. Kolchin, D.F. Kolchin, and others came into the army.

After the first day upon joining, aviators went straight into active duty, doing air reconnaissance to determine the enemy's strength. In the first months of the war their help allowed the Russian command to identify the German army's plans for taking Lvov (aviators of the 9th and 11th Corps Squadron took part in this operation). After one of these reconnaissance flights Podesaul (Staff Captain) V.M. Tkachev, managed to get his damaged plane to an airfield by plugging a hole in the fuel tank with his foot. He received an Order of St. George, 4th class, and became the first aviator to be awarded such an honor (in 1917, he headed Russian aviation, then commanded aviation in the P. N. Vrangel's army. He lived as an emigrant, was imprisoned in Siberian camps, and wrote his memoirs «The Wings of Russia»).

In spite of significant losses caused, basically, by a high accident rate, Russian pilots compensated by having experience and bravery. As a result, there were many recorded feats from outstanding aviators, like Staff Captain Pyotr Nikolaevich Nesterov (the first pilot in the world to complete a «loop-the-loop»), who commanded the 11th Corpus Airborne Squadron. On August 26, 1914, near the city Zholkov (later Nesterov), he was the world's first pilot to destroy an enemy plane in an air battle. Nesterov had to resort to a «ramming» attack, and damaged an Austrian Albatross plane, piloted by Baron Rosenthal and inspector Sergeant Major Malina, with his plane the Moran-Solnie (type J). While the enemy crew was killed, Nesterov also died. After his death he was awarded an Order of St. George, 4th class.

In general, in the first year of the war, the Order of St. George, 4th class, was awarded to 8 aviators for demonstrated courage and bravery. 12 pilots, who were enlisted men, were awarded the Soldier's Mark of Excellence of the same Order.

In the West during the war experienced and effective aviators, who shot down more than 5 planes, were called «Aces». Soon this word stuck for Russian pilots - those masters of air battles, - as well. These heroes of World War I, or, as it was also called, the Second Patriotic War, were «flying aces» or «kings of the sky» - and became «pioneers» of our air victories. Without them, there would not have been today's renown of Russian aviators and planes in the world.

At the beginning of the war, planes did not have armaments on board, except for the pilots' or inspectors' («aircraft observers») personal weapons carried in rare circumstances. Beginning in 1915, the planes began to be armed with different types of guns. In Russian aviation the best kinds of planes for this were the Farman and Vuazen that had front cabins and motors in the back: Maxim, Colt, and Madsen machine guns were fitted on these, which an inspector could man and have a good view of the forward half of the plane. In Summer 1915, the crew from the 26th Corps Airborne Squadron (CAS) under Ternopol gained a victory over Austrian aviators in an Albatross precisely because they used guns.

In 1915, 56 aviation officers were awarded golden St. George Swords, 25 pilots got an Order of St. George, 4th class, and 115 enlisted men got soldier's St. George Crosses.

Competent soldiers began to go into the Russian Air Force at about this time, with their own commanders in the name of Grand Duke Alexander Mikhailovich, who headed the Department of the Aeronautical Fleet (DAF) in 1910. On January 5, 1915, the Grand Duke was named the leader of aviation of the acting army. One of the more important decisions made by the Grand Duke concerned the creation of a Russian Air Force special fighter unit that was needed to fight for air supremacy in 1916. His order to create fighter squadrons (with 6 planes in each) came out in March 1916, but they didn't actually participate in battles until the Summer. July 4 is the day when Russian military aviation is considered to have been created, when the project was officially supported by Nicholas II.

Fighter aviators had to fly in different types of planes, refitted to fire on the enemy. The weaponry was not perfect, and air combat skills were mainly acquired through experience.

The famous Brusilov Offensive in the Summer of 1916 caused Germany to focus its aviation into the so-called «Airborne Fist» to help Austria-Hungarian soldiers in the area of Kovel. The Russian command had to quickly reorganize their forces in response: three airborne squadrons were united into a special Army Aviation Group (AAG) of the Southwestern Front, which turned into a new type of aviation concentration. Once supplemented with new planes, the First AAG started military actions in September 1916. In Autumn of that year, the Second AAG had their first battle in very difficult circumstances against German aviation forces. Its commander was the experienced military aviator Evgraf Nicholaevich Kruten.

In 1917, new maneuvering planes were introduced - Niupor-17, Niupor-24, Spads and Vikkers fighters that had good weaponry for conducting air battles.

In the Spring of 1917, the First AAG went to the Romanian Front, the Second went to the Southwestern Front, and the Third and Fourth went to the Western and Northern Fronts. At this time, the names of Russian aces began to appear in the press more often, as they had more than 5 victories. The more famous among them were Alexander Alexandrovich Kazakov, Pavel Vladimirovich Argeev, Ivan Vasiliyevich Smirnov, Grigoryi Eduardovich Sook, Vasilyi Ivanovich Yanchenko, Eduard Martinovich Pulpe, Iuryi Vladimirovich Gilsherm, Nikolai Kirillovich Kokorin, Donat Aduevich Makienok, Alexander Nicholaevich Prokofiev-Severskyi and others. 219 heroes of Russian aviation were awarded Orders of St. George, and 43 aviators died during the war.

The most successful Russian ace was Alexander Alexandrovich Kazakov with 19 unchallenged and 13 certain victories. He made 57 military flights and was awarded the Golden Order of St. George and other military medals, including the Order of St. George, 4th class.

Another flying hero was Ivan Alexandrovich Orlov, who joined the army at 19 with a diploma from the Pan-Russian Aeroclub, 299. Proving himself in battle, I.A. Orlov was awarded three soldiers' St. George Crosses, promoted to officer, and in the Summer of 1916 he became commander of the 7th Fighting Airborne Squadron. This brave pilot died in Summer 1917 while fighting a battle with four German pilots at the same time.

Nikolai Kirillovich Kokorin was a famous pilot of World War I, being the first aviator who came from the army. He received the status of officer and was awarded the Golden Sword of St. George «For Bravery», and also the Order of St. George, 4th class and third soldiers «St. George». He had 5 victories in all, and Kokorin's final battle was on May 28, 1917 with a group of German planes. He died as a hero.

Ivan Vasilevich Smirnov was a brave war aviator, who started his service in an infantry unit. After being wounded and hospitalized, he went to the Gatchina Aviation School and in Summer 1916 went into the Air Force in the 19th Corpus Airborne Squadron of the first Fighting Aviation Group. He started achieving victories on December 21, 1916, shooting down 10 enemy planes. After the collapse of the army, I.V. Smirnov left with his friends and made it to Egypt through Vladivostok, and then to Europe, where he worked in the king's Netherlands Airlines.

One of the more famous Russian war aviators, according to publications in the press, was the «Russian Knight» Evgraf Nikolaevich Kruten (on his Niupor was the image of a knight's head). E.N. Kruten had 6 victories, and had also written tactical manuals for fighters. His list of awards include the Golden Sword of St. George, an Order of St. George, 4th class, and other orders, including the French «Military Cross». He died in June 1917 in his airfield, suffering an accident during landing.

The former calvary man Iuryi Vladimirovich Gilsher became an aviator after finishing the Gatchina Aviation School in Fall 1915, and was sent immediately to the Front in Galicia (Western Ukraine) to the 4th Army Airborne Squadron. After receiving an injury, he was sent to the airplane factory Dukes in Moscow, where he recovered and worked on new planes. He finished the Odessa Aviation School (where training was done on more modern planes) and went to the 7th Fighting Airborne Squadron. On one flight he was shot down and, finding himself in a tail spin, fell from a height of 1000 m. Gilsher lost his left foot in this accident. He stayed in the hospital until October 1916 and, despite his injury, went back to the squadron, where he continued military flights, damaging four more planes.

Iuryi Gilsher was a full-fledged member of the «aces» community and at the end of 1916 took command of the 7th Airborne Squadron after the death of I.A. Orlov. V.M. Tkachev wrote thus about him: «The aviation career of Gilsher was not easy, but he showed himself to be a vehement patriot, whole-heartedly given to aviation. And as an aviator he was gifted with great self-control.» In the difficult days of the Summer retreat of 1917, I.V. Gilsher took part in an uneven battle with colleagues, in which he died.

His best friend was Vasiliy Ivanovich Yanchenko (also an «ace», and three-times over, since he had 16 victories) with a glorious war hero biography. He volunteered to go to the front and went into the 12th Airborne Squadron after graduating from the Sevastopol Aviation School in September 1915. He later went into the 7th Fighter Airborne Squadron and was hurt a few times during battle. After the revolution, he made it into the Vrangel army in the South and then went to America.

The Civil War and the decisions of the regime changed the fate of Russian pilots, separating them into Russian and foreign emigrants. Even now there is no information about many of them, except for a few facts and unidentified photographs, miraculously saved in family archives ...

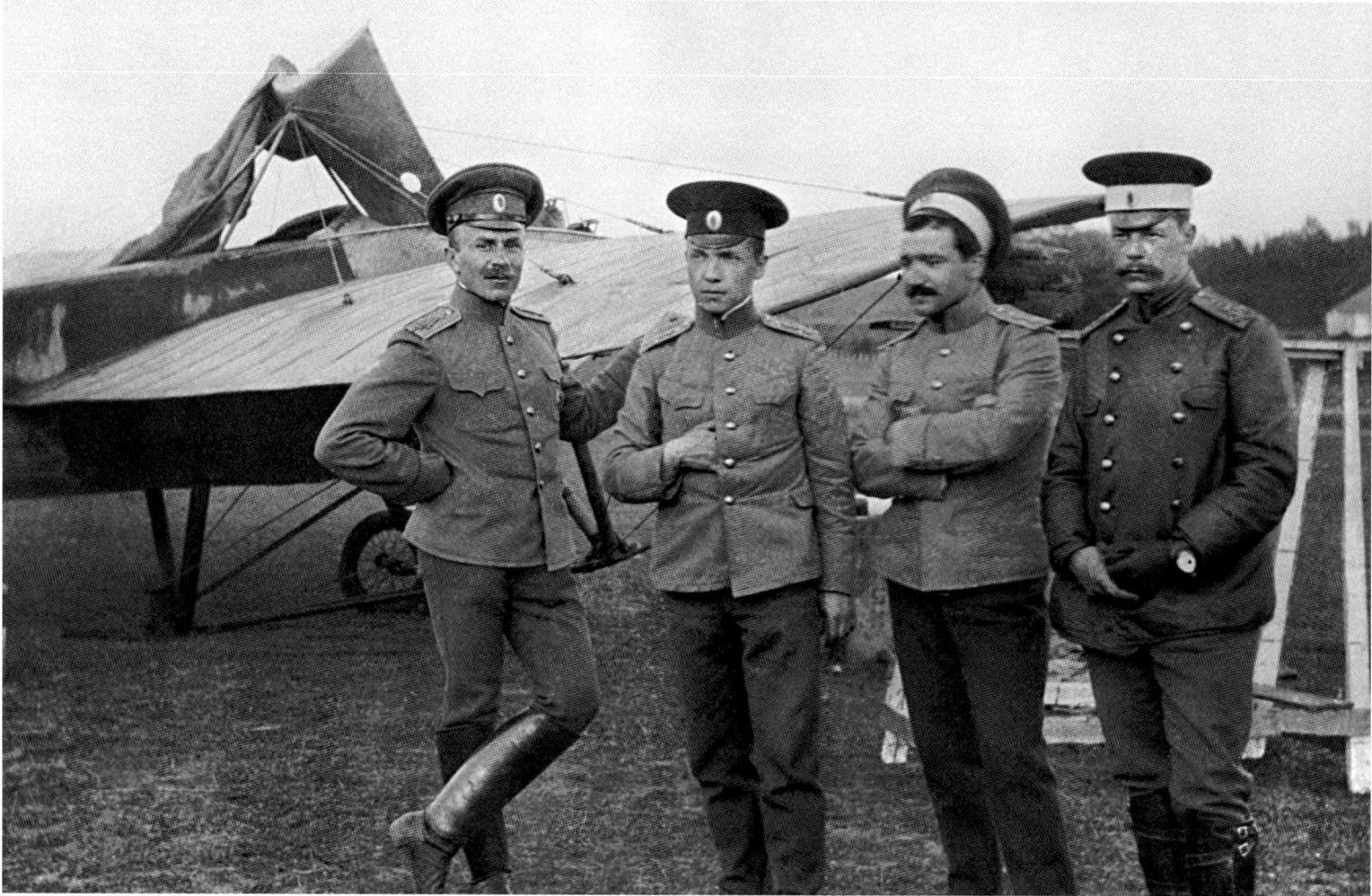

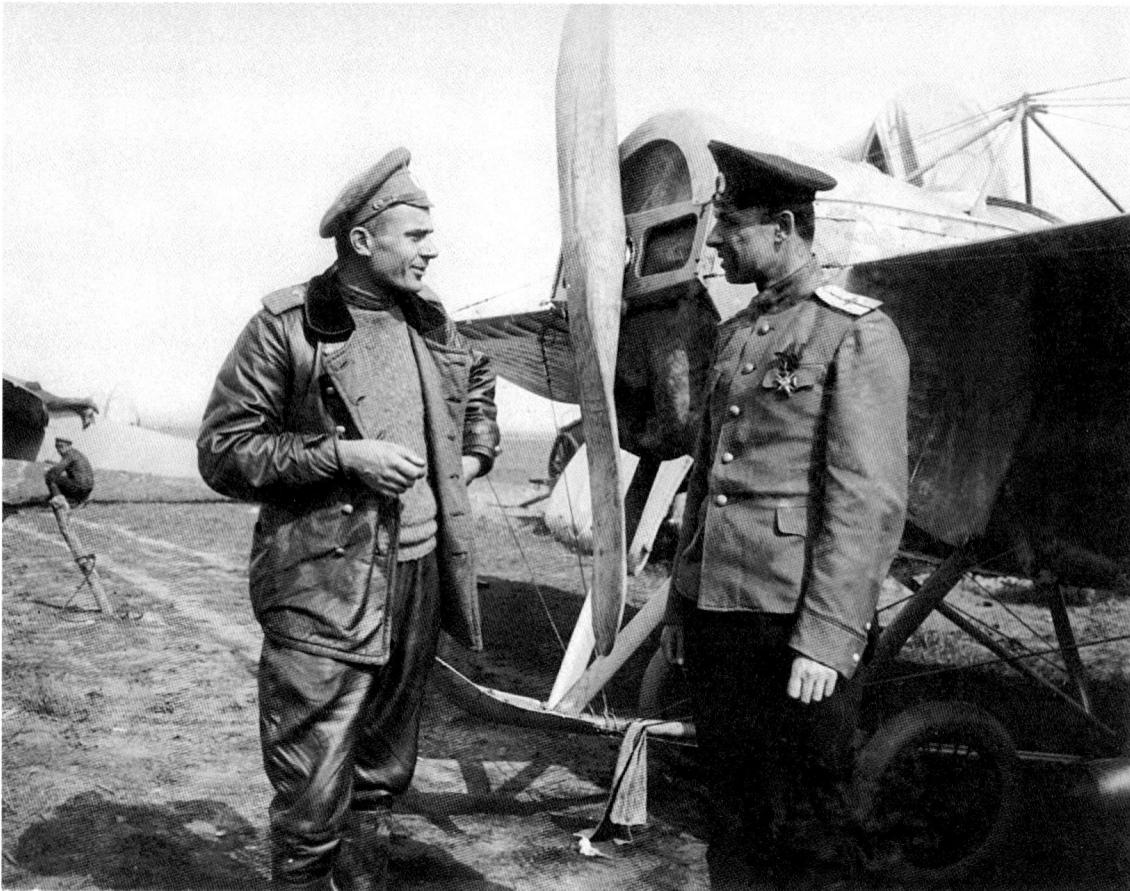

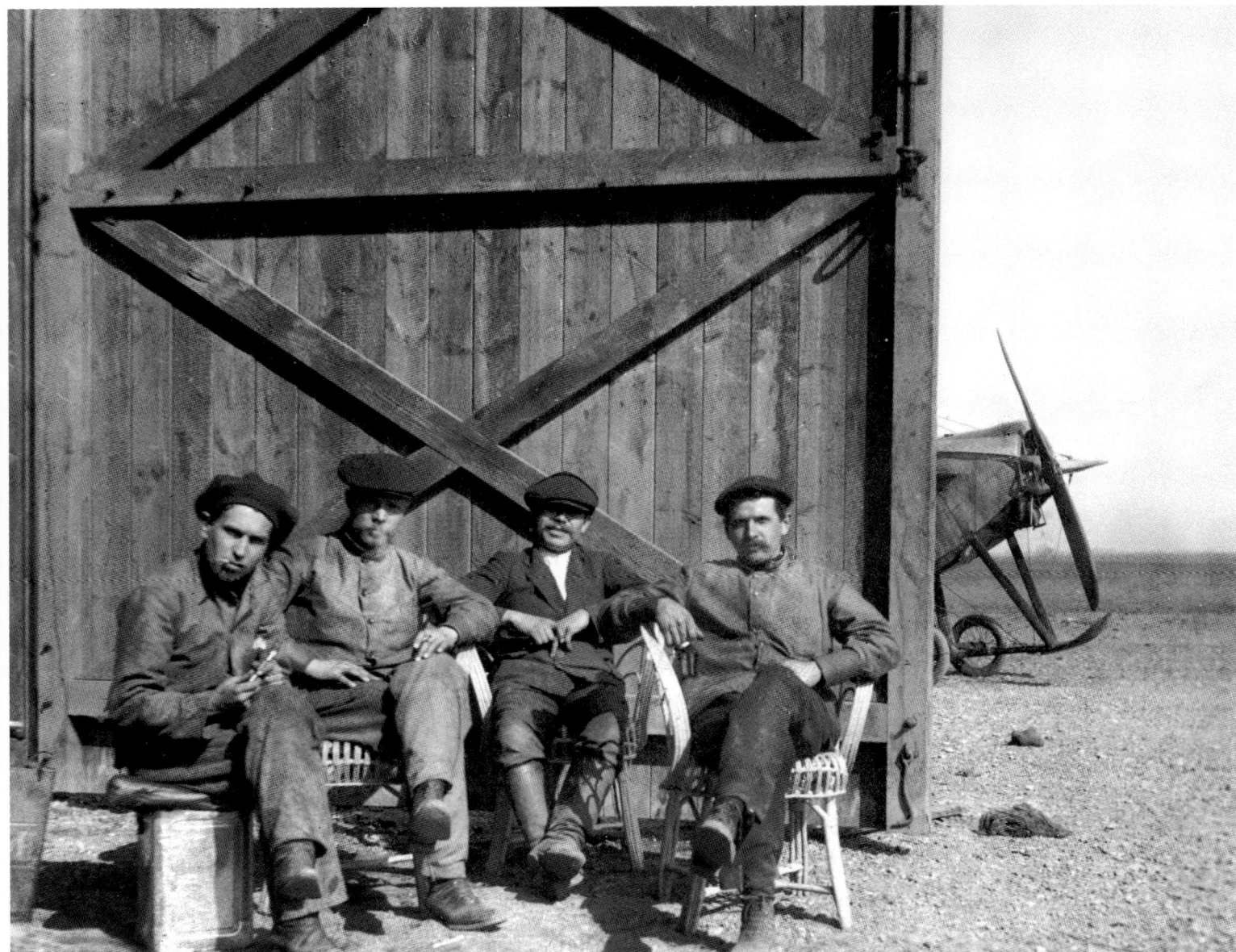

349.Graduates of the Kachinskyi Aviation School near the plane *Niupor-IV*. **On the far right is Staff Captain A.A. Kuznetsov, second from the left is Lieutenant of the Fifth Grenadier Kiev Regiment Prince V.I. Massalskyi.**
Khodunskyi Field. Moscow. 1914

350. Near the *Niupor-IV* **stand: V.I. Yanchenko (on the left), one of the most successful pilots, and Staff Captain N.A. Gavin, later a head of the Moscow Aviation School.**
Khodunskyi Field. Moscow. 1915

351. Mechanics resting, while planes are in the air.
Khodunskyi Field. Moscow. 1914 — 1917

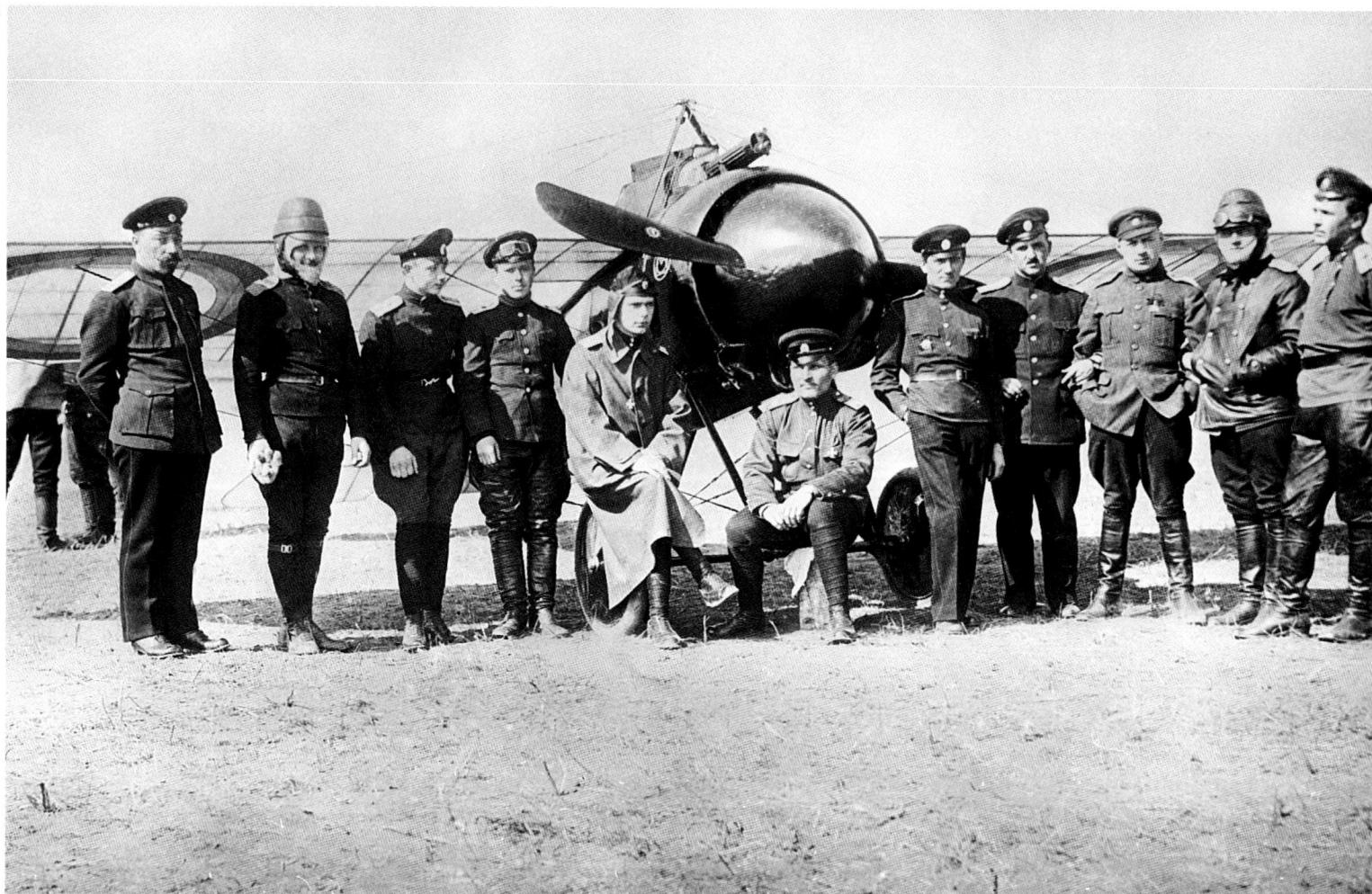

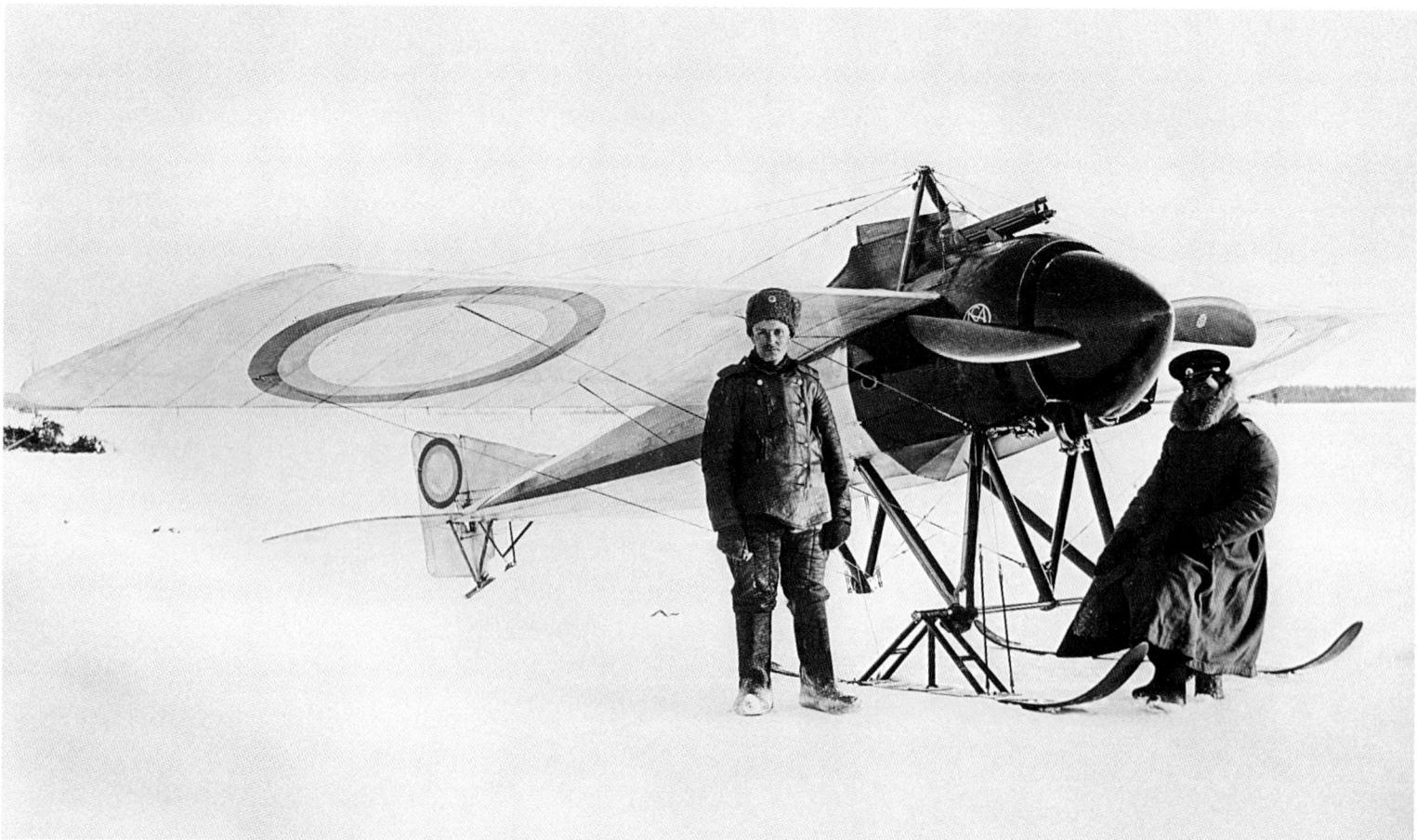

354. Aviators' winter equipment on flights at high altitudes.
The 10th Corpus Airborne Squadron. 1916

352. Aviators of the 1st Fighting Airborne Squadron near the plane *Moran-Monokok*. **Commander of the Squadron Captain K.K. Vakulovskyi sits at the wheel.**
1917

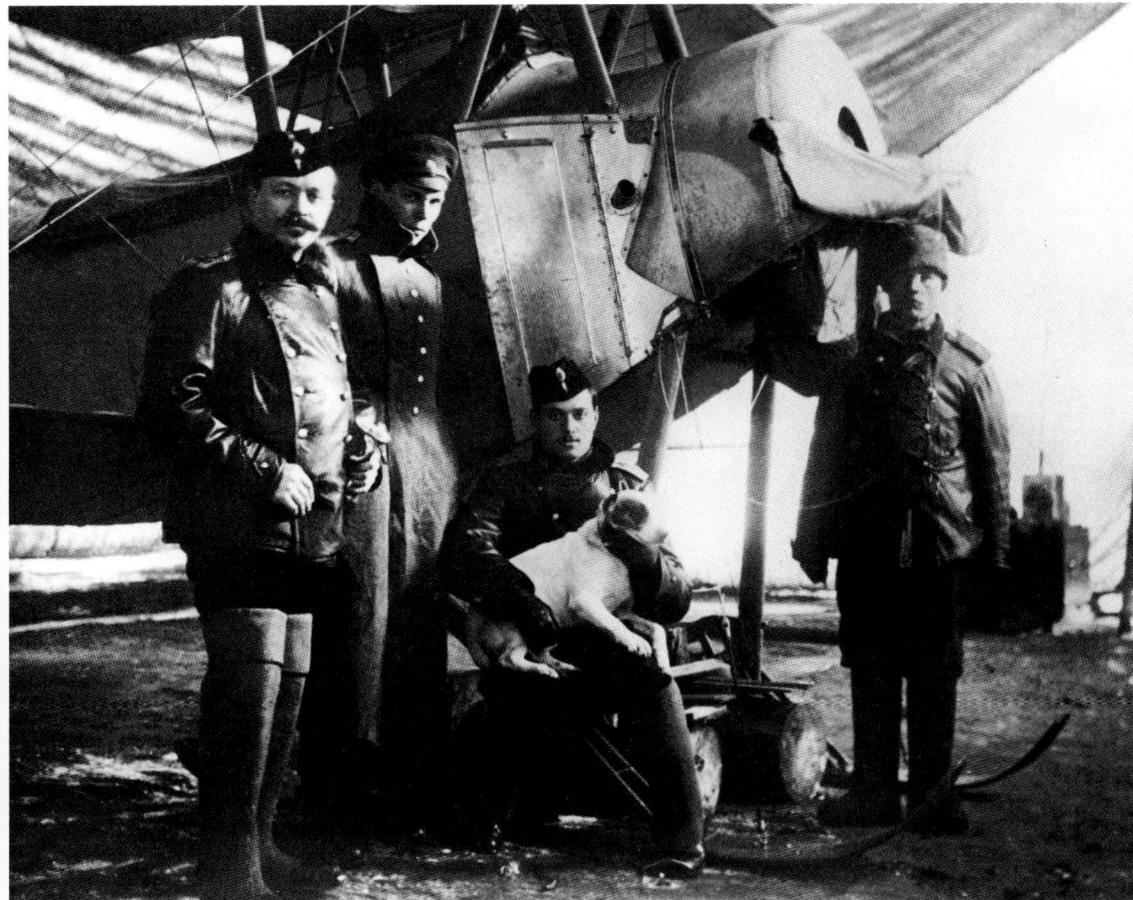

353. The plane *Moran-Monokok*, **or Mormon, with ski gear.**
The 1st Fighter Airborne Squadron. 1917

355. A pilot and aviator-observer in full equipment for a reconnaissance flight in the two-seater plane *Niupor-IV*.
1915 — 1916

356. Next to the plane *Niupor-X*. **From left to right: Second Lieutenant N. Buikov, D.A. Makienok, Cornet I.V. Gilsher, and a mechanic.**
7th Fighter Airborne Squadron. Galitsia. December 1916

357

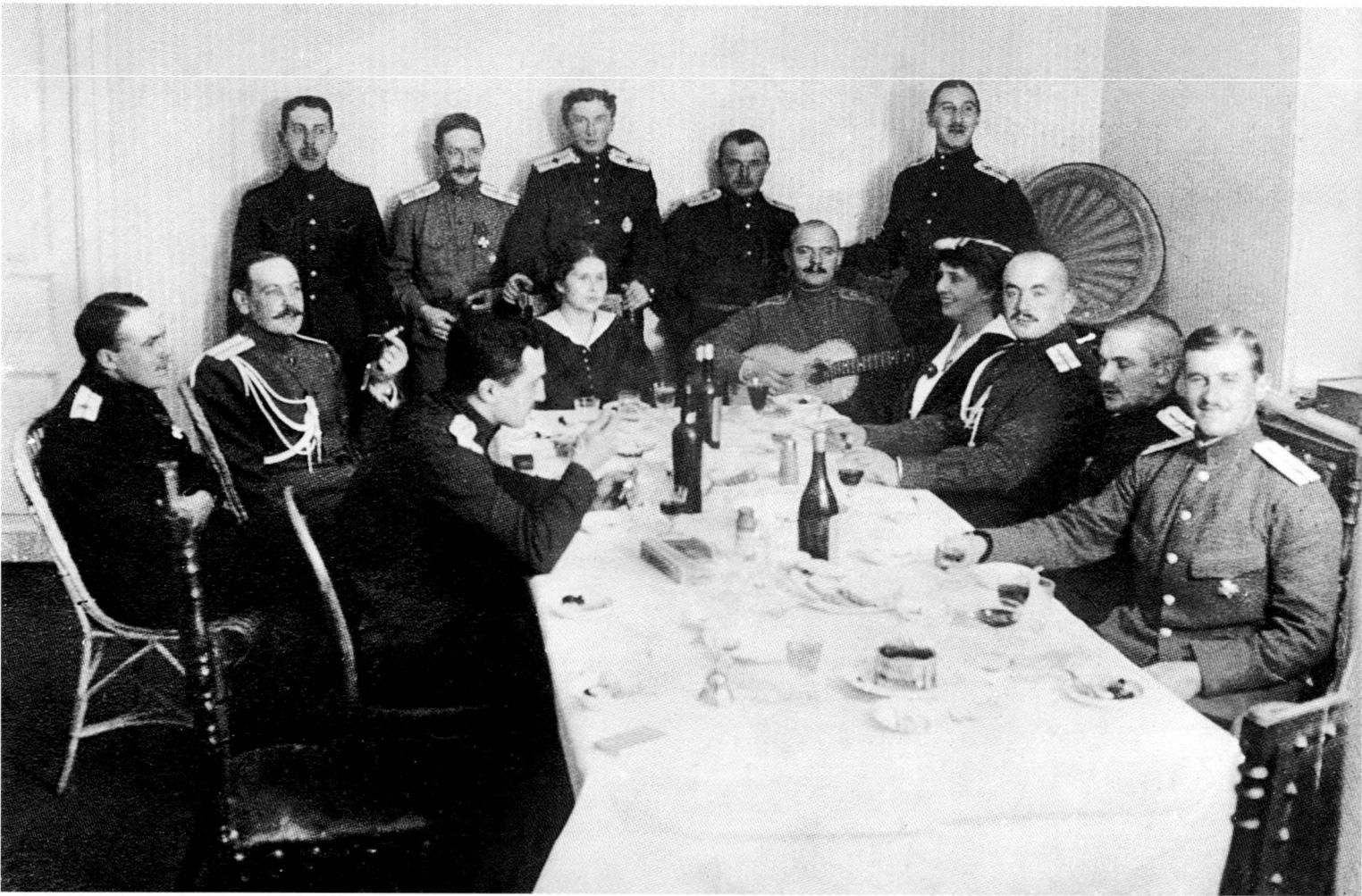

358

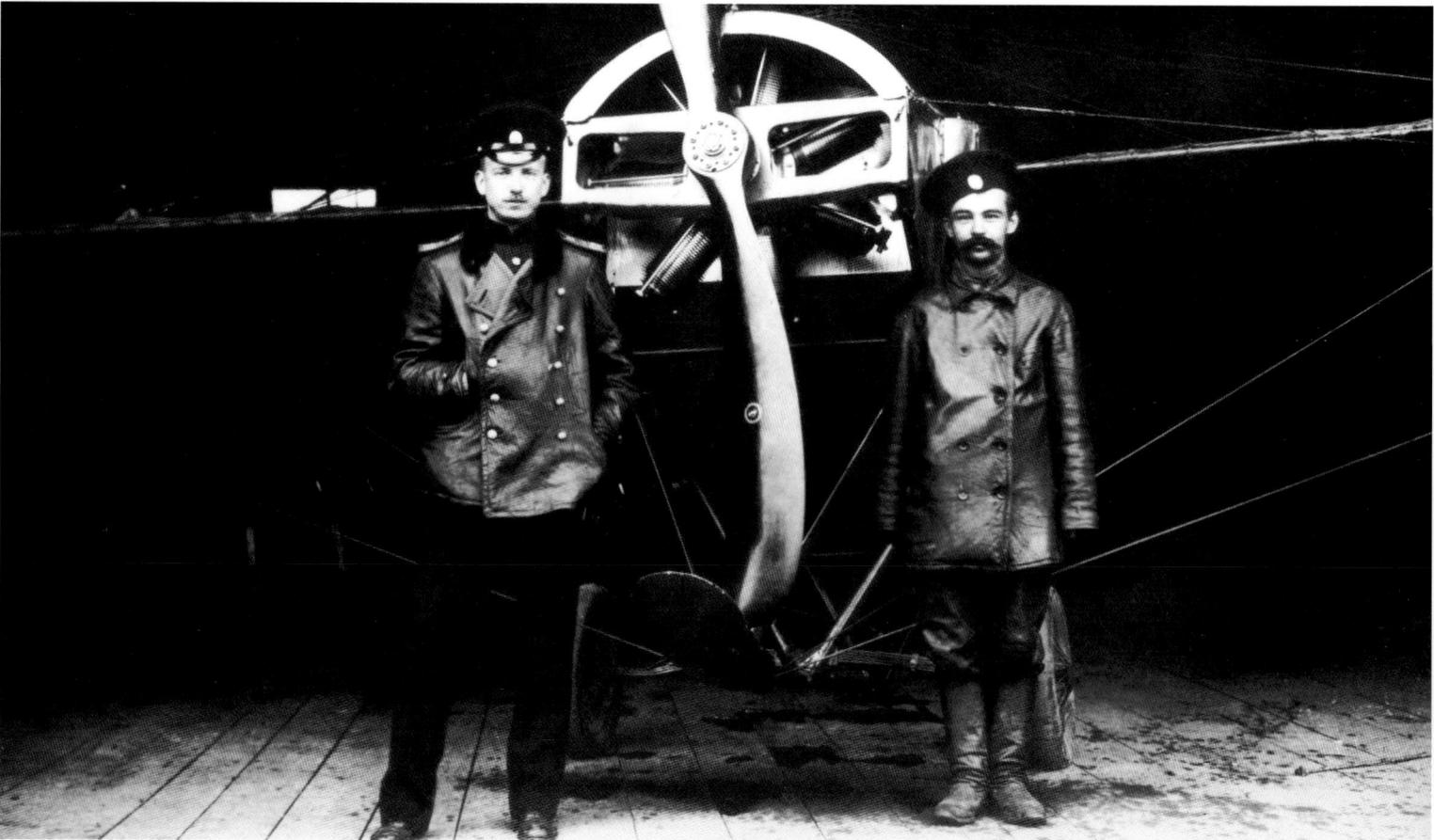

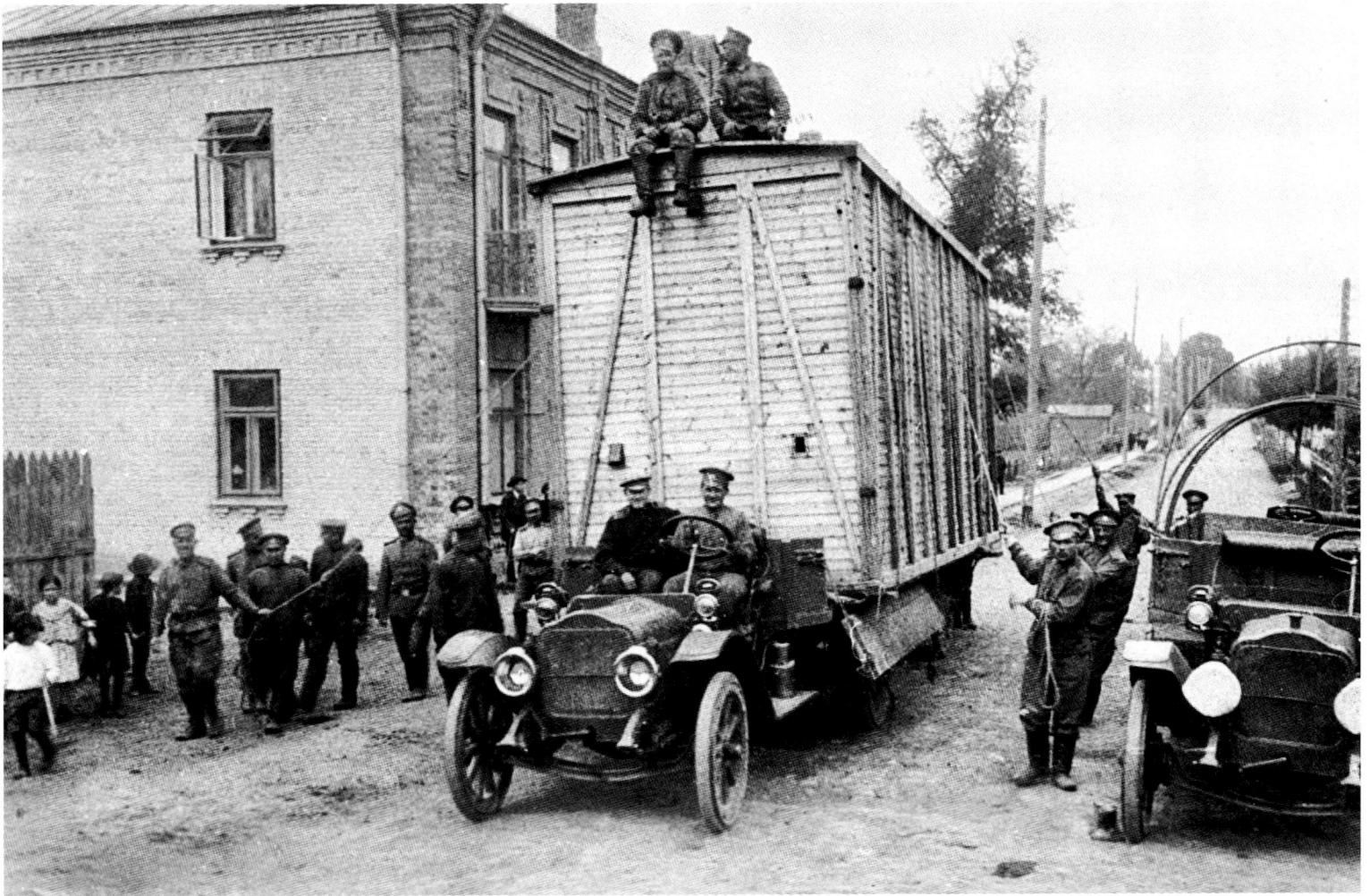

357. Aviators at a holiday feast. Left from right (around the table) sit: aviators Zmunchilo, Livotov, Lieutenant Ellis, Madam Medel, Ilin, Madam Ilina, "Ace" Ilin, Petrov, Verminskyi, Medel, Ravenskyi, Vishnyakov, Popov.

Southwestern Front. 1914—1915

Thanks to aviator Ravenskyi, many valuable photographs were saved.

358. P.N. Nesterov with mechanic G.M. Nelidovyi near the plane *Niupor-IV.*

Summer 1914

359. Delivery of a plane at a railway station.

Corpus Airborne Squadron. Carpathians of the Southwestern Front. 1916

The Farman-XVI was sent to the airfield in such containers, where they were used by aviation technicians as warehouse/workshops/housing.

360. Pyotr Nikolaevich Nesterov in ceremonial dress before a parade.

1914

360

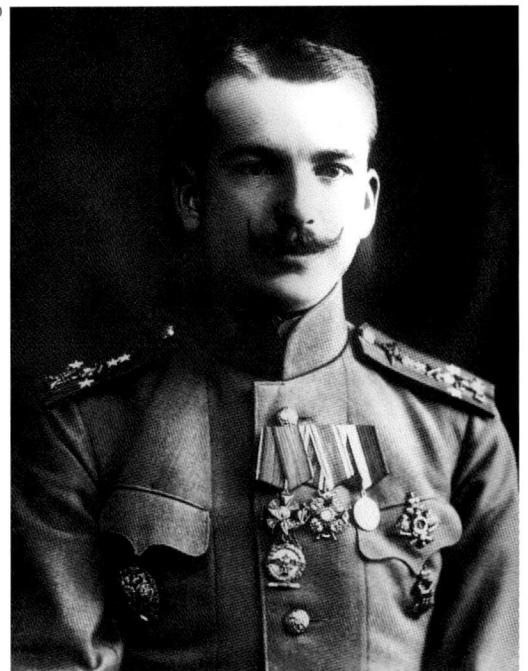

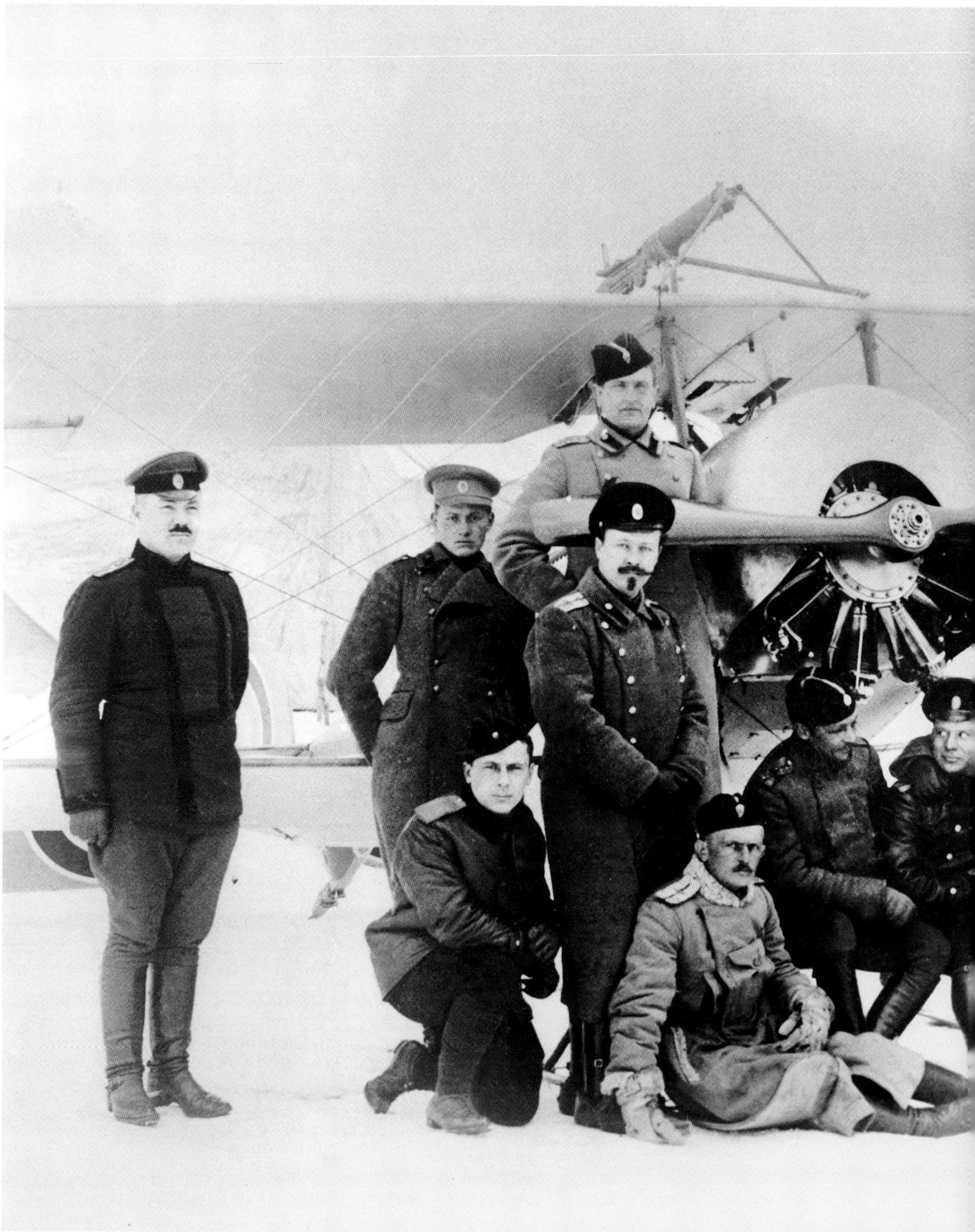

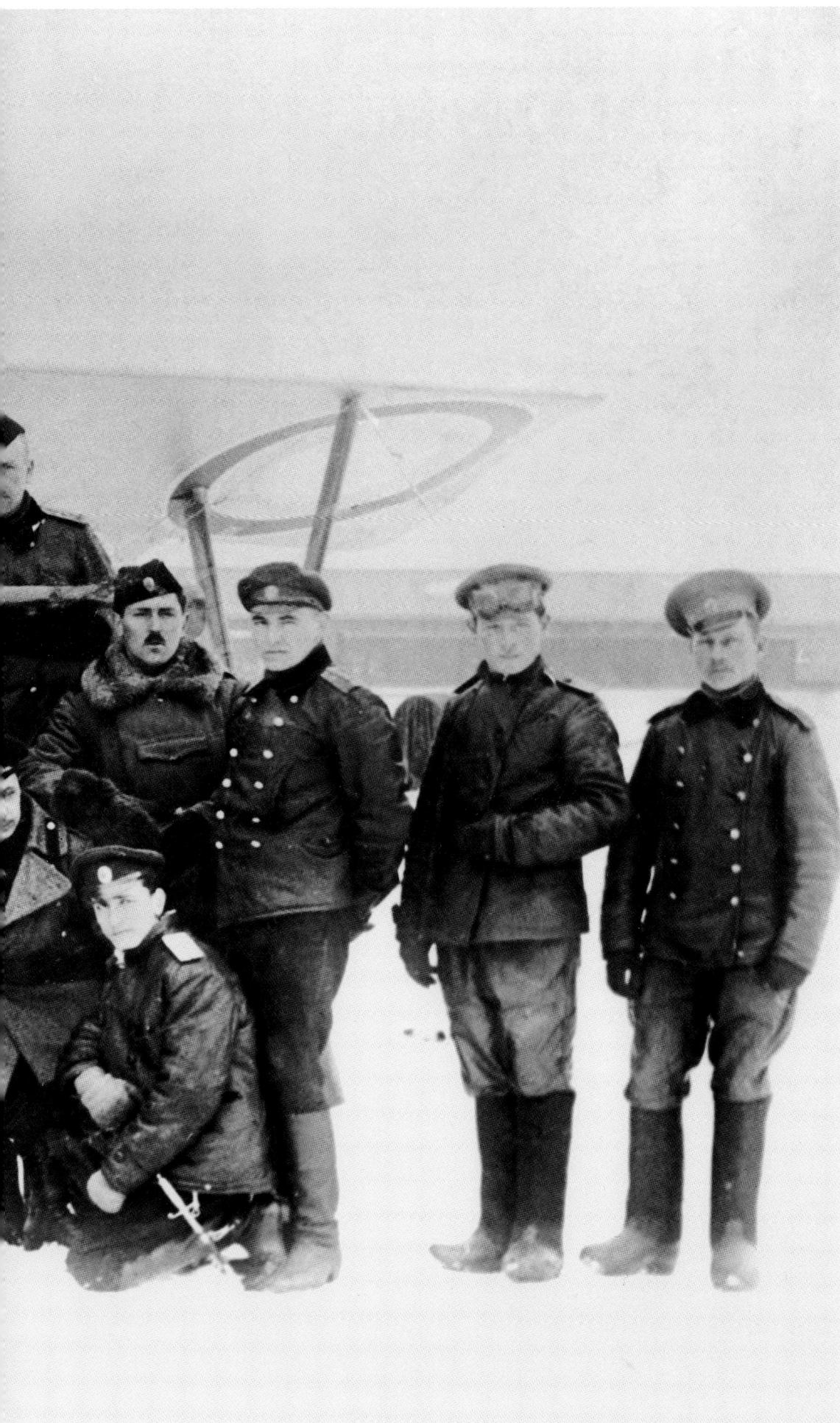

365. Aviators next to the plane *Niupor-XI*. Near the front end is the future aviation constructor K.A. Kalinin fifth (from the right), and in front of the propeller is I.I. Petrozhitskyi (third from the left).
26th Corpus Airborne Squadron. 1916—1917

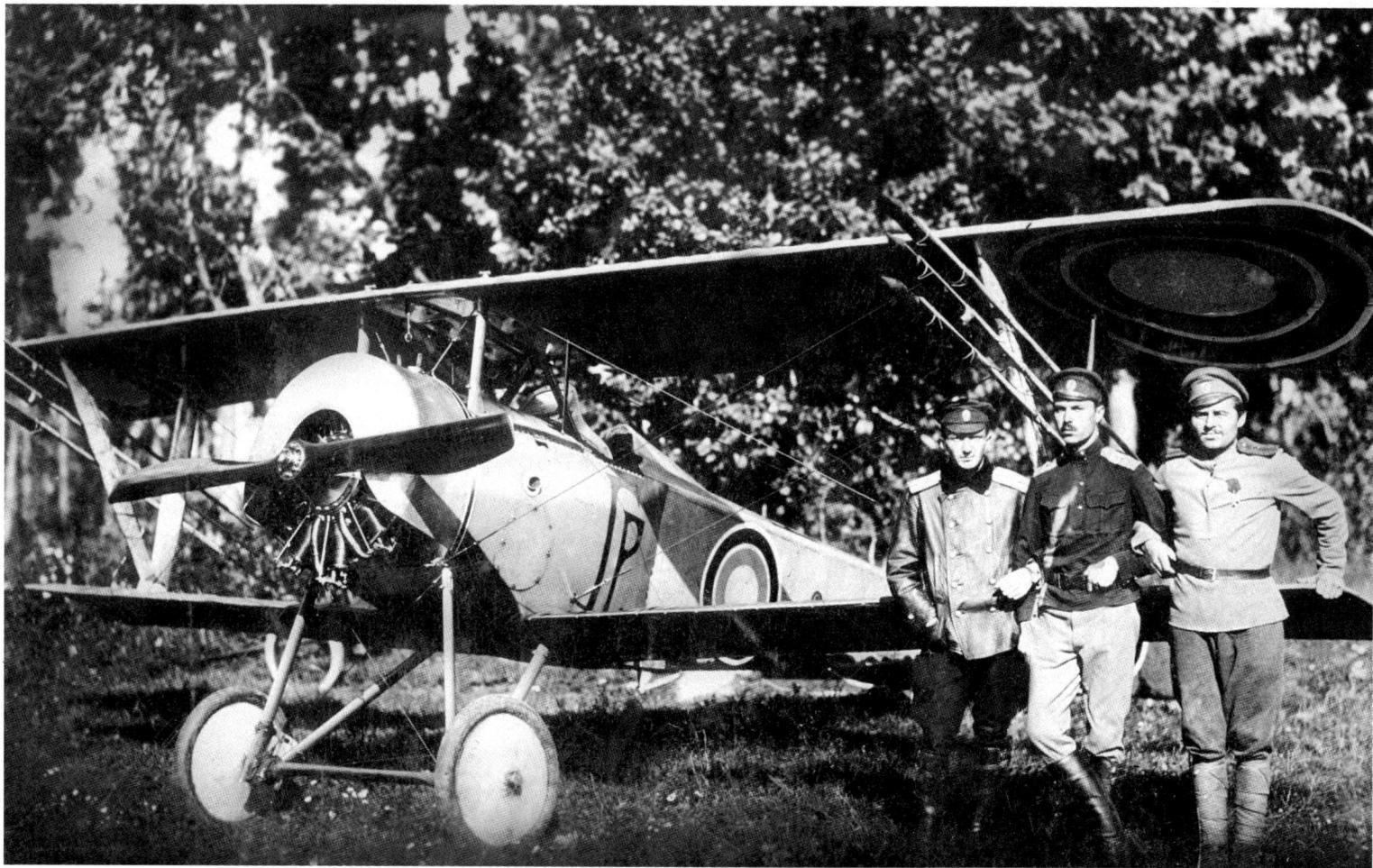

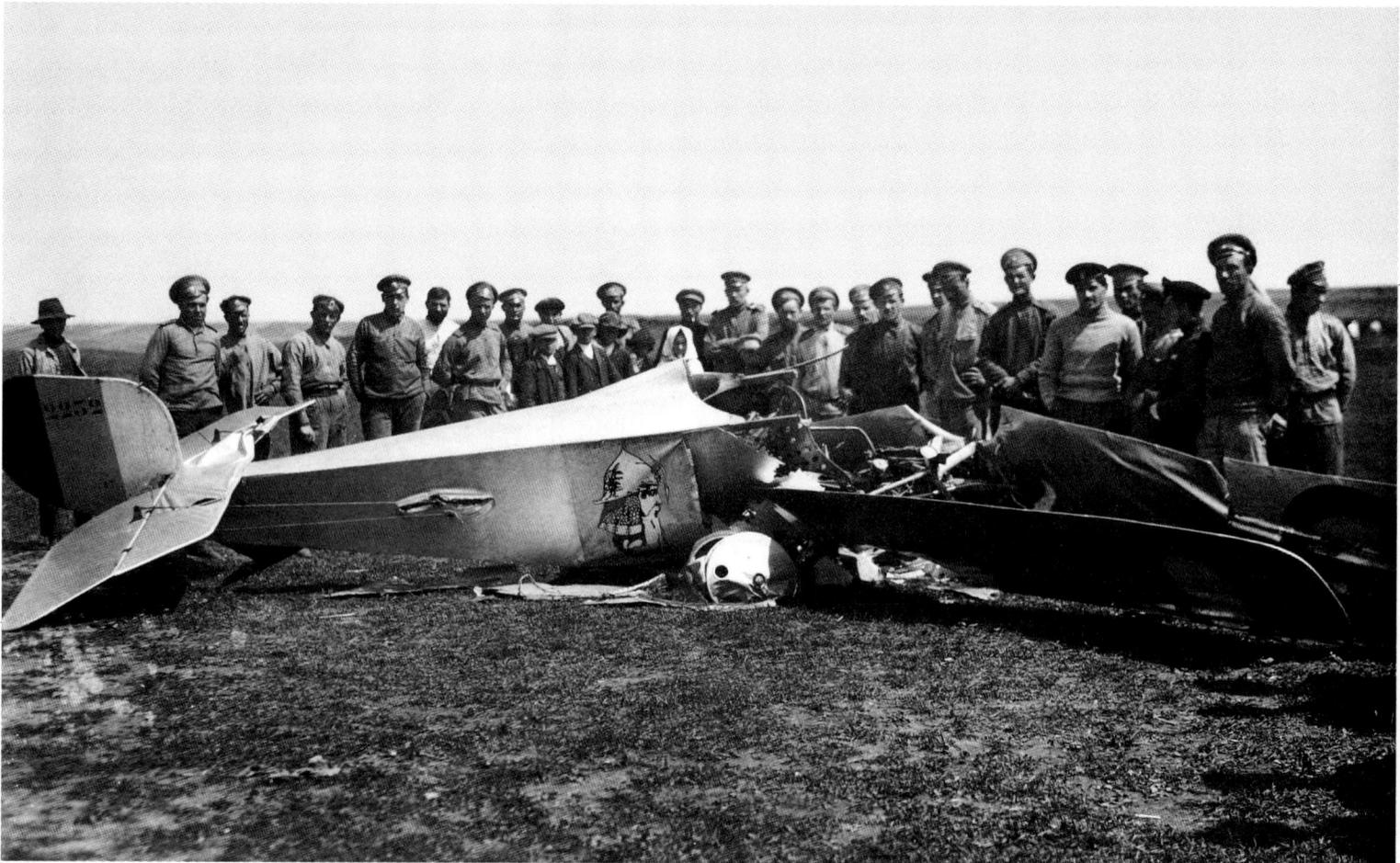

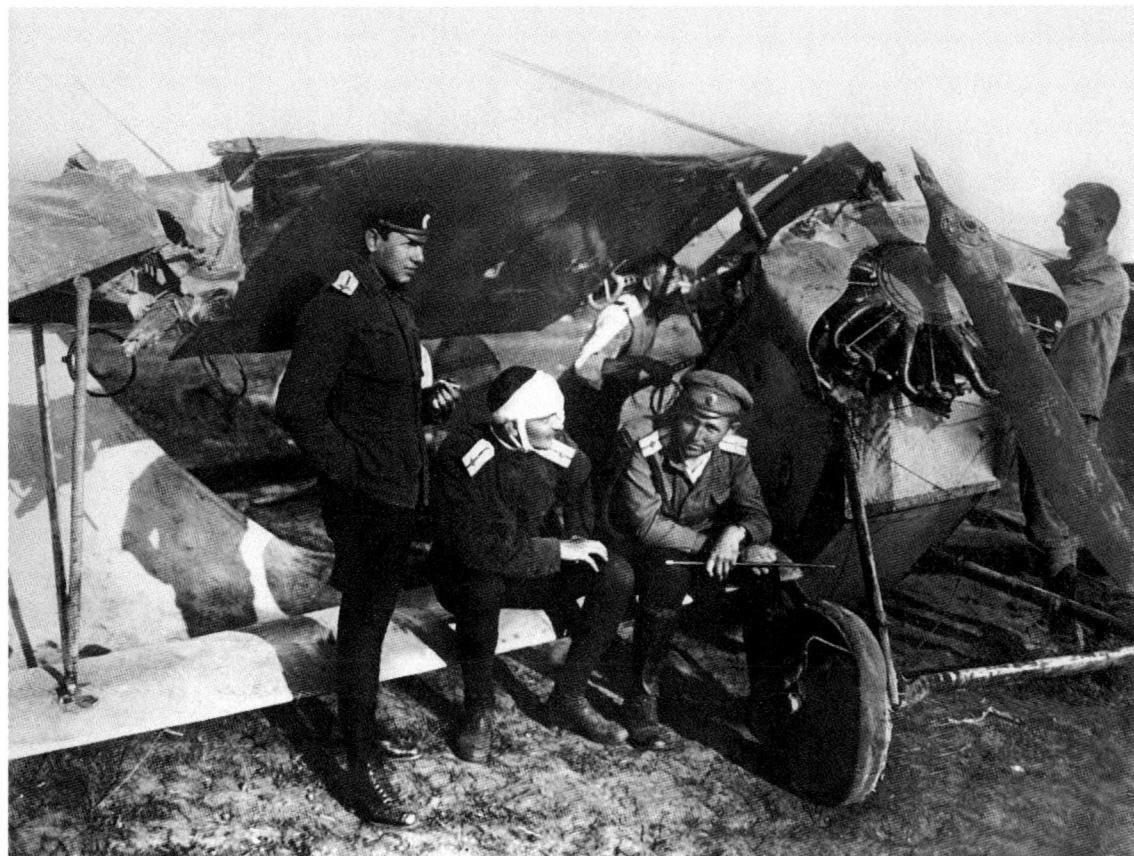

366. Pilots Ensign A.V. Kvasnikov and V.V. Kamenskyi near the fighter _Niupor-XXI_, armed with Le Prier steam rockets.

1916 — 1917

The letters "GR" on the body signify that the plane belonged to the Grenadiers Airborne Squadron.

367. Commander of the Second Battle Aviation Group Evgraf Nikolaevich Kruten, wounded in an air battle after a crash landing.

Near Zborov. June 16, 1917

The pilot was awarded the rank of Lieutenant Colonel and the Order of St. George, 3rd class, posthumously. He was buried in Kiev in the cemetery of the Vuidubetskyi Monastery.

368. Pilots discuss an unsuccessful landing of the plane _Niupor-XXI_. A.M. Shaternikov sits at the wheel.

Fourth Fighter Airborne Squadron. 1916 — 1917

369. One of the most beautiful Niupors in Russian aviation. The personal emblem of Ensign Kibasov of the Third fighting Aviation Group of the 22nd Corpus Airborne Squadron is on the body.

1916 — 1917

At the final stages of the war, pilots frequently drew their own emblems on their planes.

369

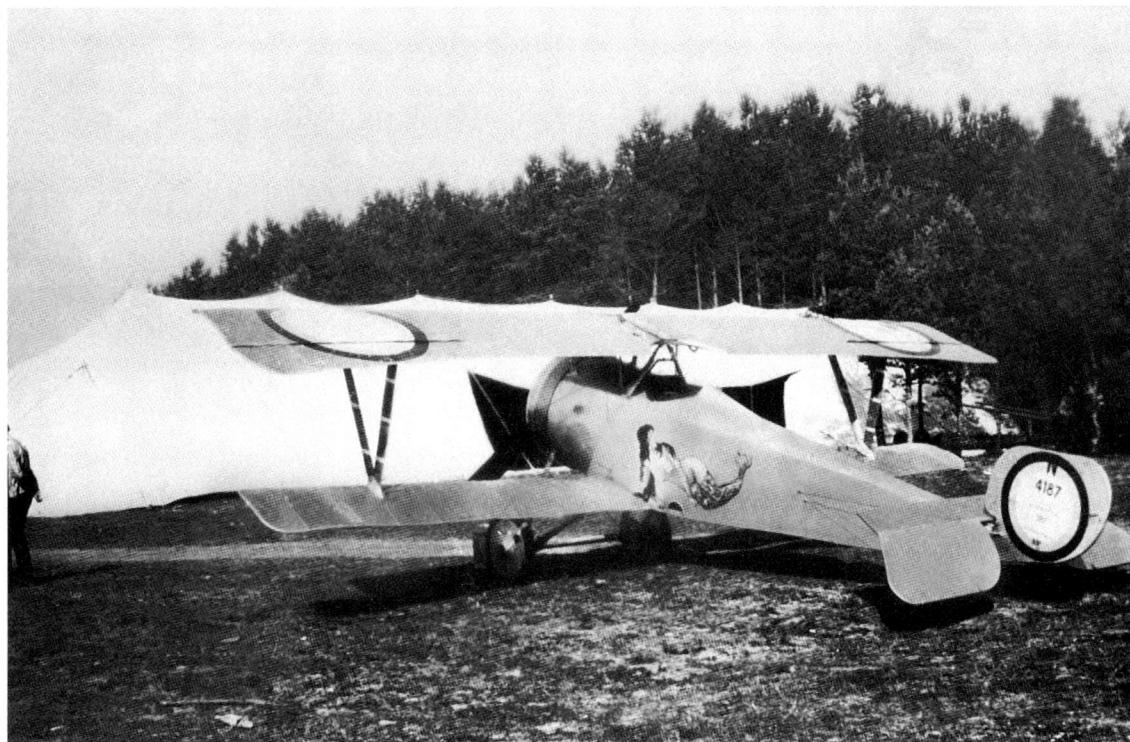

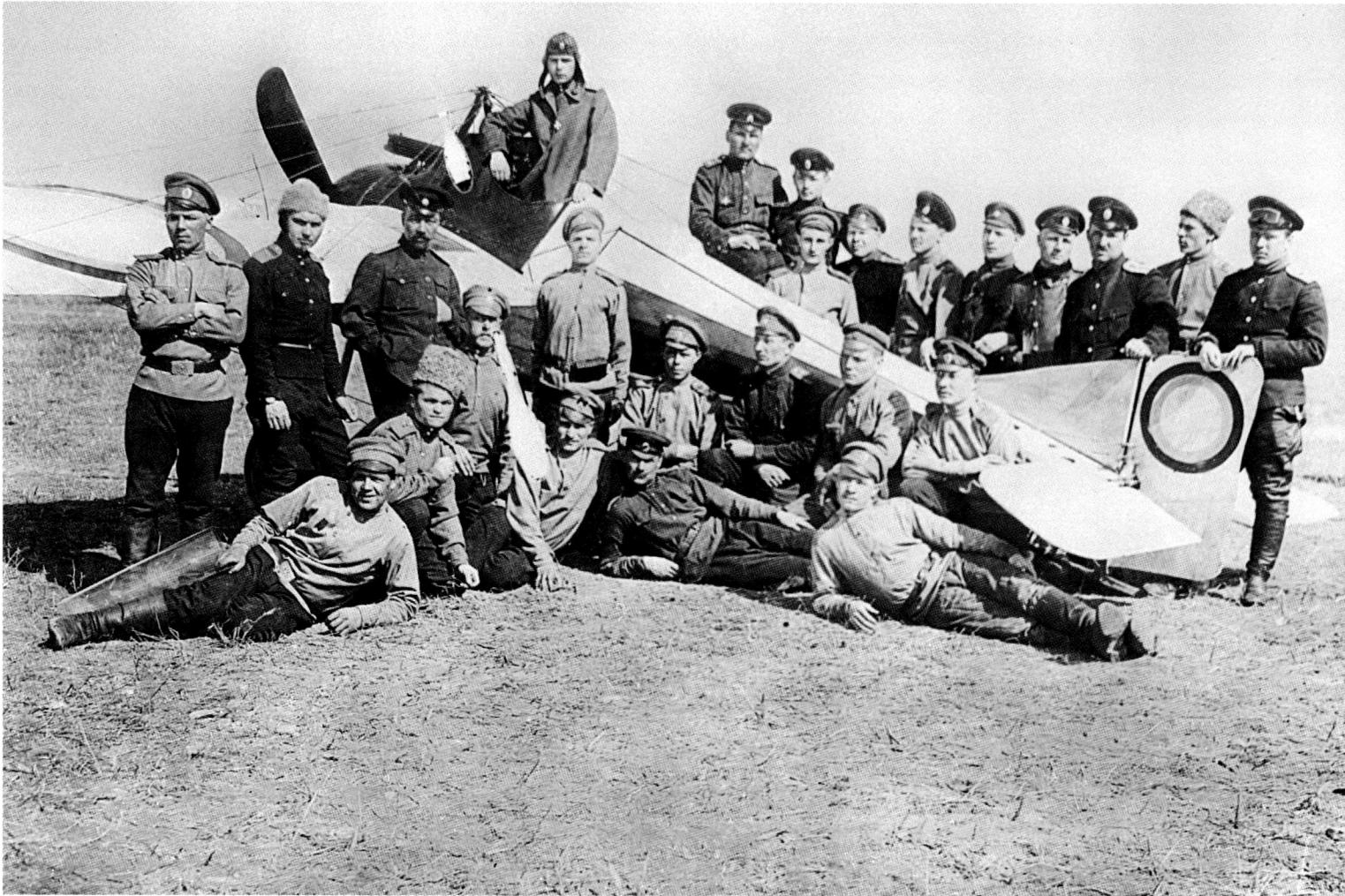

**370. Pilots and mechanics near
the plane Moran-Monokok. In the
plane (standing) is a commander
of an airborne squadron
Captain K.K. Vakulovskyi.**
First Fighter Airborne Squadron.
1915—1916

371. *Niupor* **fighters.
Two** *Moran-Monokok* **planes
are in the background.**
Airfield of the 4th Airborne squadron, of the
first Army Aviation group. Petrograd. 1917

*After the February Revolution, a few
planes of the airborne squadron of
fighters had the emblem of a white six-
pointed star (the symbol of victorious
democracy).*

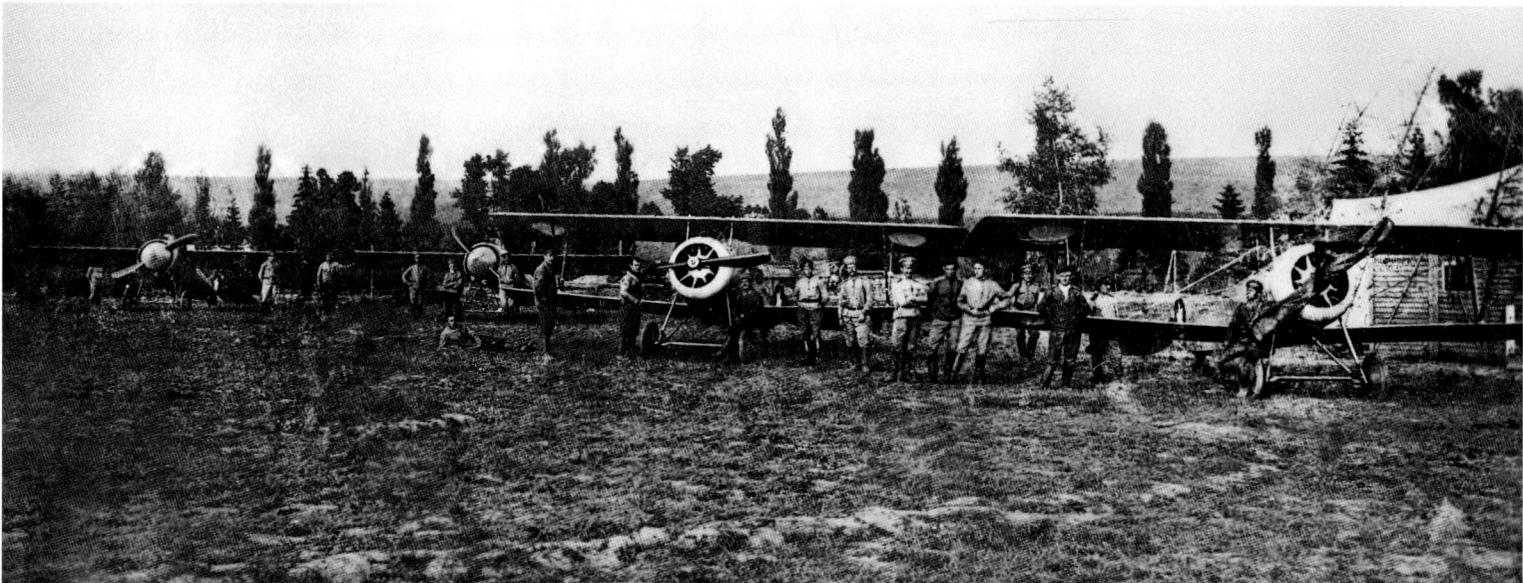

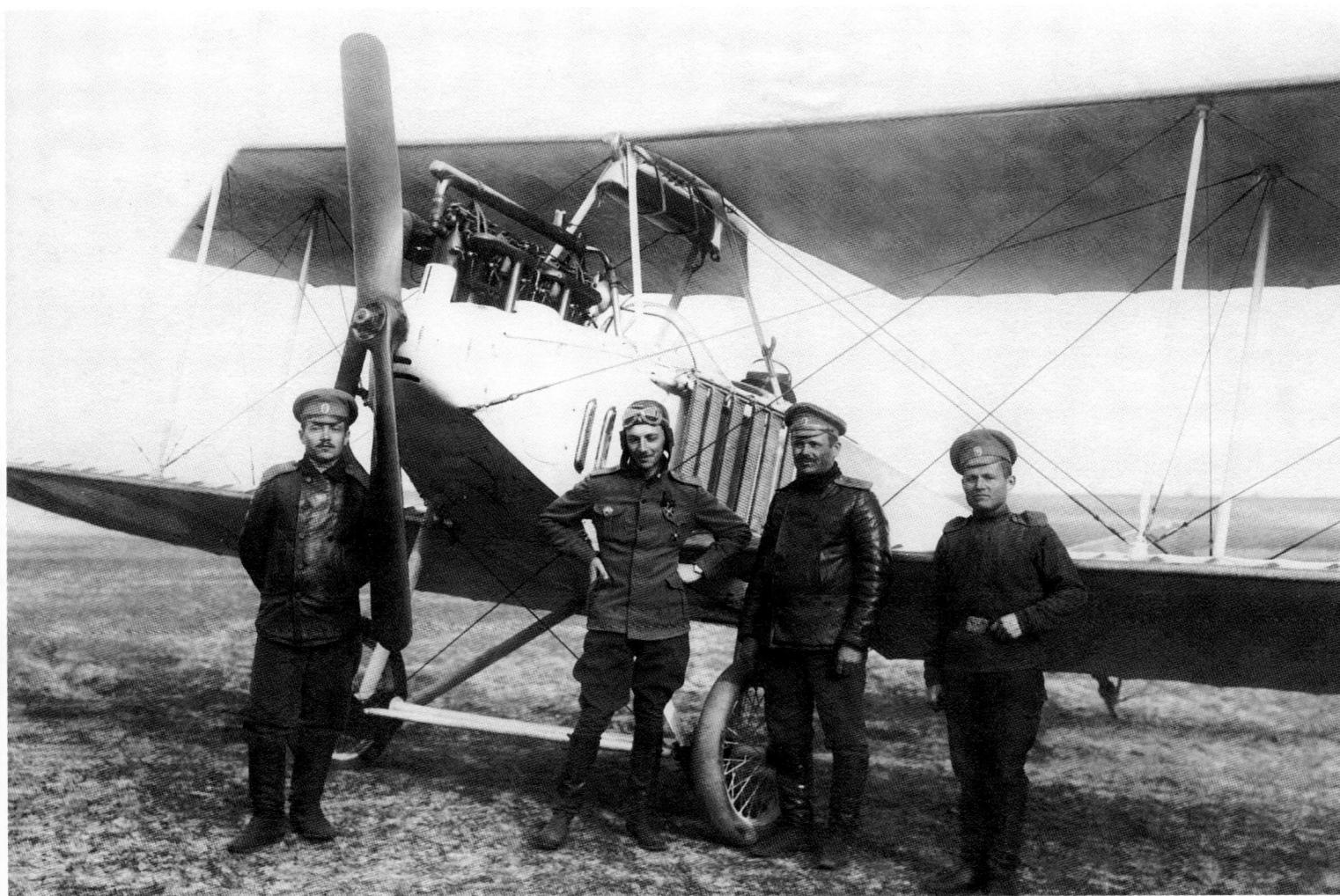

372. Ensign of the 18th Corpus Airborne Squadron K.A. Artseulov near the trophy *Albatross S-I.*

Spring 1916

373. Shot-down German *Aviatik Ts-I.*
1916
Russian pilots repaired the enemy's aviation technology and continued to fight in them.

374. The fighter *Niupor-XVII* **taking off (the pilot is Senior Non-Commissioned Officer P.K.Melnik-Koroliuk of the 8th Corpus Airborne Squadron) with an emblem of unification on the body - an ace of hearts.**
Plotuich under Tarnopol Airfield of the 2nd Army Aviation Group. 1917

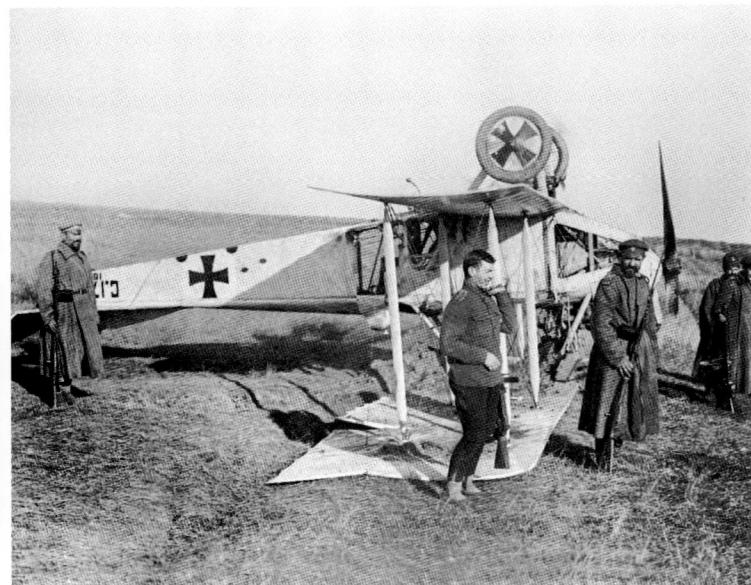

374

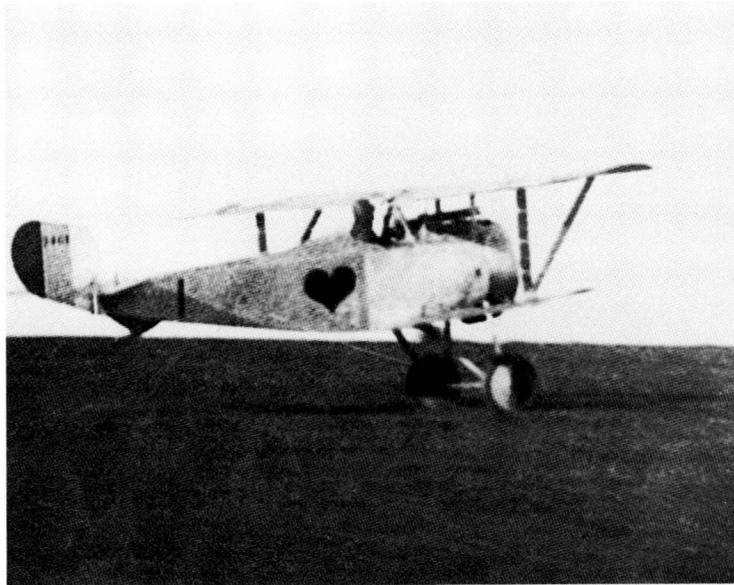

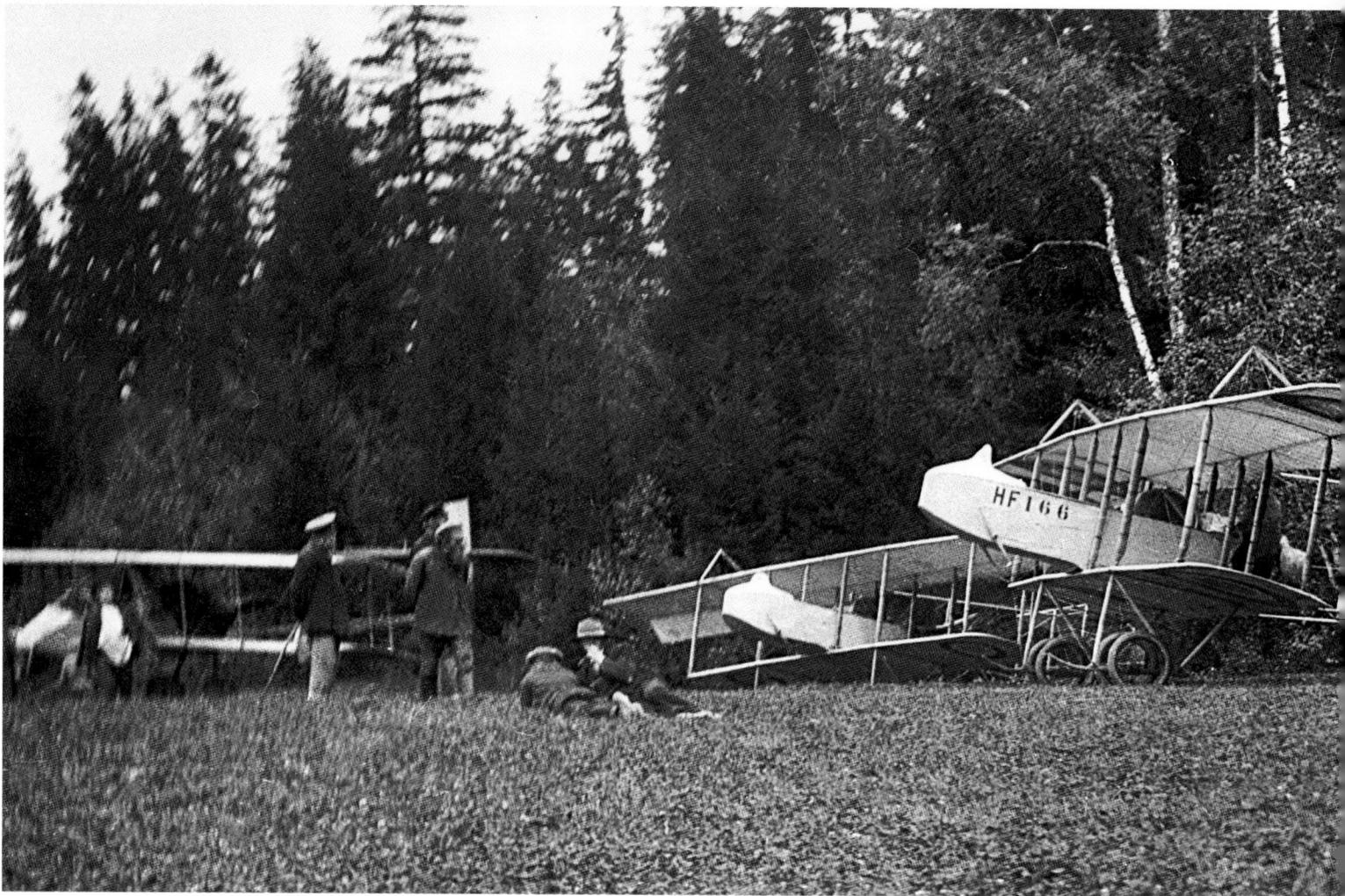

375. Panorama of an airfield. Western Front.

10th Corps Airborne Squadron. Galitsia. Summer 1916

The Farman-XXII planes were not only for reconnaissance flights; they also had a few small bombs in the cabin.

376. Second Lieutenant K. Krauze's *Niupor-XXIII.*

8th Fighter Airborne Squadron. Summer 1917

The identifying symbol of the squadron was the so-called "skull and cross-bones".

377. The Deperdiusen, one of the most comfortable planes for reconnaissance flights.

Western Front. 1916

Pilots went with aviator-observers, so that staff officers could do reconnaissance of the enemy.

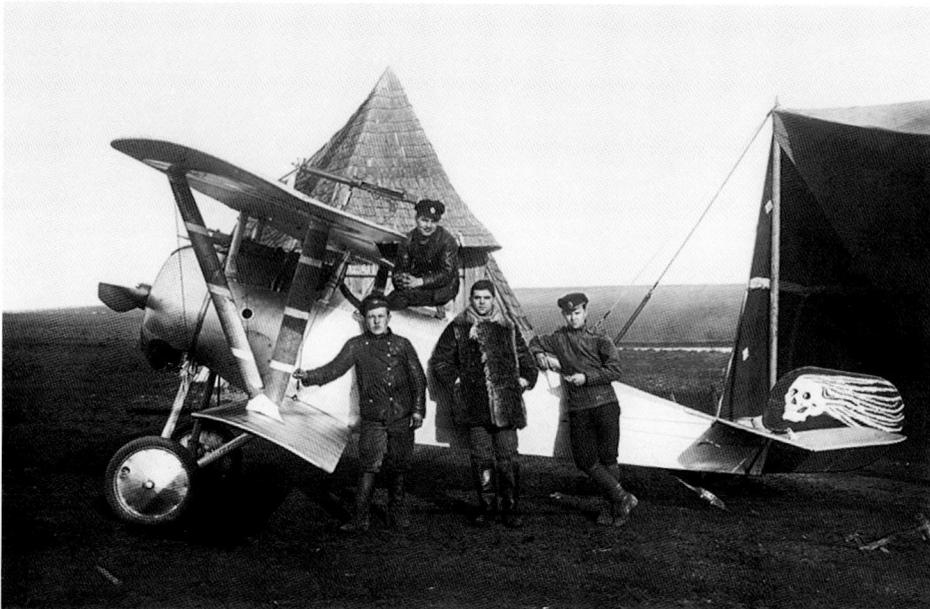

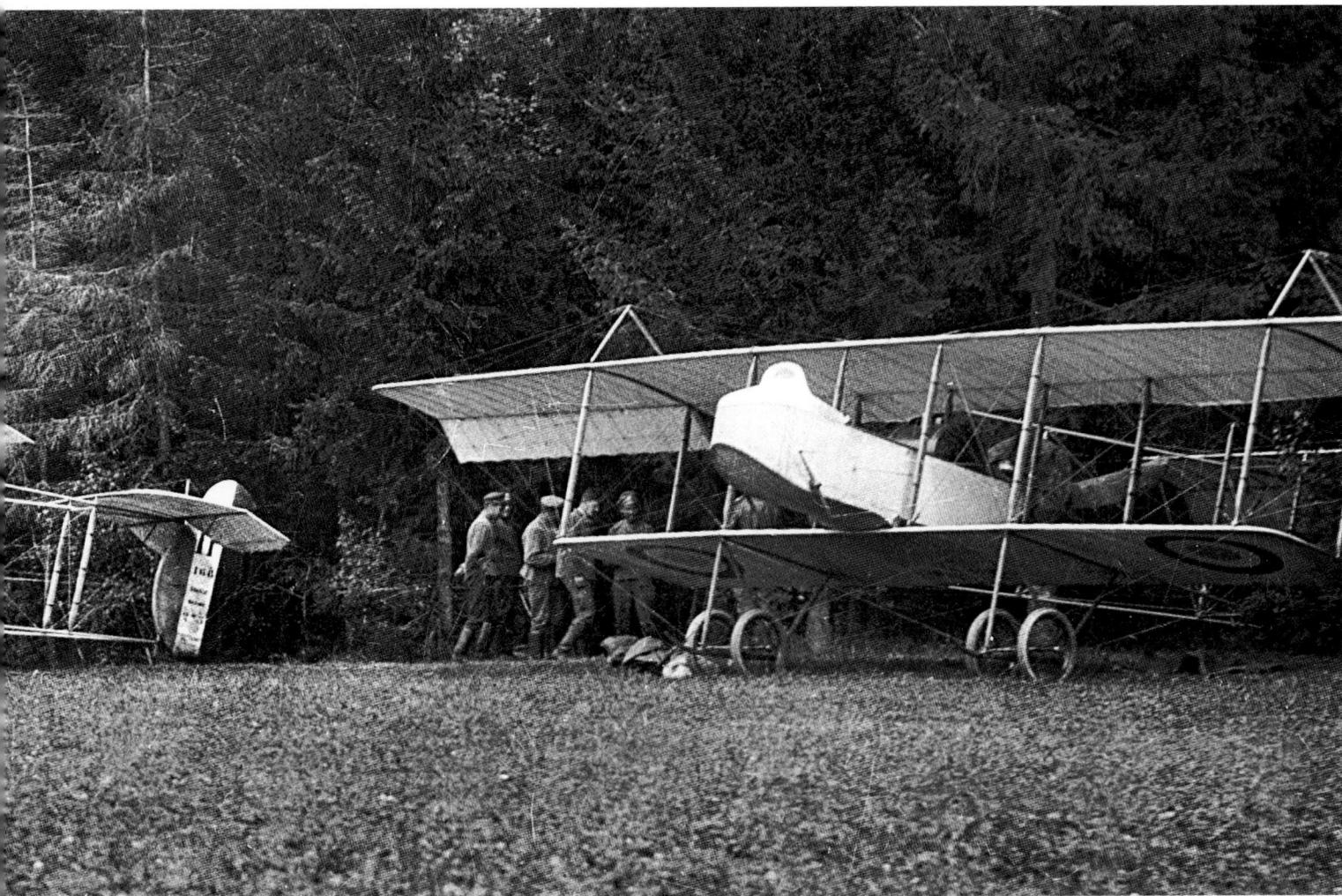

**378. The Deperdiusen
on a reconnaissance flight.**
1916—1917

378

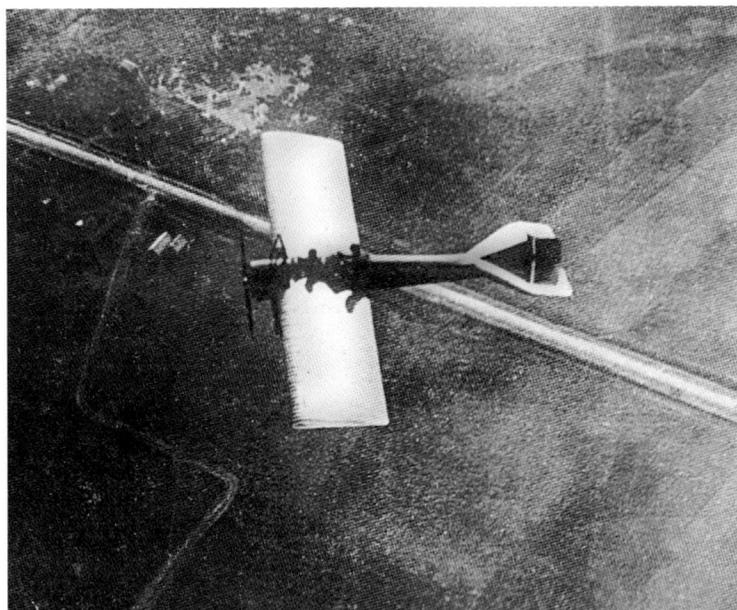

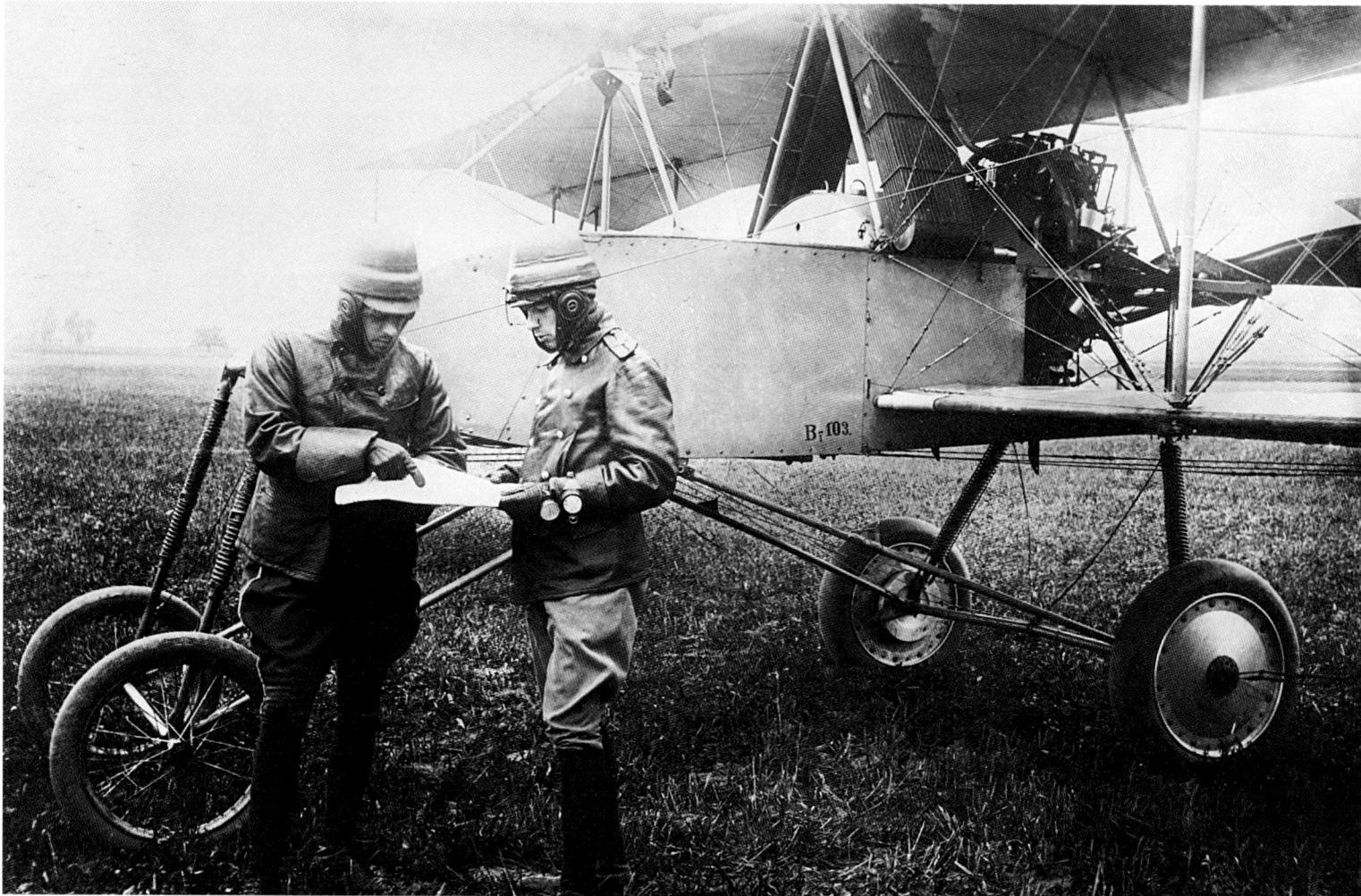

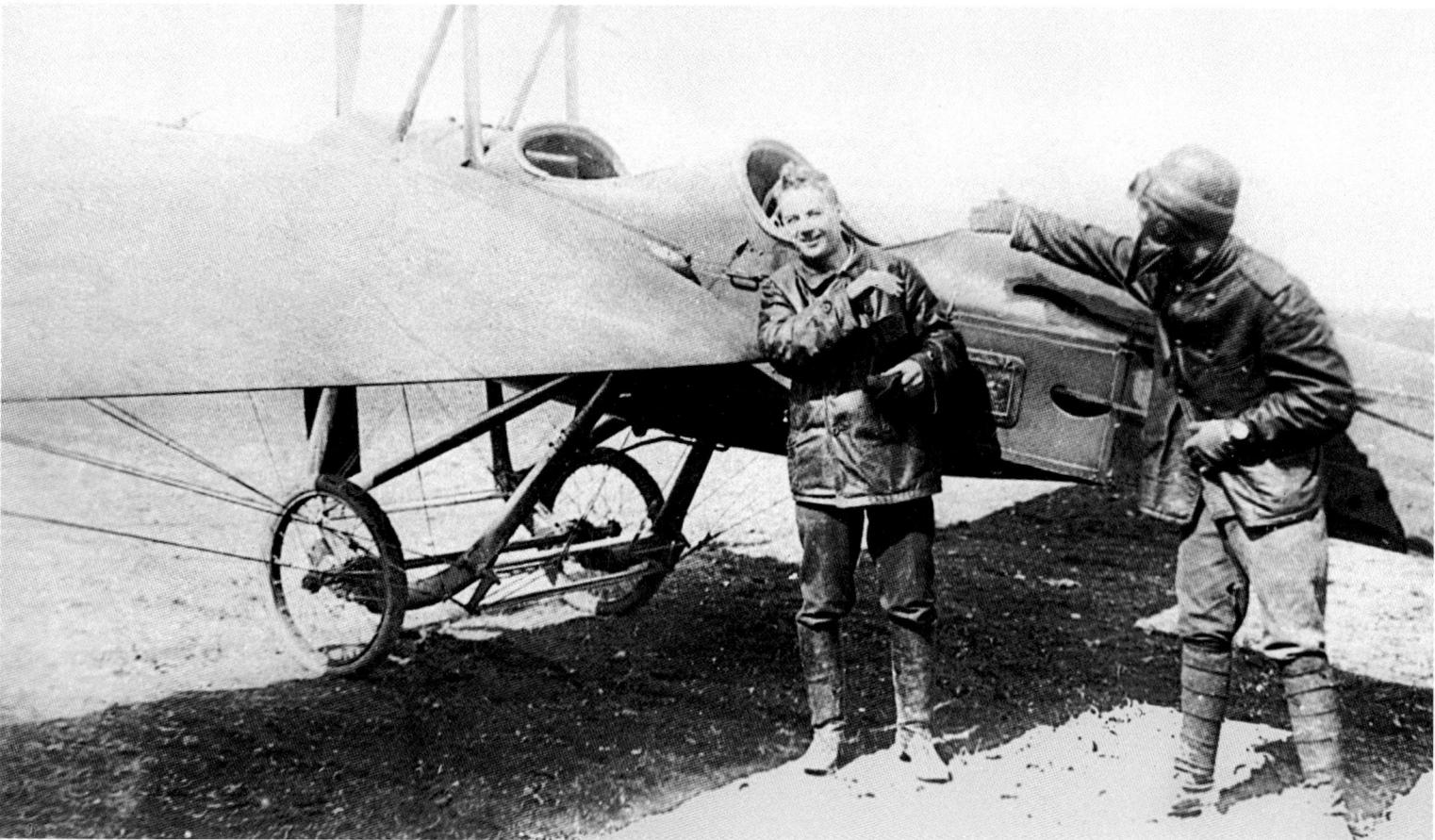

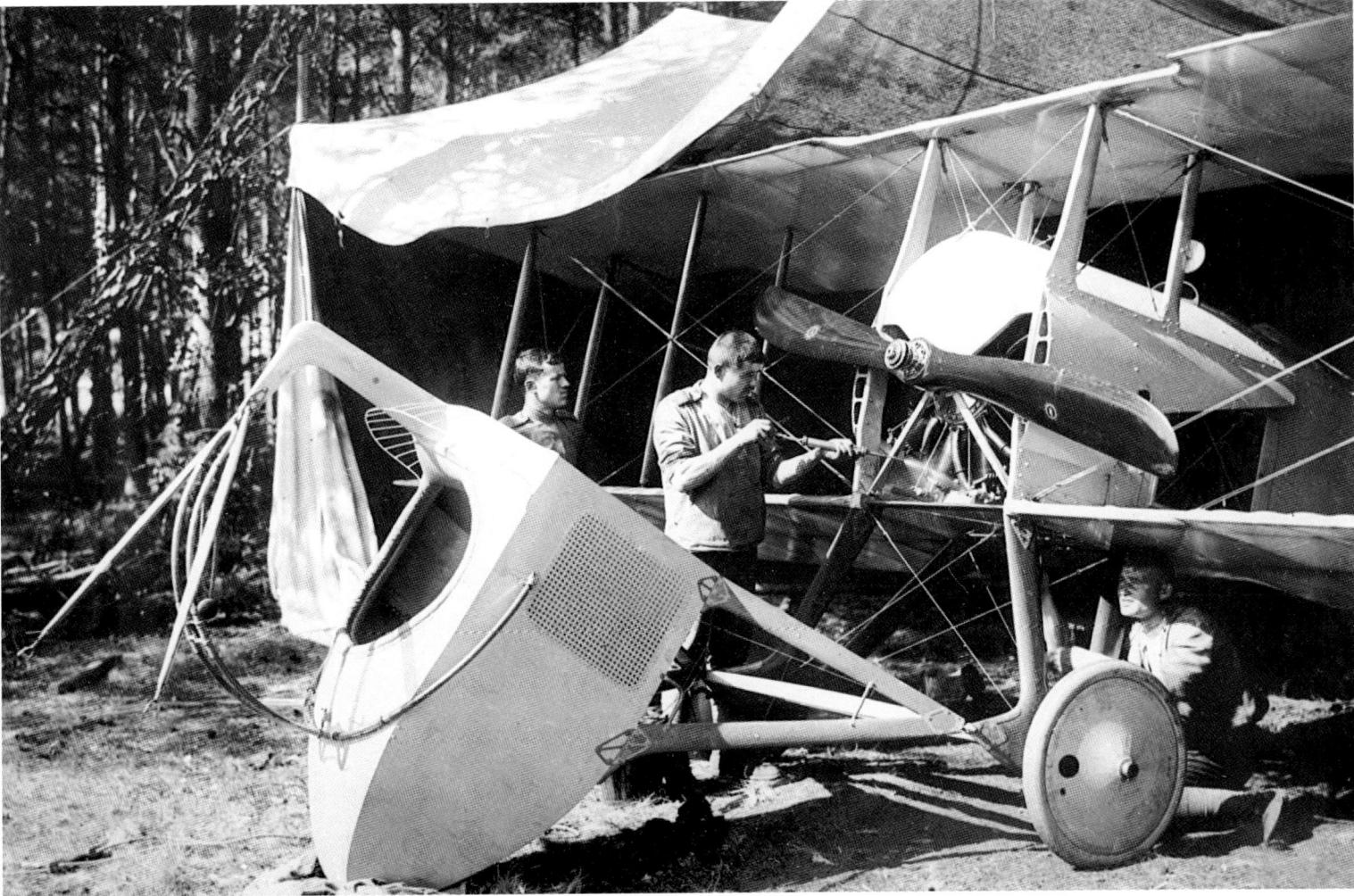

379. Report of a pilot returning on the plane *Vuazen-LA* from a reconnaissance flight.
21st Corpus Airborne Squadron. 1915 — 1916

380. Near the plane *Deperdiusen*. "Can I get a ride?".
Sevastopol Aviation School. 1916

381. The original plane *Spad* with a front cabin by designer Erbemon.
1914 — 1917
There were more than 50 such planes in Russian aviation.

382. The plane *Moran-Parasol-L*.
1917
It also had other names - the Moran-4 or Morchet.

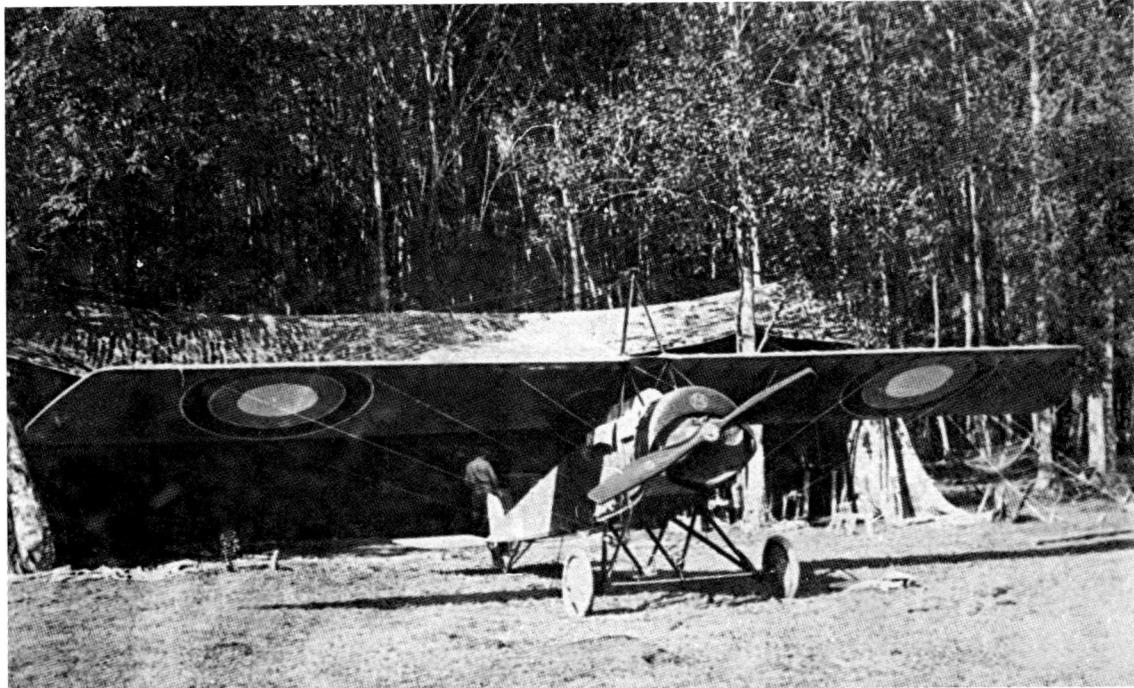

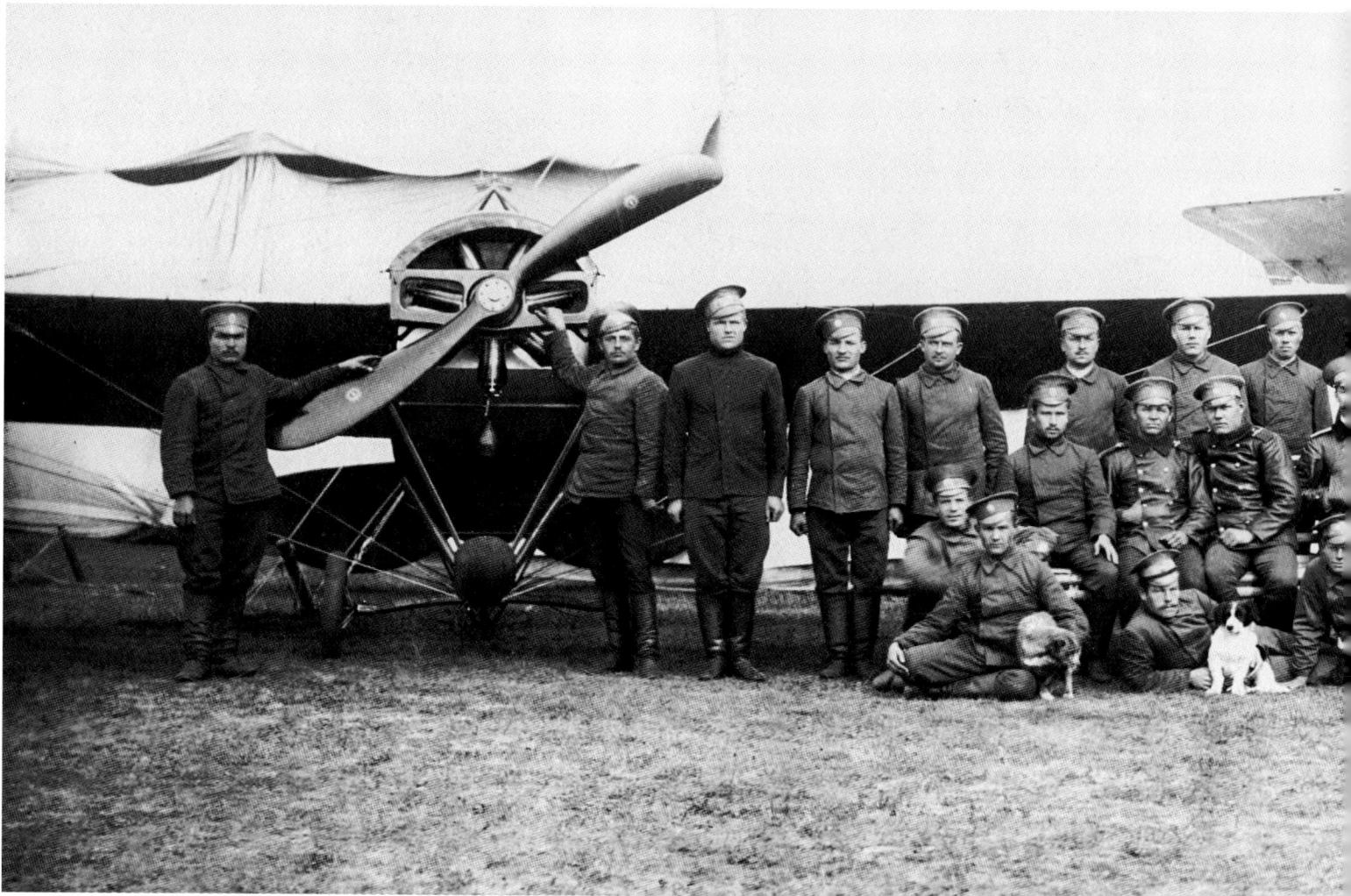

383

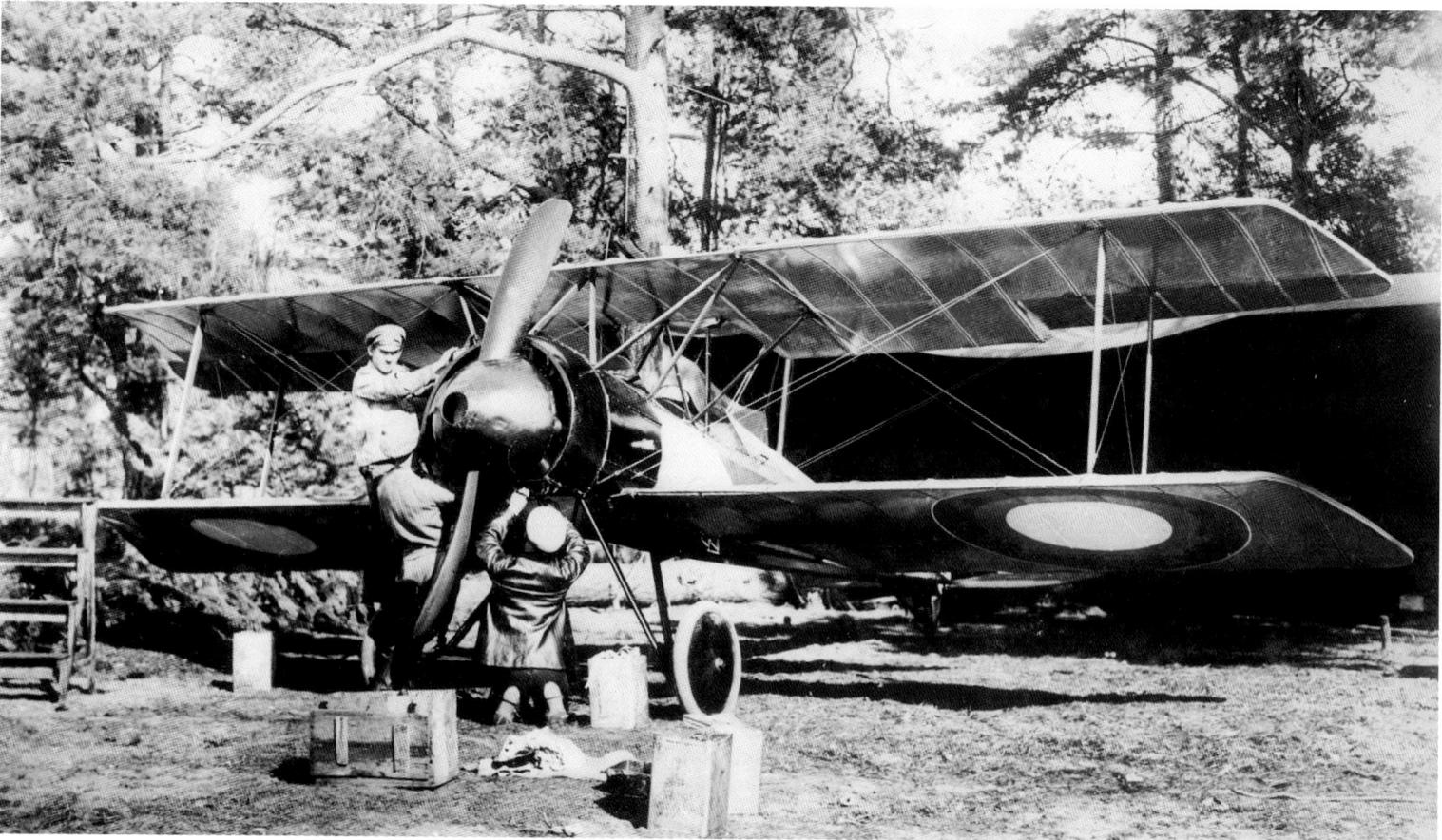

384

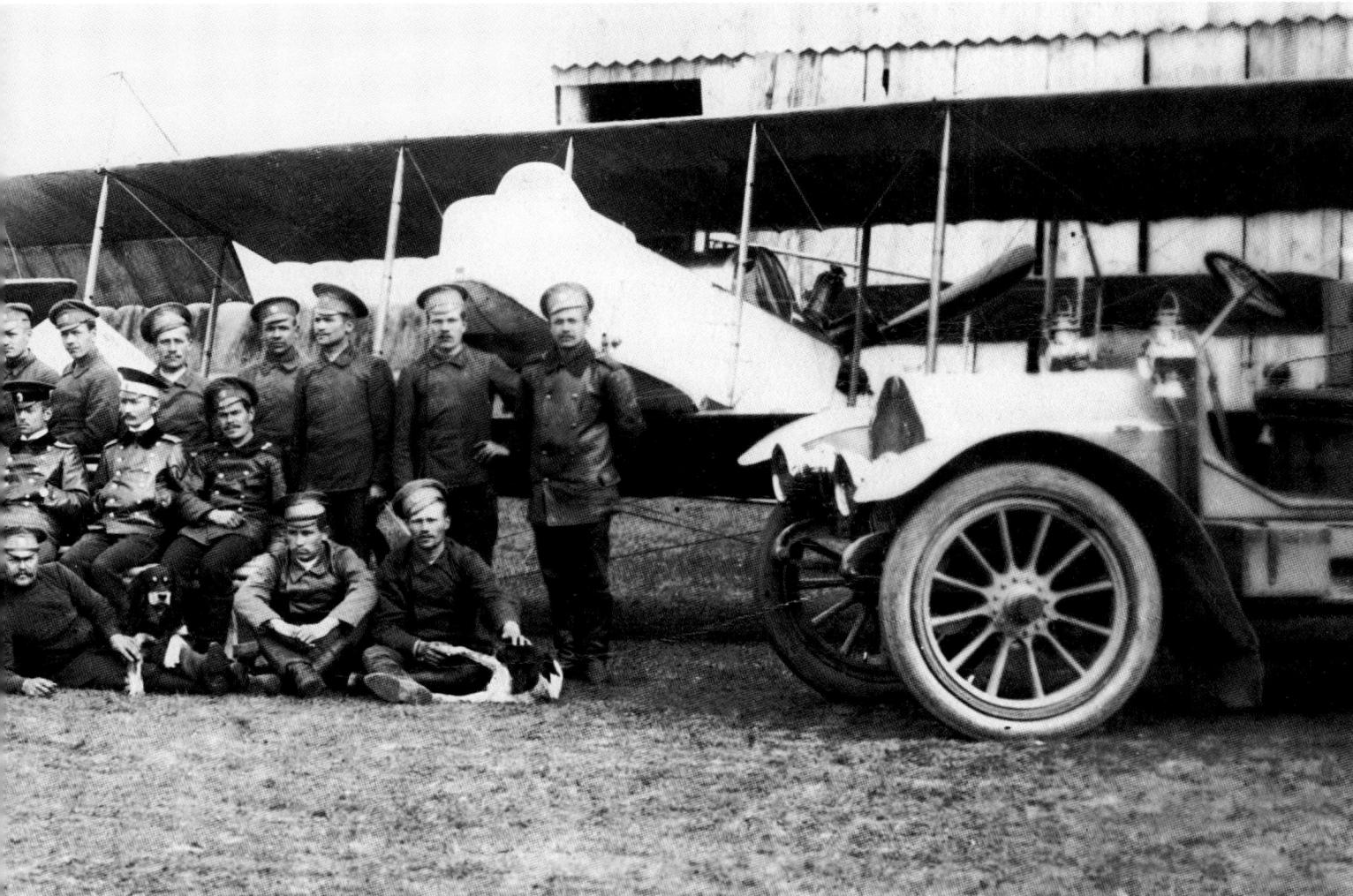

383. Inspection of an airborne squadron. Pilots and mechanics stand in front of their *Niupor-IV* **and** *Farman-XVI.*
Spring 1914

384. A rare machine for frontline aviation - the *Moran Biplane,* **or** *Morbip.* **The pilot is Senior Non-Commissioned Officer A. Andreev.**
3rd Fighting Airborne Squadron. 1916
There were only a few of such planes made.

385. The plane *Spad* **after an emergency landing on a neutral strip of land. A team of reconnaissance men of the shooting regiment stand nearby, in the midst of taking the plane to their side.**
Galitsiya. 1917

385

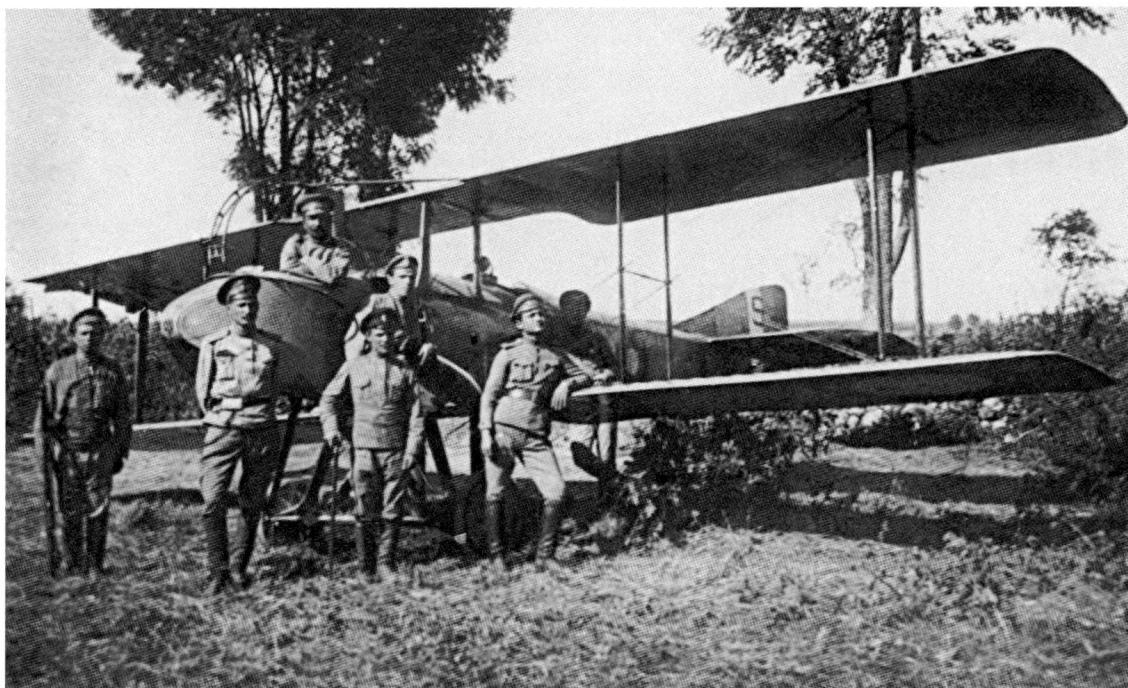

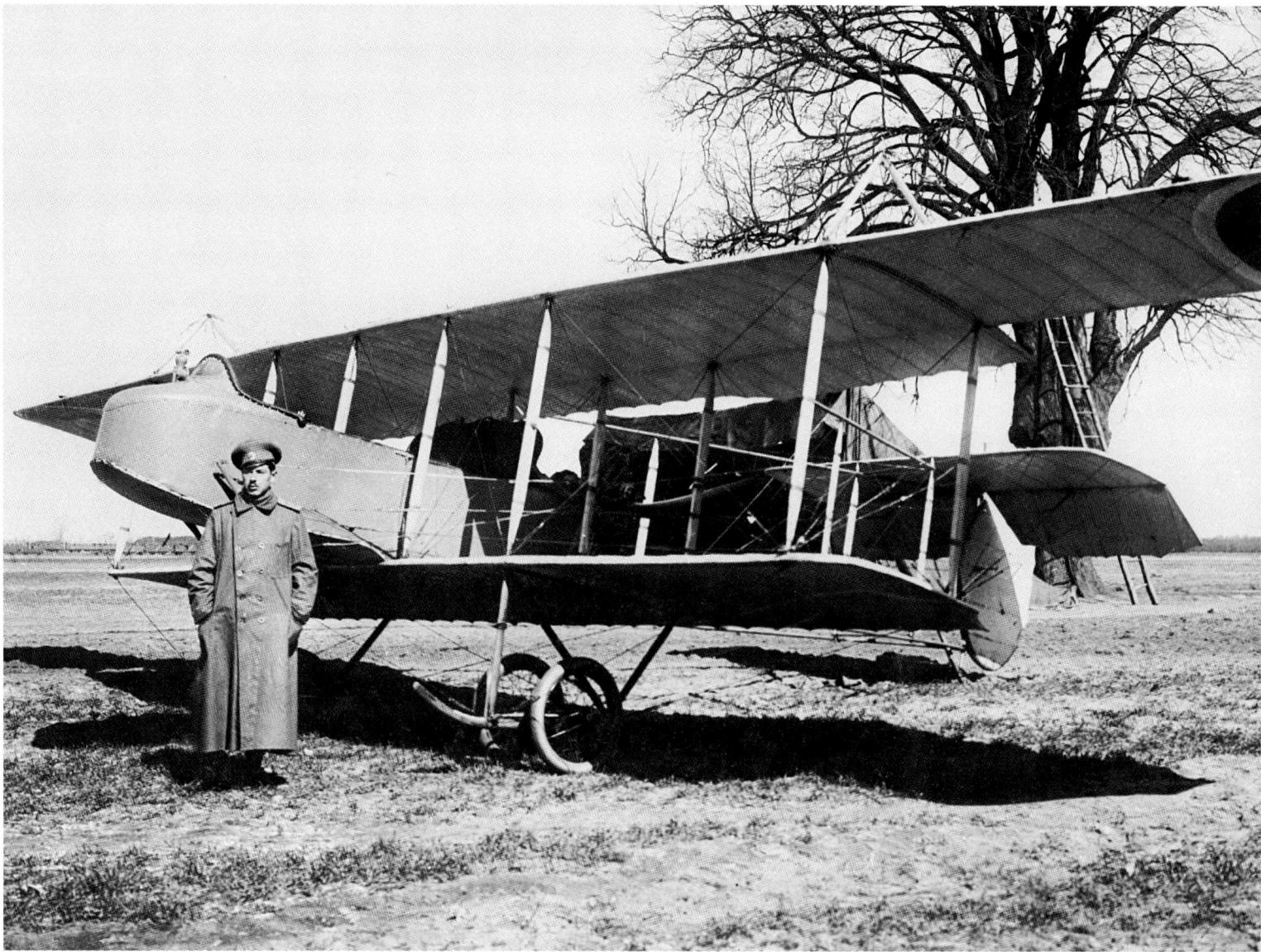

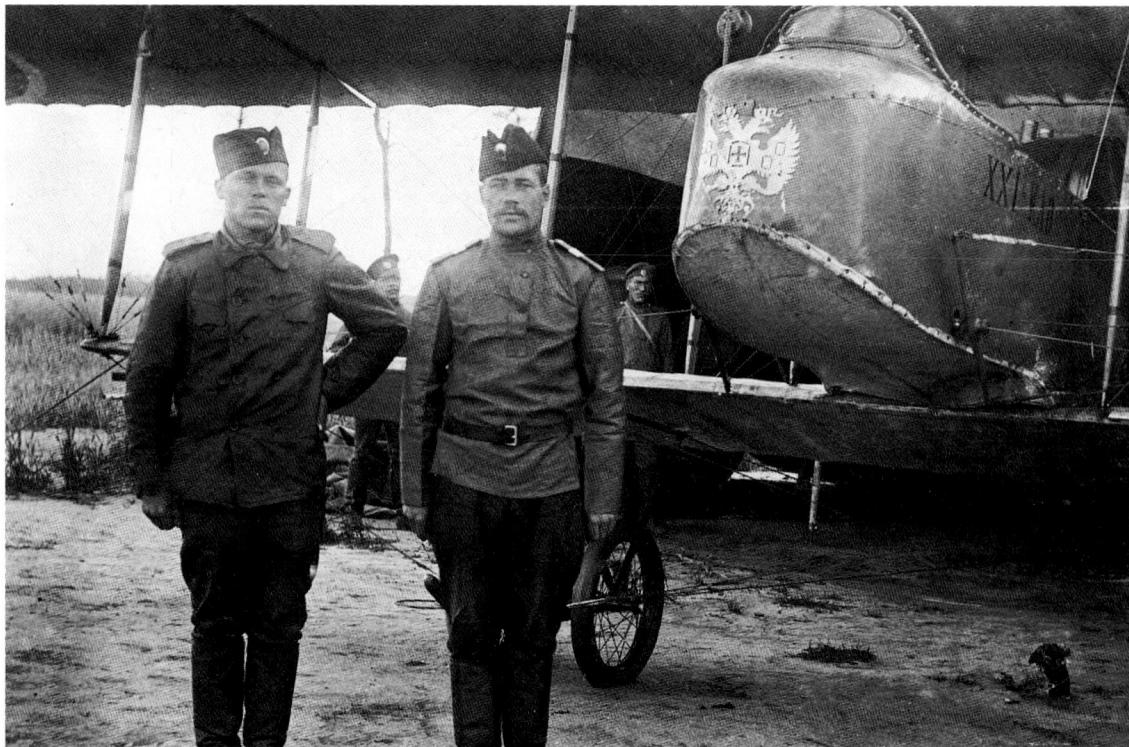

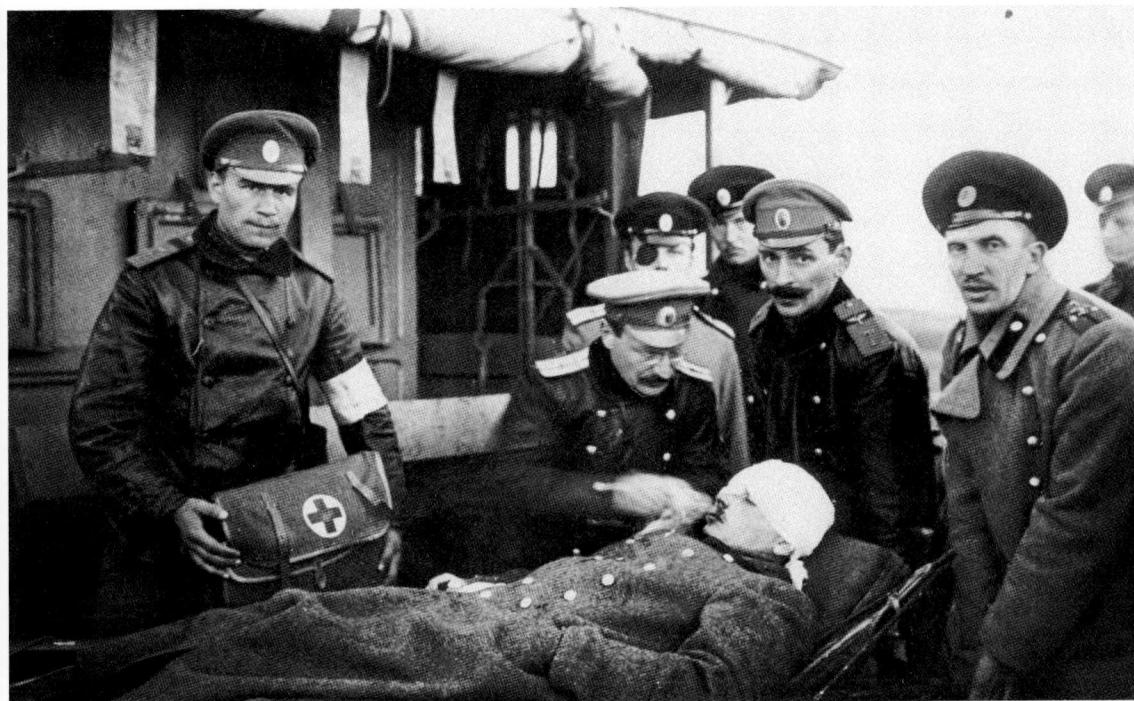

386. A pilot near his "fighting fellow" the *Farman-XXII*, during a free minute on the ground.
21st Corpus Airborne Squadron. 1916

387. Aviation mechanics near the *Farman-XXII*.
21st Corpus Airborne Squadron. 1916
The official heraldry on the plane is the two-headed eagle and the side name says it belongs to an airborne squadron.

388. Pilot-Ensign L.A. Grinev is taken to the hospital by colleagues from the 5th Airborne Squadron after an accident.
May 25, 1915

389. The aviation and technical crew of the airborne squadron under the command of V.M. Tkachev being inspected by Grand Duke Alexander Mikhailovich. First from the left is Grand Duke Alexander Mikhailovich, second is A.V. Pankratiev, third is V.N. Gatovskyi; on the right, in the foreground in a cap is A. Puare.
Konsk. 1915

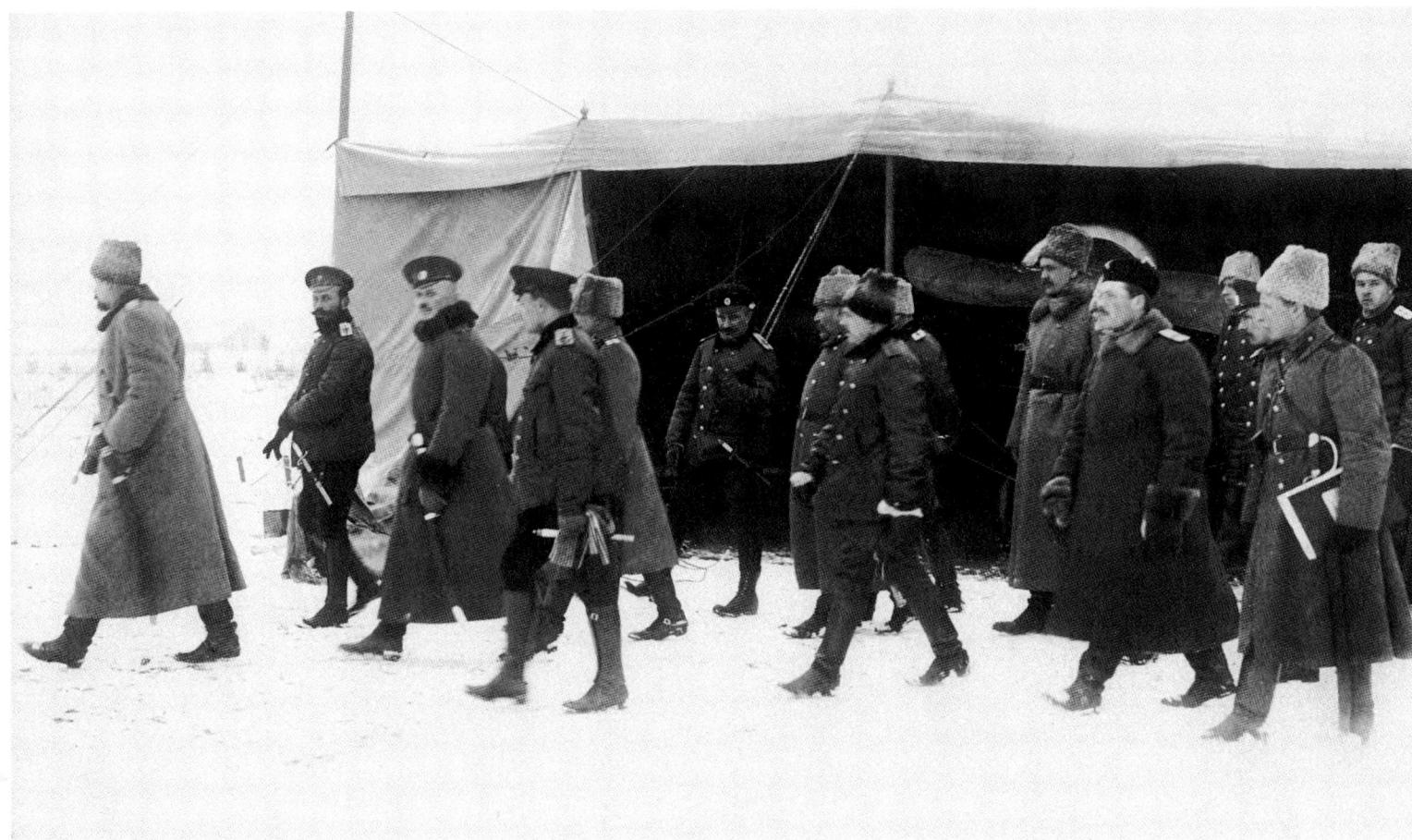

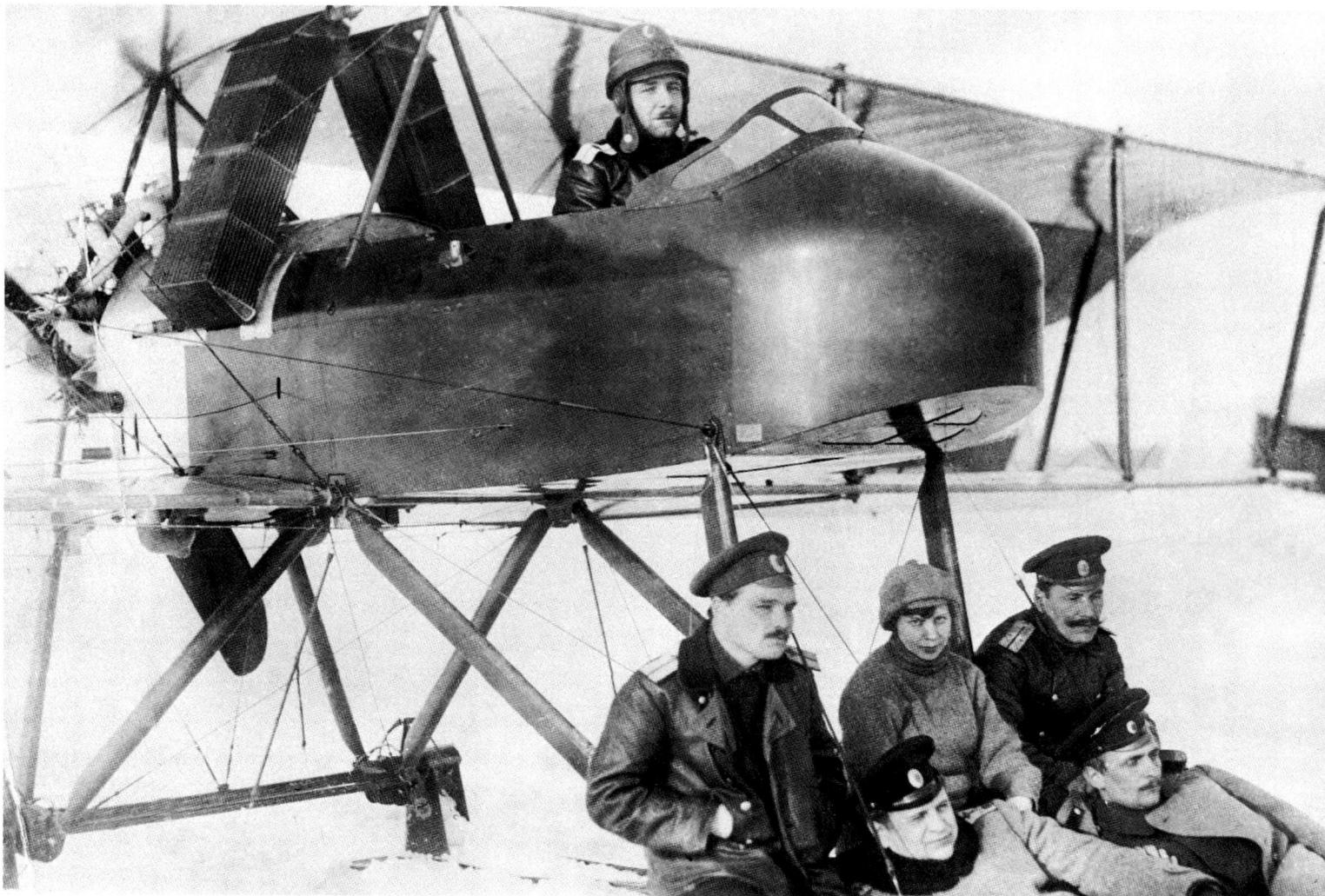

390. The *Vuazen*, modernized by aviator Second Lieutenant P.I. Ivanov.

6th Aviation Park in the city Zhmerinka. Winter 1916

The pilots are awaiting orders to fly on reconnaissance. Modifications on this Vuazen turned out to be so successful, that it was built in a series from 1916-1917.

391. An *Farman-XVI* airplane, originally made by aviator and designer A.G. Shiukov.
1916

392. A friendly lunch between frontline aviators.
1915 – 1917

393. Weekdays on the front. Regulating the motor on a *Vuazen*.
1916

391

394. Near the *Farman-XXII*, with the name *"GRD"* (belonging to Grenadiers Corpus of the Russian army).
1915—1917

395. An aviator-observer takes pictures on a reconnaissance flight on the *Farman-XVI*. **The pilot is G. Adler.**
1914—1915

396. A pilot's work station, with an aviator-observer in the cabin of a *Vuazen* plane.
1915—1917

Aviator-inspectors took bottles with incendiary mixtures, as well as standard weaponry (bombs).

397. Lieutenant V.R. Poplavko's experiment for implementing Maxim guns in the cabin of a *Farman-XXI*.
4th Airborne Squadron. City Lida.
1913—1914

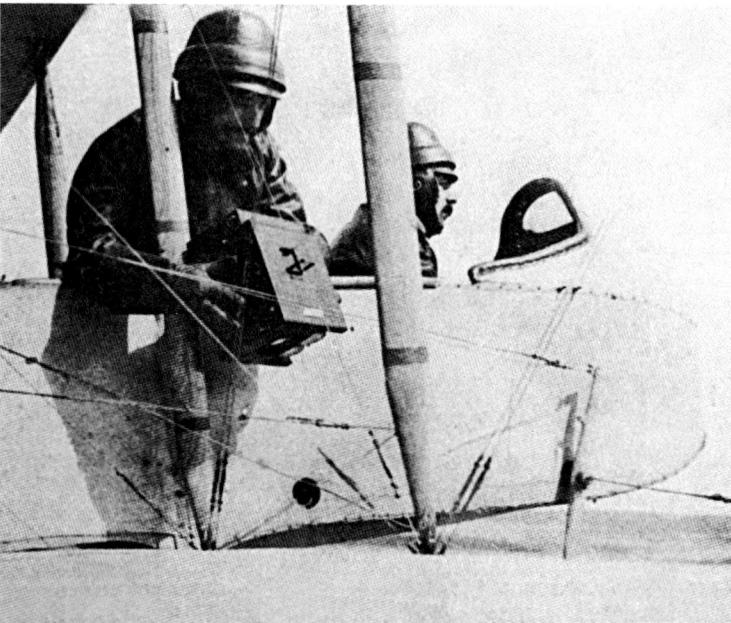

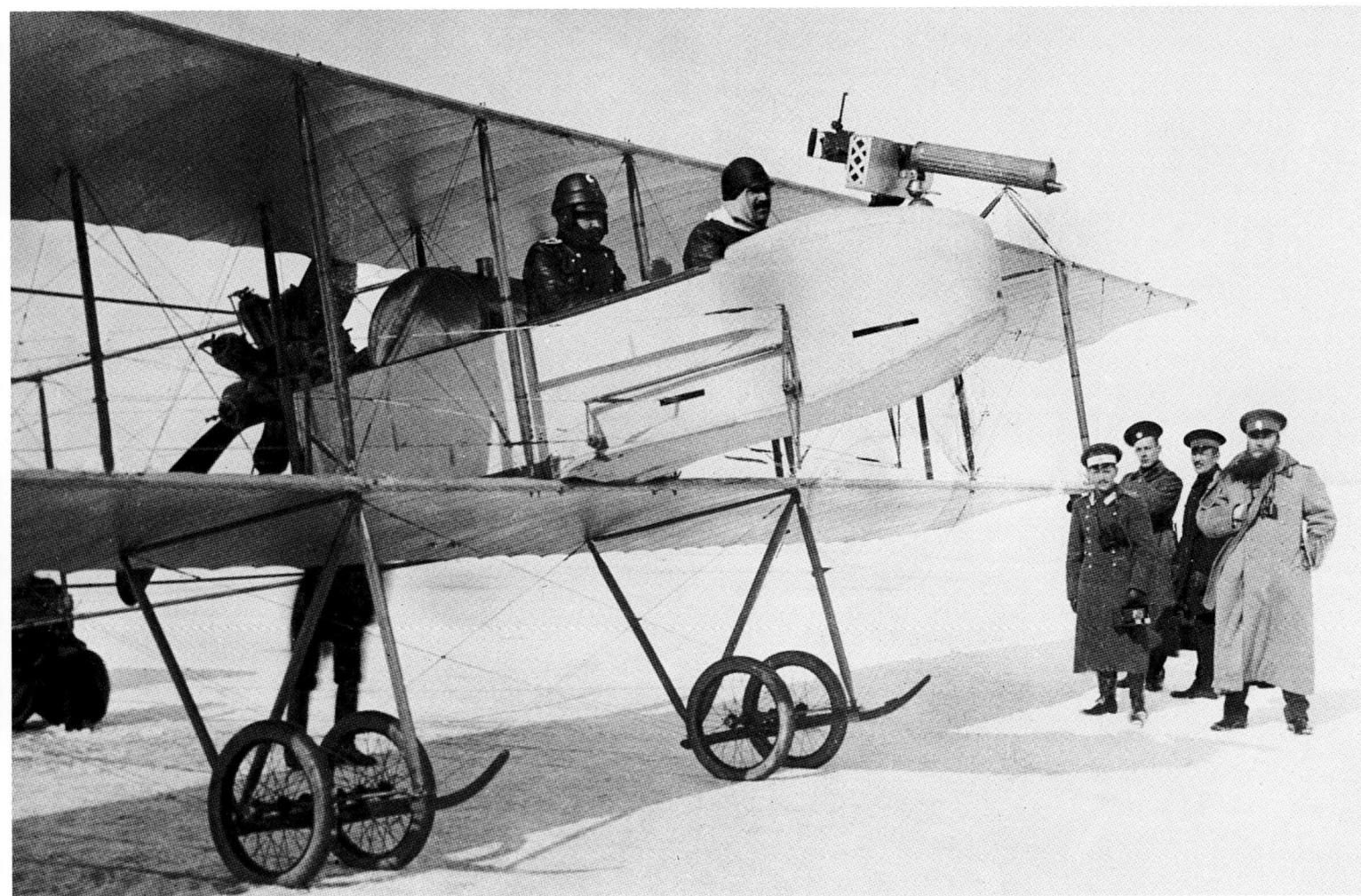

398. At the beginning of the war, bombs were dropped by hand without any special instruments. In the front of the cabin is pilot G. Adler.
1914—1915
The accuracy of the bombs completely depended on the eye of the aviator-observer.

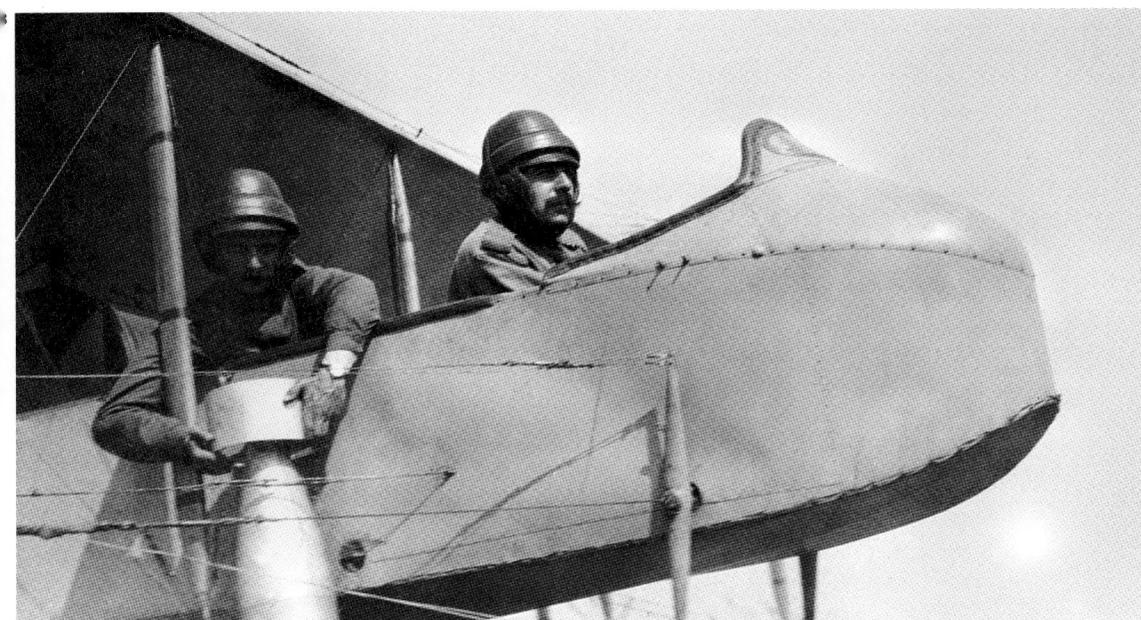

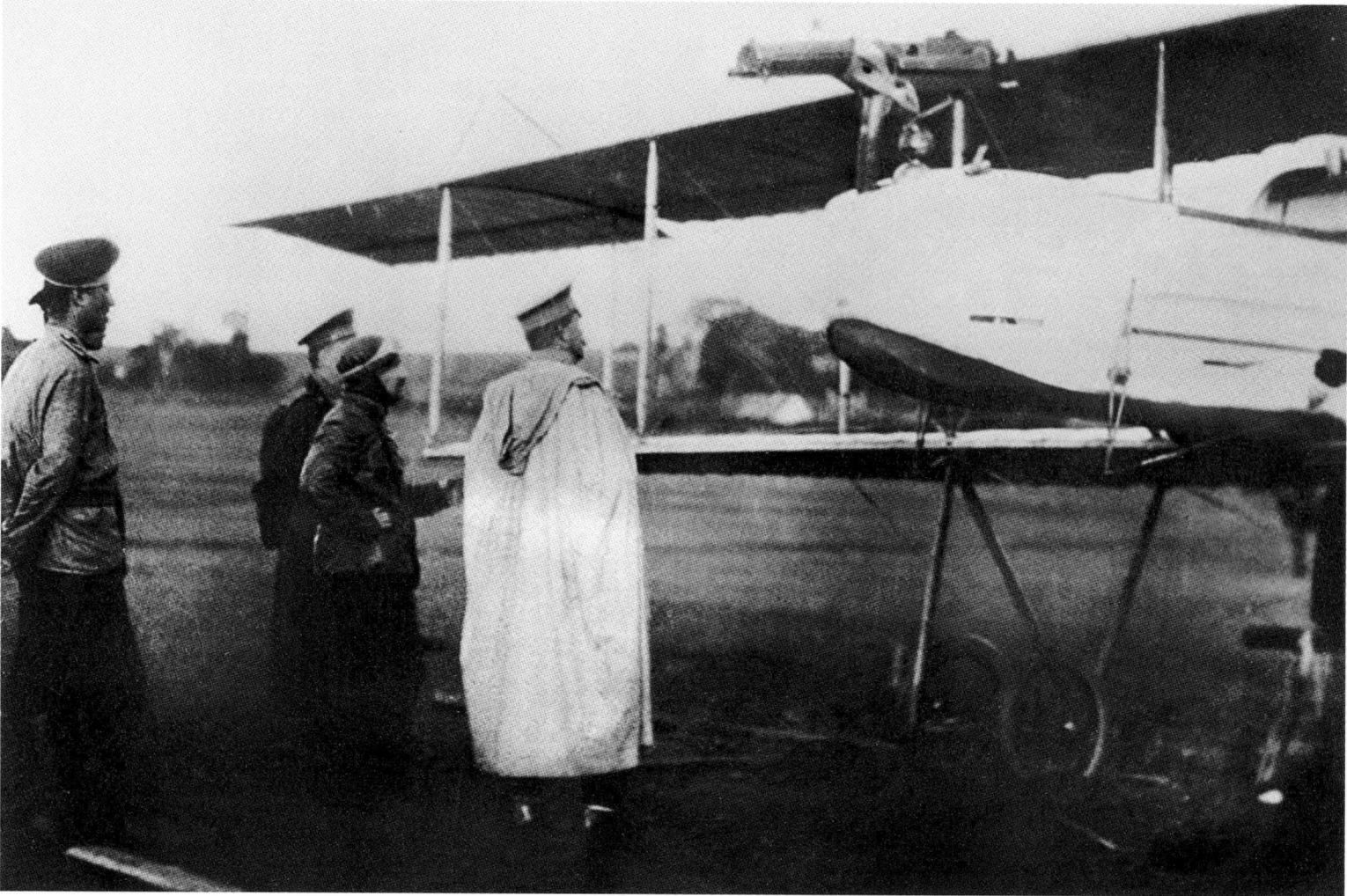

399. A pilot acquaints command with a modernized variant of the plane *Farman-XV*, armed with Maxim guns on a swivel lathe, designed by lieutenant V.R. Poplavko.

Lida Airfield. 21st Corpus Airborne Squadron. 1913 — 1914

400. The plane *Farman-XVI* under a shelter before being sent to the Front. "1st Aviation Squadron. St. Petersburg" is name written on its side On the far left is staff captain K. Prussis.

July 1914

401. Important guests visit one of the airborne squadrons. In the foreground (right from left) is Grand Duke Nikolai Nikolaevich, prince Karol (the future Karol II) and King of Romania, Ferdinand I.

[1916 г.]

402. General A.A. Batyiskyi with his family as they visit reconnaissance aviators.

10th Corpus Airborne Squadron. 1916

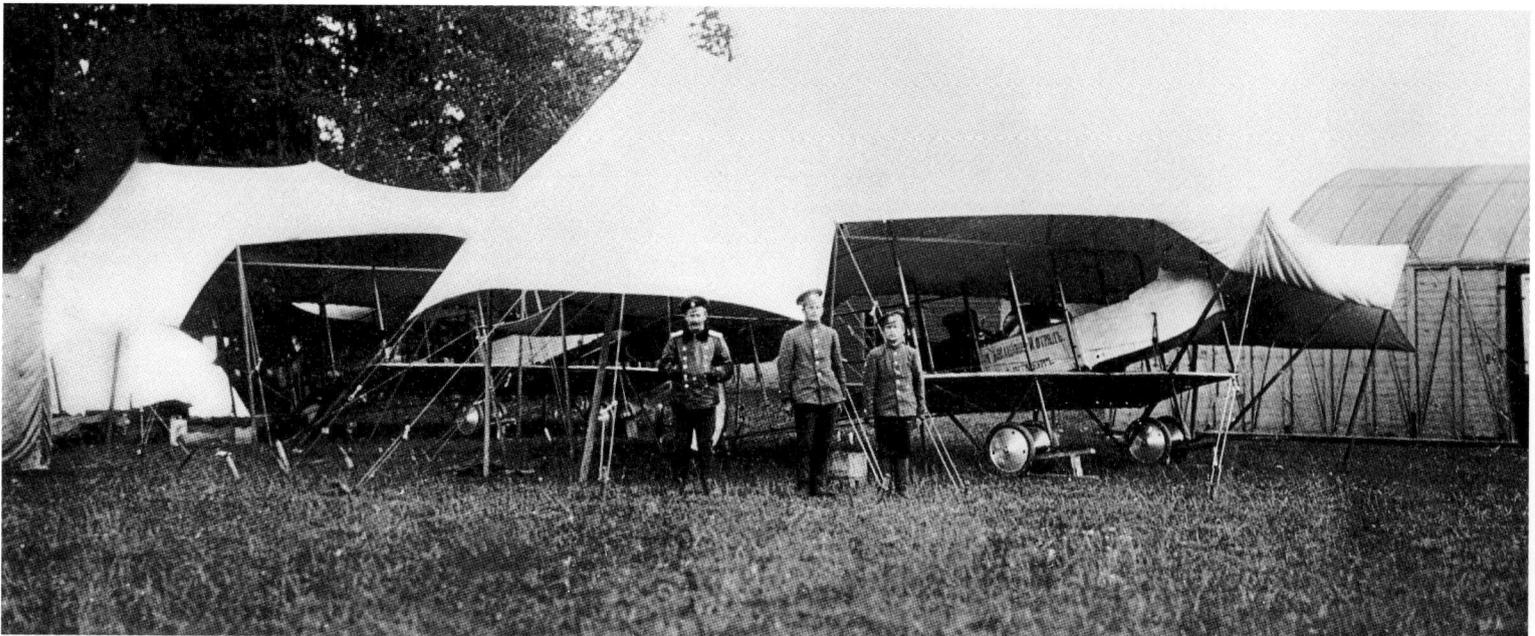

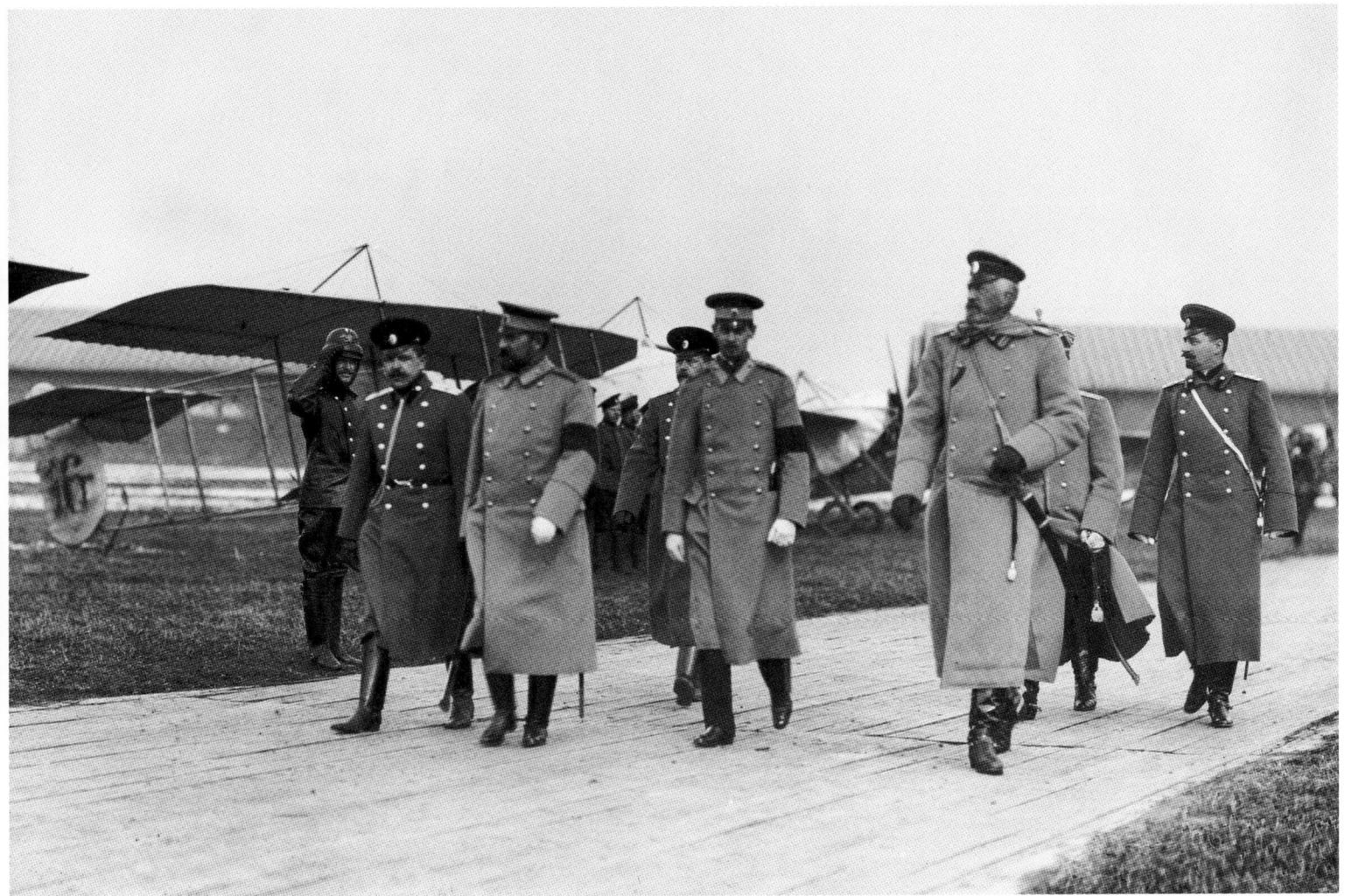

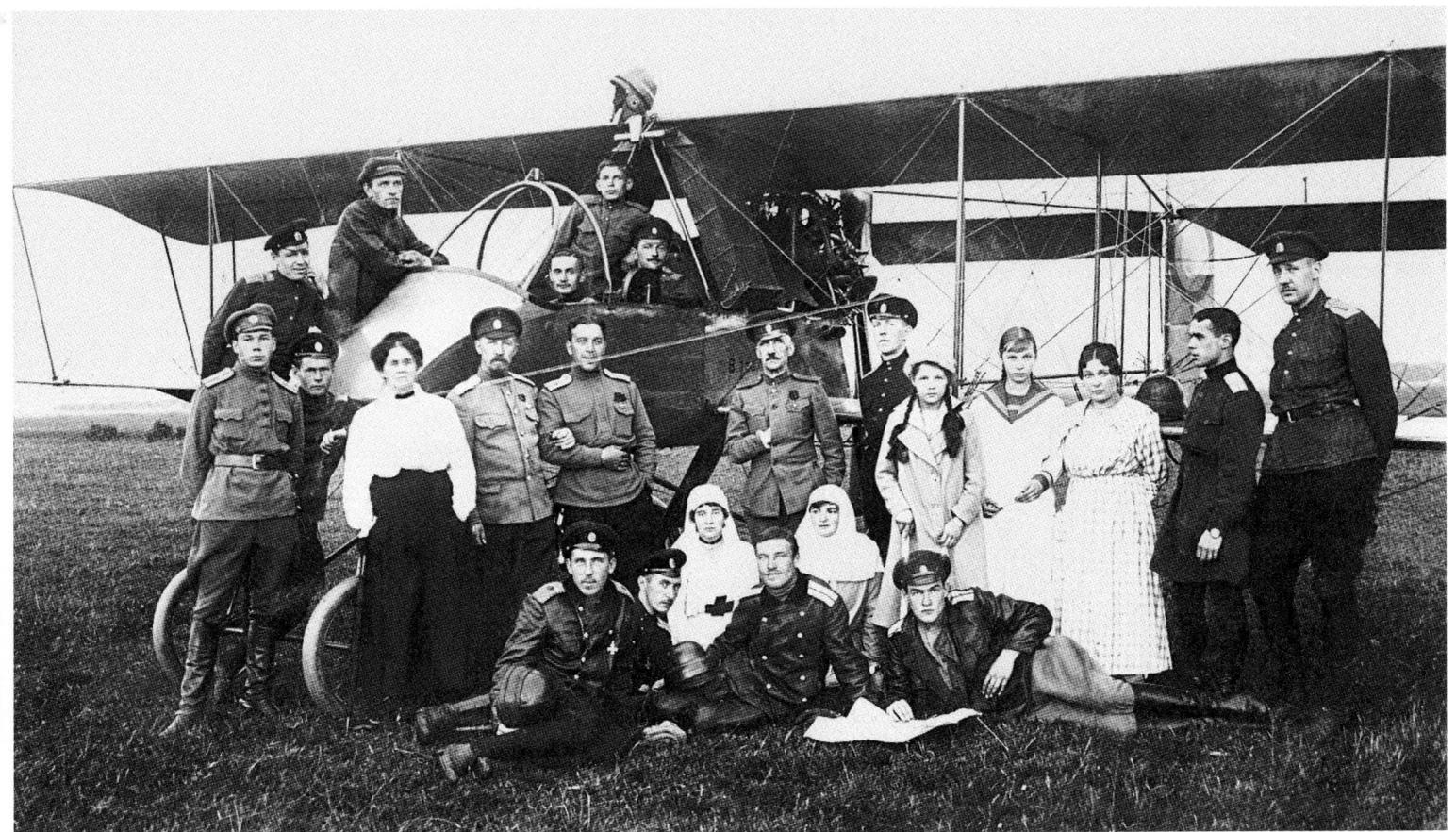

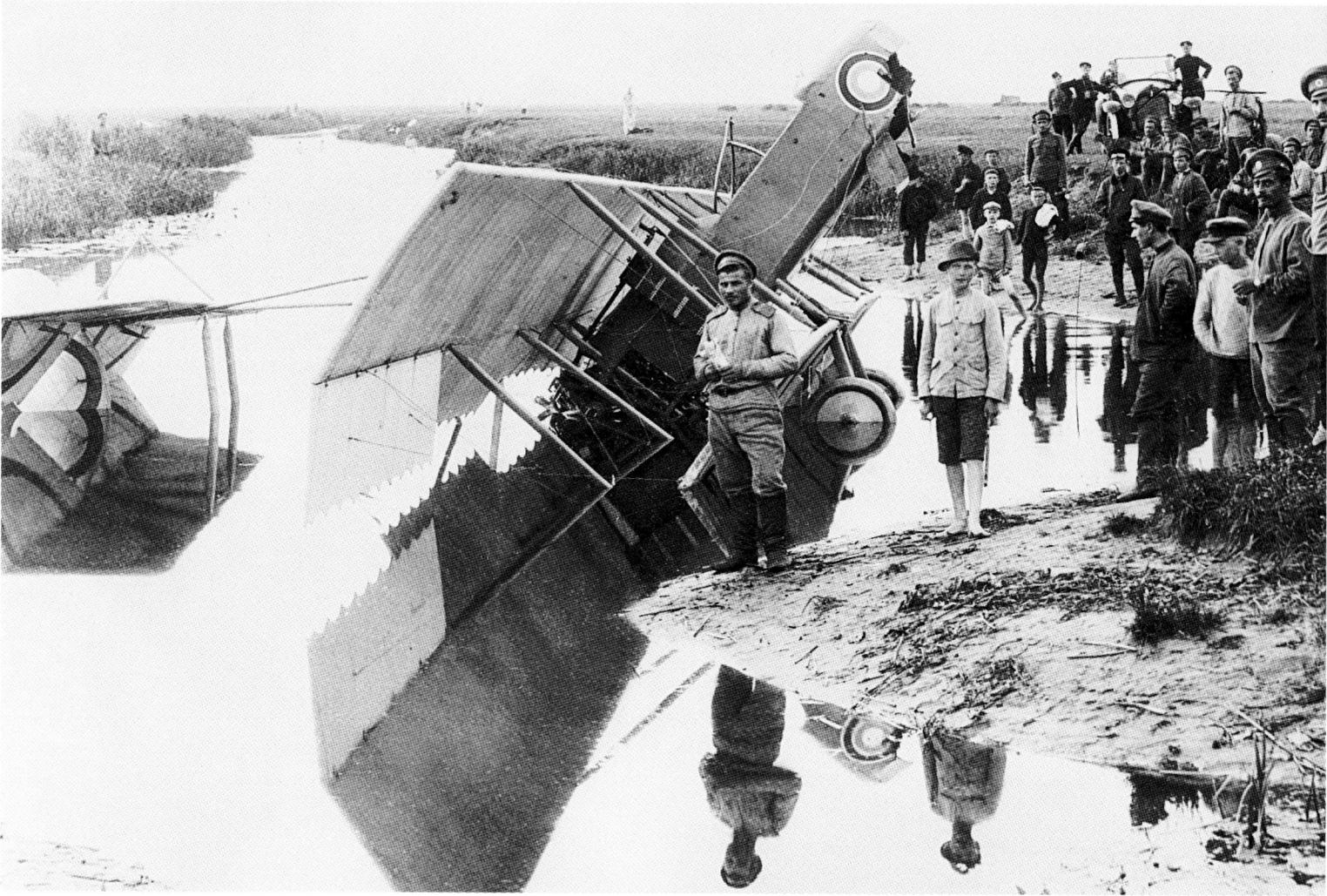

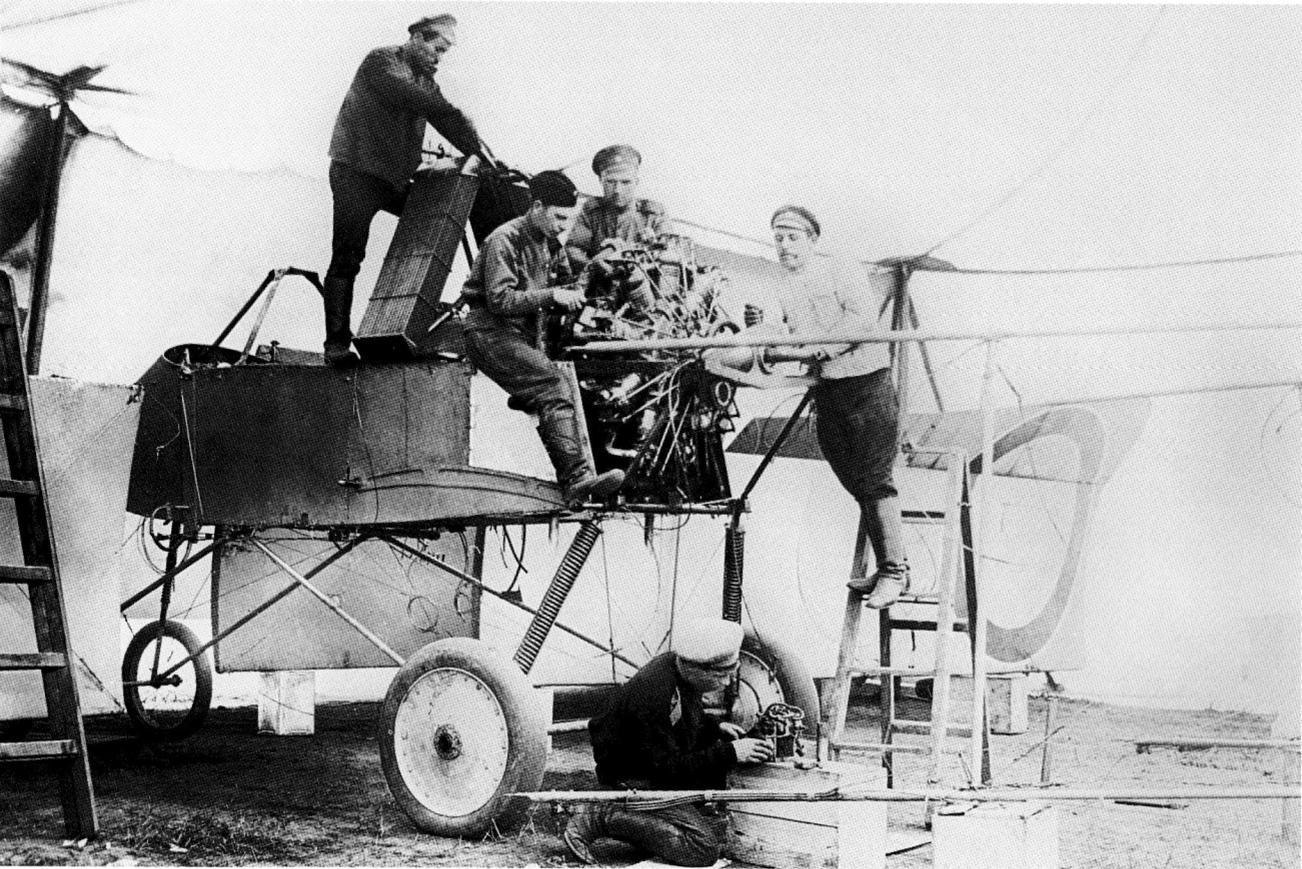

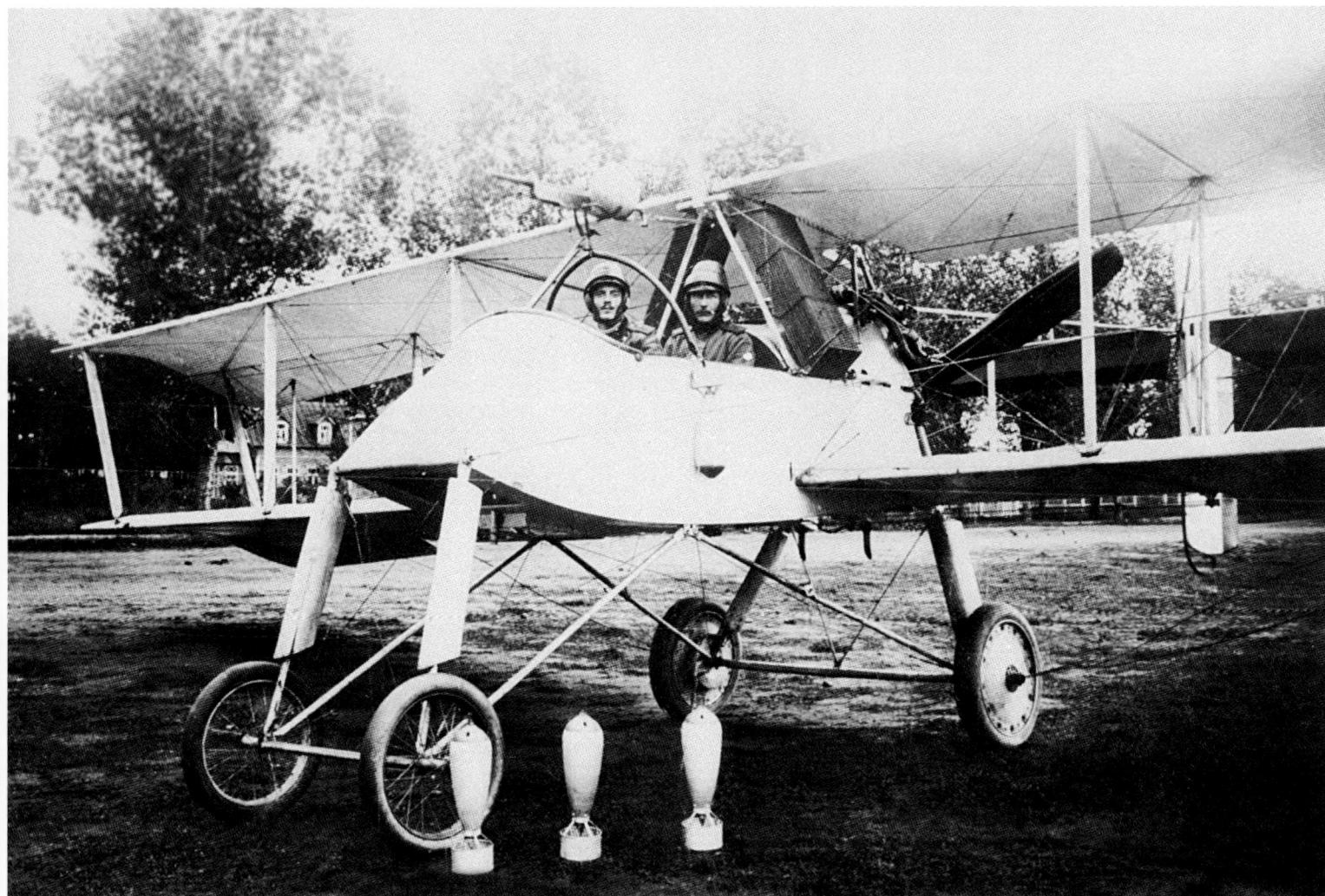

403. Pilot-Ensign G. Popov's relatively successful landing.
10th Corpus Airborne Squadron. 1916

404. Regulating the engine of the *Vuazen* in a tent for field repairs.
1916

405. The crew of the *Vuazen* with a complement of bombs, which they took into the cabin.
1916 — 1917

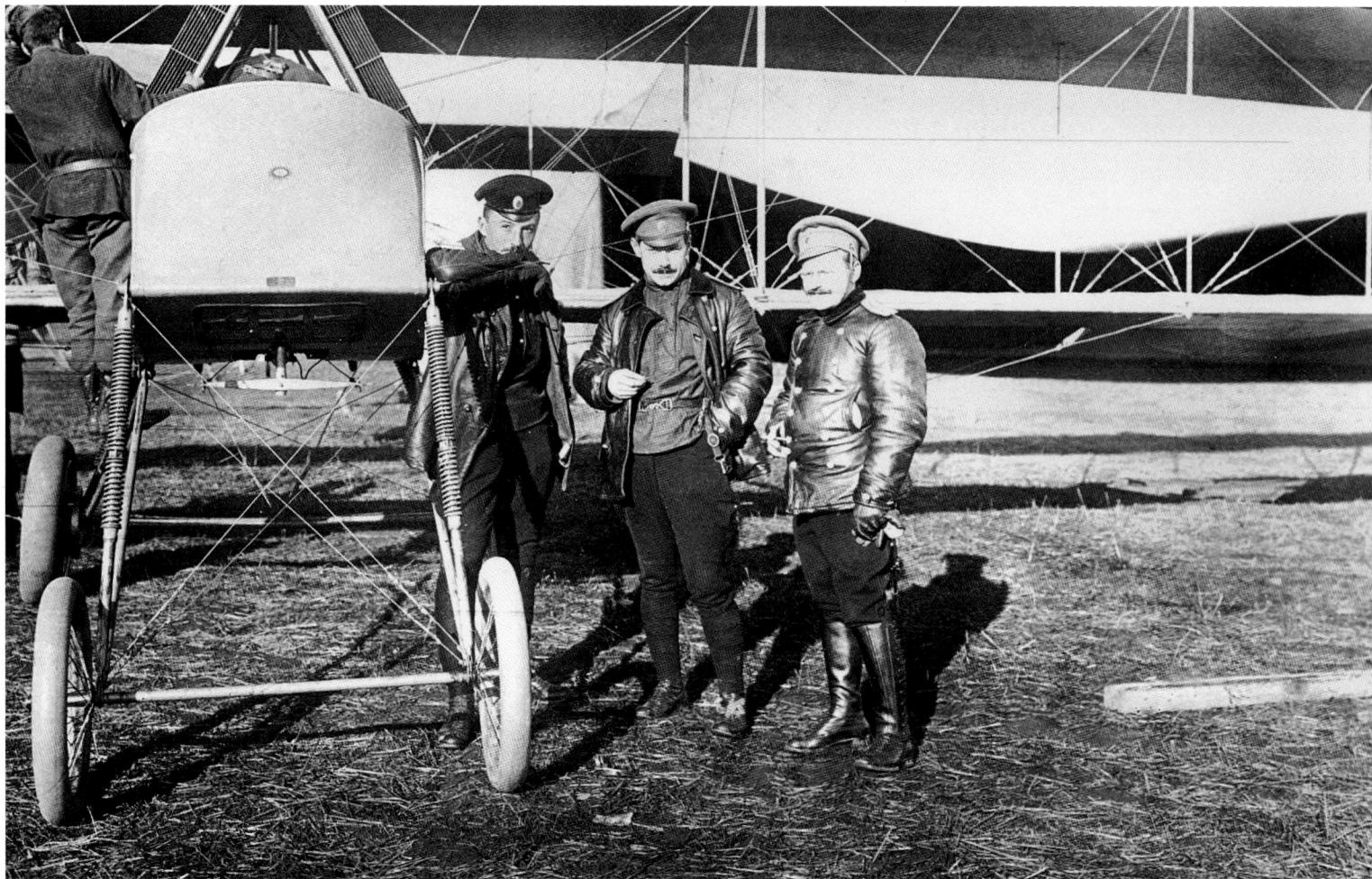

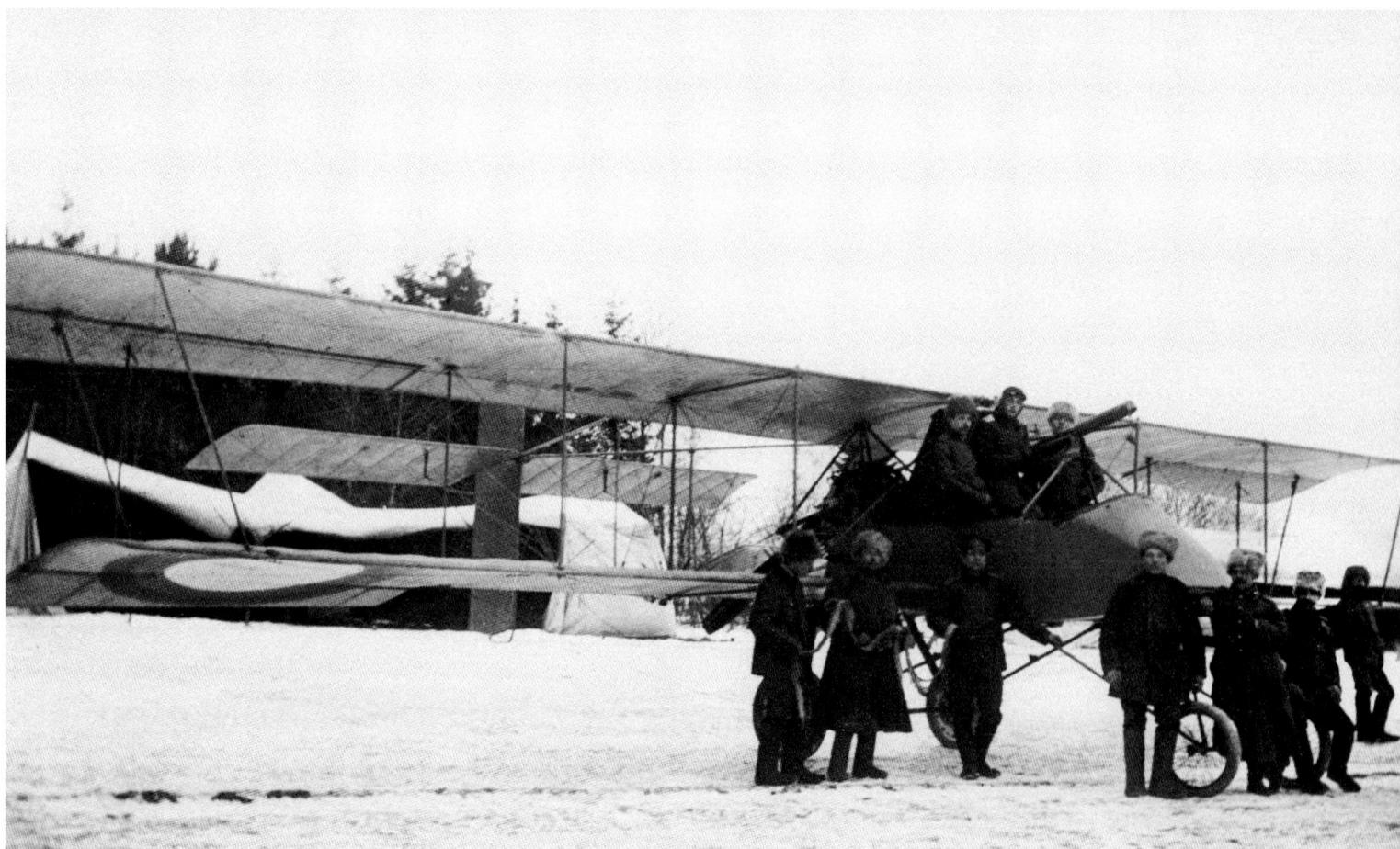

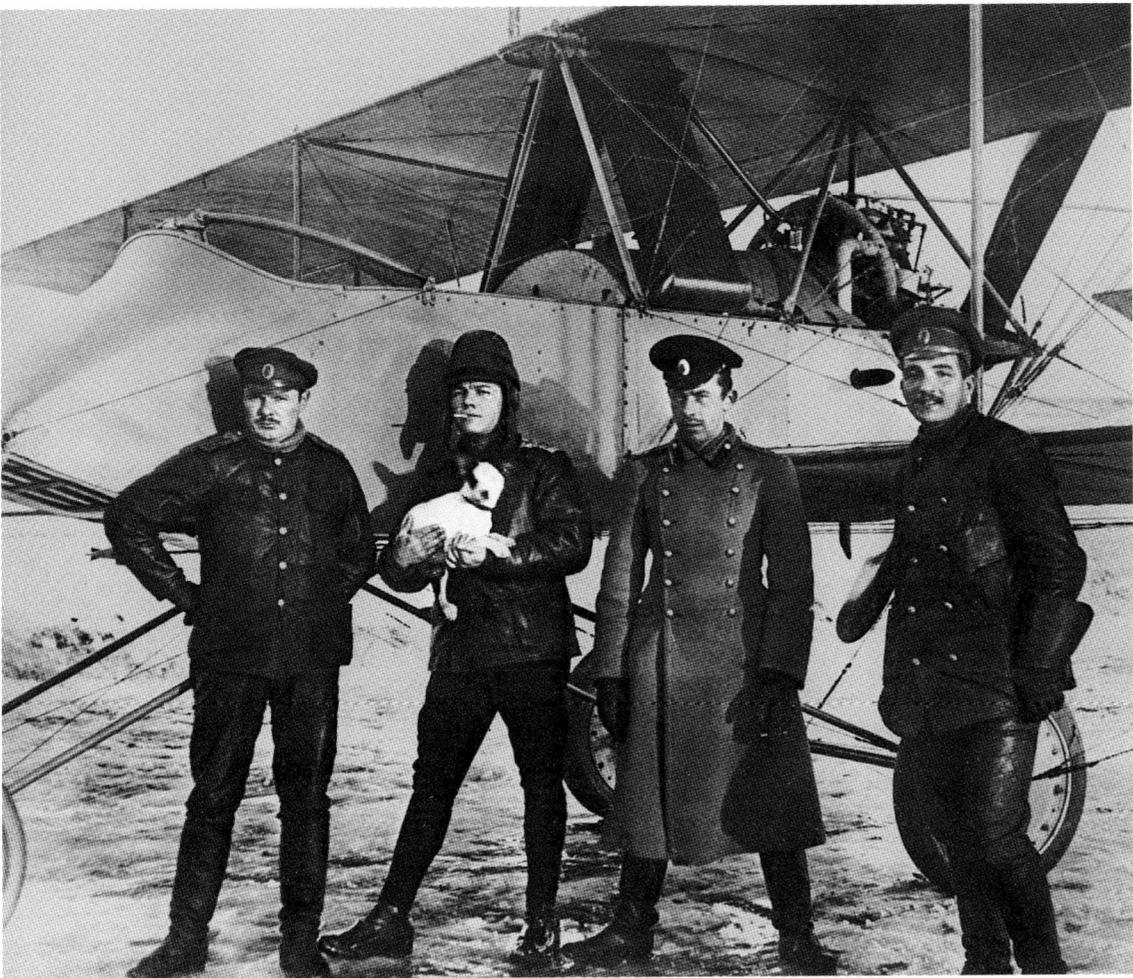

406. Pilots of the 10th Airborne Squadron near the new variant of the *Vuazen* plane.
1915

407. Planes of the *Vuazen-L* type also flew in the winter from well-plowed airfields on wheeled chassis.
Northern Front. 1916

408. Pilots of the 4th Military Squadron with their dog, near the reconnaissance airplane *Vuazen-L*.
1916 – 1917

409. A. Kerenskyi's ceremonial reception in Riga during a visit of Northern Front airborne squadrons.
Summer 1917

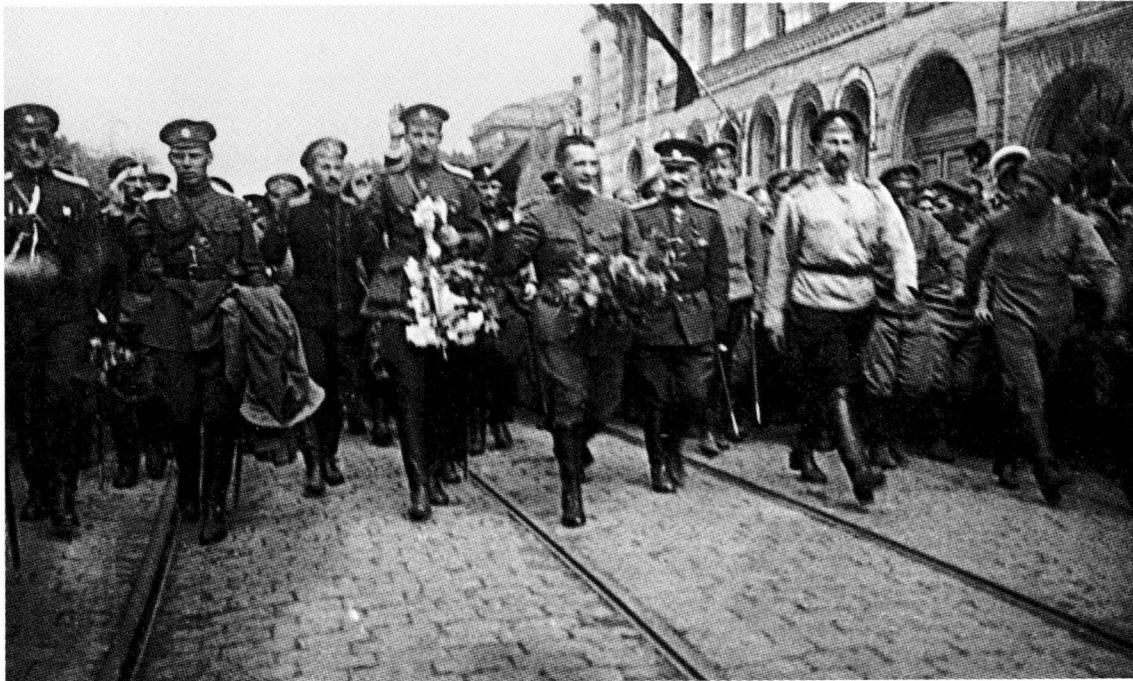

INDEX OF PLANES

INDEX OF AEROSTATS AND DIRIGIBLES

INDEX OF ABBREVIATIONS

INDEX OF NAMES

IMPERIAL RUSSIAN
AIR FORCE

In Photographs at the Beginning
of the Twentieth Century

Gennady Fedorovich Petrov